Painters and Paintings in the Early American South

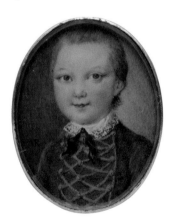

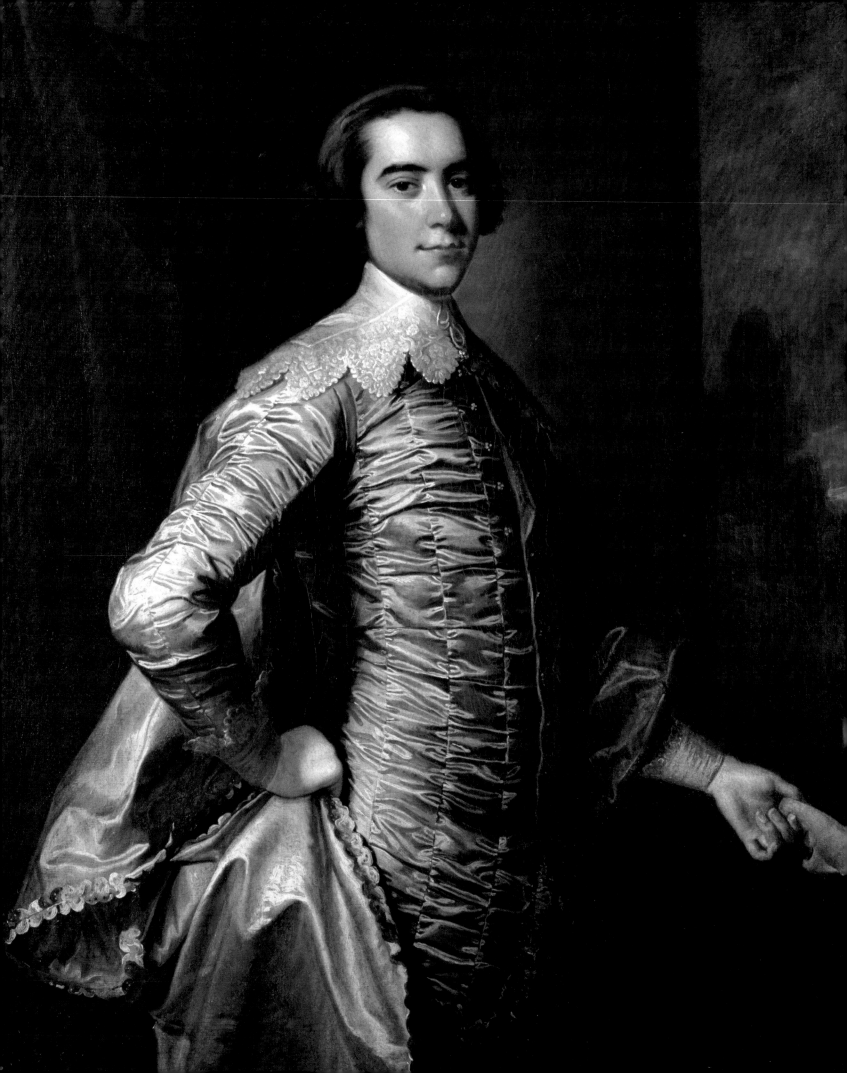

PAINTERS AND PAINTINGS IN THE
Early American South

CAROLYN J. WEEKLEY

Colonial Williamsburg

The Colonial Williamsburg Foundation
Williamsburg, Virginia

in association with

Yale

Yale University Press, New Haven & London

25 24 23 22 21 20 19 18 17 16 15 14 13 1 2 3 4 5

Library of Congress Cataloging-in-Publication Data
Weekley, Carolyn J.
Painters and paintings in the early American South /
by Carolyn J. Weekley.
 pages cm
Includes bibliographical references and index.
ISBN 978-0-87935-252-3 (hardcover : alk. paper)
ISBN 978-0-300-19076-2 (hardcover : alk. paper)
1. Painting, American—Southern States. 2. Painters—
Southern States. I. Title.

ND220.W44 2013
759.15—dc23 2012000317

Colonial Williamsburg is a registered trade name of
The Colonial Williamsburg Foundation, a not-for-
profit educational institution.

The Colonial Williamsburg Foundation
PO Box 1776
Williamsburg, VA 23187-1776
www.history.org

Published in association with Yale University Press
PO Box 209040
302 Temple Street, New Haven, CT 06520-9040
www.yalebooks.com/art

Printed in Singapore
Designed by Jo Ellen Ackerman

FRONT COVER: Henry Benbridge, *Charlotte Pepper Gignilliat* (Mrs. James Gignilliat), ca. 1775. Detail of figure 7.57.

BACK COVER: Clockwise from top left: Charles Willson Peale, *William Buckland*, begun in 1774 and completed in 1787, detail of figure 7.35. John Durand, *Elizabeth Boush*, dated 1769, detail of figure 6.9. Matthew Pratt, *Thomas Bolling*, 1773, detail of figure 7.19. John Wollaston Jr., *Mrs. Edward Thomas* (Anne Gibbes), 1767, detail of figure 5.26.

HALF-TITLE PAGE: Mary Roberts, *William Middleton*, ca. 1754. Figure 4.13.

FRONTISPIECE: Thomas Hudson, *Robert Carter III of Nomini Hall*, 1753–1754, oil on canvas, 50" x 40". Virginia Historical Society (1973.17).

Robert Carter III (1728–1804), also known as Councillor Carter, was the grandson and namesake of Robert "King" Carter of Virginia. He was twenty-five years old when he commissioned this portrait from Thomas Hudson (1701–1779). A remarkable likeness, and one of the most sophisticated portraits painted for a southerner during the eighteenth century, the painting shows him dressed in Vandyke costume and holding a mask as if preparing to attend a masquerade ball. This portrait hung in the sitter's house on Palace Green in Williamsburg before being moved to Nomini Hall in Richmond County, Virginia.

DEDICATION PAGE: Artist unidentified, *William Byrd I*, 1658–1668. Detail of figure 2.11.

CONTENTS PAGE: Bishop Roberts, *Prospect of Charles Town*, 1737–1738. Detail of figure 4.9.

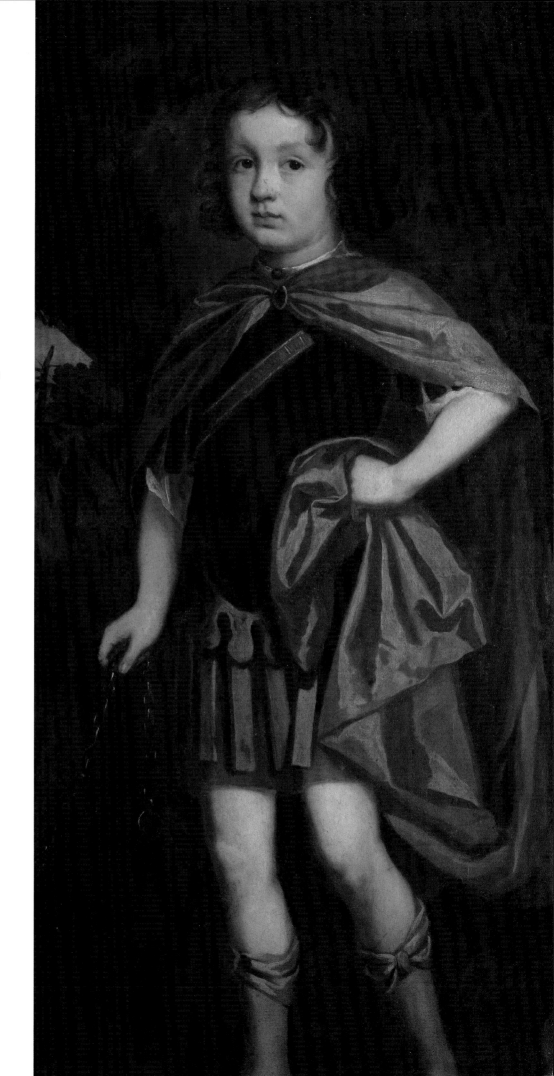

For
Juli and David Grainger,
devoted and
generous friends

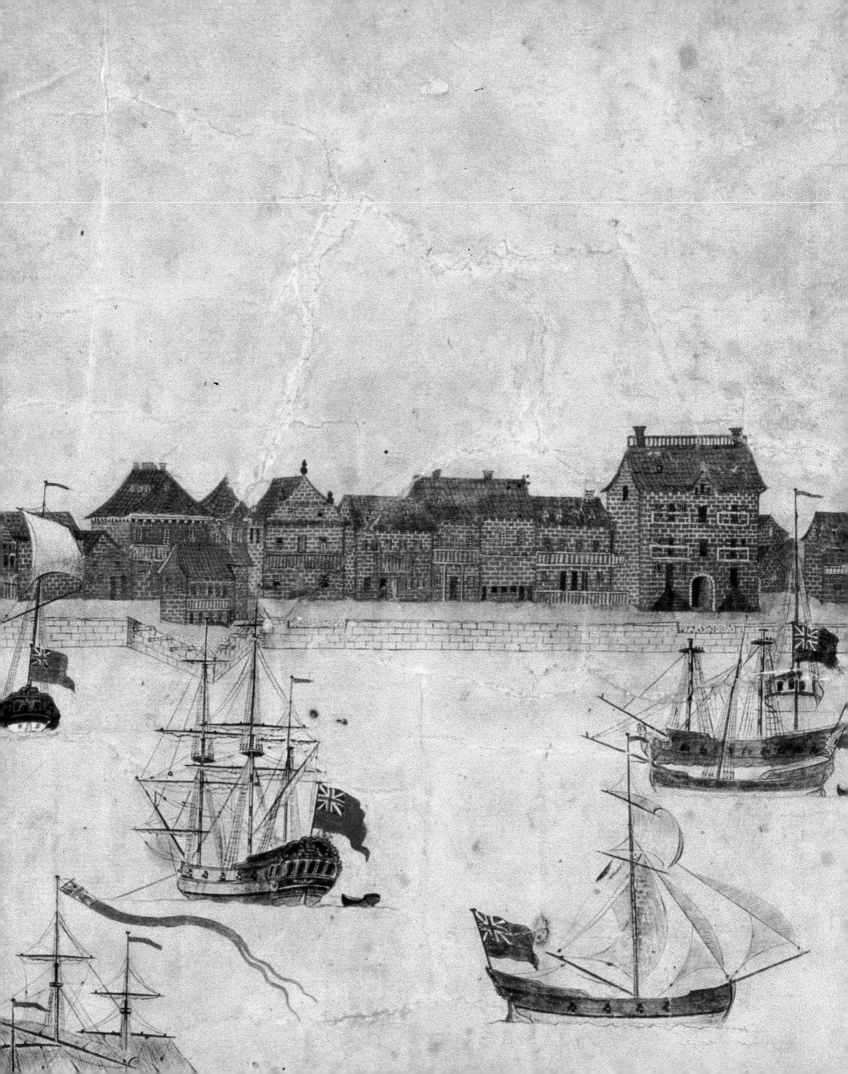

Contents

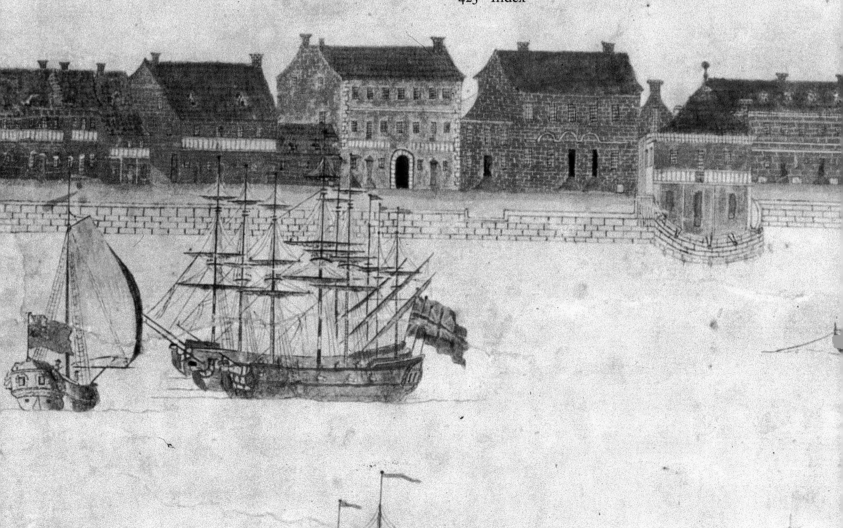

Foreword

Following an illustrious European military career, thirty-four-year-old Alexander Spotswood was commissioned lieutenant governor of Virginia in 1710. Ambitious and talented, he accomplished much during his twelve years in office. His architectural skills shaped Bruton Parish Church, the Magazine, and other Williamsburg buildings, and he effectively led efforts to control piracy, explore western regions, regulate the tobacco trade, and enhance Indian relations. In 1729 Spotswood moved inland to manage his vast estates and his burgeoning iron business from Germanna, perhaps the most lavish house in the colony. He died in 1740 at the then advanced age of sixty-four while preparing for a South American military expedition.

Spotswood sat for portraitist Charles Bridges in 1736. If not the ablest painter in the South, Bridges was among the earliest and best connected and would paint dozens of elite Virginians before returning to England. His grand likeness of Spotswood is filled with symbols of the subject's status and interests, including costly attire, a fortified castle, a military encampment, and a scroll that may originally have featured an architectural drawing. (A similar scroll, with an architectural plan, appears in an early copy of the portrait, now at the Library of Virginia.)

The Colonial Williamsburg Foundation began exploring acquisition of the Spotswood portrait in 1929 when noted advisor Louis Guerineau Myers strenuously urged its purchase. Both a record of the artist's technique and a message-laden historical document, the painting squarely addressed Colonial Williamsburg's mission— that the future may learn from the past. Interest in the portrait was a harbinger of future collecting patterns; for more than eighty years, the Foundation's curators have consistently weighed both artistry and history when considering additions to the collection. Colonial Williamsburg is thus well suited to sponsor a project such as *Painters and Paintings in the Early American South,* which explores both art and history in rich detail.

If the Colonial Williamsburg Foundation is the appropriate place for this work, Carolyn Weekley is the appropriate scholar. Weekley's interest in the study of antique objects dates to early childhood when arrowheads gathered along Virginia's York River were among the first artifacts to come under her scrutiny. Following that path, she eventually held key roles at major southern institutions, including the Museum of Early Southern Decorative Arts, the Virginia Museum of Fine Arts, and, for more than thirty years, the Colonial Williamsburg Foundation. Her scholarship has plumbed a broad range of topics, but the art of the early South always remained at the core of her curatorial curiosity. This volume is the ultimate expression of that intellectual focus. With its insights and revelations, it will become a standard reference on the subject.

Painters and Paintings in the Early American South would not have been possible without Juli and David Grainger and the Grainger Foundation. We gratefully acknowledge their public-spirited decision to fund the research, writing, and publication of the book; the design and production of the associated exhibitions at the DeWitt Wallace Decorative Arts Museum; and the conservation of several paintings depicted herein. We also acknowledge with thanks the DeWitt Wallace Fund for Colonial Williamsburg, which underwrote the curation, conservation, and exhibition of the Foundation's many southern paintings and drawings.

Ronald L. Hurst
The Carlisle H. Humelsine Chief Curator
The Colonial Williamsburg Foundation

Attributed to Charles Bridges, *Alexander Spotswood* (1676–1740), 1736, oil on canvas, 48 ⅛" x 38 ⅝". Colonial Williamsburg Foundation, Williamsburg, VA.

After negotiating with the owner for eleven years, the Foundation succeeded in purchasing this portrait in 1940.

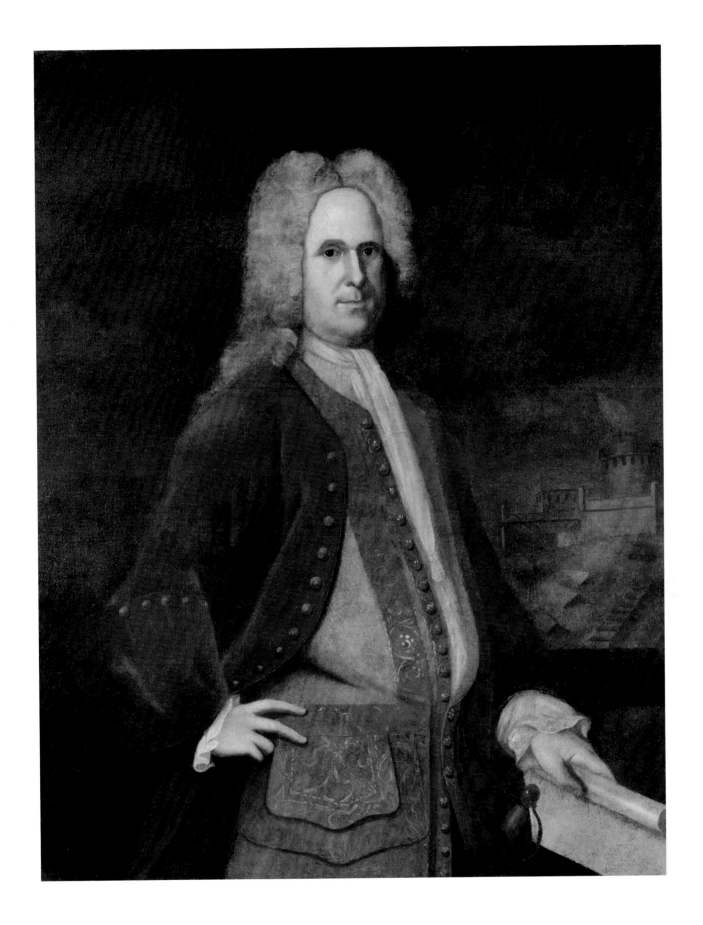

ix

Introduction

Painters and Paintings in the Early American South gathers into one volume an array of materials related to the paintings and the artists of the early South from its first explorers in 1564 through the Revolutionary period. It includes not only portraits—the predominant genre during much of the period—but also seascapes and landscapes as well as pictures made by explorers and naturalists who came to the region. Although much of the information exists in monographic studies, research has turned up important additional material in diaries, client letters, newspapers, and other sources. The integration of new with older material provides a more cohesive—and impressive—view of the subject.

There is no other volume of this sort. Wayne Craven's *Colonial American Portraiture,* Richard Saunders and Ellen Miles's *American Colonial Portraits, 1700–1776,* and Maurie D. McInnis and Angela Mack's *In Pursuit of Refinement: Charlestonians Abroad* are the only recent works addressing the early South's art in any detail. The first two of those treat all of colonial America, and the latter deals only with Charleston, South Carolina. Amy

Meyers's essay in Henrietta McBurney's *Mark Catesby's "Natural History" of America: The Watercolors from the Royal Library, Windsor Castle;* Amy Meyers and Margaret Beck Pritchard's *Empire's Nature: Mark Catesby's New World Vision;* and Paul Hulton's *The Work of Jacques Le Moyne de Morgues: A Huguenot Artist in France, Florida and England* all take up the first significant images of flora, fauna, and Native peoples of the region or those that recorded America's natural history over many decades. However, they do not address other kinds of painting in the early South.

The South of this period comprised a large area—all the settlements along the east coast from Maryland to Florida, as well as those along the Gulf Coast in the areas of present-day Biloxi and New Orleans. Western areas were also being gradually settled, but most art-making activities were confined to Atlantic coastal regions. Populations in Florida and Louisiana were small by comparison, and early European art from those regions is rare (see, for example, figs. I.1 and I.2). Even where art flourished, however, what is known about it and its creators is often

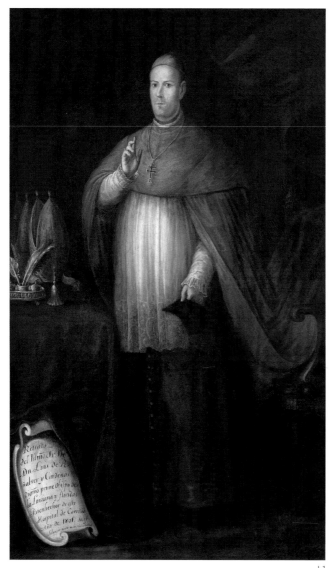

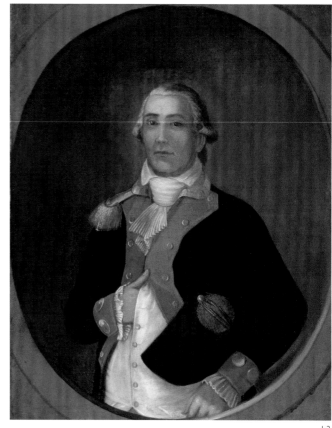

FIGURE I.1. José Francisco Xavier de Salazar y Mendoza, *Bishop Luis Ignacio Maria de Peñalver y Cárdenas*, ca. 1801, oil on canvas, 85" x 52". Courtesy of the Collections of the Louisiana State Museum.

Salazar (ca. 1750–1802) is the earliest identified artist for Louisiana. He and his family moved to Louisiana from Mexico about 1782. Cárdenas (1742–1810) was the first bishop of the Diocese of Louisiana and the Floridas in 1793.

FIGURE I.2. School of José Francisco Xavier de Salazar y Mendoza, possibly F. Godefroid (active 1807–1820), *Lieutenant Michel Dragon* (1739–1821), ca. 1800–1815, oil on canvas, 39½" x 31⁵⁄₁₆". Courtesy of the Collections of the Louisiana State Museum.

uneven. For instance, although the careers of several painters from the 1750s may be well documented, little is known about many others who were working at the same time. Furthermore, while artists' clients may have ranged from the extraordinarily wealthy to the middling sort, as they did throughout most of the late seventeenth and eighteenth centuries, having disparate classes of clientele did not always lead to the making of remarkably different pictures. The wide range of skills and training levels among painters—some of whom were considered bona fide "fine artists" while others were classified as mechanics or tradespeople—suggests a strong relationship with English practices, but again the documentation is uneven. In sum, even with all we have learned about painters who worked in the early South and the paintings owned by those who lived there, the subject remains under-researched and often unbalanced or unwieldy.

Identifying distinctive "southern" characteristics or a regional aesthetic was never a reason for this study.

While it can be said that in the South there were preferences—for certain kinds of portraits, say, or for a particular kind of dress or accessory shown in portraits—the same features nevertheless appear in other regional portraiture. Early southern portraits reflect a strong reliance on English styles, but so do many from the mid-Atlantic and northern regions. Most broad stylistic trends found in paintings in the early South are shared with other regions, in large part because many of the same painters who worked in the South also worked in the mid-Atlantic and North.

The most obvious of the southern preferences was for large canvases—life-size three-quarter-length cloths for adults and full-length or standing for children. Portraits so-sized reflect a preoccupation with gentrified living, and many of them show expansive landscape settings, some with elaborate vistas and architectural settings that evoke the importance of owning large tracts or farms called "plantations." For most wealthy or upper-middling southerners, landscape elements in general and broad vistas in particular symbolized and affirmed the most important material aspect of their everyday world: land, the source of much of their wealth and power.

Perhaps the most quintessential characteristic of painting and painters in the early South is the web of relationships that connected southern sitters, friends and relations, clients and artists, and artists and artists. While such connections can be found in other regions as well, the rural nature of the South made them of paramount importance, as reputations of artists were established, and commissions gained, through word-of-mouth reports in families and communities as well as through letters of recommendation. Indeed, such relationships ultimately shaped the South's early art history.

Here is one example of a web of artists' connections. Gustavus Hesselius (1682–1755), the Philadelphia artist who also worked in Virginia and Maryland, knew William (1739–1823) and John (1699–1777) Bartram as well as Carl Linnaeus (1707–1778). Gustavus Hesselius, who may have drawn natural history specimens himself, was the first teacher of his son, John Hesselius (1728–1778), who in turn probably knew and was thus strongly influenced by the work of New Englander Robert Feke (1705–1750?), who visited Philadelphia. After the itinerant English painter John Wollaston Jr. (ca. 1705–after 1775) visited Philadelphia and Maryland, John Hesselius began following Wollaston's style. Hesselius moved to Maryland, where he became the first teacher of Charles Willson Peale (1741–1827), who also traveled to Massachusetts to see the work of John Singleton Copley (1738–1815). Peale next studied in England with transplanted Pennsylvanian Benjamin West (1738–1820) (fig. I.3), whose first lessons had been in Philadelphia with James Claypoole Sr. (1721–1784) who knew Gustavus Hesselius and who was related to both West's wife and his first American student, Matthew Pratt (1734–1805), who also worked in the South. Peale's studies with West were supported by several gentlemen from Annapolis, at least one of whom engaged Peale, upon the artist's return, to teach his children to paint. Peale had seen, or knew of, John Wollaston's work when he returned to England after being in Charleston. Peale went on to teach his brother James Peale (1749–1831), his nephew Charles Peale Polk (1767–1822), and his children to paint, and some of them taught their own children to paint. Peale also taught two artists from Virginia and gave miniature-painting lessons to Letitia Benbridge (d. 1776), wife of the artist Henry Benbridge (1743–1812) (fig. I.4), who, as a young man, had also met Wollaston in Philadelphia. Benbridge then studied in Rome with Raphael Mengs (1728–1779) and met with West and other painters in England. Upon his return to America, Benbridge and his wife worked in Charleston where he gave lessons to the artist Thomas Coram (1756/57–1811), who copied at least one of West's paintings. That Thomas Coram claimed to be the namesake and a relative of the famous humanitarian Thomas Coram (ca. 1668–1751), who patronized a number of London painters, including William Hogarth (1697–1764). Benbridge later went to live either with or near his son in Norfolk, Virginia, where he met Lawrence (1769–1804) and Thomas (1783–1872) Sully.

The tracing of connections could continue, the web lines reaching out to other groupings and relationships,

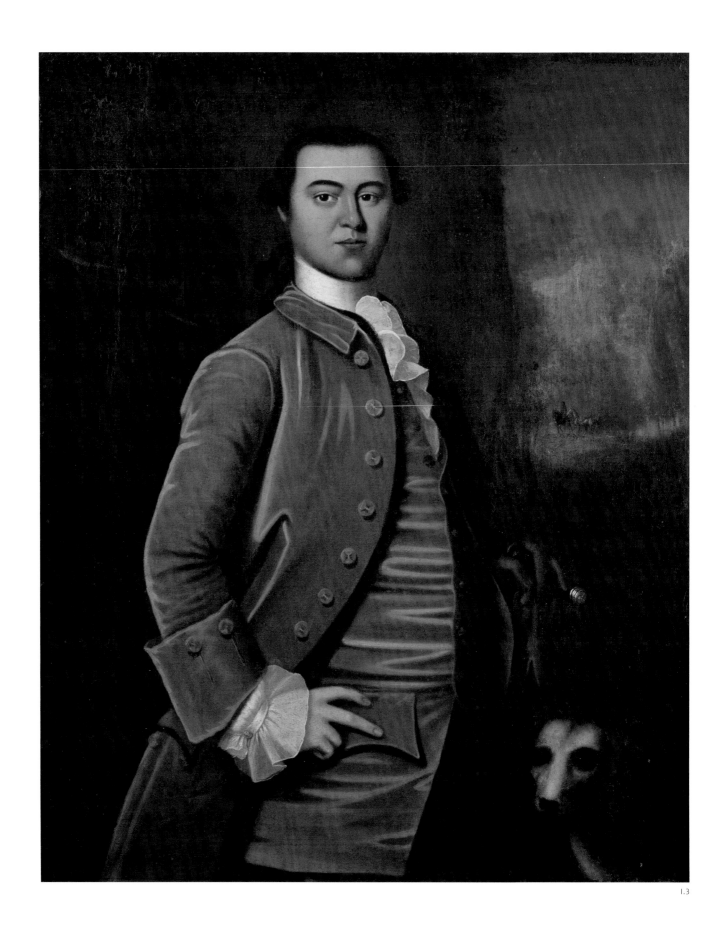

1.3

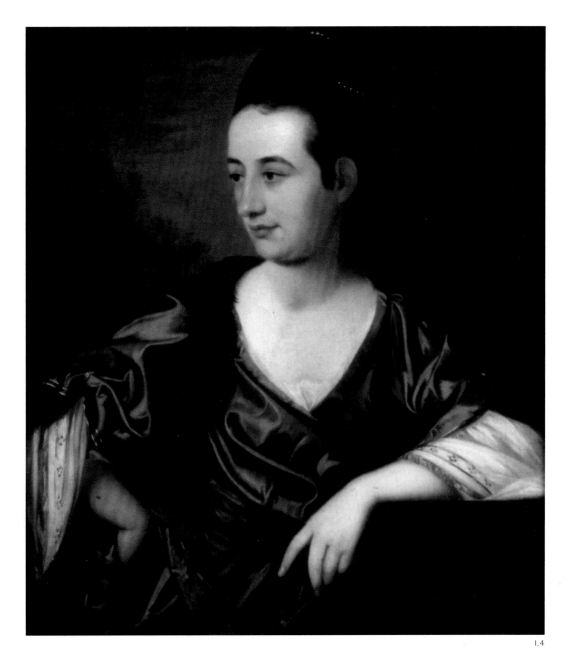

1.4

FIGURE 1.3. Benjamin West, *Severn Eyre*, 1756–1759, oil on canvas, 45½" x 37¼". Private collection.

Severn Eyre (1735–1773) lived on the Eastern Shore of Virginia, the son of Littleton Eyre and Bridgett Harmanson. The family's connection, if any, with Philadelphia, where the youthful Benjamin West was then painting, is unknown. A large Eyre family was present there, and it seems possible that some of its members were related to the Northampton County, Virginia, family. To discover such a connection might help explain how and more precisely when this portrait was painted. Stylistically, the portrait bears a strong relationship with West's other known early pictures such as the portrait of Thomas Mifflin (1744–1800) as a boy, dating 1758–1759 and owned by the Historical Society of Pennsylvania.

FIGURE 1.4. Henry Benbridge, *Rachel Moore*, ca. 1774, oil on canvas, 28" x 24¹³⁄₁₆". Courtesy of the Museum of Early Southern Decorative Arts (MESDA) at Old Salem.

Rachel Moore (1757–1839) was the great-grandchild of James Moore Jr., governor of South Carolina, and the mother of the artist Washington Allston (1779–1843). After the death of her first husband, William Allston, she married an army major from Rhode Island. The classical portrait dress and pose are typical of Henry Benbridge's Charleston work, as are the rich colors, subdued landscape, and architectural setting.

but the point is made: most painters, no matter where they were working, either knew, knew of, or learned from other painters. This study attempts to provide, where possible, similar information about connections and interconnections among artists and sitters as well.

One of the strengths of this study may be the commentary on the lives of sitters and their known occupations or class status. The nature of their livelihoods and their relationships with other sitters are important because through them one comes to understand trends regarding who bought paintings. The richest southerners did, of course, but so did a significant number of upper middle-class and middle-class consumers, many of whom inherited wealth from middle- and lower-class ancestors who made their fortunes in America. Once families attained sufficient financial means, they sought to emulate aristocratic life through the adoption of gentrified manners, material goods, and values. By the *mid*-eighteenth century, not the late eighteenth century as has sometimes been held, the pursuit of gentility was pervasive and, in fact, a middle-class phenomenon.[1] That pursuit was also continuous and ever changing over many decades; as one acquired money and material goods and assumed the appropriate social practices, one moved up through the ranks of class.

The complex and overlapping ways in which artists' and clients' lives merged and then moved on challenges a strictly linear, chronological presentation of the South's painting heritage. If the life of each artist were charted on a time line, it would be quite apparent how the careers of various artists overlapped and resulted in their potential for having mutual clients and other associates, offering similar styles, and exerting influence on each other through training or other contact. Such a time line would reveal that many resident artists worked over long periods of time in the South, while some simply visited and left, or died, after a relatively brief stay. It would also show that the trade established by an early painter was occasionally passed along to later generations of the same family.

Some chronological progression is nevertheless maintained in the book, with each chapter addressing a period in which various artists were working or in which their work was concentrated. However, sometimes the relationships among painters have necessitated the inclusion in a given chapter of artists whose careers extend beyond the general dates of that chapter. That happens particularly in discussions of families of painters, but it also occurs where artists have close professional ties with other artists. This study also provides commentary on artists' idiosyncratic styles, suggesting, where possible, how they trained and what may have influenced their work. Such observations are made in light of—and in the spirit of—historic English assessment of paintings and art instruction. Art criticism grew in tandem with art education and the collecting of art, and from it eighteenth-century principles of connoisseurship emerged. Both then and now, painted or drawn art requires visual examination and discernment regarding what one sees; viewing and writing about art has never been an objective experience.

The material in most chapters should be viewed against a general history of painting both in early America and in Europe, particularly London, and to a lesser extent Rome, during the 1770s and 1780s. The training and status of painters, the distinctions between fine art and the mechanical arts, the popularity of portraiture, and the nature of clientele are all important to any understanding of the South's art history. These matters are discussed at some length here and then reinforced by information contained in the chapters.

Southern Consumers

The establishment of a predictable, or at least a probable, southern market for painting relied on the emergence of wealth and gentrified tastes in the late seventeenth and early eighteenth centuries. The arrival of painters—whether trained to paint portraits, other sorts of pictures, or decorative useful wares—was slow, and the number of paintings actually created in the South during this period was probably small. Fewer than one hundred imported pictures and references to pictures survive to assure us of their presence. Most of the known paintings,

all portraits, were either brought with settlers or acquired by them on subsequent visits to London or elsewhere in Europe. Of those, some, such as the portraits owned by the Wetenhall family of Maryland (figs. 2.18 and 2.19) or the likeness of John Page of Virginia (fig. 2.7), were painted for moderately wealthy settlers who were not gentry by European standards but who ranked below that class.

The prevailing belief that only the extraordinarily wealthy southerners—less than 5 percent of the population by 1750—had significant familiarity with the "fine arts" or exposure to European paintings is not entirely true. In addition to affluent southern families who attained their fortunes over several generations in America, many families with European middle-class origins owned paintings. Even a cursory survey of Virginia, Maryland, and South Carolina household inventories from the seventeenth and early eighteenth centuries reveals that such folks lived comfortably. Their immigrant ancestors who had successfully worked in the trades or other middle-to-lower-class professions had acquired enough capital to purchase sizable tracts of farmland or urban parcels (as in Charleston, South Carolina). Along with the ownership of land came the pursuit of gentility through the building of substantial homes, the acquisition of tasteful furnishings, and the adoption of behaviors and customs associated with wealth.

Scholars and historians have sometimes used the words "gentry" and "aristocracy" to describe colonial families that attained a certain social standing. This study avoids those terms, however, for they can be misleading. With the exception of royal governors, only a few rich southerners could be classified as gentry by English or European standards wherein such status, bestowed by royal decree or by birth, ranked just below the nobility. The word "aristocracy" is also problematic since it too implies having a privileged genealogy along with inherited land and wealth. "Colonial aristocracy" is a slightly better designation that takes into consideration inherited wealth yet distinguishes it from the social codes of England and the European continent. However, it does not imply the all-important idea of mobility from lower to upper classes that prevailed in the South and elsewhere in America. By English seventeenth- and eighteenth-century standards, most well-heeled colonials would have been considered merely members of the comfortably well-off middle class. As Adam Smith, the English philosopher and expounder of economic thought, explained in his 1776 edition of *An Inquiry into the Nature and Causes of the Wealth of Nations,* no oppressive aristocracy had ever prevailed in the colonies. The considerably more recent work of C. Dallett Hemphill and others regarding the rise of the middle class in America recognizes that "groups of farmers, artisans, merchants, and professionals all included persons who were poor, persons who were rich, and many of middling means."[2] This study also affirms the presence of a middle class in eighteenth-century America.

The rise in wealth, consumerism, and consumption, evident by the mid-eighteenth century in both Britain and its colonies, naturally figured prominently in the success of clients and painters on both sides of the Atlantic, and the emergence of a middle class, first in Europe and ultimately in the colonies, had a direct and positive impact on levels of art making and art consumption. The economic success of the colonies, sustained by transatlantic production and trade, was also linked to the outbreak of America's war for independence. Commerce leaders on both sides of the Atlantic comprised the middling sort of bankers, merchants, tradesmen, and shipping magnates.

For instance, in South Carolina, urban merchants and tradesmen like the successful cabinetmaker Thomas Elfe could become entrepreneurs and expand their financial base by acquiring property and other income-generating interests. The very wealthy owned plantations outside of Charleston, but often they also owned dwellings in the city. Thus, South Carolina's wealth was spread not only among different classes of people but also between urban and rural settings. An upper middling sort of mostly rural dwellers owned sizable (but not necessarily the largest) plantations. Urban middlings were more likely than rural dwellers to be aware of different artists and pricing options because that information was usually available in towns.

Charleston, perhaps more than any other American city, was significantly dependent on and influenced by Britain by the time of the Revolution. Charlestonians' tastes and social codes were strongly tied to those in London and had noteworthy influence on consumer material goods and services. By the 1760s, affluent South Carolinians had already begun to commission sophisticated portraits from London's best painters.

This study also avoids the terms "patron" and "patronage" in reference to southern clientele although those terms have been used repeatedly in colonial American painting studies to name the relationship between artists and those who purchased their works. England's Samuel Johnson, writing in the mid-eighteenth century, defined a patron as "one who looks with unconcern on a man struggling for life in the water, and, when he has reached ground, encumbers him with help."[3] Johnson's cynicism actually compares favorably with the more traditional, older definition of a patron as one who assumed an air of entitlement, privilege, or superiority when giving aid, often financial, to artists. Today the term has a more neutral connotation though it still implies philanthropic financial support of the artist or arts. When referring to most clients and artists working in the pre-1790 South, however, "patron" and "patronage" seem misleading and historically inaccurate because there were few bona fide patrons. Most clients transacted commissions for paintings at prescribed and arranged prices. The distinction, though small, is essential to an understanding of the role of painters as producers of retail commodities in the southern colonies. Most artists and painters were valued for their skills. Their paintings were thought to have aesthetic appeal, but they were also considered among the finest household furnishings.

The Ranking and Training of Painters

A sense of the social and economic status of painters who worked for southern clients can be gleaned from examining wills, from reading comments of clients, and from determining where and how painters were trained and how they referred to themselves. While their wills

and inventories are rare, some do survive, including those for the eighteenth-century painters John Hesselius and his father, Gustavus, of Philadelphia; Thomas Coram and Jeremiah Theus (1716–1774), both of Charleston (fig. I.5); and two earlier painters, Robert Dowsing (1701–1730) and Richard Orchard (d. ca. 1756), both of Virginia. In the cases of John Hesselius and Theus, the values of their estates indicate an impressive degree of wealth, placing them among the well-established and successful merchant-tradesmen group. John Hesselius acquired much of his property through marriage as well as through the inheritance of his father's estate. Theus seems to have earned his wealth by undertaking a variety of painting tasks and by acquiring property in and around Charleston. Both of these artists, as well as Thomas Coram and John Hesselius's father, Gustavus Hesselius, led comfortable lives, moving easily in higher social ranks in their respective areas of residence. John Wollaston Jr., the mid-eighteenth-century London painter who came to the colonies, also seemed to have earned a respectable living as an itinerant artist, for a contemporary of his described him as being wealthy when he retired to Bath, England.[4] Wollaston may have made part of his fortune through painting, but it is more likely that he inherited money from a member of his family. He is known to have mingled with bourgeois families in the Caribbean and in Bath, England.

For the many other painters who worked in the South, advertisements indicate their pricing and give a general impression of the business they received. Speculation as to levels of wealth based solely on that information would be risky, particularly since monetary values and rates of exchange varied from place to place and period to period, making precise comparisons impossible. Nevertheless, knowing what artists charged for portraits can offer insight into their reputations and expertise. The chart at the end of this introduction provides a chronological list giving the painter's name, the type of portrait or painting, the price, and the date and place of the work's execution. Prices charged by celebrated London painters like Charles Jervas (ca. 1675–1739) appear to be much greater than those by artists like John Smibert

(1688–1751) or John Wollaston (Woolaston) Sr. (d. 1749), both of whom also worked in London. Prices charged by John Wollaston Jr. were probably consistently higher than those of John Hesselius although the only amounts known for them are dated two decades apart. As might be expected, Joseph Badger Sr. (1707–1765) in Boston received far less for his portraits than the well-known Pompeo Batoni (1708–1787) in Italy.

Pricing depended not only on the reputation and skill of the painter, the size of the portrait, and the pose but also on the inclusion of other elements and the frequency and method of payment. It was not uncommon for portraits begun in one year to languish and remain unfinished until the next because subsequent and timely sittings were inconvenient for the client. Charles Willson Peale's papers often mention his inability to finish pictures because of customer delays or because of barter, as opposed to cash, payments. His 1788 portraits for the family of Benjamin Laming (ca. 1750–1792) are a good example. On September 18, Peale spent the entire afternoon waiting for Mr. Laming to appear for his sitting. On September 27, another session with Laming was especially frustrating because "company coming interrupt us considerably, & with difficulty I compleat the likeness [head only]." Items that were added to the Laming pictures over the course of the month in which they were painted included a parrot in the background, a handkerchief in Mr. Laming's lap, and flowers at the tucker[5] of Mrs. Laming's dress and in her hand. An example of client bartering includes Peale's negotiations for the family portraits commissioned by Christopher Hughes (1744–1824), a Baltimore merchant and silversmith. Peale began his negotiations for the portraits as early as October 7, 1788, when he noted that Hughes "wanted me to paint his family & take wine & Rum in payment—which I have to consider on." Although Peale worked on the paintings throughout December and until January 4, 1789, he apparently did not accept the terms of barter for he was paid partly in cash and partly by note of credit with the firm of Robert Gilmor & Co.[6]

In the South, published praises were occasionally accorded artists and their painting skills, though such

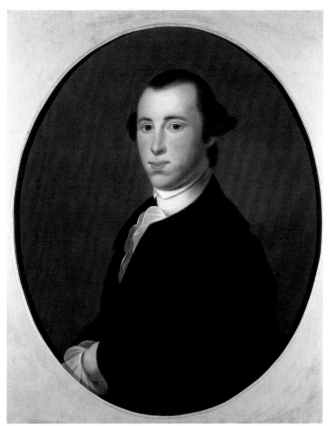

1.5

FIGURE 1.5. Copy by Charles Fraser after the original by Jeremiah Theus, *Thomas Heyward Jr.*, 1820–1825, oil on canvas, 27⅜" x 22¼". Independence National Historical Park.

It was not unusual for artists to copy each other's work. The portraits of Jeremiah Theus were copied many times; Charles Fraser (1782–1860) was but one of those who replicated the Charleston painter's pictures.

Thomas Heyward Jr. (1746–1809) was born in St. Luke's Parish, South Carolina, to a family of great wealth. His early education was in the colonies, after which he worked briefly in a law office before studying law abroad. His study was followed by a grand tour of Europe; by 1775, he had returned to South Carolina and was representing his colony in Congress. He served in the army during the Revolution. Captured and imprisoned, he had much of his property confiscated by the British. He returned to South Carolina and eventually resumed his law career.

accolades were usually reserved for studio-trained artists working in the region. Appearing in newspapers as obituaries or as flowery verses penned by persons familiar with the arts, such praises were rare, and their meaning in a larger context is hard to construe. Though they probably represented only the taste of a few knowledgeable clients, they do indicate a modest change in how consumers regarded paintings by the mid-eighteenth century, that is, as something more than decoration. It is also of note that most of the artists so extolled—Henry Benbridge, Charles Willson Peale, and John Wollaston Jr.—accurately represent by today's standards the best painters in the South during their times. The number of portraits surviving by these men suggests both that their skills were admired and that at least some clients were able to judge quality and style.

As far as client impressions go, those of William Byrd II (1674–1744) are particularly revealing. Byrd commented that the portrait he owned of Sir John Perceval (1683–1748) was "incomparably well done" and that "every connoisseur that sees it, can see t'was drawn for a generous, benevolent, & worthy person. . . . I was pleasd to find some strangers able to read your Lordships character on the canvas, as plain as if they had been physiognomists by profession."[7] Byrd stands alone in the history of southern painting before 1750 as the South's preeminent connoisseur and collector of art; his knowledge came through contacts, education, and travel abroad. He also proffered a back-handed compliment on the work of the English visiting painter Charles Bridges (1670–1747) when, on December 30, 1735, he wrote to Lieutenant Governor Alexander Spotswood that "tho' he [Bridges] have not the Masterly Hand of a Lilly [Lely], or a Kneller, yet, had he lived so long ago, as when places were given to the most Deserving, he might have pretended to be serjeant Painter of Virginia."[8] That Byrd's judgment of art was recognized and appreciated by his peers is affirmed by John Custis IV, who, from Williamsburg in 1723, wrote to Byrd in London:

> I come now to beg a favour of you . . . to get me two peices of as good painting as you can procure . . . to put in the summer before my Chimnys to hide the fire place . . . some good

flowers in potts . . . and what ever fancy else you think fit . . . I should not give you this trouble but that I well know you have good judgmt in painting . . . Mr Blair bought me some peices most horrid smearing in stead of painting.[9]

The early southern consumer's assessment of painters and their position in society is closely related to how painting skills and practices were considered in England, particularly in London. Most portrait painters who lived in or visited the southern colonies before the 1770s would have been considered provincial, third or fourth rank, or "low" by British standards. Few had extensive studio or academy training, but most were skilled, trade-trained in a range of utilitarian painting techniques with perhaps modest instruction or experience in portraiture. In either case, and irrespective of their low rank, southern painters as a whole demonstrated a strong awareness of then-current London formats, poses, and styles. Those artists most frequently advertised portrait painting when first arriving in an area. If they stayed for long periods of time or settled there, they usually included other services, such as sign painting, in subsequent ads. While additional types of painting augmented an artist's income, one cannot infer that such trades work always meant a shortage or lack of portrait business. The number of portraits an artist could paint was always relative to the size of the population and the average wealth of clients. Artists were as savvy as any other merchant or trades person and would have had some sense of the consumer base before traveling to or settling in a given area. Artists of modest rank would have expected to do both sorts of work, giving priority to portraiture because it demanded higher fees and was likely considered more prestigious than the more mundane utilitarian work.

The naive, idiosyncratic styles of some southern portraits indicate that there were at least a few artists who were self-taught, probably because of the lack of trained portrait painters and mentors in their region. Artists of this caliber, often called folk painters, usually had training in utilitarian painting. The Jaquelin-Brodnax Limner (possibly Robert Dowsing) and his

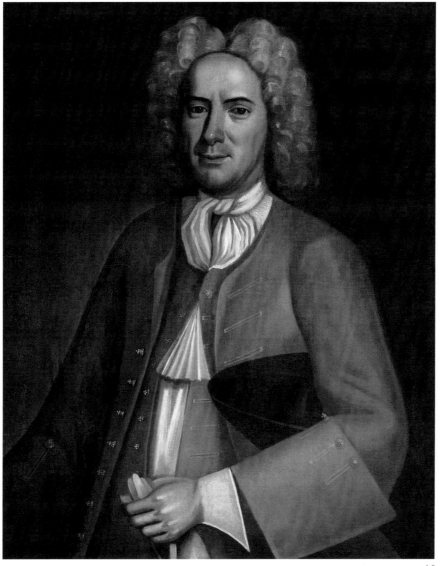

1.6

group of early Virginia likenesses (fig. I.6) might classify as "low rank" among the South's earliest painters, even though his or her skill level as a trades person may have been commendable. Frederick Kemmelmeyer (b. before 1755), working in Maryland in the late eighteenth and early nineteenth centuries, produced paintings in a variety of formats, including history pictures and portraits. His flat and linear style suggests trades training; he, too, would have been considered a low-ranking easel artist, but today he is celebrated as a talented folk painter. In fact, the work of the trade-trained painter is often aesthetically pleasing to modern eyes. How the

original owners perceived such paintings is usually unknown, but one suspects that they were satisfied and that they found the paintings acceptably decorative.

In addition to sign and "shew-board" painting,[10] most trades painters in the pre-1790 South offered the practical work of heraldic and coach painting, gilding, and

FIGURE I.6. Possibly Robert Dowsing, *William Brodnax I* (1674/75–1726/27), ca. 1721, oil on canvas, 30" x 25". Virginia Museum of Fine Arts, Richmond. Lent by the Brodnax Family Trust.

1.7

PAINTERS AND PAINTINGS IN THE EARLY AMERICAN SOUTH

FIGURE I.7. John Wollaston Jr., *Mrs. Anthony Walke II*, 1753–1756, oil on canvas. 36¼" x 28¼". Muscarelle Museum of Art at the College of William and Mary, Williamsburg, VA. Gift of Mr. and Mrs. O. W. June.

The sitter, Jane Randolph Walke (1728/29–1756), was the wife of Anthony Walke II of Fairfield plantation in Princess Anne County, Virginia.

FIGURE I.8. John Singleton Copley, *Mrs. Thomas Gage* (Margaret Kemble, 1734–1824), 1771, oil on canvas, 50" x 40". The Putnam Foundation, Timken Museum of Art, San Diego, USA/The Bridgeman Art Library Nationality.

providing faux finishes. With the exception of some of the members of the Badger family from Boston, Massachusetts, and Charleston, South Carolina, rarely did they advertize house painting and glazing. As suggested earlier, those in England who did both utilitarian work and portraiture were recognized as "artisans" or "mechanics." Many southern colonists also held to that distinction, particularly before the 1770s. In an excellent discussion of terms and period documentation, scholar Susan Rather writes that

> colonial Americans, for the most part, did regard painters, who worked with their hands, as artisans. So did many Englishmen, judging from Samuel Johnson's *Dictionary*, which defined *artisan* as: (1) "artist; professor of art," and (2) "manufacturer; low tradesman." . . . Even [period] theorists who championed painting as a liberal art had difficulty making the claim for portraiture, a genre debased, in academic terms, by its representation of unimproved, rather than ideal, nature. Artisan, mechanic, craftsman— terms roughly synonymous during the eighteenth century—all connoted manufacture of a "low," as opposed to "liberal" sort.[11]

However, one must be careful of the notion that all portraiture was considered "a genre debased . . . by its representation of unimproved, rather than ideal, nature." Many highly skilled London portrait painters such as Sir Godfrey Kneller (1646–1723), followed by Sir Joshua Reynolds (1723–1792) and the American Benjamin West, were greatly admired as artists for their portraits as well as other paintings. Rather's discussion seems to refer to third- and lower-rank portrait painters who were trade-trained or who worked as drapery painters. For example, in the South, Daniel Badger (1699–1786) would have been considered a lower-rank painter while John Wollaston Jr. (fig. I.7) at his best might have qualified as a third-rank artist. Thomas Hudson (1701–1779), Wollaston's contemporary, would have ranked as a second- or first-rank artist who did sophisticated portrait training. Later painters who worked in the South and who had similar specialized training—Henry Benbridge, Matthew

Pratt, and Charles Willson Peale—might also have been considered second or first rank in America.

The concept of nature or the naturalness in English painting is important in understanding the ranking of artists although it is also difficult to visualize. Ordinarily, one might interpret "nature" and what is "lifelike" in painting as the replication of real-world textures, objects, and human likenesses. For example, Americans praised John Singleton Copley for his realistic portrayals. Commenting on Copley's portrait of Josiah Quincy (1709–1784), painted about 1767, the American painter Gilbert Stuart (1755–1828) concurred: "Copley put the whole man upon the canvas. Mr. Quincy had a white hair in his eye-brow and there it is."[12] Matthew Pratt, the American-born artist who studied abroad and later worked in the South, saw Copley's 1771 portrait of Mrs. Thomas Gage (fig. I.8) and, according to Copley, exclaimed that it "will be flesh and Blood these 200 years to come, that every Part and line in it is Butifull [beautiful]."[13] Both of these comments were made by Americans, and both pictures were created before 1773 when Copley left for London to perfect his painting, never to return. In both portraits, Copley strove to copy "nature" a little more rigorously than Benjamin West, then president of the Royal Academy in London, found appropriate and admirable. Writing to Copley in 1766, West advised him to continue to take his subjects from "Nature" and not to deviate except in the dispositions of the figures where adjustments would make the picture an agreeable whole.[14] What West meant was that expression, deportment, and placement of the face and hands needed to be natural as well as *pleasing,* devoid of formulaic approaches and any distracting or displeasing physical features. Among a host of other qualifying skills, a first-rank London *artist* must be able to *improve* upon nature according to British academic standards. Although West's interpretation came well after the seventeenth and early eighteenth centuries, it reflected an emphasis on idealization that prevailed in portrait painting throughout those periods as well.

Exceptional painters were those, such as Sir Joshua Reynolds or Allan Ramsay (1713–1784) (fig. I.9), who could provide this illusive agreeable and pleasing quality

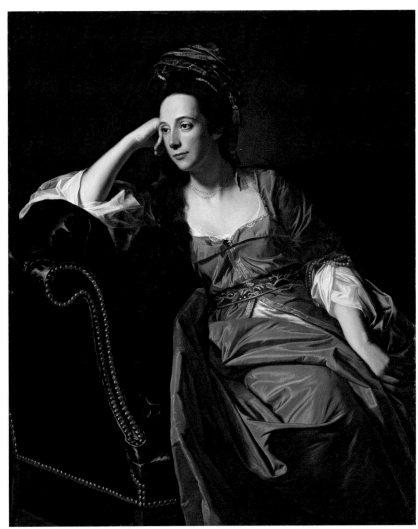

I.8

in a portrait however idealized that quality may seem to us today. Such painters were usually ranked to the elevated station of a fine artist or painter. Even so, they were not spared criticism for neglecting more enlightened formats such as history paintings. Their clients were chiefly the English royal family, royal relatives, titled gentry, and courtiers. Such clients were often patrons in the true sense of the word: they could and did reward painters through special commissions, valuable recommendations, and appointments that carried stipends. Although painters below this exalted level were ranked in

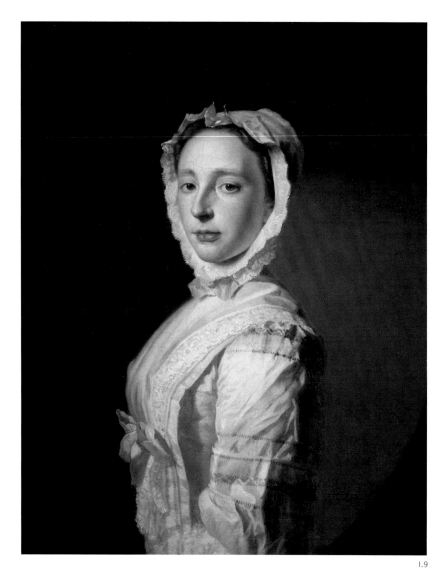

FIGURE I.9. Allan Ramsay, *Anne Bayne Ramsay* (Mrs. Allan Ramsay, d. 1743), 1739–1742, oil on canvas, 26¾" x 21½". Scottish National Portrait Gallery.

Anne Bayne was the first wife of the artist Allan Ramsay. She died in childbirth. She was the granddaughter of Sir William Bruce of Kinross, 1st Baronet (ca. 1630–1710), the wealthy politician and architect who is often credited with introducing the Palladian style of architecture into Scotland.

varying degrees, a lower classification or ranking did not mean being without skill, even exceptional skill.

While most painters who worked in the South during the eighteenth century were of the mechanic or trades-man type described by Rather, ranking within the trades in both England and the colonies was also prevalent. Blacksmiths and shoemakers (cordswainers) were generally among the lowest; tailors and common carpenters were next; and cabinetmakers, clock and instrument makers, and silversmiths ranked higher. Painters, depending on their types of service, ranked anywhere from middling to higher trade status. Rather offers several important references to support her thesis, including the comment of William Hogarth that "a man of very middling Talents may easily succeed" in portrait painting; Sir Joshua Reynolds's observation that drapery painters, whom he considered third or fourth rank among artists, were "the lowest Degree of a liberal Painter" and "a mere Mechanic Head"; and Hogarth's claim that drapery painters were "painter taylors," ranking the same as tailors.[15] By Hogarth's scale, John Wollaston Jr., who had studied with a noted drapery painter and who was painting portraits at the time of Hogarth's remark, would have been a "painter taylor," or third or fourth rank.

"Painter," "limner," "portrait painter," and "teacher" are among the array of terms found in documents and other sources pertaining to the early South, and an analysis of these terms suggests subtle distinctions among them that derived from English practice. Moreover, how painters referred to themselves and how clients referred to them were often not identical. Both painters and clients were influenced by constantly changing standards and perceptions, depending on their personal knowledge of art as well as what was available— or, in the case of painters, depending on their competition. In the southern colonies, the terms "portrait painter," "painter," and "limner" are the ones most commonly found in period records, but other terms have also been recorded. The word "limner," a term describing someone who paints pictures, was most frequently used by southern painters and their clients during the seventeenth

and eighteenth centuries.[16] If the evidence found in southern records is any indication, "limner" usually referred to painters of portraits, figures, and other types of pictorial art, such as landscapes, still lifes, and ornamentals. Limners also painted signs and heraldic devices and performed gilding and similar utilitarian work. There seems to have been little or no distinction between a "limner" who had specific portrait training or experience and a painter trained in the trades who also did portraiture. Not all scholars have defined the word in this way; some believe "limner" is a synonym for portrait painter.[17] However, in England as early as 1672, William Salmon defined "limning" as "Art whereby in water Colours, we strive to resemble Nature in every thing to the Life."[18] With the exception of the medium, "water Colours," Salmon's definition seems in line with the term as used in the early South, and possibly other regions. As a generic category, limning embraced all sorts of figural and decorative work, including portraiture in both watercolor and oil paints on supports specific to each medium, including paper, vellum, wood panels, and canvas. By Salmon's definition, the earliest of the South's artist-explorers, John White (ca. 1540–1593) and Jacques Le Moyne (ca. 1533–1588), were also limners with some training in miniature painting, calligraphy, and cartography. There was little in the way of literature on the subject at the time they were painting pictures of the New World. For instance, Edward Norgate's *Miniatura; or, The Art of Limning* was not issued until 1627–1628. In the case of both White and Le Moyne, "to limn," "limner," and other derivative words were relatively new, having emerged from an older tradition. By the seventeenth century, the limner or illuminator was considered among the top ranks of painters. The etymologies of the words "limn," "miniature," and "illumination" are quite similar, with uses in English first dating perhaps as early as the fifteenth and certainly by the late sixteenth century. A miniature was considered an image of reduced size associated with illuminating manuscripts. To "limn" or "illuminate" (manuscripts) probably traced its origins to old French and from there to the Latin *luminare*. Le Moyne's training can be reasonably docu-mented to his hometown of Liège, now in Belgium, where a school dedicated to navigation and map making was located. The techniques that White learned in using watercolors on paper were undoubtedly similar though his art making seems to have been part of a gentleman's education as opposed to tradesman training. In either case, both painters represent the larger world of art as it was developing in England, including the creation of miniature portraits, botanical and natural history drawing, and the like. The distinctions that we now impose on these different sorts of art were evolving about the same time.

The single word "painter" was used indiscriminately in both England and the colonies though occasionally it clearly refers to an easel artist.[19] In 1727, for instance, Robert "King" Carter (1662/63–1732) sat to a "Paintr" in his house at Corotoman in Lancaster County, Virginia.[20] In 1698, William Fitzhugh (1651–1701) wrote to one of his British factors that he needed some lacquered picture frames, colors for painting, pencils, walnut and linseed oils, and a half dozen three-quarter cloths to "set up a painter." These were materials for easel painting, and most likely for portraits, as indicated by the "3 quarter clothes" for three-quarter-length portraits.[21] But "painter" was not always synonymous with "limner." It also referred to those who did nothing other than utilitarian work, such as house painting and window glazing. Like "limner," it served as a catchall for other types of work. Jonathan Badger Jr. (active 1790–1799) is an example of a tradesman who referred to himself as a "Painter." On January 26, 1792, he advertised as a house, ship, and sign painter as well as a glazier, gilder, and paperhanger.[22] He may or may not have done easel paintings; no pictures by him have been identified. On the other hand, on September 6, 1740, Jeremiah Theus stated in his first advertisement in the *South-Carolina Gazette* (Charleston) that he was a "Limner," that "Gentlemen and Ladies may have their Pictures drawn," and that he painted "Landskips," crests and coats of arms for coaches, and other things. While he created a large number of portraits in Charleston, he also did other kinds of work, such as painting signboards, gilding, and

the like. In addition, Gustavus Hesselius, John Hesselius, and Henry Warren (active 1751 in Virginia), all called themselves "limners." Both Hesseliuses are known to have created works other than portraits, and Gustavus advertised utilitarian work. A more curious notice appeared in Charleston papers for 1732 when Peter Precour (active ca. 1732/33) cast himself as a "Master of Arts" and indicated that he taught drawing and that his wife painted fans.[23] Nothing attributable to either of them seems to have survived.

The question of painter terminology in the South is closely related to the distinctions that emerged between academic and vernacular painting in England during the eighteenth century. The evolution of those distinctions culminated with the founding of the Royal Academy of Arts in 1768, after which time "artists" were considered those who were trained and who focused on drawing, entertaining questions of aesthetics, and providing easel paintings such as portraits, landscapes, miniature pictures, and the like. On the other hand, "painters" were those who did house, ship, and sign painting as well as a plethora of decorative painting on objects. Many talented English "painters" continued to gravitate towards easel painting while also focusing on the more common, moneymaking aspects of their trade. The issue of hierarchy among those in London's painting professions was hotly debated in plays, pamphlets, and prints during the mid-eighteenth century. Associated with public viewing, sign painting was considered among the lowest art forms. However, as English historian Jonathan Conlin has pointed out, it was also considered a native form of British art that elicited from some "a proud patriotic respect. . . . The sign stood for a broader public than that of the connoisseur, who claimed a monopoly of such aesthetic control in the nation's best interest."[24]

William Hogarth was among the first to promote certain qualities in trades painting that he considered important, and he was partly responsible for the 1762 Bow Street exhibit in London that featured a collection of signboards. The exhibit itself was a response to arguments that persisted about painters and their ranks. Arranged by English poet, critic, and essayist Bonnell

Thornton and touted as a project of the fictitious "Society of Sign Painters," the show was mounted in Thornton's rooms on Bow Street and featured a collection of 110 London signboards. Many who saw the exhibit were amused while others were likely chagrined by its seeming ridicule of the trade. Boldly painted in gold letters on a blue background in the exhibit room where the signs were displayed was line five from Horace's *Ars Poetica: "Spectatum admissi risum teneatis."* The words, which translate as "Having been let in to see this, restrain your laughter," issued a not-so-subtle warning to the elite whose notions of art tended to overlook, or to be ignorant of, the critical aesthetic qualities and skills required of tradesmen.[25] Hogarth counted sign painting among his many talents, and he and other London artists defended sign painting as an important aspect of any trades painter's work. Another English artist, William Williams (1727–1791), declared that sign painting was "the nursery and reward of painters."[26]

With the exception of monographic studies, English art historians, and to a lesser degree American scholars, have tended to study their countries' early painting through the best examples that survive. As indicated earlier, much of the painting that existed in early America and to some extent England did not fall into the "best examples" category. Rather, it was created by skilled tradesmen who could paint signs, coaches, landscapes, and portraits and do many other related tasks. Some historians have found it convenient to apply the 1778 opinion of Sir Joshua Reynolds, that the difference between the "mere mechanic" and the artist or painter is the "intellectual dignity . . . that ennobles the painter's art."[27]

With the dubious exceptions of the English-trained Charles Bridges and John Wollaston Jr., few if any painters working in the South before 1760 considered themselves so "elevated," either by their artistic knowledge or by any skills that set them far above the coach, sign, fire bucket, "shew-board," and ornamental painters. Some who called themselves "limners" probably viewed themselves a cut above house and ship painters, but they could and, as noted, did perform such labor-intensive work as part of their offerings. Similarly, those who used

the title "house and ship painter" or just "painter" usually provided only utilitarian work but occasionally gravitated towards easel painting. Joseph Badger Sr. of Boston, who is associated with a large number of family members who were painters in the South, is a perfect example; he never advertised his portrait work, and no known signed works by him exist although several likenesses are well documented to his hand. The terms "portrait painter," "artist," and "painter" were used interchangeably in the South beginning in the 1770s, and their use was much the same in England, where Reynolds, quoted earlier, was among those who employed such terms. In the South and in Europe, the term "painter" continued to include trades work as well, making it difficult to sort out the picture makers.

Related to the ranking of painters and to consumer opinions of artists is the issue of how design and drawing, including the use of watercolors, were taught in England and the colonies. By the 1730s, when international trade competition and the manufacture of middle-range luxury goods were on the rise, the American colonies figured into the international market. European craftsmen and manufacturers—and later, American artisans—needed drawings for production. While drawing continued to be a genteel amateur pursuit, its importance was thus stimulated by commerce and, to a lesser extent, by military and cartographic needs (figs. I.10 and I.11). Art instructors stressed the importance of a practical knowledge of drawing for production purposes, and published design and drawing books soon appeared both in America and abroad.[28] Baldassare Castiglione's *Courtier,* translated into English by Sir Thomas Hoby in 1561, indicated that drawing was a pastime suitable for the highest classes and a means for learning art appreciation.

Following the publication of Hoby's translation of Castiglione, a number of manuals on the importance of drawing and art emerged. Most emphasized the importance of the arts to cultured persons, but they also discussed method, and they eventually became practical how-to manuals. Henry Peacham's (1578–1644?) *Graphice; or, The Most Auncient and Excellent Art of Drawing with*

Pen and Limning in Water Colours was first published in London in 1606, with subsequent editions following. Educated at Trinity College, Cambridge, Peacham taught at Wymondham in Norfolk. He was proficient in botany, heraldry, mathematics, drawing, and painting. His book explained various drawing and watercolor techniques—and stressed the importance of art education.

Among the earliest known drawing books in America was Jean Dubreuil's *Practice of Perspective; or, An Easy Method of Representing Natural Objects According to the Rules of Art.* Published in France in successive editions from 1642 to 1649, the first English version was issued by connoisseur Ephraim Chambers in London in 1726. Dubreuil listed the rules for perspective drawing and showed how to proportion and position figures in space for drawings and paintings. Several other London-published books found their way to the colonies, including a later edition of John Smith's 1676 *Art of Painting in Oyl,* which gave directions for decorative painting, including rendering faux finishes, preparing and mixing colors, varnishing wood, and coloring maps and prints with watercolors. A later edition of Smith's work or another work by a similar name was advertised in the *Charleston (SC) Evening Gazette* on December 6, 1785. Robert Dossie's *Handmaid to the Arts,* printed in two volumes in 1758 and one volume in 1764, was nearly encyclopedic in scope, listing all sorts of painting equipment and, among other things, directions for preparing and making colors, making dryers, preparing pastels or crayons, varnishing, taking plaster casts, gilding, silvering, bronzing, japanning, reducing pictures, tracing pictures, painting on glass and wood in addition to paper and canvas, painting enamel, coloring maps and prints, and mending and cleaning pictures and paintings. About 1763, in the early years of his painting, Charles Willson Peale purchased a copy. Recalling this event to his son Rembrandt Peale (1778–1860) in 1812, Charles Willson Peale noted that he had used it to determine what colors to purchase. A 1758 edition of volume 1 of the same book bears the inscription of John Hesselius, Peale's first teacher.[29] It seems likely that Peale bought the book on the recommendation of Hesselius.

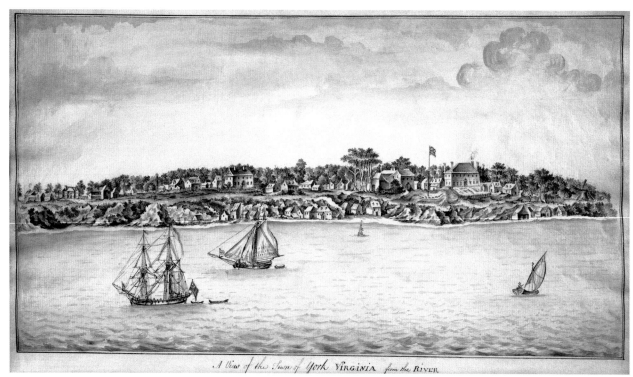

A View of the Town of York VIRGINIA from the RIVER

I.10

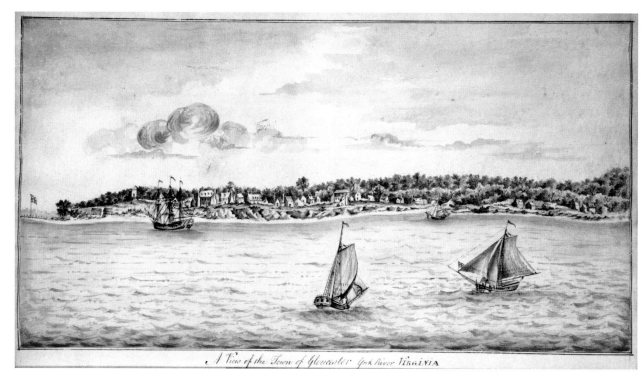

A View of the Town of Gloucester York River VIRGINIA

I.11

The Art of Drawing, and Painting in Water-Colours was the name of a treatise advertised by Jonas Payne and Philip Hearn, booksellers in Savannah, Georgia, in 1790. The author, Robert Boyle, had published a volume by this name in London in 1732 although the Georgia ad was probably for a later edition. A book titled *The Art of Paintg. in Oyl,* listed in a 1765 inventory of James Grindley of Charleston, was probably an edition of Smith's work. So far as is known, however, Grindley was not a painter but an attorney. In 1766, bookbinder and bookseller Robert Wells of Charleston imported *The English Connoisseur* from London, probably Thomas Martyn's book, a fuller title of which is *The English Connoisseur: Containing an Account of Whatever Is Curious in Painting, Sculpture, &c.,* printed in London in 1766. Wells also sold "school of arts," "complete drawing book," *The Artist's Vade Mecum,* and Hogarth's *Analysis of Beauty.* By 1779, Wells was advertising Matthew Pilkington's *Dictionary of Painters.*[30]

Knowing that at least some of these publications were present in the South is important, but how they were used and who among the painters working in the South owned or used them is—with the exception of John Hesselius, Charles Willson Peale, and Thomas Coram—unknown. Working in Charleston in the late eighteenth century, Coram mentioned in his March 19, 1778, advertisement in the *South-Carolina and American General Gazette* that he had loaned someone his "Dictionary of Arts and Sciences with Cuts." This may have been an original or later version of Ephraim Chambers's *Cyclopaedia; or, An Universal Dictionary of Arts and Sciences* (London, 1728). Coram, known for his interest in the arts as well as for his being "fond of study,"[31] probably had other similar volumes, but the contents of his library at the time of his death were not listed. Much earlier, William Byrd II of Virginia owned two books associated with painting: Roger de Piles's 1681 *Dissertation sur les ouvrages des plus fameux peintres* (Paris) and Charles-Alphonse du Fresnoy's *De Arte Graphica; or, The Art of Painting* (London, 1695). De Piles wrote a number of essays pertaining to painting approaches and history, and Du Fresnoy's work presented a series of precepts about what is beautiful and addressed such topics as how to handle drapery and groups of figures and how to understand the effect of the whole. Byrd's great interest in painting—he had studied drawing in England—and his desire to be conversant on the subject make his ownership of these publications understandable.[32]

Books of anecdotes about famous painters were also available in America for many decades prior to, and on into, the nineteenth century. But again, their usefulness to painters cannot be determined. Lessons with a master,

FIGURE I.10. Thomas Davies, *View of the Town of York Virginia from the River,* 1764–1779, watercolor and ink on paper, 10¼" x 16¾". The Mariners' Museum, Newport News, VA.

The large house left of center was built by Thomas "Scotch Tom" Nelson about 1730 and inherited by his grandson Thomas Nelson Jr. (fig. I.13), who served as a brigadier general commanding the Virginia militia during the siege of Yorktown. This house survived the battle although two blocks away the home of Nelson's uncle, Secretary Thomas Nelson, which served as British General Cornwallis's headquarters, was destroyed. Thomas Davies (1737–1812) may have done other drawings in Virginia that depicted aspects of the war. Another of his drawings features the landing of the British forces in the Jerseys on November 20, 1776 (National Archives, item 148-GW-365).

FIGURE I.11. Thomas Davies, *View of the Town of Gloucester, York River, Virginia,* 1764–1779, watercolor and ink on paper, 10¼" x 16¾". The Mariners' Museum, Newport News, VA.

Thomas Davies was a lieutenant general in the British Royal Artillery who served at various posts in North America, including cities in Canada and New York. He is better known today as an artist who studied drawing and watercolor painting under Gamaliel Massiot (active 1744–1768) at the Royal Military Academy in England. His views of North American waterfalls and cities, and later his natural history pictures, were exhibited in London, resulting in his fellowships to the Royal Society and the Linnean Society of London. Although the precise dates of these little pictures by Davies are unknown and have been cited in the past as about 1755, it seems more likely that they were created sometime during the two periods he was posted to New York.

whether a trade- or studio-trained painter, would have been preferable, and seeing the works of other, trained artists would have been more desirable and useful than reading about them in a book.

Philip Georg Friedrich von Reck (1711–1792) is a good example of the gentleman amateur who was taught drawing as a genteel and practical pursuit, and it was this skill that he used in his Georgia watercolors created in the 1730s. Whether he learned his techniques from a private tutor or in a class, they were immensely useful as he recorded the progress of the Georgia settlement, the Native Americans, and the flora and fauna he found. By the mid-eighteenth century, some twenty years after von Reck's work, drawing lessons were being offered by artists in the South, not only as genteel pursuits but also as skills for tradesmen. However, little is known about these classes, including whether manuals were used and who among the many students might have emerged as serious painters.

As the arts of drawing and painting, particularly in watercolors, became more popularly known by the public and practiced in England, efforts were made to categorize and rank their branches; however, much of the work done by artists and artisans overlapped, making a strict categorization difficult. Art encyclopedias and instructional books often allude to the tensions that grew among those associated with the fine arts, design, and craft or trade execution as London's cognoscenti sought to define the differences between a fine artist and a mechanic. After the formation of the Royal Academy in London in 1768, the first attempts were made to separate art and design into distinct functions. At that point, depending on the quality and focus of their work as well as their connections, painters could either advance with considerable additional training to become a fine artist or remain an artisan or "mechanic" in the trades or crafts. For that reason, the reputations of painters were somewhat fluid.

Occasionally a period document will indicate that one American artist gave lessons to another, but what those lessons entailed or how long they continued is all but unknown, resulting in a dearth of specific information about colonial painting apprentices and training. A small exception is found in two brief passages of letters from Charles Willson Peale to a prospective student, William Pierce (Pearce) (1753–1789). On August 26, 1774, Peale wrote:

My purpose in this first year [is] to make you well acqua[inted] with the Rudiments of the Art of Drawing of Anatomy, pers[pective] a thorough knowledge of the clair obscure and studying f[rom] figures of (?) collected for that purpose, after this I can sett [sic] you to colouring, copying and painting from nature.[33]

Writing to Pierce again in September 1774, Peale offered advice on pictures that the student had in progress, again emphasizing the importance of drawing:

I am glad to hear you are being employed about several pictures. I hope your likenesses please. Let that be well settled before you attempt to fill up your outline, or it will be like a man who pulls down the scafford [scaffold] before the walls are complete. I will not flatter you so much as to say you are [a] perfect master of drawing. Therefore apply to that part in particular.[34]

Much of the deficit of information about the training of artists in the colonial South stems from the destruction or displacement of early southern records during the Revolutionary and Civil Wars, but it also results from the informal nature of apprenticeships and the laws governing them throughout the colonies. In England, apprenticeships were more prescribed in nature, and numerous instructional guides on drawing and painting were published, as discussed earlier. Those resources were in place and thriving throughout the eighteenth century, and they give a reasonably accurate idea of how England's artists and painters were trained. Of course, some of these English-trained painters came to America, and we can perhaps extrapolate from their careers and the British system how training might have occurred in America.

For example, we know that Joseph Wright (1734–1797) of Derby, who became an associate member of the Royal

Academy in 1781 and a full member in 1784, was educated in a local grammar school and taught himself to draw by copying prints. Once he set his goal of becoming a painter, he traveled to London and studied for two years in the studio of the well-known portrait painter Thomas Hudson, who also taught Sir Joshua Reynolds. Reynolds was one of eleven children born to a Devon schoolmaster. Though he showed an early interest in art, he seems to have had no training before Hudson. Before the organization of St. Martin's Lane Academy in 1735 by William Hogarth and others, early English painters who showed promise tended to study with established skilled tradesmen—and on rare occasions with easel artists in London. By the mid-eighteenth century, a small number of London's highly trained and skilled trades painters who pursued careers in easel painting had also studied in Rome, lured by the names and reputations of both living and deceased painters and by the surviving classical antiquities and architecture.

However, there were critics of this method. On February 7, 1754, "Mr. Town," the fictitious author, "Critic," and "Censor-General" of London's *The Connoisseur,* made a number of unflattering remarks and raised questions about the popular study of antiquities—and about artists (some of them students) in Rome who copied the works of old masters. He wondered

> how much reputation, as well as profit, would accrue to my labours, by confining them to the minutest researches into Nature and Art, and poring over the rust of Antiquity. . . . Of what consequence would it be to point out the distinctions of Originals from Copies . . . that the paultry scratchings of a Modern may never hereafter be palmed on a *Connoisseur* for the labours of a *Rembrandt!* . . .
> . . . [referring to Roman Coins] What profound erudition is contained in an half-obliterated antique piece of copper![35]

William Hogarth (fig. I.12) was of the same mind. The son of a Latin school teacher, he came from a modest, if not poor, background. First apprenticed to an engraver, he eventually opened his own business that provided engraved coats of arms, shop bills, bookplates, and

similar works. Hogarth married well, to Jane Thornhill, daughter of the artist Sir James Thornhill (1675–1734), after which his climb to fame as both a painter and an engraver was assured.

While Rome was one of the most important cultural centers in Europe, some London-trained English and American painters elected to forgo studies there. The expense of such a sojourn was a concern for many. Artists like Charles Willson Peale undoubtedly admired the knowledge of aesthetics and the skills acquired in such training, but they also viewed it as impractical and perhaps superfluous for their purposes. From Philadelphia in November 1772, several years after his return to America from London, Peale wrote to John Beale Bordley (1727–1804) in Maryland, saying that

> perhaps I have a good Eye, that is all, and not half the application that I now think is necessary—a good painter of either portrait or History, must be well acquainted with the Greesian and Roman statues to be able to draw them at pleasure by memory, and account for every beauty, must know the original cause of beauty—in all he sees—these are some of the requisites of a good painter, these are more than I shall ever have time or opportunity to [*Study*] know, but as I have variety of Characters to paint I must as Rambrant did make these my Anticks [antiques] and improve myself as well as I can while I am provideing for my support.[36]

In lieu of studies in Rome, most early eighteenth-century London painters and draftsmen with like interests banded together in informal groups where they could share expertise and information as well as debate issues pertaining to their subject areas. The largest of such groups became the aforementioned St. Martin's Lane Academy, established as a direct result of the new emphasis on improving design for manufactured goods. The school emphasized drawing skills and offered classes for tradespeople of all sorts. Ambitious London painters who initially began their careers in the trades utilizing design and ornamental painting, and who were then exposed to more formal drawing and related studies with

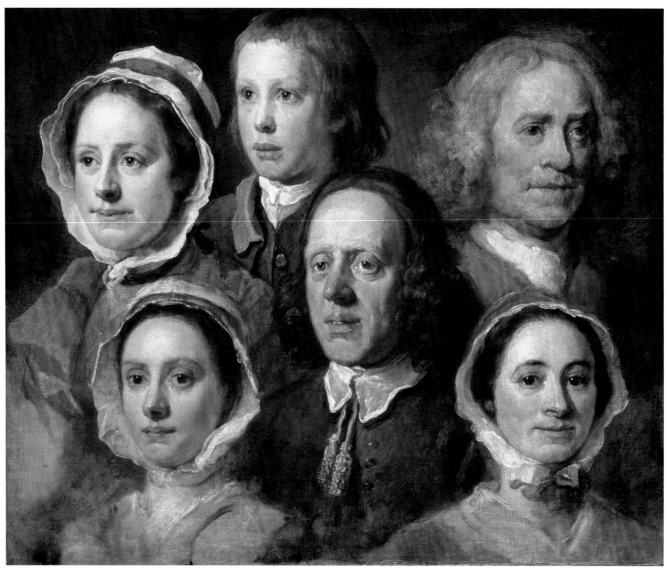

I.12

One of William Hogarth's most famous pictures features six of his personal house servants, each painted with great sensitivity and affection. The same empathy appears in other portraits in which he focused more on the personality and good nature of the sitters than on finery, wealth, and other status-conferring elements.

well-known artists at St. Martin's, often became the creators of easel pictures, including portraits.[37] Some of them, like John Durand's (1746–after 1782) teacher Charles Catton (1728–1798), gradually moved up through the guild ranks because of their extraordinary talent. Catton had a sizable coach painting shop where he took on many apprentices, and his work was recognized by the king. Hundreds of British eighteenth-

century apprenticeship records like those for Catton survive, providing important information on the size of such painters' shops as deduced from the number of apprentices and assistants they employed.

Significant research has been conducted and published in recent years on the training of English painters of all sorts. While most of that material relates directly to London tradesmen, it does have some bearing on early American artists. As mentioned earlier, the painter William Williams wrote that sign painting was "the nursery and reward of painters."[38] Williams was reflecting on the good trades training he received as a youth—and contrasting it with academy training. Paul Sandby (1731–1809), an English topographer, landscape watercolorist, and member of the Royal Academy, shared Williams's background. He felt that sign painting, while it might appear lowly, involved a style that required decisive drawing and painting to ensure that a sign had the desired effect when viewed from a distance.

The history of the Stainers Company, and later the Worshipful Company of Painter-Stainers associated with London's Livery Companies, provides insight regarding the distinctions between London- and colonial-trained painters. The two British organizations, as well as the Heralds at the College of Arms and the Plaisterers Guilds, were formed to protect and preserve their respective trades. "Stainers" applied color to woven fabrics, such as floorcloths; "painters" decorated wooden, metal, and stone objects with gilt and colors; "heralds" saw to the painting of arms; and "plaisterers" were responsible for walls. There were often blurred lines of trade practices among the guilds, accompanied by frequent disputes, particularly among the stainers and painters and later with the heralds. But it was not until the first years of the sixteenth century that two of the groups joined to create the Worshipful Company of Painter-Stainers. In 1581, Queen Elizabeth I granted them a charter; another followed from King James II in 1685.

Most scholars believe that all of the guilds associated with the painting trades were at the height of their authority and influence during the late seventeenth and early eighteenth centuries. The advantages of membership included the right to establish retail trade and the assurance of labor control that guarded against competitive monopolies on apprentices and journeymen.[39] By the eighteenth century, the interests of the Company of Painter-Stainers also extended to the fine art of painting. Many of London's most successful artists, including presidents of the Royal Academy, the institution that followed St. Martin's Lane Academy, became members as "liverymen" or "freemen."[40] In sum, one became a guild member either because of prominence and master status (often conferred by the Crown) or by successful completion of an apprenticeship and the agreement to follow the guild's established rules.[41] In England, being a guild member was critical to pursuing one's career and, as it became financially possible, becoming a master and shop owner. That was not the case in America.

Because such a rigid system did not exist in the colonies, painters of all ranks could practice whatever aspects of the trades they wanted wherever they wanted. This kind of freedom would have been highly appealing to immigrants who may have served all or part of an apprenticeship in London and encountered serious competition or restrictions there, including the control of assistants' wages by the guild system. Such freedom would also have appealed to those who simply wanted to pursue painting without spending seven years or more learning how.

American-born painters whose experiences were confined to the colonies did not have the disadvantages of the guild system, but neither did they have the advantages. Instruction available to colonial American painters was more rudimentary and cursory than training available in England. An apprenticeship to an independent painter of simple utilitarian and ornamental work could be had, but it conferred no endorsement by the Crown. A few American societies brought together persons in like trades, but their authority over trade practices was limited. Instead, American trade-trained painters usually learned by viewing works of other artists and possibly by consulting manuals or, more likely, meeting with or watching a skilled artist paint an easel picture. In fact, consultations and brief training sessions

with professional painters were probably more common than we know. For instance, Charles Willson Peale's early studies with John Hesselius can be documented. Often, however, the presumptions of relationships between painters and their exchange of information regarding techniques are based solely on circumstantial evidence, such as observing similarities in the painting styles of painters who were in the same place at the same time. For example, the contact thought to exist between Robert Feke and John Hesselius and between Hesselius and Wollaston Jr., while having no basis in documented fact, seems very plausible.

Portraiture and Other Paintings

As previously noted, most early southern artists and those who purchased their work thought of paintings of all sorts as important, aesthetically pleasing, and decorative commodities—not as vehicles of exalted expression. For instance, the request of John Custis IV for William Byrd II to purchase him a suitable fireboard in London (see page 10) implied that Byrd's ability to judge the painting of such a practical item was no different—and no less important than—his ability to judge paintings in general. The idea that one might ascribe aesthetic qualities only to portraiture or canvas art limits our understanding of the sensibilities of early Americans. The Custis request is but one bit of evidence that paintings other than portraits were available to and present in some eighteenth-century southern dwellings even though portraiture prevailed as the art of choice in the South, just as it did in England.[42]

The question of why and how portraits became the primary type of painting in the colonies has been explored by several historians.[43] Although southern clients and artists have left little commentary on the popularity of painted likenesses, the reasons for that preference are fairly straightforward. By the end of the seventeenth century, the subjects of most portraits were family members and friends, often those who were absent but fondly remembered through their images. William Byrd II said as much in a letter of July 12, 1736,

to John Perceval, Earl of Egmont. Byrd wrote, "I had the honour of your Lordships commands of the 9th of September, and since that have the pleasure of conversing a great deal with your picture. It is incomparably well done & the painter has not only hit your ayr, but some of the vertues too."[44] In a 1759 defense of portraiture as the most popular form of painting in England, the English commentator Dr. Samuel Johnson expressed a similar rationale:

> That the painters find no encouragement among the English for many other works than portraits, has been imputed to national selfishness. 'Tis vain, says the satirist, to set before any Englishman the scenes of landscapes, or the heroes of history; nature and antiquity are nothing to his eye; he has no value but for himself, nor desires any copy but of his own form.
>
> Whoever is delighted with his own picture must derive his pleasure from the pleasure of another. . . . those whom he loves, and by whom he hopes to be remembered. The use of the art is a natural and reasonable consequence of affection . . . it is often complicated with pride, yet even such pride is more laudable than that, by which palaces are covered with pictures, that, however excellent, neither imply the owner's virtue nor excite it.

Johnson went on to say that portraiture was used to extend friendship and revive tenderness by "quickening the affection of the absent, and continuing the presence of the dead."[45]

In the colonies, the tightly structured family unit of loved ones was more important to social and economic success during the seventeenth and eighteenth centuries than it is today. Particularly in the early eighteenth century in rural areas of the South, family portraits were often commissioned en suite, recording every member of the household in a single, double, or group format. As noted in chapter 2, the infrequency of artists' visits to rural areas made multiple commissions so practical that they often became the norm. Plantation lands associated with the South's agrarian economy—and with the most affluent consumers—comprised hundreds and thousands of acres.

There were few towns, and travel by land was time-consuming, especially in the coastal tidewater that was riddled with marshes, creeks, and small estuaries where ferries hauled people and products back and forth according to the tides. Unlike consumers in Philadelphia, New York, and some New England areas before the 1760s and 1770s, southerners were less likely to commission portraits at the time of marriage or the coming of age. While many companion portraits in Maryland, Virginia, and South Carolina were created to commemorate marriage, often their dates are later than the actual event. Overwhelmingly, most early southern portraits were created when artists and income were available. The only variances to this practice were wealthy southerners' infrequent engagements of London artists to create portraits of their sons while they attended schools in England and the occasional commissioning of portraits from the few artists resident in urban centers.

In addition, there is real and inferred evidence about how consumers' increasing expectations for finery and a comfortable lifestyle paralleled the growing popularity of portraiture as well as other types of painting. Portraits, like other fine furnishings, had status-conferring intent. They reflected the sitter's ability to provide a home environment of worldly fashion and taste, which in turn reflected a socially acceptable level of education and sophisticated knowledge, including the rules of deportment and decorum. For the established southern "colonial aristocracy," these qualities were usually gained through familial instruction and attention to gentry trends abroad. For the middle class, these traits could be easily learned through adopting gentrified manners, achieving literacy, and working toward self-improvement. Usually the accrual of wealth and the attainment of social acceptability were concurrent.

Possessing individual likenesses therefore conveyed a sense of self-worth, respect, and family pride since the accomplishments and expectations of all members contributed to one's self-esteem.[46] The same was true of owning and displaying portraits of "friends," that is, acquaintances who figured among the socially well connected or politically prominent. One extraordinary

example of this practice in Virginia was William Byrd II's impressive collection of portraits of both friends and family. Few mid-eighteenth-century southern households had collections that even approached Byrd's, but the portraits they did have served the same purposes. Often hung in entrance halls or other rooms where visitors were entertained, they were meant to send powerful messages of social standing to all who saw them.[47] Passed from one generation to the next by gift or bequest, wall-hung likenesses tended to move out of a household only when they moved into that of another family member, usually a son or daughter. The only likenesses intentionally created for private consumption were the small and intimate miniature and cabinet-size portraits that could be worn as pendants or stored discreetly out of sight. However, with the exception of the miniatures Mary Roberts (ca. 1715–1761) created for several Charleston families and a few rare European examples, such portraits were not widely popular in the colonies during the first three quarters of the eighteenth century.

Provincial full-size portraiture in rural Europe, particularly in seventeenth- and eighteenth-century England, probably functioned in the same manner as it did in colonial America, although such likelihood cannot be verified from the few studies that exist. Published information about British provincial painting is limited, and most of the known portraits are illustrated and briefly described in obscure monographs by or about sitters or in historic house accounts. In addition, many have lost their histories through dispersal to American and other antique markets where they have become unknown sitters by unidentified painters—or instant ancestors by purchasers in need of a pedigree. British historians have usually dismissed provincial English portraiture as being inferior and having only modest extrinsic value.[48] Studies of rural German and French portraiture for the period fare no better and yield the predictable low ranking of provincial artists as compared to urban painters with the highest styles and greater technical achievements. There is some evidence to support the idea that the absence of rural or provincial painters in England during the eighteenth century was

due to London's emergence as an important cultural center—and the relative ease of travel to and from London from outlying English provinces. England had many established towns, a superior system of roads, and few waterways to cross, unlike the colonies. In addition to serving clients coming into London, painters were more likely able to move in and out of the English countryside without prolonged stays, unlike their colonial peers.

In fact, by 1700, London was the second or third largest city in the world and the largest in Europe. Throughout most of the eighteenth century, it handled 80 percent of England's imports, 69 percent of its exports, and 86 percent of the trading and redistribution or reexport of the country's goods. Looking to London as their capital, Britain's American colonies played a significant role in London's growth and, in return, benefited from that growth. For many years, London attracted and supported a variety of tradespeople, including painters from Scotland, Ireland, and mainland Europe. With the exception of foreign artists of the first rank like Michael Dahl (1659–1743) of Sweden, most painters who worked in London received their earliest training there in the trades and only afterwards acquired instruction in portraiture or other types of easel art from higher-rank painters with studios. London's lesser-ranked painters made their living by copying old masters pictures, providing portraits for the upper middling sort, and serving as assistants in the ateliers patronized by royalty and gentry. Wealthy American colonists traveling abroad found willing and capable painters in London who could furnish portraits in a short period of time. The most celebrated painters created a few such likenesses, usually for the most discerning and affluent clients, some of whom were young and attending school in England (see, for example, frontispiece, *Robert Carter III,* and fig. I.13, *Thomas Nelson Jr.*). Some southerners also commissioned likenesses from lesser-rank artists whose names have yet to be identified. It therefore comes as no surprise that some southern clients, accustomed to seeking art from abroad, eagerly sought portraits by itinerant painters

trained or based in London who traveled to America. For example, the visiting Londoner John Wollaston Jr., painted portraits for nearly every wealthy family in Virginia as well as for a large number in Maryland and others in South Carolina.

In both England and America, the rise of an art market occurred between 1700 and 1750, encouraged and promoted by essays and published analyses of art by men like Jonathan Richardson (1667–1745). Such critical writings helped shape ideas of taste—including a taste for portrait painting.[49] While some connoisseurs abroad and perhaps a few in America considered portraiture inferior to other kinds of painting—chiefly history and landscape paintings, sometimes referred to as nature painting—the portrait continued to dominate the art markets in both England and America until its demise in the mid-nineteenth century.

Closing Note

Painters and Paintings of the Early American South includes detailed information on each artist, insofar as such information is known and as space permits. Some painters are more thoroughly discussed than others. When appropriate, previously published artists' biographies are summarized and fully credited. Even there, however, the information is usually augmented by new research or by new analyses informed by primary sources and older, more obscure publications such as early county, city, and state historical journals as well as references to artists contained in studies other than art. Whenever possible, such sources have been located and reviewed for the accuracy of data they contain, and pertinent findings have been woven into a plausible account of each artist's life. The exceptions to this approach are a few London artists and some of the later painters such as John Singleton Copley, Benjamin West, Charles Willson Peale, and Henry Benbridge. Because these four American-born artists and many of the London-based painters have been thoroughly chronicled in previous publications, this volume focuses more on their southern work and less on their entire careers.

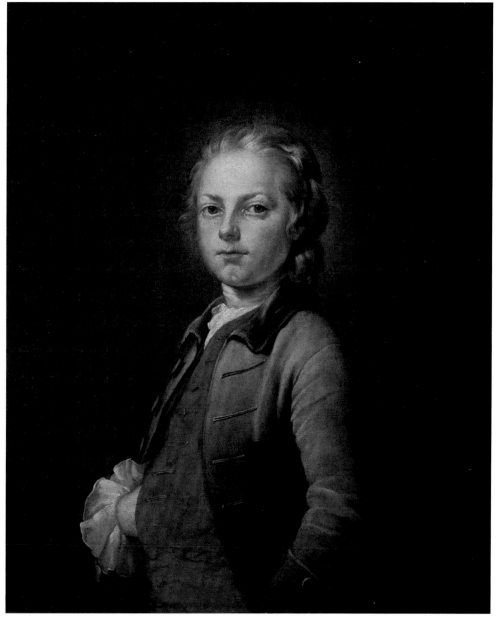

I.13

FIGURE I.13. Mason Chamberlin, *Thomas Nelson Jr.*, 1754, oil on canvas, 29⅛" x 24⅜". Virginia Museum of Fine Arts, Richmond. Gift of Dr. John Randolph Page. Photograph by Katherine Wetzel.

Mason Chamberlin (1727–1787) was a founding member of the Royal Academy. He painted this portrait when Thomas Nelson Jr. (1738–1789), then sixteen years old, was attending school in Cambridge, England. Nelson returned to his home in Yorktown, Virginia, when he was twenty-two. His parents, Mr. and Mrs. William Nelson, had been painted by Robert Feke several years before (figs. 5.30 and 5.31). Born into wealth, Thomas Nelson Jr. owned large tracts of land in Virginia, served as a soldier during the siege at Yorktown, and signed the Declaration of Independence.

Each chapter of this book ends with profuse notes with material that is sometimes lengthy and complex in the hope that such notes will enrich the reader's understanding of the context in which the artists lived and worked—the persons they knew, the events they participated in, the places to which they traveled, and the ways in which they practiced business. Some of that contextual evidence is clear and direct while some is nuanced and subtle. However, without such information, the shape and quality of the artists' lives cannot be fully grasped. It is also hoped that the information contained in the notes will encourage new research, especially toward locating works other than portraits and discovering paintings by those artists currently known only by name.

In addition, the book endeavors to include life dates for all artists and sitters mentioned as well as for a few persons who figure significantly in various discussions. When an artist's life dates are unknown, a date or dates are provided for his or her period of activity (e.g., "active 1750–1790"). For the many instances in which dates cannot be verified through existing genealogical sources, the dates provided are those most frequently cited in other materials, both published and unpublished.[50] The date of execution for each work illustrated in the book is given in one of several ways: as a range of dates (e.g., "1755–1767"); as a circa date (e.g., "ca. 1750"), meaning possibly up to five years before or after the year given; or as a fixed date (e.g., "1750"), implying that sufficient documentation exists to be certain of that date. If a year is given on the work itself, that fact is indicated by the word "dated" (e.g., "dated 1750").

Regarding the attribution of works included in this study, an artist's name is given for each painting that is in some way documented to the artist or is in other ways strongly attributable to him or her. Where there is some doubt as to the attribution, the level of that doubt is expressed in degrees of uncertainty through use of the words "possibly" or "probably" or by a question mark.

Portrait Prices Charged by Artists in Europe and North America from 1647 to 1786*

Date Range	Painter's Name	Type of Portrait	Cost	Location
1647	Peter Lely	bust-length	£5	England
	Peter Lely	3/4-length	£10	England
1670	Peter Lely	bust-length	£20	England
	Peter Lely	3/4-length	£40	England
1700–1720	Godfrey Kneller	bust-length	15 G†	London
	Godfrey Kneller	3/4-length	30 G	London
	Godfrey Kneller	kit-kat	20 G	London
	Godfrey Kneller	full-length	60 G	London
c. 1720	John Wollaston Sr.	3/4-length	5 G	London
1720	Charles Jervas	bust-length	20 G	London
	Charles Jervas	3/4-length	30 G	London
	Charles Jervas	full-length	70 G	London
1720–1724	John Smibert	bust-length	£7 7s. 6d.–£6 6s.	London
	John Smibert	3/4-length	10–15 G	London
	John Smibert	kit-kat	11 G	London
1720–1730	Michael Dahl	3/4-length	20–30 G	London
	Jonathan Richardson	3/4-length	20–30 G	London
	Joseph Highmore	3/4-length	20–30 G	London
1722	Gustavus Hesselius	Last Supper	£17	St. Mary's, MD
1723	Thomas Gibson	3/4-length	12 G	London
1736	Jeremiah Theus	3/4-length	£30	Charleston, SC
1750–1770	Pompeo Batoni	miniature	60 scudi‡	Rome
	Pompeo Batoni	half-length	30 scudi	Rome
	Joshua Reynolds	half-length	15 G	London
	George Romney	half-length	15 G	London

Date Range	Painter's Name	Type of Portrait	Cost	Location
1752	John Wollaston Jr.	half-length	2 for £36	Philadelphia, PA
1757	John Wollaston Jr.	3/4-length	3 for £56.pistoles	Virginia
1766	Joseph Badger Jr.	floorcloth	£24	Charleston, SC
1767	Lewis Turtaz	miniature	£20	Charleston, SC
1769	Pompeo Batoni	half-length	50 G	Rome
1770–1775	Charles Willson Peale	head-size	£5 5s.	Maryland, New York, Pennsylvania, Virginia
	Charles Willson Peale	kit-kat	£6 6s. 9d.	Maryland, New York, Pennsylvania, Virginia
	Charles Willson Peale	half-length	£10 10s.	Maryland, New York, Pennsylvania, Virginia
	Charles Willson Peale	full-length	£22 1s.	Maryland, New York, Pennsylvania, Virginia
	Charles Willson Peale	miniature	£5 5s.	Maryland, New York, Pennsylvania, Virginia
1773	Jeremiah Theus	various	3 for £113 15s.	South Carolina for shipment to Georgia
1774	Pompeo Batoni	bust-length	30 G	Rome
	Pompeo Batoni	half-length	40 G	Rome
	Pompeo Batoni	full-length	125–250 G	Rome
1776	Charles Willson Peale	miniature	$28–56	Maryland, Pennsylvania, Virginia
1778	Charles Willson Peale	miniature	$120	Maryland, Pennsylvania, Virginia
1780	Charles Willson Peale	half-length	10 G	Maryland, Pennsylvania, Virginia
	Charles Willson Peale	"replicas"	8 G	Maryland, Pennsylvania, Virginia
	Charles Willson Peale	full-length	30 G	Maryland, Pennsylvania, Virginia
1786	Charles Willson Peale	head-size	5 G	Maryland, Pennsylvania, Virginia
	Charles Willson Peale	kit-kat	8 G	Maryland, Pennsylvania, Virginia
	Charles Willson Peale	half-length	16 G	Maryland, Pennsylvania, Virginia
	Charles Willson Peale	full-length	30 G	Maryland, Pennsylvania, Virginia

*Data for this chart comes from numerous sources including monographic works on individual artists, surviving receipts from artists, newspaper advertisements, and general histories of early English and American paintings.
† Guinea
‡ An Italian silver coin used in the eighteenth and nineteenth centuries.

1. The study of middle-class values and definitions as pursued by many historians has provided no clear consensus as to when an American middle class—as opposed to the middling sort—emerged. Of course, there were degrees or wealth within each class. The terms "middling sort" and "middle class" are used throughout this text interchangeably since the myriad finite distinctions are far too numerous to mention here. See C. Dallett Hemphill's essay, "Middle Class Rising," 320.

2. Hemphill, "Middle Class Rising," 318.

3. Boswell, *Life of Samuel Johnson,* 1:113.

4. Sartain, *Reminiscences,* 147. See also n55 in ch. 5.

5. A tucker is usually the small cloth or a piece of lace at the neckline of a dress.

6. Miller, *Selected Papers,* 535–538, 550–551.

7. Byrd to Perceval, 12 July 1736, in Tinling, *Correspondence of Three Byrds,* 2:487.

8. William Byrd II, "Letters of the Byrd Family," 211–212.

9. *Letterbook,* 62–63.

10. The precise definition of a "shew-board" versus a "sign" remains somewhat vague. "Shew-boards" mentioned in English records are described as lettered placards (paper and sometimes wood) hanging by rope, cord, or other impermanent device on the front walls of stores. "Signs" and "signboards" seem to refer to more elaborate and permanently attached wood or metal devices. See, for example, Gustavus Hesselius and John Winter's advertisement in the *Pennsylvania Gazette* (Philadelphia), Sept. 25, 1740.

11. "Carpenter, Tailor," 269.

12. As quoted in Winsor, *Memorial History of Boston,* 121n1.

13. Copley to Henry Pelham, 6 Nov. 1771, in Copley and Pelham, *Letters and Papers,* 174.

14. West to Copley, 4 Aug. 1766, in ibid., 44–45, 51.

15. "Carpenter, Tailor," 271–272. Renowned artists like Sir Joshua Reynolds and Sir Godfrey Kneller hired drapery painters to execute the fabrics of a sitter's costume/dress and other elements such as swagged curtains behind the sitter, upholstery fabric on chairs, and so forth. Rather's painter-tailor analogy is apt, and it helps explain the rank of portrait painters in relationship to other tradespeople of the period. She notes that colonial independence affected this sort of ranking in America. In his *History of the Rise and Progress of the Arts of Design in the United States* (1834), William Dunlap, America's early art historian, indicates a similar shift in how painters were regarded after the Revolution (16–17).

16. According to the *Oxford English Dictionary,* the etymology of "limner" is associated with several word forms. As a verb, "to limn" or "lymn" derives from the early fifteenth century and refers to lettering, usually lettering embellished with gold and rarely in colors. By the sixteenth century, the word meant "to paint (a picture or portrait)" or simply "to paint," or "to paint in water-colour or distemper." In the seventeenth century, the word "limning" was sometimes used to describe drawing as well as painting pictures. The word "limner" or "lymner" dates to the fourteenth century when it was used to describe an illuminator of manuscripts, one who lettered as well as one who worked in gold leaf and with paints. Sixteenth- and seventeenth-century meanings of the word vary, from "painter" to watercolor painter to "portrait painter." In eighteenth-century documents, the word "limner" is more strongly nuanced towards portrait painting but does not exclude other work.

17. According to Ellen G. Miles, "The social status of the painter can also be suggested by the terminology used for him or his work. The term 'limner' surfaces with some frequency in this period as a synonym for a portrait painter. It is derived from the verb 'to limn,' which had its origins in medieval manuscript illumination and subsequently in miniatures. Because most miniatures were portraits, the term came to mean 'portrait painter.' In contrast, the word 'painter' was used to denote anyone whose trade involved painting on flat surfaces, such as walls, coaches, or heraldic shields, and not to indicate the intellectual skills of an artist as the modern age envisions him" ("Portrait in America," 42). In the discussion that follows, Miles lists various American artists who were called "limner" in a variety of documents, but the records of most interest are advertisements or related pieces wherein the artist personally assigns his or her designated profession. For example, says Miles, Thomas McIlworth's (active 1757–1770) advertisement used the words "Portrait Painter" in New York in 1758; John Mare (1738/39–1804), same city, was referred to as a "Limner" in 1765 but called himself a "Portrait Painter" in 1772; also in earlier New York, Raphael Goelet (1695/96–1747/48) and Gerardus Duyckinck II (1695–1746) were called "limners." Miles notes that Charles Willson Peale, a trained portrait painter who also did other pictures, called himself a "Limner" in 1774. But Peale, out of modesty or prudence, tended to underestimate his learned skills. He wrote that he had neither the time nor the inclination to slavishly follow classical models, something he considered necessary for an advanced portrait painter. He also believed that it was possible for anyone with sufficient desire and physical ability to learn how to paint, an attitude that was pragmatic and obviously encouraging to his family members. Miller, *Selected Papers,* 88n8. In 1771, for instance, he explained in a letter to Benjamin West that two of his brothers had begun "some essays in art. The youngest, James, will be a painter, he copy [*sic*] very well, and has painted a little from life." Peale went on to say that what surprised him was the effort of his younger brother St. George Peale (1745–1788), who had shown no interest in art. However, when St. George was twenty-five years old, Charles Willson challenged him to draw Hogarth's line of beauty. That "amused" the younger brother and sparked his interest. Charles Willson later wrote that St. George had "shown the application of this

line in various drawings, how it may be made a part of the face in profile, and the character varied. . . . and within three months, St. George was as great a proficient, that he could paint a tolerable portrait in Crayons." Charles W. Peale to Benjamin West, 20 Apr. 1771, Charles Willson Peale Letterbook I, and Charles Willson Peale, Autobiography, 54, Peale-Sellers Papers, American Philosophical Society, Philadelphia, as quoted in Simmons, *Charles Peale Polk,* 3.

18. Salmon, *Polygraphice,* 123.

19. The word's origins are in the Latin *pictor,* meaning painter and derived from *pingere* (paint); the word came into use many years before "limner" and referred to a person who applied colors. Its historic use in reference to pictures is difficult to pinpoint, but it was not associated with illumination.

20. Aug. 31, 1727, Diary, Correspondence, and Papers.

21. "Letters," 160–161.

22. *City Gazette & Daily Advertiser* (Charleston).

23. *South-Carolina Gazette* (Charleston), Mar. 24, 1732.

24. "'Expense of the Public': Sign Painters' Exhibition," 3.

25. See Taylor, *Art for the Nation,* 19.

26. *Essay on the Mechanic of Oil Colours,* 10. The unknown author of an essay about Paul Sandby (1731–1809) concurred as to the value of sign painting, saying that "though it may appear contemptible in the eye of modern practice. . . . It may also be . . . [a] style of painting [requiring] . . . a firm pencil and a decided touch, together with an effect which might tell at a distance,—no bad foundation for skilful execution in art" ("Paul Sandby and His Times," 339). For more on Williams and Sandby, see page 23.

27. From "Discourse III" in *Discourses,* 83–84.

28. The standard works on treatises and art manuals in America are two essays by Janice G. Schimmelman: "Books on Drawing and Painting Techniques Available in Eighteenth-Century American Libraries and Bookstores" and "A Checklist of European Treatises on Art and Essays on Aesthetics Available in America through 1815."

29. Saunders and Miles, *American Colonial Portraits,* 228–229.

30. *South-Carolina and American General Gazette* (Charleston), Aug. 22, 1766; Mar. 20 and Oct. 16, 1767; and Aug. 13, 1779, as found in Museum of Early Southern Decorative (MESDA) Craftsman Database. In the same paper, Wells's advertisement of Apr. 6, 1772, has an extensive list of publications, engraved prints, and "Designs of those eminent Masters, Watteau, Boucher, Le Brun, Bouchardon, Eisen, &c, &c."

31. From an editorial about Coram, believed to have been written by Charles Fraser (1782–1860), published on the day of Coram's funeral, May 3, 1811, in the *Charleston (SC) Times.*

32. In addition to the items owned by Byrd and others in America, many more publications devoted to drawing, painting, and related subjects were published in England and France. Translations from the French included Gerard De Lairesse's *The Principles of Drawing: or, An Easy and Familiar Method Whereby Youth Are Directed in the Practice of That Useful Art* (1733 and later editions), his *The Art of Painting, in All Its Branches, Methodically Demonstrated* (translated by J. F. Fritsch, 1738), and a plagiarized anonymous version of *The Principles of Drawing . . . ,* published in Dublin in 1768. Another early French work, by Jean Dubreuil, was translated and published in London in 1726 by Ephraim Chambers, *The Practice of Perspective; or, An Easy Method of Representing Natural Objects According to the Rules of Art.* Other early books on perspective included those by Dr. Brook Taylor; Joseph Highmore (1692–1780), the portrait painter; and John Hoofnaile and Joshua Kirby (1716–1774). Books on anatomy included William Cheselden's *Osteographia; or, The Anatomy of Bones* (1733 and later), John Senex's republication of *An Anatomy Improv'd and Illustrated with Regard to the Uses Thereof in Designing* (1723), and John Brisbane's *The Anatomy of Painting; or, A Short and Easy Introduction to Anatomy* (1769). There were also other manuals, too numerous to mention here. Unfortunately, not much is known about their presence in the South. Where such information exists, it is cited in the text that follows.

33. American Philosophical Society, Philadelphia, as quoted in Simmons, *Charles Peale Polk,* 3. Pierce often signed his name as "William Pierce Jr.," although his father's name was Matthew. William was born in York County, VA, and, after his studies with Peale, sided with the American patriots and in 1776 was commissioned a captain in the First Continental Regiment of Artillery. He probably met Peale when both were serving in the army at Valley Forge, PA.

34. As quoted in Charles C. Sellers, *Portraits and Miniatures,* 9.

35. *The Connoisseur* was created in London by Bonnell Thornton, Robert Lloyde, and George Coleman to promote, through satire, their campaign against the hypocrisy of "connoisseurs" who preferred old master and imported foreign art over that of English artists.

36. Miller, *Selected Papers,* 127.

37. Neither Matthew Lock (active ca. 1748–1760?), the engraver responsible for many of the illustrations in Thomas Chippendale's (1718–1779) *Gentleman and Cabinet-Maker's Director* (London, 1754), nor Chippendale himself was a member of the academy. Lock, who was accomplished in drawing, opened his evening classes for tradespeople in 1748.

38. Williams, *Essay on the Mechanic of Oil Colours,* 10. In 1768, the Royal Academy of Arts was founded in London, and Sir Joshua Reynolds became its first president. Reynolds was dedicated to promoting the intellectual and noble aspects of art, those things that distinguished an ordinary "painter" or mechanic from the fine arts painter. He reputedly said that he would rather be an apothecary than an ordinary painter and, if given the chance, he would rather be

bound to an eminent painter than be an apothecary who functioned independently of a master.

39. The apprentice–journeyman–master system of ranking a trades person's status still exists in many trades. After completing an apprenticeship, the trades person is named a journeyman (or woman) and is usually allowed to charge a fee for work. A master tradesman usually was a member of a guild, elected to membership after producing a sum of money and creating a masterpiece of his trade acceptable to the masters.

40. The Royal Academy eventually replaced both St. Martin's Lane Academy and the Society of Artists. "Freemen" and "liverymen" comprised two categories of membership in the guilds; admission to each was granted according to certain criteria, including having served an apprenticeship in the trade for a specific number of years. Some of the celebrated painters were honorary freemen.

41. An exception to the rule was foreign painters, many of whom were superbly trained and had immigrated to England because of religious persecution. These artists tended to form their own groups and/or were also engaged by the ruling monarchs.

42. Paintings other than portraiture derived from eighteenth-century southern sources are not discussed here but include the landscapes, seascapes, still lifes, and an occasional "picture" after known old masters that are mentioned in the chapters following.

43. Most notable is Margaretta Lovell in her *Art in a Season of Revolution: Painters, Artisans, and Patrons in Early America* (2005). Although most of her examples have a northern provenance, her points are well-taken and have relevance for the South, though they will not be repeated here.

44. In Tinling, *Correspondence of Three Byrds,* 2:487.

45. Murphy, *Works of Samuel Johnson,* 399. Johnson's argument, part of an essay defending portrait painting, was originally published in London on Feb. 24, 1758, in the *Idler.* A comment from one of Henry Benbridge's clients also expressed a similar function for portraits. The letter is from the Reverend Thomas Coombe (1742–1822) in London to Sarah, his sister, in Philadelphia: "My portrait must serve to put you in mind of me 'till I make my appearance in Philadelphia. It is allowed to be a good resemblance and I have no doubt [it] will give you much pleasure." As quoted in Stewart, *Henry Benbridge,* 32.

46. "Accomplishments" is broadly defined here; it may include property ownership, political and economic successes, leadership in institutions, business dealings, community standing, marital connections, and the like. See Daniel B. Smith, *Inside the Great House,* and Lewis, *Pursuit of Happiness.*

47. William Byrd II hung many, if not most, of his portrait paintings in his library, which was an intimate space as well as one he shared with visitors. However, inventories from Byrd's period and later also list portraits and other paintings in more public rooms and hallways.

48. Although not intended as a comparative analysis of rural and urban painters and paintings in America and England, Susan Rather's "Carpenter, Tailor" comes the closest to addressing the ranks of painters, including how those ranks were defined by consumers. Published surveys of English provincial and naive painting include Andras Kalman, *English Naive Paintings: From the Collection of Mr. and Mrs. Andras Kalman,* and James Ayres, *English Naive Painting, 1750–1900.* Neither of the latter two publications features more than a handful of eighteenth-century paintings, and, of those included, few are portraits. Publications dealing specifically with British or English provincial painting in the seventeenth and eighteenth centuries do not exist. Either the material has been considered too mundane and inexpert—and thus unattractive to English scholars—or its existence is sparse. Andras Kalman, the English collector and dealer mentioned here, put together an important collection of signboards, still-life paintings, and animal portraiture dating mostly to the nineteenth century. Kalman's research revealed few early provincial portraits, suggesting that comparable material as we know it in America has been little studied in England.

49. See Harrison, Wood, and Gaiger, *Art in Theory, 1648–1815,* for period writings that address connoisseurship of paintings by men such as Richardson.

50. The problem of dating is further complicated by calendar changes that began in parts of Europe in 1582 and continued in other places, including Great Britain and the eastern North American colonies, through the mid-eighteenth century. If uncertainty exists among researchers about which year is correct, birth or death dates are cited in paired years (e.g., 1731/32).

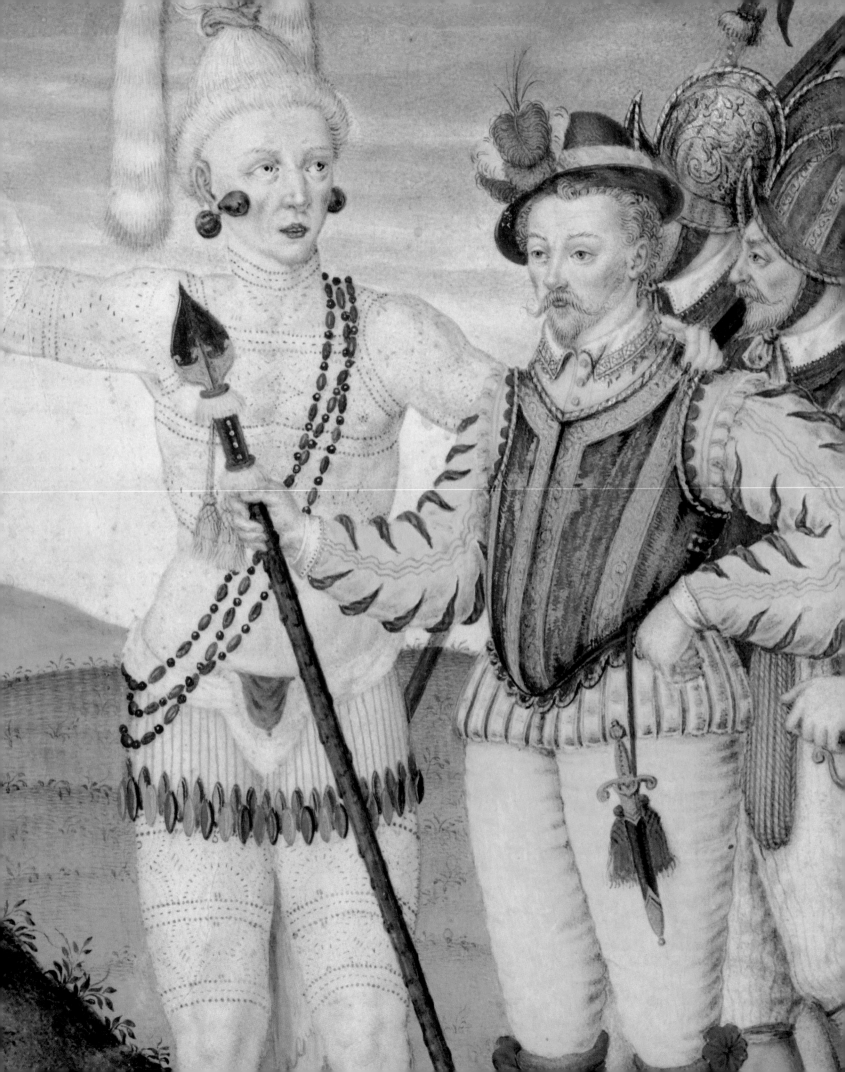

Every Country left to it selfe, and not much molested with famine, or devoured by warres, will at length grow too populous, unable to sustaine it's owne weight, and relieve it's owne Inhabitants. Whence it hath bin a policy practised by most Kings & States in such cases, to make forraine expeditions, and send forth Colonies into other Countryes lesse peopled, to disburden their owne of such encombrances; as we see the Kings of *Spaine* to have sent many into the *West Indies*; and we at this day discharge many *Idlers* into *Virginia* and the *Barmudas*.

NATHANAEL CARPENTER, 1625[1]

CHAPTER 1
Exploring the New World

Beginning as early as 1000 CE and continuing through the 1520s, numerous oceanic voyagers set out from Europe to explore islands and other lands associated with the Americas, including the Canadian Maritimes. Most historians believe that the first adventurers were Norse sailors who traveled either to or within range of the North American continent and who also visited Greenland and Iceland. Fishermen from England, Portugal, and France eventually found routes to those regions for summer cod fishing as well. After roughly 1400 CE, the overwhelming majority of exploratory voyages were driven by the desire for increasing world power and imperial wealth, made possible by territorial expansion and the discovery of precious commodities such as copper, silver, and gold. By 1494, the Spanish claimed lands to the west of longitude 46°37' west, with everything east of that line, including parts of Newfoundland and Labrador, going to the Portuguese.[2] During the 1500s, Spain and Portugal continued to send voyages west, attempting to establish routes to commercial interests in Asia, including the Moluccas, or Spice

Islands; and, in the 1530s, Jacques Cartier explored New France via the St. Lawrence River. However, most of the explorations to the New World were confined to the east coasts of North and South America, whose large land masses were variously called "Antillia," "Atlantis," "Utopia," "Arcadia," "Eldorado," and "America" by the different European peoples that visited them.[3]

The idea of conquest is often cited as a rationale for these explorations, although some recent scholarship challenges that idea. Historian Joyce Chaplin, for example, discusses how the concept of conquest figured into the thinking and literature of English explorers who, she claims, "were not conquerors—not really" but who were motivated by an intellectual drive to define "the composition of the material world, the technology to exploit material resources, and—above all—the nature of human bodies that wielded the technology."[4] Nevertheless, English exploration of the New World was also focused on the prospect of finding specific valuable natural resources, including gold, silver, and copper. In addition, the earliest English explorers were searching

Detail of fig. 1.8

FIGURE 1.1. Artist unidentified, *John Dee*, ca. 1594, oil on canvas, 29¹⁵⁄₁₆" x 25". Ashmolean Museum, University of Oxford, UK/The Bridgeman Art Library Nationality.

John Dee's (1527–1608/09) various publications included a book on navigation and a study of hieroglyphics (including the creation of a hieroglyphic of his own). Eventually he took an interest in the supernatural. He lived as a recluse in Poland for several years before returning to England. There he found his impressive library destroyed by vandals and many materials stolen. He died a pauper.

FIGURE 1.2. Artist unidentified, *Queen Elizabeth I*, possibly 1599, oil on canvas, 88" (including 9" later extension below) x 66½". Hardwick Hall/The Devonshire Collection (acquired through the National Land Fund and transferred to the National Trust in 1959).

According to scholar Janet Arnold, this was one of three portraits of Elizabeth I (1533–1603) listed at Hardwick Hall in 1601. Some speculate that the material for the dress was a New Year's gift from Elizabeth Hardwick, Countess of Shrewsbury, to the monarch. Although that supposition cannot be verified, such gifts were common, and the queen's tailor could well have made the fabric into royal clothing. For a fuller discussion of the dress and its motifs, see Arnold, *Queen Elizabeth's Wardrobe*, 76–80.

for a shorter passage to "Cathay," or China. The quest for this route purposed the late fifteenth-century explorations of Italian-born John Cabot on behalf of England.[5] Richard Hakluyt the Elder, a lawyer and noted geographer who had a passion for navigation and cosmography, was also among those pursuing a northeast route to Cathay in the 1550s.[6]

So too was John Dee (fig. 1.1), the British polymath (mathematician, astronomer, and astrologer). When Queen Elizabeth I (fig. 1.2) succeeded her half sister, Mary, to the throne in 1558, England still had no established American colony. Dee, who counseled the queen with regard to astrology and science, including maritime matters, was a strong advocate for the imperial expansion of Britain, specifically through voyages of discovery that would lead to the claiming, exploring, and colonizing of foreign lands.[7] With information gathered from a

number of well-known European navigators and cosmographers,[8] Dee trained British explorers in mathematics and navigation and advised those involved in New World voyages and explorations.

Elizabeth's brother-in-law, Philip II of Spain, who had been Mary's consort, considered nearly all of the Americas as part of the Spanish empire. Such a large land mass was hard to defend, however, and Spain's dominance was not

1.3

FIGURE 1.3. Willem (ca. 1598–1637) or Magdalena (1600–1638) van de Passe, engravers, *Sir Humphrey Gilbert*, ink on paper, from *Heroologia Anglica*, published in Amsterdam, 1620. © The Trustees of the British Museum.

Humphrey Gilbert (ca. 1537–1583) was an ardent supporter of the English Crown in both his military service and his work as an explorer. He had numerous connections with the court of Elizabeth I through, among others, his mother and Sir Walter Raleigh, his half brother. Educated at the University of Oxford, where he acquired a sound knowledge of navigation, he eventually presented the queen with a proposal to discover a new northwest passage to China (published in 1576). His various voyages included his laying claim to Newfoundland in 1583 by letters of patent awarded in 1578 from the Crown. In 1584, the year following his death, Gilbert's patent was reissued to his half brother Raleigh, who organized the Roanoke expedition.

FIGURE 1.4. Artist Unidentified, *Sir Walter Raleigh*, ca. 1590, oil originally on panel, later transferred to pressed fiberboard, 44³/₁₆″ x 33⁷/₈″. Colonial Williamsburg Foundation, Williamsburg, VA. Gift of Sir Harold Harmsworth.

Sir Walter Raleigh (ca. 1552–1618) was the well-known English soldier, explorer, and courtier knighted by Queen Elizabeth I in 1585. A Protestant by birth, he was famous for suppressing rebellions in Ireland, which earned him the queen's favor. His half brother Humphrey Gilbert first held the patent to explore and colonize Virginia. Raleigh gained possession of the patent after Gilbert's death. In 1618, under King James I and after leading a brutal attack on the Spanish outpost in San Thomé in Guiana, Raleigh was arrested and beheaded at Whitehall.

Originally presented by Queen Elizabeth I to her cousin Thomas Sackville, 1st Earl of Dorset, the portrait remained in the family for two centuries before being purchased by Sir Leicester Harmsworth and subsequently given to the Colonial Williamsburg Foundation by Harmsworth's son.

recognized by major European powers such as England and France, which were pursuing their own plans. Humphrey Gilbert (fig. 1.3), the older, half brother of Sir Walter Raleigh (fig. 1.4), had renewed an interest in finding a shorter passage to Cathay, but his plan to discover that passage failed. A few years later, in 1572–1573, Sir Francis Drake (fig. 1.5) sailed the Caribbean and returned with treasures pirated from the Spanish—also without having found a trade route to Cathay, although by 1580 he had sailed around the world by another route. Martin Frobisher was the next English explorer to pursue Cathay on voyages in 1576 and 1577. Throughout England and the rest of Europe, navigators, monarchs and government officials, investors, and other interested parties eagerly sought information about explorations from each other, although much of that information was guarded and some of it was inaccurate or deliberately misleading.[9] Of the various accounts, only a few were illustrated with detailed and reliable images, including maps (fig. 1.6).

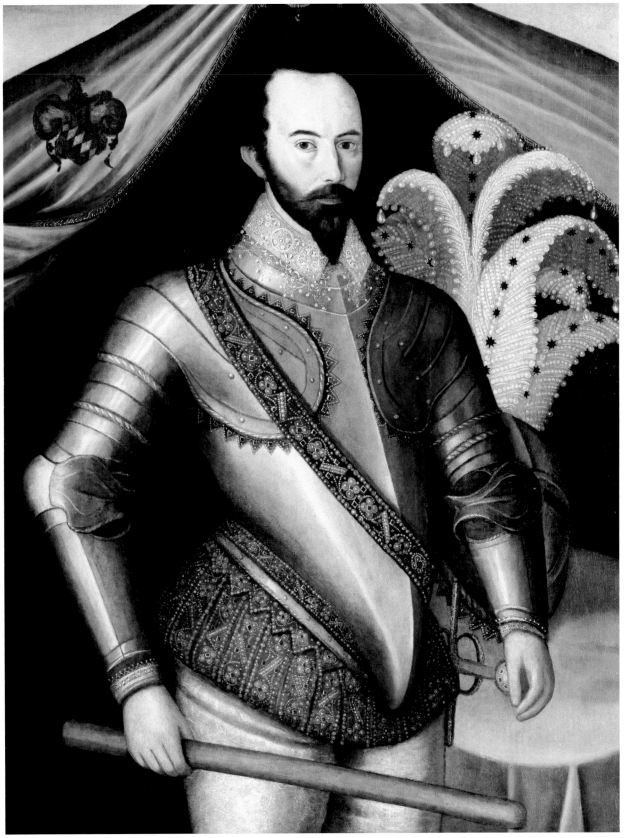

1.4

The earliest surviving North American paintings are also the earliest known works by painters associated with expeditions to the sixteenth-century South, roughly the coastal region from present-day Florida to Virginia and Maryland. The painters, Frenchman Jacques Le Moyne de Morgues (ca. 1533–1588) and Englishman John White (ca. 1540–1593), each created a series of rare watercolor images featuring Native people, their activities, and their towns as well as the flora and fauna of the region, much of which the artists personally observed (figs. 1.7 and 1.8). The original pictures were known at first only to a few, chiefly the European royalty and their supporters, navigators, and other scientists who were engaged in planning and often participating in voyages. The pictures became more widely known through engravings of them published in Germany in two books by Theodore De Bry (1527/28–1598) (fig. 1.9). Yet another artist probably accompanied Sir Francis Drake on his 1586 voyage.[10] *Histoire naturelle des Indes,* a journal associated with Drake and thought to be from that expedition, includes an engraving undoubtedly based on a watercolor painting of an American Indian titled *Hinde de Loranbec.*

Spanish explorers also created drawings or possibly paintings of some sort in these early years, for the younger Richard Hakluyt made reference to that practice in his 1585 manuscript, "Inducements to the Liking of the Voyage Intended towards Virginia in 40. and 42. Degrees." Regarding which tradespeople should be included on the voyage, he advised that a "skilfull painter is also to be caried with you which the Spaniards used commonly in all their discoveries to bring the descriptions of all beasts, birds, fishes, trees, townes, &c."[11] However, little is known about the images the Spanish explorers made, including whether any, with the exception of one, pertained to the southern coasts and gulf of North America. Most of the known images survive through engravings or woodcuts produced in Germany or elsewhere in northern Europe.[12] Often influenced by Protestant sentiment, those images sometimes exaggerated the Spanish explorers' treatment of the Native peoples who lived in Florida and South America. The one unbiased Spanish drawing known is a map with an aerial view featuring the garrison at St. Augustine, Florida,

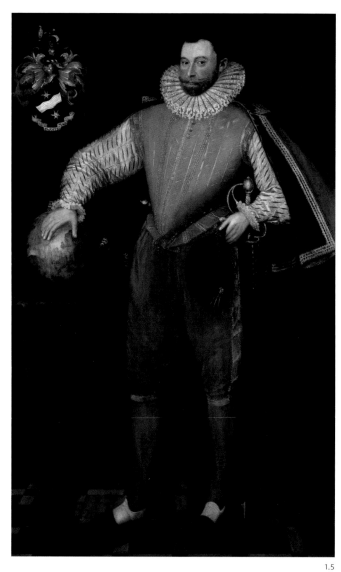

1.5

with buildings and some landscape elements. It dates to 1577. Though images exist of other sites in South America, no additional views of the Florida area are known.

Of the two painters featured in this discussion, Le Moyne was the older, his work predating White's by some twenty years. Although his single surviving watercolor associated with his 1564 voyage to North America (fig. 1.8) is usually given only brief mention in American art histories, much can be learned from De Bry's engravings after Le Moyne's lost pictures from that voyage and from Le Moyne's later watercolor drawings of flowers and other natural history subjects that have been researched and studied in recent years.[13] Le Moyne's

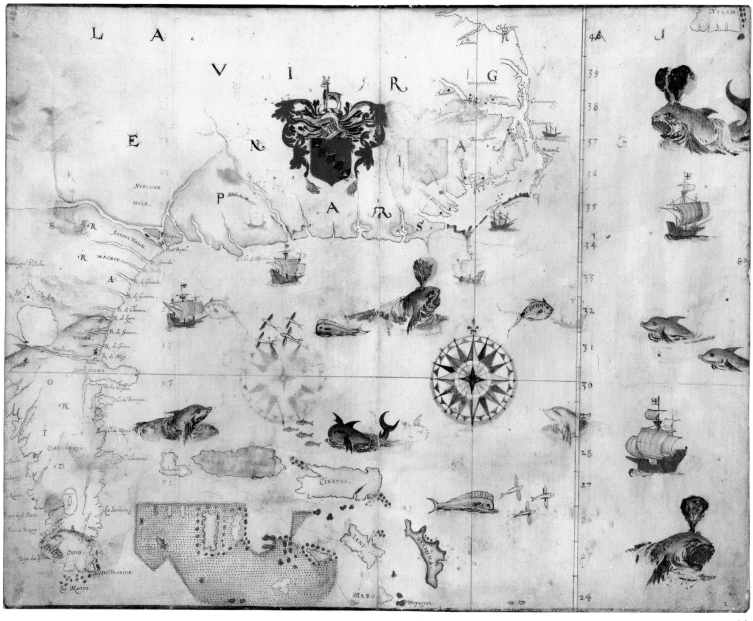

1.6

FIGURE 1.5. Unidentified artist, *Sir Francis Drake*, ca. 1580, oil on panel, 71⅜″ x 44½″. © National Portrait Gallery, London.

Sir Francis Drake (1540/45–1596), privateer and navigator, was knighted by Elizabeth I in 1581. His claims to fame include his service as the vice admiral of the English fleet during the 1588 war against the Spanish Armada, his notorious piracy of Spanish vessels in seas abroad and in regions of the New World, and his circumnavigation of the earth during the period 1577 to 1580.

FIGURE 1.6. John White, *La Virgenia Pars*, 1585–1588, ink over black lead and watercolors with gold leaf on paper, 14½″ x 18½″. © The Trustees of the British Museum.

The map illustrates the east coast of North America from the Chesapeake Bay to the Florida Keys.

41

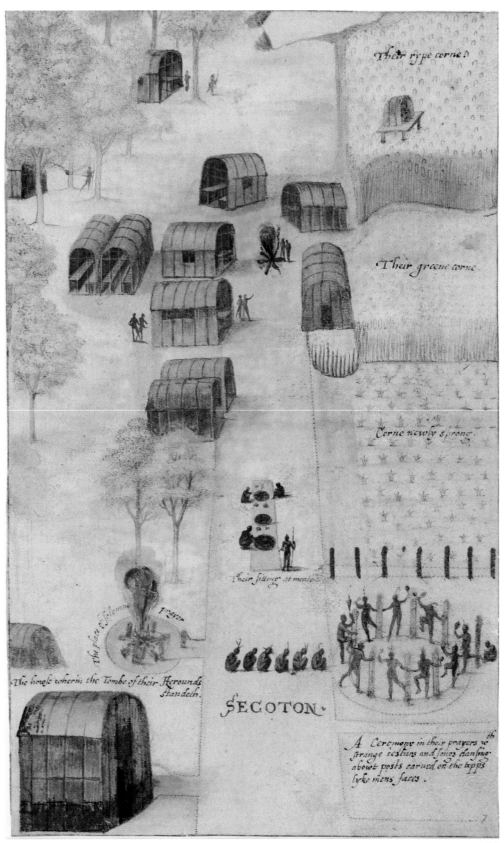

Their rype corne

Their greene corne

Corne newly sprong

Their sitting at meate

The place of solemne prayer

The house wherin the Tombe of their Herounds standeth.

SEGOTON

A Ceremony in their prayers wth strange testurs and songs dansing abowt posts carued on the topps lyke mens faces.

1.7

42

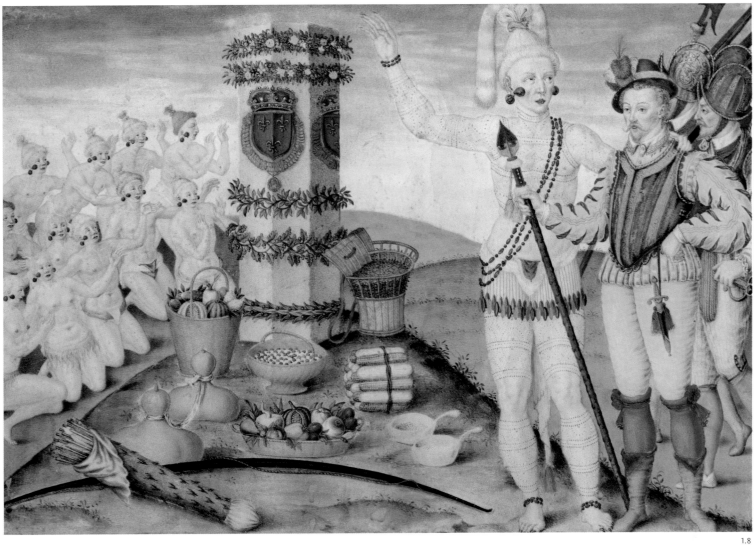

FIGURE 1.7. John White, *The Town of Secotan*, 1585–1588, watercolor over black lead heightened with body color (altered) and inscribed with brown ink on paper, 12¾″ x 7¹³⁄₁₆″. © The Trustees of the British Museum.

John White was with the party of men who sailed west across the Pamlico Sound in present-day North Carolina to Secotan, a village located on the mainland. Secotan was one of the large towns visited by the group, the other being Pomeiooc. The picture is remarkable for its detailed recording of Native homes and activities that White carefully labeled. Beginning at upper right and going clockwise, White's inscriptions read: "Their rype corne";

"Their greene corne"; "Corne newly sprong"; "Their Sitting at meals"; "SECOTON"; "A Ceremony in their prayers with strainge ies'tuns [?] and songs dansing about posts carved on the topps lyke mens faces"; "The house wherein the tombs of their Herounds frankedin [?]"; and "The place of Solmine prayer."

FIGURE 1.8. Jacques Le Moyne de Morgues, *Rene Goulaine de Laudonniere and Chief Athore at the Column of Jean Ribaut*, 1564–1566, watercolor and ink on vellum, 7″ x 10¼″. Print Collection, Miriam and Ira D. Wallach Division of Art, Prints and Photographs, the New York Public Library, Astor, Lenox and Tilden Foundations.

1.9

profession as a miniature painter familiar with cartography was tied closely to his place of birth: Dieppe, France, a port town located on the east coast of the English Channel. Sixteenth-century Dieppe was noted for its schools in cartography and illumination, including the highly detailed borders of flowers and other natural history subjects. It was also a major port town from which several Atlantic expeditions departed. It seems likely not only that Le Moyne was trained in one of

FIGURE 1.9. Theodor De Bry, engraver, *Self-Portrait*, ink on paper, from Jean-Jacques Boissard, *Pars Romanae urbis topographiae et antiquitatum*, published in Frankfurt, 1597. © The Trustees of the British Museum.

Dieppe's schools but also that he was well aware of the town's role in oceanic travel and exploration.

Nothing is known about the artist's family, his other involvements in Dieppe, or the particulars of his service as the recording artist on the second of two French expeditions to the New World. Historian Paul Hulton concludes that Le Moyne's painting and drawing skills must have been sufficiently impressive to those organizing the French voyage.[14] It seems more probable that in addition to his skills, some family, social, or political connection was involved in his selection, including a possible acquaintanceship with Jean Ribaut (Ribault) (ca. 1520–1565), the Huguenot explorer also born in Dieppe who was an officer closely involved with the French voyages to the New World. Le Moyne was also a Huguenot, as were most of the other leaders and participants in the voyage.

Le Moyne's story as gleaned from his single surviving picture is inextricably tied to events associated with the first French voyage in 1562 and the establishment of a garrison in Florida. Organized by Gaspard de Coligny, a popular Huguenot who was admiral of France at the time, and led by Jean Ribaut and his lieutenant Rene de Laudonniere (ca. 1529–1582), the group making that voyage left from Le Havre, France, on February 18.[15] After crossing the Atlantic, they explored what are now the Florida, Georgia, and South Carolina coasts, planting four stone columns at several points to mark the boundaries of French territories. None of these stones has been discovered, but documentation indicates that one was located on the south side of the St. John's River in modern-day Jacksonville, Florida; another near Charlesfort, their fortified settlement on Parris Island off the coast of present-day South Carolina; a third at Port Royal, South Carolina; and the fourth on an island the French called Lybourne (Libourne).[16] Thirty men were left at Charlesfort with the expectation that Ribaut, who departed for France that spring, would return with additional settlers and supplies.[17] However, Ribaut was detained, first by the outbreak of France's religious wars and then by a brief exile and imprisonment in England for suspected conspiracy. In 1564, a second expedition sailed for Florida without Ribaut, who was not able to join it until 1565. Nevertheless,

Ribaut's descriptions of the first trip were published in London in May 1563, titled *The Whole and Truthful Discoverye of Terra Florida*. Although not illustrated, that publication was a powerful inducement for further exploration by France and England.[18]

The second French expedition, led by Rene de Laudonniere, who had served as Ribaut's lieutenant on the first voyage, took the artist and cartographer Jacques Le Moyne to the New World. Comprised of three ships and approximately three hundred people, mostly French Huguenots, the expedition arrived during the summer of 1564. Le Moyne's narrative indicates that they met with the Indians at the French column (fig. 1.8) before they found a site for Fort Caroline. According to that account, de Laudonniere

went down on shore himself, accompanied by twenty-five arquebusiers, and was received in greeting by the Indians. . . . Even the chief Athore came, who lives four or five miles from the seashore; and when they had exchanged gifts and all manner of courtesies he indicated that he wished to show them something special and asked them for this reason to go along with him. . . . to the island on which Ribault had placed on top of a certain mound a marker of rock carved with the arms of the King of France. Drawing close they noticed that the Indians were worshipping this stone as if it were an idol. For when the chief himself had saluted it and shown it the sort of reverence he was accustomed to receive from his subjects, he kissed it; his people copied him and encouraged us to do the same. In front of the stone were lying various offerings of fruits of the district and roots that were either good to eat or medicinally useful, dishes full of fragrant oils, and bows and arrows; it was also encircled from top to bottom with garlands of all kinds of flowers, and with branches of their most highly prized trees.[19]

Le Moyne's description taken alone is a powerful and evocative picture of the event he also captured in his painting. Although one would not want to read too much more into the painting, it is tempting to see the image as a factual document and not as a propagandistic assertion of French superiority over the Indians, who relinquished

their weapons and offered gifts of food. While both interpretations may be correct, Le Moyne concluded his narrative sympathetically, saying that he had witnessed the "rites of these poor savage people" as if their reverent demeanor were naive, both unexpected and unnecessary. He went on to describe the chief, Athore, as "an extremely handsome man, intelligent, reliable, strong, of exceptional height, exceeding our tallest men by a foot and a half, and endowed with a certain restrained dignity, so that in him a remarkable majesty shown forth."[20]

Of greater concern to ethnohistorians than understanding the Indians' response to the Europeans has been studying the picture's accuracy concerning aspects of Indian material culture and life. From an ethnological standpoint, the Le Moyne watercolor and those that were copied in engravings by De Bry are considered unreliable in many of their details. For example, objects such as the baskets and the form of Indian weapons are European in design. Many of White's landscape settings as copied by De Bry are contrived, as are the muscular bodies of the Natives.[21] With Le Moyne, there was the unfortunate Spanish attack on Fort Caroline, his frantic exit, and several days of traveling through swampy terrain before rescue. For any of his drawings or sketches actually made in America to have survived is highly unlikely. While Le Moyne's published narrative and the accompanying pictures probably reflect actual events witnessed and remembered by the artist, many of the details are nevertheless unreliable.

It seems likely that the French Huguenots counted on an alliance with the native Timucuan for help in two areas: procuring food and defending against the Spanish, their common enemy. At first, the French traded for corn, beans, venison, and other foodstuffs; later, however, some resorted to force and others to treachery.[22] As a result, by the time of Jean Ribaut's long-awaited return with supplies and reinforcements on August 14, 1565, most of the Native people of the area had gradually withdrawn from contact with the settlers, which perhaps explains their absence from accounts of the French-Spanish conflict when it finally broke out. On September 4, 1565, the French sighted off the Florida coast a Spanish

fleet of fifteen ships and 2,600 men, led by Pedro Menendez de Aviles. Taking his own forces along with most of the able-bodied men from several ships in Le Moyne's group, Ribaut attempted to defend the French holdings. Weather was a cruel factor in this exchange, however, and a large tropical storm destroyed the French ships and killed many of the men; others, including Jean Ribaut, were captured and killed by the Spanish.[23] What happened after that is confusing, although it is certain that Rene de Laudonniere and Le Moyne, who had remained at Fort Caroline, escaped, making their way to two French ships safeguarded by Jacques Ribaut, Jean's son, who transported them to Bristol, England. In 1566, they returned to France.[24]

Most scholars believe that Le Moyne's original paintings and sketches were burned or lost in Florida and that Le Moyne made replicas in Paris. Hulton notes that in 1566, Le Moyne met with the French king, whom "it seems that he satisfied . . . by some demonstrable means"—perhaps some finished pictures?—"that he had the ability to complete a full graphic record of the Florida venture which he was then pressed to undertake."[25]

Le Moyne's whereabouts and activities for the next fifteen years are unknown, but, by mid-1581, he was in England, where he received denization letters.[26] From 1582 to 1584, he was listed as a painter in Blackfriars, Parish of St. Anne's, London. Sometime during or after

1585, Raleigh commissioned Le Moyne to do some drawings. Perhaps that commission produced some of the pictures, now lost, that served as the basis for De Bry's engravings. Le Moyne was married, but when and where is unknown. He died in London in 1588.[27]

Le Moyne, Theodore De Bry, Richard Hakluyt, John White, and Sir Walter Raleigh were all acquainted. Hakluyt was England's chief promoter of American colonization, and Raleigh's interests in the New World are legendary. As an engraver, De Bry was also enormously influential in promoting colonization through published narratives and illustrations of explorations to the New World.[28] De Bry was in London in 1587 to negotiate some of the said publications with Hakluyt, Raleigh, and Thomas Hariot, whose narrative John White's pictures illustrate. It was during the London trip that De Bry met Jacques Le Moyne and made an unsuccessful attempt to buy his drawings.[29] Finally purchased from the artist's widow in 1588, the drawings were engraved and published in 1591 by De Bry (figs. 1.10 and 1.11). Presumably, De Bry was the last to own the original pictures before all but one disappeared.

In addition to the American views, Le Moyne created an album of fifty-nine exquisite watercolors of botanical species (figs. 1.12 and 1.13). That album was acquired in 1856 by London's British Museum. No direct relationship between those watercolors and the American pictures is

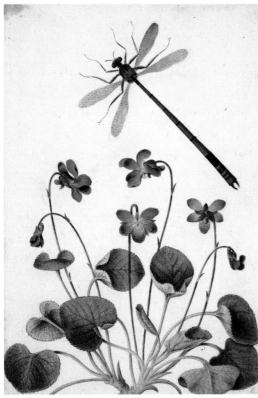

1.12

1.13

FIGURE 1.10. Johann Wechel (dates unknown), engraver, and Theodore De Bry, publisher, after Jacques Le Moyne de Morgues, *Outinae in bellum proficifcentis militaris disciplina*, ink on paper, from *Brevis narratio eorum quae in Florida America provincial Gallis acciderunt* (America, part 2), published in Frankfurt, 1591. Special Collections, John D. Rockefeller, Jr. Library, the Colonial Williamsburg Foundation, Williamsburg, VA.

The title translates as "Florida Indians Going to War."

FIGURE 1.11. Johann Wechel, engraver, and Theodore De Bry, publisher, after Jacques Le Moyne de Morgues, *Timucua Indians Preparing Land and Sowing Seeds*, ink on paper, from *Brevis narratio eorum quae in Florida America provincial Gallis acciderunt* (America, part 2), published in Frankfurt, 1591. Courtesy of the Library of Congress.

FIGURE 1.12. Jacques Le Moyne de Morgues, *Dog Violet and Damselfly*, ca. 1585, watercolor and body color on paper, 8½" x 5¹³⁄₁₆". © The Trustees of the British Museum.

The precise date of Jacques Le Moyne's botanical drawings is unknown. Some scholars have indicated an earlier date, perhaps soon after he came to England. However, it seems more likely that these drawings were done over a period of time and were based on either plant life seen in America and Europe or, perhaps, specimens seen in England. The American dog violet *(Viola conspersa)* grows in many southern regions and looks as much like this picture as any of the species of dog violets from the British Isles and northern Europe. The red damselfly is more like one of the larger species found in the United Kingdom, although quite similar insects are known to the southeast American coast. John White was probably familiar with Le Moyne's botanical drawings and may have copied some of them. The styles and technical abilities of these two painters were quite distinct, Le Moyne being the better trained and more highly skilled of the two.

Another version of the dog violet attributed to Le Moyne sold on January 6, 2005, at Sotheby's in New York, along with other flowers in an album of botanical works.

FIGURE 1.13. Jacques Le Moyne de Morgues, *Pine and Pinecone*, ca. 1585, watercolor and body color on paper, 8½" x 5¹³⁄₁₆". © The Trustees of the British Museum.

Like the dog violet (fig. 1.12), the pine and pinecone watercolor was created by the artist either from a specimen or from another artist's work. It probably represents an American longleaf variety. The delicate handling of the needles reinforces the notion that Jacques Le Moyne was highly skilled and trained.

known, but some, which show plants found in the South, need further study. His watercolor botanicals were probably the inspiration for his 1586 work featuring woodcut pictures of flowers, animals, and birds as sample designs for decorative work such as engravings, carvings, and embroideries. Titled *La Clef des Champs,* the book, which includes a sonnet, was dedicated to Lady Sidney (Mary Dudley), whose son Sir Philip Sidney, the poet, was interested in colonization.[30]

Le Moyne's richly detailed and brightly colored botanical paintings attest to both his sensitivity as an artist and his expertise in using watercolors. The tradition of naturalistic flower drawing was also associated with painted and printed pictures created by herbalists. Although the herbalists' concern was chiefly with medicinal properties, and thus with accurate portrayals by which plants could be identified, there was, by Le Moyne's period, a greater general concern for aesthetic quality, especially the use of saturated color. An increasing interest in the study of botany, the collection of specimens, and the introduction of new specimens into gardens also influenced the popularity of, and the greater aesthetic attention given to, flower painting. Le Moyne's

ability to render a variety of textures is especially notable in pictures like the *Dog Violet and Damselfly* and *Pine and Pinecone* (figs. 1.12 and 1.13), which reflect not only his training but also the influence of other fifteenth- and sixteenth-century French, and possibly Flemish, botanical painters.[31] Both of the drawings resemble plants native to southeastern America.

John White was the next artist to record life in the unsettled South. Ultimately, his images became the best known worldwide, and, fortunately, many of his original watercolor paintings survive (figs. 1.14–1.16 and 1.24 and 1.25). White had the advantage of having access to Le Moyne's earlier watercolor pictures, several of which he copied. White's association with Richard Hakluyt and Sir Walter Raleigh would have introduced him to much of the exploration literature published in other countries. Such material certainly facilitated White's planning for his role as an artist/cartographer/recorder—and thus his art.[32] Most authorities agree that White's firsthand studies, or preliminary sketches, were made during his second voyage to America in 1585.

White's five voyages to the New World included a reconnaissance expedition under Philip Amadas and Arthur Barlowe in 1584 and a military expedition to establish a colony under Governor Ralph Lane in 1585. He also sailed to the New World as the governor of "Cittie of Raleigh" (known as the Lost Colony) in 1587, and he accompanied two failed attempts to rescue and sustain that colony in 1588 and 1590.[33] Most of these expeditions were under the patronage of Sir Walter Raleigh who held the patent from the queen for planting a settlement in the land he christened "Virginia" in her honor.[34] The territory was large and included present-day North Carolina—its outer banks, islands, and mainland.

Very little is known about other aspects of White's background, training, or personal life. Theodore De Bry, in his introduction to Thomas Hariot's *Briefe and True Report of the New Found Land of Virginia,* spoke of White as

> Maister Ihon White an Englisch paynter who was sent into the contrye by the queenes Maiestye, onlye to draw the description of the place, lynelye [lively] to describe the

FIGURE 1.14. John White, *A Cheife Herowans Wyfe of Pomeoc. / and Her Daughter of the Age of .8 or. 10. Yeares.,* 1585–1588, watercolor over black lead with body color and gold leaf on paper, 10⁷/₁₆" x 5¹⁵/₁₆". © The Trustees of the British Museum.

Noteworthy aspects include the three(?)-strand necklace of blue and red beads with pendant the child touches with one hand and the doll she holds in the other. Both items were of European manufacture and were typical of the things presented to America's Native people, probably during their time of contact with White and those traveling with him. The child is modestly dressed in a thong tied at her waist. Details in gold and silver appear on the doll's clothing although they cannot be seen in this small illustration. The mother is carrying a large gourd vessel and either wears strands of beads or has tattoos around her neck. She is also wearing a fringed apron and a headband, and she has tattoos or painted designs on her face and arms.

FIGURE 1.15. Detail of figure 1.14.

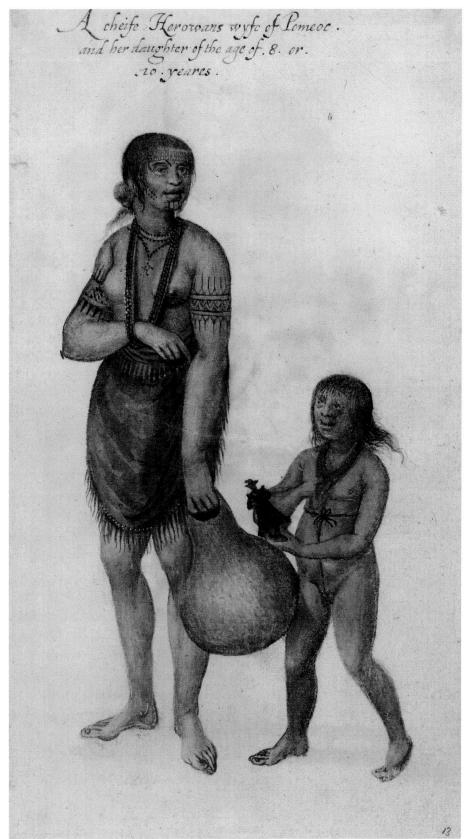

A cheife Heroroans wyfe of Pomeoc.
and her daughter of the age of. 8. or.
.10. yeares.

1.14

1.15

49

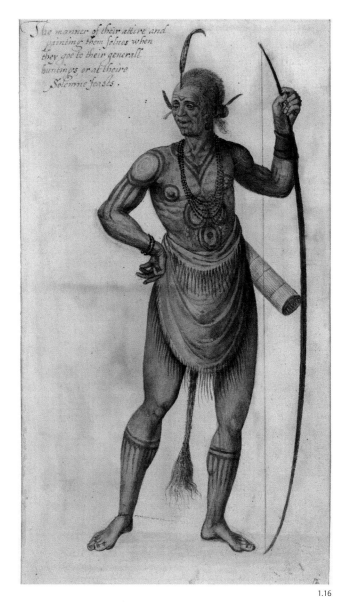

The manner of their attire and
painting them selves when
they goe to their generall
huntings or at theire
Solemne feasts.

1.16

FIGURE 1.16. John White, *The Manner of Their Attire and /
Painting Them Selves When / They Goe to Their Generall /
Huntings, or at Theire / Solemne Feasts*, 1585–1588,
watercolor over black lead with body color and gold leaf
on paper, 10⁷⁄₁₆" x 5¹⁵⁄₁₆". © The Trustees of the British
Museum.

John White's pen-and-ink titles and other noted
descriptions that appear on a large number of the
drawings are usually short though they reflect sensitivity
and a degree of respect that is often overlooked. Most
evident in his dancing figures, those qualities can also be
found in his descriptions of individual persons. Although
the artist was tasked with recording details quickly and
factually, he was also aware of personalities, deportment,
and social and familial interactions.

shapes of the Inhabitants their apparell, manners of
Livinge, and fashions, att the speciall Charges of the worthy
knighte, Sir WALTER RALEGH.[35]

White was well-known to various navigators, mathema-
ticians, and explorers in Raleigh's circle, including
Thomas Hariot, an expert mathematician and a naviga-
tion specialist and the author of the narrative accompa-
nying White's engraved and published drawings. White
continued to be associated with Raleigh in the years after
his return to England. His final letter to Richard Hakluyt,
written in 1593, indicates that he was living in the town of
Munster, near Cork, in a house on land given to Raleigh
by Queen Elizabeth I.[36] The artist's roots were probably
Cornish; his coat of arms was granted in 1587 when he
was living in London and was named governor of the
Virginia Colony. Recent research indicates that White
married Thomasine Cooper in 1566. Their son, Thomas,
was born in 1567 but died the next year; a daughter,
Elinor (Elyonor), christened in 1568, married Ananias
Dare in 1583. That couple accompanied White on the 1587
voyage to Roanoke, and Elinor gave birth to their
daughter, Virginia Dare, the same year.

White's specific artistic training can only be conjec-
tured. If he were of gentle birth, as scholars now claim,
he probably learned to paint and draw as part of his
education. An interest and ability in the art of limning or
miniature painting in watercolors on vellum or paper
was an acceptable preoccupation for someone of White's
presumed social rank. Of greater interest are how and
when he became associated with Raleigh and the royal
court and how he was selected for the various voyages.
Several theories exist, the most plausible involving either
connections his family had or those he himself made
while a student, probably at Cambridge or Oxford.

Initially Kim Sloan believed that John White's finished
pictures were created during the 1585 Roanoke voyage
under the command of Richard Grenville, but she has
since changed her opinion, noting that the final pictures
were likely created in London after White's return.[37] The
seven ships associated with this voyage left Plymouth,
England, on April 9, 1585. The journal for the *Tyger*,

Richard Grenville's ship, indicates that, on reaching their destination, White went ashore with others on July 11, returned to the ship on July 18, and undoubtedly made other trips ashore before sailing for England on the *Tyger* on August 25. White would have had six weeks and three days to complete his detailed pictures featuring different towns and a large number of Algonquin Indians from various towns. Accounts for explorations ashore on July 11 through 18 indicate that Grenville and his men visited four Indian villages as well as areas of the Neuse River, all of which are shown on John White's map accompanying the drawings.

Grenville first mentioned White's activity in his report of the voyage dated July 11, 1585, saying that "John White in another ship-boate, passed over the water from Wococon to the maine land victualled for eight dayes, in which voyage we first discovered the townes of Pomejok, Aquascogoc and Secotan, and also the great lake called by the Savages Paquipe."[38]

When routes between towns are traced and time is calculated for rowing and straight-line sailing, the results are sobering:[39] a large part of White's time would have been spent in travel and in on-land activities, such as hauling supplies from boats and setting up at least a few camps after traveling on foot to places such as Lake Mattamuskeet ("Paquipe") in present-day Hyde County. White would have had time to execute preparatory sketches, detailing specific intricate aspects of costume and the like and providing enough coloring to inform his final paintings, but little else. His final paintings would have required considerably more time and concentration. White's final work also included interpretations of Le Moyne's watercolors that probably were not available to the English artist in Virginia. The current theory is that White executed his watercolor drawings in England immediately after his return.

Just how well White's sketches and later finished watercolors were received in England is unknown, but surely those who saw them would have been amazed and would have considered them of great interest and importance. Queen Elizabeth I had undoubtedly already seen Le Moyne's pictures before she saw White's, and, as

the sponsoring monarch of the Virginia voyages, she must have been curious to see White's painted impressions, too. One indication of the monarch's interest is suggested by the details of an embroidered dress she wore in a portrait probably commissioned by Elizabeth Hardwick, later Countess of Shrewsbury, more popularly known as Bess of Hardwick (fig. 1.2).[40] The picture, variously dated to the late 1590s, has previously been attributed to Nicholas Hilliard (ca. 1547–1619) although such an assignment is not supported by documentation. The portrait's history of ownership is firm, however, and the picture still hangs in Hardwick Hall in Derbyshire, one of England's most impressive Elizabethan homes. Janet Arnold, the noted authority on the wardrobe of Elizabeth I, suggests several sources for the designs, presumably embroidered by Bess of Hardwick, who was known as a talented needlewoman. Arnold wrote that Sebastian Münster's (1488–1552) *Cosmographia* (1544) may have been the source for the sea monsters and that John Gerard's *Herball; or, Generall Historie of Plantes* (1597) may have been the source for the flowers.[41]

Another possible source is the drawings of John White and possibly White after Jacques Le Moyne. Several facts support this theory. First, as Sloan has pointed out, White probably made multiple sets of the New World drawings, and one of those sets must have still been with the De Bry family in 1617.[42] Other sets may have been circulating among members of the court and those who heavily financed the 1585 voyage. Secondly, and more importantly, many similarities are found between the embroidery designs and the New World drawings and botanicals by White (and White after Le Moyne) (figs. 1.12, 1.17–1.21, and 1.22–1.25). The flower details, while not visually definitive of American plants, are close to them and, given the frontal facing positions of the blossoms, are clearly derived from botanicals. The animals and birds and the double-spouted monsters seen on the dress are quite similar to those in White's drawings not only in form but also in color, which cannot be said for Gerard's black and white engraved illustrations.

Of all the extant clothing and dresses seen in Elizabeth I's portraits, no others show design elements so obviously

1.17

1.18

1.19

1.20

FIGURES 1.17–1.21. Embroidery details from the portrait *Queen Elizabeth I* shown in figure 1.2.

FIGURE 1.17. Two-spouted sea monster
FIGURE 1.18. Iris plant
FIGURE 1.19. Great frigate bird
FIGURE 1.20. Alligator
FIGURE 1.21. Viola plant

1.21

1.22

1.23

1.24

1.25

FIGURE 1.22. Associated with John White, *Iris germanica*, 1580s–1590s, watercolor and body color on paper, 15⁵⁄₁₆" x 10⁷⁄₁₆". © The Trustees of the British Museum.

FIGURE 1.23. Associated with John White, *Iris sibirica*, 1580s–1590s, watercolor and body color on paper, 15⁵⁄₁₆" x 10⁷⁄₁₆". © The Trustees of the British Museum.

FIGURE 1.24. John White, *Fregata magnificens rothschildi*, 1580s–1590s, watercolor over black lead and body color on paper, 5⁷⁄₁₆" x 8³⁄₁₆". © The Trustees of the British Museum.

FIGURE 1.25. John White, *Allagatto. This Being but One Moneth Old as. 3. Foote 4. Ynches in Length. and Lyue in Water.*, 1580s–1590s, watercolor over black lead and body color with gold leaf on eye on paper, 4³⁄₈" x 8³⁄₄". © The Trustees of the British Museum.

taken from natural history drawings. A few of the individual motifs are repeated on this dress, but most represent one-of-a-kind specimens. The dress features birds, flowers and other plants, snakes, an alligator, a whale or porpoise, and waterfowl, including a frigate bird—all of the type associated with North American species drawn and painted by White. It is entirely possible that Bess of Hardwick had access to White's drawings, or to copies of them, because of her connections at court. Her children by her second husband, Sir William Cavendish, included William Cavendish, 1st Earl of Devonshire, an important supporter of the colonizing of Virginia. Another relative of the family through the elder Cavendish was Sir Thomas Cavendish, whom Richard Grenville called "Tomas Candish" in his report. Thomas was an explorer; in 1585, he purchased the small ship *Elizabeth* that sailed as part of Sir Richard Grenville's voyage to Virginia. This was the same voyage that White accompanied and on which he made his preparatory pictures of the flora and fauna and of the Native Americans.

Seventy-five of White's watercolors survive, all created after 1585 and before 1588, the year that Hakluyt and De Bry negotiated publishing them with Hariot's extended report and captions explaining the pictures.[43] The original paintings were rediscovered in the nineteenth century after being damaged by water in a warehouse fire. As a result of dampness, some of the pigments were transferred, or offset, to blank pages that interleafed the drawings. For this reason, the original images have lost some of their paint and are sometimes described as muted.[44] Even so, they are remarkably detailed, and their colors, while somber, are still sufficiently saturated to impress the viewer. John White was obviously a practiced painter who was captivated by the details of the place and its inhabitants. Yet he was perhaps not as skilled as Le Moyne, whose single surviving picture is detailed like a miniature portrait. Even though less precise in execution, White's rendering of objects, Native dress, and other features is far more accurate than Le Moyne's. White's biographer suggests that his art, like that of Le Moyne, was based in a combination of portrait, illumination, and natural history painting traditions.[45]

The large number of White pictures, when compared to the De Bry engraved versions, also indicates the extent to which the engraver imposed formulaic and muscular body types and European facial features. By comparison, White's Native figures are individualistic and, for their time, more sensitive portrayals of actual people. De Bry also enhanced many of the images by adding both front and back views of Native Americans in costume (fig. 1.26), additional foodstuffs, tools or other objects, and full-blown landscape backgrounds.[46]

The painting of an Indian woman with her daughter (figs. 1.14 and 1.15) has often been used to demonstrate White's perceptive interpretation of the Indians. However, it is also an interesting example of how White's images were further propagandized by De Bry and later writers. First, the picture shows a contented mother and child, both of whom seem comfortable in their familial relationship and both of whom are thriving in their natural (though uncivilized by European standards) environment. The Elizabethan-style doll held by the child is a striking addition, recognizing not only the concept of play known both to European and Indian children but also symbolizing the Native peoples' willingness to accept, trade for, and experience European culture. De Bry made major changes to this picture in the engraved version by creating more space between—and thereby separating—the mother and child and by putting a European rattle in the child's other hand (fig. 1.27). In doing so, he effectively lessened the sense of familial bond and further reinforced the idea of cultural and material trade.

Joyce E. Chaplin has compared this image engraved by De Bry with the later engraving by Simon Gribelin (1661–1733) in Robert Beverley's 1705 *History and Present State of Virginia* (fig. 1.28). Gribelin's version, based on De Bry's, replaced the European rattle and doll with an Indian gourd rattle and an ear of corn.[47] Chaplin interprets these changes as a shift in the English perception of Native Americans over time—from the early colonizers' general view that Europeans shared some similarities with them to the later concept that Europeans were culturally superior to the Indians, whose material life and methods were less advanced.[48]

1.26

1.27

FIGURE 1.26. Theodor De Bry, engraver and publisher, after John White, *Der Fürsten und Herrn in Virginia abcontra fentung*, ink on paper, from Thomas Hariot, *A Briefe and True Report of the New Found Land of Virginia*, published in Frankfurt, 1590. Virginia Historical Society.

Theodor De Bry's interpretation of John White's watercolors of individual Indians often included front and back views, as in this example that is based on the original watercolor drawing seen in figure 1.16.

FIGURE 1.27. Theodor De Bry, engraver and publisher, after John White, *Einedel Leibvon Pomeiooc*, ink on paper, Thomas Hariot, *A Briefe and True Report of the New Found Land of Virginia*, published in Frankfurt, 1590. Virginia Historical Society.

Theodor De Bry's interpretation of the John White drawing seen in figure 1.14 reveals that he was faithful in some ways to the artist's original picture but that he also took liberties. In this case, the child, shown much larger, is actively moving with the addition of a rattle. De Bry also tended to exaggerate the musculature of his figures, making each individual look larger and more anatomically perfect—and therefore more aggressive in gesture. White's pictures are more lifelike and accurate renderings of the people he saw in North America.

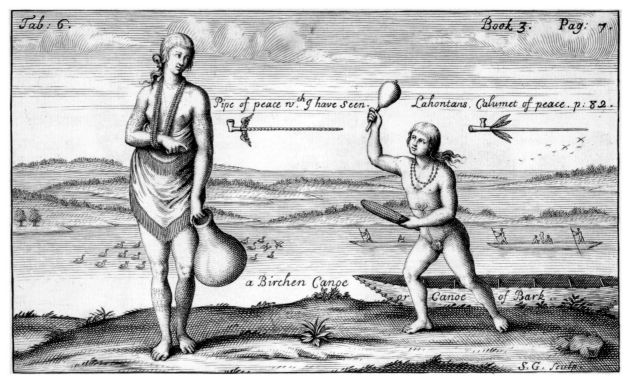

Tab. 6. Book 3. Pag: 7.

Pipe of peace w:ch I have Seen. Lahontans. Calumet of peace. p: 82.

a Birchen Canoe or Canoe of Bark.

S. G. Sculp

1.28

White's watercolor of the town of Secotan and the De Bry engraving after it pose important questions about the reliability of some, but certainly not all, of White's images (figs. 1.7 and 1.29). One suspects that White organized his view in a linear fashion with neat rows of houses along a central avenue flanked by manicured gardens on one side, and with other discreet activities along the way, as a means of capturing a complex subject in a simple manner that was familiar to him. He was, after all, a European whose view and experience of the physical world was extraordinarily different from that of Native Americans. A fundamental preoccupation with ordering the land, organizing urban environments with geometrically planned roads and streets, had been a centuries-old European practice. While his arrangement of the Native American town he had seen was artificial, its design was also intentional. By combining many key activities and places into one picture, he created a scene that a European viewer could readily comprehend. White's description of the various corn crops in the picture as "rype," "greene," or "new" illustrates his effort to show

Native agriculture over several months, not merely at one time. Only a few of the large number of Indians who occupied this town could have been accommodated in the eight or so huts shown. All of the Algonquin Indian villages that White visited were likely more open and less rigid in design than what is shown in this view—although, as Hariot noted in his narrative, some (though not Secotan) did have palisades. The details of the Secotan charnel house (a place for prayers), the tomb or special hut for departed chiefs, the half round hut on stilts that served as a place for guarding their crops from pests, the dance ground, and other details seem to be accurate vignettes, and they relate closely to similar and larger views by White.

De Bry included only twenty-three of White's known drawings in his first volume, which went through at least seventeen printings from 1590 to 1620. They were copied many times by others, and they appeared in other early books, such as Beverley's. However, White's remaining American and European pictures are now familiar to us through recent publications.[49] These include various comparative images of European Pictish warriors and

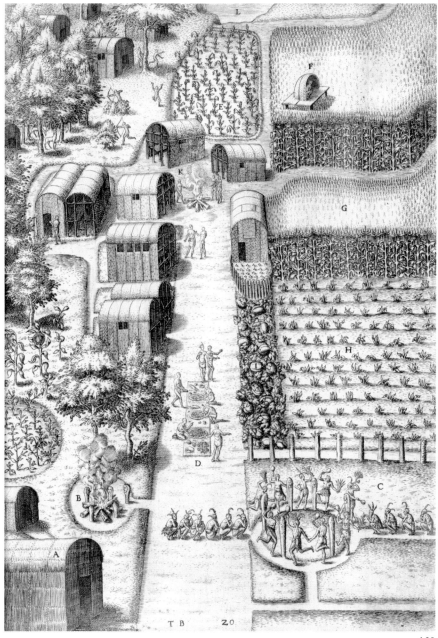

1.29

FIGURE 1.28. Simon Gribelin, engraver, *Mother and Child*, ink on paper, from Robert Beverley, *The History and Present State of Virginia*, published in London, 1705. Special Collections, John D. Rockefeller, Jr. Library, the Colonial Williamsburg Foundation, Williamsburg, VA.

The image was one of several that Robert Beverley used in his volume. Most details were taken from Theodor De Bry's engravings based on the John White drawing. Beverley was born into a wealthy planter family in Middlesex, Virginia, and educated in England.

FIGURE 1.29. Theodor De Bry, engraver, after John White, *The Towne of Secota*, ink on paper, from Thomas Hariot, *A Briefe and True Report of the New Found Land of Virginia*, published in Frankfurt, 1590. Virginia Historical Society.

Theodor De Bry included details that were not in the original John White drawing: additional foods on the table at center, many more crop fields at center top and lower left, and more buildings at the top left. The identified activities, labeled with letters in the De Bry version, are very close to White's work.

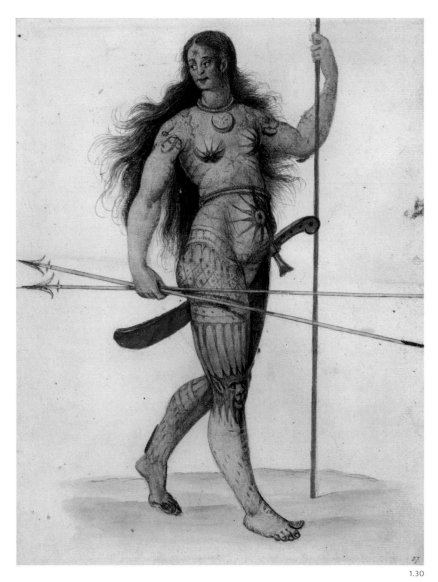

1.30

The Picts were a confederation of tribes in what is now eastern and northern Scotland; they are thought to have been descendants of the Caladonii. Aspects of their life and culture were chronicled by both the Romans and the Greeks. In 297 CE, the Greek writer Eumenius first used the word *Iliktoi*, which translated into Latin as *pingere*, "paint," and which was taken to mean "painted or tattooed people." John White's paintings were based on earlier examples and descriptions. The inclusion of such images in the Thomas Hariot account was purposeful: to illustrate that "savage" peoples were similar to Native Americans and to show that they had inhabited Europe in ancient times. Jacques Le Moyne made a similar drawing. See Sloan, *New World*, figures 94 on 152 and 98 on 158.

women (fig. 1.30), illustrations of cooking fires, pictures of flora and fauna, and copies of White's work made by other, unidentified early artists. White, like Le Moyne, was not an empiricist in the strictest scientific sense. Rather, he seemed to delight in the beauty of the natural world he captured in paints.

If there were paintings, sketches, or other images created by other English or French explorers who ventured to the southern areas of North America in the last decades of the sixteenth century, they are unknown today. In his 1624 *Generall Historie of Virginia, New-England, and the Summer Isles,* John Smith stated that, after White's last voyage and the Lost Colony at Roanoke, "all hopes of *Virginia* thus abandoned, it lay dead and obscured from 1590 till this yeare 1602."[50] Voyages before 1602 were to the northern part of Virginia or areas north of Maryland. Smith's discovery and establishment of the English colony at Jamestown followed in 1606–1607. The only other sustained European settlement at the time in North America was associated with Spanish military fortifications in the area of St. Augustine, approximately nine of which predated the well-known Castillo de San Marcos, which was begun in 1672. Spanish religious art was undoubtedly present in these areas, created by now unknown artists.

Only archaeological material survives for the Jamestown period or the years immediately thereafter. Thus, the rare and exquisite original painting by Le Moyne and the remarkable watercolors of White remain the earliest noteworthy art for the South and, indeed, for all of North America.[51] Neither artist's work was acclaimed for its aesthetic qualities, but, in both cases, it was admired and closely studied by an elite cadre of explorers, investors, patrons, and monarchs as tangible evidence of a distant land, rich with resources, to be claimed, named, and settled. As proof of the place, the paintings were therefore a critical influence in support of North American colonization. They were also major contributions to the international study of natural philosophy and the development of the seventeenth- and eighteenth-century scientific inquiry that would figure prominently in the South's art and cultural history as well.

NOTES

1. *Geography Delineated,* 137.

2. For an account of Spain's early mid-Atlantic outposts that failed in the 1570s, see Horn, *Land as God Made It,* 1–10.

3. For the purposes of this discussion, the early Spanish expeditions into the interior areas of South and Central America as well as the western areas of North America are excluded. However, it should be noted that the narratives their explorers wrote were undoubtedly useful to English and French expedition planners.

4. *Subject Matter,* 7–8.

5. Sloan, *New World,* 14–15. See also n34.

6. This Richard Hakluyt was a cousin of his namesake, the celebrated Richard Hakluyt the Younger, who became deeply involved in the Virginia voyages and whose role is discussed later in this chapter.

7. The idea of planting colonies can be traced through European history back to the writings of Julius Caesar and the Roman historian Livy. Renaissance writers such as Niccolo Machiavelli were later proponents of colonization. Another Renaissance writer, Thomas Linacre, an English scholar, produced one of the earliest works proclaiming that the whole surface of the globe was habitable. He knew Thomas More of Oxford, who, by 1515, was familiar with "new discoveries" literature. More's *Utopia,* published in 1516, addressed the legitimacy of colonization; it was probably the first publication to use the word "colonia." Educated explorers such as Dee and Cabot were undoubtedly familiar with these writings that were influential during the years of exploration. See Cumming, Shelton, and Quinn, *Discovery of North America,* 73–75.

8. They included Abraham Ortelius, a Flemish cartographer and geographer, and Gerardos Mercator, also a Flemish cartographer. See Sloan, *New World,* 16.

9. Richard Hakluyt the Younger was one who gathered large quantities of information. In 1583, he was sent to Paris by Francis Walsingham, principal secretary to Elizabeth I. There he served nominally as chaplain and secretary to the English ambassador to the French court, but the real purpose of his sojourn was to gather information about Spanish and French exploration. In Paris, Hakluyt began writing his famous *A Particuler Discourse Concerning the Great Necessitie and Manifolde Commodyties That Are Like to Growe to This Realme of Englande by the Westerne Discoveries Lately Attempted, Written in the Yere 1584.* More commonly known as *Discourse of Western Planting,* that work put forth a strong argument exhorting England to reclaim rights to portions of America discovered on English voyages by John Cabot and his son Sebastian in 1497–1498. Hakluyt dedicated this manuscript to the queen; his purpose was to gain support for Sir Walter Raleigh's patent to colonize in the New World. While in France, Hakluyt became familiar with the published report of French explorer Rene de Laudonniere.

10. Sloan, *New World,* 37. See also 230–233 where Sloan illustrates and discusses a group of watercolors of North Carolina birds, fish, and reptiles that appear to be by an artist other than White or Le Moyne. Sloan notes that Thomas Hariot, who traveled to America with White and wrote the narrative about the trip published by De Bry, had a "long-time servant Christopher Kellett, a 'Lymning paynter'" (231). He is a possible candidate for having painted these pictures. Although undated, they were in existence by the time Hakluyt knew them between 1608 and 1614.

11. Quinn, *English Plans for North America,* 69.

12. See Sloan, *New World,* 65–70, for a succinct summary of previously published and illustrated sixteenth-century works, most of which used crude woodcuts executed by artists who never traveled to the New World. These works include *La natural hystoria de las Indias* by Gonzalo Fernández de Oviedo y Valdéz, published in 1526; an arrangement of forty woodcuts in a 1557 illustrated narrative prepared by Hans Staden, a Hessian mercenary in the service of Portugal who was captured by the Indians in Brazil; *Les singularitez de la France Antarctique* by André Thevet (1557), containing seventeen engravings from the same area; and *La historia del mondo nuovo* by Girolamo Benzoni, with sixteen woodcuts, published in 1565. Sloan notes that Jean de Léry (1536–1613) adapted some of Benzoni's illustrations in his account published in 1578. Some of the Léry images inspired the later work of the artist and cartographer John White, who may have gotten them through Richard Hakluyt. Sloan further notes that none of these works or other ethnographic illustrations of the Americas were published in England before the Martin Frobisher and John White Roanoke voyages. See also Horn, *Land as God Made It,* for information on Spanish settlement and exploration in the Chesapeake and other coastal regions.

13. The comprehensive work on Le Moyne is Paul Hulton, *The Work of Jacques Le Moyne de Morgues: A Huguenot Artist in France, Florida and England,* with contributions by D. B. Quinn, R. A. Skelton, William C. Sturtevant, and William T. Stern.

14. Ibid, 4.

15. De Coligny became a disciplined Huguenot leader in the French Wars of Religion. An important reason for this and other voyages was to establish a safe haven for Huguenots in the New World. Ribaut and de Laudonniere were not the first French explorers. Giovanni da Verrazzano (1485–1528), Jacques Cartier (1491–1557), and Nicolas Durand sieur de Villegagnon (1510–1571) predate them.

16. The Lybourne column may have been near Beaufort, SC, or it may be confused with the Port Royal one.

17. Jean Ribaut's son, Jacques, was left with this group. See Quinn, "Attempted Colonization," 20. The garrison failed and some of its inhabitants managed to sail back to the English Channel where they were rescued.

18. Like his patron, Gaspard de Coligny, Ribaut was a Huguenot;

England, then ruled by the Protestant Queen Elizabeth I, was therefore a safe haven for the explorer. Noting the publication of his report in 1563, the queen offered to pay Ribaut a salary and provide him with a house. Her motives were clearly influenced by her investment in Thomas Stukeley's effort to fit out a fleet of five ships bound for Florida. Ribaut is also reported to have invested in the venture, an action that was deemed suspicious by British authorities. He and three other French pilots were imprisoned, accused of stealing ships with the intent of escaping to France. Eventually released, Ribaut joined the second French exploration in North America in 1565. In 1563 Thomas Hacket was responsible for preparing and publishing a limited number of Jean Ribaut's account of his first voyage, a copy of which is in the British Museum. Biggar, "Jean Ribaut's Discoverye of Terra Florida."

19. Hulton, *Work of Jacques Le Moyne,* 1:141. Hulton provides a modern translation of the original Latin text published by De Bry.

20. Ibid.

21. See Sturtevant, "Ethnological Evaluation," and Hulton, "Jacques Le Moyne, *Peintre.*"

22. See Quinn, "Attempted Colonization," 24–27.

23. For details of the engagement between the French and Spanish, see Bransford, "Hurricane That Made History."

24. Quinn, "Attempted Colonization," 32–33. At the time, de Laudonniere was ill; he reportedly had suffered a head wound during the Spanish attack on Fort Caroline. Le Moyne had apparently suffered a leg wound at some unspecified previous time and was also in poor health.

25. Hulton, "Jacques Le Moyne, *Peintre,*" 75.

26. Denization letters were letters of patent issued through royal prerogative. A "denizen" took an oath to the Crown and had the right to hold land as well as some other rights that allowed residency in English territories. A fee for these rights was usually required.

27. Hulton speculates that Le Moyne had met John White by 1585 or 1586. "Le Moyne: Biographical Sketch," 10.

28. The importance of early printed books in disseminating knowledge about—and promoting interest in—colonization cannot be overstated. The printed word tended to validate national claims and possession of lands.

29. Stallybrass, *"Admiranda narratio,"* 9–10. According to Stallybrass, it was likely Le Moyne's idea to have his drawings reproduced via engravings by De Bry although he was apparently unprepared to release the drawings in 1587. There is no specific evidence that Le Moyne's volume was intentionally delayed in favor of another project, one championed by Richard Hakluyt—an expensive edition by Thomas Hariot that would promote English colonization. However, scholars have suggested such a scenario because De Bry published the

Hariot work with engravings after White's drawings *before* Le Moyne's work, which appeared in a second volume afterwards.

30. Hulton, "Le Moyne: Biographical Sketch," 11.

31. See Stearn, "Plant Portraitist," 56–57, for a discussion of influences.

32. See Sloan, *New World,* 17. White may have accompanied Martin Frobisher, the English explorer, on his second (1577) voyage to locate a route to Cathay, although the artist's name does not appear on a list of personnel who received wages for the expedition. Sloan suggests that White may have been compensated in other ways. During this voyage, White may have witnessed and sketched the party's skirmish with native Inuits, and he may have also sketched the two drawings attributed to him in the British Museum collections. On the other hand, the latter drawings may have been executed in England after the Native Americans were taken to Bristol, Eng., in 1577.

33. White outlined these voyages in the last known record from his hand, a 1593 letter to Richard Hakluyt the Younger. According to Kim Sloan, the only record of White's being on this voyage is in the journal of the *Tyger,* the ship captained by Richard Grenville (*New World,* 43). In 1589, Sir Walter Raleigh sold his interest in the Virginia colonization venture to John White, Richard Hakluyt, and others. Thus, White, as the investor with firsthand experience in Virginia, agreed to return.

34. Sir Humphrey Gilbert, Raleigh's half brother, who died in 1583, had previously held this patent. Raleigh also had the support of the monarch's chief ministers, Francis Walsingham and Lord Burghley, as well as of her advisor John Dee. See ibid., 12–13, for a summary discussion of these voyages. Sloan notes that the principal reasons for the expeditions included the dream of discovering rich deposits of gold and silver and other commodities; privateering, especially from the laden Spanish ships and occasionally the French; and, importantly, the planting of Protestant colonies with military capabilities to help protect England's interests in North America from the two other competing nations—Spain and France—and to propagate "true religion." Colonization was also viewed as a means by which England could export its criminals and the starving poor of London.

35. Hariot, *Briefe and True Report,* facing page 6. See also Sloan, *New World,* 23, 25, and 26.

36. Sloan, *New World,* 46–48. White's home was in Newtown in Kylmore, north and west of the town of Youghal, near Cork. Sloan quotes from a 1593 letter White wrote that ends abruptly and mysteriously: "I take my leave from my house at Newtowne in Kylmore the 4 February, 1593" (49). There are no later references to White.

37. Lecture, Jamestown, VA, July 2008.

38. "Voiage to Virginia," 316.

39. Travel time probably totaled one to two of the five weeks. Information on the nautical speed of a pinnace (pinasse), the type of

boat used for the longer portions of travel, has not been confirmed from records of the period. Assuming the White pinnace was light and of the smaller of several boat types by this name, it probably was less than fifty feet long, with a mast fore and another aft. It was likely fitted for eight oars. Using an average of 6.30 knots per hour for a thirty- to fifty-foot boat in straight-line sailing, the trip (without interruption) from Roanoke Island to a point near Secotan village at 79.33 nautical miles would require ten hours or more. From descriptions of these expeditions, travel in the Pamlico Sound was difficult, and the men encountered numerous shoals along the way. Their boat, which accommodated probably four sails and four sets of oars, was hardly a speedy craft.

40. Bess of Hardwick (1527–1608) was married, and widowed, four times: first to Robert Barlow; second to courtier Sir William Cavendish; third to Sir William St. Loe, captain of the guard to Queen Elizabeth I and chief butler of England; and fourth to George Talbot, 6th Earl of Shrewsbury. Through her own inheritance and those associated with her various marriages, she became the second wealthiest woman in England, after Elizabeth I, the wealthiest.

41. *Queen Elizabeth's Wardrobe,* 79. Münster's and Gerard's works were likely known by White and Le Moyne, as were other herbals. Le Moyne was familiar with the concept of botanicals serving as design sources for embroideries. There is no reason to doubt that this was a commonly known practice.

42. Sloan, *New World,* 81–82.

43. Stallybrass, *"Admiranda narratio,"* 10–12. Hariot originally wrote the captions in Latin, but Hakluyt translated them into English.

44. See Sloan, *New World,* 234–235. In her analysis of White's techniques and pigments, Sloan states that the white lead—used for highlights and for mixing other colors—and the silver powder have turned to black and gray in many areas of White's paintings. In her critical notes on the condition of the pictures, she attributes the

grainy appearance in some of the drawings to the offset process that occurred as the volume of pictures lay soaking in water after the nineteenth-century fire.

45. See ibid., 23–37.

46. De Bry and others involved in making the engravings are of less interest to this study than the original work they copied.

47. It should be noted that Beverley used fewer illustrations in his book than De Bry. Beverley created composite views by combining elements of several De Bry engravings into one. Thus, the mother and child picture in Beverley includes canoes, an Indian pipe, and other objects not found in De Bry's version of the mother and child but found in other De Bry engravings.

48. *Subject Matter,* 36–38. Chaplin's thesis is far more complex than this simple statement can convey. It provides important context for understanding European, and particularly English, attitudes towards Native Americans. It is also an important discussion of intellectual history as it emerged and developed during the same years as colonization, reflected not only in White's work but also in the general phenomenon of natural history exploration and painting.

49. Sloan, *New World,* for example.

50. *Generall Historie of Virginia,* 16.

51. Samuel de Champlain (ca. 1567 or 1580–1635) was the first European to travel in the Great Lakes region and among the various Indian tribes in that area and in Canada. Champlain established a French settlement in 1608 that is now the city of Quebec. His report, with a few illustrations, was not published until 1870. It is not known whether the 1870 illustrations were based on early sketches by Champlain or someone on his expedition.

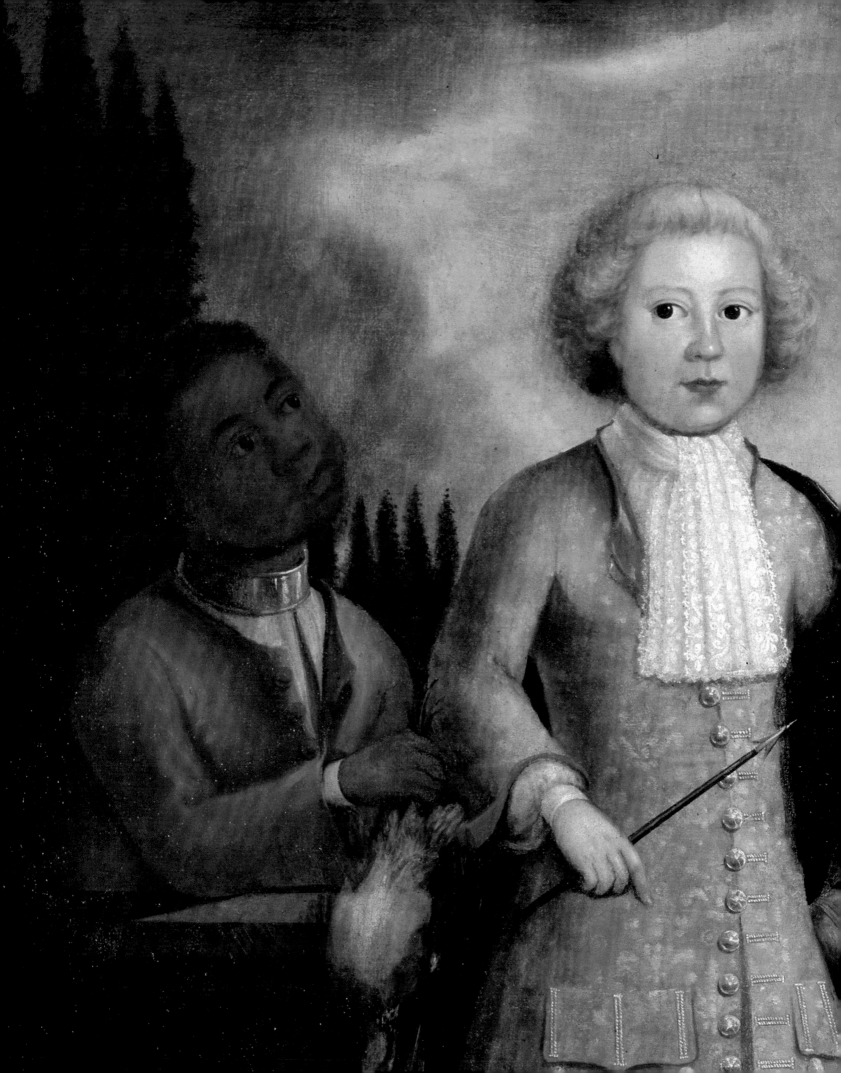

The artist who feels the necessity of patronage, must do one of two things—abandon his high and responsible character, bow to the golden calf that he may partake of the bread and wine set before the idol, or abandon his profession—grasp the axe and the plough, instead of the crayon and pencil....

The artists who visited the colonies found friends and employers; they did not need protectors. They exchanged the product of their skill and labour for the money of the rich, and received kindness and hospitality "in the bargain."

WILLIAM DUNLAP, 1834[1]

CHAPTER 2

Immigrants and Early Settlers

In the sixteenth century, English, French, and Basque fishing fleets made regular voyages to Newfoundland and as far south as Cape Cod, sometimes setting up semipermanent shelters to dry fish, but they planted no colonies. In fact, after the 1585–1587 Roanoke experiences, no attempts were made to establish permanent settlements along the east coast and north of Florida until the building of Jamestown, Virginia, in 1607. By 1614, the Dutch had peopled parts of New York, but Plymouth was not established until the 1620s, and the Massachusetts Bay Company did not settle in the New World until 1629.

Although English immigrants came to dominate most of the seventeenth-century settlements in the South, Spain continued to occupy Florida, where St. Augustine and adjacent regions had been colonized years before. The earliest view or aerial perspective of an American colonial town north of Mexico depicts St. Augustine (fig. 2.1). This engraving was based on a painting created by John White. The engraved version was prepared by Baptista Boazio (active 1588–1606), an Italian artist working in London, for the 1589 first edition of Walter Bigges's narrative of Sir Francis Drake's pillaging through the Caribbean and along Florida coasts. That narrative also included a similar view of Cartegena in South America (fig. 2.2).

After the establishment of Jamestown, other settlements slowly developed along the coast. Most were small and isolated, comprised at first of crudely constructed dwellings and forts. Native American towns persisted throughout the region, though nearly all of them would gradually be forced westward as Europeans claimed the land. Southern towns began to emerge around ports and landings, but they were not as large or commercially diverse as their northern counterparts, in which an increasing number of homes and businesses made seaports the centers of daily life.[2] In the South, where commerce and trade relied on agriculture and related activities, homes were often established on large tracts of farmland called "plantations."[3] Although towns and ports were essential for the exchange of cash crops for goods, credit, or money, southerners spent most of their

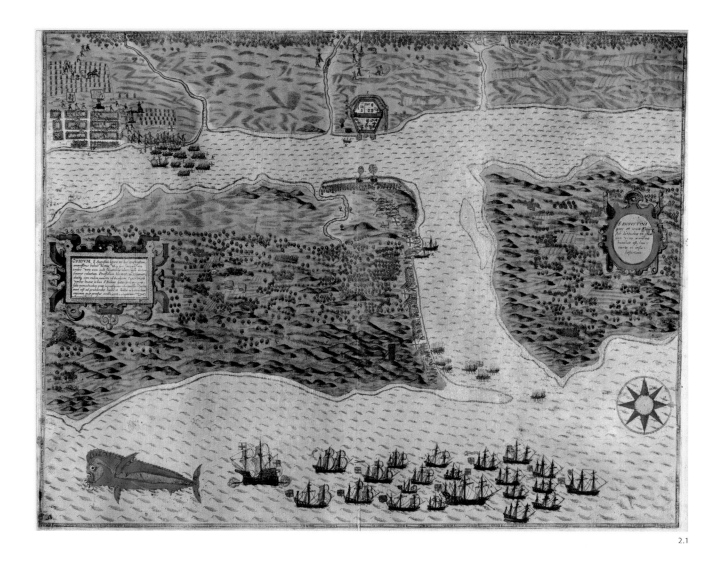

2.1

FIGURE 2.1. Baptista Boazio, engraver, *S. Augustini: Pars est terra Florida, sub latitudine 30 grad, ora vero maritime humilior est*, watercolor and ink on paper, 1588/89, from Walter Bigges, *A Summarie and True Discourse of Sir Francis Drakes West Indian Voyage....* London, 1589. Courtesy of the Library of Congress.

The print illustrates an event from 1586 when Sir Francis Drake's fleet attacked two Spanish settlements, St. Augustine and Cartegena (fig. 2.2). Drake had been ordered by Queen Elizabeth to plunder and rid the Caribbean area of Spanish occupation and claim the lands for England. Neither attack succeeded in destroying the settlements.

FIGURE 2.2. Baptista Boazio, engraver, *Cartegena*, watercolor and ink on paper, 1588/89, from Walter Bigges, *A Summarie and True Discourse of Sir Francis Drakes West Indian Voyage....* London, 1589. Courtesy of the Library of Congress.

time on plantations.[4] Often those plantations were located along rivers and estuaries and had their own wharfs for the shipping and delivery of goods. If artists were working in the small towns or moving from home to home during this early period, their names are unknown to scholars today. Unlike what is known for New England, evidence of paintings and printed pictures in the seventeenth-century South is slim. However, that paucity may mean little, as the South's population was spread across the rural countryside rather than concentrated in town centers where artists tended to live or visit; moreover, the survival of material culture of any sort for the early colonial South is modest. Still, recent excavations at the Jamestown fort have revealed that at least some settlers brought with them sophisticated

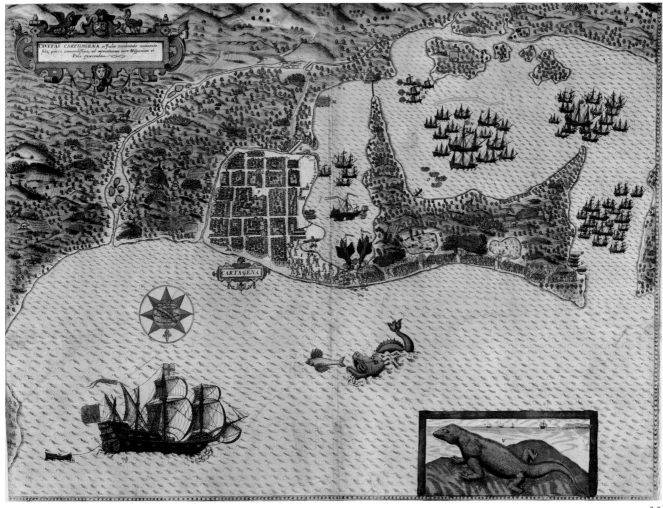

clothing, ceramics, and other possessions. Portable art, such as miniature portraits, may also have been brought to Jamestown.

Seventeenth-century portraits from the Chesapeake region of Virginia are known to have survived. Probably brought with the settlers, they probably date before about 1649, when the sitters came to Virginia. These likenesses include four, documented to the Moseley family, that have not been located since the 1919 publication of the first two volumes of Charles Knowles Bolton's *The Founders*. One shows a woman, possibly Mrs. William (Susanna) Moseley, elaborately dressed in Elizabethan clothing and wearing various pieces of jewelry (fig. 2.4). The portraits of William Moseley (fig. 2.3) and his two sons, Arthur Moseley and William

Moseley Jr. (figs. 2.5 and 2.6), as well as the portrait of the woman have been attributed to Cornelius Janssen van Ceulen (1593–1661) and before that to Sir Anthony Vandyke (1599–1641), although neither of these assignments can be verified from documents or from the poor illustrations at hand. The Moseley pictures are probably the most ambitious portraits known for seventeenth-century Virginia. In dress and in poses, they echo some of the stylistic fussiness and stiffness of late seventeenth-century portraiture.[5] Other paintings from this period in Virginia include the portrait of John Page (fig. 2.7), attributed to Sir Peter Lely (1618–1680); the portrait of Robert Bolling (fig. 2.8), by an unidentified English painter; and the seventeenth-century likenesses of William and Mary Isham Randolph (or another woman

2.3

2.4

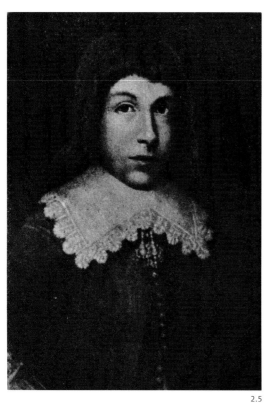

2.5

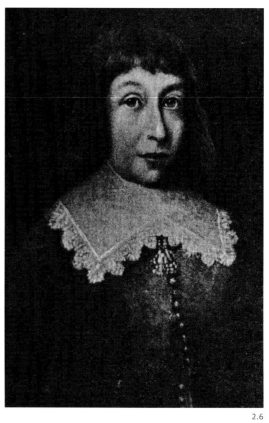

2.6

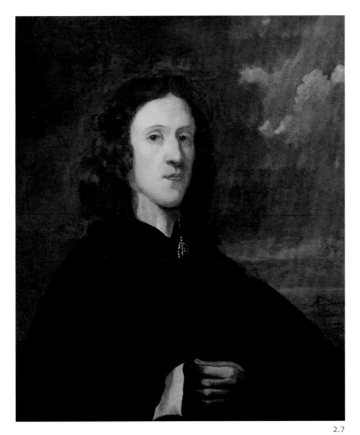

2.7

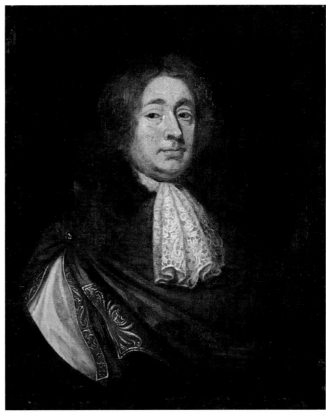

2.8

FIGURES 2.3–2.6. Attributed to Cornelius Janssen van Ceulen?, *William Moseley*, *Mrs. William (Susanna) Moseley*, *Arthur Moseley*, and *William Moseley Jr.*, before ca. 1649, probably oil on canvas, dimensions unknown. Location unknown. Illustrations taken from Bolton, *Founders*, 1:177, 181, 185, and 189. Special Collections, John D. Rockefeller, Jr. Library, the Colonial Williamsburg Foundation, Williamsburg, VA.

These portraits may be the earliest known for Virginia. Their history to 1919 included ownership about 1870 by Burwell Bassett Moseley of Norfolk, Virginia, a lineal descendant of William Moseley. The parents' portraits were reportedly sold to a Mrs. Bloomfield Moore of Philadelphia, but there appears to be some discrepancy in the sizes of the paintings. Mrs. Moore apparently visited Sir Oswald Moseley (Mosley), the infamous philanderer and founder of the British Union of Fascists, of Rolleston, Burton-on-Trent, Staffordshire, England, and found full-lengths of the portraits she had bought; hers were half-lengths. (See Bolton, *Founders*, 1:175–176.) Rolleston, Oswald Moseley's house, was sold in 1923 and destroyed by fire several years later. Efforts to locate the portraits that were hanging in the house have yielded no results.

The American-owned versions illustrated in Bolton appear to be three-quarter-length for Susanna (d. 1656) and William (d. 1655) and bust length for Arthur (b. before 1638) and William Jr. (ca. 1630–1671), although photographs of the latter two may have been cropped for publication.

FIGURE 2.7. Attributed to Sir Peter Lely, *John Page the Immigrant*, ca. 1660, oil on canvas, 24″ x 23″. Muscarelle Museum of Art at the College of William and Mary, Williamsburg, VA. Gift of Dr. R. C. M. Page.

John Page (1628–1692) was a well-to-do Virginia merchant, a member of the House of Burgesses, and the owner of large tracts of land. He came to Virginia from England about 1650, living first at Jamestown and then building an impressive cross-plan house, the foundation of which survives, in Williamsburg. Page donated the land for Bruton Parish Church, first built and dedicated in 1683. He was a strong supporter of Commissary James Blair's interest in education and the founding of the College of William and Mary. Page also promoted the move of the colony's capital from Jamestown to Middle Plantation, ultimately named Williamsburg.

FIGURE 2.8. Unidentified artist, *Robert Bolling*, ca. 1695, oil on canvas, 30″ x 25″. Muscarelle Museum of Art at the College of William and Mary, Williamsburg, VA. Gift of Mrs. Robert Malcolm Littlejohn.

Robert Bolling (1646–1709) was born in Barking Parish, London, and came to the Virginia Colony in 1660 when he was fourteen years old. In 1674, he married his first wife, Jane Rolfe, the granddaughter of Pocahontas. After her death, he married Anne Stith. Bolling was a merchant/planter like many of his peers in early Virginia. He was a member of the House of Burgesses from Charles City County and a colonel in the local militia.

of the Randolph family) of Turkey Island (figs. 2.9 and 2.10). The Bolling picture and that of John Page are the finest of the pictures now located. Both have well-developed facial features, and the Bolling portrait has significant detail in the sitter's costume. In addition, both are conservative in style, reminiscent of English bust-length likenesses. Because of their size, they were easily transported to the colonies.

Other portraits that were probably executed abroad and brought with immigrants to the colonies include the seventeenth-century English miniature portraits of Sir Thomas Lunsford (ca. 1611–1656) and his brother Colonel Henry Lunsford (dates unknown).[6] These existed in the early twentieth century, but their current location has not been discovered. Another early portrait, thought to represent William Byrd I, (fig. 2.11) was undoubtedly created in England and brought to Virginia. Shown full-length in a standing pose and draped in the attire of a Roman soldier, young William holds the chain-link leash of his black and white dog seen at the lower left. In the 1726 version of his will, Robert "King" Carter left portraits of himself and his first wife, who died in 1699, to his son John. Probably neither survives, but the likeness of King Carter has been copied several times (fig. 2.12). Another unlocated pair of portraits of Carter and his second wife is mentioned in his will as being left to their son Robert.

One of the earliest references to portraiture in Virginia is found in the will of Colonel Thomas Ludlow of York County, who died in 1660. He listed a waist-length portrait of a Judge Richardson, appraised at fifty pounds of tobacco. But the most important seventeenth-century reference for the southern colonies comes from the 1700 will of William Fitzhugh (1651–1701) of Stafford County, Virginia. Fitzhugh left to his son "my own & wife's pictures & the other 6 Pictures of my Relations." The original Fitzhugh portraits have never been located. In 1751, however, John Hesselius replicated the one of William, as well as the one of his father, and inscribed on the back, "Col. William Fitzhugh, 1651–1701, son of Henry Fitzhugh (aetatis 46) born 1614. Cop by John Hesselius 1751" (figs. 2.13 and 5.41).[7] It is very likely a good copy, for it shows the appropriate late seventeenth-century clothing

and hair style and does not display Hesselius's more robust baroque manner. Fitzhugh's interest in pictures is substantiated further by his letter of July 21, 1698, to a British factor indicating that he had an indentured servant who was "a singular good engraver." Perhaps this was the same person for whom, on July 26, Fitzhugh ordered from another factor in London lacquered picture frames, forty shillings' worth of colors for painting with pencils (artist's brushes), walnut and linseed oil, and "half a doz. 3 quarter clothes [cloths] to set up a painter."[8] There can be little question about the intended use of these materials, particularly the three-quarter cloths, one of the common phrases for three-quarter-length portrait canvases.

Several other portraits of Virginia settlers were either brought to the colonies from England or acquired in England on later visits. These include the bust-length likeness of Richard Lee I (1618–1684) by an unidentified artist and the previously mentioned painting of Robert Bolling (fig. 2.8).[9] Another important survival for the period is the portrait of Sir Edmund Andros (fig. 2.14), attributed to the English painter Mary Beale (1632/33–1699).

The survival rate of paintings for early South Carolina is equally low. Charles II gave the colony's lands to eight gentlemen who, like the Calverts in Maryland, functioned as lords proprietor (fig. 2.15). The territory extended into part of present-day North Carolina and included the Cape Fear River, where Barbadians established a small colony in the 1660s. The first colonists to establish a place called Charles Town arrived in the 1670s. In 1679, this settlement, originally on the west bank of the Ashley River, was moved across the river to its present location where it was managed at first by governors appointed by the lords proprietor. A decade later, an estimated 2,500 persons lived in the village, and the town continued to grow rapidly.[10]

The oil-on-canvas portrait of Isaac Mazyck of Charleston (fig. 2.16) was probably created by a French or Dutch artist sometime before the sitter's immigration to the colonies in 1686 or during his travels abroad a few years later. Similarly, the likeness of Francis Le Brasseur (fig. 2.17) was probably painted in France during the last

2.9

2.10

FIGURE 2.9. Artist unidentified, *William Randolph*, ca. 1670, oil on canvas, 36″ x 29″. Virginia Historical Society.

William Randolph (1650–1711), who owned extensive tracts of land in Virginia, was involved in the governing of the colony until his death. He was born in Warwickshire, England, but he may have spent much of his youth in Ireland, where his parents moved about 1655. He came to Virginia sometime in or before 1672. How he made his fortune in Virginia is speculative but was probably associated with tobacco cultivation and trade and possibly with building. He also received several grants about 1700 when new lands were opened for settlement. Ultimately, he built a mansion on Turkey Island in the James River, a mansion which, because of its ribbed dome, became known as the "Bird's Cage." In 1680, he married Mary Isham, the daughter of Captain Henry Isham, born in London, and Katharine Banks Royall of Kent, England. The Ishams and the Royalls moved to Bermuda Hundred in Henrico County, Virginia, before the 1660s.

This portrait of William and the copy portrait of a Randolph woman, possibly his wife, in figure 2.10 have been erroneously attributed to John Hesselius in some publications.

FIGURE 2.10. John Wollaston Jr., copied circa 1755 from an undated earlier portrait by an unidentified artist, *Mary Isham Randolph, Elizabeth Beverley Randolph*, or *Unidentified Woman of the Randolph Family*, oil on canvas, 36″ x 27¹⁵/₁₆″. Virginia Historical Society.

In the past, this portrait of a Randolph family woman has been identified as William Randolph's wife, Mary Isham Randolph (1652–1735). The Virginia Historical Society staff now believes she represents another member of the family, perhaps Elizabeth Beverley Randolph (1691–1723). This copied portrait bears all the traits of John Wollaston Jr.'s work; however, without the sitter's identity, it is difficult to consider when the earlier, original portrait was painted. Aspects of the dress may have been updated by Wollaston. The woman seems to wear a white mantilla, which, unfortunately, was a type of head covering in both the seventeenth and eighteenth centuries.

2.11

2.12

FIGURE 2.11. Artist unidentified, *William Byrd I*, 1658–1668, oil on canvas, 48¼" x 40½". Virginia Museum of Fine Arts, Richmond. Gift of Mrs. Edmund Randolph Cocke in memory of George Byrd Harrison, M.D. Photo: Katherine Wetzel.

William Byrd I (1652–1704) was the son of John Byrd, a goldsmith in London, England. John Byrd had in-laws with the surname Stegge (Stegges, Stagges) living in Virginia, from whom William inherited significant property on the James River. William Byrd came to Virginia around 1670. Around 1673, he married Mary Horsmanden Filmer, the daughter of Warham St. Leger Horsmanden of Kent, England.

Byrd was a member of the building committee for the College of William and Mary as well as a member of the House of Burgesses (1677–1682) and the Council (1680–1704). He served as auditor and receiver general of the colony from 1687 until his death in 1704. He made his fortune as a successful trader in the Richmond area.

FIGURE 2.12. Probably copied by Marietta Minnigerode Andrews (1869–1931) after a pre-1699 English portrait by Sir Peter Lely or one of his students, *Robert "King" Carter*, ca. 1900, oil on canvas, 59½" x 41½". Virginia Historical Society.

There are several surviving portraits identified as Robert "King" Carter (1662/63–1732), this example being a copy of what was probably the earliest portrait of Carter, which is unlocated. A later portrait showing him as a wealthy planter is owned by the College of William and Mary, Williamsburg, Virginia. Three other portraits that supposedly represent King Carter may be misidentified. (See Hood, *Bridges and Dering*, 70–73. One of the portraits is owned by Mr. and Mrs. Hill Carter, Shirley Plantation, Charles City County, Virginia. Another is in the collection of the National Portrait Gallery, Smithsonian Institution, Washington, D.C.)

Carter was one of the most influential persons in the Virginia Colony during his lifetime, with landholdings that totaled about three hundred thousand acres and included some forty-five plantations with approximately seven hundred slaves. In 1691, he was elected to the House of Burgesses. In 1688, he married Judith Armistead of Hesse in Gloucester County, Virginia. In 1701, two years after his first wife's death, he married Betty Landon Willis. By these two marriages, Carter had fifteen children, many of whom married into leading Virginia families.

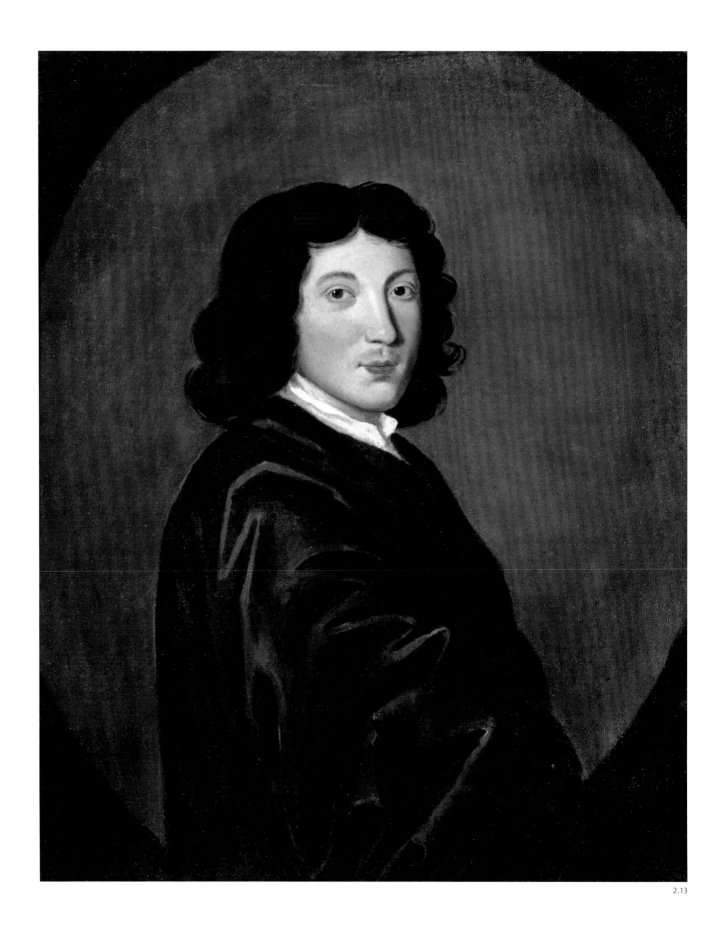

2.13

quarter of the seventeenth century before he immigrated to Charleston. Both pictures are under life-size and oval in format. As small portraits, they would have been easy to transport to South Carolina. They are also very plain, one waist-length and the other bust-length, with the sitters in dark, conservative dress without hands or accessories. While these qualities might reflect provincial style or preference, it is more likely that the austere quality was at least partially due to size and price. Mazyck came from an affluent, middle-class merchant family, and Le Brasseur presumably had a similar background. They probably could have afforded bust- or half-length portraits but nothing larger. If these portraits were painted in France, they rank among the few of that origin that were brought to the colonies. No other seventeenth-century paintings or references to them exist for South Carolina for these years, and none exist for North Carolina.[11]

A group of six waist-length portraits dating from about 1650 to the early 1700s descended in the de Coursey (de Courcy, de Courcey, Coursy) and related branches of that family in Maryland (figs. 2.18 and 2.19).[12] For their time and place, they are sophisticated, well-finished portraits in the manner of court painting of the period. Unfortunately, the identification of the sitters cannot be confirmed from the various Wetenhall, Saunders, and Bedingfield family names associated with the pictures, now owned by the Society of the Cincinnati in Washington, D.C. One of the two illustrated here has

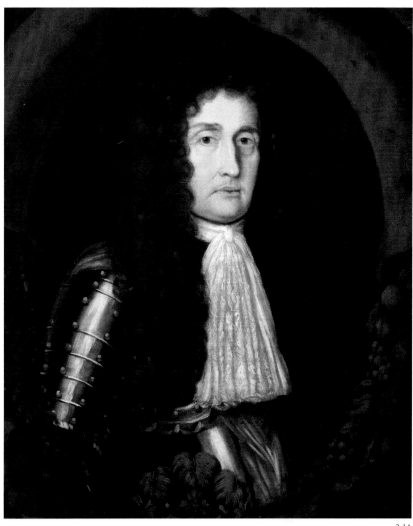

2.14

FIGURE 2.13. John Hesselius after an earlier portrait by an unidentified artist, *Henry Fitzhugh*, dated 1751, oil on canvas, 29⅛" x 24¼". Virginia Historical Society.

Henry Fitzhugh (1614–1664) lived in England his entire life. His son William Fitzhugh (fig. 5.41) was the first of the family to move to Virginia, bringing with him his own portrait and that of his father. Both portraits were commissioned by William's second son, Captain Henry Fitzhugh. Captain Henry Fitzhugh commissioned other works from the artist, including his portrait and that of his son, Major Henry Fitzhugh (fig. 5.42).

FIGURE 2.14. Attributed to Mary Beale, *Sir Edmund Andros*, ca. 1690, oil on canvas, 30" x 25". Virginia Historical Society.

Sir Edmund Andros (1637–1714) came to the colonies as governor of New York and New Jersey, serving from 1674 to 1681. In 1686, he was named governor of the Dominion of New England, at which time he relocated his administrative quarters to Boston. There he was despised for his officious behavior, his inability to control unruly British soldiers, and his association with the Church of England. Eventually removed from his Massachusetts post, he returned briefly to England. In 1692, he served as governor of Virginia. He moved the next year to Maryland.

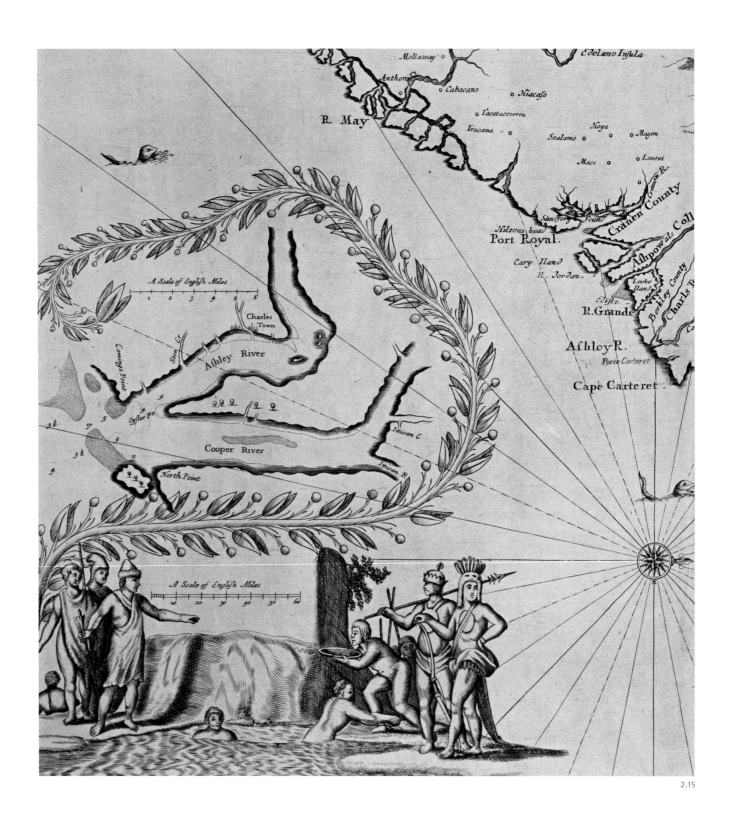

Mollaway
Edelano Insula
Anthorp
Cabacano
Hiacaso
R. May
Tacatacourrou
Iracana
Hoya
Stalame
Magon
Maco
Lonexi

Crauen County

Sandford
Hiltons head
Port Royal.

Cary Iland
R. Jordan

Ashpowal. Coll

Locke
Iland
Berkley County
Charls T

Ecisto
R.Grande

Ashley R.
Portt Carteret

Cape Carteret.

A Scale of English Miles

Charles Town

Comings Point
Stone Cr
Ashley River

Oyster pt

Cooper River

Ittiwan C

North Point

Ittiwan R.

A Scale of English Miles

2.15

2.16

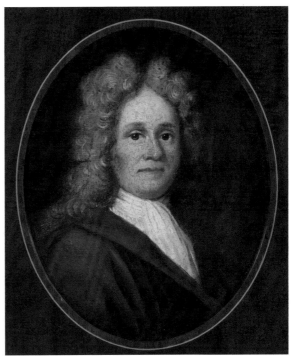

2.17

FIGURE 2.16. Unidentified artist, probably French or Dutch, *Isaac Mazyck*, probably before 1686, oil on canvas, 11¼" x 10". © Image Courtesy Gibbes Museum of Art/Carolina Art Association.

Isaac Mazyck (1660/61–1735/36) came from an affluent Huguenot family of successful merchants in La Rochelle, France. In 1686, he arrived in Charleston, South Carolina, and established a trading business among ports in Charleston, England, Madeira and other parts of Portugal, and the West Indies. As his trading fortunes increased, he purchased considerable land in the Charleston area.

FIGURE 2.15. John Ogilby (1600–1676), cartographer, and James Moxon (d. 1708), engraver, detail of *A New Discription of Carolina by Order of the Lords Proprietors*, London, 1672, ink on paper, 16½" x 21½". Colonial Williamsburg Foundation, Williamsburg, VA.

Charles II granted the province of Carolina to eight men who had assisted him in regaining the throne of England. Their map and the accompanying text that described the place, its inhabitants, and its resources were used to attract settlers to the region. (Information courtesy of Margaret Beck Pritchard, curator of prints, maps, and wallpapers, the Colonial Williamsburg Foundation, Williamsburg, Virginia. See also Pritchard and Taliaferro, *Degrees of Latitude*, 92–95.)

FIGURE 2.17. Unidentified artist, probably French, *Francis Le Brasseur*, about 1674?, oil on canvas, 6¼" x 5¼" oval. © Image Courtesy Gibbes Museum of Art/Carolina Art Association.

Francis Le Brasseur (d. 1725) was but one of numerous French Huguenots who left France after the revocation of the Edict of Nantes in 1685. Many of these families immigrated to England and other areas that, at the time, tolerated Protestants. A large number of Huguenots immigrated to Charleston during this period. Le Brasseur married in Charleston and attended St. Philip's Church. His great-grandson Abraham Motte claimed that the portrait was painted about 1674.

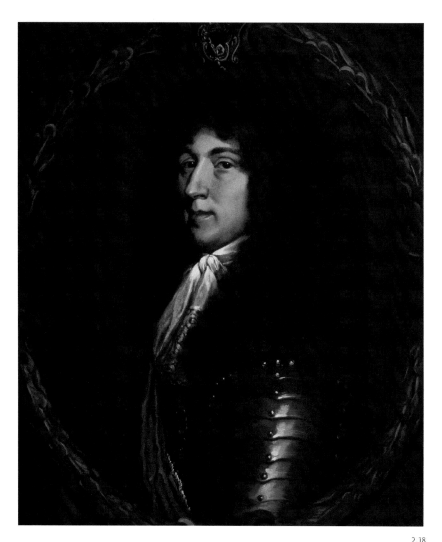

2.18

FIGURE 2.18. Artist unidentified, *Sir Thomas Wetenhall*, probably before 1665, oil on canvas, sight 30" x 25". The Society of the Cincinnati, Washington, DC. Photograph courtesy of the Colonial Williamsburg Foundation, Williamsburg, VA.

This portrait and the one shown in figure 2.19 descended together in the family of Henry Coleman de Courcy May of Maryland, along with four other seventeenth- or very early eighteenth-century portraits. May is said to be a descendant of Colonel Henry Coursey who, along with his brothers William and John, arrived in America in 1649. Nothing definitive is known about the sitters, but persons with the Wetenhall name were in early Maryland. There were several branches of the de Coursey family in seventeenth-century Maryland as well.

The six paintings feature the hands of several artists, including Sir Peter Lely. They are all bust length, and the frames, possibly English or Dutch, are thought to be original. With their deft modeling and highlighting, the two likenesses shown are among the most sophisticated of the group.

been attributed to Sir Peter Lely or one of his followers. Others in the group may be associated with a French artist. The paintings await additional research.

There are few references in seventeenth-century documents to paintings or "pictures" in Maryland. The inventory of Joseph Edwards, who died in Calvert County in 1695, is the earliest record that can be associated with a painter of portraits or other pictures. Edwards had in his possession at the time of death "a parcel of Pictures oyle coulors and other Implements for Painting" valued at ten pounds.[13] Currently, no other references to Edwards are known.

However, seventeenth-century portraits of members of Maryland's Calvert family created in England include the following: Cecil Calvert (1605–1675), 2nd Lord Baltimore, by Gerard Soest (ca. 1600–1681), owned by the Enoch Pratt Free Library in Baltimore, and Charles Calvert (1637–1714/15), 3rd Lord Baltimore, attributed to John Closterman (1660–1715), a European artist represented by at least one other painting in the early southern colonies (see fig. 2.27).[14] It is doubtful that either of the Calvert pictures hung in Maryland. The family portraits should not be confused with the likeness of the 5th Lord Baltimore portrait illustrated on page 169.

The lack of additional southern seventeenth-century examples and references to them makes it difficult to draw informed conclusions about the quality and range of painted art in southern homes during the period. The fact that art did exist in those homes is perhaps the most important conclusion one can reach. Most of the known or referenced paintings were created for the upper middling class of settlers or officials coming to the colonies, and the majority were a conservative bust- or waist-length. Most were also created by unidentified artists—not the leading European painters but those who copied or made portraits for a living, probably in tandem with other painted work.

Much has been written about seventeenth- and early eighteenth-century portrait painting—its beginnings, its popularity in Europe, and its transfer to the colonies, where basic formats came to imitate English examples that were international in style. It is therefore this body

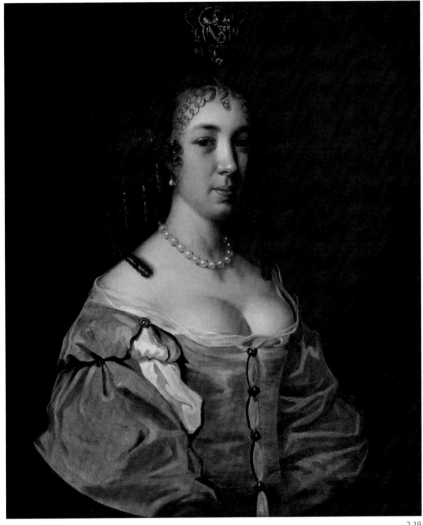

2.19

of material, rather than surviving examples, that best describes the taste for painting as it emerged in the seventeenth-century South. Portraits from all American regions prior to 1740 were more international in style than those of later years. This was the case throughout much of Europe, where artists of different ranks and nationalities tended to move among patrons in several countries. With the exception of monumental scenes, usually in fresco and painted on walls, likenesses had dominated much of the painting done abroad since the Renaissance. The Protestant Reformation caused a serious decline in commissions,[15] but monarchies and the aristocracy provided continuous patronage for portraits. The more intimate and jewel-like miniature

portrait was also a favored format for many years. Most of the artists who worked in England as miniaturists were well-trained, accomplished immigrants. Nicholas Hilliard (ca. 1547–1619) (fig. 2.20), noted for his delicate and highly detailed miniatures, was followed by Samuel

FIGURE 2.19. Possibly Sir Peter Lely or one of his followers, *Lady Thomas Wetenhall* (Elizabeth?), probably before 1665, oil on canvas, sight 30" x 25". The Society of the Cincinnati, Washington, DC. Photograph courtesy of the Colonial Williamsburg Foundation, Williamsburg, VA.

Nothing definitive is known about the sitter, but an Elizabeth Wetenhall, daughter of Edward Wetenhall, was in early Maryland. Presumably, she is the Elizabeth who was born in Queen Anne's County, Maryland, in 1689.

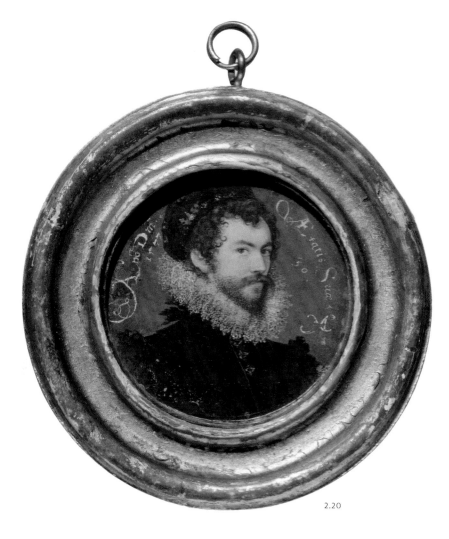

2.20

FIGURE 2.20. Nicholas Hilliard, *Self-Portrait*, 1577, watercolor on vellum, 1⅝" diameter. © V&A Images/ Victoria and Albert Museum, London.

This is believed to be Nicholas Hilliard's earliest self-portrait. Like his father, Richard Hilliard, Nicholas was a trained goldsmith and a Protestant who was exiled during the reign of Queen Mary I of England. He eventually returned to England, where he was apprenticed to Elizabeth I's jeweler Robert Brandon. After other studies in limning, he was eventually appointed limner and goldsmith to Elizabeth I. Hilliard traveled to France to gain commissions among the country's royalty and courtiers. He then returned to England where he worked for the courts of both Elizabeth I and James I as well as for wealthy clientele. About 1600, Nicholas Hilliard wrote *A Treatise Concerning the Arte of Limning*. That treatise, which gives a wealth of information on techniques associated with his art, is preserved in the Bodleian Library at Oxford.

Cooper (1609–1672) and John Hoskins (d. 1664). Under Charles II, Peter Lely, who is rumored to have created portraits of Virginia immigrants, became the country's principal painter. By the end of the seventeenth century, bust- and waist-length portraiture was especially common, and full-length likenesses were also popular among the wealthiest clients. Picture consumption in England was driven by economic and social forces that ultimately became important in the colonies.

The English painter Jonathan Richardson (1667–1745) and the moralist Anthony Ashley-Cooper, 3rd Earl of Shaftesbury, were among the first to offer comments on attitudes towards paintings in general. Shaftesbury contended that pictures were liked for the wrong reason, that is, for being ornaments that appeal to the senses rather than being something that provokes reflection or "satisfys the Thought and Reason." On the other hand, Richardson felt that pictures were objects of delight to be enjoyed through the senses—but not at the expense of overlooking their instructional potential. Instead of envisioning European painting acquisition as the purview solely of royalty and wealthy gentry, both of these men understood that middle-class people purchased pictures of all sorts, including portraits, to decorate their homes.[16] Such a practice, which had been the case in the Netherlands for many decades, had spread to other countries by the late seventeenth century. American historians sometimes overlook the evidence that, by the mid- to late 1600s, middle-class colonists owned paintings.

The population of the southern American colonies, which grew steadily during the mid-seventeenth and early eighteenth centuries, was comprised of disparate classes. Most of the settlers emigrated from or through England, and they included small groups of French, German, Swiss, and Swedish Protestants that were often supported by charitable organizations in England. Usually the continental Europeans immigrated to the South to escape continued religious persecution (fig. 2.21). Some of them, like the English immigrants, ranked among the educated middle class. Overall, however, the English colonists far exceeded the European ones in

2.21

number.[17] Titled English families with land grants or official governing positions comprised a very small segment of the population. The colonial "elite" was instead comprised chiefly of successful middle-class men and women—and they would be among the first to have portraits that reflected affluence and social standing.

At the same time, the middle class in England and some other European countries also earned enough to acquire greater quantities of material goods. They and their colonial peers included merchants, lawyers, physicians, surgeons, apothecaries, and persons working in the trades and commercial trading. By the end of the seventeenth century, persons of this rank in the South also included planters who had made their fortunes from the land and/or trade. These ambitious southerners quickly expanded their land and slave holdings to

FIGURE 2.21. David Böecklin (active 1725–1731), engraver, *Lutherans Leaving Salzburg*, 1731, watercolor and ink on paper, from *Die freundliche Bewilkommung*, published in Leipzig, 1732. Rare Books Division, the New York Public Library, Astor, Lenox and Tilden Foundations.

The scene shows Lutheran families preparing to leave Salzburg, Austria, after their expulsion by Archbishop Leopold von Firmian in October 1731. Lutherans without property were given eight days to depart while those who owned property had three months to prepare for departure. Among those who left were a group of Salzburgers who went first to England and then sailed to Georgia to establish settlements such as New Ebenezer.

2.22

FIGURE 2.22. Artist unidentified, *Isham Randolph*, ca. 1724, oil on canvas, 34" x 26". Virginia Historical Society.

Born in Virginia, Isham Randolph (1685–1742) was the third son of William Randolph (fig. 2.9) and his wife, Mary Isham Randolph (see fig. 2.10). Isham Randolph spent an unspecified period of time commanding a merchant ship, and he lived in London, where he married Jan (Jane) Rogers. He returned to Virginia with his family in the 1720s and died there in 1742. Jane Randolph, daughter of Isham and Jan (Jane) Randolph, married Peter Jefferson, and their first son, Thomas Jefferson, was born in 1743.

provide both ready cash and trade credit. They also built substantial houses and acquired expensive furnishings.

William Fitzhugh (fig. 5.41), son of a successful English woolen draper, is a classic example of a middle-class settler whose fortunes grew rapidly after his immigration to Virginia. Fitzhugh arrived about 1673. By the end of his life, he was a prosperous tobacco farmer who held nearly fifty-five thousand acres of land and owned a large number of slaves. In addition to the seventeenth-century portraits mentioned earlier, Fitzhugh and his children acquired many more likenesses in subsequent years.[18] Although Fitzhugh and men like him had roots in the middle class, many of them assumed an elitist or aristocratic status on the western side of the Atlantic once they became accomplished in—and amassed fortunes through—New World enterprise. Their successful paths were repeated by others, establishing by the mid-eighteenth century a strong consumer base for paintings and therefore for commissions to artists who either visited or settled in the South. Indeed, it can be argued that the consumer revolution in both England and America was at least partially due to colonization, which fueled trade and economic opportunities. The procurement of luxury goods, including artwork, was an obvious result of this burgeoning transatlantic economy.

The best summaries of scholarly and period references to early eighteenth-century portraiture in the South are provided by Graham Hood in *Charles Bridges and William Dering: Two Virginia Painters, 1735–1750,* Wayne Craven in *Colonial American Portraiture,* and Richard Beale Davis in *Intellectual Life in the Colonial South, 1585–1763.*[19] In addition to the likenesses already listed, the portraits they cite include an Isham Randolph portrait (fig. 2.22), perhaps American but possibly English, circa 1724; the likeness of John Baylor III as a young boy, circa 1722 (fig. 2.23); a portrait of William Randolph II (fig. 2.24) that in 1755 was copied by John Wollaston Jr. (ca. 1705–after 1775) from an earlier original by an unidentified artist;[20] the 1727 portrait at Sabine Hall showing a man of the Carter family, possibly Robert "King" Carter;[21] a portrait of John Bolling Sr. (1676–1729);

2.23

2.24

FIGURE 2.23. Unidentified artist or possibly Charles Bridges, *John Baylor III*, ca. 1722, oil on canvas, 48½" x 39³⁄₁₆". Virginia Historical Society.

John Baylor III (1705–1772), son of John Baylor II, attained his reputation and wealth through slave dealing. He had the dubious distinction of being the largest importer and seller of slaves in the Virginia Colony. After his education in England and the receipt of a significant inheritance, John III built a plantation of some twenty thousand acres and over 180 slaves in Caroline County, Virginia. Baylor named his seat Newmarket after the English horse racing course near Cambridge. He married Frances Lucy Walker of Yorktown, Virginia. Baylor was a member of the House of Burgesses from 1742 to 1752 and from 1756 to 1765. (Katheder, *Baylors of Newmarket*, 1–4.)

FIGURE 2.24. John Wollaston Jr. after a 1729 original by an unidentified artist, *William Randolph II of Turkey Island*, dated 1755, oil on canvas, 36" x 29". Virginia Historical Society.

John Wollaston Jr., whose southern career is discussed in chapter 5, copied several early portraits for Virginia clients, including this one of William Randolph II (1681–1741/42) and another for another member of the family (fig. 2.10). The strongly highlighted fabrics, pose, chubby hands, and all details except the face are unmistakably Wollaston's in style and painting. The earlier portraits on which all of the Wollastons were based have not been located and probably no longer exist. Whether they were painted in England or in Virginia is unknown.

William Randolph II inherited the sizable plantation estate on Turkey Island from his father, and he also served as a lawyer in the colony. He married Elizabeth Beverley in Virginia.

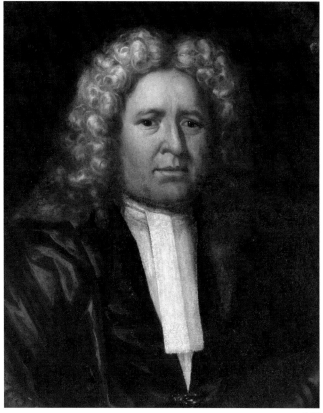

2.25

2.26

FIGURE 2.25. Artist unidentified, *Colonel George Eskridge*, before 1715, oil on canvas, 25½" x 21½". Virginia Historical Society.

George Eskridge (d. 1735?) and his wife Rebecca Bonum Eskridge (fig. 2.26) lived in Westmoreland County, Virginia. He was a member of the House of Burgesses from 1705 until his death. Well educated, he left an impressive library of books pertaining to religion, philosophy, law, and history. He and his wife raised Mary Ball when she became orphaned. Mary would become Mary Ball Washington, the mother of George Washington. It is said that Mary named her son George in remembrance of Eskridge. (Information courtesy of the Virginia Historical Society.)

FIGURE 2.26. Artist unidentified, *Rebecca Bonum Eskridge*, before 1715, oil on canvas, 25½" x 21½". Virginia Historical Society.

The provenance of the portraits of Rebecca Bonum Eskridge (d. 1715) and her husband, George Eskridge, (fig. 2.25) is unknown although it is probable that the likenesses were painted in England. If so, they would date to the late sixteenth or early seventeenth century. The sitters were in the Virginia Colony by 1705 when George first served in the House of Burgesses. In these likenesses, they appear to be middle-aged.

FIGURE 2.27. Attributed to John Closterman, *Daniel Parke II*, ca. 1705, oil on canvas, 56" x 47". Virginia Historical Society.

Daniel Parke II (1669–1710) is shown posed against the Battle of Blenheim, England, where he served under the Duke of Marlborough. His elegant dress includes a miniature portrait of Queen Anne, given to him by the queen for his role in the battle. (The miniature is now owned by the Mount Vernon Ladies' Association.) Several of England's allies, including the Netherlands, awarded Parke medals for his service. Those medals are shown at the lower left. Presumably the portrait was painted about the time that William Byrd II married Parke's daughter Lucy in 1706. That same year, Queen Anne appointed Parke governor of the Leeward Islands; he was murdered at the statehouse in Antigua in 1711. (Information courtesy of the Virginia Historical Society.)

John Closterman, a native of Osnaburg, Hanover, learned to paint from his father before studying in France. About 1680, he went to England where he worked in the studio of John Riley (1646–1691) painting drapery, hands, and other details until Riley's death. Closterman then traveled, painting portraits in Spain and Rome before returning to England in late 1702. (Waterhouse, *Dictionary of Painters*, 94–95.) His talents as a drapery painter and his skillful rendering of costume details and accessories are especially evident in this picture of Parke.

2.27

the portraits of Colonel George Eskridge (fig. 2.25) and his wife Rebecca Bonum Eskridge (fig. 2.26), previously attributed to an artist named Hargreaves (dates unknown) in London in 1705; a portrait of the Reverend James Blair (1656–1743);[22] a portrait of Colonel Daniel Parke Custis (1711–1757) by an unidentified English painter (previously attributed to Sir Godfrey Kneller, 1646–1723); portraits of

Richard Lee II (1647–1715) and his wife, Letitia (Laetitia) Corbin Lee (1657–1706), circa 1705, by an unidentified artist or artists working in either Virginia or England; and the circa 1705 likeness of Daniel Parke II (fig. 2.27) by John Closterman.[23]

The portrait of John Baylor III, usually given an English provenance, is presumed to have been painted

when the subject was in England attending school, probably Caius College, Cambridge. Graham Hood has recently attributed the portrait to Charles Bridges, noting that it could have been created early in the artist's career when he was in Cambridge painting portraits.[24] The portrait is similar to Bridges's other known portraits in terms of pose, costume details, and general painterly quality. Some details of the Baylor portrait—particularly the pose; the somewhat crisp painting of the face, hands, and shirt cuffs; and the shape and execution of the clouds and foliage in the vista behind the subject—also compare favorably with those details in the portrait of a member of the Carter family, thought for many years to represent Robert "King" Carter or possibly John Hill Carter (fig. 2.28), by an unidentified artist. Unfortunately, matters of condition for both pictures make a definitive attribution nearly impossible. However, if the Baylor and Carter portraits are by the same painter, one could make a case for both pictures having been painted in Virginia by the same unidentified artist.[25]

William Byrd II (fig. 2.29) figures prominently in the discussion because he had the largest collection of sophisticated portraits in Virginia or any other colony. Politically and socially well connected, Byrd had been educated in England in grammar school and later at Middle Temple for law. While there, he also gained practical experience in business and trade and took watercolor lessons from Eleazar Albin (active 1713–1759),

FIGURE 2.28. Artist unidentified, *Member of the Carter Family, Possibly John Hill Carter?*, ca. 1725, oil on canvas, framed 54½" x 44½". Courtesy of the Carter Family of Shirley Plantation in Charles City, VA.

FIGURE 2.29. Attributed to Hans Hyssing, *William Byrd II*, 1724, oil on canvas, 48¹³⁄₁₆" x 39⁷⁄₁₆". Virginia Historical Society.

William Byrd II (1674–1744) was born in Virginia, the son of William Byrd I of London who had married the widow Mary (Maria) Horsmanden Filmer (Mrs. Samuel Filmer) of Kent, England, about 1673. William II married Lucy Parke, daughter of Daniel Parke II (fig. 2.27). After her death, he married Maria Taylor. Educated in England, the sitter returned to Virginia in 1692. At the death of

his father in 1704, William II inherited large estates, including the Westover plantation lands on the James River where his son William Byrd III later built an impressive house that still stands.

In 1728, William Byrd II was selected to serve as a commissioner in establishing the dividing line between Virginia and North Carolina. At Westover, he amassed a large library of some four thousand volumes and an impressive collection of portrait paintings, prints, and other items. As a member of the Royal Society, he contributed greatly to European knowledge of America's natural history, and he met with Mark Catesby (1682–1749) when Catesby was in Virginia. Byrd was politically and socially well connected both in the colonies and abroad.

Inscribed on the verso is "The picture of Wm. Byrd Esqr. Of Virginia Given by him to Charles Earl of Orrery. Anno 1725."

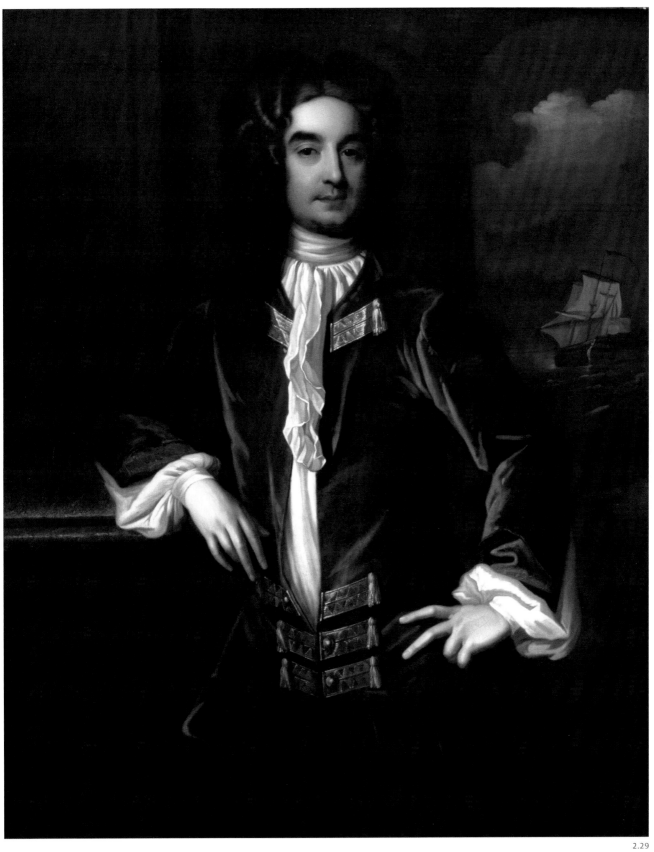

the English naturalist and watercolorist who also taught painting. On his second trip to England, Byrd moved among English aristocracy and became a member of the Royal Society, as did several other southerners in later years. He had his portrait painted about 1704, probably in the studio of Sir Godfrey Kneller (fig. 2.30). Byrd made other trips to England during the following years until 1726. His plantation, Westover, stood northwest of Williamsburg, Virginia, on the James River.[26] The English portraits that hung in the mansion during Byrd II's lifetime included one of Sir Robert Southwell II (fig. 2.31),which was copied sometime between 1696 and 1704 by an unidentified artist in England after the circa 1695 Sir Godfrey Kneller original, and another listed as Elizabeth Southwell (1647–1681), Robert's wife, presumably of the same origin.[27] Sir Robert had sponsored Byrd's appointment to the Royal Society. Also hanging at Westover were portraits of Sir Robert Walpole, 1st Earl of Oxford, (1676–1745); John Perceval (Percival), 1st Earl of Egmont, (1683–1748); Charles Boyle, 4th Earl of Orrery, (1676–1731); William Anne Keppel, 2nd Earl of Albemarle, (1702–1754); Charles Montagu, Earl of Halifax, (1661–1715), president of the Royal Society when Byrd was elected in 1696; Sir Wilfrid Lawson, 3rd Baronet of

Isell, Cumberland, (ca. 1696–1737); Lady Elizabeth Cromwell[28] (1674–1709), the daughter-in-law of Sir Robert Southwell II; Sir Charles Wager (1666–1743); Mary Churchill, Duchess of Montagu, (fig. 2.32); a gentleman known only as Barrister Dutton, painted about 1700; an unidentified boy, probably a member of the Byrd family, by a unidentified English artist, circa 1689; a gentleman identified, perhaps incorrectly, as John Campbell, 2nd Duke of Argyll, (1680–1743), a powerful military and political leader during the reign of George I; one portrait painting "of [by] Rubins" and a painting "of [by] Titian"; and a portrait of Byrd's Virginia friend Nathaniel Walthoe (d. 1770) by an unidentified artist.[29] In addition, Byrd II commissioned his own portrait and a number of other family likenesses, including those of his wives and some, if not all, of his children. Byrd wrote to Virginia governor Alexander Spotswood in 1735 that Charles Bridges had painted portraits of his children. Unfortunately, none of the existing paintings associated with the family can be authoritatively assigned to Bridges.

There were six children at that time: Evelyn (b. 1707) and Wilhelmina (b. 1715), daughters of Byrd and his first wife, Lucy Parke Byrd (d. 1716), and Anne (b. 1725/26), Maria (b. 1727), William III (b. 1728), and Jane (b. 1729), children of Byrd and his second wife, Maria Taylor Byrd (1698–1771), who were married in 1724. English portraits exist for Evelyn (fig. 2.33), probably painted abroad during the late 1720s, as she may have stayed in England with her sister; Anne, who was born in England and remained there until 1729 or early 1730 in the care of her mother's sister;[30] and Byrd's wife Maria, whose likeness is at the Metropolitan Museum in New York City. A portrait identified as Lucy Parke Byrd, the colonel's first wife, is at the Virginia Historical Society and was likely painted in England. The portrait of young William Byrd III was painted in Virginia by an unidentified artist when he was a child of about two years and has, perhaps incorrectly, been assigned to Charles Bridges in the past. A portrait of Jane Byrd "by [Charles] Bridges" was published in a lithograph illustration in 1883, but its current whereabouts is unknown, and it cannot be attributed to any artist based on the print.[31] The likeness

FIGURE 2.30. Studio of Sir Godfrey Kneller, *William Byrd II*, 1700–1704, oil on canvas, 49½" x 39¾". Colonial Williamsburg Foundation, Williamsburg, VA.

In addition to owning one of the most impressive collections of portraits in the colonies, William Byrd II was painted twice in England, once for the presentation portrait shown in figure 2.29 and secondly for this highly sophisticated likeness now attributed to the studio of Sir Godfrey Kneller, whose style dominated English painting in the late seventeenth and early eighteenth centuries.

German by birth, Kneller studied first in Leiden and later in Amsterdam with Rembrandt Harmenszoon van Rijn (1606–1669). He and his brother, an ornamental painter, traveled to Italy, painting there in the 1670s and then returning to Hamburg before going to England. Kneller was appointed court painter to Charles II when Sir Peter Lely died in 1680. He also worked as court painter to George I, and, over the course of his career, he introduced many portrait compositions and poses that became the standard for English artists.

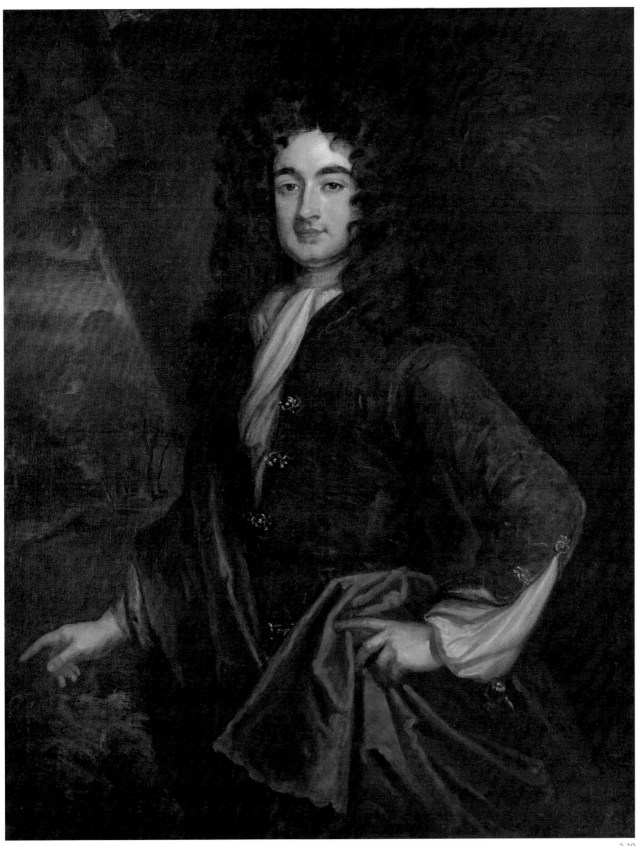

2.30

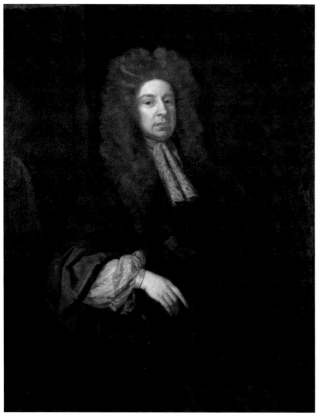

2.31

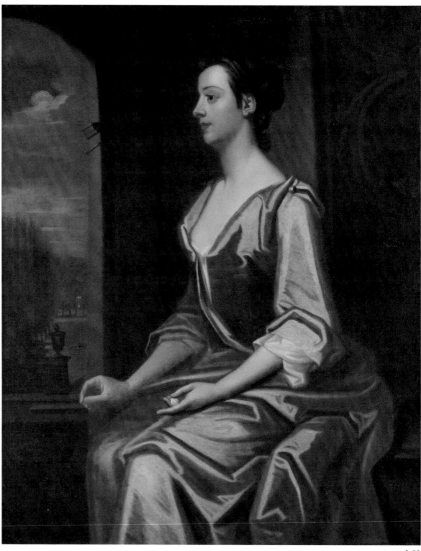

2.32

FIGURE 2.31. Unidentified artist after the circa 1695 original by Sir Godfrey Kneller, *Sir Robert Southwell II*, 1696–1704, oil on canvas, 49¼" x 39⅜". Virginia Historical Society.

Owned by William Byrd II, the Southwell portrait hung at Westover until 1815. Scholars claim that the subject was one of the most important figures in Byrd's life. An Irish diplomat who eventually moved to England yet retained his Irish estates, Sir Robert Southwell II (1635–1702) served as King William's principal secretary after the ascension of William and Mary. Elected a fellow of the Royal Society in 1662, he served as its president from 1690 to 1695.

FIGURE 2.32. Artist unidentified, possibly a follower of Sir Godfrey Kneller, *Mary Churchill, Duchess of Montagu*, 1722–1726, oil on canvas, 49½" x 40¼". Colonial Williamsburg Foundation, Williamsburg, VA.

Mary Churchill (1689–1751) was the daughter of John Churchill, 1st Duke of Marlborough, who had influential ties to both Queen Anne and King George I. In 1705, she married John Montagu, 2nd Duke of Montagu.

FIGURE 2.33. Artist unidentified, possibly a follower of Sir Godfrey Kneller, *Evelyn Byrd*, probably 1725–1726, oil on canvas, 50³⁄₁₆" x 40⅜". Colonial Williamsburg Foundation, Williamsburg, VA.

Evelyn Byrd (1707–1737) was the oldest daughter of William Byrd II and his first wife, Lucy Parke Byrd. Evelyn died, unmarried, when she was thirty years old. She is buried at Westover.

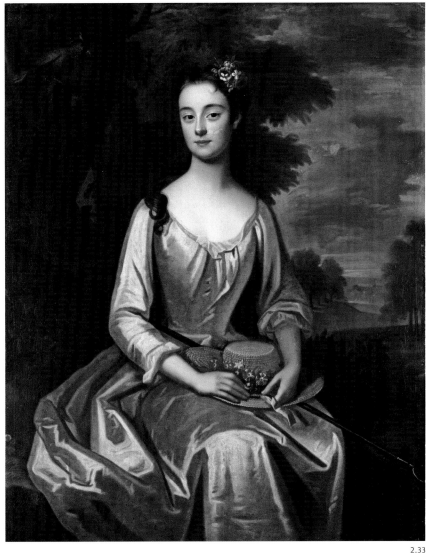

2.33

of daughter Maria, on long-term loan to the College of William and Mary, is attributed, probably incorrectly, to William Dering, whose career in Virginia followed that of Bridges. No likenesses of Wilhelmina are known.

The two surviving portraits of William Byrd II were both painted in England. One dates to 1724, during Byrd's last stay in England (fig. 2.29). Attributable to Hans Hyssing (1678–1752/1753), it bears an inscription indicating that it was presented as a memento to the Earl of Orrery, probably in "Anno 1725," as inscribed on the verso. The earlier likeness, which shows a younger man, was created about 1700–1704 and is attributed to the school of Sir Godfrey Kneller (fig. 2.30). Both are elegant,

aristocratic portrayals, indicating a high degree of artistic discernment on the part of Byrd, a wealthy, Virginia-born planter whose immigrant ancestor was a well-connected fur trader who, through his labors, had amassed a fortune and made significant purchases of land. That wealth also made it possible for Byrd I to advance his son's status through education abroad, which resulted in valuable social connections. It was through those connections that Byrd II came to know many of the nonfamily subjects in his collection of paintings. It was also through those channels that the young Byrd would have first learned about painting. At least six of the portraits in Byrd's collection are associated

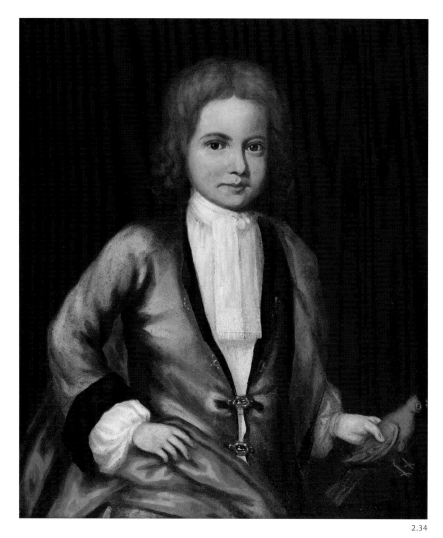

2.34

FIGURE 2.34. Unidentified artist, *David Lyde* (1713–1729), ca. 1720, oil on canvas, 27⅞" x 23¼". Courtesy of the Tayloe Family, Mount Airy, VA. Photography courtesy of the Colonial Williamsburg Foundation, Williamsburg, VA.

FIGURE 2.35. Unidentified artist, *Elizabeth Gwynne Lyde Tayloe* (1692–1734), ca. 1720, oil on canvas, 25" x 24". Courtesy of the Tayloe Family, Mount Airy, VA. Photography courtesy of the Colonial Williamsburg Foundation, Williamsburg, VA.

with well-established and highly ranked European painters. Three of the paintings have been assigned to Hans Hyssing, another to William Aikman (1682–1731), one to Closterman, and one to Kneller or his studio. Such an assemblage, even of just those six paintings, was unprecedented in any other southern household during those years. Although there is no evidence to verify in every case who engaged the artists—the sitter or Byrd—it seems likely Byrd would have selected the painters for his family's portraits while his friends probably used either artists of their own choosing or ones Byrd recommended.

There were important relationships between Byrd and the sitters. The Virginian met a number of them through introductions from Southwell, including Boyle, Campbell, and Perceval.[32] Byrd acquired the previously mentioned 1705 likeness of his brother-in-law Daniel Parke II of Virginia (fig. 2.27), painted by John Closterman, while the sitter was in England. Parke was a member of the Virginia Council from 1695 to 1697, and he served as aide to John Churchill, 1st Duke of Marlborough, at the Battle of Blenheim. Mary Churchill, Duchess of Montagu, (fig. 2.32) was Churchill's daughter.

With the exception of Byrd's collection, most of the paintings found in southern homes during the first half of the eighteenth century were either by lesser-rank European painters whose names are unidentified or by trade-trained painters who lived in or traveled and stayed for a time in the colonies. Several of the early eighteenth-century portraits that descended in the Tayloe family of Mt. Airy plantation, Virginia, were very likely painted in Virginia by an unidentified artist of this rank. These include a young boy named David Lyde (fig. 2.34), half brother of John Tayloe II; John Tayloe I (1688–1747); Tayloe I's wife, Elizabeth Gwynne Lyde Tayloe (fig. 2.35); and another couple of either the Tayloe or related Corbin families.[33] The portraits share many of the same characteristics, including sketchy development of fabric and its highlights, identical garment clasps, and strongly drawn facial features such as upper and lower eyelids and slightly oversized lower lips with similar shading and foreshortening. They may have been

painted in Richmond County where the Tayloes lived.

Three men in Virginia are associated with easel painting during the first quarter of the eighteenth century, but it is unlikely that any of them was responsible for the Tayloe-Lyde group or the other portraits named here. Lieutenant Governor William Gooch described one of these men, Peter Wagener (Waggoner) (d. 1742), on May 21, 1739, in a letter to the Bishop of London:

> I am perswaded your Lordship will be Surprized when I declare upon the Testimony of Gentlemen, who have equally at heart the Interest of Religion, that the Person I am speaking of, is much better remembered here as a bad Painter, than as a Divine.

Wagener was born in Middlesex County, England, and is probably the man who attended Trinity College, Cambridge, in 1701, before being licensed by the bishop of London on August 9, 1703. He was in Virginia only two years, beginning in 1705, after which he returned to England, where he served as rector of Stisted Parish, County Essex, until his death in 1742.[34] Obviously he created one or more pictures in Virginia, for Gooch had seen his work.

The second of these men, Robert Dowsing (1701–1730) of Yorktown, was most likely a portrait painter and perhaps a looking glass maker if the types of equipment and materials listed in his estate inventory are any indication.[35] Pertinent items listed and their values are:

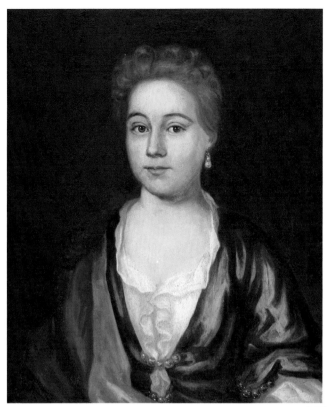

2.35

To 8 Looking Glasses	£ 2.4.0
To 6 small do. without frames	0.2.6
. .	
To 8 pictures or Land Skips	1.10.0
. .	
To 3 lb. quick Silver	0.18.0
. .	
To Turpentine & Turpentine Oyl & Varnish	0.2.0
. .	
.To 4 Picktures & 2 blanks 19/	[part of] 2.14.0
. .	
To 26 printing blocks & Cushions 14/ . . .	[part of] 0.19.0

To 16 Picture boards cover'd with Canvas 16/ . . .	[part of] 1.6.0
.to 150 lb whiting & painting potts 5/	[part of] 0.12.6
. .	
To 1 Stone & Muller 4/ To 1 grinding wheel 3/	
To 1 Mortar & two glew potts 6/	0.13.0
. .	
To 1 large Slate & wts for Silverg looking glass	1. .
To ground paints & paints £ 1.0.0 To books of	
gold Leafe, Do. of Silver Leafe 12/	1.12.0
To 2 doz.n pencils 2/ . . .	[part of] 3.7.4
To 3 oz. 3 of Prussian blue 10/9	
To 1 small hone 1/8	0.12.5
. .	
To 1 Pint & f[?] of Varnish 1/10 f[?] . . .	[part of] 0.3.8 f[?]

Although the inventory mentions no smithing tools, in the 1720s, a Robert Dowsing is listed in York County records as being a blacksmith, a profession he may have learned from his father. He was probably the son of John

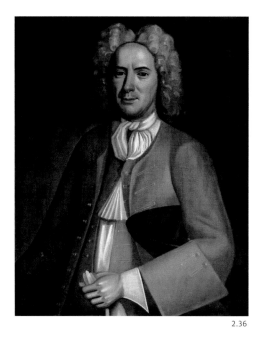

2.36

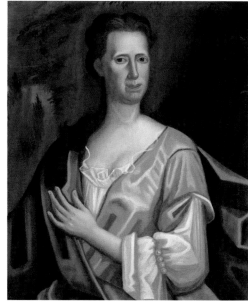

2.37

FIGURES 2.36–2.43. Possibly Robert Dowsing, portraits of members of the Jaquelin and Brodnax families, 1720–1723, oil on canvas, all approximately 30" x 25". Virginia Museum of Fine Arts, Richmond. Lent by the Brodnax Family Trust.

FIGURE 2.36. William Brodnax I (1674/75–1726/27).
FIGURE 2.37. Rebeckah Champion (Mrs. William Brodnax) (1676/77–1723).
FIGURE 2.38. William H. Brodnax (1706–1771).
FIGURE 2.39. Elizabeth Rebecca Brodnax (b. 1710/11).
FIGURE 2.40. Edward Brodnax (b. 1701).
FIGURE 2.41. Martha Jaquelin (1711–1792).
FIGURE 2.42. Edward Jaquelin II (1716–1734).
FIGURE 2.43. Matthew Jaquelin (1707–1727).

As a whole, the Jaquelin-Brodnax and Custis pictures form one of the three largest known portrait groups associated with artists who worked in the southern colonies before 1730. The two other groups represent the work of Justus Engelhardt Kuhn of Maryland and Henrietta Johnston of Charleston, South Carolina. The poses and costumes in the Virginia portraits were derived from English sources, nearly all of which were done as prints after the work of Sir Godfrey Kneller or reflect characteristics seen in his paintings as seen in figs. 2.45 and 2.46.

and Mary Stark Dowsing of Warwick, Virginia, and married to a Mary Gordon of the same area.

Presumably Dowsing was practicing the trade of limner by the end of his life. No paintings have been firmly attributed to him, although the Jaquelin-Brodnax (Broadnax) family pictures (figs. 2.36–2.43) and possibly a portrait of a Custis child (fig. 2.44) are candidates. Though the Jaquelin and Brodnax families were connected by marriage after the portraits were painted, there was no familial connection between them and the Custis family during the period or afterwards.[36]

With the exceptions of the Lyde and Tayloe portraits (figs. 2.34 and 2.35), the Jaquelin-Brodnax portraits are the only other known stylistically related group of Virginia-made portraits from the period. Likely painted between 1720 and 1723,[37] they include members of the Jaquelin family of Jamestown, the Brodnax family[38] of Jamestown and Yorktown (figs. 2.36–2.40), and possibly two portraits of Custis family members,[39] including one traditionally identified as Frances Parke Custis (fig. 2.44)

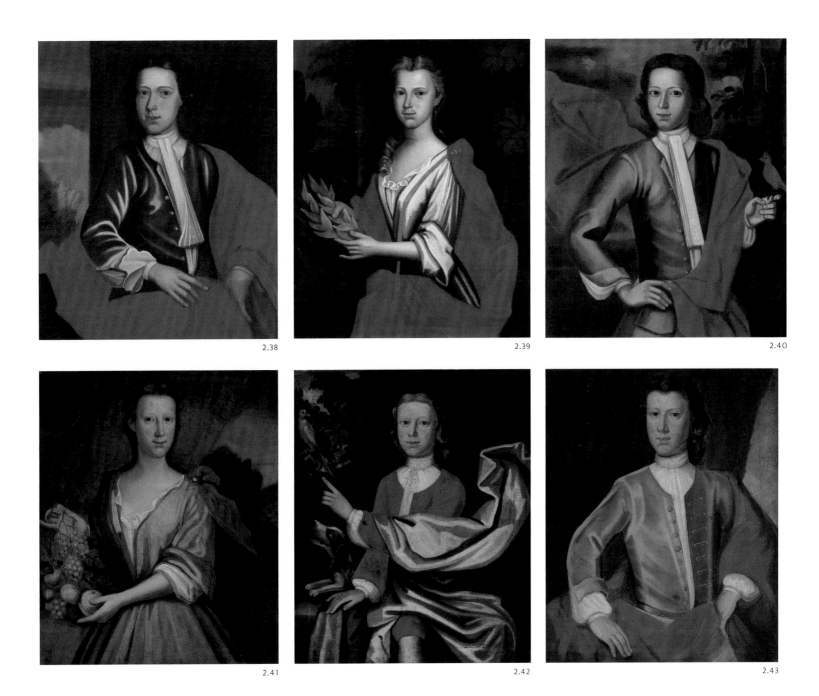

2.38

2.39

2.40

2.41

2.42

2.43

from Williamsburg. It is worth noting that Robert Dowsing certainly knew members of the Brodnax family and the Richard Amblers of Yorktown who lived nearby. Ambler married Elizabeth Jaquelin, one of the portrait sitters (not shown here), and witnessed one and possibly more legal transactions for Dowsing.

The likenesses in question have been widely published and discussed in two articles by the art historian Mary

Black, making the case that they were painted by Nehemiah Partridge (1683–1737), a Boston japanner who was also a portrait painter from 1712 to 1714.[40] Sometime before 1718, he moved to New York, where he was noted as a "Limner."[41] The New York paintings attributed to Partridge do share a few similarities with the Virginia group, particularly the general shape of the eyes and hands, the limited depth, and the inept modeling of all

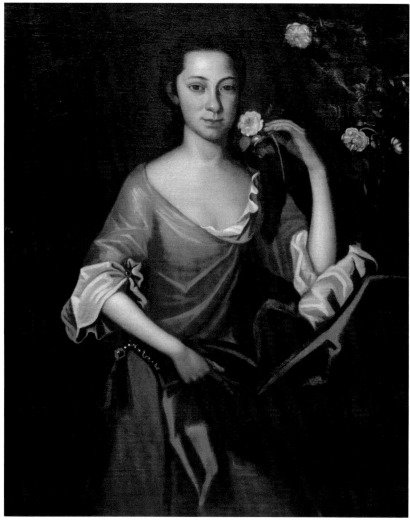

2.44

2.45

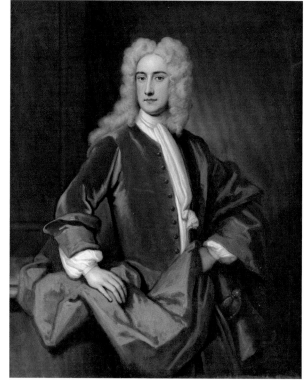

2.46

FIGURE 2.44. Possibly Robert Dowsing, *Frances Parke Custis*?, 1722?, oil on canvas, 36" x 28¾". Washington-Custis-Lee Collection, Washington and Lee University, Lexington, VA.

The sitter's bold pose, the quickly painted highlights on fabrics, and the modeling of the face and hands are all very similar to those seen in the larger group of Brodnax and Jaquelin portraits (figs. 2.36–2.43). However, if by the Jaquelin-Brodnax limner (possibly Robert Dowsing), the identity of the sitter is incorrect, for Frances Parke Custis was born in 1753 and died in 1757 at the age of four. The earlier Frances Parke (b. 1685) was the daughter of Daniel Parke II; she died in 1714. The portrait, probably later than 1714, seems earlier than 1753 and may represent someone else in the family.

FIGURE 2.45. Engraved by John Smith after Sir Godfrey Kneller, *The Right Honorable Lady Elizabeth Cromwell* (1674–1709), ink on paper, 1699–1702, 14⅞" x 11". © National Portrait Gallery, London.

FIGURE 2.46. Sir Godfrey Kneller, *Samuel Sandys, 1st Baron Sandys of Ombersley* (1695–1770), 1720, oil on canvas, 50" x 40³⁄₁₆". Private Collection. Photo © Philip Mould Ltd. London/The Bridgeman Art Library Nationality.

areas. Those similarities, however, are not enough to suggest that the Virginia pictures are by Partridge. Additionally, there are no references to a person or painter by the name of Nehemiah Partridge in Virginia during the 1720s. On August 31, 1727, Robert "King" Carter noted in his diary that he "sat to the Paintr" at his home; however, he failed to record the painter's name.[42] Dowsing is therefore the only name for an artist that can be associated with paintings surviving from Virginia for the 1720s.

Early eighteenth-century paintings in Maryland include a portrait sometimes identified as Henry Carroll (1697–1719) by an unidentified English painter, 1707–1719. Often assigned to Justus Engelhardt Kuhn (d. 1717), that portrait appears to have been made by another painter whose origins could be English or American. The likeness has features similar to New York paintings associated with Nehemiah Partridge although it is not by his hand. A portrait of Carroll's wife, Mary Darnall (1678–1742), appears to date from the same period and may be by the same painter. The latter has been erroneously attributed to Gustavus Hesselius in several modern publications.

Settled later than Virginia, Maryland had a smaller population. Its first capital, St. Mary's City, at the mouth of the Potomac River, was moved in 1694 to Annapolis, a town further north along the bay and nearer to areas of Protestant settlement. It was to this town that Justus Engelhardt Kuhn, Maryland's earliest known painter associated with surviving pictures, went sometime prior to December 3, 1708, when he applied for naturalization. Documents pertaining to his application indicate that he was a German Protestant and a painter. He is known to have joined the Church of England, served as a church warden, and lived in Annapolis until his death.[43] Other information on Kuhn can be extrapolated from the contents of his estate inventory, which includes landscape paintings and an unfinished coat of arms.[44] Many years later, the celebrated American artist Charles Willson Peale wrote that, in his estimation, Kuhn was the earliest portrait artist in the Maryland province.[45]

There seems to have been little, if any, itinerancy among portrait painters in the southern colonies before the 1730s. So far as is known, Kuhn worked exclusively in Maryland for wealthy families, including the Carroll, Digges, and Darnall families and possibly the Franks and the Harrisons.[46] Kuhn's best work is represented by the full-length portraits of Henry Darnall III (fig. 2.47); the pendant portrait of his sister, Eleanor, (fig. 2.48); a child often identified as Charles Carroll of Annapolis (fig. 2.49); and Ignatius Digges (1707/09–1785). Based on the sitters' estimated ages, the Darnall portraits were probably painted circa 1710. The Charles Carroll of Annapolis portrait is inscribed "AEtatis Sua[e].X." If it represents Charles, it dates to 1712 when, as the inscription indicates, he was ten years old. The Digges painting is similarly inscribed "AEtatis Sua[e] 2 1/2 1710. E. Kuhn Feci[t]." All of Kuhn's pictures of children are remarkable for their deep baroque coloration, their elaborate architectural and garden settings, and their details of costumes. Showing limited modeling, they are painted in the flat, naive style of someone who was probably trade-trained in sign, coach, heraldic, or other types of ornamental painting. Many scholars have associated these compositions with print sources, or possibly with early portraits existing in Maryland that Kuhn might have examined firsthand.[47] Other historians such as Elisabeth Louise Roark continue to point out that Kuhn was probably familiar through prints with the work of Sir Anthony Vandyke and other European baroque painters.[48] Kuhn is known to have had over a dozen "Pictures & Landskipps" and three "Pictures unfinished" in his possession at the time of his death. Those were probably paintings, although some may have been prints that served as the source for backgrounds he used in large portraits. His inventory also listed "Mr. Doynes Coat of Armes unfinished."[49] At least one early eighteenth-century painter in the South is documented as owning a large collection of prints that undoubtedly served as sources of inspiration for his pictures.[50]

Independent of their considerable charm and decorative appeal, Kuhn's portraits of children stand out as especially interesting compositions. The Darnall boy and his sister are each shown against a balustrade that looks out on a formal garden set before a large estate. A similar

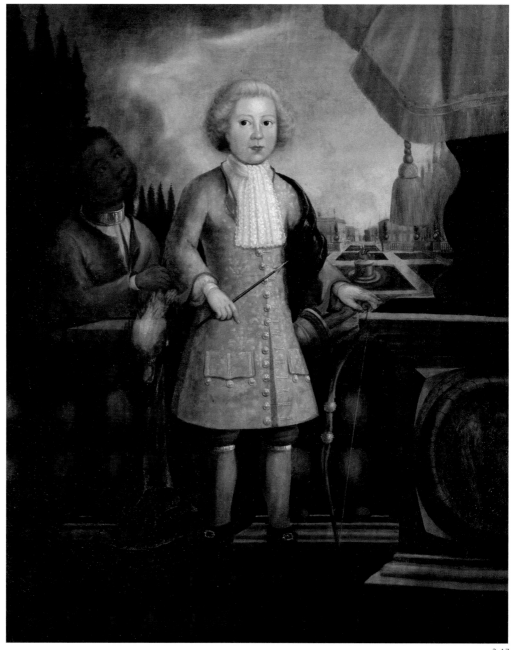

FIGURE 2.47. Justus Engelhardt Kuhn, *Henry Darnall III*, ca. 1710, oil on canvas, 53⅞" x 44". Courtesy of the Maryland Historical Society (Image ID # 1912.1.3).

Henry Darnall III (1702–1788) was the son of Henry Darnall II and the grandson of Colonel Henry Darnall, who went to Maryland from England in the 1670s. Colonel Darnall held a number of important colonial offices, including that of chancellor of Maryland from 1683 to 1689. He served as the receiver general beginning in 1684 until his death in 1711. He built the family home, Woodyard, and owned about thirty-five thousand acres of land that were inherited by Henry II. It was at Woodyard that Henry III and his sister, Eleanor Darnall, (fig. 2.48) lived during their early lives. Their father left the colony in 1730 after amassing considerable debt. A lawyer, Henry III served in various government posts until 1761 when he, like his father, found himself in great debt. He eventually left the colonies for Belgium.

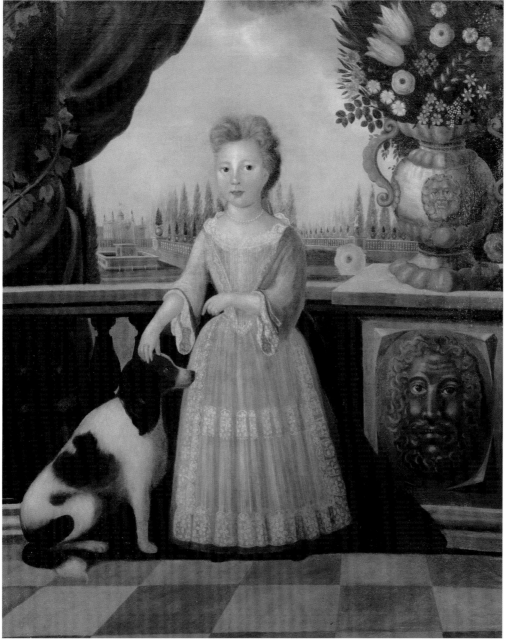

2.48

FIGURE 2.48. Justus Engelhardt Kuhn, *Eleanor Darnall*, ca. 1710, oil on canvas, 54¹/₁₆" x 44³/₁₆". Courtesy of the Maryland Historical Society (Image ID # 1912.1.5).

In addition to the portraits of Eleanor Darnall (1704–1796) and her brother, Henry Darnall III, (fig. 2.47), Justus Engelhardt Kuhn probably painted likenesses of their grandfather Henry Darnall (1645–1711) and his wife,

Eleanor Darnall (ca. 1642–1724), about the same time although they are known today only through nineteenth-century copies owned by the Maryland Historical Society. The sitter married Daniel Carroll of Upper Marlboro; one of their sons, John Carroll, became the archbishop of Maryland.

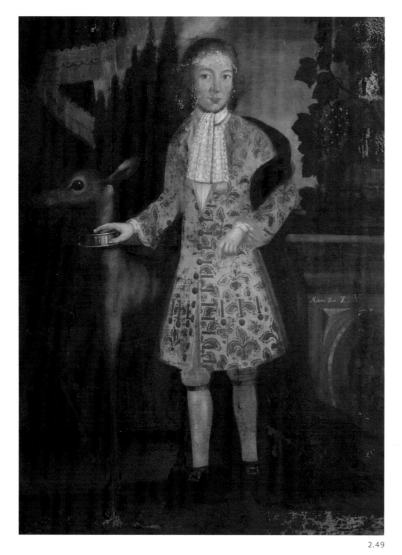

2.49

balustrade appears in the Carroll likeness. The similarities end there, however. Kuhn added a deer to the right of the Carroll child, whereas Henry Darnall is accompanied by his slave servant, and Eleanor has her dog. It is impossible to know if the dog and deer were actual pets or elements borrowed from print sources; however, the incorporation of pets, whether real or copied and whether domestic or tamed from the wild, is common in children's eighteenth-century portraiture. In another portrait, Kuhn included a parrot so accurately portrayed that its species of macaw, common to Central and South American, can be identified. Perhaps Kuhn was aware that that bird was used symbolically in the seventeenth and eighteenth centuries to represent America. At any rate, such devices, meant to reflect an affluent lifestyle, were imitative of European aristocratic portraits and were often associated with gender. Dogs and vases of flowers are typical in girls' portraits while the bow and arrow and one or more dead birds are often seen in early portraits of boys.[51]

Gustavus Hesselius (1682–1755) was probably the next painter to work in Maryland (fig. 2.50), and he most likely visited Virginia as well. Born in Sweden, probably in Folkerna, Dalana, he is said to have been a nephew-in-law of Bishop Jesper Svedberg. Hesselius, his daughter Mary, and his brother Andreas left Sweden in 1711, disembarked from the ship *Potopsico Merchant* in Delaware in 1712, and moved to Pennsylvania soon thereafter;[52] another brother, Samuel, joined them within the next two years.[53] Both of the artist's brothers were priests in the Swedish Lutheran Church, and all three men were educated and well connected in professional and learned circles in Uppsala and Stockholm. One of the three, probably Gustavus, sent plant specimens to Carl Linnaeus.[54]

A letter of June 26, 1714, that Gustavus wrote to his mother in Folkerna, Sweden, provides considerable information about his family and his experience in the colonies. When he first arrived in America, he lived with a saddlemaker called Rabbinson who treated him very badly; after that, he boarded for a year with "Mast: [Master] Eisten" who treated him well and was "one of the most noble English." He married Lydia Getchie (fig. 2.51) on April 4, 1714. Of her, he wrote:

FIGURE 2.49. Justus Engelhardt Kuhn, probably *Charles Carroll of Annapolis*, probably 1712, oil on canvas, 53⅛" x 38¹¹⁄₁₆". Courtesy of the Maryland Historical Society (Image ID # 1949.69.3).

If the identification of Charles Carroll of Annapolis (1702–1782) is correct, the sitter was the son of Charles Carroll the Settler, who came to Maryland in the late 1680s, and his wife, Mary Darnall Carroll, the daughter of Henry Darnall I. The Carroll family ranked among Maryland's wealthy, politically well-connected families throughout the history of the colony. They, as well as the Darnalls, had connections with the proprietor of the colony, Charles Calvert, 3rd Lord Baltimore. The sitter, Charles Carroll, married Elizabeth Brooke (1709–1761), both later painted by John Wollaston Jr. (fig. 5.19). Their son was Charles Carroll of Carrollton.

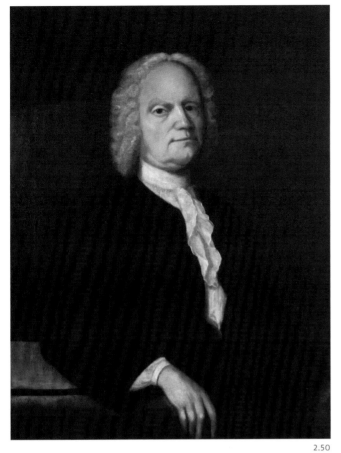

2.50

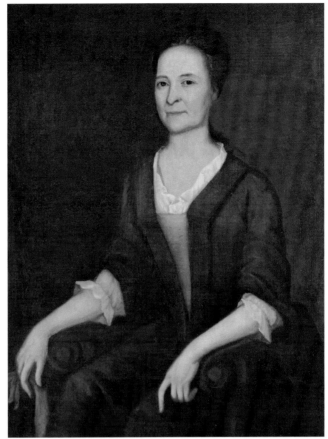

2.51

My Lydia is born of English parents in a large city called Bostarn [Boston] in New England here in America 300 English miles from here. The father is a tradesman and lives nowadays here in Philadelphia, lives well and sound; has his own stonehouse and a new lovely garden where I now live.

The artist went on to explain that his father-in-law "leaves his home and house for my use as long as I stay here in this country." Lydia's mother was deceased at that time, probably making it necessary for her and Hesselius to care for her aging father. Hesselius described Lydia as a pious, virtuous woman, and, in closing the letter, he added, "My Lydia sends her greetings to My D. Mother and sends her portrait with the request it D. Mother will please. It is her complete likeness."[55]

In Hesselius's words, both Philadelphia and the Pennsylvania countryside were "very beautiful and lovely and abundant with God's blessings on both land and sea." He praised the farming, fruits, and other

foodstuffs; the variety and use of trees; such intriguing, tasty items as watermelons; and calabash used for vessels such as bowls and scoops. Philadelphians were, however, another matter, "mostly sinful and ungodly, a mixture of many religions." His interest in the American Native peoples was well established by then, as was his desire to paint a portrait of one (fig. 2.53). The Native peoples were, in his words,

FIGURE 2.50. Gustavus Hesselius, *Self-Portrait*, ca. 1740, oil on canvas, 36¼" x 28". Courtesy of the Philadelphia History Museum at the Atwater Kent, the Historical Society of Pennsylvania Collection.

FIGURE 2.51. Gustavus Hesselius, *Lydia Getchie* (Mrs. Gustavus Hesselius, d. 1745/50), ca. 1740, oil on canvas, 35⁷/₁₆" x 27³/₁₆". Courtesy of the Philadelphia History Museum at the Atwater Kent, the Historical Society of Pennsylvania Collection.

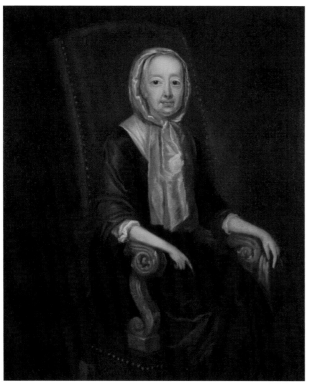

FIGURE 2.52. Gustavus Hesselius after an unidentified artist, *Mrs. William Penn* (Hannah Callowhill), ca. 1740–1742, oil on canvas, 17¹⁵/₁₆" x 14¾". Courtesy of the Philadelphia History Museum at the Atwater Kent, the Historical Society of Pennsylvania Collection.

Hannah Callowhill Penn (1664/71–1726), whose father operated a button factory in England, served as the acting proprietor of Pennsylvania during the illness of her husband, William Penn, who died in 1719. She was the mother of John and Thomas Penn.

FIGURE 2.53. Gustavus Hesselius, *Lapowinsa*, 1735, oil on canvas, 33" x 25". Courtesy of the Philadelphia History Museum at the Atwater Kent, the Historical Society of Pennsylvania Collection.

Lapowinsa (b. ca. 1700?) was one of the Lenape Indian chiefs involved in the Walking Purchase Treaty of 1735/37 with John and Thomas Penn. The purported treaty granted the Penns a huge tract of land comprising about 1,200,000 acres—about the size of Rhode Island. The Lenapes were never successful in challenging or overturning the agreement, which had deprived them of this property.

This is one of two pictures of the Lenape chiefs created by the artist. The second picture, which features Tishcohan, is also owned by the Historical Society of Pennsylvania and shares the same history of being painted for the Penn family. The pictures were inscribed with the Indians' names on the dark backgrounds adjacent to their heads. Lapowinsa wears a beaded necklace with an animal-skin pouch around his neck.

a savage and terrifying folk. They are naked both menfolk and womenfolk, and have only a little loincloth on, they mark their faces and bodies with many kinds of colors as red, blue and black. The womenfolk shave their head on one side, on the other side they let the hair grow. . . . They grease their bodies and head with bearfat and hang broken tobacco pipes in their ears, some hang rabbit tails and other devilments. . . . I have always thought of painting an Indian and sending to Sweden but have not seen any for a while. Last year one of their kings visited me and saw my portraits they astonished him very much. I painted also his face with red color he gave me an otterskin for my trouble and promised I could paint his Portrait to send to Sweden; but I did not see him later. . . . Some time they eat man meat when they kill each other. Last year, I saw with my own eyes that an Indian killed his own Wife in bright daylight in the street here in Philadelphia, and that bothered him nothing.[56]

The artist's opinion of Native Americans was also marked by a degree of objectivity and, though not stated, curiosity about their peculiar ways. He wrote later in the letter that they were "very friendly with the Christians and do us no harm and would rather defend us if it should be needed." These comments are especially interesting in light of Hesselius's 1735 portraits of the Indian chiefs Lapowinsa and Tishcohan for the Penn family, the proprietors of Pennsylvania.[57] Another passage in the letter also reveals how Gustavus was able to make a living in Philadelphia:

I now live among the English in Philadelphia [and] have thank God my rich livelihood among them. there is no other Portrait Painter here, work I have enough, money is scarce. For a Portrait I only have a meagre 4 pound[s] which is as much as 80 Dʳ copper coins in Sweden.[58]

Hesselius's ties to Maryland were made early in his life, beginning with his naturalization there in 1721.[59] That year he was commissioned by the vestry of St. Barnabas Church, Queen Anne's Parish in Upper Marlboro, Prince George's County, Maryland, to paint *The Last Supper* (fig. 2.54). This large religious picture

was undoubtedly based on a print after Leonardo da Vinci's (1452–1519) monumental fresco of the same subject painted in the 1490s. Hesselius's picture is the finest and oldest of such religious pictures created in America. Although it was painted to be viewed from a distance, the artist provided considerable detail in the fabrics, the vessels on the table, and the faces of Christ and the disciples, which are best seen and thus appreciated when the picture is viewed at close range. Hesselius also painted a religious picture titled *The Holy Family* about 1735 (fig. 2.55).

Like other colonial portrait painters, Hesselius offered a variety of work. On September 25, 1740, he advertised in the *Pennsylvania Gazette* (Philadelphia) that he and his partner John Winter (active 1740–1771?), from London, executed coats of arms on coaches, chaises, and other items and did any kind of ornaments, landscapes, signs, "Shew-boards,"[60] ship and house painting, gilding, writing in gold or colors, and cleaning and mending of old pictures.[61] No pictures by Hesselius that can be strictly defined as landscapes are known, although his two surviving mythological paintings (fig. 2.56) clearly illustrate his ability to paint trees, foliage, and vistas. For him at least, such pictures may have fallen into the category of landscapes.

It is not known when Hesselius purchased land in Maryland, only that he sold a tract called Swedeland to John Haymond, a carpenter in Prince George's County, Maryland, on December 22, 1726.[62] The artist is thought to have lived in that area for an undetermined length of time, perhaps moving back and forth to Philadelphia, which he used as his home base.[63] His son, John Hesselius (1728–1778), was also an artist, probably born in Philadelphia. Other references to the elder Hesselius include the purchase of paper from Benjamin Franklin, recorded in the latter's shop book for July 1739. In that record and possibly others, the artist is referred to as Mr. "Selis."[64] Gustavus died in Philadelphia on May 25, 1755; his son, John, was listed as the executor of his estate.

Several portraits from Philadelphia, Maryland, and Virginia are attributed to Gustavus Hesselius. None of those paintings are signed, but early references to a few of the pictures do exist. On September 18, 1742, Richard

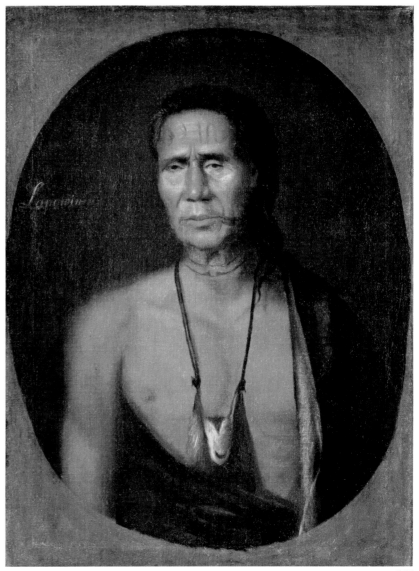

2.53

Hockley of Philadelphia wrote to Thomas Penn that he had sent "Coppys of Mrs Penn's and Mr Freame's pictures with the owl [ship]" and that "they are the best I ever saw of Hesseliu's Painting" (fig. 2.52).[65] Both of those paintings survive, and both show the characteristics associated with other pictures attributed to Gustavus, characteristics that include a painterly manner; disproportionately large foreheads as well as small hands and arms such as seen in the likeness of his second wife, Lydia, from about 1740 (fig. 2.51); and formulaic European poses and compositions.

2.55

FIGURE 2.54. Gustavus Hesselius, *The Last Supper*, 1721–1722, oil on canvas, 34¾" x 115¼". St. Barnabas Church, Upper Marlboro, MD. Courtesy of the Museum of Early Southern Decorative Arts (MESDA) at Old Salem.

Commissioned by the vestry of St. Barnabas Church, Queen Anne's Parish, Maryland, in October 1721, Gustavus Hesselius's *Last Supper* ranks as his largest painting, measuring about three feet in height by more than nine feet in length. It is one of two religious paintings surviving by the artist's hand. See also figure 2.55.

FIGURE 2.55. Gustavus Hesselius, *The Holy Family*, ca. 1735, oil on canvas, 40" x 50³⁄₁₆". Courtesy of the Pennsylvania Academy of the Fine Arts, Philadelphia. Gift of John Frederick Lewis.

This painting may be the one by the same title that was mentioned in the estate inventory of John Hesselius, son of Gustavus Hesselius, although there is no additional information to support this notion. The prevalence— or rarity—of such pictorial subjects, particularly painted ones, in early southern homes is impossible to determine. Few religious pictures survive, although some are occasionally mentioned in inventories.

FIGURE 2.56. Gustavus Hesselius, *Bacchanalian Revel*, probably 1730s, oil on canvas, 24½" x 32¾". Courtesy of the Pennsylvania Academy of the Fine Arts, Philadelphia. Joseph E. Temple Fund.

Gustavus Hesselius's mythological pictures, of which there are two surviving, and his two surviving religious paintings (figs. 2.54 and 2.55) are important examples of nonportrait painting in America.

Other works by Gustavus Hesselius include the Maryland Historical Society's likeness of Thomas Bordley (1682–1726), circa 1720, and the large Virginia portrait showing the children of Philip and Mary Randolph Grymes of Brandon in Middlesex County, Virginia, that has been attributed to both Gustavus and John Hesselius (fig. 2.57). The Grymeses had thirteen children born before 1748, the first three of whom died in 1747. The painting's incomplete history, dating back to the nineteenth century, identifies the children from left to right as Lucy, born August 24, 1743; Philip, born April 15, 1746; John, born March 28, 1745; and Charles, born sometime in 1748. As the youngest, and clearly still an infant, Charles is probably two years old or younger, resulting in a date of 1749–1750 for the painting. John Hesselius is known to have painted portraits for the Fitzhugh and Corbin families in Virginia about that time, but the style of those likenesses does not compare favorably with that of the Grymes group. The latter

2.54

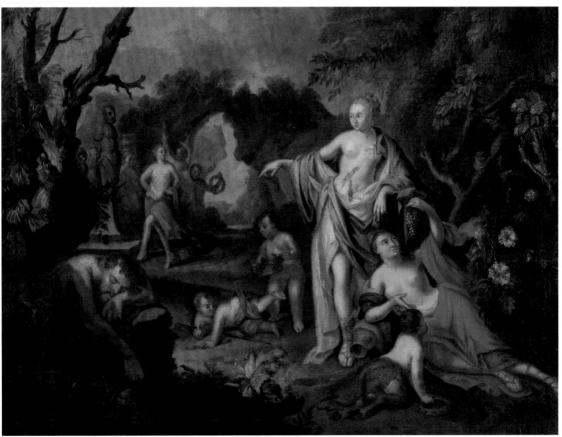

2.56

FIGURE 2.57. Attributed to Gustavus Hesselius, *The Grymes Children*, 1749–1750, oil on canvas, 54" x 65". Virginia Historical Society.

FIGURES 2.58 AND 2.59. Details of figure 2.57.

FIGURE 2.60. Detail of figure 2.50.

2.58

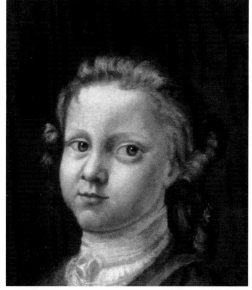

2.59

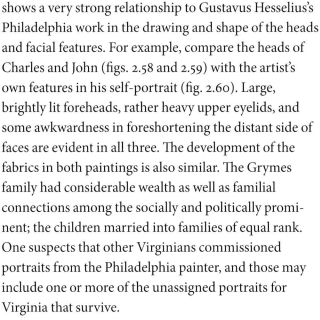

2.60

shows a very strong relationship to Gustavus Hesselius's Philadelphia work in the drawing and shape of the heads and facial features. For example, compare the heads of Charles and John (figs. 2.58 and 2.59) with the artist's own features in his self-portrait (fig. 2.60). Large, brightly lit foreheads, rather heavy upper eyelids, and some awkwardness in foreshortening the distant side of faces are evident in all three. The development of the fabrics in both paintings is also similar. The Grymes family had considerable wealth as well as familial connections among the socially and politically prominent; the children married into families of equal rank. One suspects that other Virginians commissioned portraits from the Philadelphia painter, and those may include one or more of the unassigned portraits for Virginia that survive.

By the late 1730s, South Carolina's urban center, "Charlestown," emerged as the South's busiest seaport and most sophisticated city, although it was still plagued with economic instability. The white population of South Carolina was predominately English and Anglican. As noted previously, protestant French, Swiss, and German families also went to South Carolina in significant numbers, some directly from the continent and others from the Caribbean trade islands. Slavery had been well established in South Carolina by 1700 and continued to

grow throughout the eighteenth century to include about twelve thousand persons in 1720.[66]

Two portraits by an unidentified artist, one of Sir Nathaniel Johnson (fig. 2.61) and the other possibly of his wife, survive for South Carolina for this period.[67] Both were probably created in England and taken to Carolina with the Johnsons or Johnson, who moved there in 1689 and served as the colony's governor from 1702 to 1708. Previously, he was a colonel in the British army and a member of Parliament who had been

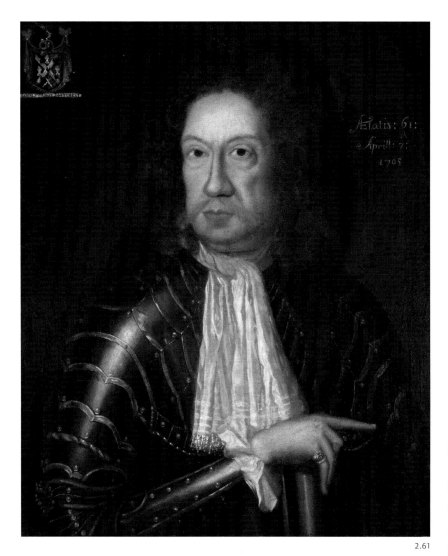

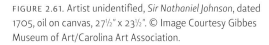

2.61

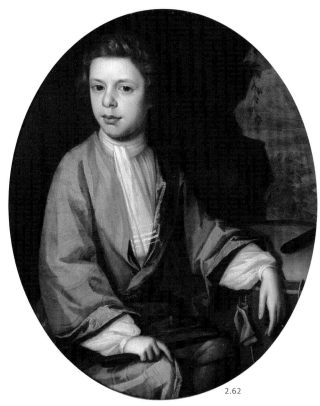

2.62

FIGURE 2.61. Artist unidentified, *Sir Nathaniel Johnson*, dated 1705, oil on canvas, 27½" x 23½". © Image Courtesy Gibbes Museum of Art/Carolina Art Association.

Nathaniel Johnson (1644–1713) was named a landgrave in 1702 and then appointed governor of the Carolinas from 1702 to 1708. Before going to Charleston in 1689, he served as the governor of the Leeward Islands. In South Carolina, he lived at his plantation named Silkhope where he introduced silkworm culture.

FIGURE 2.62. Possibly Sir Godfrey Kneller's studio, *William Roper*, before 1721, oil on canvas, 29" x 24" oval. © Image Courtesy Gibbes Museum of Art/Carolina Art Association.

Assuming this is the William Roper born in 1700 who died in 1772, the sitter went to Charleston when he was about twenty-one years old. He worked first as a clerk for a local merchant and later established his own mercantile and shipping business. Twice married, he lived at a house called Cornhill.

appointed by James II as governor of the Leeward Islands. His military prowess in that region was critical in sustaining England's holdings and trade interests. Governor Johnson's portrait is inscribed "Aetatis 61 / Aprill 7th / 1705." If the inscription is authentic, the portrait must have been painted during a return trip to England after he was appointed governor of Carolina. In terms of style and execution, it is similar to Virginia English portraits of the same period. Like them, Johnson's portrait is modest; it was probably created by a low-ranking London artist.

Three other pre-1730 South Carolina portraits exist. The pre-1721 picture thought to be William Roper (fig. 2.62) is probably English; the two others, of the same period, are of Mme. Jacques Le Serurier and Count Jacques Le Serurier [68] (fig. 2.63), French Huguenots. Her painting is usually referred to as a self-portrait, although such an assignment cannot be verified. The privately owned portrait of her husband, who settled in Charleston in 1684/85, may be by the same hand.[69] Both of these portraits show limited understanding of anatomy and

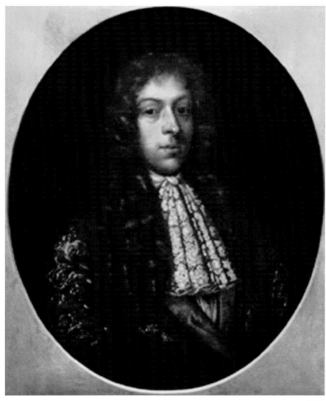

2.63

drapery painting, making a good case for their South Carolina origin and the hand of a provincial artist working there. Roper's likeness is more sophisticated and better executed in its modeling and details, making possible an attribution to Kneller or, more likely, one of his skilled followers. Roper was the son of an English merchant who went to Charleston about 1721 and served in various public positions.

Other early eighteenth-century portraits created by unidentified painters and associated with Charleston residents also exist. Although they have not been thoroughly researched, they include members of the Gibbes family. Two of them, representing Colonel John Gibbes (1696–1764) and his wife Mary Woodward Gibbes (1703–1743), are oil on canvas and may predate 1740–1743 if the identity of the sitters is correct. They are not by Jeremiah Theus (1716–1774), who arrived in the 1730s. The third is a circa 1800 pastel copy of an earlier likeness of Charles Cotesworth Pinckney (1746–1825) at age six.[70]

The only artist associated with South Carolina during the first quarter of the eighteenth century is Henrietta de

Beaulieu Dering Johnston (1674–1729), who arrived in the colony in 1708 with her husband Commissary Gideon Johnston.[71] Henrietta was of French Huguenot heritage. Recent research indicates that she went to London with her parents, Francis and Suzanna (Susannah) de Beaulieu.[72] Other scholars, including Whaley Batson, have indicated that she was probably born in France in 1674 and that she, her mother, and a sister were communicants at St. Martin-in-the-Fields in London in the late seventeenth century. Henrietta married first Robert Dering, one of the children of Sir Edward Dering and Lady Dering (Mary Harvey) who wed in 1648 and lived at Surrendon (Surrenden) Dering, the family seat in Pluckley, County Kent, England.[73] Politically well connected, Sir Edward had served in the Irish House of Commons although he is best known for his strong interest in theater and plays and for his attacks on the ecclesiastical hierarchy in the Church of England.[74] Lady Dering was the first English female composer to publish songs.[75] Among Henrietta's other in-laws were Elizabeth Dering, who married Sir Robert Southwell II, and Katherine Dering, who married Sir John Perceval, 3rd Baronet.[76] Henrietta and Robert Dering had at least two children, both daughters, and possibly other children, for it is now known that Robert died on January 24, 1703, not between 1698 and 1702, as previously believed. One daughter, named Mary, who died in 1747, was appointed dresser extraordinary to the royal princesses, the daughters

FIGURE 2.63. Possibly Elizabeth Leger Le Serurier or Madam La Mere?, *Count Jacques Le Serurier*, possibly 1675, oil on canvas, framed 34⅛" x 29⅝". Courtesy of Henry L. Ravenel Jr., photograph by James J. Ravenel III.

Elizabeth Leger Le Serurier (ca. 1650–1725) and her husband, Count Jacques Le Serurier (d. before 1706), were Huguenots who immigrated to Charleston sometime in the late seventeenth century. They married in 1674. Tradition holds that Elizabeth Le Serurier was a painter although no information has been found to confirm this. This portrait of her husband shares some features with a surviving portrait of her, such as the shape and drawing of the eyes. The attribution of either likeness to Le Serurier is very tentative and without documentation.

of George II. Helena, a second daughter, died in 1704, a year after her father. Her posthumous portrait by her mother survives (fig. 2.64).[77] In summary, the Derings were one of the oldest aristocratic families in Ireland, and Henrietta would have enjoyed the largesse of her relationships with other members of the family when she was in England and Ireland.

In 1705, Henrietta married her second husband, Gideon Johnston, who may have been born in the small town of Loony located in County Mayo, Ireland. After his graduation from Trinity College in Dublin, he served as vicar of Castlemore, the position he held when he married Henrietta.[78]

After Robert's death and before her second marriage, Henrietta likely stayed in one of the large manor houses owned by Robert Dering's extended family that included the Percevals and the Southwells (figs. 2.65–2.67). During this time, she created twelve of the forty-three surviving portraits either signed by or attributed to her. Henrietta's small pictures are not paintings in the strictest sense, for they were executed with pastels or "crayons," not liquefied

FIGURE 2.64. Henrietta Dering (later Johnston), *Helena Dering*, probably 1704–1705, crayon on paper, 11⅝″ x 8⅞″. John and Judith Herdeg Collection.

John and Judith Herdeg, collectors and scholars, are responsible for researching and documenting this significant and most unusual work to Henrietta's hand. They discovered that the picture was inscribed by the artist on its wooden backboard, a common feature of Henrietta's works that retain their original framing. However, the identity of the sitter as the artist's deceased daughter required additional sleuthing, including deciphering the funerary hatchment drawn at the top of the picture, one side of which bears the arms of the Dering family. Two sets of initials, "R. D." and "H. D.," appear on the plinth, undoubtedly for Robert Dering, the father, who died the previous year, and the deceased child, Helena (1702–1704). The Herdegs traced the burial documents for both father and daughter to St. Andrew's Parish in Dublin, Ireland. Independent of the important new information on Robert's death date and the second child's name is the composition and iconography of the portrait, unique among Henrietta's known work.

colors applied with a brush. Nevertheless, they functioned like oil portraits, and they offer an important glimpse of the art available to early Charlestonians.

Pastel pigments were the same as those used for watercolors and oils but were created by mixing the colors with small amounts of water and binder and shaping them into sticks for drawing. Pastels, which are almost pure pigment, should not be confused with chalk. They are usually applied to a toothed, or fiber-raised, paper that catches the dry color. Nor does their name refer to delicate coloring; rather it derives from the French *pastiche,* meaning "mixture." The medium dates back to the fifteenth or sixteenth century, and various countries claim its invention. With the exception of the Italian pastellist Rosalba Carriera (1675–1757) who went to France, few European female artists were working in this medium during Henrietta's lifetime. Henrietta was highly skilled, as illustrated by the Irish likenesses (figs. 2.65–2.67) that reflect a strong understanding of drawing with the medium, a fine sense of human anatomy, and proficiency in mixing color for skin tones. Such expertise could only have come with training or extraordinary talent or both.

Pastel painting, as it was sometimes called, was still a relatively new technique in Henrietta's time. Practitioners of the medium in London or Ireland during the late 1690s or early 1700s were also rare. Although several London artists have been named as potential instructors to Henrietta, it is difficult to confirm her association with them without further documentation.[79] It is entirely possible that she was trained in France at a young age. The French engraver Robert Nanteuil (1623–1678) often executed portraits in pastels instead of oils as a matter of efficiency and economy, and he had several students who might have trained Henrietta. The French painter Joseph Vivien (1657–1734) also made his reputation in pastel portraiture. In London, several artists worked in pastels, including Mary Beale, a student of Sir Peter Lely. Beale worked in both oils and pastels, and she not only produced portraits but also taught painting and drawing.

According to William King, Gideon Johnston went to England with his family in 1707 in response to "the

2.64

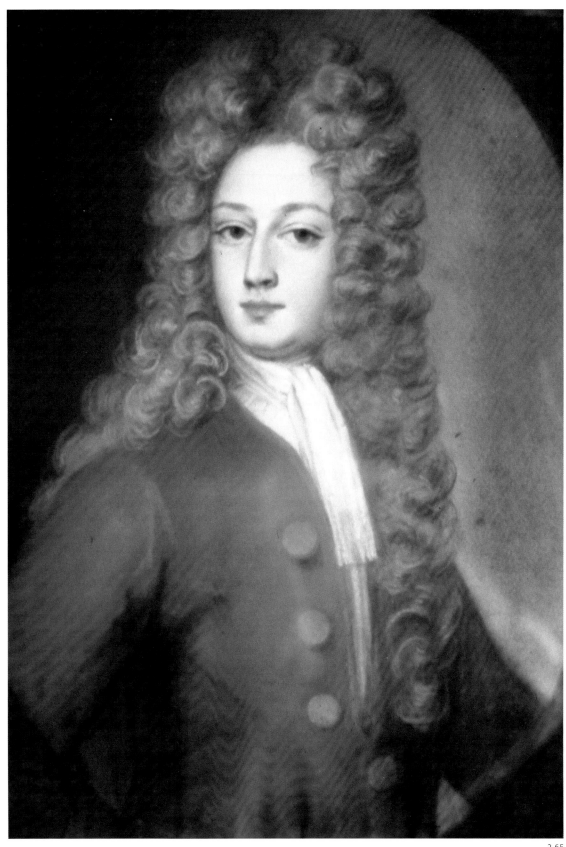

2.65

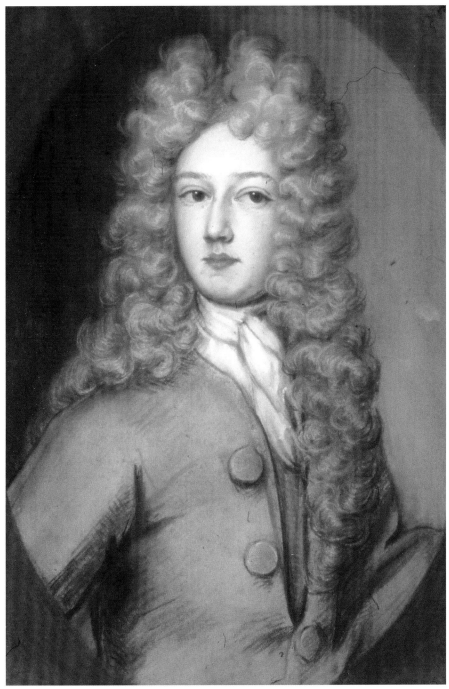

2.66

FIGURE 2.65. Henrietta Dering (later Johnston), *Philip Perceval*, dated 1704, crayon on paper, 14″ x 10″. Courtesy of the Museum of Early Southern Decorative Arts (MESDA) at Old Salem.

This likeness of Philip Perceval (1686–1748) is one of several Irish portraits by Henrietta Dering (Johnston) that has been recently identified. All of the sitters in these portraits were related to the artist's first husband, Robert Dering. According to Whaley Batson, this subject was Robert's nephew, the son of Sir John Perceval, 3rd Baronet, and Robert's sister Katherine Dering (see Alexander, *Henrietta Johnston*, 24). Philip's portrait and those for his brother Sir John Perceval, 1st Earl of Egmont, (fig. 2.66) and a gentleman of the Southwell family (fig. 2.67) rank among the finest surviving by the artist and reveal her sophisticated techniques and style.

FIGURE 2.66. Henrietta Dering (later Johnston), *Sir John Perceval, 1st Earl of Egmont*, dated 1705, crayon on paper, 13¾″ x 9½″. Courtesy of the Museum of Early Southern Decorative Arts (MESDA) at Old Salem.

Sir John Perceval (1683–1748), a brother of Philip Perceval (fig. 2.65), was another nephew of Robert Dering, Henrietta's first husband. He was the son of Sir John Perceval, 3rd Baronet, and Katherine Dering, sister of Robert and daughter of Sir Edward Dering. The subject served in the Irish House of Commons for County Cork in 1703 and 1713–1715. In 1715, he was made Baron Perceval, and, in 1722, he was named Viscount Perceval. In 1727, he was elected to the British House of Commons, and the next year he was admitted to the Privy Council. He was well connected with members of the royal family and other influential leaders. Sir John was also a Fellow of the Royal Society. According to Whaley Batson, he was one of the trustees for establishing Georgia (see Alexander, *Henrietta Johnston*, 41).

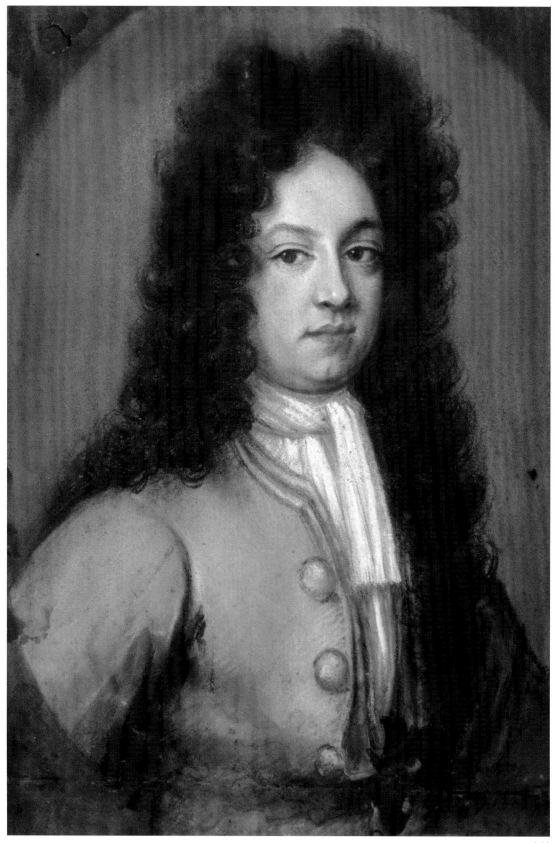

2.67

report he had heard of the great need of Ministers" in the colonies.[80] This was the first of Johnston's seemingly impromptu decisions that indicate his impetuous nature. Various records of the Society for the Propagation of the Gospel in Foreign Parts document that he, Henrietta, and eight or nine other members of their family found it difficult to subsist in London. By November, he claimed to have exhausted his resources, but he continued to pursue travel to South Carolina.[81]

Against the advice of Dublin's Archbishop William King, voiced in his letters as early as October 1706, the Johnstons apparently left London in December 1707, arriving in Charleston in early 1708.[82] Johnston's surviving correspondence with the secretary of the society reveals a great deal about the family's experience and hard times. They were not prepared for the conditions they found in South Carolina. Johnston soon discovered that Richard Marsden would not relinquish his post. Marsden was described by church leaders as "a fugitive clergyman" who was "insinuating in manner," had "ingratiated himself with a party in the church, and secured by misrepresentations an election" to the position of rector at St. Philip's, Johnston's assigned church.[83] In contrast to Anglican protocol, Charlestonians in that parish congregation usually elected their rector in Presbyterian fashion. Marsden was eventually removed by the Board of Lay Commissioners, and Johnston was given his post, but the wait was a constant strain on the family finances, and expenses continued to plague the Johnstons for many years.

On November 11, 1709, Johnston wrote again to the Lord Bishop of Sarum, saying that

> [I] am still deprived of the use of my hands, and . . . many things contribute to make my life very uneasie, the Scantiness of my Salary, and the excessive rate of all things here are such, that were it not for the Assistance my wife gives me by drawing of Pictures (which can last but a little time in a place so ill peopled) I shou'd not have been able to live.[84]

Henrietta was among several people who also wrote to the Lord Bishop of Sarum, asking for financial help on her husband's behalf.[85] By 1710, Johnston stressed that "for what between poverty, diseases, & debts, both I and my family (10 in number) are in a most miserable and languishing Condicon." He went on to say that

> my wife who greatly helped me, by drawing pictures, has long ago made an end of her materials, and to add to the misfortune, God has been pleased to visit her with a long and tedious Sickness; She now is struggling with the fflux and ffeaver, as I also am.

After many other complaints and explanations as to his illness, the family's poverty, and the difficulties of his church work, Johnston issued the first of his repeated requests to return to England for treatment and possible reassignment.[86] His requests were apparently denied. Henrietta was sent to London the next year with papers requesting, among other things, money and a curate to assist her husband; she returned in 1712, just months before Johnston, still in bad health, left for London in May 1713.[87] One suspects that he had hoped to stay in England, since he did not return to Charleston until two years later. He died in 1716. Henrietta continued to live and work in Charleston until her death on March 9, 1729, presumably intestate, for no probate records have been found for her. She was at the time about forty-five years old and was very likely exhausted by her efforts to support her family.

FIGURE 2.67. Henrietta Dering (later Johnston), *Gentleman of the Southwell Family*, dated 1705, crayon on paper, 14 " x 11½". Courtesy of the Museum of Early Southern Decorative Arts (MESDA) at Old Salem.

In her catalog of Henrietta's work, Whaley Batson indicates that this sitter may be Sir Robert Southwell II's son, Edward (see Alexander, *Henrietta Johnston*, 41). The Southwells were related to the Derings and the Percevals. Sir Robert Southwell II, the English diplomat and Fellow of the Royal Society who was a friend of William Byrd II (figs. 2.29 and 2.30), married Elizabeth Dering, daughter of Sir Edward Dering and sister of Robert Dering.

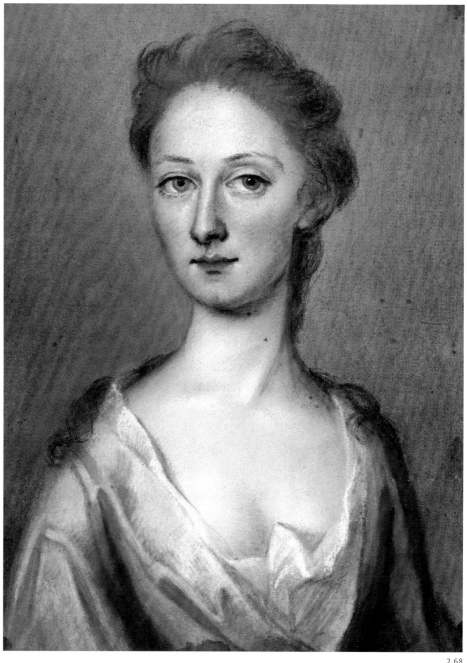

2.68

Henrietta's Charleston portraits are as nicely drawn as her Irish examples, although many of them have suffered irreparable loss of pigment and some discoloration of the paper support. The portraits of Mrs. Samuel Wragg (fig. 2.68) and Henriette Charlotte de Chastaigner (fig. 2.69) of Charleston are among the best of her South Carolina likenesses and compare well with her Irish work, having the same degree of elegance and a delicacy in the drawing of the face and clothing. The portrait of Colonel William Rhett (fig. 2.70) shows him in armor and illustrates Henrietta's ability to render a variety of fabric materials as well as metals with their strong highlights. Although not favored by South Carolina's royal governors, Rhett was a prominent, wealthy, and well-connected London immigrant who

2.69

2.70

FIGURE 2.68. Henrietta Johnston, *Mrs. Samuel Wragg* (Mary DuBose or DuBosc), dated 1708, crayon on paper, 11½" x 8¾". © Image Courtesy Gibbes Museum of Art/Carolina Art Association.

The subject's identity has been passed along by family tradition. Whaley Batson speculates that she may be the Mary DuBose (dates unknown), eldest daughter of Jacques and Mary Dugue DuBose, who arrived in Charleston between 1695 and 1696 (see Alexander, *Henrietta Johnston*, 42; see also Baldwin, *First Settlers of South Carolina*, 75). If so, Mary's mother was married again, after the death of her first husband, to Dr. John Thomas, the physician who cared for the Johnston family during their various illnesses. Gideon Johnston's surviving letters make reference to him.

FIGURE 2.69. Henrietta Johnston, *Henriette Charlotte de Chastaigner de Lisle*, dated 1711, crayon on paper, 11⅝" x 8¾". © Image courtesy Gibbes Museum of Art/Carolina Art Association.

The portrait of Henriette Charlotte de Chastaigner (ca. 1695–1754) may have been done about the time of her marriage to Nathaniel Broughton of Charleston. She was the daughter of Alexander Thesee de Chastaigner and his wife, Susannah Elizabeth Le Noble de Chastaigner. The Broughtons had at least five children, including Nathaniel Broughton II, who owned Mulberry plantation.

FIGURE 2.70. Henrietta Johnston, *Colonel Rhett*, 1710–1711, crayon on paper, 11½" x 9". © Image courtesy Gibbes Museum of Art/Carolina Art Association.

William Rhett (1666–1723) arrived in South Carolina in the 1690s. He became influential in the colony's government, serving as the Speaker of the House and in other positions. He also served as vice admiral of South Carolina, and, in 1718, he captured the pirate Stede Bonnet, commonly known as "the gentleman pirate" because he had been born into a wealthy Barbadian plantation family.

served in the colony's militia and held other important posts. He and his wife were supportive of Gideon Johnston and the church and thereby became friends with the Johnston family. It should be noted that most, if not all, of Henrietta's known portraits of identified sitters represent family friends and relatives. In Charleston, her clientele included members of prominent families. Examples from Charleston are dated as late as 1726, three years before her death. Some scholars believe that Henrietta visited New York in 1725, the year when she signed and dated one or more of the four portraits for the Moore family and one for the Coldens.[88] The histories and locations of some of these pictures are either incomplete or unknown.[89]

The numerous pictures that survive for the early years of the eighteenth-century South form a disparate group in terms of quality and taste. They range from highly sophisticated European portraits either brought to the colonies or commissioned by its wealthy citizens to likenesses created by minimally trained, and probably trade-trained, painters. William Byrd II's extensive collection of pictures at Westover was atypical, but his tastes were undoubtedly shared by others who arrived with wealth or who acquired it and then used it to garner gentrified manners and objects. Comments by Byrd provide some sense of his arts awareness and his proficiency in assessing pictures and painters. For instance, he called one European painter a "Bungler for falling so short" of the sitter's likeness.[90] Curiously, we find that in addition to the large majority of European pictures he acquired, Byrd later owned works by two local painters, Charles Bridges and William Dering, whose styles and manner fell far short of a Kneller or a Hyssing. Some of the pictures commissioned in Virginia were of family members, but at least two were of other persons he knew in the colony. Thus, Byrd, like many early southerners, accepted local painters when he had no other choice.

Local painters were also available for southern clients who could not—or would not—travel abroad for portraiture. Of those working locally, only one opinion is recorded, and that from someone familiar with superior painting: Lieutenant Governor Gooch who, as previously mentioned, called the elusive Peter Wagener (Wag-

goner), who worked in Virginia, a "bad Painter."[91] Just how bad cannot be determined, for none of Wagener's work seems to have survived. In general, one draws the conclusion that superior quality painting may have been important (and affordable) for only a few and that a higher standard of artistry was imposed for imported pictures. Colonists like Byrd may have been more tolerant and accepting of the inadequacies of local painters while those who were unfamiliar with European art could not fully judge.

If there were any contact between portrait artists living in South Carolina, Virginia, and Maryland during these years, it is unknown today. North Carolina did not become a separate colony until 1712.[92] Settlements existed in that area, but they were widely dispersed, and no artists or paintings are known for them. Similarly, the territory now known as Georgia had no significant settlement until the 1730s. Constant conflict between Spain and Britain over Georgia's coastal areas had begun about 1670 when the province of Carolina was being settled. Spain had previously established several missionary outposts, but these had all failed by 1704. The Georgia coast was held by English-allied Yamasee Indians until their destruction in the war of 1715–1717. James Oglethorpe, a member of British Parliament, led a group called the trustees of the colony of Georgia that, in 1732, secured a royal charter to settle the area. The first group of colonists arrived on February 12, 1733. With that group of Salzburgers came Philip Georg Friedrich von Reck, who recorded what he saw, including aspects of the natural world and Native Americans.

Von Reck and a few others like him followed in the footsteps of the earliest American explorer-artists, John White and Jacques Le Moyne, by providing visual evidence of the floral and faunal resources and of the Native Americans that still peopled the southern colonies. Although the art of these men was not meant to embellish walls or in other ways suggest the worldly sophistication of its owners, it was, like the art of White and Le Moyne, powerful propaganda that continued to feed the imaginations of the rich and learned both in America and Europe.

NOTES

1. *History of the Arts,* 1:17.

2. Caucasian population statistics are imprecise and can be misleading for these early years. For example, in 1650, Virginia's white population was about 19,000; in Massachusetts, about 16,000; and in Maryland, New York, and Connecticut, about 4,000 each. By 1700, these numbers had increased substantially, to 58,600 in Virginia; 56,000 in Massachusetts; 30,000 in Maryland; 20,000 in New York; and 26,000 in Connecticut. Other colonies in both the North and the South also grew significantly by 1700. Even though Virginia had the largest population throughout the period, it had no towns the size of Boston, with 2,000 white residents in 1650 and 7,000 in 1700, or New York, with 5,000 in 1700. Also by 1700, 2,500 residents of South Carolina—almost half of its population—were slaves; in Virginia, over 16,000 were slaves; and in Maryland, 3,200. By comparison, the slave population of Massachusetts was 800, and of Connecticut, 50. Slave labor, far more prevalent in the South than the North, became the backbone of southern agricultural work and the southern economy. This pattern, established early in the South's history, continued for well over 150 years.

3. A "plantation" is a large farm devoted to growing cash crops. In early America, plantations were first associated with the colonization of tracts of land planted by immigrants; the term did not refer to a manor house. As the seventeenth century progressed, the term became associated with large farms, and, by the end of the eighteenth century, it began to suggest a large house, wealth, and fine material goods. Large southern plantations evolved into self-sustaining operations with slave tradesmen and tradeswomen providing services that otherwise would have been relegated to townspeople.

4. A lack of extensive acreage of clear, rock-free, fertile soil—along with a shorter growing season—made cash crop farming in New England more difficult than in the South. A New England family could make a living wage from farming, but economic gain and advancement were difficult. Fishing, shipbuilding, shipping, and the mercantile businesses those trades supported were more the norm.

5. Both Vandyke and Janssen were working for the English court about the time the Moseley portraits were painted. The paintings could also have been done by a follower of one of those two well-known artists. Craven writes that William Moseley "reportedly brought over, either at the time of his immigration [in 1649] or on two subsequent trips back from England [before his death in 1655], twenty-two pictures to adorn his plantation house, Rolleston Hall" (*Colonial American Portraiture,* 182), apparently named after the ancestral Moseley estate in England. The four portraits discussed here, or some of them, were probably included with the twenty-two or in the inventory references. Susanna Moseley's estate inventory taken in 1656 refers to two portraits, and her son's 1671 inventory lists "Foure picktures" valued at two hundred pounds ("Families of Lower Norfolk," 329–330). Craven also refers to family papers from 1782 in which the estate of Edward Hack Moseley, great-great-grandson of the immigrant, included "thirty-nine pictures, of which fourteen were specified as 'Family Pictures,'" probably portraits (*Colonial American Portraiture,* 182–183).

6. Bolton, *Founders,* 2:616.

7. *William Fitzhugh and His Chesapeake World,* 379. Hesselius's inscription comes from Virginius C. Hall, *Portraits in the Collection of the Virginia Historical Society,* 85. The word "picture" is often difficult to interpret since it was used in inventories and other documents to refer to oil-on-canvas and other types of painted images and prints. Often portraits are cited as "my picture" or as a "picture of" a particular person. Other sample references to "pictures" in seventeenth-century southern records include the following: John Brewer, Isle of Wight County, VA, whose 1669 will cites twelve small pictures; Edward Digges, of York County, VA, whose 1692 will cites six pictures; Thomas Madestard, of Lancaster, VA, whose will cites "pictures"; David Fox of Lancaster, VA, whose 1692 will speaks of three pictures in the parlor and twenty-five pictures of scenes (probably prints) in the hall. (Stanard, *Colonial Virginia,* 361–317.) In the case of inventories, distinctions between painted and printed images can sometimes be made on the basis of value given. See Davis, *Intellectual Life in the South,* 3:1224–1225.

8. "Letters," 71, 160–161. The supplies were obviously intended for portrait painting. Although the name of the artist is not revealed, he or she is probably the same artist who painted the 1698 portrait that Hesselius copied.

9. See Craven, *Colonial American Portraiture,* 189–193, for a discussion of these and other pictures. Craven also illustrates portraits of Colonel Richard Lee II and his wife, Letitia Corbin Lee. See also n23.

10. In 1719, the proprietary government was overthrown and South Carolina became a royal province. However, its first appointed royal governor did not arrive until 1730.

11. When Anna Wells Rutledge published her *Artists in the Life of Charleston,* she noted that many of the French Huguenots who immigrated to South Carolina between 1680 and 1690 were of the wealthy middling sort and could have brought portraits with them (111). The Mazyck miniature likeness and that of Le Brasseur are the only examples known. Harriott Horry Ravenel wrote that Mazyck "was an educated and rather accomplished man, with some taste and skill in drawing. Some of his sketches and topographical drawings of fortified places in France were long preserved by his descendants" (*Charleston,* 92). The location of these drawings is unknown. The seventeenth-century household inventories that Rutledge researched and those searched by the Museum of Early Southern Decorative Arts (MESDA) reveal considerable jewelry, silver, and other expensive items, but no paintings or pictures.

12. The de Coursey family had its roots in France, although its members seem to have gone to Maryland from England, where they

had lived for a number of years before immigrating to the colonies. The portraits were probably created in England.

13. Maryland Prerogative Court, Annapolis, Wills, vol. 7, Liber H, 1695–1698, p. 51, Apr. 2, 1695.

14. The Calvert portrait by Closterman is owned by the Carroll Institute, Baltimore, MD.

15. The reformation that occurred in sixteenth-century Europe created a split in Christianity. The primary divide between Catholicism (mostly southern countries) and Protestantism (northern ones) also resulted in the formation of numerous Protestant branches. Of those, many considered religious art unacceptable, and some groups considered all art, including portraiture, unacceptable. A Protestant iconography for religious narrative art emerged in a few regions while secular genre pictures and landscapes became popular in the Netherlands. Portrait painting was still practiced to some degree in all areas, but, like religious art, it was frowned on by members of many splinter groups, like the early Quakers, in England and prerevolutionary America. Many lesser-rank portrait artists in England and other areas were negatively affected when their businesses declined due to the upheavals of the period.

16. Gibson-Wood, "Picture Consumption in London," 491. Gibson-Wood's analysis of picture consumption in England at the end of the seventeenth century, through study of contemporaneous auction catalogs dating from 1689 to 1692, offers important insights into the demands and tastes of middle-class consumers and their role in the evolution of the London art market. In turn, her findings have significant implications for understanding America's small though growing "elite," most of whom made their fortunes in the colonies and could afford pictures.

17. In 1598, Henry IV of France signed into law the Edict of Nantes, consisting of a number of articles and *brevets*, or letters patent, that granted select privileges to Protestants and provided places of safety for them. France still maintained Catholic allegiance, but the edict allowed for religious tolerance and formed a basis for certain civil rights afforded to the Protestants. La Rochelle and Montauban became two of the best-known fortified Protestant towns in France. Even with the edict, however, there were limitations for Protestants pertaining to marriage, holidays, and other matters. In 1685, Louis XIV of France, grandson of Henry IV, revoked the Edict of Nantes, causing many Protestants to leave. Many ultimately settled in England, Prussia, and Holland; some came to the New World. The persecution of Protestants by Catholics in Europe during these, earlier, and later years has a long and complex history, as does the persecution of Catholics by Protestants. In 1689, England renounced such activities and, through the Church of England, provided assistance to those who wished to immigrate to the new American settlements. Two major immigration events occurred in South Carolina and Georgia during the 1730s. The Switzers, or Swiss Protestants, moved mostly into South Carolina, settling towns such as Purrysburg on the Savannah River, Amelia on the Santee River, Saxe-Gotha on the Congaree River, and Orangeburg on the Edisto. In Georgia during the 1730s, refugees from Salzburg and surrounding areas of Germany established Savannah and New and Old Ebenezer.

18. See ch. 5 n79 for a list.

19. Note, however, that the portrait Davis lists of Hannah Harrison Ludwell as by Sir Godfrey Kneller is convincingly attributed by Hood to Charles Bridges (Davis, *Intellectual Life in the South,* 3:1230–1231, and Hood, *Bridges and Dering,* 43–47). Hood also assigns another portrait of Hannah Ludwell with her children to Bridges. See 44, fig. 19, and 45, fig. 20, and the color plate facing page 16 in Hood for illustrations.

20. Staff at the Virginia Historical Society have also suggested that the woman featured in fig. 2.10 may be William Randolph II's wife, Elizabeth Beverley Randolph.

21. Hood, *Bridges and Dering,* 5n8. There is another portrait possibly of "King" Carter at Shirley Plantation, VA, by an unknown painter.

22. See ibid., 29, 29n35, and 35. The painting is illustrated as the frontispiece in Rouse, *James Blair of Virginia.* Another portrait of Blair (fig. 4.18) is attributed to Charles Bridges and is illustrated in Hood as fig. 15. Both Blair portraits are mentioned in the College of William and Mary faculty minutes of 1859 that describe the college's Wren Building and its contents.

23. Craven, *Colonial American Portraiture,* 190–193.The Lee portraits are illustrated as figs. 90 and 91. Craven concluded that the portrait of Letitia Corbin Lee "must have been painted in Virginia" since she never traveled abroad and dated it ca. 1705. Craven dated the portrait of her husband, Richard Lee, about ten years earlier (ca. 1695) because of his apparent age in the picture. The provenance for the colonel's portrait has traditionally been given as England. In light of Hood's work on Bridges and other early portraits surviving in Virginia, the dates and origins of both paintings need to be reassessed. Both portraits appear to be somewhat later in date, and Mrs. Lee's portrait seems similar to other Lee likenesses created by Charles Bridges. The locations of the Lee portraits are currently unknown; they were in one or more private collections in 1986.

24. Graham Hood to author, July 2010. The other possibility is misidentification of the sitter as John Baylor III. In either case, Baylor's costume seems to be more in the style of the Carter portrait in fig. 2.28 and of a date earlier than 1735, the year Bridges arrived in Virginia. See page 84 for a full discussion of Bridges.

25. See Hood, *Bridges and Dering,* 4–5. Hood makes a convincing argument that supports the notion of a trained portrait painter at work in Virginia prior to the arrival of Bridges. At 5n8, Hood discusses the Isham Randolph portrait at length, noting its similarity to the portrait of William Randolph (a later copy by Wollaston) in terms of pose and other features.

26. The Westover mansion was probably a large frame house owned first by William Byrd I and then by his son, William Byrd II. That frame house stood on the property before William Byrd III built an imposing brick mansion. The library of William Byrd II contained several books on art, including Charles-Alphonse du Fresnoy's *De Arte Graphica; or, The Art of Painting* (1695); Roger de Piles's *Dissertation sur les ouvrages des plus fameux peintres* (1681), *The Art of Painting* (1706), and *Principles of Painting* (1743); John Elsum's *The Art of Painting after the Italian Manner* (1703); Anthony Ashley-Cooper's *Characteristicks* (1711); Bernard de Montfaucon's *L'antiquité expliquée et représentée en figures* (1719); and a volume that was probably George Turnbull's *Treatise on Ancient Painting* (1740).

27. Southwell's wife was Elizabeth Dering, sister-in-law to the artist Henrietta Dering (later Henrietta Johnston) who first married Robert Dering. See appendix C, Dering Family Tree.

28. Byrd corresponded regularly with Lady Cromwell, addressing her in one letter as "the only darling object of my thoughts" (17 June 1703, in Tinling, *Correspondence of Three Byrds,* 1:219). Lady Cromwell is illustrated in fig. 2.45 in an engraving after her portrait by Sir Godfrey Kneller. Whether Byrd owned an oil-on-canvas version of the Kneller is unknown.

29. The comprehensive discussion of Byrd's collection is found in David Meschutt, "William Byrd and His Portrait Collection." Most of the information given here is from Meschutt's list of the pictures (45–46). Much of what is known of Byrd's painting collection is gleaned from the list provided in the December 1813 will (probated in April 1814) of Mary Willing Byrd, who inherited the paintings through her husband, William Byrd III, son and heir of William II. The original will is recorded in Charles City County, VA, Will Book 2, 1808–1824, 269. For a transcribed copy, see Mary Willing Byrd, "Letters," 145–154. The quotations about the Titian and Rubens paintings are found on 148–149. The European portraits hanging at Westover were undoubtedly seen by local artists, including Charles Bridges and William Dering and may have influenced them. Painters in the colonies would also have been influenced by portraits of the royal family and monarchs that existed in Williamsburg and elsewhere in the southern colonies. Most of those pictures are now known only by references in period documents. See, for example, Palmer, *Calendar of Virginia State Papers,* 94–95, which notes Gov. Francis Nicholson's payment to Sir Godfrey Kneller in 1704 for a portrait of Queen Anne to be installed in the new Capitol building at Williamsburg.

30. In addition to this portrait of Anne as a child by an English artist, there is a second one created by William Dering (fig. 4.28). The Colonial Williamsburg Foundation owns both.

31. Page, *Genealogy of the Page Family,* 86. The College of William and Mary also owns a copy portrait identified as "Jane Byrd Page" that may have served as the source of the print, but this cannot be verified.

32. See pages 107–108 and 110–113 and appendix C for more about Robert Southwell and John Perceval and their families.

33. All of these paintings have similar early twentieth-century plaques on their frames identifying the sitters. David Lyde was the son of Elizabeth Gwynne, who married first Stephen Lyde and next John Tayloe I.

34. Brydon, "Virginia Clergy," 56. Peter Wagener, the son of the painter, was born in Essex, Eng., in 1717. He also went to Virginia, where he married in 1739 and served as clerk of both Fairfax and Prince William Counties. He was captain of a company of Virginia Rangers, and he was still living in Virginia at the time of the Revolution.

35. York County, VA, Records, Wills and Inventories 18, 1732–1740, 370–371, as found in the MESDA Craftsman Database.

36. According to a family account, the Jaquelin pictures were passed from the father and sitter to his sons Matthew and Edward II; after their deaths, the pictures became the property of their sister, Elizabeth, who married Richard Ambler of Yorktown, VA, in 1729. The pictures were probably inherited by their son John Ambler, who married Catherine Bush (Brush?). They were next owned by John Ambler's son, John Jaquelin Ambler, who married Elizabeth Barbour and lived at Glen Ambler, his estate about ten miles from Lynchburg, VA. An account, very likely inaccurate, states: "Whilst on a visit to England with his family, he [Edward Jaquelin I] caused to be painted every member of it by an artist of the greatest merit he could find. These portraits he brought with him to Virginia." See Ambler, Excerpt from narrative, 51–52. The descent of the Brodnax pictures through the family to the current owner, who also inherited the Jaquelin pictures, is partially undetermined. A letter from John W. Brodnax dated Dec. 22, 1900, states that the Brodnax family Bible was in the possession of Mrs. W. S. Roulhac (de Roulhac?) of Spray, NC, and that Frederick Brodnax of Wilmington, NC, owned the portraits that were "very old and difficult to photograph." See "Brodnax Family," 54. Another painting, presumably of earlier date, was also inherited by John Jaquelin Ambler and described as being of "a young man named Matthew Whaley." The location of this painting is unknown, but it may represent the Matthew Whaley whose tomb in the Bruton Parish Church yard in Williamsburg, VA, indicates that he died in 1705 at the age of nine. See Tyler, "Grammar and Mattey," 6–7.

37. The portraits are usually assigned to 1722, assuming they were all painted the year that the so-called Frances Parke Custis likeness was dated on the verso by the painter. The terminus date of 1723 seems likely since one of the sitters, Rebeckah Champion Brodnax (Mrs. William Brodnax), died in December of that year. The ages of several of the children in both families suggest a date in the early 1720s and likely no earlier.

38. Two sons of Robert Brodnax of London, a goldsmith, settled in Virginia. One was Major John Brodnax, of York and James City

Counties, VA. His brother, William Brodnax, settled on Jamestown Island and carried on his father's goldsmith trade until his death.

39. The early Custis family portraits include those of John Custis IV (1678–1749), known only from a copy portrait attributed to Charles Bridges (see Hood, *Bridges and Dering*, 69, fig. 40), and a likeness of his daughter (fig. 2.44). The painting and drawing quality of the Custis child's portrait seems, at first glance, better than that of the Jaquelin-Brodnax group although this may simply reflect a difference in the individual paintings' conditions. The latter group had considerable damage as reported by conservators Eleanor and Russell Quandt, who restored them in the twentieth century. The Custis picture seems to be in better condition. It also may be related to other portraits painted in Virginia during this period for which no artist assignment has been made.

40. See Black, "Case Reviewed" and "Case of the Red and Green Birds." See also Hood, *Bridges and Dering*, 28–29, regarding the use of portrait prints as sources for the poses, costumes, and other accoutrements shown in the Jaquelin-Brodnax family portraits (figs. 2.39 and 2.40). Hood notes that mezzotints, perhaps a series of them, by the British engraver John Smith, after the paintings of London artist William Wissing (1656–1687), are the likely sources.

41. *Collections of the New-York Historical Society,* 97.

42. Diary, Correspondence, and Papers. Carter recorded for Aug. 31 two visitors, a "mr Jones" and Charles Stegge. Hood provides enough information on Stegge, a dancing master, to eliminate him as the possible painter (*Bridges and Dering*, 5–6n8). "Jones" could have been any one of a number of persons by that name living in the area, none of whom are listed as painters or practitioners of related professions.

43. Pleasants, *Justus Engelhardt Kuhn,* 7–8.

44. Maryland Prerogative Court, Annapolis, Inventories and Accounts, vol. 37, 1716–1717, 98.

45. According to Charles C. Sellers, *Artist of the Revolution,* 52, Peale wrote in his autobiography: "Before these times [Peale's] there had been in Maryland only four persons professing the art of portrait Painting. The first was a Mr. Cain [Kuhn]."

46. To date, fifteen portraits have been attributed to Kuhn or noted as copies of his work. The genealogical relationships among the sitters—specifically those of the Carroll, Digges, and Darnall families—are not clearly defined although there were connections. The attribution of other portraits, such as that of Elizabeth Frank (b. ca. 1705) (owned by the Milwaukee Art Museum, WI) and the portrait of Charles Carroll the Settler (1660/61–1720) (also previously attributed to Gustavus Hesselius by its owner, the Maryland Historical Society), needs to be reassessed.

47. The unsigned 1707–1719 English portrait of a child of the Carroll family, identified sometimes as Henry Carroll, is one example of a painting in Maryland that might have been seen by Hesselius. Owned by the Maryland Historical Society, the Carroll portrait shows an architectural plinth, a large elaborate urn, balustrade, and distant landscape similar to Kuhn's settings.

48. *Artists of Colonial America,* 75.

49. Maryland Prerogative Court, Annapolis, Inventories and Accounts, vol. 37, 1716–1717, p. 98.

50. William Dering, who worked in Virginia and possibly in Pennsylvania before that, owned a trunk of prints as noted in the inventory of the contents of his mortgaged house in Williamsburg. As Graham Hood has said, these may have previously belonged to the painter Charles Bridges. *Bridges and Dering,* 101.

51. For in-depth studies of the objects and decorative devices seen in Kuhn's portraits of children, including their derivation and possible social and religious meanings, see Roark, *Artists of Colonial America,* 73–90, and Fleischer, "Emblems and Colonial American Painting," 2–35.

52. Wyand and Wyand, *Colonial Maryland Naturalizations,* 11. The record lists Gustavus Hesselius of Prince George's County, "limner, Swedish," as naturalized on Aug. 5, 1721; the next in the listing is Mary Hesselius, the artist's daughter. It is not known whether Gustavus's first wife was alive at the time he immigrated, and, if so, whether she too came to America. In any event, she was deceased by 1714 when the artist married a second time.

53. The genealogical information for Hesselius, unless otherwise noted, is from Lockridge, "Overcoming Nausea," or Fleischer, "Gustavus Hesselius: Study of His Style." Lockridge notes that Samuel and Andreas returned to Sweden and were assigned to parishes but that Gustavus remained (pt. 1). The date of their return is based on the discovery and publication of a letter from Gustavus to his mother. For a translation and interpretation of the contents of this letter, see Arnborg and Fleischer, "'With God's Blessings.'"

54. Clifford and Zigrosser, "World of Flowers," 237.

55. Arnborg and Fleischer, "'With God's Blessings.'" 9, 11. The reference to a "complete" likeness may indicate that the image was either three-quarter-length or full-length, showing her as a young woman. This portrait has not been located, but Gustavus's likeness of Lydia as an older woman (fig. 2.51) is owned by the Historical Society of Pennsylvania. Ibid., 11.

56. Ibid., 8–9.

57. The pictures, painted about the time of the treaty negotiations of 1735, were sent to England where they descended in the Penn family until 1834 when they were acquired by the Historical Society of Pennsylvania in Philadelphia. They are unsigned, but, according to Historical Society records, Gustavus Hesselius is mentioned in the Penn family financial accounts as receiving sixteen pounds the month after the Indians presumably made a visit to Pennsbury Manor in

May 1735. The attribution seems reasonable, particularly since the stylistic and painterly aspects of the portraits compare favorably with other works assigned to the artist.

58. Arnborg and Fleischer, "'With God's Blessing,'" 5, 7, 9. See also Fleischer, "Gustavus Hesselius and Penn Family Portraits."

59. See n52.

60. For more on "shew-boards," see introduction, n10.

61. John Winter advertised his independent business in the *Pennsylvania Gazette* (Philadelphia) on Mar. 12, 1740: "DONE by *John Winter,* Painter, from *London,* at the Sign of the easy Chair in *Chestnut-Street,* Landskip and Coach Painting, Coats of Arms, Signs, Shewboards, Gilding, Writing in Gold or common Colours and Ornaments of all Kinds very reasonable. *N. B.* He has a very good Sign of the King's Arms to dispose of very cheap." On June 26, 1760, John Fendall of Maryland gave notice in the *Maryland Gazette* (Annapolis) that a painter by the name of John Winter had run away. According to that notice, a man named John Winter—perhaps the same John Winter who advertised in Pennsylvania or perhaps his relative—did fine graining, faux painting, and floorcloths. Fendall's notice also indicated that the John Winter he sought was a convict servant who had worked for "Col. *Washington* near *Alexandria* [Virginia]." In *American Painting,* Virgil Barker records that another John Winter, or perhaps one of these, advertised in Philadelphia in 1771 that he had for sale a portrait of Mary, Queen of Scots, (1542–1587) copied from Hans Holbein (ca. 1498–1543), landscapes in the manner of Nicolas Poussin (1594–1665), and six small landscapes as originals by Francesco Zucarelli (1701–1788) (192).

62. Jourdan, *Land Records of Prince George's County,* 12.

63. Other scholars have noted that Hesselius moved to Maryland about 1720 and stayed there until 1728 although this information cannot be verified from existing records.

64. Benjamin Franklin's Shop Book, 1738–1739, American Philosophical Society, as quoted in Doud, "John Hesselius," 130n6.

65. Hockley, "Selected Letters," 36.

66. At the time, Charleston was surrounded by large plantations whose crops were grown and harvested by African slaves. Most of the plantation produce was traded in Charleston, the most important North American port associated with the Middle Passage, the three-destination voyages that began in Europe. Those voyages left Europe with trade goods that were exchanged for slaves in the coastal towns of Africa; traveled to ports in the Americas where slaves were exchanged for raw commodities such as tobacco, rice, and sugar; and returned to Europe, where American trade cargo was sold or bartered.

67. There are questions about the identity of the woman, sometimes referred to as Anne Overton (dates unknown). Some early histories of South Carolina indicate that Johnson's wife died in prison before he came to the colonies; other names for his spouse have also been suggested.

68. The last name is variously spelled in both old and modern records as Serrurier, Serurier, and Surrurier, with the "Le" sometimes affixed to the name and sometimes given separately before it. The Le Seruriers had a daughter, Susanne, who married Jean Francois Gignilliat, the first of that family to come to South Carolina from Switzerland. Their son James married Charlotte Pepper, whose portraits by Henry Benbridge are illustrated in figs. 7.56 and 7.57.

69. See Rutledge, *Artists in Charleston,* 111.

70. As found in the MESDA Object Database.

71. The most current scholarship on Henrietta Johnston is contained in Batson, "Henrietta Johnston." Unless otherwise noted, biographical information on the artist is taken from that source.

72. Shaw, *Letters of Denization,* 203.

73. Henrietta's marriage is verified in London records by a license issued to Robert Dering on May 23, 1694. Henrietta is described in the document as about twenty years old and the daughter of Susannah de Beaulieu, a widow. The marriage took place in Holy Trinity Church, Knightsbridge. See Batson, "Henrietta Johnston," 1.

74. For more on Sir Edward, see Salt, "Origins of Dering's Attack on the Ecclesiastical Hierarchy," and Lennam, "Sir Edward Dering's Collection of Playbooks."

75. For more on Lady Dering, see Kerr, "Mary Harvey."

76. Virginian William Byrd II considered the Southwell and Perceval families among his important peers; he owned portraits of members of both families (see page 86). Sir Robert Southwell II was born in County Cork, Ireland, and served as secretary of state for Ireland beginning in 1690. For additional information on these connections, see the Dering family tree in appendix C.

77. Batson notes that there were two daughters ("Henrietta Johnston," 5); the name of the second was discovered by John A. Herdeg, first published in the *Walpole Society Note Book (1999–2000)* and later in the article "Re-Introducing Helena." All information on Helena Dering comes from that article. See Saunders and Miles, *American Colonial Portraits,* 95, regarding Mary Dering's death date.

78. Batson states that Johnston was a curate at Tuam Cathedral in Dublin ("Henrietta Johnston," 5). Technically, that was not possible as that cathedral, built in the nineteenth century, was a Catholic place of worship. Johnston did, however, serve in a church in Tuam for an unspecified length of time, according to Klingberg, who writes in *Carolina Chronicle* that "Commissary Gideon Johnston was born about 1671 in Tuam, Ireland. His father, 'a very worthy Clergyman, of good Reputation and Loyalty,' died while Johnston was still a minor" (172). Klingberg goes on to say that Johnston himself had served as

curate in Tuam, though he does not say at what church. The words he quotes were written in a letter from William King, archbishop of Dublin, to the Society for the Propagation of the Gospel in Foreign Parts (SPG), dated May 13, 1707. That letter is in the SPG's manuscript collection (L.C. Trans.), A3, 52, no. 97.

79. See Batson, "Henrietta Johnston," 4.

80. 13 May 1707, SPG manuscript collection (L. C. Trans.), A3, 52, no. 97, as quoted in Klingberg, *Carolina Chronicle,* 172. See also Lambeth Palace Library, National Church Institutions Archives of Manuscripts, SPG XVI, American Colonies, 1702–1710, items 168, 169, 170–171. These records are the earliest letters of recommendation from Ireland's bishops to the secretary in London for Johnston to go to South Carolina: Bishop of Tuam's letter dated July 21, 1707; Bishop of Elphin, Aug. 15, 1707; and Bishop of Killala, Aug. 29, 1707.

81. Gideon was habitually impatient, and he made frequent complaints. Never satisfied with his salary, he argued that the monetary exchange values were different in the colonies and that he, in particular, suffered from this fact. However, it was Henrietta Johnston, not Gideon, who made an effort to find income in other ways. Gideon's first letter to the Lord Bishop of Sarum on Sept. 20, 1708, reveals other complaints: "The People here, generally speaking, are the Vilest race of Men upon the Earth they have neither honour, nor honesty . . . made up of Bank[r]upts, pirates, decayed Libertines, Sectaries [sectarians] and Enthusiasts of all sorts" and "I never repented so much of any thing, my Sins only excepted, as my coming to this Place, nor has ever Man been treated with less humanity and Compassion, considering how much I had suffered in my Passage, than I have been since my Arrival in it." For some unexplained and probably unjustified reason, Gideon had left the ship taking him and his family to Charleston and had gone ashore early with several others to a barrier island. Marooned there for twelve days, he became ill. Once his absence was discovered aboard ship, in his words, "Sloops and Boats, Perigoes and Canoos were dispatch'd . . . and on the twelfth day in the Evening a Canoo got to us." Klingberg, *Carolina Chronicle,* 19–22. Gideon never fully recovered from that illness, as later letters reveal.

82. Batson, "Henrietta Johnston," 9. Batson notes that she acquired this information from Margaret Middleton's unpublished papers but that Middleton did not give a source for it. Margaret Middleton was Henrietta Johnston's twentieth-century biographer. See also Lambeth Palace Library, National Church Institutions Manuscripts and Archives, SPG I, Minutes 1701–1708, item 103-4. Apparently the Bishop of London had originally recommended that Johnston be sent to North Carolina, but the commissary refused to go there.

83. Perry, *History of the American Episcopal Church,* 377–378. On occasion, as in the Marsden debacle, Gideon Johnston was the victim of circumstances beyond his control, and his complaints were justified.

84. Klingberg, *Carolina Chronicle,* 31. By "ill peopled," Gideon probably had two points in mind: one, that the people were the "Vilest race of Men upon the Earth" (see n81) and, two, that the population was small.

85. The location of the earliest of these letters is unknown, but Gideon's July 5, 1710, letter mentions that Henrietta had written to the bishop (ibid., 35). He also mentions that others had written on his behalf (ibid., 34).

86. Johnston to the "Secry" [John Chamberlayne], 5 July 1710, in Klingberg, *Carolina Chronicle,* 35, 40. Not all of the ten individuals in the Johnston household can be identified. In October 1706, two years prior to the family's departure from London for South Carolina, there were four persons, presumably Henrietta, her husband, and two others. A year later, there were ten or eleven persons in the family household, and just as many in 1713. Henrietta's two known children, Mary (appointed dresser to the king's daughters sometime before 1727, who probably continued to live with the Derings) and Helena (who died in 1704) were not in the 1713 group. Gideon is said to have had two sons by a previous marriage, but they were in school near London and did not make the voyage. Two other references in 1713, after the family came to America, indicate that Henrietta's "niece," unknown by name, came to live with the Johnstons and that the family of a Reverend Richard Marsden came to stay with the Johnstons. It seems likely that there were other children belonging either commonly to Henrietta and Gideon or to one or the other at the time they came to America and, perhaps, remaining in the household for several years afterwards. See Batson, "Henrietta Johnston," 9–12.

87. Batson, "Henrietta Johnston," 11–12. Gideon did not return to Charles Town until September 1715; he probably made a brief trip to Ireland as part of his trip; there is a strong possibility that his delayed return was intentional. Without the strong urging of the society, he might never have returned.

88. Ibid., 16.

89. The privately owned *Colonel John Moore* and paintings of other members of the Moore and Colden family comprise this group. The portraits of Colonel Moore (1686–1749) and his wife, Frances Lambert Moore (ca. 1692–1782), daughter Frances Lambert Moore Bayard (Mrs. Samuel Bayard, 1715–1805), and son Thomas Moore (b. ca. 1720) have been assigned to Henrietta Johnston on the basis of inscriptions appearing on one or more of the pictures. The portrait of Colonel Moore bears one of these inscriptions. It reads: "Henrietta Johnston Fecit New York Ano 1725." Alexander, *Henrietta Johnston,* 65–67, 72. Col. John Moore was reported to have been born in St. Thomas Parish, SC, in 1686; to have married in 1714; and to have moved later to Pennsylvania and then to New York (ibid., 65). Existing genealogical records indicate many conflicting facts about the relationships between the New York Moore family and the Moores of South Carolina as well as North Carolina. The portrait of

the boy identified as Thomas Moore was credited as being the father of Bishop Richard Channing Moore of New York and Richmond, VA (ibid., 66). However, Richard Channing Moore's biography offers a genealogical record for the family that does not include a Col. John Moore who moved to New York from South Carolina (Henshaw, *Memoir of Richard Channing Moore,* 12–13). Given these disparate and confusing bits of information, it may be risky to assume Henrietta actually visited New York.

90. Byrd to Mrs. Taylor, 10 Oct. 1735, in William Byrd II, "Letters of William Byrd," 229. For other art-related comments made by Byrd, see page 24.

91. See page 91.

92. Carolina, or the Carolinas, was at first an area owned by a group of proprietors and locally ruled by an appointed governor. The section northeast of Cape Fear, or North Carolina, was given its own governor in 1712. Both North and South Carolina were made royal colonies in 1729/30.

Kipaha

And all depends on keeping the eye steadily fixed upon the facts of nature and so receiving their images simply as they are. For God forbid that we should give out a dream of our own imagination for a pattern of the world.

SIR FRANCIS BACON (1620)[1]

CHAPTER 3

Native People and the Natural World

American eighteenth-century painting, regardless of its specific provenance and type, was almost always influenced by some trend, cultural tradition, or ideology that originated in Europe. By 1740, most colonists were immigrants or were only a generation or two away from their immigrant ancestors. Most of the southern paintings discussed thus far were portraits—seemingly straightforward pictures made in the colonies or, in rare cases, elegant portrayals of friends and family. Their presence in private dwellings indicates varying degrees of taste, knowledge, self-esteem, and status in society. Rarely was this art objective and completely true to observable "facts of nature," as Sir Francis Bacon suggested.[2] Rather, as discussed in the last chapter, portraits were intentionally contrived to support the sitters' standing within the family and society, and, as noted in the introduction, they commonly bore some degree of idealization.

Other kinds of easel art existed, and a few rare early examples are illustrated in the previous chapter, though such pictures were never as popular as portraits. However, another type of art prevailed in the South, one that

nurtured a strong relationship with, and reliance on, European intellectual movements of the period, including some of Bacon's ideas. This was the more realistic art of explorers and natural scientists such as Mark Catesby (1682–1749), who is today the best known of those who traveled in the southeast.[3] As previously discussed, John White (ca. 1540–1593), Jacques Le Moyne (ca. 1533–1588), and, possibly, unidentified Spanish artists were the first to paint pictures of the flora and fauna of the New World as a means of showing monarchs and sponsors what existed. Neither White nor Le Moyne made any attempt to organize or codify his examples systematically although the findings of both, and of other earlier explorers, fueled the imaginations and minds of European philosophers, botanical and horticultural collectors, and profiteers.

In the years that followed the travels of explorers like White, enthusiasts in England and Europe created large collections of actual botanical and faunal specimens as well as prints and drawings based on them. Such items came not only from the new American world but also from other lands being explored, particularly areas of

Detail of fig. 3.29

Africa, Asia, and the Middle East. Members of the Temple Coffee House Botany Club of London were among the first to seriously gather specimens from the colonies for research and possible propagation. Among them were the prominent naturalists Sir Hans Sloane (fig. 3.1) and James Petiver, both of whom were also members of the Royal Society.[4] Virginians William Byrd I (fig. 2.11) and his son, William Byrd II (figs. 2.29 and 2.30), also deeply interested in natural history, knew and maintained extensive contacts with notable collectors and scientists in England. They were among the earliest colonists to send specimens to London.[5] John Custis IV was another Virginian who corresponded with many leading horticultural specialists in England, including Peter Collinson, the Quaker cloth merchant who was also a plant and seed collector and distributor.[6] Custis's Williamsburg garden, comprising approximately four acres, was well-known.

Likewise, in 1694, Robert Steevens of Goose Creek, South Carolina, was in correspondence with several

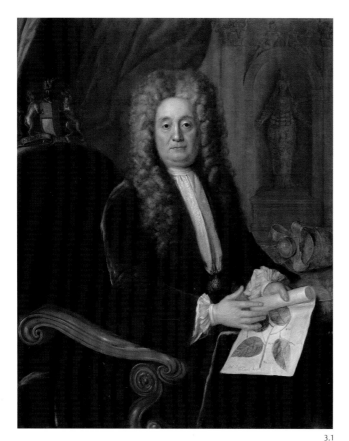

3.1

FIGURE 3.1. Stephen Slaughter (1697?–1765), *Sir Hans Sloane, Bt.*, 1736, oil on canvas, 49½" x 39¾". © National Portrait Gallery, London.

Sir Hans Sloane (1660–1753) studied medicine in London for several years before traveling to France, where he received his degree in medicine. He focused his studies on pharmacy and *materia medica*, and he collected plants. Sloane also traveled to Jamaica, where he collected approximately eight hundred botanical specimens. He was married there. After his return to London, he was a member—and, in 1719, president—of the Royal College of Physicians. He was also one of the governors of Thomas Coram's (fig. 6.20) Foundling Hospital in London. In 1716, he was designated a baronet.

FIGURE 3.2. Title page of John Lawson, *A New Voyage to Carolina; Containing the Exact Description and Natural History of That Country: Together with the Present State Thereof. And a Journal of a Thousand Miles, Travel'd thro' Several Nations of Indians. Giving a Particular Account of Their Customs, Manners, &c.*, published in London, 1709. Special Collections, John D. Rockefeller, Jr. Library, the Colonial Williamsburg Foundation, Williamsburg, VA.

FIGURE 3.3. Baron Christoph von Graffenried, *The Death of John Lawson*, 1711–1712, watercolor, gouache, and ink on paper, 8⁵⁄₁₆" x 13⁹⁄₁₆". Burgerbibliothek, Bern, Mss. Mül. 466(1).

John Lawson arrived in New York in 1700. After several weeks, he moved to Charleston, South Carolina, where he was charged with surveying the province's western and northern parts. With several others, Lawson explored the Carolinas, ending his trek at the Pamlico River. Lawson settled in the region on land that would become the site of New Bern in Bath County. Returning to England in 1709 to publish a book describing what would become North Carolina, he met Christoph von Graffenried. Both men were back in Carolina, exploring the Neuse River, when the incident captured in this drawing occurred. Von Graffenried had led a group of Swiss and German immigrants to the New World, where they settled on land traditionally belonging to the powerful Tuscarora Indians and located in the same area as Lawson's home. As von Graffenried and the others continued to seize land, evicting the Indians in the process, conflict was inevitable. Lawson's death was the first, or among the first, in the resulting Tuscarora War, a conflict between Tuscarora Indians and European settlers that lasted from the autumn of 1711 to the winter of 1715.

In the center of the picture, von Graffenried, his servant, and John Lawson are shown as captives of the Tuscaroras shortly before Lawson's death. Von Graffenried and his servant were released.

important English botanist-gardeners. By 1700, Sloane and Petiver, who were forming large collections in England, had received shipments from several Carolinians, including not only Steevens but also Edmund Bohm of Archdale Plantation, Robert Ellis, and Joseph Lord. Lord, a minister from Massachusetts who had settled about twenty miles north of Charleston, South Carolina, was probably the first serious investigator of natural history there. In addition, Hannah Williams of Massachusetts, the first documented female collector in America, was among the earliest colonists who supplied London collectors with materials.

In 1709, John Lawson (1674–1711), who had gone to South Carolina in 1700 to assume the appointment of surveyor general of Carolina, published his history of Carolina, the earliest extensive account of flora and fauna of South and present-day North Carolina (fig. 3.2).[7] Two years later, on an expedition up the Neuse River in Carolina, he was captured and killed by the Tuscaroras (fig. 3.3). Baron Christoph von Graffenried (1661–1743), an amateur artist and investor in the Neuse

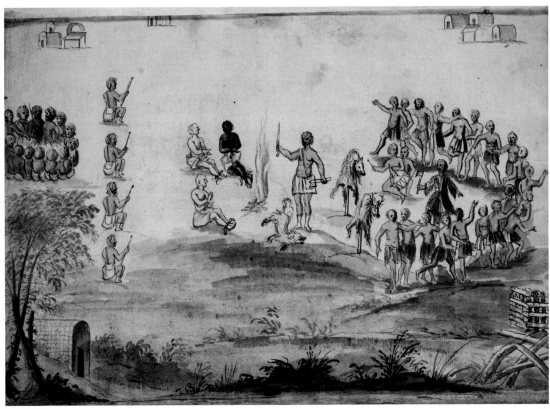

River settlements, was Lawson's traveling companion at the time. Lawson's book contains a single engraved illustration of animals (fig. 3.4), the source for which may have been von Graffenried, who may have prepared a series of sketches or watercolors taken from life and specimens collected on this trip with Lawson. Lawson's *History of Carolina,* with its detailed text, was familiar to the naturalist and artist Mark Catesby.

FIGURE 3.4. Engraver unknown, *The Beasts of Carolina,* ink on paper, 1709, from John Lawson, *A New Voyage to Carolina; Containing the Exact Description and Natural History of That Country: Together with the Present State Thereof. And a Journal of a Thousand Miles, Travel'd thro' Several Nations of Indians. Giving a Particular Account of Their Customs, Manners, &c.,* published in London, 1709. Special Collections, John D. Rockefeller, Jr. Library, the Colonial Williamsburg Foundation, Williamsburg, VA.

Correspondence, including the exchange of specimens and information among early European naturalists, was extensive, persisting throughout the eighteenth century and into the nineteenth. Many specimens gathered by seventeenth-century collectors in England and elsewhere were treated as curiosities and were mingled with artifacts of various kinds to create collections of the rare and marvelous (figs. 3.5 and 3.6). Ownership of such collections was usually limited to those who could afford to amass and keep them in cabinets or dedicated rooms with shelves and other storage devices, thus the name "cabinets of curiosities" or *Wunderkammern* ("cabinets of wonder"). Seventeenth-century and early eighteenth-century examples of *Kunstkammern* ("art cabinets" or "rooms") were described as being filled with preserved animals, tusks, minerals, ethnographic objects (such as weapons from exotic locations), claws, feathers, dried plants, shells, preserved sea creatures, insects, and other items, both from home and abroad. John Tradescant the Elder was among the first to create such an environment. Called the Museaeum Tradescantianum, it was made accessible to the public about 1627. Often named as the first public museum in England, it included Tradescant's collection of rare and strange natural history specimens and ethnographic objects obtained through his contacts in England and on his travels to various other countries. The display areas were located in the Tradescant family's large house, known as "The Ark," which was located in South Lambeth, London. Tradescant was a friend of Captain John Smith of Jamestown settlement fame; Smith provided him with specimens from the Virginia Colony. In 1656, John Tradescant the Younger followed the interests of his father by publishing a catalog of the collection. The younger Tradescant also made one and perhaps two other collecting trips to Virginia between 1628 and 1662.[8]

Modern historians often credit these assemblages as efforts to overturn Aristotelian boundaries between art and nature. While most collections reflected the idiosyncratic interests of their owners, the idea behind them was to astound viewers and awaken curiosity, thus enlarging humankind's quest for knowledge. Certainly the

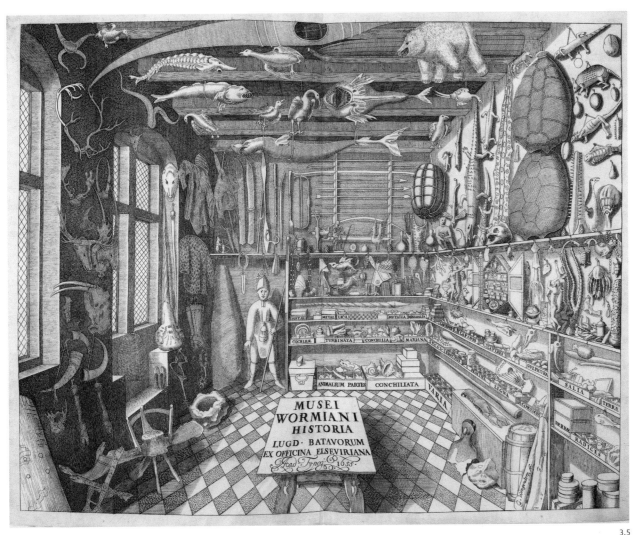

3.5

FIGURES 3.5 AND 3.6. Villiam Worm (dates unknown), Carel (Karel) van Mander (1548–1606), and G. Wingendorp (active ca. 1650), engravers, frontispiece, ink on paper, from Ole Worm, *Museum Wormianum. Seu Historia rerum rariorum, tam naturalium, quam artificialium, tam domesticarum, quam exoticarum, quae Hafniae Danorum in aedibus authoris servantur*, published in Amsterdam, 1655. Courtesy of the Smithsonian Institution Libraries, Washington, DC.

The view shows Ole Worm's (1588–1655) collection of natural history specimens from several places, including the North American continent. After studying medicine in various Danish universities, Worm moved to Copenhagen where he taught and became physician to King Christian IV of Denmark. He is also known to have made drawings and possibly watercolor pictures of specimens. His book was published after his death.

3.6

Linné.

3.7

approaches and modeled his *Natural History* on their books containing numerous illustrations.[10] Such an approach affirmed concepts associated with the European enlightenment, a movement that dominated Western thought. Knowledge was basically divided into two main branches: the humanities, which included theology, and the study of nature, which included the more analytical study of nature called natural philosophy (what today is called the physical sciences). Based in rational and empirical inquiry, the pursuit of scientific knowledge flourished in the aftermath of the religious conflicts of the Protestant Reformation.

Ultimately, it was Carl Linnaeus (fig. 3.7), the Swedish botanist, physician, and zoologist, who made the most significant contributions to this approach when he introduced his taxonomy, which became the foundation of binomial nomenclature, the scientific classification now widely used in biological sciences.[11] The Linnaean system classified nature within a hierarchy of kingdoms followed by classes, orders, genera, and species with occasional lower ranks of varieties. By the 1760s, Linnaeus's methods were known to most natural history collectors and audiences, including important southern collectors such as John Clayton (1694–1773), John Bartram (1699–1777), his son William Bartram (1739–1823), their friend Jane Colden (1724–1766), and later, Thomas Jefferson (1743–1826).[12] However, not all naturalist artists felt equally committed to rendering flora and fauna in ways that would systematize them.

Mark Catesby, whose work was created in the years when Linnaean taxonomy emerged, aimed for objectivity in his drawing, naming, and describing of flora and fauna. Catesby's approach tended toward "the Baconian project of receiving the facts of nature 'simply as they are.'"[13] Catesby also recognized and explored the environmental relationships between flora and fauna by illustrating and discussing birds and animals along with plants that were their natural food sources or by including some detail common to their habitats. His approach was thus new and unique among illustrated natural histories of the period.[14] Historian Joyce E. Chaplin has described Catesby as "a skeptical Newtonian in America."

juxtapositions of many different objects created a world view that was dynamic and changing, leading ultimately to formative scientific taxonomy, theory, and ways of understanding relationships between and among life forms.

For Mark Catesby, the latter was of particular interest. During his time, a more organized method evolved, much of it based in Newtonian theory.[9] Not all naturalists adhered strictly to a Newtonian taxonomy, but, as inquiry continued and scientific ideas emerged, such an approach became increasingly essential to the formation of collections and the preservation of knowledge about them. John Ray established methods for plant classification and advanced principles for classifying animals through his work on the writings of Francis Willoughby, and the work of both men greatly influenced Catesby, who used their

FIGURE 3.7. Alexander Roslin (1718–1793), *Carl von Linné* (1707–1778), ca. 1755, oil on canvas, 22¹⁄₁₆" x 18⅛". © Photo: Nationalmuseum, Stockholm.

She writes that "he did look for recurrent pattern" in nature but also "saw more puzzles than patterns" and "emphasized phenomena . . . that appeared violent and disorderly, and questioned whether those capacities could be represented as possessing predictable tendencies, let alone laws."[15]

Scholars point out that Catesby believed that the organic relationships he observed in nature in the New World held important and beneficial possibilities for cultivation and other possible human uses.[16] He was not, however, an exploiter of his subject, collecting and selling specimens or encouraging the commercial cultivation of species at the expense of careful study and research. Rather, as Amy Meyers suggests, Catesby's work reveals a "sophisticated understanding of the benefits and the costs that might accrue from . . . cultural amalgamation," that is, what might result from the interrelationships of all life forms in the New World. Meyers sees Catesby's ideas as applying not only to plants and animals but also to humans of disparate ethnicities—Africans, Native Americans, and Europeans.[17] While Catesby's pictures reflect some of these issues as related to flora and fauna, his text, though brief, provides important notes regarding his approach. For example, he discussed the climate of various parts of the South, noting that bird species diminish in number as one moves closer to the North Pole and making it clear that certain species are associated with cold environments and others with warm ones.

The American South, along with the Bahama Islands just off its coast, is home to an exotic and rich variety of plants and animals that thrive in warm climates, and the profusion of flora and fauna in that region likely explains Catesby's choice to develop his particular approach there.[18] Longer growing and blooming periods and associations among migratory species of birds also known in Central and South America were other important factors, as was the already established natural history and gardening interests of colonists in the South. William Byrd II and John Custis IV were but two of several southerners interested in natural history who aided Catesby during his trip to Virginia. In South Carolina, others were also paying attention to his work.

Catesby had grown up in the small town of Sudbury, in Suffolk, East Anglia, England. His father, John Catesby, was a lawyer. Nothing is known of his mother except that her maiden name was Elizabeth Jekyll and that her paternal uncle (or father) Nicholas Jekyll knew John Ray, a well-known naturalist who lived nearby in Black Notley, Essex.[19] That he could read and write in Latin suggests that Catesby was educated in a local grammar school or taught by a private tutor. His great-uncle (or grandfather) probably introduced him to Ray. The naturalist painter George Edwards (1694–1773) believed that Ray had inspired Catesby and had encouraged his interest in natural history. Through these various connections, Catesby came to know Samuel Dale, who became one of Catesby's most important patrons. In addition, Dr. Thomas Dale, Samuel Dale's nephew, moved from England to Charleston, South Carolina, about 1725 and assisted Catesby on his second trip.[20]

Catesby made his first trip to the colonies in April 1712 when he and Elizabeth Cocke, his sister, sailed from England to Virginia. She had married Dr. William Cocke, who moved to Williamsburg in 1710.[21] By 1713, Cocke, well established as a physician, had received several political appointments. He had also renewed or established an acquaintance with the wealthy planters William Byrd II and John Custis IV as well as other influential Virginians.[22] Deeply interested in the natural world, both Byrd and Custis maintained large gardens and attempted to cultivate plants for both enjoyment and useful purposes. For many years, Byrd had bemoaned the lack of persons in Virginia who shared his interest in natural history. On April 20, 1706, he wrote:

> The country where fortune hath cast my Lot, is a large feild for natural inquirys, and tis much to be lamented, that we have not some people of skil and curiosity amongst us. I know no body here capable of makeing very great discoverys, So that Nature has thrown away a vast deal of her bounty upon Us to no purpose.[23]

Byrd would thus have been eager to meet and befriend Catesby. Furthermore, as someone whose interests were

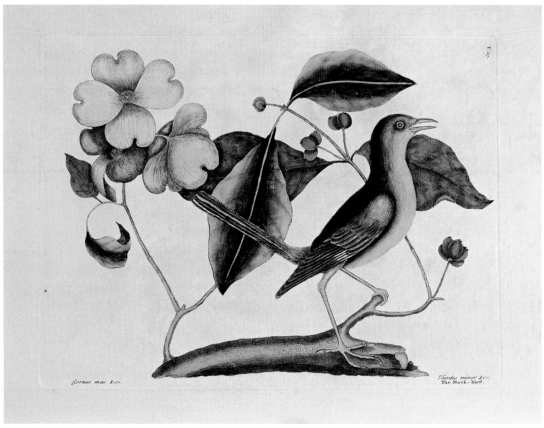

FIGURE 3.8. Mark Catesby, *The Dogwood Tree and the Mock-Bird*, ink and watercolor on paper, from *Natural History*, vol. 1, published in London, 1731. Colonial Williamsburg Foundation, Williamsburg, VA.

FIGURE 3.9. Mark Catesby, *The Little Brown Bead Snake and Corallodendron humile* (Coral bush), 1730–1745, watercolor and gouache heightened with gum arabic and touches of graphite on paper, 14¾″ x 10⅝″. The Royal Collection © 2010 Her Majesty Queen Elizabeth II.

Catesby noted that the snake in this illustration resembled a string of pearls and that it was commonly found underground among plant roots. Hence, it is shown here wrapped gracefully around the large root of the coral bush. Catesby's ability to compose striking, balanced compositions is especially evident in this picture with its combination of curvilinear elements—the snake, root, and seedpods—juxtaposed successfully with the strong diagonal of open blossoms and the vertical budding branch. The small green leaves of the bush at the top of the root link the upper halves of the composition, and they complement the sprawling seedpods that unite the base. Independent of his scientific proficiencies, Catesby's sense

of artistry and design is strong, sometimes surprising, and always carefully developed. While his art never seems to overpower his dedication to displaying nature objectively, he was criticized for what some believed to be overly elaborate productions of nature that reflected too much of his subjective perceptions about his subject.

FIGURE 3.10. Mark Catesby, *The Blue Jay and Bay-Leaved Smilax*, 1730–1745, watercolor and gouache heightened with gum arabic (on berries) over ink on paper, 10¹³⁄₁₆″ x 14½″. The Royal Collection © 2010 Her Majesty Queen Elizabeth II.

Catesby called the bird the "crested Jay," as can be seen in the title inscription at the top left of the paper. Describing the smilax plant in the *Natural History*, he notes it as the favorite food of the blue jay. That comment typifies his recording of relationships between flora and fauna. His habit of close observation is seen again in the way he draws the bird posed in its typically lively, aggressive manner, hunched forward with its crest up and its beak open, as if sounding its familiar alarm, a harsh "jay jay." Catesby's ability to capture and convey such gestures faithfully in watercolor was extraordinary.

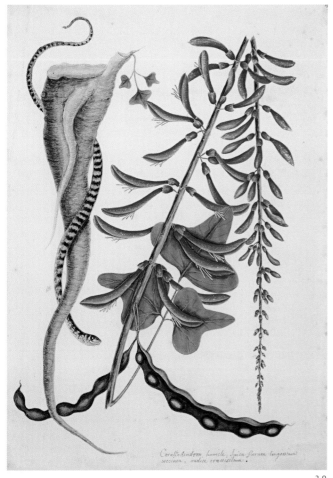

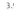

3.9

far ranging and whose abilities included both private and published writings, Byrd would have relished having someone record and ultimately publish a natural history of America's vast array of plant and animal life.[24] He took Catesby to nearby Native American towns, including the Pamunkey village on the north side of the York River. Catesby was especially interested in the American Indians, recognizing and admiring their knowledge of native plant habitats and their medicinal uses of plant material. In 1743, the naturalist presented a paper to the Royal Society in London titled "Of the Indians of Carolina and Florida," a version of which was published along with sections of the second volume of the *Natural History*.

From 1712–1719, Catesby resided with the Cockes in Williamsburg, traveling from there to undeveloped areas and plantation lands in Virginia's Tidewater region. His explorations also carried him up the James River toward the Appalachian Mountains. He collected seeds, plants, and other specimens on these excursions, and he probably sketched and noted the great variety of indigenous plants, birds, and animals he encountered along the way.[25] He later admitted that he had no plan for a published work during the Virginia travels and that his

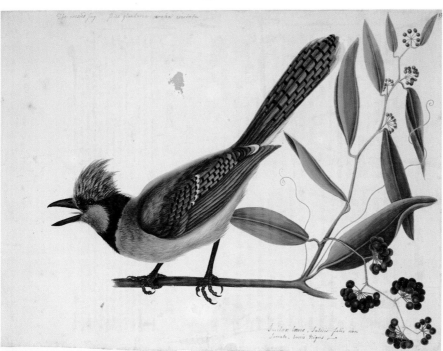

3.10

FIGURE 3.11. Mark Catesby, *The Squirrel Fish*, 1730–1745, watercolor and gouache heightened with gum arabic over graphite on paper, 10⁹/₁₆″ x 14¹⁵/₁₆″. The Royal Collection © 2010 Her Majesty Queen Elizabeth II.

The squirrel fish appears in Catesby's engraved version with the "Croker," known today as the Atlantic croaker because of the noise it makes when hooked or caught and handled. Catesby noted both fish as being "good eating." He also wrote about the difficulty he had in capturing the bright color of the squirrel fish because, as soon as the fish was pulled from the water, its color faded. The delicacy of Catesby's brushwork is particularly noticeable in his development of the fish's fins and tail and in the deft shading around the eye and gill.

FIGURE 3.12. Mark Catesby, *The Land Frog, the Water Frog, and the Green Tree Frog*, 1730–1745, watercolor and gouache heightened with gum arabic over ink and graphite on paper, 14⁹/₁₆″ x 10¹/₂″. The Royal Collection © 2010 Her Majesty Queen Elizabeth II.

The land frog is sitting on a board or some similar three-dimensional object—but not a natural habitat of vegetation. The water frog and the green tree frog are shown completely decontextualized, out of their habitat and with nothing around or behind them except the white paper background. These three frogs were each combined with plants in the etchings created for the *Natural History*, a process seen with some regularity in Catesby's work. Clearly Catesby was capable of seeing and rendering these creatures two ways: as individual specimens and as parts of a larger, more complex, and interdependent world of living things.

documentation of species was informal. Writing in the preface to volume 1 of the *Natural History*, Catesby said,

I thought then so little of prosecuting a Design of the Nature of this Work, that in the Seven Years I resided in that Country [Virginia], (I am ashamed to own it) I chiefly gratified my Inclination in observing and admiring the various Productions of those Countries,—only sending from thence some dried Specimens of Plants and some of the most Specious of them in Tubs of Earth, at the Request of some curious Friends.

He continued by noting that a few of the specimens he collected were sent to "Mr. *Dale*" (Samuel Dale in Essex, England), who communicated with William Sherard, "one of the most celebrated Botanists of this Age, who favoured me with his Friendship on my Return to *England*."[26]

In 1719, Catesby arrived in England with his specimens and probably a sizable collection of drawings from his Virginia trip. In addition to maintaining ties with Dale after his return, the naturalist continued his friendship with Sherard, one of the most outstanding English botanists of his day whose taxonomic work would help refine the nomenclature of Carl Linnaeus. In October of that year, Dale wrote to Sherard of Catesby's interest and abilities, noting that Catesby intended to revisit the colonies and needed encouragement. Sometime in the next months, Sherard saw and admired Catesby's drawings. With the help of Sherard and others during the next two years, plans were perfected for Catesby's return to America to collect specimens and make drawings for his *Natural History*.[27]

At the meeting of the Royal Society of London on October 20, 1720, Colonel Francis Nicholson promised Catesby a pension of twenty pounds per annum for as long as Nicholson served as governor of South Carolina.[28] Nicholson had extensive knowledge of the colonies, having served as governor of both Maryland and Virginia prior to his South Carolina appointment, and he had previously helped support two earlier botanists, Hugh Jones, a cleric in Annapolis from 1696–1702, and William Vernon, who died in 1706.[29] Nicholson's appointment to

South Carolina came in September 1720, and he departed London on March 11, 1721; he had expected Catesby to accompany him to the colony, but "Mr. Keatsby" did not.[30] Apparently Catesby was undecided at that time whether to make an American or African expedition. Nicholson followed with two letters to Alban Thomas of the Royal Society. The first one urged Thomas to discuss the matter with Sir Hans Sloane and William Sherard[31] and warned that his financial support of Catesby could be changed. The second, containing much the same content, was issued in November. Catesby subsequently made ready to depart for South Carolina.[32]

Catesby wrote that he arrived in Charleston, South Carolina, on May 23, 1722.[33] Soon thereafter he "waited on General *Nicholson,* then Governour of that Province, who received me with much Kindness."[34] As agreed, Nicholson provided funding and introduced the naturalist to influential planters, many of whom had particular interests in the region's natural resources and owned vast tracts of land. Catesby is known to have traveled through plantations in the vicinity of Charleston owned by the Draytons, Moores, Blakes, Bulls, Johnsons, Warings, Chenes, and other families, collecting specimens and making drawings,[35] and he was aware of the need to survey each area during the different seasons of the year.[36]

Catesby also completed three trips to Fort Moore (Moor) (now Augusta, Georgia), situated 140 miles inland on the Savannah River. On the first inland trip he purchased a slave to assist him, and on later excursions he "employ'd an *Indian* to carry my Box," a box he described as containing his painting and drawing materials.[37] He later clearly acknowledged his indebtedness to the Native people, writing that "I not only subsisted on what they shot, but their First Care was to erect a Bark Hut, at the Approach of Rain to keep me and my Cargo from Wet."[38] By the winter of 1723/24, Catesby had planned a four-hundred-mile trip inland to the Appalachian Mountains to collect specimens and become familiar with the Cherokee Indians. However, there is no evidence that he ever attempted that trip.

In 1725, Catesby left South Carolina for a brief expedition to the Bahamas, where he continued collecting and

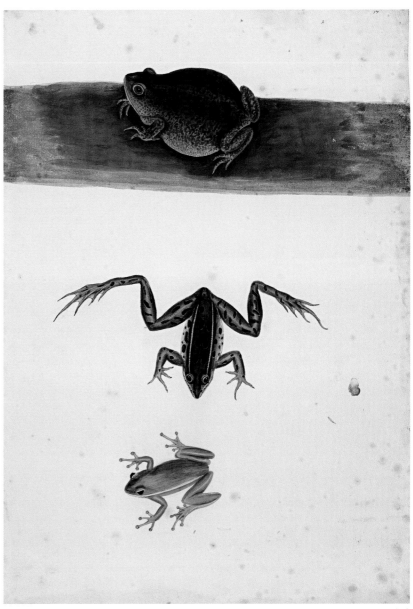

3.12

drawing. He then returned to South Carolina for a few months before leaving for London, arriving there in 1726. His American specimens and drawings generated significant interest among botanists and collectors, so much that Catesby was greatly encouraged and became determined to publish the information. Unlike many of his collector/naturalist colleagues, Catesby's personal funds were modest. To support himself while preparing volume 1 of the *Natural History,* he worked as a horticulturalist at two nurseries until sometime during or after

3.13

FIGURE 3.13. Mark Catesby, *The Wampum Snake and the Red Lily*, 1730–1745, watercolor and gouache over ink and touches of graphite (snake), watercolor outlines over graphite (plant), 15″ x 10⅝″. The Royal Collection © 2010 Her Majesty Queen Elizabeth II.

This dark and light blue snake received its name "Wampum" because of its color, similar to the blue to lavender shades of Atlantic conch and whelk shells used by southern Indians for jewelry and money. Of interest in this original painting is the lightly sketched preliminary drawing of the lily flower and stem at right and the bulb at left behind the snake. These elements were also fully developed in another Catesby watercolor. Here the artist was experimenting with a composition that combined the snake with the flower. The etched view in the *Natural History* is the end result. It shows the fully developed lily juxtaposed in the same way with the snake.

1733. He already had influential contacts in the botanical world and would quickly establish many more. Peter Collinson became an important supporter of Catesby's publication, not only lending funds to the project but also providing helpful contacts with botanists such as John Bartram, a native-born American who could furnish Catesby with additional specimens.[39] Other supporters in kind continued to include Sir Hans Sloane, president of the Royal Society at that time, and William Sherard and other persons who held financial interests in Catesby's 1722–1727 expedition. Catesby frequently attended meetings of the Royal Society as Collinson's guest. On February 1, 1732/33, after the completion of the *Natural History* and probably at the instigation of Collinson, Catesby was nominated a Fellow of the Royal Society.

Prior to receiving that award, however, in preparing the *Natural History,* Catesby had struggled to find funding for the etchings after the drawings and other aspects of production. He described both the problem and his solution, saying that

> the Expence of Graving would make it too burthensome an Undertaking. . . . At length by the kind Advice and Instructions of that inimitable Painter Mr. *Joseph Goupy* [fig. 3.14], I undertook and was initiated in the way of Etching them myself, which, tho' I may not have done in a Graver-like manner, choosing rather to omit their method of cross-Hatching, and to follow the humour of the Feathers, which is more laborious, and I hope has proved more to the purpose.[40]

In addition to the money-saving strategy of preparing the etched plates himself, Catesby also arranged to sell the book by subscription and to do so in folios that could later be bound into books. The printed proposal stated that the *Natural History* was

> intended to [be] publish[ed] every Four Months TWENTY PLATES, with their DESCRIPTIONS, and printed on the same Paper as these PROPOSALS. The Price of which will be One Guinea.
>
> For the Satisfaction of the CURIOUS, some Copies will be printed on the finest Imperial Paper, and the Figures put in

their Natural Colours from the Original Paintings, at the Price of Two Guineas.[41]

The first edition of volume 1, completed in 1731/32, featured birds, most of which are shown with their plant food sources. Catesby, who had personally hand-colored the etchings pulled for the first sets, was modest about his accomplishments as an artist.[42] Of his efforts, he wrote:

> As I was not bred a Painter I hope some faults in Perspective, and other Niceties, may be more readily excused, for I humbly conceive Plants, and other Things done in a Flat, tho' exact manner, may serve the Purpose of Natural History, better in some Measure than in a more bold and Painter like Way.[43]

As other scholars have pointed out, Catesby's lack of training as an artist was probably fortunate since it freed him from stylistic contrivances associated with fine arts painting. He did include highlights and shadows to enhance the volumetric aspects of his subjects, but the use of plants with some of his animals was a less objective device, and he was criticized by some as being "showy" and indulging "fancies of his own brain."[44]

The first section of the second volume of the *Natural History* was completed, printed, and sent to subscribers beginning in 1735; the next sections continued to appear sporadically until the last was issued in December of 1743. These included illustrations of insects, some mammals, sea creatures, and reptiles. Some of the pictures also included plant food sources while others, such as fish and sea creatures, understandably had no background images or plant settings. Once subscribers had collected all of the sections for either volume, they could take those sections to bookbinders and have them bound together. In the preface to the work (which in most first edition copies was bound with the second volume), Catesby provided an overview of the geographical areas his expedition covered and a map showing some of the British colonies in the Americas.[45] The artist's correspondence with John Bartram and others in

3.14

the colonies resulted in additional specimens and data, enough for an appendix to the two volumes to be issued three years later. Catesby completed a second and smaller book, *Hortus Britanno-Americanus,* before his death in 1749, but that volume was not published until 1763. A second edition, published in 1767 as *Hortus Europae Americanus,* featured trees and provided descriptions and information on the native habitat for each species illustrated.

FIGURE 3.14. Joseph Goupy, *The Charming Brute* (George Frideric Handel), 1754, ink on paper, 12½" x 9⅞". Fitzwilliam Museum, University of Cambridge, UK/The Bridgeman Art Library Nationality.

There are no known portraits of Joseph Goupy (1689–1769), the French artist living in London who instructed Mark Catesby in etching. Goupy had commissions from the Prince of Wales, and he is said to have been a good friend of the composer George Frideric Handel, although that friendship may have ended after the engraver produced this caricature that was widely circulated in London.

3.15

Mark Catesby's two-volume *Natural History* was revised and republished two additional times in England during the eighteenth century. There were also separate German and Dutch editions that rendered the images in a smaller format. As noted earlier, Catesby's innovative uniting of animals, particularly birds, with their plant habitats and food sources was an important advance in scientific illustration. Catesby's colleague George Edwards (fig. 3.15), as well as other naturalists, also incorporated trees and foliage into many of his bird pictures, but he did not attempt to establish any scientific relationships between the animals and plants. Nor was Edwards adept at capturing the natural movements and postures of birds to the degree seen in Catesby's work. The Catesby volumes were also the first major published works on North American ornithology that combined pictures of birds with detailed descriptions. Because of its superb images, the *Natural History* soon set the standard that several other naturalists followed.

The 263 surviving original Catesby watercolors from the Royal Library on which the naturalist based his etchings are works of precision and refinement in both drawing and coloration. Their fine overall condition owes to their careful preservation. Catesby's watercolor methods, flat and linear because of the need for accuracy, involved little use of color perspective so that all aspects of the figures were nearly equally detailed. The artist took particular care to portray as many creatures as possible from life, which resulted in his being able to capture movements and gestures peculiar to each subject. That practice was especially true in his drawing of fish, which, as he noted, once removed from the water quickly lose their color. Catesby also drew from preserved specimens, only rarely using other known illustrations for his sources. The particular qualities of his subjects were of great importance to Catesby; capturing them required immense powers of observation and concentrated periods of work.

Catesby's numerous contacts in the colonies continued to send him specimens for many years, and he wrote to several people to request specific items. The naturalist John Clayton, who settled in what is now Mathews County, Virginia, is one of those who probably kept contact with Catesby after the artist returned to England. No drawings or paintings by Clayton are known; instead, his fame stems from his botanical garden and his close contact with Carl Linnaeus.[46]

Other naturalists rendered pictures of flora and fauna in the American South during these and later years. George Edwards (figs. 3.15, 3.16, 3.17, 3.18, and 3.19), a Catesby supporter and a member of the Royal Society,

FIGURE 3.15. J. S. Miller (1715?–1790?) after Bartholomew Dandridge (1691–ca. 1755), *George Edwards*, 1754, ink engraving on paper, 5½" x 4⁷⁄₁₆". © Royal College of Physicians, London.

George Edwards is sometimes referred to as the "father of British ornithology" although he also did drawings of many animals. Well-known among collectors and scholars of natural history in Europe as well as America, he lived most of his life in London and served many years as the librarian to the Royal College of Physicians.

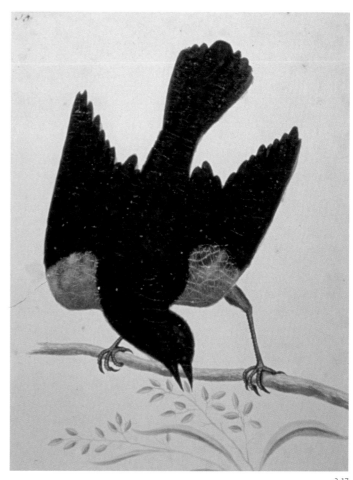

3.16

3.17

never visited the colonies, but he corresponded with several prominent gentlemen, including John Drayton of South Carolina.[47] Catesby is known to have shared one of the two Virginia specimens of the "Whip-poor-will" with George Edwards, whose engraved version is shown in figure 3.19. However, it is not known whether Edwards's original painting of the bird, owned by John Drayton and dating possibly as early as 1733, was a copy after Catesby or served as a source for Catesby. Drayton owned over forty pictures by Edwards, including the elusive goatsucker, or whippoorwill, one of three related birds that caused debate and confusion about their exact identities among the members of the Royal Society (figs. 3.18 and 3.19). Edwards may have copied a pre-1733 version that Catesby created, or he may have created the painting from a specimen of the goatsucker sent to London. In 1742, Catesby had written to John Bartram of Philadelphia and William Byrd II in Virginia asking their

FIGURE 3.16. Attributed to George Edwards, *Red-Winged Blackbird*, 1733, watercolor, gouache, and ink on paper, 9" x 7". Colonial Williamsburg Foundation, Williamsburg, VA.

This picture was originally part of a larger group of watercolor paintings of birds owned by John Drayton of South Carolina. Research by Margaret Pritchard, curator of prints, maps, and wallpapers for the Colonial Williamsburg Foundation, revealed that *Red-Winged Blackbird* was copied by Edwards after one of Catesby's original drawings. The Catesby drawings were purchased in 1768 by George III and are in the British Royal Collection of the Royal Library at Windsor Castle, England. (See Pritchard, "John Drayton's Watercolors," 169.)

FIGURE 3.17. Attributed to George Edwards, *Red-Winged Blackbird*, 1733, watercolor, gouache, and ink on paper, 9" x 7". Colonial Williamsburg Foundation, Williamsburg, VA.

This view shows George Edwards's *Red-Winged Blackbird* with considerable overpainting, the condition in which it was acquired by the Colonial Williamsburg Foundation. Figure 3.16 shows the bird after conservation treatment, including the removal of overpaint to reveal Edwards's original work.

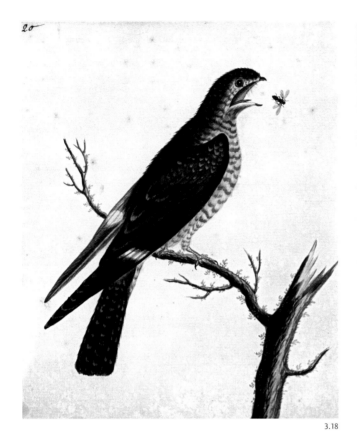

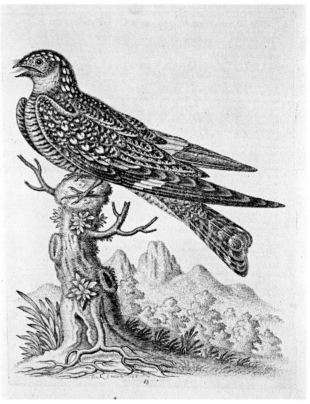

3.18

3.19

FIGURE 3.18. Attributed to George Edwards, *Whip-poor-will or Lesser Goat Sucker*, probably 1732, watercolor and ink on paper, 10¾" x 9". Courtesy of the Museum of Early Southern Decorative Arts (MESDA) at Old Salem.

FIGURE 3.19. George Edwards, artist and engraver, *The Whip-poor-will or Lesser Goat-Sucker*, 1743–1751, watercolor and ink on paper from George Edwards, *A Natural History of Birds. . . .* , vol. 1 of *A Natural History of Uncommon Birds, and of Some Other Rare and Undescribed Animals . . .* , published in London, 1743. Colonial Williamsburg Foundation, Williamsburg, VA.

FIGURE 3.20. Mark Catesby, *The Whip-poor-will and the Ginseng or Nin-Sin of the Chinese*, before 1733, watercolor, gouache, and gum arabic over graphite on paper, 14¾" x 10½". The Royal Collection © 2010 Her Majesty Queen Elizabeth II.

Catesby authority Henrietta McBurney notes that the artist, in creating this painting, seems to have confused the whippoorwill, or lesser goatsucker, (*Caprimulgus vociferous* Wilson) with a species of the nighthawk family (*Chordeiles minor*). (*Mark Catesby's "Natural History,"* 70.)

assistance in obtaining a specimen of the goatsucker. The one he received was drawn and etched for the final plates of his "Appendix," added to his *Natural History* in 1747 (fig. 3.20). The Drayton version may have existed as early as 1732, which is the date appearing on the original portfolio in which it and other bird paintings descended in the family until the 1970s.

William Byrd II, whose interests were encyclopedic, was probably involved in some capacity with the production of a book featuring natural history illustrations (fig. 3.21). The evidence includes seven copperplates engraved with flora, fauna, and views of public buildings constructed in early Williamsburg; maps featuring areas of North and South America and the Leeward Islands; and strikes either from the plates or other plates now missing from the set. Byrd scholars Margaret Beck Pritchard and Virginia Lascara Sites have researched the original materials and supporting documents and concluded that Byrd very likely commissioned the seven

existing plates and possibly additional plates to illustrate a larger history of North and portions of South America, including the islands. One of the plates features a map of the Virginia–North Carolina dividing line, probably created to illustrate Byrd's *History of the Dividing Line,* published posthumously in 1841 by Edmund Ruffin in *The Westover Manuscripts: Containing the History of the Dividing Line betwixt Virginia and North Carolina; A Journey to the Land of Eden, A. D. 1733; and a Progress to the Mines. Written from 1728 to 1736, and Now First Published.* Byrd authored several books during his lifetime, and, when in England on one and possibly other trips, he took drawing lessons from Eleazar Albin (active 1713–1759), the German-born engraver, watercolorist, and draftsman who specialized in natural history.[48]

The years 1734 and 1735 marked the appearance of another artist who was neither a professional limner nor naturalist but a schooled amateur who tried his hand at both: Philip Georg Friedrich von Reck (1711–1792). Like that of a few other artists who worked in the early South, von Reck's arrival was part of a larger chapter in history, one marked by religious upheavals begun in Europe during the previous century that resulted in widespread executions and punishment of Protestants in several countries, particularly Germany. In 1688, Catholic leaders threatened to expel all Protestants from the country. By 1728, surveys of Protestant households ranked their occupants in categories ranging from dangerous heretics to suspicious persons. Persecutions soon followed in the form of restrictions, imprisonments, and harsher punitive acts. By autumn 1731, German Catholic officials had issued the "emigrations patent" that classified Protestants as criminals and ordered them out of Salzburg by specific deadlines (fig. 2.21). Two Hanoverian kings, George I and then George II of England, and King Frederick William I of Prussia were among the monarchs to offer assistance to the exiles.

About this time, several important events occurred. First, in 1732, a group of trustees interested in settling the colony of Georgia was granted a charter by George II. General James Edward Oglethorpe, a member of Parliament, was the group's appointed leader. He, with a small group of about 120 settlers, arrived at the Savannah River

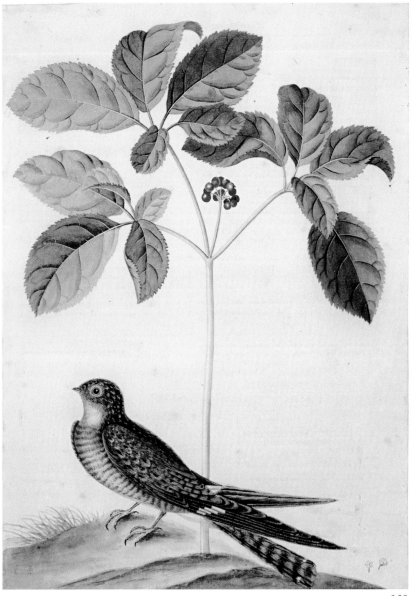

3.20

in February 1733 and, once a site was selected, laid out the plan for the town of Savannah as illustrated in *A View of Savannah as It Stood the 29th of March, 1734* (fig. 3.22). Ogelthorpe wrote an article that told of the persecutions and hardships the Salzburgers had endured that was later edited by Samuel Urlsperger (1685–1772), a Lutheran theologian from Augsburg. Another trustee, Thomas Coram[49] (fig. 6.20), a wealthy London seaman and merchant and a member of the Society for Promoting Christian Knowledge, became closely involved in the effort to settle Georgia. Urlsperger was also a member of

FIGURE 3.21. Unidentified artist, possibly John Carwitham, engraver, strike pulled in 1938 from the original copperplate that probably dates 1728–1733, ink on paper, 10⅛" x 14". Colonial Williamsburg Foundation, Williamsburg, VA.

This is the image on one of two plates that Colonial Williamsburg researchers discovered in 1929 at the Bodleian Library, Oxford, England. William Byrd may have been associated with the plates in some way—as artist, sponsor, commissioner, or author of an accompanying text that is now lost. Library records indicate the library's receipt of this and six other plates by bequest of Richard Rawlinson, an English antiquarian, at his death in 1755. The plates are unsigned, but two prints from now missing plates in the set bear the signature of John Carwitham (b. 1697?), the English engraver. Carwitham's brother Thomas Carwitham (active 1713–

1733) was a painter, draftsman, and architect who, with Thomas Heath, invented an architectonic sector and possibly other drafting devices. John Carwitham was also involved in related architectural design work for the landscape designer Batty Langley. Either of the Carwithams would have been capable of drawing and engraving the buildings and other images featured on the Williamsburg plate. The question that remains is who created the original drawings.

The buildings shown include, at top, the Wren Building and two flanking structures at the College of William and Mary; and at center, beginning at left, two views of the Capitol and, at right, the Governor's Palace with flanking dependencies. The lower part shows various examples of plants, a sea horse, a spider, and a beetle, all of which are flanked at extreme left and right by Native Americans.

His Majestys Colony of Georgia in America

1 The Stairs going up	5 The publick Mill	9 The Lott for the Church	13 The Pallisadoes
2 M.r Oglethorpes Tent	6 The House for Strangers	10 The publick Stores	14 The Guard House and
3 The Crane & Bell	7 The publick Oven	11 The Fort	Battery of Cannon
4 The Tabernacle & Court House	8 The draw Well	12 The Parsonage House	15 Hutchinsons Island

By
George Jones

3.22

Noble Jones (1702/05–1775) was among the first immigrants who settled in Georgia, having arrived with James Oglethorpe's group. He was a physician and carpenter as well as a member of Oglethorpe's 42nd Regiment of Foot. Noble's son, Noble Wimberly Jones, was an important Georgia official.

The picture illustrates the layout of Savannah, as envisioned by Oglethorpe, in an orderly geometric arrangement of alternating public and residential wards. Each residential ward had forty individual lots and faced a public square. At first glance, the Savannah design might be mistaken as a purely European model. However, it reflects Oglethorpe's utopian idea of the promised land where good persons of lower, middling, and upper middling status could settle and thrive together on equal portions of land. Savannah surveyor Noble Jones was engaged to draw the general plan, which was then taken to George Jones (active 1733–1734) in London to create the sketch from which Paul Fourdrinier (1698–1758) created the engraving. George Jones's name appears in the lower center. The engraved version (fig. 4.4) was used with other materials to encourage settlement and support of the colony.

Peter Gordon, whose name appears on the engraving as "P. Gordon Inv." and as the "Obliged most Obedient Servant," had traditionally been credited as the picture's draftsman, but he was not. Gordon conveyed the original drawing to Fourdrinier, who engraved the plate. See Baine and De Vorsey, "Provenance and Historical Accuracy of 'A View of Savannah,'" for their complex research that resulted in the reattribution.

the society. Its trustees ultimately responded and agreed to help the exiles by providing them passage and supplies to establish a settlement in Georgia. Urlsperger was assisted in making plans for the exiles by Johann von Reck, the ambassador for the English at the Diet of Regensburg. It was Johann von Reck who selected Philip Georg Friedrich von Reck, his nephew, to accompany the Salzburgers on their journey.[50] Von Reck was twenty-

FIGURE 3.23. Philip Georg Friedrich von Reck, *Die erste Hütten und Gezelte zu Ebenezer* (The First Huts and Shelters in Ebenezer), 1735, graphite drawing on paper, 7½″ x 10½″. The Royal Library, Manuscripts and Rare Books Department, Copenhagen K Denmark.

As illustrated here, von Reck was proficient in drawing landscapes and rendering details of foliage. The figure in the foreground is probably carrying a musket while other figures appear to be preparing lumber for construction.

FIGURE 3.24. Philip Georg Friedrich von Reck, *Eine junge Wasser Schlange / Uchi Creek / Saa Zitto / (a, b, c, d) Eine kleine Castanie so süss und angenehm zu essen / (e) Jonto: Eichel / Alagether eine Art von Crocodill / Tap-ap-te-ha Hal-pa-ta* (A Young Water Snake / (a, b, c, d) A Small Chestnut So Sweet and Pleasant to Eat / (e) Acorn / Alligator, a Sort of Crocodile/ [unknown]), 1735, watercolor and ink on paper, 7½″ x 10½″. The Royal Library, Manuscripts and Rare Books Department, Copenhagen K Denmark.

(All of the von Reck translations come from Hvidt, *Von Reck's Voyage.*)

three years old when he arrived in Georgia with the first transport of Salzburg Protestant exiles in March 1734. University educated, he was versatile in languages, and he expressed great interest in the Georgia project, ultimately leading the refugees first to Rotterdam, then to England, and finally on to Georgia. The philanthropist Thomas Coram was very pleased with the young German, noting in a letter that he "is of a healing temper. The more I see of him the more I like him and all that I have said about him is not half enough."[51]

Von Reck's initial stay in Georgia was brief, but, while there, he was able to select a settlement site named Ebenezer and to assist the settlers in building temporary shelters. He then traveled north to Philadelphia, going from there by horseback to Boston before sailing for England. Von Reck's second transport of refugees to America departed Regensburg, Germany, on August 16, 1735, and arrived at Harwick, a port town along the coast of Suffolk, England, on October 1. Although the group boarded ship in late October, it was at least a month before the winds were favorable for departure. By the afternoon of January 16, the group had anchored at Tybee Island in the Savannah River.

One of von Reck's purposes on the second trip was to obtain "ocular proof" of the settlement and other details of the place by making the watercolor sketches that are known today.[52] His second stay was fraught with difficulties from the day he arrived. Ebenezer was isolated, crops had failed, many people had died, and the town needed to be moved. New Ebenezer was then established on the southern bank of the Savannah River and laid out in a European grid similar to Savannah. Von Reck's sketch (fig. 3.23) shows two shelters for the new arrivals under construction at New Ebenezer during the month of February. Work continued on the new town through March, and by April nearly all of the residents of the old village had moved there. Building was slow, however, and the provisions were inadequate.

Von Reck's plan was to remain in Georgia, but disagreements and rivalry between him and religious leaders and a prolonged illness finally forced him to leave.[53] He sailed for London on October 24, 1736, returning to

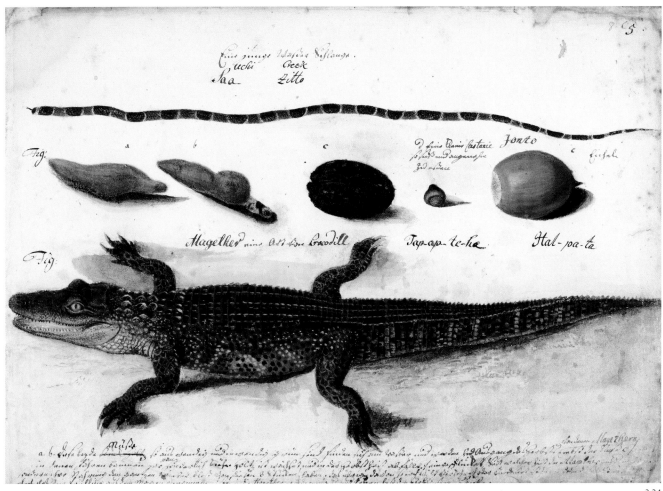

3.24

Europe in disgrace.[54] Von Reck held various positions in Germany, and, from 1763 until his death at age 82, he served as a district revenue collector for Frederick V, the Danish king.[55] Although parts of his diary were published by Urlsperger in *Ausfuhrliche Nachrichten* in 1740 and he himself published it in 1777,[56] his pictures were never published. They were, however, preserved by the Danish kings after von Reck's death in 1792 and were discovered by a Danish researcher among papers in the Royal Library at Copenhagen, Denmark, in 1976.

Von Reck was a talented amateur artist whose works indicate training in drawing but limited skill in watercolor painting (fig. 3.24). His shading and coloration of various animals, birds, and plants is convincing but often crude in its details, in no way as accomplished as Catesby's work. Of course, each man had a different purpose for his art. Von Reck's goal was more akin to that of John White—to record the construction of a settlement, the Native people, and the surrounding flora and fauna for religious leaders and philosophers. It was not his goal to provide scientific or highly detailed and ordered records of natural history subjects for learned men. Most of von Reck's birds (fig. 3.25) were obviously done from dead specimens that lay on their sides or backs with closed eyes. Catesby's birds were posed as if alive and were situated in "natural" settings.

Among von Reck's most historically interesting and successful renderings are views of the Salzburgers' two ships, the *London Merchant* and the *Simonds,* passing the Isle of Wight in England (fig. 3.26); a waterspout encountered near the coast of America; the garden plots assigned to the settlers in New Ebenezer; a petiagua (a

3.25

3.26

flat-bottomed boat of about twenty-five tons commonly used along the coast); two types of huts used by inhabitants on Saint Simons Island (fig. 3.27); and a large drawing that may represent the settlement of New Ebenezer as it underwent construction. There are passages of expert sketching in many of these.

The most important von Reck pictures are those of the Yuchi Indians (figs. 3.28 and 3.29) that he encountered near the Salzburger settlements. One, titled *Ein Georgianischer Indianer und Indianerinn in ihrer Natürl. Kleidung,* shows a man and a woman. Their images are curious because they appear to be copied from an engraved source; the postures of the two figures recall those used by numerous artists in earlier seventeenth-century accounts of voyages, suggesting that von Reck had consulted such sources before going to Georgia. All of the Indian drawings and watercolor pictures that appear after these two were probably created "from life" and show the Yuchis in natural poses with objects they used in daily work. One of the most striking is the likeness titled *Der oberste Kriegs Hauptmann der Uchi Indianischen Nation nahmens / Kipahalgwa* (fig. 3.29). The portrayal is sensitive and realistic, in every detail as faithful a likeness of the man and his clothing as von Reck was able to render. As with other pictures, von Reck's notes above the figure describe the details. Another picture, titled *A War Dance,* illustrates a Yuchi busk, an annual festival that included storytelling, dancing, and singing with drums and rattles. Von Reck sometimes traveled with Indians to learn more about the region; his writings indicate that he attended at least two of these ceremonies during his stays in Georgia.[57]

The artist departed Georgia and the colonies via Charleston, South Carolina. He had visited that city several times, and he, Oglethorpe, and John Vat were aware of Jean Pierre Purry, the Swiss Protestant who led the immigration efforts from his country to South Carolina during 1735–1737. All located on rivers for easy passage of supplies and people, Purry's townships included Purrysburgh on the Savannah River, Orangeburg on the Edisto River, Saxe-Gotha on the Congaree, and Amelia on the Santee.[58] Simon Theus and his family,

3.27

FIGURE 3.25. Philip Georg Friedrich von Reck, *Fliegendes Eichborn wenn man es fangen wolle so muss man nur den Ast worauf es sitzt nieder abhauen hernach den Baum selbst fällen, mit welchem es zugleich fällt und um den Stamm beständig herumläuft, so dass man es lebendig fangen kann. / Fliegendes Eichhorn. Indianische, Zishagzafen, Wajo / Zozashi, Fu-zag-ta / Zoo, Jo-wei-ka,* 1735, watercolor and ink on paper, 7½" x 10½". The Royal Library, Manuscripts and Rare Books Department, Copenhagen K Denmark.

The first part of the title translates as "Flying Squirrel, if you want to catch it you must cut down the branch on which it is sitting and then the tree itself. It will continue to run around the trunk and you will be able to catch it alive." *Zishagzafen* is the Yuchi word for *Wajo; Wajo* is the Creek word for flying squirrel. *Zozashi* is Yuchi for redbird. *Fu-zag-ta* is Creek for redbird. *Jo-wei-ka* is Creek for bluebird.

FIGURE 3.26. Philip Georg Friedrich von Reck, *The Needles and Shols by the Isle of Wight in the English Channel / Die Needles,* 1735, watercolor and ink on paper, 7½" x 10½". The Royal Library, Manuscripts and Rare Books Department, Copenhagen K Denmark.

FIGURE 3.27. Philip Georg Friedrich von Reck, *Hütten zu Friderica von Palmlaube geflochten* (Huts in Frederica Woven of Palm Leaves), 1735, graphite on paper, 7½" x 10½". The Royal Library, Manuscripts and Rare Books Department, Copenhagen K Denmark.

According to the artist's biographer, these huts probably represent the first types of dwellings built by the Salzburgers at Saint Simons Island. In 1736, they would travel from the island to Frederica, Georgia, where they were building a larger fortification. Similar buildings were made by the earlier group of Salzburgers at Ebenezer. (See Hvidt, *Von Reck's Voyage,* 74–75; see also fig. 3.23.)

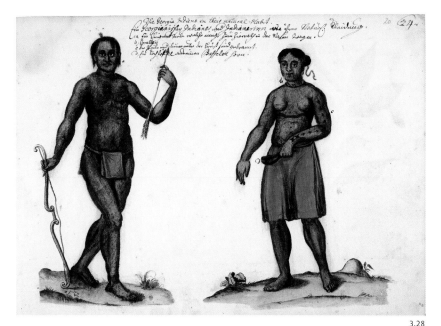

FIGURE 3.28. Philip Georg Friedrich von Reck, *Ein Georgianischer Indianer und Indianerinn in ihrer Natürl. Kleidung. / (a) Ein Ring und Perle welche einige zum Zierrath in der Nasen tragen. / (b) Corallen / (c) Die Pfeile und Linien unter der Brust sind gebrannt / (d) Ein Kochlöffel aus einem Baffeloe Horn*, 1735, watercolor and ink on paper, 7½" x 10½". The Royal Library, Manuscripts and Rare Books Department, Copenhagen K Denmark.

The title translates as "The Georgia Indians in their natural habit / (a) A ring and pearl which some carry in the nose / (b) Corals / (c) The arrows and lines under the breast are burned / (d) A ladle made from a buffalo horn." Some of the details mentioned in the artist's description of these Native people are difficult to see, even in reproduction prints the same size as the originals. In (a), the ring and pearl refer to the male figure. The corals in (b) and the lines mentioned in (c) refer to the female figures, and it is the female figure holding the ladle in (d). Von Reck was very interested in these features and was consistently diligent in recording them in all of his Native American pictures.

FIGURE 3.29. Philip Georg Friedrich von Reck, *Der oberste Kriegs Hauptmann der Uchi Indianischen Nation nahmens / Kipahalgwa / (1) Der Wirbel auf dem Kopf ist etwas mit rother Farbe beschmiert / (2) Das Gesicht ist so bemahlet dass schwarze Zeichen in der Schläfe ist, auf der Brust und dem Halse ist gebrannt. / (3) Ein Büschel weicher Federn durchs Ohr gezogen an welcher eine Perle hänget / (4) Ein Hembd / (5) Camaschen / (6) Schue*, 1735, watercolor and ink on paper, 7½" x 10½". The Royal Library, Manuscripts and Rare Books Department, Copenhagen K Denmark.

The title translates as "The supreme commander of the Yuchi Indian nation, whose name is Kipahalgwa / (1) The topknot on his head is slightly painted with red color. / (2) The face is painted in this way with the black signs on the temple, the breast and neck burned. / (3) A bunch of soft feathers drawn through the ear, from which a pearl is hanging / (4) A shirt / (5) Leggings / (6) Shoes."

including Theus's twenty-year-old son Jeremiah, would be among those who settled in Orangeburg in 1736/37. Jeremiah was a trained European artist whose career in Charleston represented the first major period of portrait and easel painting in South Carolina.[59]

Although later in date, several other colonists associated with the South contributed to natural history studies and should be mentioned here.[60] One, Dr. Alexander Garden, who came from Scotland, lived for many years in Charleston, South Carolina. A physician by trade, he also pursued the study of natural history, particularly zoology. Although no paintings or drawings are known by him, he wrote about insects, the mud iguana, and medical subjects, and he was a source of information to naturalists who did paint in the colonies as well as to collectors abroad. Because he was a Loyalist during the American Revolution, his property was confiscated. In 1783, he returned to England, where he became vice president of the Royal Society.

Another colonist, Gustavus Hesselius (1682–1755), lived in both Maryland and Pennsylvania and painted in Virginia. It was probably Gustavus, not one of his brothers in Philadelphia, who shipped specimens to Carl Linnaeus and escorted Peter Kalm, Linnaeus's assistant, on his travels in Pennsylvania in 1748–1750. It would be easy to speculate that Gustavus may have done some pictures of the mid-Atlantic natural world since his letters home expressed his admiration for local plants.[61]

In addition, an amateur artist from Philadelphia named William Young Jr. (1742–1784) created hundreds of colored drawings of plant species from North and South Carolina (fig. 3.30). These drawings are contained in a 1767 manuscript in the Natural History Museum in London although they are little known to Americans today. Young lived near John Bartram in Pennsylvania, and he knew virtually all the primary botanists in America and England. He corresponded with Bartram's cousin Humphry Marshall (1722–1801) as well as with Linnaeus, Peter Collinson, and John Ellis.

Correspondence between Bartram and Collinson sheds light on the competition Young posed to Bartram. On September 23, 1764, Bartram wrote to Collinson that

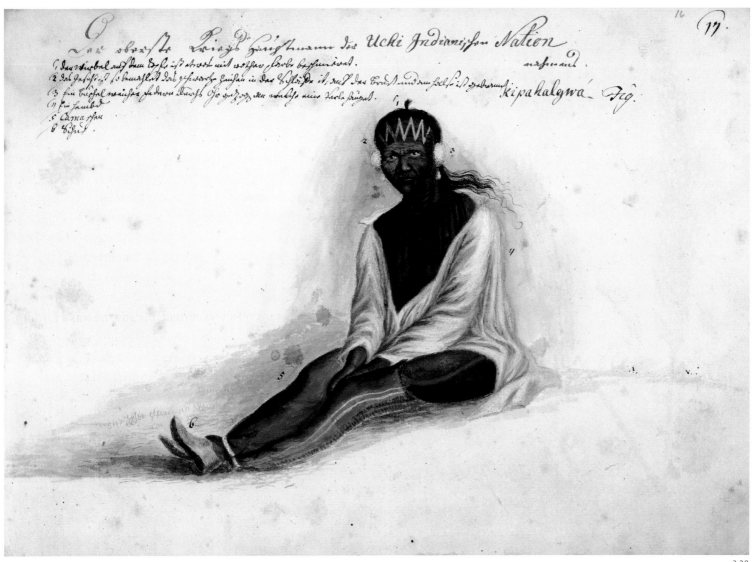

3.29

"my neighbour YOUNG's sudden preferment has astonished . . . our inhabitants. . . . [H]e has got more honour by a few miles' travelling to pick up a few common plants, than I have by near thirty years' travel, with great danger and peril." On April 9, 1765, Collinson wrote that he had secured for Bartram an appointment as botanist to King George III. It was already clear, though, that Young was the protégé of Queen Charlotte, George III's wife.[62] Collinson wrote Bartram again on May 28, 1766, saying,

My dear JOHN, I wonder thou should trouble thyself about the Queen, as she has YOUNG, and everything will be shown

him. It cannot be expected he will favour any one's interest but his own. He is now . . . grown so fine and fashionable, with his hair curled and tied in a black bag, that my people . . . did not know him.

On December 5, 1766, Bartram wrote to Collinson, saying, "I am surprised that YOUNG is come back [to the colonies] so soon. He cuts the greatest figure in town, struts along the streets, whistling, with his sword and gold lace, &c. . . . He is just going to winter in the Carolinas." By January 1766, Young had indeed become the queen's botanist.[63]

3.30

FIGURE 3.30. William Young Jr., *Palmata digitalis, Aster, Tetandria Moss*, 1766–1767, watercolor and ink on paper, 15″ x 8½″. The Natural History Museum, London.

For the sum of three hundred pounds, the king of England commissioned William Young Jr. to provide pictures of the plants of North and South Carolina. Over three hundred of those watercolors survive, including this example of a palm tree and assorted flowers.

Young's pictures are charming, neatly prepared with much detail; however, they do reveal the hand of someone largely self-taught or minimally trained. His compositions, awkward and stiff, seem more decorative than scientific. Apparently they were never published.

After Catesby, and with the exception of Young, William Bartram (fig. 3.31) and his father, John, became the best known of the naturalists who studied American plants and had an association with the South.[64] The Bartram family had emigrated from England in the early 1700s, settling in the Cape Fear region of what is now North Carolina. Members of the elder Bartram's generation moved to areas in and near Philadelphia. John Bartram was never the artist his son would become, but he was well respected internationally, and he served as a major source of specimens sent abroad. Considered by Linnaeus as one of the greatest botanists in the world, he traveled extensively north and south of his native Philadelphia, and he established a famous botanical garden. Both his home and his botanical garden were located in Kingsessing on the Schuylkill River. His brother, Colonel William Bartram, returned to North Carolina and took over the family estate there.

William Bartram, the botanist, artist, and son of John Bartram, took an interest in drawing as a youth, but he did not pursue it with any regularity until the 1760s when he was in his twenties. His Quaker parents provided him with a classical education, including attendance at the Philadelphia Academy. His father worried that William would not be able to support himself through drawing, and so, in 1756 or 1757, William was apprenticed to a merchant. In 1761, he moved to Bladen County, North Carolina, to live with his uncle Colonel William Bartram. There he operated a store and also studied the plant and animal life in the Cape Fear region.

When John Bartram traveled to Florida via the Carolinas in 1765–1766, he took his son William with him. The father returned to Philadelphia early due to illness, but the son remained and lived in East Florida until 1767. William Bartram then returned to Philadelphia, where he resumed storekeeping and provided

paintings of insects and plants to Peter Collinson, his father's good friend in England.

With Collinson's help in promoting William Bartram's work, Bartram's reputation as a painter of flora and fauna grew among collectors and naturalists in England. Yet Bartram was deeply in debt, and his creditors in Philadelphia ultimately drove him back to the South, where he developed a plan to return to Florida. After considerable correspondence with Dr. John Fothergill, the noted English botanist and horticulturist, Bartram secured Fothergill's endorsement and financial support for a southern expedition. He began his travels in 1773. He continued to send drawings and reports to Fothergill and to collect hundreds of specimens. Although the body of material associated with his southern trip, including his journals, was impressive, Bartram did not assimilate and publish the material until 1791 (figs. 3.32 and 3.33). Events leading up to the Revolutionary War were one reason for the delay, as were events of the war itself, including the threat made by British troops to Philadelphia. The death of his father in 1775 was another factor, as were injuries William himself sustained from a fall.

Bartram's surviving pictures brim with activity, as animals, insects, and plants from a given environment mingle. His approach differed from Catesby's and that of other naturalist painters who worked in America before him. Because Bartram excelled in painting and often animated the creatures in his drawings in a dramatic manner, his pictures are sometimes described as more lifelike and artistic than Catesby's (fig. 3.34). Such qualities prompted praise for Bartram's *Travels*[65]—as well as considerable criticism from peers, including Dr. Fothergill, who felt that the work was romanticized and often lacked the objectivity of scientific illustration.

The context for such opinions is important, and several scholars knowledgeable about Bartram and the many other naturalists who created illustrations during this period help shed light on that context for the modern viewer. Margaret Beck Pritchard, for example, synthesizes some of the thinking that affected Bartram's pictures, including that of the essayist and poet Joseph Addison, the dramatist and critic John Dennis, and later the philosopher Edmund

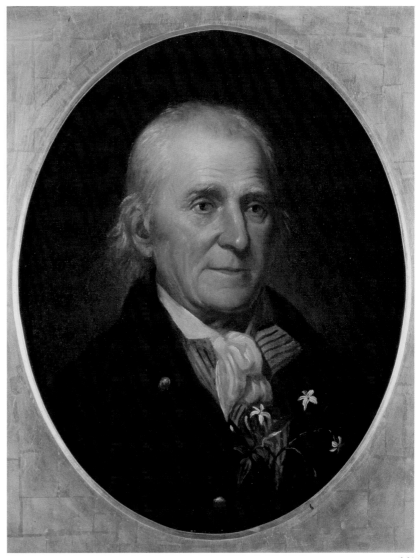

3.31

FIGURE 3.31. Charles Willson Peale, *William Bartram*, 1808, oil on canvas, 23" x 19". Independence National Historical Park.

Both the artist and subject were members of the American Philosophical Society. Charles Willson Peale (1741–1827) created the portrait for his museum gallery. The flower shown in this portrait was incorrectly identified many years ago as a double anemone. Unfortunately, its identity is still uncertain although it must have had some special significance for William Bartram, Peale, or both.

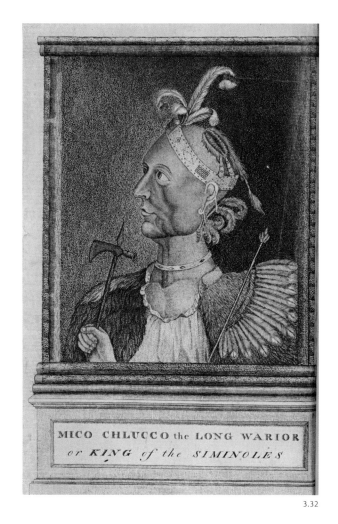

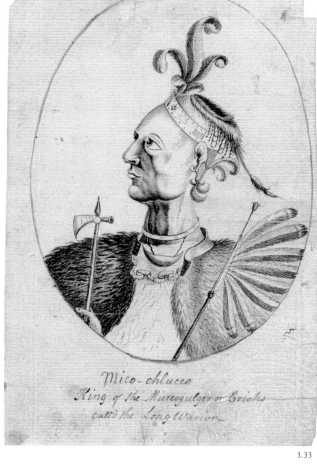

FIGURE 3.32. William Bartram, artist, James Trenchard (1749–after 1794), engraver, *Mico Chlucco the Long Warior or King of the Siminoles*, ink on paper, frontispiece from *Travels through North & South Carolina, Georgia, East & West Florida, the Cherokee Country, the Extensive Territories of the Muscogulges . . .*, published in Philadelphia, 1791. Virginia Historical Society.

FIGURE 3.33. William Bartram, *Mico-chlucco / King of the Muscogulges or Cricks, Call'd the Long Warior*, 1774–1790, ink and graphite on paper, 7⅝" x 5⁵⁄₁₆". American Philosophical Society.

This is William Bartram's original sketch for the frontispiece of his book *Travels through North & South Carolina, Georgia, East & West Florida*. It is considered the earliest known portrait of a Seminole. Mico-chlucco was the chief of the Okone band of Florida Seminoles.

Burke.[66] These men advanced an aesthetic theory known as "the sublime," which, in its simplest definition, recognized aesthetic qualities ranging from the fearful and irregular to the harmonious, great, unbounded, vast, awesome, and uncommon.[67] Philosopher and politician Anthony Ashley-Cooper, 3rd Earl of Shaftesbury, might also be added to this list since he, too, expressed an interest in the irregular, sometimes fearful aspects of the natural world. William Bartram's art and his explorations of nature were strongly influenced by his emotional response to the natural world and its mysteries. Bartram wrote that

> I attempt only to exhibit to your Notice, the outward furniture of Nature, or the productions of the Surface of the earth; without troubleing you with any notions, of their particular causes or design by Providence, such attempts I leave for the amusement of Men of Letters & Superior gen[i]us.[68]

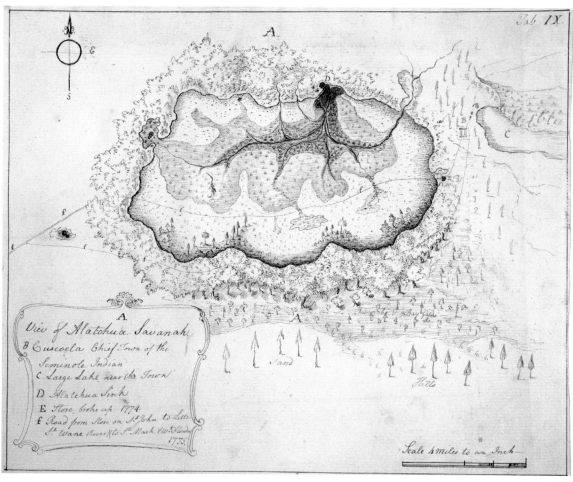

Scholars have interpreted this comment in various ways, the most revealing of which suggests that Bartram preferred not to follow the rigid, empirical approaches and theories of the natural sciences adhered to by "Men of Letters & Superior gen[i]us."

For Bartram, "the outward furniture of Nature" was not only to be seen but also to be experienced and witnessed on an emotional level, one that recognized the natural world's uncertainties, endless diversity, and unexpected phenomena.[69] Nature was not wholly predictable and could not be finitely classified but rather was filled with interactions of life forms of many sizes populating a universe that is unlimited in scope and beyond under-standing. Unlike the work of other naturalist painters, Bartram's pictures often show a greater preoccupation with depth—and the unknowns that might exist in that depth. His view *Great Alachua-Savanna* (fig. 3.34) illus-trates these points with its overall organic appearance, its complex perspective rendered with several vanishing points that confound an orderly sense of depth, and its disproportionate sizes of birds and other elements in the same areas of the view. One commentator suggests that viewers of *Great Alachua-Savanna*

FIGURE 3.34. William Bartram, *The Great Alachua-Savanna*, probably 1773–1774, ink on paper, 8¹/₁₆" x 9¹³/₁₆". The Natural History Museum, London.

Bartram created two views of the Alachua savanna, the other perhaps as a revision of this picture. Both images reflect Bartram's unique interplay of surfaces and depths. As viewers, we seem to hover above the landscape and simultaneously to plunge towards parts of it. Whether such was the artist's intention or not, the effect parallels his perception of nature's curious depths—and man's inability to codify and classify them.

3.35

FIGURE 3.35. William Bartram, *Podophyllum peltatum* (Mayapple), probably 1773–1780s, ink on paper, 20³⁄₁₆″ x 13³⁄₄″. American Philosophical Society.

Bartram's drawing of the mayapple shows the plant in both its above- and belowground details, including a large rendering of the blossom at left. The plant is set against what appears to be a bank along the edge of water with other landscape features receding into space on top of the bank. With regard to its linear perspective and the disparate sizes of elements, the picture bears a strong relationship to the artist's approach in the Alachua savanna picture (fig. 3.34).

FIGURE 3.36. William Bartram, *Alligator of St. Johns*, probably 1773–1774, ink on paper, 9¹⁄₄″ x 14⁷⁄₁₆″. The National History Museum, London.

sense two different worlds in dialogue: the subterranean world of roots and the visible realm of the earth's surface. . . . this dialogue . . . revolves around the sink hole located at the top center of the drawing. . . . For Bartram, these sink holes operate according to a double logic: they are the great "mouths" of nature. . . . and they also are the sources. . . . The dark, circular sink. . . . is a void *from* which the visibility of nature proceeds and *into* which it must return.[70]

Bartram's narrative accompanying his illustrations of the savanna treats the creatures he observed—and, indeed, whole environments that he experienced as teeming with life (fig. 3.35)—with unabashed wonder. In characteristic Bartram language, ponds and other bodies of water are often "glittering," groves are "aromatic" and "sylvan," evenings are "gray" and "pensive," and both nights and thickets could be "gloomy." Such descriptors, found throughout *Travels,* not only express Bartram's feelings but also imbue the natural world itself with emotions. Historians have pointed out that during the late eighteenth century, America experienced a "rhetorical revolution" in which "natural language" was preferred over expression based in social propriety and nuance.[71] This new language was coupled with gesture and tone and in turn was believed to be more sincere and truthful. Bartram's art seems to have some of the same qualities.

George Roupell (1726–1794) of Charleston, South Carolina,[72] was another southerner who did botanical drawings, usually at the request of Dr. Alexander Garden of Charleston.[73] Roupell is not known today for his botanicals, for none have been identified, although they were admirable, according to Garden. In 1756, Garden had accompanied the South Carolina governor on an expedition to the interior of the colony and had noted that "one of our company [i.e., Roupell] was a very accurate drawer." Garden also requested John Ellis in London to send a drawing by Georg Dionysius Ehret (1708–1770) as a model for Roupell to study. Garden apparently sent either Roupell's copy of the picture or others to Ellis, who responded that "Mr. Roupel has shown an excellent genius in drawing. I am persuaded he has copied nature most exactly."[74] In January 1760,

3.36

Garden wrote to Ellis again, saying that Roupell was making drawings that would be sent to the Edinburgh Society; he was still working on specimen drawings as late as 1764 and possibly until the outbreak of the Revolutionary War.

Today, Roupell's artwork is represented by pictures of a different sort—including his celebrated circa 1754 ink-and-wash drawing titled *Peter Manigault and His Friends,* which shows eight gentlemen gathered around Manigault's (1731–1773) dining table for a dinner party (figs. 3.37 and 3.38). Probably made after or during Roupell's visit to Steepbrook, Manigault's home situated on Goose Creek in St. James Parish, the picture is often touted as one of the most important visual records of social life for colonial America. One other drawing by Roupell is known, a profile likeness of Isaac Mazyck.[75]

Three other important artists who, like von Reck, observed and recorded new settlements in the early eighteenth-century South should be also noted: Jean-Pierre de Lassus (1694–1758), Jean-Baptiste Michel Le Bouteux (1682–1764), and Alexandre de Batz (active ca. 1728–1759). None were naturalists; rather, they were involved with the land as engravers, surveyors, engineers, and architects.

Born in Montréjeau (Haut-Garoone), France, Lassus became an engineering officer in the French navy. Assigned the task of surveying in Louisiana, he arrived there in 1725. His *Veüe et perspective de la Nouvelle Orleans,* painted in 1726, remains the earliest known European artwork for the Louisiana settlement (fig. 3.40). Lassus probably created other views and pictures while in the area although no others are known today. He was a gifted draftsman who obviously had training in the rendering of perspective and shadows to create depth and in the use of ink washes and watercolors. The image of New Orleans is nicely detailed, showing a number of activities that are too small to see in the illustration published here. Those activities include slaves felling trees, other figures spearing an alligator and a snake, and various persons rowing small watercraft. Other details include a deer, small dwellings in the town, and ships near the town.[76]

French by birth and an engraver and surveyor by trade, Le Bouteux was active in the Mississippi and Louisiana area during the 1720s. Presumably it was just after his southern visit that he went to Portugal where he worked until his death. His painting of John Law's trading post at New Biloxi in Mississippi is the earliest known surviving southern prospect, or view (fig. 3.39).

3.37

3.38

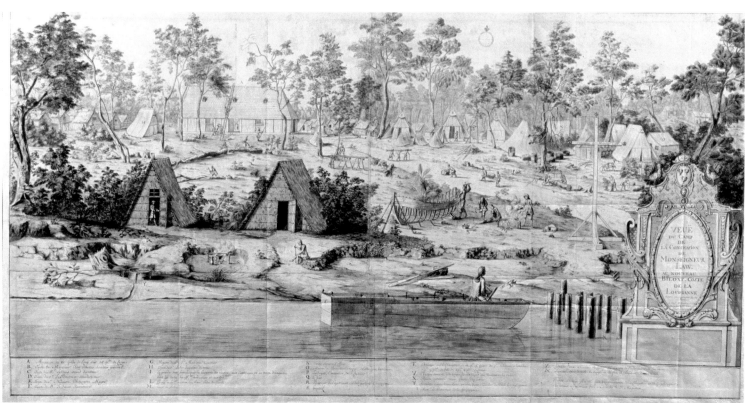

3.39

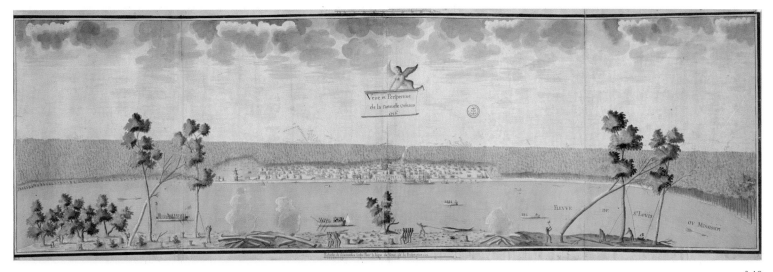

FIGURE 3.37. George Roupell, *Peter Manigault and His Friends*, ca. 1754, ink and ink wash on paper, 10³⁄₁₆" x 12³⁄₁₆". Courtesy Winterthur Museum.

FIGURE 3.38. Louis Manigault, *Mr. Peter Manigault and His Friends*, 1854, ink and ink wash on paper, 10¹⁄₂" x 13". © Image courtesy Gibbes Museum of Art/Carolina Art Association.

Louis Manigault (1828–1899), great-grandson of the subject, made this copy a hundred years after the original. He did not include the balloons with comments seen in the original, but he did provide an important key that identifies all the party participants.

FIGURE 3.39. Jean-Baptiste Michel Le Bouteux, *Veuë du camp de la concesion de Monseigneur Law, au Nouveau Biloxy. Coste de la Louisianne* (View of Mr. Law's Concession Camp at New Biloxi. Louisiana Coast), ca. 1720, ink and gouache on paper, 19¹⁄₂" x 35³⁄₈". Photograph courtesy of the Newberry Library, Chicago. Call # Ayer MS Map 30, Sheet 77.

"Monseigneur Law" was John Law, the finance minister of France, who developed a plan for expanding settlements in Louisiana. Biloxi was the chosen site for new operations. Jean-Baptiste Michel Le Bouteux, who was trained as an architect, was one of the first to settle the area.

FIGURE 3.40. Jean-Pierre de Lassus, *Veüe et perspective de la Nouvelle Orleans*, 1726, ink and watercolor on paper, 18⁷⁄₈" x 59¹⁄₄". Archives nationales d'outre-mer, Aix-en-Province, France.

FIGURE 3.41. Detail of 3.40.

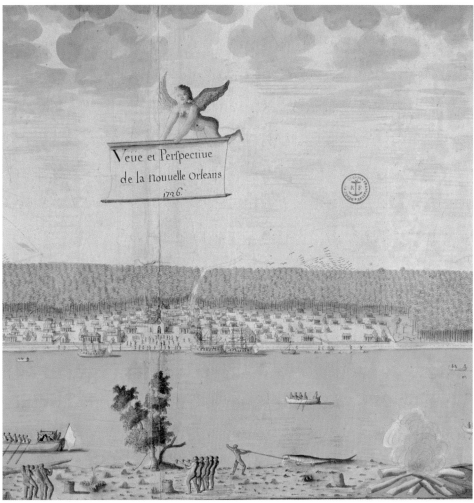

FIGURE 3.42. Alexandre de Batz, *Temple des sauvages, cabanne de chef* (Indian Temple and Chief's Cabin), 1732, ink and ink wash on paper, 12⅝" x 9³⁄₁₆". Courtesy of the Peabody Museum of Archaeology and Ethnology, Harvard University, 41-72-10/16.

Highly detailed and rendered in accurate and complex perspective, the trading post view reveals Le Bouteux's skill as a draftsman.[77]

The third artist, Alexandre de Batz, an engineer and architect, was probably a native of Montaterre in Picardy, France. Many of his drawings survive in the collections of the Archives Nationales in Paris, France. De Batz designed various buildings in Louisiana, including the Ursuline Convent and a house called the Observatory that briefly functioned as the governor's residence. His most remarkable drawing, however, features the Indian temple and cabin he saw in a small village occupied by the Colapissas near present-day Lake Pontchartrain (fig. 3.42). The picture is wonderfully detailed, and it is surrounded by de Batz's neatly penned notes that give particulars of the construction, materials, and dimensions of the structures. De Batz continued to travel until the late 1750s, moving throughout the French territories in the South and as far north as present-day Illinois. In addition to architectural renderings, de Batz also drew pictures of Native Americans, including members of the Atakapa and Tunica tribes. He was a talented draftsman whose work stands alone in representing pictorial art in the early Louisiana Territory.

NOTES

1. From *Instauration Magna [The Great Instauration]*, in *Selection of His Works*, 323.

2. Bacon's methodology for scientific query, well-known during his lifetime, was but a small part of his philosophical advocacy of science and scientific study.

3. Unless otherwise noted, biographical information for Catesby comes from McBurney, *Mark Catesby's "Natural History"* with an introductory essay by Meyers, "'Perfecting of Natural History,'" and from Meyers and Pritchard, *Empire's Nature*.

4. See Sanders and Anderson, *Natural History Investigations*, 5, 8, and 10. Sloane would later financially back Mark Catesby's expedition of 1723–1725, the basis for Catesby's *Natural History*.

5. Regarding the elder Byrd's participation as a Temple Coffee House Botany Club correspondent, see McCully, "Governor Francis Nicholson," 323–324. Regarding his enthusiasm for sharing seeds, roots, and plants with others interested in natural history, see Pritchard and Sites, *William Byrd II*, 100.

6. Collinson's involvement in the collection of seeds and their dispersal to gentlemen gardeners in America and England is well-known, as are his patronage of Catesby's work, his support of the struggling American Philosophical Society founded in Philadelphia in 1743, and, in his native England, his support of the Foundling Hospital established by Thomas Coram (see pages 287–299). He knew many other Americans involved in natural history collecting, including John Bartram and Benjamin Franklin. For his extensive correspondence with Custis, see Swem, *Brothers of the Spade*.

7. There were also later editions. See Lawson, *History of Carolina*, 1714.

8. Eventually acquired by Elias Ashmole, the Tradescant collections formed the nucleus of material that became the Ashmolean Museum in Oxford, Eng.

9. Sir Isaac Newton was perhaps the greatest English philosopher of the late seventeenth and early eighteenth centuries; in his writings, he emphasized a scientific method of placing events in nature into a lawlike order. The ideas of John Locke and David Hume also influenced scientific inquiry. Hume in particular questioned uniform laws of biological nature and their predictability. His philosophical skepticism seems to have been among the various approaches that influenced Catesby.

10. Meyers, "'Perfecting of Natural History,'" 12.

11. Linnaeus published his system for plants in 1753 and for animals in 1758. The Linnaean Society of London was founded in 1788.

12. Thomas Jefferson commented later about the advantages of Linnaean taxonomy in light of what he and others recognized as abstractions and deviations in nature, saying that "we are obliged . . . to distribute them into masses, throwing into each of these all the individuals which have a certain degree of resemblance; to subdivide these again into smaller groups, according to certain points of dissimilitude observable in them, and so on until we have formed what we call a system of classes, orders, genera and species." Jefferson to John Manners, 22 Feb. 1814, in Jefferson, *Writings,* 98.

13. Gaudio, "Surface and Depth," 56.

14. The only other collector and scientific illustrator who used a similar approach was Maria Sybilla Merian (1647–1717), a native of Germany who traveled to the Netherlands, to Surinam in South America, and elsewhere collecting and studying insects. Merian documented the metamorphoses and life cycles of insects, chiefly butterflies and moths, dispelling the traditional belief that insects came from spontaneous generation of rotting mud. Familiar with, and influenced by, her published work, Catesby cited her in his own text.

15. "Mark Catesby," 34–35.

16. See for example Meyers, "Picturing a World in Flux," 229.

17. Ibid.

18. Chaplin, "Mark Catesby," 47. Chaplin notes that "without a doubt, Catesby's boldest attempts at theory had to do with climate," a subject that interested him and many others concerned with natural history systems and laws.

19. There is conflicting genealogical data on the Catesby family; other sources name Nicholas Jekyll as Elizabeth's father; still others list Catesby's mother as Mary Jekyll.

20. See Stearns, *Science in the British Colonies,* 286.

21. See Lockridge, *Diary, and Life, of Byrd,* 17. Apparently Cocke and William Byrd II had studied together at Felsted, for Byrd once referred to "Dr. Cocke, my old school-fellow." *Secret Diary,* 194.

22. See "A List of the Encouragers of This Work" in the front matter of the *Natural History,* vol. 1, where Catesby mentions others in addition to Byrd who assisted him, including Alexander Hume, "*Mrs.* Holloway" and Sir John Randolph, both of Virginia, and Robert Johnson, governor of South Carolina. As to other connections, see Meyers and Pritchard, *Empire's Nature,* 3–7.

23. Byrd and Sloane, "Letters," 186.

24. In the eighteenth century, Byrd was not widely known for his writing. In addition to his diaries, letters, occasional witty character sketches, and other private writings, his published material included an early piece for the Royal Society, a book of light verse in 1719 titled *Tunbrigalia,* and in 1721 *A Discourse Concerning the Plague.* Perhaps his most important contribution was an account of Virginia published in John Oldmixon's *British Empire in America.* Oldmixon's work was first published in 1708, but it was not until the 1741 edition that the author acknowledged Byrd's contribution. See Pritchard and Sites, *William Byrd II,* 95.

25. In 1714, Catesby also sailed to Jamaica to collect flora and fauna.

26. *Natural History,* 1:v. See also Stearns, *Science in the British Colonies,* 594. Dale, a physician and botanist, received his medical degree from Leiden and lived in Braintree, Essex, Eng.

27. Catesby may have completed one or more of his final drawings based on renderings made in Virginia. As Margaret Pritchard has pointed out, in discussion with the author (Sept. 2010), the artist probably made preliminary sketches and watercolor studies of the dogwood flowers and leaves and the mockingbird in Virginia. After returning to England, Catesby likely used those sketches to complete the original picture shown in fig. 3.8.

28. See Meyers, "'Perfecting of Natural History,'" 14. Meyers makes the important observation that, although the Royal Society did not fund Catesby, the circumstances of Nicholson's announcement can be viewed as an implied approval of the expedition.

29. Stearns, *Science in the British Colonies,* 262–268. See also McCully, "Governor Francis Nicholson," 324, regarding Jones as well as Vernon and his son in Maryland in 1698.

30. Nicholson to Alban Thomas, 25 Mar. 1720/21, Royal Society, MSS Letters 1, 2N, no. 89, as quoted in McCully, "Governor Francis Nicholson," 325.

31. Sherard's influence in promoting Catesby was critical. Having accumulated a fortune as British consul at Smyrna prior to 1716, Sherard returned to England where he patronized many naturalists, including Catesby, and endowed the chair of botany at Oxford University. James Sherard, his brother, was noted for cultivating rare plants in his garden at Eltham in Kent (now part of London). Among other Catesby supporters were Charles Dubois; James Brydges, 1st Duke of Chandos; and Dr. Richard Mead.

32. See McCully, "Governor Francis Nicholson," 325. Nicholson was especially interested in documenting the flora and fauna in the colonies. He was familiar with and a benefactor to several botanists

and shared this interest with his friend in Virginia, Colonel William Byrd II.

33. Meyers and Pritchard, *Empire's Nature,* xv.

34. *Natural History,* 1:viii.

35. Weekley, "Early Years," 13.

36. Meyers, "'Perfecting of Natural History,'" 14.

37. Catesby, *Natural History,* 1:viii. Catesby indicated that he also put in this "Box" his dried plant specimens, seeds, "&c." as he collected them. Although the artist mentions only "an" Indian, he had the assistance of more than one.

38. Ibid., viii–ix. See also Frick and Stearns, *Mark Catesby,* 25.

39. See pages 150–151 for more on John and William Bartram of North Carolina and Pennsylvania. John Bartram married Anne Mendenhall, became a botanist, and established extensive botanical gardens outside of Philadelphia; he is the Bartram listed in Catesby's preface to volume 1 as one who provided encouragement. His cousin, Humphry Marshall, a botanist in Chester County, PA, led an expedition into the Carolinas and Georgia in the 1790s.

40. *Natural History,* 1:xi. Joseph Goupy, a French engraver, painter, and watercolorist, was a member of St. Martin's Lane Academy, London. See fig. 3.14.

41. Quoted from the original broadside, Chelsea Physic Garden, London, illustrated in McBurney, *Mark Catesby's "Natural History,"* 17.

42. See Meyers, "'Perfecting of Natural History,'" 23–24, wherein she notes that Catesby's signature alone appears on the plates of the first volume; the name of Georg Dionysius Ehret (1708–1770) appears on two plates for volume 2. Ehret was a German botanist and entomologist and one of Europe's most influential botanical artists; his first illustrations were drawn in 1735–1736 for Carl Linnaeus and the wealthy botanist George Clifford III. Ehret spent the last thirty-five years of his life in England. Catesby invited him to contribute to volume 2. Ehret made 2 of the 220 etchings; he also made several of the watercolors bound into the Royal Collection set. In addition to being influenced by the work of Maria Sybilla Merian, mentioned in n14, Catesby was influenced by Ehret and used some of his techniques in his later work, specifically three-dimensional modeling and compositions.

43. *Natural History,* 1:xi.

44. Alexander Garden to Carl Linnaeus, 2 Jan. 1760, in James E. Smith, *Selection of Correspondence,* 300–301. Dr. Alexander Garden, a physician, zoologist, and botanist, was born and raised in Scotland before moving to South Carolina in 1755. Garden corresponded frequently with John Ellis, a merchant and zoologist in London, and Carl Linnaeus in Sweden. For more about Garden, see page 148. See also Meyers, "Sketches from the Wilderness."

45. Catesby modeled his map on a portion of Henry Popple's map titled "Map of the British Empire in America with the French and Spanish Settlements Adjacent Thereto" printed in London in 1733. In "A List of the Encouragers of This Work" in volume 1 of *Natural History,* Catesby also named Popple as a supporter.

46. For additional information on Clayton, see Berkeley and Berkeley, *John Clayton.*

47. John Drayton passed on his interest in natural history to his son John Drayton (1766–1822), a South Carolina lawyer who served twice as governor. The son John translated Thomas Walter's 1788 *Flora caroliniana, secundum systema vegetabilium perillustris Linnaei digesta . . .* (London, Eng., 1788). Drayton's original 1798 manuscript translation, owned by the University of South Carolina, is titled "The Carolinian Florist; As Adapted (in English) to the More Ready Use of the Flora Caroliniana of Thomas Walter." Drayton mentions a general indebtedness to Catesby for his "imperfect descriptions of plants and flowers" but praises the work of William Bartram (as quoted in Gee, "South Carolina Botanists," 25).

48. Pritchard and Sites, *William Byrd II,* 1–20, 62. See also n24.

49. Thomas Coram, who also operated a shipbuilding business in Taunton, MA, from 1694–1705, spent the rest of his life in England. He was a great philanthropist who sponsored a colony for unemployed trades persons in Nova Scotia. In 1739, he received a charter from George II to establish the Foundling Hospital, which was built in 1742–1745 in Bloomsbury, London. William Hogarth, the artist, was among its first governors; together with other artists, Hogarth decorated the Governors' Court Room and donated paintings to the hospital. Today the Foundling Museum houses a portrait of Coram by Hogarth (fig. 6.20).

50. Urlsperger, *Detailed Reports,* 1–24.

51. E. von der Becke-Klüchtzner, *Stamm-Tafeln des Adels des Grokherzogthums Baden* (Baden-Baden, Ger., 1886) as quoted in Hvidt, *Von Reck's Voyage,* 13. Other biographical information about von Reck is derived from Hvidt as well.

52. Von Reck's use of the term "ocular proof" should not be confused with its interpretation by Catesby or other naturalists and philosophers of the period who believed that one must remain passive and disciplined, curbing all interfering thoughts and perceptions, when recording images of nature. In this sense, von Reck was not a passive or objective observer, and his images fall outside of natural history formal studies.

53. Two of these leaders were the ministers John Martin Bolzius and Israel Christian Gronau who left their instructor posts at the Francke Foundation in Halle to join the first Salzburgers that went to Georgia. The third official was John Vat, or Jean Vat, of Biel, Canton Bern, a Swiss who served as the secretary to the Ebenezer settlement and kept the accounts; he had come with the second transport. For more on Bolzius, see n54. For more on Vat, see n58.

54. See Hvidt, *Von Reck's Voyage,* 17–25. Von Reck had numerous

encounters with settlement leaders John Vat and, particularly, John Martin Bolzius. In the latter's writings, von Reck is described as hotheaded, irascible and angry, and threatening to the colonists. The artist was ill, collapsing with fever on Aug. 13, 1736 (23). "When his paroxysm was passed," Bolzius noted, "he had me called to him and announced [that]. . . . the people would not obey him . . . his authority had been greatly weakened, he was entirely useless here, and therefore he would resolve to go completely out of the country and to spend his life somewhere in tranquility." Urlsperger, *Detailed Reports*, 192.

55. Hvidt, *Von Reck's Voyage*, 24. Von Reck married a wealthy widow and lived out the remainder of his life in the town of Barmstedt, north of Hamburg.

56. Ibid., 137. Von Reck's Georgia memoir titled *Kurzgefasste Nachricht von dem Etablissement derer Salzburgischen Emigranten zu Ebenezer in der Provinz Georgien in Nord-Amerika* (Hamburg, 1777) has never been translated into English. That von Reck probably intended to publish it is evidenced by the fact that most of its drawings are numbered and have corresponding descriptive texts.

57. Broadly defined, a "busk" is the gathering of people for several days of ceremonial events. Von Reck may have attended the busk in Frederica when the Yuchi met James Oglethorpe, an event reported in the *New-York Weekly Journal* (New York), July 19, 1736. See Pitcher, "A Busk—An Indian Council."

58. John Vat worked as a recruiting agent with colonizer Jean Pierre Purry as early as 1725 and before he became involved with the Salzburgers. Purry had established an empirically based theory of climatology that revealed the best places for successful colonization. South Carolina was one of his selections, influenced as much by the politics of the day as by his peculiar theory. After years of negotiations and compromise with the British Board of Trade, Purry's experiment was approved, and lands were made available to Swiss immigrants.

59. See pages 193–208 for a discussion of Jeremiah Theus.

60. The English-born artist and naturalist John Abbott (1751–ca. 1840) came to America in 1773, settling first in Hanover County, VA. However, his principal work, an important resource for early nineteenth-century naturalists, was not published until 1797, well beyond the scope of this study. After spending nearly two years in Virginia, collecting and drawing insects, Abbott moved to Georgia, where he spent the rest of his life drawing and writing about that region's plants and animals.

61. Clifford and Zigrosser, "World of Flowers," 237. In addition to the few mentioned here, other collectors, chiefly botanists, visited the South before 1790, including André Michaux and his son François.

62. Queen Charlotte was an amateur botanist who helped establish the gardens at Kew, one of the royal residences located in southwest London.

63. Darlington, *Memorials*, 266, 268, 279, 285. See also Young, *Botanica Neglecta*, iv–viii.

64. Unless otherwise noted, biographical information on Bartram is from Waselkov and Braund, *William Bartram*, 1–21.

65. The full title of Bartram's book is *Travels through North & South Carolina, Georgia, East & West Florida, the Cherokee Country, the Extensive Territories of the Muscogulges, or Creek Confederacy, and the Country of the Chactaws; Containing an Account of the Soil and Natural Productions of Those Regions, Together with Observations on the Manners of the Indians* (Philadelphia, 1791).

66. Pritchard, "Protracted View," forthcoming.

67. The sublime is also associated with the romantic movement in art and literature that reached its culmination in the mid-nineteenth century. It too was a reaction against rational and scientific theory.

68. "Travels in Georgia and Florida," 138.

69. Ideas in this section are summarized from Michael Gaudio's perceptive discussion of Bartram's art in "Surface and Depth: The Art of Early American Natural History."

70. Ibid., 71.

71. As quoted in ibid., 68. Gaudio quotes these words from the literary historian Jay Fliegelman in his *Declaring Independence: Jefferson, Natural Language, and the Culture of Performance* (Stanford, CA: Stanford University Press, 1993), 2. In so doing, Gaudio makes the point that "this was a cultural revolution in which conventional modes of public expression were rejected and replaced with a new sincerity in self-presentation." Gaudio argues that Bartram's art reflects this natural language in which the "essential natures" of his subjects are "transparently upon the surfaces they presented to the world" (68–69).

72. Unless otherwise noted, information on Roupell comes from Rutledge, "After the Cloth Was Removed."

73. See n44.

74. Garden to Ellis, 6 May 1757, and Ellis to Garden, 25 Aug. 1759, in James E. Smith, *Selection of Correspondence*, 394, 461.

75. The Mazyck picture is in the Gibbes Museum of Art, Carolina Art Association, Charleston, SC. For more on Roupell and for a portrait of George Boone Roupell (1762–1838), his son, see McInnis and Mack, *In Pursuit of Refinement*, 120–121.

76. Information regarding Lassus is courtesy of Margaret Beck Pritchard, curator of prints, maps, and wallpapers, the Colonial Williamsburg Foundation (CWF).

77. In 1728, Le Bouteux also drew a map of the French settlement and surrounding Indian villages at Natchez in present-day Mississippi.

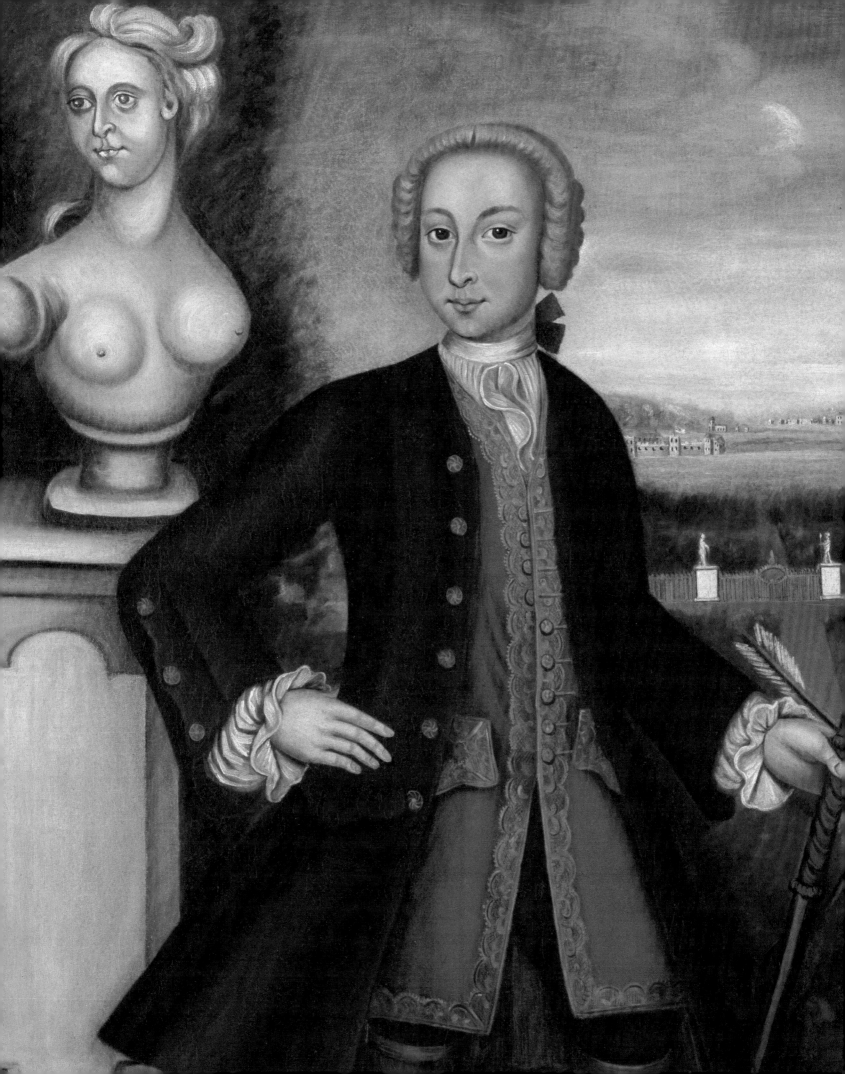

MANNER, is that habitude which painters have acquired, not only in the management of the pencil, but also in the principal parts of painting, invention, design, and colouring. It is by the manner in painting, that a picture is judged to be by the hand of [a given artist]. Some masters have had a variety in their manners, at different periods of life; and others have so constantly adhered to one manner, that those who have seen even a few of them, will immediately know them, and judge of them without any risque of a mistake.

MATTHEW PILKINGTON, 1770[1]

CHAPTER 4
A Taste for Art Emerges

Throughout much of the colonial period, the colonies of Virginia and South Carolina continued to dominate the South in political, social, and economic affairs and to serve as the centers of two distinct regions. Those parts of Maryland, Virginia, and northeastern North Carolina that lay closest to the Chesapeake Bay formed one cohesive culture, while southern North Carolina, South Carolina, Georgia, and northeastern Florida comprised another, often referred to as the "low country" (figs. 4.1– 4.4). Increases in both the planter and slave populations in the two southern regions resulted in increased numbers of farms and large plantations, most of which were situated on or near navigable waters. The econo- mies of both regions relied on coastal and European trade, but especially on trade with England, where profits from the colonies' cash crops could be exchanged for credit or cash and for a wide assortment of British supplies and goods. England continued to rule its Atlantic maritime empire. Its merchant-factors, entre- preneurs, and government had all invested heavily in settling and establishing trade with the North American colonies. Economic returns on these investments were expected, and indeed, proved to be impressive.

In the Chesapeake region, a small percentage of shrewd, slave-owning plantation families continued to acquire large landholdings and increased numbers of slaves, becoming wealthy in the process. They perfected the cultivation of tobacco for trade purposes,[2] built important contacts and credit abroad, and quickly emerged as colonial political leaders, forming a part of what has sometimes been called the South's "aristocracy." The Chesapeake region's greatest wealth resided in their hands, although the number of merchants and planters was on the rise. As far as their purses allowed, both groups surrounded themselves with expensive furnish- ings of excellent quality, built fine houses, entertained with music and dance, and dressed in a manner appro- priate to their stations in society. These affluent, materi- ally minded colonists usually owned portraits and other types of paintings.

The Chesapeake area's demographic makeup contin- ued to evolve. A steady increase in small planters,

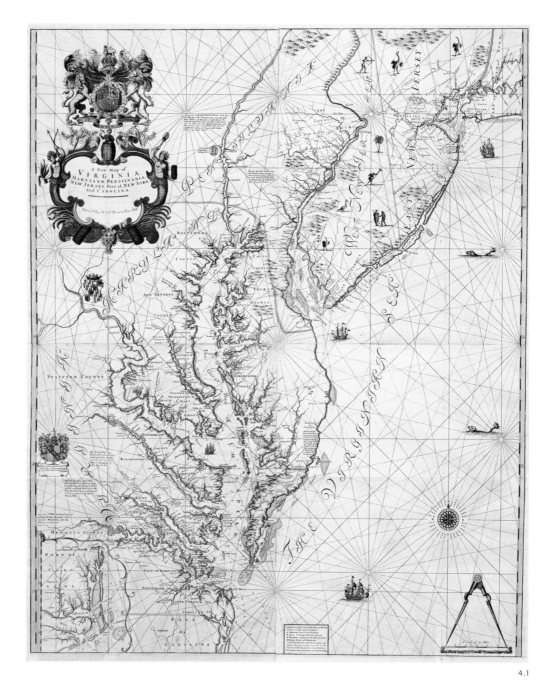

4.1

FIGURE 4.1. John Thornton, cartographer, and unknown engraver, *A New Map of Virginia, Maryland, Pensilvania, New Jersey, Part of New York, and Carolina*, ca. 1723–1728, ink on paper with period color, 42⅛" x 34⅝". Colonial Williamsburg Foundation, Williamsburg, VA.

The earliest version of this map was drawn by John Thornton (1641–1708) and first published about 1701. It was based on an earlier chart made by Augustine Herrman (1605/21–1696). The Perry family coat of arms can be seen at the lower left, accompanied by a dedication to Micajah Perry of the London firm of Perry and Lane, a large trading company of the seventeenth and eighteenth centuries specializing in fur and tobacco. Their tobacco trade was primarily with Virginia and Maryland.

The map illustrates the region surrounding the Chesapeake Bay, with the smaller bays, many rivers, and other bodies of water that emptied into the bay. Much of this water was easily navigable, and numerous private landings and ports were created for the purposes of shipping and transportation.

FIGURE 4.2. Detail of figure 4.1.

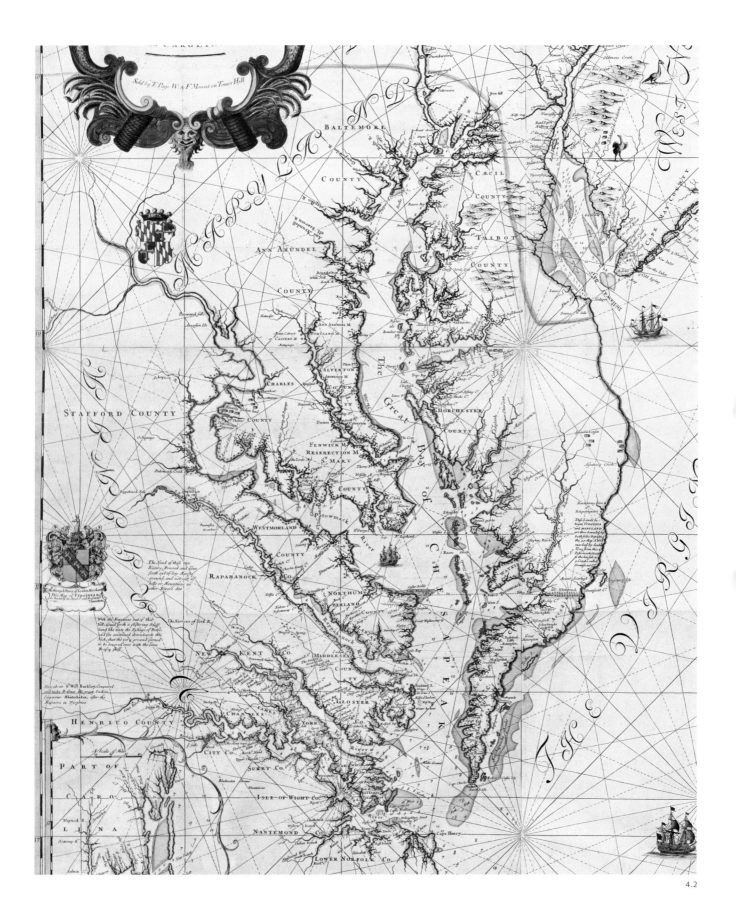

4.2

165

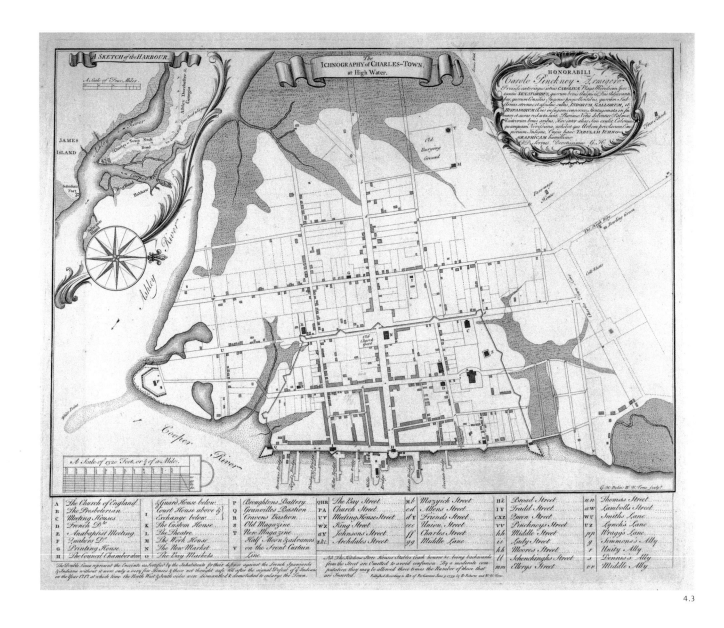

4.3

FIGURE 4.3. George Hunter (probably) and Bishop Roberts, *The Ichnography of Charles-Town. at High Water. A Sketch of the Harbour*, 1739, ink on paper, 17¾" x 21¹¹⁄₁₆". Courtesy of the Museum of Early Southern Decorative Arts (MESDA) at Old Salem.

George Hunter (d. 1755) was the surveyor general of Charleston at the time this plan was created. His sketches likely served as the basis for Bishop Roberts's final drawings that were sent to London engraver William Henry Toms (ca. 1700–ca. 1750). Charlestown was created in a grid pattern of streets centered around a plaza and, as noted in this map, was originally fortified for protection against the Indians, the French, and the Spanish. The fort

was later dismantled so that the city could expand along the design seen here. The waterfront saw much of the town's early development. For several blocks back, it was densely populated with buildings, and its wharfs projected into the harbor of the Cooper River. For more on George Hunter, see note 99.

FIGURE 4.4. Paul Fourdrinier (1698–1758), engraver, after the original drawing by George Jones (fig. 3.22), *A View of Savannah as It Stood the 29th of March 1734*, ca. 1734, ink on paper, 20⅛" x 27⅞". Colonial Williamsburg Foundation, Williamsburg, VA.

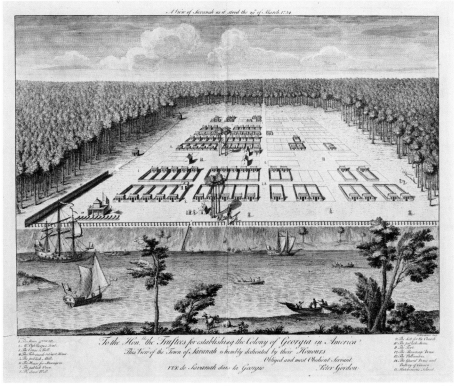

A View of Savannah as it stood the 29th of March 1734

To the Hon.ble the Trustees for establishing the Colony of Georgia in America
This View of the Town of Savanah is humbly dedicated by their Honours
Obliged and most Obedient Servant
VUE de Savannah dans la Georgie Peter Gordon·

4.4

tradespersons, and merchants constantly built up and replenished a consumer-based middle class, as upper middlings became part of the upper 5 percent. The growth in numbers of merchants and tradespersons was inevitable, for these folks were the ones who carried on and managed much of the transatlantic dealings. Many towns, most of which were still small, served as centers for colonial government as well as for retail establishments that offered imported goods and the products of trained artisans. All of this commerce was sustained by a complex system of credit and barter that met the needs of colonial consumers. Chesapeake towns also supported inns and taverns, postal services, printing shops, and many other services, though such amenities often lacked the sophistication of those in Philadelphia, Boston, and New York. During this period, the Chesapeake's major centers were Annapolis in Maryland and Norfolk and Fredericksburg in Virginia. Williamsburg, though somewhat smaller, continued to be an important place of business because it was still the capital of the Virginia Colony. Edenton and Newbern in northeastern North Carolina became the major port towns in that colony.

North and South Carolina functioned as one colony called the Province of Carolina until efforts to divide into two colonies began about 1712. "North" and "South" distinctions were made from 1712 on, although the two sections continued to be governed by the same proprietor until 1719, when difficulties between the proprietors and colonists resulted in the termination of the charter and the substitution of a royal government. South and North Carolina were each named a Crown colony in 1729. Like Virginia and Maryland, South Carolina experienced increases in population and trade that resulted in proportionately greater consumption of material goods by both the colonial upper and middle classes, whereas North Carolina's population grew more slowly. Similar systems of plantations with large tracts of farmland evolved in South Carolina and southeastern North Carolina, although the latter was more sparsely settled. Tar, turpentine, and deerskins were among the earliest trade commodities from both areas.[3] In South Carolina, these were soon outranked by what became the colony's chief cash crops: rice and, later, indigo. Since 1680, Charleston had been the colony's seat of government and

an important commercial center. By 1775, it had grown to be the largest city in the South and the fourth largest in the North American colonies. Many wealthy plantation owners also built handsome houses in Charleston, where they and their families lived during the warmest months of the year. Disease was a common fear among affluent families living on remote plantations where marshy fields, essential for rice crops, provided a natural breeding ground for malaria-carrying mosquitoes.

Charleston's economy developed rapidly during the first half of the eighteenth century as a result of the seasonal influx of plantation families, the trade generated by cash crops, and the businesses that supported consumers' needs. South Carolina's elite were acquisitive, purchasing fine objects both locally and from England to furnish their large town and plantation dwellings. They dressed in the latest fashions, frequented private clubs, and attended balls, festive assemblies, and other social events in Charleston. The colony's population was largely British, but its ethnic mix also included greater numbers of German, Swiss, and French settlers and of African slaves than did areas of the Chesapeake.[4] The influence of these groups is sometimes found in the region's material culture, such as furniture, but rarely in its paintings.

Both the rural and urban areas of the coastal South continued to be frequented by painters, although only a few of them are known by name and even fewer by their work. Wealthy clients often had painters visit their homes in town or travel to their plantations in the country. Painters usually rented rooms in town and often displayed samples of their work there. Little is known about those accommodations and whether they commonly included studio rooms, where clients could sit for likenesses, or simply served as lodgings for the artists.[5] However, when working for more distant customers who wanted multiple family portraits, the painters might stay several days with their clients. For each likeness, the oil painting process required at least two or three sittings.[6] The process also required about a six-month curing period for a painting to dry completely before being varnished and framed.[7]

References to painters in surviving records for the 1730s and 1740s are sparse, although a respectable number of "pictures" are mentioned in inventories and wills of the middling and wealthier classes. Occasionally, a bequest or listing of particular portraits is also mentioned, identified by the sitters' names. Most family likenesses were not listed in estate inventories. Some family portraits may have been given to loved ones before the owner's death, in which case they may have been considered private transactions, exempt from inventories.

In addition to family portraits, a small number of likenesses of royal monarchs and proprietors were present in the early South, mostly on display in Capitol buildings and the dwellings of governing authorities. Whether any of them influenced local painters is unknown, although the artist Charles Willson Peale commented on the portrait of Charles Calvert, 5th Lord Baltimore. Painted by Herman Van der Mijn (1684–1741) in London about 1732 (fig. 4.5), the Calvert likeness is large and exquisitely detailed. Peale saw the portrait when he was a boy, probably in the 1750s when it was hanging in the old State House in Annapolis. In 1766, the portrait of Frederick Calvert, 6th Lord Baltimore and the son of Charles Calvert, arrived in Annapolis and was hung in the "Council-Room, near that of his Noble Father" (fig. 4.6).[8] A royal portrait documented to the South is Sir Godfrey Kneller's (1646–1723) painting of Queen Anne (1665–1714) that was ordered by the Virginia Colony on February 23, 1702/03, the year she was crowned queen of England.[9] The picture, which had arrived in Virginia by April 21, 1704, was installed in the uncompleted Capitol building about that time. That portrait, along with those of King George II (1683–1760) and Queen Caroline (1683–1737), was also hanging in the rebuilt Capitol's Hall of Burgesses in 1777, according to Ebenezer Hazard, who saw all three of them in June of that year.[10] The likenesses of King George III (1738–1820) and Queen Charlotte (1744–1818) were also created for official display in Williamsburg. Painted in Allan Ramsay's (1713–1784) studio in England, they arrived in the colony during the governorship of Norborne Berkeley, Baron de Botetourt, which began in 1768. After Botetourt's death, the pictures were probably given to the colony by Henry Somerset, 5th Duke of Beaufort,

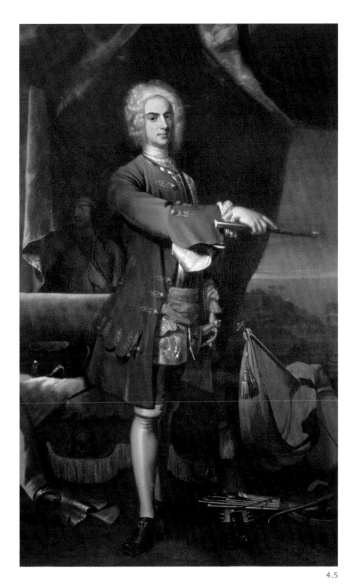

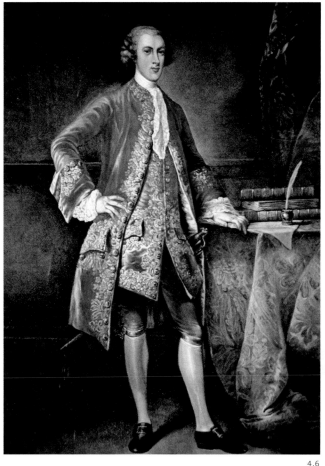

4.6

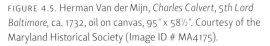

4.5

FIGURE 4.6. Unknown lithographer after Johann Ludwig Tietz, *Frederick Calvert, 6th Lord Baltimore*, date unknown, ink on paper, 88" x 58". Private Collection/Peter Newark American Pictures/The Bridgeman Art Library Nationality.

FIGURE 4.5. Herman Van der Mijn, *Charles Calvert, 5th Lord Baltimore*, ca. 1732, oil on canvas, 95" x 58½". Courtesy of the Maryland Historical Society (Image ID # MA4175).

At the death of his father, Benedict Leonard Calvert, 4th Lord Baltimore, in 1715, sixteen-year-old Charles Calvert (1699–1751) was awarded the powers associated with the Maryland charter. He traveled to Maryland for the first time that year, mainly to inspect his interests and to investigate a boundary dispute with the sons of William Penn. The disagreement was eventually settled in the Penns' favor. In 1767, well after Charles Calvert's death, a boundary between Maryland and Pennsylvania was established that became known as the Mason–Dixon line.

Johann Ludwig Tietz (d. 1793) was a German painter who created a portrait of Queen Charlotte (1744–1818) and possibly other members of the Hanoverian court. Little else is known about his work. Frederick Calvert (1731–1771), the last Lord Baltimore, inherited the proprietorship from his father, Charles Calvert (fig. 4.5). He never visited Maryland. He was known as a rake and his reputation was greatly damaged when he was tried for the rape of Sarah Woodcock, a milliner in London in 1768. Acquitted because of his rank, he left England and his wife, never to return. When he died in Italy in 1771, his son and heir, Henry Hartford, inherited his estates, including the proprietorship of Maryland, but Hartford could not inherit his father title because he was illegitimate. During the American Revolution, the state of Maryland was created, and Hartford's properties were seized in 1781.

Full-length portraits of each of the six barons of Baltimore survive. Although only the two portraits illustrated in this chapter were in Maryland during the lifetimes of their sitters, all six are now in the collection of the Enoch Pratt Free Library, Baltimore, Maryland.

Botetourt's nephew and primary heir, although another theory holds that the portraits were moved to the Capitol when John Murray, 4th Earl of Dunmore, (1732–1809) was appointed royal governor following Botetourt's death.[11] Murray is believed to have brought another pair of the monarchs' portraits to Virginia. Other royal family likenesses hung in the Governor's Palace in Williamsburg, and printed portraits of the monarchs and other royal subjects probably comprised some of the elusive "pictures" mentioned in inventories of colonial homes in Virginia and other areas of the South.

Most of the surviving paintings for this period, and written references to them, confirm that the colonists prized portraits of themselves and, occasionally, their European ancestors.[12] In fact, portraits were by far the most valued pictures, commonly saved because they recorded loved ones and provided testimonies to ancestral lineage, thereby preserving significant information for successive generations. Painted pictures other than portraits did exist during the 1730s and 1740s, though references to them are few and extant examples are exceedingly rare. Among the types mentioned are landscapes, seascapes, genre pictures, still lifes, and vistas of towns. Of those, some, if not most, were probably imported from abroad or brought with immigrating settlers. However, unless they featured a family home, oil and watercolor views probably had little intrinsic or extrinsic value, and so they were relegated to storage in attics, basements, and outbuildings before being discarded after years of environmental abuse.

The newly discovered view of Drayton Hall, the plantation built in South Carolina by John Drayton, is probably the earliest known view of a private residence in the South (fig. 4.7). Signed "P.E.D." and dated 1765 by the artist, Pierre Eugène du Simitière (ca. 1736–1784), the picture descended, along with twelve other views by the artist, in the family of Jeremiah Warden, a Philadelphia merchant, to the present owner. Du Simitière was a Swiss artist and naturalist who worked in the Caribbean Islands during the 1750s. He was passing through Charleston on his way to Philadelphia when he created the small view of Drayton Hall.[13] Prospect views of east coast towns were one type of painting that enjoyed modest popularity in the colonies throughout the eighteenth century. Bishop Roberts's view of Charleston was the first of several views of that city.

Bishop (d. 1739) and Mary Roberts (ca. 1715–1761) were a particularly talented husband and wife team in Charleston, South Carolina. His first advertisement appeared on May 17, 1735, listing his work as portrait painting, engraving, heraldry painting, and house painting.[14] No mention is made of Mary Roberts's painting at that time, but she was probably active as a miniature painter. Bishop Roberts must have done well in Charleston, for later that year he imported several slaves at the value of fifty pounds.[15] The next year he worked for the colony in the capacity of engraver, which involved "stamping Bills" or cutting plates for printing South Carolina paper money in the form of bills of credit.[16] Roberts also advertised that he executed landscapes suitable for chimneypieces in all sizes as well as "Draughts of their Houses in Colours [watercolors] or Indian Ink."[17] The chimneypieces or overmantel paintings were probably painted in oils, making them more durable for hanging above fireplaces, or they may have been painted directly on wooden panels later inset into architectural framing above the fireplace. Though examples of painted early southern overmantels are extraordinarily rare, one survives from a parlor originally in Morattico Hall in Richmond County, Virginia: a circa 1715–1725 overmantel landscape view of an unidentified manor house (fig. 4.8).

No chimneypieces by Roberts survive, although it was in 1737–1738 that he executed his large watercolor-and-ink view of Charleston harbor (fig. 4.9), from which William Henry Toms (ca. 1700–ca. 1750), the London engraver, made the plate for the more elegant printed version (fig. 4.10). The prints carry the provenance and publication date of London, June 9, 1739, several months before Roberts's death. They were pulled in London and shipped to Roberts, for at least some of them had been distributed by February 9, 1739/40, when the artist's widow, Mary Roberts, placed a notice in the *South-Carolina Gazette* (Charleston). She informed those who

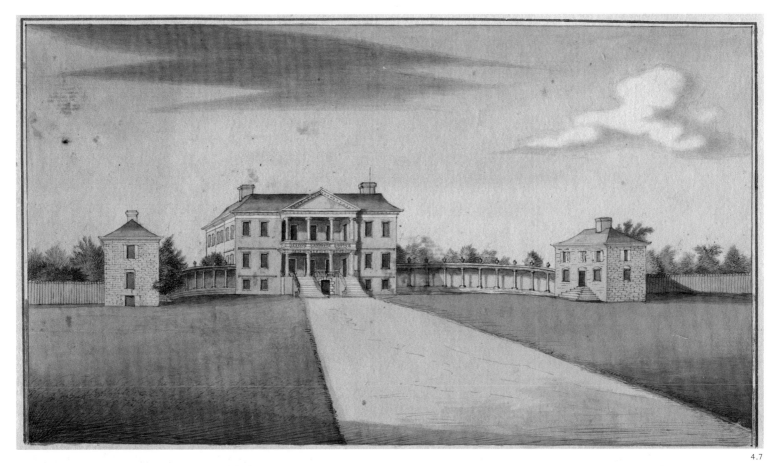

4.7

4.8

FIGURE 4.7. Pierre Eugène du Simitière, *Drayton Hall, South Carolina*, dated 1765, watercolor and ink on paper, 3⅜" x 12½". Courtesy of Jim Lockard.

Born in Geneva, Switzerland, Pierre Eugène du Simitière was noted as a portrait painter. A member of the American Philosophical Society located in Philadelphia, he was also known for his political cartoons. Having served on the committee that designed the Great Seal of the United States, he is credited with suggesting the motto *E pluribus unum*. He died in Philadelphia.

FIGURE 4.8. Artist unidentified, *Morattico Hall Overmantel*, 1715–1725, oil on wood panel, 20¹⁄₁₆" x 91¾". Courtesy Winterthur Museum.

Nothing is known about the hand responsible for this long panel picture that was installed over a fireplace as part of the original woodwork in Morattico Hall in Virginia. The overall modest quality of the picture indicates someone with limited training in decorative painting or possibly coach painting. The manor house seen at right in the view was probably inspired by or copied from an English print source.

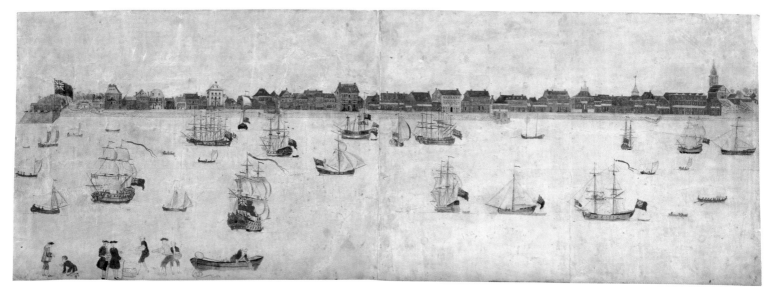

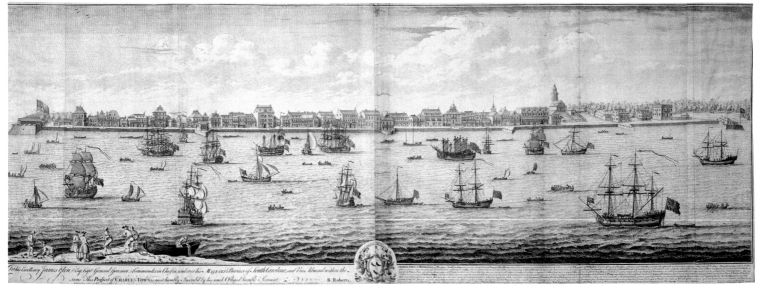

FIGURE 4.9. Bishop Roberts, *Prospect of Charles Town*, 1737–1738, watercolor and ink on paper, 15" x 43⅜". Colonial Williamsburg Foundation, Williamsburg, VA.

FIGURE 4.10. Bishop Roberts, painter, and William Henry Toms, engraver, *Prospect of Charles Town*, 1739, ink on paper, 19¾" x 55½". Colonial Williamsburg Foundation, Williamsburg, VA.

The Bishop Roberts and Henry Toms prospect is the earliest known view of Charleston, South Carolina. Published in London, it faithfully portrays a number of landmark buildings facing Charleston's busy harbor. The view compares favorably with the few other American scenes from this period, such as *South East View of the Great Town of Boston*, drawn by William Burgis (active 1717–1731) in 1725, revised by William Price (dates unknown), and engraved by John Harris (1686–1740) before 1740.

The harbor is filled with sailing vessels, mostly squared rigged brigs with smaller single- or double-masted sailing boats and rowed boats or barges. A great variety of smaller boats were needed to transport goods and passengers back and forth within the harbor.

had subscribed to the Charleston plan that she was the "Widow and Administratrix" of her husband's estate and said that the prints could be collected at her residence in Tradd Street. She also advised that persons who already had possession of the prints needed to pay for them. Roberts noted at the end of this ad that she did "Face Painting" and that she had several pictures as well as a printing press for sale.

Payments were not forthcoming from all subscribers, and, on August 16, 1740, Mary Roberts advertised again, this time listing the names of those who had not paid. A month later, she was selling articles from her husband's estate, including "sundry Picture[s] and Prints" as well as some of the views of Charleston. She probably did not sell her printing press, or, if she did, she had acquired another "Rolling Press" by 1743 when she posted this indignant notice in the papers:

> WHEREAS it has been reported that the Subscriber cannot print Copies off Copper Plates, &c. but at such Times as the Publick shall require the Use of her Rolling Press, this is to certify that the same is a manifest Falshood, for that she is ready and willing to serve all Gentlemen and others as shall be pleased to employ her for that Purpose.[18]

A rolling press was essential for pulling prints off engraved or etched copper plates. It consisted of a plank that carried the inked plate on which the sheet of paper was laid and then passed through the "press" by means of rollers. Roberts was apparently supplying printed broadsides and other pieces intended for public consumption. That she was willing to serve "all Gentlemen" suggests that engraved plates, and perhaps some woodcut blocks and the like, were owned by Charlestonians in need of a press. The possibility of such a practice is interesting—and as yet unexplored.

Bishop Roberts was capable of engraving as well as pulling the prints of his Charleston view on his press in Charleston, but he elected instead to have a well-known London engraver prepare them: Henry Toms, whose name would have made them more marketable both in America and abroad. But one wonders, too, if Bishop or

4.11

4.12

Mary might have colored any of the prints after their arrival in Charleston. Each was certainly proficient enough to do so, and Bishop had advertised working in watercolors in 1735. However, colored versions are not mentioned in any of their newspaper notices, and none have ever been found.

Roberts's panoramic view may have been influenced by Dutch print and painting scenes that proliferated in the seventeenth and eighteenth centuries. Some of those depict harbors and port towns, but most are devoted to battles, ship launchings, or, simply, portraits of ships. Printed town views, as well as harbor views of London, were also produced in England.[19] Judging from the physical evidence provided in Bishop's picture and the

FIGURE 4.11. Detail of figure 4.9.

FIGURE 4.12. Detail of figure 4.10.

information contained in his advertisements, it seems reasonable to conclude that he was a draftsman, trained in the use of pen and ink and watercolors and also, probably, in engraving. He may have had cartographic skills as well, and he likely owned a few engraved seascapes or harbor scenes that informed his approach to the Charleston view.

The original Roberts ink and watercolor (fig. 4.9) is obviously important because of its great rarity as the earliest prospect view of Charleston—and, in fact, one of the earliest views of any American city, whether in the South or elsewhere. It shows the town's eastern side across the Cooper River. Many of the buildings and landmarks can be identified, including Granville Bastion, the Court of Guard, St. Philip's Church, the Custom House and Secretary's Office, and the facades of fifty-two private homes. The harbor is filled with a variety of large and small sailing vessels of the type that would have served the increasingly busy trade of the seaport. In the lower margin of the Toms print (fig. 4.10), there are seven lines of descriptive text about the town and eight references to points of interest. One other resident of early Charleston, Peter Chassereau (active 1734–1745), might have been capable of similar views.[20] His 1734 and 1735 advertisements mention that he had arrived from London, did surveying work, made "neat" maps, drew plans and elevations of all kinds of buildings, and did perspective views or prospects of towns, houses, and plantations.[21] However, none of his work is currently known.

For many years, Mary Roberts's miniature painting was known by a single example, a privately owned portrait of Charles Pinckney (1699–1758) of Charleston signed "MR." Several other miniatures, including that of an unidentified woman of the Shoolbred family and another of a child of the Jones family of Charleston, have subsequently been attributed to Roberts.[22] In 2007, the Metropolitan Museum of Art in New York City purchased the most important body of work now known by the artist: five miniatures, all of which are signed "MR" in a manner identical to the signed Charles Pinckney likeness. They feature the children of brothers William and Henry Middleton of Charleston (figs. 4.13–4.17). The ages of the various children indicate that the likenesses

were probably painted late in the artist's career. Each of these small portraits displays skill in the rendering of anatomical detail. The brushwork is delicate, and the color is clear and well mixed. The subjects are uniformly pleasant although they are a bit formulaic and show little individualism. Roberts had probably received some training in England before going to Charleston. Miniature portraits were more popular abroad than they were in the colonies during these years, due chiefly to the scarcity of artists working in that medium. In Charleston, little likenesses were probably highly valued luxuries, affordable only to the wealthy.

Given the dearth of other painters working in Charleston in the early 1730s, one might conclude that the Robertses made a reasonable living from creating pictures; however, their advertisements also reflect the necessity of being versatile and willing to provide several kinds of painting services—portraits, house views, and chimneypieces that were probably landscape or pastoral views. Such services were in addition to pulling prints, engraving, and doing house painting, the last being the lowest form.

One other reference to Mary Roberts appears in Charleston records in the will of William Watkins. In 1747, Watkins, a local surgeon, left her fifty pounds to support and maintain her son, Mitchell Roberts, described in the will as being incapable of supporting himself.[23] Mary died in 1761 and was buried at St. Philips's Parish Church. Nothing more is recorded about her or her son, Mitchell.

The 1730s marked the arrival in the South of several painters who specialized in portraiture. Charles Bridges (1670–1747) was in Virginia by May 1735, and William Dering (active 1735–1755) had moved from Philadelphia to Virginia sometime between 1735 and 1737. Jeremiah Theus (1716–1774), who became a prolific painter for several decades, arrived in Charleston in the 1730s, as did Daniel Badger (1699–1786). The styles, levels of training, and successes of these painters varied widely. Of Bridges, Dering, Theus, and Badger, the most accomplished was Charles Bridges, who seems to have worked exclusively in Virginia. His career is discussed in Graham Hood's

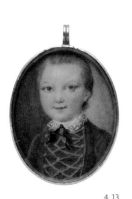 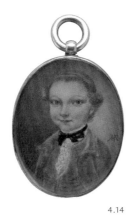 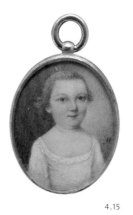 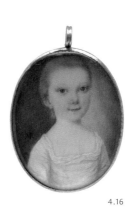 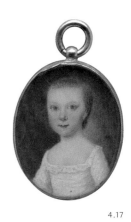

4.13　　　　　　　4.14　　　　　　　4.15　　　　　　　4.16　　　　　　　4.17

book *Charles Bridges and William Dering,* an important resource for anyone seeking not only to understand Bridges but also to grasp the complexities of successfully attributing a large body of mostly unsigned and thinly documented work to an early painter.[24]

Hood, and before him Suzanne Neale, identified the correct pedigree for Charles Bridges making it possible to say that his family was of high rank and that he was well educated. In fact, the artist's grandfather was the Parliamentarian Major Bridges of Alcester. His father, John Bridges, moved from Warwickshire, purchased the house known today as Barton Seagrave Hall, and served as sheriff of Northampton in 1675. The artist's brother, also named John Bridges (1666–1742), an antiquarian and a Fellow of the Royal Society, inherited the house. At his death, the house passed to William Bridges, another brother, who incurred large debts while completing renovations to the house originally begun by their father. The estate was forced into mortgage in 1733 and then passed out of the family.[25] A portrait of John Bridges the son was painted by Sir Godfrey Kneller in 1706 and later engraved by George Vertue (1684–1756).

Charles Bridges was christened at Barton Seagrave, Northamptonshire, on April 2, 1670.[26] His mother was Elizabeth Trumbull (Trumball) Bridges. The Bridges family has been described as "gentry," and several of the artist's close relatives were Anglican clergy. Probably as a result of these relationships, Bridges also became deeply involved in charitable and religious work, a common

pursuit for younger sons in wealthy English families. In addition, the Bridges family's early association with sparsely populated Warwickshire was another likely influence on Bridges, since it was there that the energetic Anglican priest Thomas Bray served in various capacities, including as chaplain to Sir Thomas Price.[27] Bray was especially interested in education, and, in 1698, he founded the Society for Promoting Christian Knowledge (SPCK), a philanthropic group devoted to doing missionary work in foreign lands, giving aid to the poor and uneducated at home and abroad, and assisting persecuted Christians. By 1699, his work had come to the attention of Henry Compton, bishop of London, who appointed him commissary to Maryland. Bray spent

FIGURES 4.13–4.17. Mary Roberts, *The Middleton Cousins,* ca. 1754, watercolor on ivory, each sight 1" x 1". Image © The Metropolitan Museum of Art/Art Resource, NY.

These were the grandchildren of Arthur Middleton of the Oaks and the children of brothers William Middleton of Crowfield in South Carolina and, after 1754, Shrublands in England and Henry Middleton of Middleton Place. William was the father of Henry (1752–1758) and William (1748–1774); Henry was the father of Hester (1754–1789), Henrietta (1750–1792), and Thomas (1753–1779). The miniatures were discovered in 2005 when Shrublands was sold. If the portraits were all executed about the same time, as presumed, the date must be close to 1754, the year in which Hester was born and William Middleton, her uncle, moved with his family to England.

several months in the colony learning more about the needs of the Church of England in America, specifically the need for libraries. Although the society he founded was at first small, consisting of Bray's like-minded friends and other philanthropists, it grew to include many wealthy and influential patrons with extensive social and political connections.[28]

Charles Bridges joined Bray's new society either in 1698 or within months of its formation, and, as one of its earliest members, would have attended meetings with its founder, Thomas Bray.[29] By 1699, Bridges was an active agent. Like other society members, he volunteered his time and money to promote education of the poor by supporting schools and libraries and by distributing religious books in an effort to convert nonwhite peoples in the West Indies and America to Christianity, an interest he later pursued in Virginia. In America, the society provided books and related support to clergy and schools, and it funded passage and provided supplies for several European Protestant groups relocating to the southern British colonies to escape religious persecution. According to Graham Hood, Bridges maintained close contact with the society until 1713 and assisted with the charity schools, numbering about fifty, in London and elsewhere during a portion of that time.[30]

Nothing is known about Bridges's artistic training, including when and with whom he trained, although Hood suggests a possible association with Charles Jervas (ca. 1675–1739), who succeeded Sir Godfrey Kneller as the principal portrait painter to Charles I.[31] It is the late Virginia portraits by Bridges that show the strongest stylistic relationship with the work of both Kneller and Jervas. Born in Ireland, Jervas went to London to study with Sir Godfrey Kneller and then traveled to Rome and Paris for additional studies. Interestingly, Jervas returned to London in 1709, about the time that Bridges may have returned from a possible first trip to the colonies.[32] Bridges was undoubtedly familiar with Kneller's work and style, as Kneller had painted his brother in 1706. The most striking similarities between Bridges's portraits and those of Jervas and Kneller are seen in the poses, many having landscape backgrounds, and the elaborate

expanses of dress fabric in female portraits. Other details, such as the hand positions with rather attenuated fingers and the pleasant, though slight, smiles, are also common to the work of all three artists. While Bridges's portraits are elegant by comparison with the offerings of other painters working in the South, they lack the flowing, graceful rendering associated with both Jervas and Kneller.

The name of Charles Bridges does not appear in the society's records for the twenty years between 1713 and 1733. Sometime after 1717, he was painting in Cambridge, England. Bridges probably continued to be involved in charitable work during that time, perhaps as a member of a related group called the Society for the Propagation of the Gospel in Foreign Parts (SPG), an organization founded in 1701 as a result of an inquiry on behalf of the bishop of London as to the state of the Church of England in the American colonies.[33] However, in 1733, Bridges wrote to Henry Newman, secretary of the SPCK,[34] saying that he felt a "strong inclination in himself to go to Georgia and should soon come to a Resolution."[35]

It is curious that a portrait painter in his sixties would want to go to Georgia, a place with few residents, a place that was not much more than a wilderness, unless he had some particular motive. The new colony of Georgia had been established in 1731. The first of its settlers arrived there in 1732 with General James Oglethorpe.[36] Other ships brought additional persons in the months following. Bridges and Oglethorpe shared numerous interests, particularly in educating the poor and "Instructing the Negroes."[37] In addition, both knew Thomas Bray, and both were members of societies he established.

About the same time, the Georgia trustees, several of whom were members of the SPCK, learned of Protestant expulsions that had left dissenters in Austria homeless. Through the efforts of Henry Newman and the trustees, negotiations between the SPCK and Salzburg leaders resulted in the plan to settle the dissenters in Georgia. The first group sailed from Dover, England, in January 1734.[38] In 1735/36, the SPCK funded the transporting and settling of an even larger number of exiled German Protestants in Georgia. Whether Bridges arrived with

one of those groups or one of the ships that brought colonists to Oglethorpe's new town of Savannah is unknown, but it is likely that he did, for, in 1735, he arrived in Virginia, from parts unknown, with his daughters and a son.

When Bridges first wrote to Newman in 1733 about his "inclination" to go to Georgia, he must have known the conditions there. However, if the artist did in fact follow through with his inclination, he chose not to remain in Georgia. Instead he settled in a more established place: Williamsburg, with its College of William and Mary presided over by a familiar church leader, Commissary James Blair (fig. 4.18). Virginia was the place in the South where the Church of England had its greatest authority. Commissary Blair's work in Virginia was well-known abroad. He had been a corresponding member of the SPCK since 1701, and his published sermons were of great interest to society members. Williamsburg was also the capital of the colony, an area where wealthy planters would welcome the services of a portrait painter, and Bridges undoubtedly needed to support himself and his children who accompanied him. He arrived in Virginia armed with letters of introduction to both the commissary and the lieutenant governor, William Gooch.

It is now clear that Bridges may in fact have been more familiar with the concerns of both the SPCK and the SPG in the colonies than scholars have thought. Furthermore, evidence gleaned from various sources poses the tantalizing possibility that Bridges may have visited the colonies prior to 1735—earlier than previously thought. While his correspondence from the 1730s suggests that he came to Virginia in no official society or church capacity, he may have hoped for an official appointment. Of particular interest is Bridges's relationship with Commissary Blair, whose portrait he painted about 1735. Henry Compton, bishop of London, had sent Blair to Virginia in 1685. Blair, Compton, and Bridges were all familiar with Thomas Bray and the work of both the SPCK and the SPG. Blair, who had enormous influence in matters ecclesiastical in the southern colonies, had married into the wealthy Harrison family of Virginia, and he had twice served as a member of the Governor's Council.[39] While Blair was but one of the colonial clergy who had close ties to Anglican leadership in England, he was among the most important. It is also of interest here that Edmund Gibson, then bishop of London, had furnished Bridges with a letter of recommendation to Blair, the Virginian who probably continued to befriend the artist until his death in 1743. What was Bridges's relationship with the bishop and the church?

An important nineteenth-century history of the church in Virginia uses the title "Rev." when mentioning Bridges.[40] Bridges may have been ordained or he may have served in some official capacity such as a curate or deacon in the colonies in previous times. In that case, his coming to Virginia in the 1730s would have been a subsequent trip late in his life. There was a Charles Bridges who was a clergyman or missionary funded by the SPCK in Boston, Massachusetts, in the early 1700s. That Charles Bridges was next in Narragansett (although the listing there is for a Christopher Bridges), where, in addition to problems regarding his salary, "the faults of his own temperament" contributed to making his stay "stormy." Presumably, that Bridges moved on to Rye "in New England."[41]

The only early Church of England parish associated with a town named "Rye" was in Rye, New York. That church has no record of a priest or curate named "Charles" Bridges. However, the ecclesiastical records for the state of New York indicate that a Christopher Bridge(s) became pastor at Rye in 1709 and a Thomas Bridge was inducted there in 1710.[42] Only those two Bridge(s) names are repeatedly found in the Rye records. A cursory search of other Anglican records for the colonies shows no one by the name Charles Bridges located elsewhere. "Stormy" Charles Bridges, presumably of Boston and Narragansett, managed to attract complaints, including one stating that he was not qualified to be a minister.[43] That complaint might have been more accurately phrased as he had not the "character" for such work. Charles Bridges the artist lamented in 1735 that he had not "sought for a Character" when he had the opportunity.[44] Was Charles Bridges, the artist, lamenting an earlier bungled opportunity as a representative of the church?

If the artist and the minister are one and the same, Bridges probably returned to England as early as 1708/1709, where he may have been encouraged to pursue an alternative career. He remained moderately active in church affairs, principally through the SPCK, enough so that Bishop Gibson recommended him to Commissary Blair in Virginia. Blair shared Bridges's interest in education, and the artist was aware of that mutual concern when he formed a 1735 proposal for educating the "poor Ignorant Souls among the Negroes" in Virginia. Hood provides a particularly clear discussion of the complex issues associated with the proposal. He notes that Bridges was careful to write that

> as to my own part I shall be glad to do any thing that is in my power to further it, and wish now I had sought for a Character when I had the opportunity, that might more effectually have helped me to promote it. But since I have no other design in this but the good of human Nature I hope by the direction of so good a Guide as my Bishop, my labour will not be in vain.[45]

The words "my Bishop" also suggest a formal relationship between Bridges and the Church of England. And, finally, the letter was assigned to the "Rev." Charles Bridges, a minister of St. Paul's, Hanover, according to

FIGURE 4.18. Charles Bridges, *Commissary James Blair*, 1733–1736, oil on canvas, 48⁹⁄₁₆" x 38⁷⁄₈". Muscarelle Museum of Art at the College of William and Mary, Williamsburg, VA.

James Blair (1656?–1743), who was born in Scotland, returned to England from Virginia in 1691 to petition for the establishment of the College of William and Mary, which was chartered in 1693. The following year, King William appointed him as a member of the Virginia Council, for which he served as president from 1740 to 1741. Charles Bridges's portrait of Blair was one of his most important commissions. Blair stands in front of a window overlooking the college's first building—the oldest college building in the United States, later named after Sir Christopher Wren (1632–1723), the famous English architect who was at one time credited with designing the building.

Bishop William Meade's 1857 book, *Old Churches, Ministers and Families of Virginia*.[46]

A letter recommending Bridges to William Gooch, the lieutenant governor of Virginia, from Gooch's brother, Thomas, then master of Caius College, Cambridge, and canon of Canterbury and later a bishop, further exemplifies Bridges's connection with Anglican leadership in England. The lieutenant governor in Virginia responded that he had met the artist and had promised to sit for a portrait by him but added that "it looks a little odd for a Governour to shew so much favour to a Painter" and described that "favour" as including the loan of a coach to move Bridges's belongings, along with his children, to Williamsburg.[47] William Byrd II also alluded to Bridges's birth into a gentry family when he wrote that Bridges was "a man, of a Good Family" who, having lost his resources "by the Frowns of Fortune, or his own mismanagement, is obliged to seek his Bread, a little of the latest in a Strange Land."[48] "Mismanagement" would ordinarily suggest that Bridges had either squandered his inheritance or, more likely, had lost favor with his source of income, probably the church or SPCK. However, it may also allude to the want of character noted for Bridges earlier in his life.

The wealthy and educated Byrd considered himself a man of discerning taste. He was indeed a connoisseur of art, as evidenced by his extensive painting collection and his firsthand knowledge of England's top portrait painters. In fact, he had already engaged Kneller or someone in Kneller's studio to do his own portrait (fig. 2.30). Byrd probably did patronize Bridges in the truest sense, not only commissioning him to do portraits of his children but likely encouraging others to commission Bridges for portraits as well. Byrd wrote later that Bridges lacked "the Masterly Hand of a Lilly [Lely], or a Kneller, yet, had he lived so long ago, as when places were given to the most Deserving, he might have pretended to be serjeant Painter of Virginia."[49] Byrd's words are puzzling. He suggests that Bridges, had he lived in Virginia sometime earlier, might have claimed to be its highest-ranking painter, and yet there is no evidence of a painter, one equaling Bridges's skill, working in Virginia

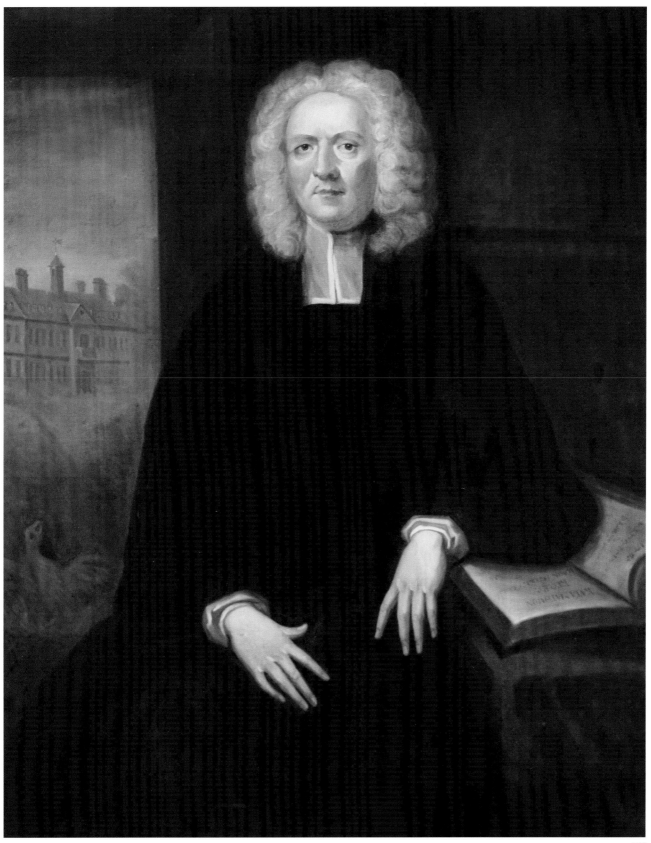

either before 1735 or during his visit. For all intents and purposes, Bridges *was* the colony's first "serjeant Painter."

Hood makes various references to events in the artist's life in Williamsburg, Virginia, including the death of his daughter Mary during the summer of 1736 and his rental of property in Williamsburg through part of 1737,[50] the year in which he moved to Hanover County, as indicated by his advertisement in the *Virginia Gazette*:

> *Whereas one Box, mark'd* C.B. *about 4 Feet square, and 14 Inches deep; and one other Box, mark'd* C.B. *about 5 Feet long, 1 Foot wide, and 1 Foot deep, were brought by Capt. Bolling, from England, last Year, for the Subscriber, living in Hanover County, and cannot be heard of by him: These are to request the Favour of the Person who has them in Possession, to give Notice to him, or to the Printer hereof, where they are, and they shall be handsomely satisfy'd for their Trouble, by*
>
> Charles Bridges.[51]

Bridges had accounts with Hanover local merchants, and two of his children were living with him in 1739 and 1740.[52] However, except for his work as a "Rev." for St. Paul's, there would have been little reason to move there. The town, a small crossroads with few portrait clients, would not have served the promotion of his art. Judging from the few surviving portraits of this period, his clients could as easily have been served from Williamsburg as from Hanover. The same is true of the work he did for the Caroline County courthouse, for which he painted the royal arms during these years.[53]

The last known reference to Bridges in Virginia is for October 1743 when he was listed in the accounts of Francis Jerdone, a Hanover County merchant. It is believed that the artist left the colony sometime in 1744, after completing a portrait of Mann Page II and another of Page's wife holding their first child (figs. 4.19 and 4.20).[54] According to references obtained by Hood, the artist returned to England where he died; he was buried on December 18, 1747. One other reference to "Mr. Charles Bridges" in England appears in George Vertue's notebook the year before.[55]

Any analysis of Bridges's painting must be prefaced by Graham Hood's observations as to the condition of the surviving portraits assigned to the artist. Only a few are in fine condition, while many more have suffered considerable damage due to age and inexpert, none-too-gentle restorations. This damage makes assessing Bridges's painting method, his level of skill, and his idiosyncratic style challenging at best. Hood was the first scholar to tackle this problem by bringing together a group of portraits that are remarkably consistent in their various characteristics. Three other portraits are recognized by Hood as possibilities.[56] Because they may not be by Bridges, they are not considered in this discussion. In addition, the portrait of Anne Byrd that Hood attributed to Bridges is now thought to have been painted in England; the likeness of William Byrd III is probably not by Bridges but by an unidentified painter. What is important is a comparison of the artist's reliably attributed or documented pictures that are in the best condition and that span the course of his career. Those are the best sources for understanding his training and later development.

The earliest portrait work documented to Bridges exists in five painted versions, all presumably by the same hand. The subject is the Reverend Thomas Baker (fig. 4.21), fellow of St. John's College, Cambridge, who lived most of his life at the college, except for a short period as rector of Long Newton in the diocese of Durham. Baker then returned to St. John's College, but, because he, like many other clergy of his day, refused to swear the oath of loyalty required by William III, he lost first his rectorship and then his fellowship. He continued to live at the college, however, and he built a huge collection of books and manuscripts that he left to St. John's. Bridges's portraits were created after 1717; one of them presumably served as the basis for the mezzotint engraving by John Simon (1675–1751).[57]

The Baker likenesses appear to be highly finished, with sure brushwork that is well controlled and modeled. At first glance, the smooth transitions of tones between highlighted and shaded areas seem to indicate considerable practice and knowledge of studio technique, but these features may stem as much from overcleaning as from Bridges's early painting style. The pictures' compromised condition and their early date, nearly twenty years

preceding the artist's Virginia portraits, make the Baker portraits difficult to assess. Bridges must have executed other commissions by this time, but, unfortunately, no other English paintings by him have been identified to aid in any comparison.

Bridges's portrait of Mrs. Mann Page II and child (fig. 4.20) serves as an important key in this discussion because it bears a nineteenth-century inscription that probably copies the artist's eighteenth-century one now hidden beneath the lining canvas on the verso of the picture. It is the only known Bridges portrait that can be associated with his signature. The subject is shown in a three-quarter seated pose, facing front with her body slightly turned; her child is standing at her right knee. For the most part, the anatomical drawing in this portrait is correct, although there are mannerisms peculiar to Bridges's personal style that affect the accuracy of the likenesses; these are discussed a little later. What is important to observe in this painting and the companion portrait of Mann Page II, as well as in other pictures by Bridges, is the artist's ability to consistently create convincing, fashionable likenesses through sophisticated studio skills and prescribed techniques he learned in England.

In the Page and other portraits, including those of Commissary James Blair (fig. 4.18) and John Bolling Jr. (fig. 4.22), Bridges achieved convincing spatial relationships among forms and also gave them a sense of volume. His familiarity with formats and compositions common to English portraiture is consistently evident—and at least partially responsible for his rendering of convincing depth. Bridges also imbued his sitters with ease, gracefulness, and elegance, qualities that were associated with gentrified manners and deportment that all good portrait painters were expected to capture, if not create. While these attributes were important to southern clients, they were rarely fully achieved by other painters working in the colonies before the 1750s. Thus, Bridges's paintings must have seemed especially appealing to his clients.

The artist was not obsessed with small details—such an obsession being a common failing in the work of lesser-trained painters—but rather painted the strong highlights of silks and satins and the soft textures of velvets in a painterly manner, with quick, accurate brushwork born of experience and practice. These features do not dominate but are subordinate to the whole composition. It is his understanding of what makes a pleasing whole effect, coupled with his ability to achieve that effect, that make Bridges's work so successful and enjoyable to view. His compositions and his selection of varying shades of colors, often rich blues and reds, are also nicely balanced. In most instances, his paint colors are carefully laid on and worked to create light and shadow—and thus a convincing depth.

The likeness of John Bolling Jr. demonstrates the artist's skill in rendering faces. The planes of the sitter's face are well defined and carefully modeled, and the coloring is

FOLLOWING PAGES:

FIGURE 4.19. Charles Bridges, *Mann Page II*, probably 1744 or early 1745, oil on canvas, 45½" x 35½". Muscarelle Museum of Art at the College of William and Mary, Williamsburg, VA. Gift of Dr. R. C. M. Page. Photograph courtesy of the Colonial Williamsburg Foundation, Williamsburg, VA.

Mann Page II (1718–1778) married twice, first to Ann Corbin Tayloe and next to Alice Grymes, who is seen in figure 4.20. Two of Mann Page II's children were painted by John Wollaston Jr. and are illustrated in figure 5.21.

The Pages lived in Gloucester County, Virginia, on a large plantation known as Rosewell. Built by Mann Page I, the father of the sitter, Rosewell was second only to the Governor's Palace in Williamsburg in architectural sophistication and size.

FIGURE 4.20. Charles Bridges, *Mrs. Mann Page II and Child*, probably 1744 or early 1745, oil on canvas, 45½" x 35½". Muscarelle Museum of Art at the College of William and Mary, Williamsburg, VA. Gift of Dr. R. C. M. Page. Photograph courtesy of the Colonial Williamsburg Foundation, Williamsburg, VA.

The portrait of Mrs. Mann Page II (Alice Grymes, 1723–1746) and her child (probably John Page, 1743–1808) is one of the most important works by the artist, not only because of its size and elegance but also because it bears what is probably a copy of an original inscription on the back of its canvas support. The copied inscription makes the portrait indispensable in assigning other works to Bridges.

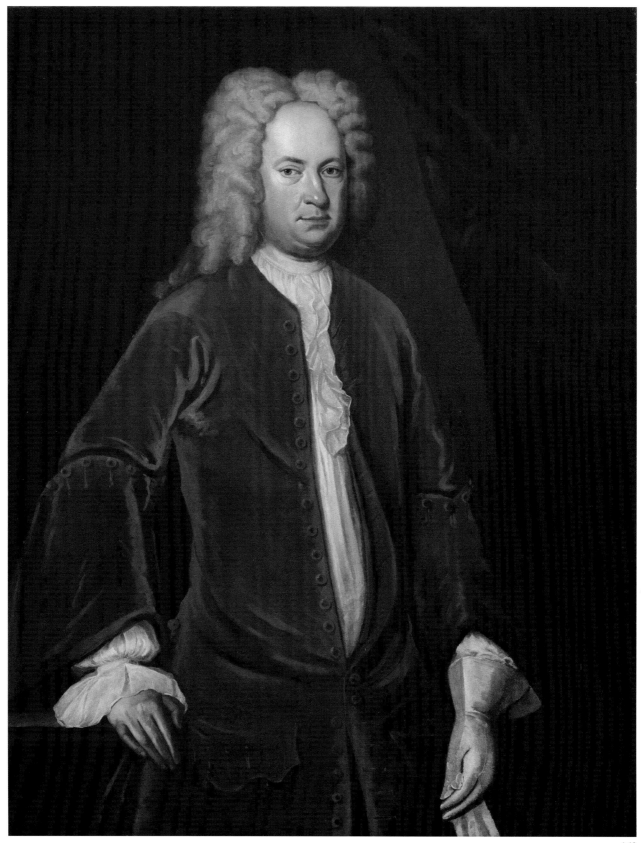

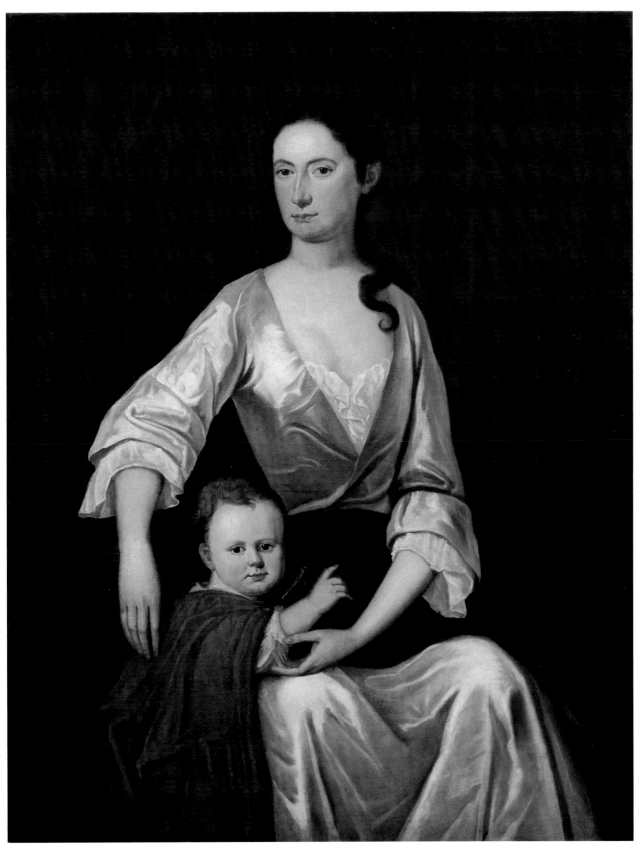

4.20

4.21

FIGURE 4.21. Charles Bridges, *The Reverend Thomas Baker*, after 1717, oil on canvas, 30⅛" x 25". Bodleian Library, LP 240.

Graham Hood identified five versions of this picture but believes this to be the original portrait of the Reverend Thomas Baker. For an illustration of the engraved portrait by John Simon, see Hood, *Bridges and Dering*, 12, figure 1.

FIGURE 4.22. Charles Bridges, *John Bolling Jr.*, ca. 1740, oil on canvas, 30⅛" x 25⅜". Muscarelle Museum of Art at the College of William and Mary, Williamsburg, VA. Gift of Mrs. Robert Malcolm Littlejohn.

The portrait of John Bolling Jr. (1700–1768) is the best of the surviving paintings by Charles Bridges. Its fine condition documents the artist's skill, and the painterly quality of his brushwork is at its best—fine modeling and highlights made graceful and natural by quickly yet carefully placed paint in the execution of various textures, as seen in the rendering of the buttons, the hair, and the attractive blue jacket. These areas are fluidly painted, more suggestive than precisely delineated, but, when viewed at the appropriate distance, they are lifelike and tactile.

superb. Bridges was adept at mixing and layering skin tones, and he was particularly good in using appropriate warm colors for shading on the nose and lips, under the chin, on the far side of the face (away from the light source), and at the hair or wig line. The stylistic relationship between Bridges's and Jervas's work is readily apparent in these areas and in the use of muted highlights for velvet. For comparison, see Jervas's portrait of Dorothy, Viscountess Townshend (fig. 4.23). However, like all painters, Bridges had an idiosyncratic way of drawing faces, hands, and other elements. In Bridges's case, one of these idiosyncrasies is the strong lighting on noses, making them seem in some cases disproportionately long. Such mannerisms, not evident in all of his paintings, may represent nothing more than problems with condition or slight changes in his drawing. Otherwise, the heads are well formed and erect, the eyes slightly slanted, and the hair softly defined (see fig. 4.24).

The portrait of Commissary Blair is notable for Bridges's subtle handling of details and his sensitivity especially towards those details that had symbolic or iconic meaning for the sitter. Hood has provided an in-depth discussion of this that needs not to be repeated here, other than to note that Blair had been instrumental in bringing financial stability and growth to the College of William and Mary, seen through the window over the sitter's shoulder, and that the Bible, in Greek, is turned to a passage that had inspired one of the sitter's sermons published in London in 1722. Additionally, as Hood points out, the view of the college (from the southeast) is from a window in the Brafferton, a charity school for the education of Indian children constructed in 1723 and administered by the college.[58] Blair would have been proud of that school and its mission, and Bridges would have shared his enthusiasm for educational philanthropy.

Nearly all of the known portraits currently assigned to Bridges represent members of Virginia's wealthy planter families, often second to fourth generation descendants of earlier settlers whose financial circumstances had been far less impressive. Most of his sitters and their parents amassed their fortunes in the colony through

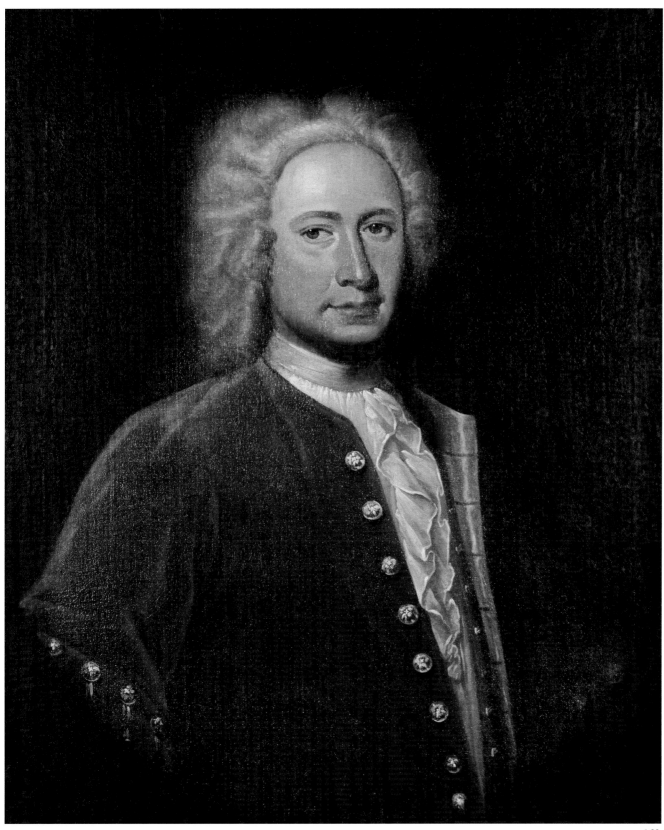

4.22

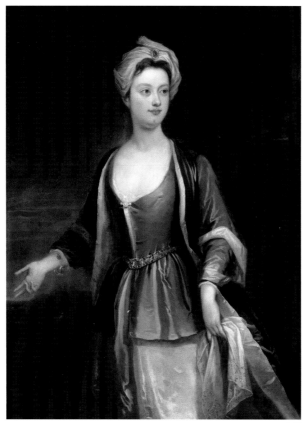

4.23

FIGURE 4.23. Charles Jervas, *Dorothy, Viscountess Townshend* (1686–1726), ca. 1715, oil on canvas, 48¾" x 36¼". © National Portrait Gallery, London.

FIGURE 4.24. Charles Bridges, *Boys of the Grymes Family*, probably 1735–1740, oil on canvas, 45" x 50". Virginia Historical Society.

Charles Bridges painted two appealing double portraits of the children of John Grymes and Lucy Ludwell Grymes of Brandon in Middlesex County, Virginia. The paintings were unusual for the southern colonies at this time in both composition and size, but they reflected a taste that was common among English gentry. Behind his young sitters, Bridges created landscape settings that suggested the family's plantation holdings and wealth.

Seven children were born to the Grymeses. Other than the fact that two boys are represented here and two girls appear in the other portrait, little is known about their identity. One daughter, Sarah, and a son, Charles, were both deceased before Bridges arrived in Virginia. The remaining three girls were Hannah, Lucy, and Alice. The last was painted as an adult by Bridges; she married Mann Page II (see figs. 4.19 and 4.20). The surviving Grymes boys were John (1718–1740), Benjamin (1725–1776), and Ludwell (1733–1795). Benjamin and Ludwell's birth dates seem to reflect the approximate ages of the children in the portrait.

cash crop farming and trade, particularly the tobacco trade. There was certainly an attractive quality to Bridges's work, but the timing of his arrival in the colony was also propitious, for the competition was limited—if it existed at all—and the number of potential clients living in the colony was significant by the 1730s and 1740s. The only other painter known to visit and live in Virginia at that time was William Dering, who came probably two to three years after Bridges. Dering's skills, obviously limited by inexperience and minimal if any professional training, were far inferior to those of Bridges.

Given the sparse information available, it seems plausible that Dering received some drawing lessons as part of a genteel education, for he himself was learned, and he circulated among Virginia's learned upper class with ease.[59] The inventory of his household furnishings and other references indicate that he strove to maintain the trappings of a fashionable gentleman's lifestyle. Dering consistently advertised as a dancing master in Philadelphia, Virginia, and, later, South Carolina. His wife also earned income for the family through her teaching.

Dering's first advertisements were in Philadelphia. On April 17, 1735, his notice in the *Pennsylvania Gazette* (Philadelphia), which stated that he "now divided" his dancing school into separate sessions for beginning and advanced students, indicated that he had arrived in the city sometime before that date.[60] In the same paper on February 19, 1736, about ten months later, Dering noted that classes in "Writing, Dancing, Plain Work, Marking, Embroidery, and . . . French" were given at his house on Mulberry Street. Those lessons were probably taught by both Dering and his wife. By June of that year, he had moved to a Front Street address where the jeweler Michael Cario, from London, also worked.[61] About that same time, Dering advertised in local Philadelphia papers for his runaway horse.[62]

Dering's first advertisements as a "Dancing-Master" in Virginia appeared November 25 and December 2, 1737, when he promoted dancing classes "*according to the newest* French *Manner, on* Fridays *and* Saturdays *once in Three Weeks*" at the College of William and Mary.[63] The Derings were probably living twenty-five to thirty miles

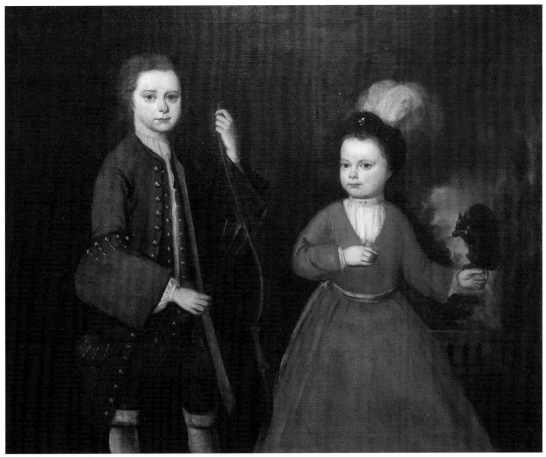

4.24

away in Gloucester County, Virginia, at the time. Hood notes that a debt suit entered in the York County court for 1739 listed the artist as "Wm. Dering" also called "J. Wm. Dering of the County of Glosr [Gloucester]."[64] This is the earliest indication of the financial woes that would plague Dering until his departure from Virginia in the 1750s. The only other reference to the artist's presence in Gloucester comes from the Register of Abingdon Parish Church, which records for October 8, 1738, that "William, son of Mr. William and Sarah Dearing, was baptized."[65] Apparently, Dering moved back and forth from his residence in Gloucester in order to work in Williamsburg and outlying areas, possibly staying in Henry Wetherburn's tavern during a portion of the time.

Perhaps the most remarkable association that Dering cultivated was one with William Byrd II. Byrd's diary reveals that between July 3, 1740, and July 31, 1741, Dering visited Byrd on fourteen different occasions, often staying with him. One diary entry refers to "Dance day" at "Mr. Cary's," an event to and from which Byrd rode in "Mr. Dering's chair." Dance days at outlying plantations were likely regular events and may have precipitated some of the visits mentioned in Byrd's diary. However, the relationship between the two men seems to have encompassed common interests. At Byrd's home on March 1, 1741, for instance, Dering played the French horn. Moreover, Dering sometimes took Byrd the latest newspapers, walked with him, and "at night told stories." Byrd also noted that he "showed Dering my prints."[66] Byrd would also have shown him his impressive library and collection of paintings, and he would have discussed the paintings with him. In addition, as will shortly be seen, Dering may also have had family connections with the sitters in two of the portraits: Sir Robert Southwell II (1635–1702) and Sir

John Perceval (1683–1748). Byrd's surviving diaries end in 1741; he died in 1744, and the relationship between the two men probably continued until then.

The artist purchased his Williamsburg residence and its contents in August 1742, and, by May 1744, he had mortgaged that property and the contents of the house to Bernard Moore, possibly of Chelsea in King William County, and Peter Hay, a physician in Williamsburg.[67] As Hood has noted, the mortgage was assumed by Philip Lightfoot in 1745 and, at his death, by his son and heir, William Lightfoot. Dering's inability to pay off the property mortgage probably became a central reason for his departure from Williamsburg in 1750.[68]

A comparison of the household inventories submitted with these transactions reveals that Dering had acquired or brought with him a significant number of furnishings, some considered luxury items. Also notable are references to materials associated with paintings or prints, including, for 1744, eight pictures in gilt frames, nine in black frames, and ten without frames. A 1745 inventory taken just one year later indicates that Dering owned forty-four pictures, a paint box, some gold and black frames, and a large hair trunk containing about two hundred prints. As Hood points out, this may have been the large box that was previously owned by Charles Bridges who left the colony sometime during 1744.[69] The inventory also mentions two large tablecloths to fit tables in the Capitol, which is where Dering held balls in 1744. Presumably these cloths were for the refreshment tables.[70]

There are also other legal references to Dering, including the suit brought against him by "Theos. Pugh" on June 17, 1745, and another by the John Blairs Sr. and Jr., in which the artist is listed as "I [or J] Wm. Dering" of Williamsburg, "Gent."[71] During March, September, and October 1746, Dering continued to advertise balls and assemblies in the Williamsburg *Virginia Gazette*.[72] Other references to him appear on February 22 and September 21, 1747, when his household was named on Dr. John de Sequeyra's smallpox list and on a tithables list, respectively.[73] De Sequeyra (fig. 4.25), who had his portrait painted by Dering about this time, indicated that five people in Dering's dwelling had recovered from smallpox; and the tithables list indicated that six people in Dering's household qualified as taxable persons, that is, all males sixteen years of age and older and all African-American women sixteen years and older. Dering would have been the sole family member who qualified since his son was only nine years old; the other five were probably servants or slaves, representing an expensive investment. Finally, an undated reference found in the Essex County Orphans Book for 1731–1760 includes this entry: "To Betty Smiths Entrance to dances Mr Deering 1:16:6 1737 Mar 14."[74]

In addition to the mortgage held on Dering's property in 1749–1750 by William Lightfoot, several other court and debt transactions are recorded for the years 1749, 1750, 1751, and 1754.[75] Hood found references to the artist's account with John Mercer, a Stafford County lawyer who lodged with the Derings when he was attending General Court sessions in Williamsburg. Mercer's accounts show that in May 1749, he provided Dering with "sundry Paints"; in exchange, Dering was to draw his portrait at the cost of £9 2s.[76]

FIGURE 4.25. William Dering, *Dr. John de Sequeyra*, 1745–1750, oil on canvas, 23½" x 19⅜". Courtesy Winterthur Museum. Bequest of Henry Francis du Pont.

Dr. John de Sequeyra (1712–1795) was born in London to a Portuguese family and earned a degree in medical studies in 1739 from the University of Leiden in Holland. In 1745, he immigrated to Virginia, where he practiced medicine until his death in 1795. In addition to serving the townspeople, de Sequeyra was appointed visiting physician at the Public Hospital, an institution for persons with mental illness built in Williamsburg in 1771 (Gill, "Dr. de Sequeyra's 'Diseases,'" 295).

The elaborate painted canvas in which the sitter stares through a stone porthole with a shelf holding books, a journal, writing utensils, and other objects was surely copied from or inspired by a British print of an earlier portrait since this type of setting was out of style by the 1740s. The effect is thus dramatic and unusual compared with other Virginia portraits of the same period. Dering seemed to relish such occasional quirkiness in his work, reflected also in the portrait of young George Booth (fig. 4.27). In the de Sequeyra painting, however, the sitter's body is actually very simple in its straightforward waist-length pose with no hands showing, with only the flourish of drapery placed over his shoulder.

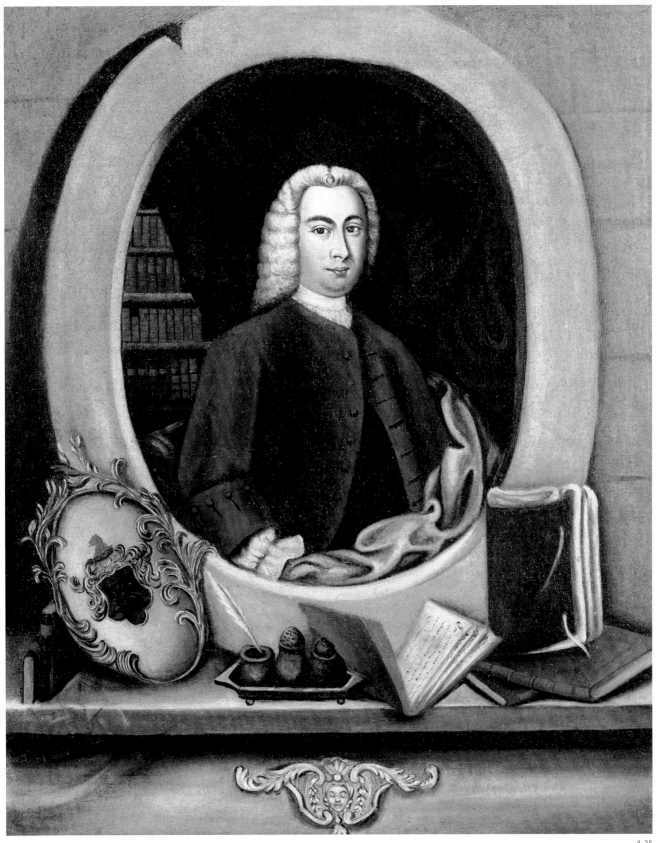

Despite his unresolved debts—or perhaps because of them—by December 1749, Dering either had moved permanently or was in the process of moving.[77] On the 11th of the month, he and Nicholas Scanlan (Scanlon), a dancing master of Charleston, South Carolina, advertised a ball in the *South-Carolina Gazette* (Charleston). Dering was probably still in Charleston when, in Williamsburg, John Blair recorded in his diary that the day was "Cloudy & cold p.m. at M.rs Derings outcry [public auction],"[78] at which she was selling the family's personal property. Whether she and her son ever joined her husband in Charleston is unknown, and other Charleston references to the artist are few though one is particularly curious. On May 20, 1751, John Blair Jr. of Williamsburg wrote to Lewis Burwell, acting governor of Virginia, about two criminals, Seal and Lowe Jackson, who had been indicted for counterfeiting but had escaped from Virginia:

> Lowe Jackson went to North Carolina, and shipt himself there for Barbadoes, but being driven in again by a violent Wind repurchased his Horse, and got to Charles Town in South Carolina . . . having mett with his Acquaintance Mr Deering (who had a little before gone from hence) he readily acknowledged to him the Occasion of his coming. Mr. Deering it seems accosted him with a How now Mr Jackson what brings you here? Is it any Thing of the old Affair? . . . and he was forced to fly from Justice; and in Confidence of his then Safety confessed to Mr Deering he had coined an hundred [doubloons] . . . Bird [James Bird had been sent to Charleston to get the Governor to apprehend Jackson.] upon the Trial made Oath here, that he was present when Deering made Oath to this Purpose before a Magistrate in Charles Town upon which Jackson was committed to Prison.[79]

Dering continued to live well beyond his means in Charleston. On May 6, 1751, he again mortgaged personal property to a long list of townspeople, including the cabinetmaker Thomas Elfe, the dancing teacher Nicholas Scanlan, and many others. His debt amounted to £1,026 10s. 5 3/4d. and included such expensive items as six mahogany silk bottom chairs, two mahogany tea tables, a mahogany table with three leaves and backgammon

tables, and various pieces of china.[80] References that are probably to William Dering are also contained in the manuscript catalog of the collections belonging to Sir Hans Sloane, bequeathed by him to the British nation in 1753.[81] It is known that the material came to England before 1753. Unfortunately, no exact dates of receipt were given, but the items mentioned include the following: "1485 An Indian fann made of canes some colored black, from Carolina, by Mr. Dering" and "1371 A Cherekee Indian garter made of the ravelings of the cadene [a sort of inferior Turkish carpet imported from the Levant] they buy of the English. From Mr Dering of South Carolina."[82]

Dering may have had relatives in Charleston as at least one other person with the Dering surname was living there: William Cholmondeley (Cholmeley, Colmondley, Cholmedy) Dering (Dearing). That person was of age by October 31, 1758, when he married Elizabeth Ellinger at St. Andrew's Parish, Charleston. An interesting aspect of the Dering name is its possible association with Henrietta de Beaulieu Dering Johnston, whose first husband, Robert Dering, was the son of Edward Dering, 2nd Baronet, and Mary Harvey Dering of Surrenden, Kent. The family intermarried with the Cholmeleys.[83]

The name Cholmeley (and its variants) was uncommon in the North American colonies. William Dering the dancing master/artist may well have been related to the English Derings of Surrenden, Kent, and thus to Henrietta Dering Johnston. William Dering was fluent in French, knew music and dance extremely well, could draw, and was conversant with the sophisticated William Byrd II and other well-heeled families in Virginia. These facts suggest that he was an educated person familiar with music and with fashion—as were the English Derings.[84] His lifestyle, his social contacts in Virginia, and a reference to him as a "gentleman"[85] also suggest that Dering's origins were genteel. Moreover, the fact that Dering's debts were due in large measure to the items he purchased for his homes, first in Virginia and then in Charleston, indicates that he was a person accustomed to fashion and comfort. There is no evidence that he painted in Charleston, and there are no specific references to him, his family, or his dancing classes after 1751.

However, at some unknown point in time, he may have gone to Jamaica. In June 1766, a marriage notice in a Charleston newspaper read, in part, as follows:

> From Jamaica we learn that Mr. William Dering, of this province, was married there on the 25th past to the widow of George Alpress, Esq.; possessed of a fortune of 4,000 l. Jamaica money per annum, during her natural life; and that she was unfortunately drowned the 29th, . . . by which her whole estate devolves to an only son of Mr. Alpress.

A week later, on July 7, another notice appeared with a correction: "In our last, for 'Mr. William Dering,' read Mr. Cholmondeley Dering, married to the widow Alpress, &c."[86] The confusion about the names suggests, once again, some relationship between these men.

Of the paintings that have been assigned to Dering in the past, this study supports only those of Dr. John de Sequeyra (fig. 4.25), Mrs. Mordecai Booth (fig. 4.26), her son George Booth (fig. 4.27), Anne Byrd Carter (Mrs. Charles Carter) (fig. 4.28), and Mrs. Drury Stith (fig. 4.29). The portrait of Mrs. Drury Stith is signed "AEtatis Suae 50" at lower left and "W. Dering" at lower right and serves as the basis for the current attributions.[87]

Dering's style was basically a watered-down and naive version of the Knelleresque, flatter and somewhat awkward in both the drawing and painting of forms and anatomy. Dering understood the concept of chiaroscuro, or the use of contrasting light and dark, to achieve a sense of volume. However, his ability to lay in light and dark colors and then blend them to create three-dimensional form was limited. Instead, his shadows are muddy, probably due to the repeated application of wet-on-wet paint. Oil paints were always meant to be worked wet on wet, but, in early portrait painting, it was essential that they be minimally worked or blended. The "torturing" of the paint, as some artists call it, usually resulted in overly dark or dead shadows that appear hard-edged and lack subtle transitions in tone. A minimally trained portrait painter like Dering would often compensate by piling on additional paint or brighter colors, just as he did in painting the flesh tones and some other areas of George

4.26

Booth. Such unschooled handling of paint varies in degree from painting to painting and artist to artist because artists with little or no training experimented constantly with techniques, attempting to imitate the work of studio-trained painters. Dering's portraits also

FIGURE 4.26. William Dering, *Mrs. Mordecai Booth*, 1748–1750, oil on canvas, 49¹¹⁄₁₆" x 39⅛". Courtesy of the Museum of Early Southern Decorative Arts (MESDA) at Old Salem.

Mrs. Mordecai Booth (Joyce or Judith Armistead, 1710–1770) was the wife of Mordecai Booth (1703–1775) of Ware Neck, Gloucester County, Virginia, and the daughter of William Armistead (1671–1711) of Hesse, according to family descendants, who also name her as the mother of George Booth (fig. 4.27). The drawing and painting of her head is nearly identical to that of Mrs. Stith (fig. 4.29). She holds a snuffbox in her right hand and leans on a marble slab-top table similar to examples known to have been in eighteenth-century Virginia although Dering likely borrowed his example from a print source.

reveal a limited understanding of linear perspective; his sitters seem very close to the viewer and appear somewhat detached from their painted settings. The features of Dering's sitters are generally pleasant, but anatomy was difficult for the artist. Mrs. Booth's proper left arm and hand appear to be suspended in space, and neither is appropriately delicate for a woman of her social standing.

Dering's portraits of Anne Byrd Carter and Dr. Sequeyra share many of the characteristics discussed here, but it is in the portrait of the young George Booth that Dering's imagination comes fully into play. Booth proudly stands centered between two highly evocative female busts on plinths. His youthful prowess with a bow and arrow is demonstrated by a small dead bird held in the sharp teeth of his equally small canine companion. The reference to such manly pursuits was appropriate for young boys' portraits. While the presence of any sculpture in American colonial painting is rare (though see also fig. 2.49), busts of this sort are not only unusual, they are unique. Although we do not know what garden and buildings are shown in the background of this portrait, their configuration seems specific enough to be a real place. Both of the Booth portraits illustrate Dering's proclivity for full-length, gentrified portraiture. They also illustrate the charm of his aesthetic, even if that aesthetic is naive.

One factor explaining why Dering would not have pursued painting in Charleston was the presence of a long-established—and better—painter: Jeremiah Theus. The Theus family had arrived from Switzerland with other immigrants to Orangeburg Township of South Carolina on July 19, 1735. By September, Simon Theus, the father of the artist, was issued a land grant there for 250 acres and a town lot number I, 264.[88] The acreage was based on the number of persons in the Theus family, presumably five, including the mother, the father, and the three sons who are documented in South Carolina. In 1957, the art historian Louisa Dresser discovered additional genealogical information about the family. Simon, the father, had married Anna Alser (Walser, Wolser) in Chur, Graübunden, Switzerland, in 1715. The family included four sons and two daughters: Jeremiah

4.28

FIGURE 4.27. William Dering, *George Booth*, 1748–1750, oil on canvas, 50¼" x 39½". Colonial Williamsburg Foundation, Williamsburg, VA.

Probably born about 1720, George Booth died in 1777. He grew up in Gloucester County, Virginia, where William Dering had lived for a brief period before moving to Williamsburg. Although naive in its rendering, the pose and setting make the portrait one of the most pretentious of its time.

FIGURE 4.28. William Dering, *Anne Byrd Carter* (Mrs. Charles Carter), probably 1742–1746, oil on canvas, 50" x 40". Colonial Williamsburg Foundation, Williamsburg, VA. Gift of Mrs. E. Alban Watson.

Anne Byrd (1725/26–1757) married Charles Carter of Cleve in 1742, several years after William Dering arrived in Virginia. The Carters lived near the Governor's Palace and directly across from Dering in a house that was later owned by (and is now named after) Robert Carter III, a relative (see frontispiece) (Hood, *Bridges and Dering*, 109). Anne Byrd Carter was portrayed again in 1750–1755 in a painting by John Hesselius that includes two of her children.

4.29

(1716–1774), the artist; Christian (1717–1793 or after); Simeon Jorg (Simon) (1720–1760); Margareta (b. 1718); Jorg (b. 1723); and Elsbeth (b. 1724).[89] Dresser also indicated that Simon the father may have been a painter, for he is called "Master" in Swiss records. Of course, that term could apply to many other professions, and South Carolina records for the father do not provide any information. By the mid-eighteenth century, the extended Theus family in South Carolina was large, and its members were very much a part of their communities, chiefly in Charleston and at Monck's Corner.

In 1739, the artist's brother Christian Theus was ordained a minister by the Charles Town Presbytery; he moved to Saxe-Gotha, below Columbia and near the Congaree River, where he served a congregation until his death sometime in 1793 or after.[90] Both Christian and Jeremiah were acquainted with the famous German Lutheran pastor Henry Melchior Muhlenberg, who was sent to North America as a missionary.[91] In 1750, brother Simeon Jorg Theus opened a store and tavern in Charleston that failed after a couple of years of operation; he returned to Monck's Corner, worked as a vintner, married in 1754, and died in 1760, leaving a son, James, and a daughter, born after her father's death, whose name is not known. Jeremiah Theus was one of the executors of Simeon Jorg's estate.[92]

Jeremiah Theus was an adult and fully trained as a painter when he arrived in America. His first advertisement was published in the *South-Carolina Gazette* (Charleston) on September 6, 1740:

Notice is hereby given, that Jeremiah Theus Limner is remov'd into the Market Square near Mr. John Laurens Sadler, where all Gentlemen and Ladies may have their Pictures drawn, likewise Landskips of all sizes, Crests and Coats of Arms for Coaches or Chaises. Likewise for the Conveniency of those who live in the Country, he is willing to wait on them at their respective Plantations.

Where Theus was living in Charleston before this is unknown, but his new address placed him in a busy mercantile section of the town where various trades were

carried on and most residents were probably of similar middle-class social and economic status.[93] Middleton's research indicates that Theus married twice, first to Cathrina Elizabeth Shaumlefall, the seventeen-year-old daughter of John Shaumlefall, on January 13, 1741.[94] There were six children from this marriage: Mary (b. before 1742); Elizabeth (b. March 8, 1743); John (b. January 31, 1745); Jeremiah (b. ca. 1748–1780); Simeon (dates unknown); Anne (dates unknown); and a seventh child who may have died with the mother on November 8, 1754. Cathrina Elizabeth was alive earlier in the year when the Theuses entertained Israel Christian Gronau, another well-known Lutheran pastor, in their home. His second wife was Mrs. Eva Rosanna Hilt (née Ainslie), the widow of George Hilt and, before that, a Mr. Mortimer. Children from their circa 1755 union included Samuel, George, Charlotte Dorothy, and Mary, all minors when the artist died in 1774. Nothing further is known about those offspring.[95]

The artist's second advertisement, which appeared in the *South-Carolina Gazette* (Charleston) on October 22, 1744, read as follows:

This is to give Notice, to all young Gentlemen and Ladies inclinable to be taught the Art of DRAWING, That an Evening School for that Purpose will be opened on the first of *November,* next, at my House in *Friend street,* where every Branch of that Art will be taught with the greatest exactness by *Jeremiah Theus,* Limner.

The advertisement gave a new address for the painter, one situated not far from the first. The addition of drawing classes probably indicates that Theus wanted

FIGURE 4.29. William Dering, *Elizabeth Buckner Stith* (Mrs. Drury Stith), 1745–1750, oil on canvas, 30" x 22". Colonial Williamsburg Foundation, Williamsburg, VA.

Because the portrait of Elizabeth Buckner Stith (b. 1695–1700) is signed by William Dering, it served as the basis for attributing the Booth portraits and eventually helped to determine other attributions to the artist. The inscription reads, at lower right, "W. Dering" and, at lower left, "AEtatis Suae 50." The subject was from York County, Virginia.

more work to support his large family. He purchased his last residence for two thousand pounds on September 25, 1755, about the time of his second marriage. This property, located in a more affluent neighborhood, was more impressive, consisting of two lots and a sizable brick dwelling at the corner of Mazyck (now Logan) and Broad Streets in the northwest end of town. The house, two stories with a Dutch roof, was described in considerable detail by Theus eighteen years later when he advertised it for sale.[96]

Among the painter's community interests in Charleston was his membership in the South Carolina Society, sometimes known as the Two-Bit Society, where, in 1748, he served as junior warden. The group took an interest in education, and it offered assistance to widows and orphans of its members. Theus's religious affiliation during his lifetime was not entirely consistent. He was a Lutheran when he arrived. He was listed among the members and supporters of the Independent Congregational Church of Charleston on January 17, 1750, along with the painter Daniel and cabinetmaker Jonathan Badger, both from New England,[97] and later he owned a pew at St. Michael's Church, an Anglican congregation, in Charleston. He was paid £77 10s. for work he completed at St. Michael's on November 28, 1756, whereby, among other things, he "gilded the dragon vane . . . and [affixed a] representation of Satan with the golden lightning rod of the Archangel [Michael], stationed this emblem of the conquest over evil on the highest point in the city, the summit of St. Michael's steeple."[98]

Other references to Theus include his serving as a juror in the Court of Common Pleas in 1769; his acting as a witness to various wills; in the case of George Hunter's will,[99] his being the recipient of an "Ox Eyed Camera" (figs. 4.30 and 4.31), a mechanical device used in drawing;[100] his being paid for work for the Commons House of Assembly in 1742, work that included his creating an unidentified item for the Cherokee War; his serving the province of South Carolina in 1750 as a German interpreter; and, in 1751, his "copying a plat of the Cherokees and painting and glossing two large constables' staffs." Sometime later he was also paid for

preparing a map or plat of the Cherokee country,[101] perhaps making a copy or reversed version of his 1751 plat. The latter two references are rare and important allusions to the artist's cartographic skills.

The painter died on May 17, 1774, and he may have been buried at St. Michael's, although such a burial is difficult to prove in the absence of a gravestone and without the church's registry, which was destroyed during the Civil War. Theus's will, fully discussed in Middleton's volume, lists a large number of expensive material goods and considerable real estate, some inherited, some purchased.[102] Theus was well-off when he died, ranking among the most successful of his peer artisans in Charleston. The notice of his death in the city's papers stated that he was "a very ingenious and honest Man . . . who had followed the Business of a Portrait-Painter here upwards of 30 Years."[103] The emphasis given to his profession as a portrait painter without mention of other branches of his trade is important, indicating that his easel art was his chief occupation or, at the very least, that his portraiture was seen as more important than his other work as a painter or limner.

The nature of Jeremiah Theus's training in Switzerland prior to coming to South Carolina remains unresolved. He probably trained with a "painter," one who executed a variety of work that included easel art. Because of similarities between his work and that of a peer, Elias Gottlob Haussmann (1695–1774) (fig. 4.32), Middleton suggested Haussmann's father, Elias Haussmann (1663–1733), as one possibility.[104] Another candidate is Johann Joseph Kauffman (1707–1782) (fig. 4.33), who frequently worked in Chur in Graübunden, Switzerland, Theus's hometown. A man of modest means, Kauffman was a skilled painter who traveled for work, suggesting that he offered a range of painting services, as did the South Carolina artist. He was also the father of the famous female artist Angelica Kauffman (1741–1807).

Some art historians have described Theus's style of painting as "northern baroque"—whatever that means. Most of the notable Swiss and Austrian painters who specialized in portraits and stylish canvas art were trained in France; some also trained in London and

4.30

FIGURE 4.30. Denis Diderot and Jean Le Rond d'Alembert, *Dessein*, *Chambre Obscure* (Illustrating the Veiled Chamber), ink on paper, as illustrated in *Recueil de Planches, sur les Sciences, les Arts Libéraux, et les Arts Méchaniques, avec leur Explication*, "Dessein," plate v, published in Paris, 1763. Special Collections, John D. Rockefeller, Jr. Library, the Colonial Williamsburg Foundation, Williamsburg, VA.

A camera obscura (also called a veiled chamber or ox-eye camera) is an optical instrument used in drawing. Although theories and proposals for such devices can be traced as far back as Euclid's *Optics* (ca. 300 BCE), actual mechanisms were not commonly used until they were adopted in the fifteenth century by such artists as Leonardo da Vinci (1452–1519). By the seventeenth century, they were probably more common although scholars continue to debate this point. Eighteenth-century improvements included making the device more compact and portable. It therefore became quite useful to surveyors such as George Hunter in Charleston and artists such as Sir Joshua Reynolds (fig. 4.31) and Paul Sandby (1731–1809), the English engraver and artist famous for his aquatint landscape views. Theus's specific use of the camera is unknown but his association with it suggests that he may have been producing landscapes and other views.

FIGURE 4.31. Maker unidentified, Camera Obscura owned by Sir Joshua Reynolds, probably made in England in the mid-eighteenth century. Science Museum/SSPL.

Sir Joshua Reynolds (1723–1792) was probably one among many artists in London who found the camera device helpful. Other artists who worked in the American South and who owned such equipment include John Hesselius, Cosmo Alexander, and Charles Willson Peale. Thomas Jefferson owned two or more cameras obscura during his lifetime, including one he purchased in Philadelphia in 1773 from David Rittenhouse, also a friend of Peale, and another he bought in 1805 from Learmonths and Berry, Merchants, in London. One of these instruments is on view at Monticello, Jefferson's Virginia estate.

4.31

4.32

4.33

FIGURE 4.32. Elias Gottlob Haussmann, *Johann Sebastian Bach* (1685–1750), 1748, oil on canvas, 30½" x 24¾". Stadtgeschichtliches Museum Leipzig.

There is a tradition that this picture or an earlier 1746 version was painted as a requirement for Elias Gottlob Haussmann's membership in a music society organized by Lorenz Christoph Mizler von Kolof (Koloff), the well-educated German amateur composer and mathematician who also studied law and medicine. Only a few late portraits by Haussmann seem to have survived, making a comparison with Theus's work extremely difficult. This example does not show a strong relationship with Theus's portraits.

FIGURE 4.33. Johann Joseph Kauffman, *Bildnis des Carl von Büren, Oberst in der holländischen Schweizergarde* (Portrait of Carl von Buren, Colonel in the Dutch Swiss Guard) (1731–1787), 1779, oil on canvas, 36¼" x 30½". Archive, Dorotheum Vienna.

Johann Joseph Kauffman's portraits, like those of Elias Gottlob Haussmann, are difficult to locate for comparison with Theus's work. It is observed and tentatively suggested, however, that a stylistic relationship between Theus's and Kauffman's portrait paintings is stronger than one between Theus and Haussmann.

Venice. Theus, however, was probably trained locally in a watered-down version of the international baroque style that is best described as provincial. He continued to work in this basic style throughout his lifetime, although his palette was lighter and his poses were updated towards the end of his career to reflect the rococo tendencies introduced by John Wollaston Jr. and possibly others.

Theus's portrait of Mrs. Peter Manigault (Elizabeth Wragg) (fig. 4.34) was evidently created as a companion to the likeness of her husband, painted by Allan Ramsay in London in or just after 1751 (fig. 4.35). The story of those companion portraits is but one revealing example of how the wealthiest southerners went about commissioning their likenesses. The choice of Ramsay is also intriguing, for Theus seems to have been inspired by Ramsay's work though whether Theus had seen some of Ramsay's paintings or knew his work through prints is unknown. It should be noted, however, that Theus borrowed some poses and other costume details from other London artists, including Francis Cotes (1726–1770).

The Manigault portrait story began on August 2, 1750, when Peter Manigault wrote his mother, Mrs. Gabriel Manigault (Ann Ashby), from England, saying that "M^r Corbett[105] thinks I had better stay till the Winter, before I have my Picture drawn, he also thinks it had better be drawn at full Length, and that twould be throwing away Money, to have it drawn at half Length." On November 1, 1750, Manigault wrote again to his mother, informing her that he was sending her by ship

> two Busts, which were designed for me, you'll judge how like they are, I have no Thoughts of having my Picture drawn, till I hear whether you'll have it full length, which I should like best; if my Friend M^r Rutledge thinks one of the Busts worth his Acceptance, he will do me a Pleasure by taking one of them.

In another of Peter Manigault's letters written from London to his mother several months later, on April 15, 1751, he described his portrait, which had been completed by Allan Ramsay, asking her to show it to Theus when it arrived, thereby getting his opinion of

my Picture, which comes by this Opportunity. Tis done by one of the best Hands in England, and is accounted by all Judges here, not only an Exceeding good Likeness, but a very good Piece of Painting: The Drapery is all taken from my own Clothes, & the very Flowers in the lace, upon the Hat, are taken from a Hat of my own; I desire M^r Theus may see it, as soon as is convenient after it arrives. I was advised to have it done by one Keble [fig. 4.36], that drew Tom Smith, & several others that went over to Carolina, but upon seeing his Paintings, I found . . . his Likenesses . . . were some of them very good, yet his Paint seemed to be laid on with a Trowel, and looked more like Plaistering than Painting. . . . As Theus will have an Opportunity of seeing both [Manigault's and Smith's portraits], I'll be extremely obliged to you, if you'll let me know his Judgment; You'll also tell me if you think any Part of it to gay.[106]

In 1755, the year he and Elizabeth Wragg were married, Manigault commissioned Theus to paint his wife's portrait as a companion to his own. The picture was completed in 1757, as indicated by the artist's inscription.[107] Prosperous and socially prominent, Elizabeth is shown three-quarter length, dressed like British royalty in an imposing architectural and landscape setting. The costume was likely derived from a print source, a common practice seen in other works by Theus such as the monumental portraits of Captain John Reynolds (fig. 4.37) and Colonel and Mrs. Barnard Elliott Jr. (figs. 4.38 and 4.39), the latter two both probably painted about the time of the Elliotts' marriage in 1766. With the exception of the Reynolds portrait, however, these large-scale works by Theus tend to be less successful than his smaller likenesses.

The use of print sources for overall poses and general costuming was common in eighteenth-century American portraiture, but rarely did artists copy diligently the smallest costume details such as the embroidered button holes on the waistcoat worn by Colonel Elliott and the ermine, lace, jewels, and other features in Mrs. Elliott's likeness. These passages, which are highly appealing and technically noteworthy, indicate the artist's considerable skill, but, because they tend to stand out, they detract

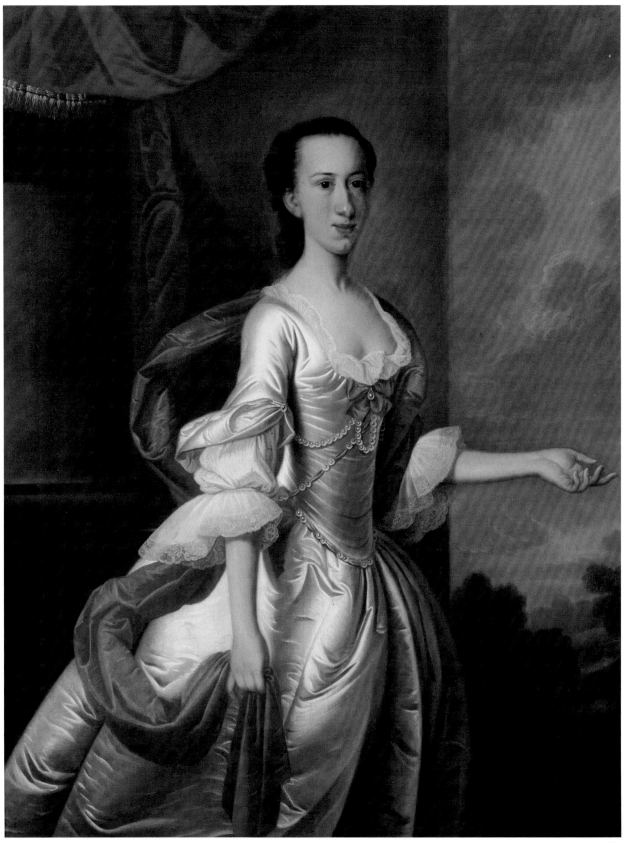

4.34

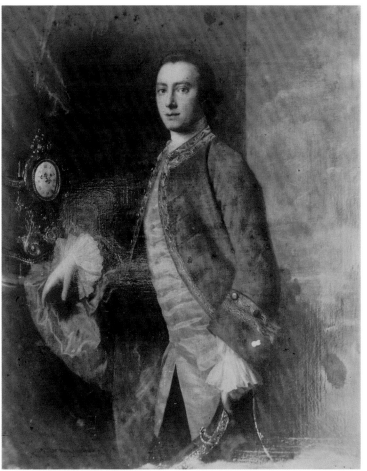

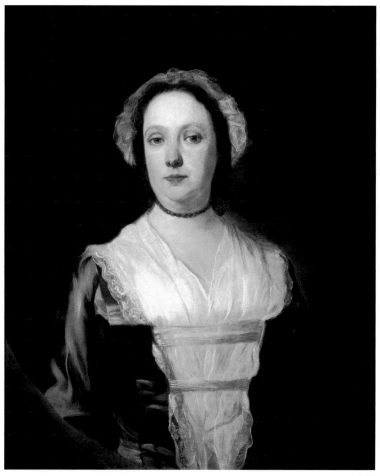

FIGURE 4.34. Jeremiah Theus, *Mrs. Peter Manigault* (Elizabeth Wragg), 1757, oil on canvas, 49⁷⁄₁₆" x 39⁵⁄₈". Courtesy of the Charleston Museum, Charleston, SC.

Elizabeth Wragg Manigault (1736–1772) was the daughter of Joseph Wragg and Judith Dubosc (DuBose) Wragg. Joseph Wragg was a successful merchant in Charleston and a member of His Majesty's Council. The likeness of Judith Wragg (1698–1769) drawn by Henrietta Johnston is owned by the Gibbes Museum of Art, Carolina Art Association, Charleston, South Carolina.

Elizabeth's pose is very reminiscent of Allan Ramsay's 1761–1762 likeness of Queen Charlotte (1744–1818), consort of George III (1738–1820), whom Ramsay painted earlier in 1760–1761.

FIGURE 4.35. Allan Ramsay, *Peter Manigault*, 1751–1752, oil on canvas, dimensions unknown. Current location unknown. © Image courtesy Gibbes Museum of Art/Carolina Art Association.

Peter Manigault (1731–1773) was active in the governmental affairs of the colony and served as a member and as Speaker of the Commons House of Assembly. The location and ownership of his portrait have been unknown at least since 1949 when Anna Wells Rutledge published her *Artists in the Life of Charleston*. According to another early author, Alice Morse Earle, Charles Manigault of

Charleston owned the portrait in 1903, and it was exhibited at some undetermined date in New York (City?). Alastair Smart, in his definitive catalog on Ramsay's work, also notes that the portrait was owned by Charles Manigault and sold by him to an unidentified Chicago, Illinois, dealer in 1906 (see Earle, *Two Centuries of Costume*, viii, and Smart, *Allan Ramsay*, 154–155). Other sources speculate that another family member, George Edwards Manigault, owned the portrait in the early twentieth century; however, he died in the late nineteenth century. Finally, it may have been part of a larger collection of paintings owned by Louis Manigault early in the twentieth century. Peter Manigault's correspondence requesting that Jeremiah Theus inspect the Ramsay portrait is an extraordinary compliment to the South Carolina painter's expertise.

FIGURE 4.36. William Keable, *Mrs. Benjamin Smith* (Anne Loughton, 1722–1760), dated 1749, oil on canvas, 29⁷⁄₈" x 25". © Image courtesy Gibbes Museum of Art/Carolina Art Association.

William Keable (ca. 1714–1774) probably painted a pendant portrait of Benjamin Smith (1717–1770), but it has not been located. The only portrait that has been identified as Benjamin Smith bears a stronger resemblance to the work of John Wollaston Jr. That portrait is owned by the Albrecht-Kemper Museum, St. Joseph, Missouri.

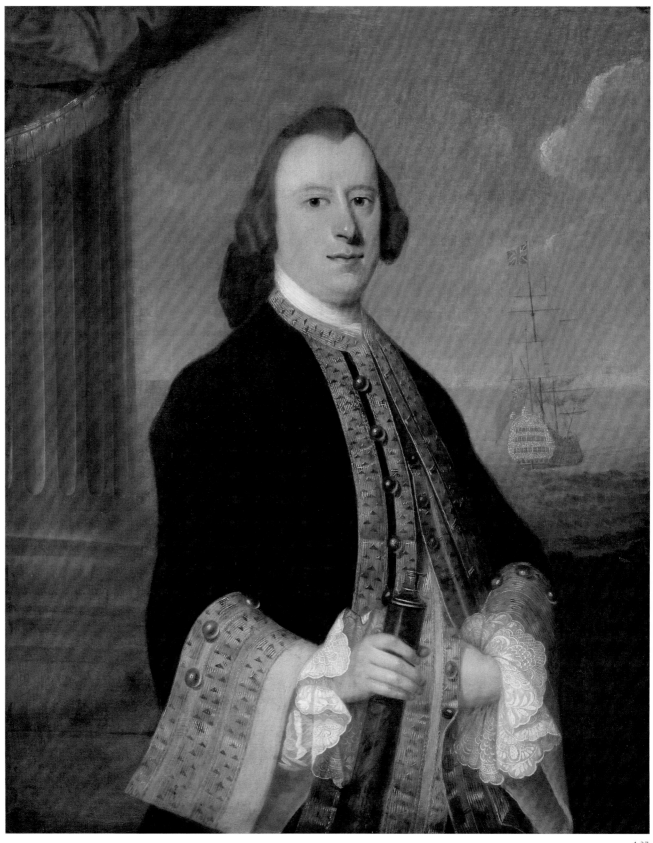

4.37

from both the face of the sitter and the overall effect of the picture. The point of portraiture during this period was to capture the likeness of the sitter as well as to provide a pleasant, elegant demeanor and setting. No part was to overshadow the face. Charles Bridges was able to meet such requirements in his larger canvases; Theus was not always as successful. Although his large pictures like that of Mrs. Barnard Elliott often have considerable charm, Theus was never completely comfortable with foreshortening, shading, and rendering natural or graceful postures, particularly in three-quarter-length images. His subjects like the Elliotts and Mrs. Manigault therefore appear wooden. In the case of the Elliotts, the sitters seem to be in the frontal plane of the picture and not fully incorporated into the setting.

His bust and waist-length pictures and his portraits of children are more successful in anatomical rendering, and they also achieve a better balance between the portrayal of details and the capturing of the sitter's likeness. Two examples of successful smaller works include his portraits of Mrs. Algernon Wilson (fig. 4.40), a rare example of Theus's cabinet, or undersized, portraits, and Mrs. Gabriel Manigault (fig. 4.42). Mrs. Manigault and her husband (fig. 4.41) elected to have small, waist-length portraits from Theus. Although they were among the wealthiest of the colony's citizens and could afford anything Theus could offer, they were older clients who may have had their likenesses done earlier by another painter. The Elliotts, on the other hand, were younger, and the Theus pictures were likely the first, or among the first, large canvases they purchased.

Two other important issues should be mentioned in reference to the paintings cited here. First, the Elliott portraits and that of Mrs. Algernon Wilson are in their original frames, probably made by a Charleston carver or cabinetmaker. Previous scholars have speculated that the local cabinetmaker Thomas Elfe was responsible for them. Documentary evidence lending credence to this theory includes Elfe's business accounts that list Theus as the purchaser of frames, packing boxes, and strainers for canvas. Carved furniture attributed to Elfe's shop has also been compared to the frames.

FIGURE 4.37. Jeremiah Theus, *Captain John Reynolds*, ca. 1754–1758, oil on canvas, 42″ x 34″. Image # BHC2963 © National Maritime Museum, Greenwich, London.

Painted in South Carolina but taken by the sitter to Georgia in the 1750s, this portrait is one of the four most impressive works now assigned to Theus, the others being the likenesses of Mrs. Peter Manigault (fig. 4.34) and of Colonel and Mrs. Barnard Elliott (figs. 4.38 and 4.39). John Reynolds (1713–1788) is shown wearing a captain's uniform as a ship flying the Union Jack flag sails away behind him. The sitter is known to have commanded the *Arundel* that sailed first in the English Channel and then came to Charleston, South Carolina, for an unspecified period of time before 1754. In that year, Reynolds went to Georgia where he served as governor until 1758. The painting bears a later inscription with the date 1786, which was added sometime after Reynolds returned to England and became a vice admiral.

FOLLOWING PAGES
FIGURE 4.38. Jeremiah Theus, *Mrs. Barnard Elliott Jr.*, 1766–1774, oil on canvas, 50″ x 40″. © Image courtesy Gibbes Museum of Art/Carolina Art Association.

A print source showing a costume nearly identical to that worn by Mrs. Barnard Elliott Jr. (Mary Elizabeth Bellinger Elliott, 1751–1774) has not been found. However, a very close relationship is observed with a 1692 English mezzotint of Queen Anne (1665–1714) when she was Princess of Denmark, published by John Smith (1652–1743) after the original oil painting by Sir Godfrey Kneller.

FIGURE 4.39. Jeremiah Theus, *Colonel Barnard (Bernard) Elliott Jr.*, 1766–1774, oil on canvas, 50″ x 40″. © Image courtesy Gibbes Museum of Art/Carolina Art Association.

The precise dates of the portraits of Barnard Elliott Jr. (1740–1778) and his first wife, Mary Elizabeth (fig. 4.38), are unknown since the artist did not inscribe them. However, it is believed that they were painted about the time of the Elliotts' marriage in 1766. Barnard and Mary were first cousins. Colonel Elliott served with the Second Regiment South Carolina Troops, and his journal that describes his recruitment of troops is in the Charleston Library Society, South Carolina.

Margaret Middleton documented thirteen Elliott family portraits to Jeremiah Theus, including one of Barnard Elliott Jr. as a child (*Jeremiah Theus*, 127–131). Portraits of his parents and siblings by Theus also survive.

4.38

4.39

4.40

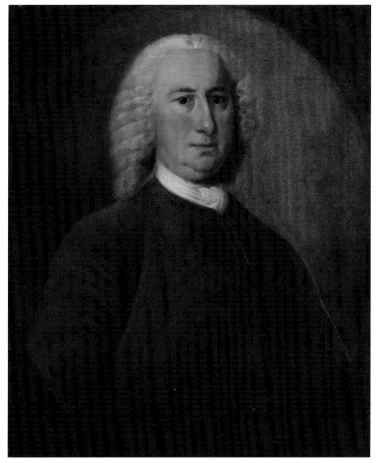

4.41

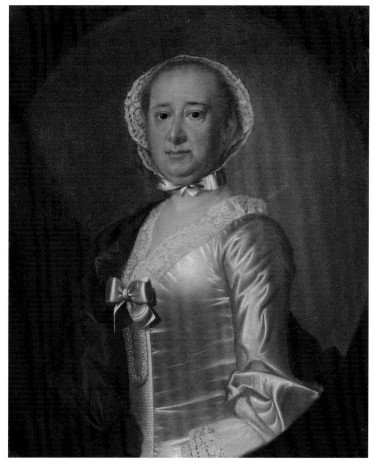

4.42

FIGURE 4.40. Jeremiah Theus, *Mrs. Algernon Wilson*, oil on canvas, dated 1756, 16⅝" x 14¼". Courtesy of the Museum of Early Southern Decorative Arts (MESDA) at Old Salem.

The sitter, Sarah Procter Daniel (b. 1726/27), married Algernon Wilson in 1745/46 in Charleston, and they had nine children. Her portrait is one of only a few small likenesses created by the artist. Theus was particularly adept in rendering miniatures and smaller portraits, and the details and coloration in these paintings are nicely balanced, giving them an overall jewel-like appearance. This portrait's original carved frame was probably fitted with glass, as suggested by the inclusion of an interior rabbet. Such framing for small, under life-size portraits may have been more common than we know, although the survival of such frames is quite rare.

FIGURE 4.41. Jeremiah Theus, *Gabriel Manigault* (1704–1780), dated 1757, oil on canvas, 30" x 24½". Image © The Metropolitan Museum of Art/Art Resource, NY.

FIGURE 4.42. Jeremiah Theus, *Mrs. Gabriel Manigault* (Ann Ashby, 1705–1782), dated 1757, oil on canvas, 30" x 24¾". Image © The Metropolitan Museum of Art/Art Resource, NY.

Secondly, Ann Manigault, Peter Manigault's mother, recorded in her journal in 1757 that she and her husband, Gabriel, as well as her daughter-in-law Elizabeth Wragg Manigault (fig. 4.34), were all being painted during April and May:

> April 14. Sat for my picture. 15. Mr. M. and my daughter sat for their pictures. 22. Sat again for my picture. 23 do. Mr. Manigault.
> May 17. I went to Mrs. Wittier's in the country. 19. Sat for my picture.

On July 1, she noted, "Our pictures came home."[108] Theus's name is not mentioned in the journal, but his signed and dated 1757 portraits of Gabriel and the daughter-in-law Elizabeth (Mrs. Peter Manigault) and the survival of Ann Manigault's portrait from the same period make it abundantly clear that the references were to him.[109] Mrs. Manigault's note that their pictures "came home" also supports the notion that artists often finished such likenesses in their studios, not in the sitters' homes.

Theus was not an itinerant artist in the traditional sense of moving regularly from town to town or colony to colony. He probably traveled only once, in the 1770s to Savannah. A letter to him from Governor James Habersham acknowledges receipt of "all my Family Pictures, besides Mr Wylly's, Mrs Crookes, Coll Jones' Grandchild, and two for Mr Clay."[110] All of these paintings were delivered to Savannah sometime before July 31, 1772, the date of Habersham's letter. A portrait of a little girl thought to be Mary Habersham (fig. 4.43) may be one of the pictures referenced, an example that also shows Theus's reliance on print sources and familiarity with English portrait styles for his compositions (compare fig. 4.44). A comparison of Theus's portrait of Mrs. Charles Lowndes (fig. 4.45) and the Richard Houston's print of Elizabeth Gunning, Duchess of Hamilton, (fig. 4.46) also reveals, again, the Charleston artist's reliance on British prototypes. Jeremiah Theus's long career as a portrait painter living in a single eighteenth-century southern city was not common among artists who worked in the South. Most painters working in the mid-eighteenth century, which corresponds to the last half of Theus's career, either moved their residences one or more times or traveled frequently in search of portrait commissions and other work.

The departure of Bridges for England and the disappearance of Dering, who vanished from Charleston records after 1750 or 1751, left Theus as the principal resident painter in the South. Virginia and Maryland were open and receptive to other painters, specifically portrait painters, and, by 1750, John Hesselius (1728–1778) had begun to fill the void. Robert Feke (1705–1750?) is believed to have made one brief visit to Virginia about the same time, but he did not stay, and attributions to his hand are difficult to make. Gustavus Hesselius (1682–1755) probably did not travel outside of Philadelphia, even with his son, John, after the 1740s. Florida was principally a military outpost maintained by the Spanish where naturalists continued to travel to collect and where some topographical work was created. The same was true of the areas along the coast of the Gulf of Mexico. With the exception of the views for Louisiana shown in figures 3.39 and 3.40, no significant painting activity took place there.

The names of a few other painters appear in southern records—for example, Michael Haddon and Jane Voyer in Charleston and John Keeff in Williamsburg—but their life dates are unknown and none of their works are known to survive. Haddon was probably acquainted with Jeremiah Theus, who appraised his estate on February 8, 1750/1751. He was referred to as a "limbner" in his will, and his inventory listed such items as a small easel, a stretching frame, paints, paint pots, and brushes and an old "pait g [painting] book."[111] One of several drawing masters and mistresses whose work is now lost, Jane Voyer advertised that she taught drawing and drew "Patterns for any kind of Needle work, and will teach the same."[112] On April 18, 1751, John Keeff advertised that, having recently arrived from London, he would perform "all Sorts of Lanskape, Herald, and House Painting, in the best and exactest Manner, at reasonable Rates," adding that "Whoever are pleas'd to employ me, shall be faithfully serv'd" and giving the name of both a watchmaker and a tailor in Williamsburg through whom he could be reached.[113]

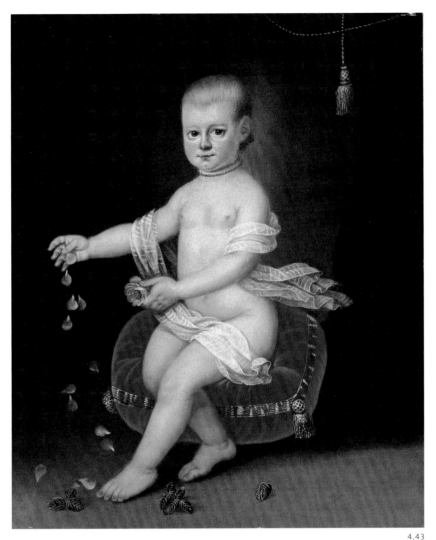

4.43

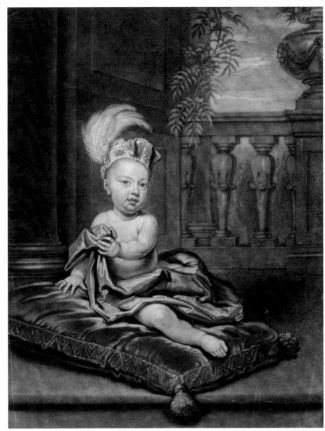

4.44

FIGURE 4.43. Jeremiah Theus, *Portrait of a Child*, possibly Mary Habersham (dates unknown), possibly 1771–1772, oil on canvas, 30⅛" x 25⅛". Colonial Williamsburg Foundation, Williamsburg, VA.

The identity of the child in this portrait is unknown, but there is no question regarding its attribution to Theus since the overall quality of painting, the hands, and the facial features all compare favorably with these aspects in other Theus paintings. The pose, however, is unusual for Theus, as are the single tassel suspended from drapery that is mostly out of view at the top, the type of flower being held by the child, and the gesture in which the child removes and drops flower petals. Whether any special meaning can be inferred from these details is unknown. The pink rose with falling petals may symbolize the passing of youth or be merely a decorative device. Although this format is unique among Theus's known pictures, it is similar to a picture created by Sir Godfrey Kneller (see fig. 4.44). Apparently the tasseled cushion was a common device in portraits of infants, for it is found, with differing compositions and poses, in other English portraits of the same period.

FIGURE 4.44. John Smith, engraver, after Sir Godfrey Kneller, *William Anne Keppel, 2nd Earl of Albemarle*, 1703–1705, ink on paper, 13½" x 9¾". © National Portrait Gallery, London.

John Smith (1652–1743) created over one thousand portrait prints during his career, many after likenesses by Sir Godfrey Kneller. These circulated widely in both England and the colonies. William Anne Keppel (1702–1754) lived to adulthood, and at least four portraits of him at different ages are known today. This example is not identical in pose or costume to the Theus likeness in figure 4.43, but it reflects the same idea of a child placed on a plush cushion with corner tassels.

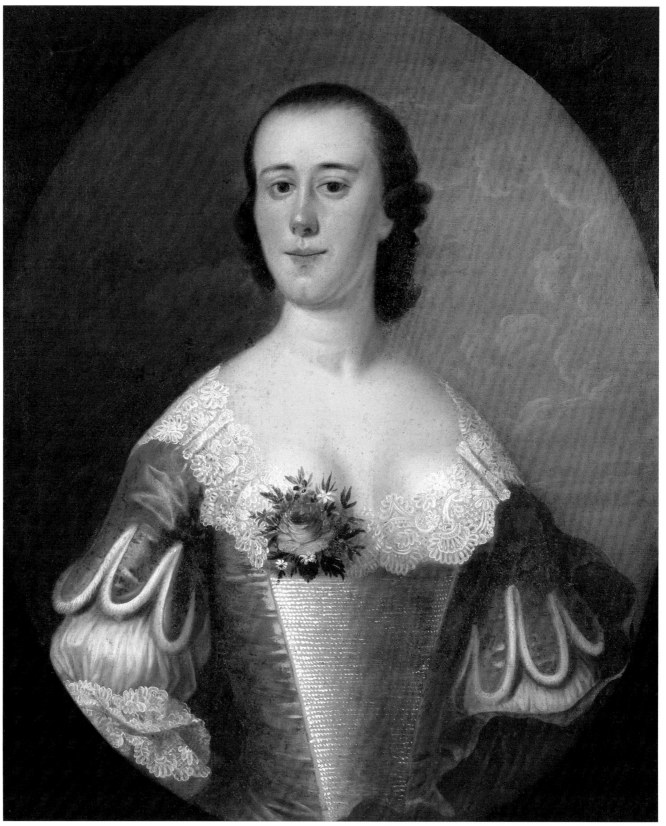

4.45

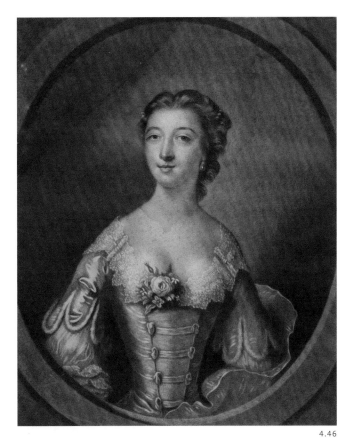

4.46

FIGURE 4.45. Jeremiah Theus, *Mrs. Charles Lowndes*, 1755–1763, oil on canvas, 29″ x 24¼″. © Image courtesy Gibbes Museum of Art/Carolina Art Association.

The subject, Sarah Parker Lowndes (d. after 1763), was the wife of Charles Lowndes, who was born circa 1719 in St. Kitts. He died in Charleston, South Carolina, in 1763/64.

Jeremiah Theus used the pose and costume seen in this portrait frequently, having borrowed them, scholars note, from a print by Richard Houston (1721–1775) after a Francis Cotes portrait of Elizabeth Gunning, Duchess of Hamilton and Argyll (fig. 4.46) (see Severens, "Jeremiah Theus"). Other English artists used similar costumes, borrowing from each other, in whole or in part, poses, costumes, and costume details. It appears that Theus also tended to take some aspects of costume from more than one source. The 1740s style of dress seen in both paintings was also commonly used by Allan Ramsay and Francis Cotes (see fig. 4.46), and, although Mrs. Lowndes's dress and flower are quite similar to aspects of the duchess's portrait, other details are reminiscent of 1740s portraits by Allan Ramsay. Theus, like other artists, sometimes borrowed and combined elements from several sources. He also created a few devices of his own.

FIGURE 4.46. Richard Houston after Francis Cotes, *Elizabeth Gunning, Duchess of Hamilton* (1733–1790), 1751, ink on paper, 15¼″ x 9⅞″. © National Portrait Gallery, London.

There was never a long hiatus of art activity in the South. In fact, a taste for art and painting was solidly grounded in the South during this period, and even though the artist population was not large, significant numbers of pictures were produced for and collected by southern consumers. The look and orientation of this art was basically English even when created by immigrant painters from northern Europe. So it would remain throughout most of the eighteenth century.

NOTES

1. *Dictionary of Painters,* xviii–xix.

2. In the Chesapeake, first tobacco and, later, wheat and corn were the principal cash crops, although tar, turpentine, and naval stores were important trade goods for some areas. Tobacco was already known in Europe by the time Jamestown was settled. John Rolfe introduced a species of tobacco that grew well in the Chesapeake, and other settlers began to cultivate it for profit. Eventually two types were grown, and, in the late seventeenth century, tobacco became the stable cash crop of the Chesapeake region's economy. Its production became so great that it soon glutted European markets, causing its value to decline. Beginning in 1730, a series of Inspection Acts, or tobacco trade laws, were passed in Virginia and Maryland. Those laws regulated the amount of raw product that could be produced for trade, insuring economic stability and allowing larger landowners with slave labor to continue building their fortunes. Wheat and corn were produced for trade much later, although they were grown and sold for local consumption throughout the colonial period. The gradual but pervasive failure of tobacco in the third quarter of the eighteenth century resulted from its depletion of soil nutrients vital to the growth of tobacco or any other crop.

3. On June 13, 1777, while traveling to Edenton, NC, Ebenezer Hazard noted: "Tar & Turpentine are the Staple of the South Parts of Virginia" ("Journal," 412).

4. By the mid-eighteenth century, sizable immigrations of Scots-Irish and Germans had populated the backcountry, or "back parts," of Virginia, Maryland, and North and South Carolina. Except for some portraits that may have been brought to Salem, NC, no paintings are known for those remote areas.

5. Information is available on the studios of only a few artists in America. Those artists include John Smibert, John Singleton Copley, and Charles Willson Peale. It is not clear that sittings were consistently or frequently held in the studios though the artists probably did complete portraits there, especially the costumes and backgrounds.

6. See pages 247 and 288. Painting sessions with clients are mentioned by the client-sitters of both John Wollaston Jr. in Charleston, SC, and John Durand in Virginia.

7. It is unlikely that all artists returned to varnish their work; clients may have engaged others, perhaps frame makers, for this task. Several of John Durand's surviving portraits were never varnished.

8. *Maryland Gazette* (Annapolis), May 22, 1766. See Saunders and Miles, *American Colonial Portraits,* 149–150, for a fuller discussion of these paintings and their documentation. According to the authors, the portrait of Charles Calvert, 5th Lord Baltimore, continued to hang in the council room at the State House until sometime after the Revolution. Charles Willson Peale recorded seeing it twice, once as a child in the 1750s and again in an Annapolis ballroom in 1823. The portrait's subsequent history includes Peale's acquisition of it for his museum in Philadelphia, PA; the deposit of the picture to the Pennsylvania Academy of Fine Arts by Peale descendants; and its acquisition in 1957 by the Peale Museum in Baltimore, MD.

9. There is some question as to whether the portrait was by Kneller's hand or from the studio of Kneller.

10. "Journal," 407–409. In his entry for June 2, 1777, Hazard noted, "Upon entering the Capitol you get into a Room in which the Courts of Justice are held; it is large & convenient; here is a fine whole Length Picture of Queen Anne by Van Dyck." Regarding the room where the House of Burgesses met, Hazard wrote, "On one Side of this Room hangs a whole Length of King George the 2d. & on the other another of Queen Caroline."

11. For more information on the royal portraits in Williamsburg, see Hood, "'Easy, Erect and Noble.'" Allan Ramsay was appointed one of the Crown's principal painters in 1761. After King George III married Charlotte that year, Ramsay was engaged to paint the coronation portraits as well as replications for other dignitaries. Other portrait copies were subsequently ordered for royal residences and other persons. Ramsay ultimately set up two studios to produce copies, and he hired numerous assistants to paint them. Hood notes that there were at least two hundred copies of George III.

12. For a fuller discussion of the popularity of portraiture, see pages 24–25.

13. See McDaniel and Hudgins, "Mystery at Drayton Hall."

14. *South-Carolina Gazette* (Charleston), May 17, 1735.

15. Higgins, "Charles Town Merchants," 205–206, 215. The average duty paid during this year is calculated at approximately ten pounds per slave, indicating that Roberts probably purchased at least four slaves, a significant number for any merchant or tradesman working in Charleston at the time.

16. See Easterby, *Journal of the Commons House of Assembly,* 203. Due to widespread counterfeiting of South Carolina's 1731 issue of paper money, by an act of June 7, 1735, the colony recalled and overprinted all genuine notes. "Overprinting" meant printing something new on the blank reverses of the old notes. Another act of the same date authorized an additional ten thousand pounds in new notes to replace old ones.

17. *South-Carolina Gazette* (Charleston), July 30, 1737.

18. Ibid., Aug. 16 and Sept. 6, 1740, and Sept. 12, 1743.

19. Ludolf Backhuysen (Bakhuizen) (1630–1708) and Willem Van de Velde the Younger (1633–1707) were among the most famous of the many Dutch painters who specialized in those views. In America, the Dutch-trained surveyor-cartographer Augustine Herrman (1605/21–1686) moved to New Amsterdam (New York City), where he created two views in the 1640s and 1650s. He later moved to Maryland, where he completed a map in exchange for four thousand acres of land in the Chesapeake Bay area. Whether or not he ever did any marine views in Maryland is unknown. See White, "Marine Art in the South," 60–61.

20. Thomas Mellish (active 1761–1778) painted a view of Charleston about 1760. He was a British marine painter who regularly exhibited at London's Society of Artists. There is no evidence that Mellish went to Charleston, but prints after his pictures probably did (see for example fig. 7.1).

21. *South-Carolina Gazette* (Charleston), Jan. 4 and Jan. 11, 1734/35. These ads also mention that Chassereau laid out the grounds "for Gardens or Parks, in a grand and rural manner." By 1745, Chassereau may have returned to England, for a man by that name did maps and sketches and similar surveying work in Shoreditch, Middlesex, and other English towns.

22. The miniature of the Shoolbred woman is owned by the Gibbes Museum of Art, Charleston, SC. The miniature of the Jones child is owned by MESDA, Old Salem, NC.

23. Rutledge, *Artists in Charleston,* 113.

24. Suzanne Neale has also done formative work on Bridges's English career in "Charles Bridges: Painter and Humanitarian." Unless otherwise noted, all biographical information on Bridges comes from either Neale or Hood, *Bridges and Dering*.

25. According to the younger John Bridges's biography, there were seven sons and five daughters born to his and Charles's parents. See Bridges, *History and Antiquities,* 1:v.

26. There is conflicting information given about Charles Bridges. Both *The English Baronetage,* vol. 4, 189, published in London in 1741 for Tho. Wotton, and Kimber and Johnson's *Baronetage of England,* vol. 3, 56, printed in London in 1771 for G. Woodfall, indicate that John Bridges of Warwickshire and Barton Seagrave Hall had seven sons and five daughters and list Charles as the fourth son. The same two sources also say that this Charles Bridges was twice married but had no issue that lived to maturity. However, in a letter of May 26, 1735, Lt. Gov. William Gooch in Virginia mentioned to his brother, Thomas, that he had loaned Bridges a coach to move his "Goods" and "his Daughters and Son" (Letter used by permission of Sir Arthur Gooch, Suffolk, Eng., accessed on microfilm at the John D. Rockefeller, Jr. Library, CWF, VA). The 1771 *Baronetage* spoke of Charles Bridges in the past tense. However, the earlier 1741 *Baronetage* gave its

information in the present tense: "Charles Bridges, who has been twice married, but hath no issue living." Confusion over the survival of Charles's children may have occurred because the artist was in the colonies in 1741 and his status could not be verified. The 1771 source probably repeated the erroneous information from the 1741—or an earlier—source. It seems likely that Charles Bridges, the artist, probably had little if any contact with Barton Seagrave once his father's house passed out of the family just after 1733, at which point his lineage could have been inaccurately recorded. The names and ages of Charles Bridges's daughters cannot be verified from existing sources. However, the son was probably the George Bridges who died in North Carolina in the 1770s, as listed in various online genealogies in Ancestry. com. The Mary Bridges who died in 1736, as listed in the Bruton Parish Church records, is called "Mrs. Charles Bridges, Sr." Those records are the only source that indicates the artist's wife was present in Virginia; perhaps she came separately from the rest of the family, who arrived, as Governor Gooch mentioned, in 1735. Goodwin, *Historical Sketch,* 142.

27. Information about Thomas Bray is from "Our History," the Society for Promoting Christian Knowledge (SPCK), accessed June 28, 2011, www.spck.org.uk/about-spck/history/.

28. One of those was Thomas Coram (fig. 6.20), probably the Thomas Coram who married Eunice Waite of Boston on June 27, 1700. At some undetermined later time, Coram returned to England where he became a highly successful London merchant, philanthropist, and patron of the arts. In 1739, he received a royal charter from George II to establish a hospital for abandoned, homeless children living in the streets of London. Coram was a friend of William Hogarth, who was one of the hospital's first governors and who joined other artists in contributing paintings to the Foundling Hospital. George Frideric Handel also contributed to the hospital by allowing a benefit performance of *Messiah* and by composing an anthem, known as "Foundling Hospital Anthem," for performance there. This Thomas Coram may have been related in some fashion to the Thomas Coram who was an artist in Charleston, SC. See pages 297–298.

29. Transcriptions of some of the earliest meeting minutes are found in Allen and McClure, *Two Hundred Years.* Charles Bridges is recorded as attending and reporting on his work to establish schools from May 18, 1699, through the early months of the following year (31–53). Though this "Bridge" or "Bridges" was probably the artist, Peter Meadows, SPCK archivist, noted that there is some question as to whether the Bridges mentioned in the 1699 society minutes was the Charles Bridges whose name appears in the 1709 minutes (e-mail to author, Jan. 6, 2009).

30. *Bridges and Dering,* 2.

31. Ibid.

32. Despite Jervas's success as a painter, Kneller was not particularly fond of his work. According to one humorous popular account of their relationship, Kneller, upon being told that Jervas had purchased a carriage with four horses, exclaimed, "Ach, mein Gott! if his horses do not draw better than he does, he will never get to his journey's end" (Solomon, "Pope as a Painter," 268).

33. Thomas Bray, whom Bridges knew from the SPCK, had encouraged the SPG's formation. Unfortunately, no additional information on Bridges can be found in the SPG's archives at Cambridge University, UK.

34. Henry Newman was an orphan, born in Massachusetts and educated at Harvard, from which he graduated in 1687. He joined the Church of England and worked as a merchant in Newfoundland and, ultimately, in England. He was deeply involved in promoting both the settling of Protestant refugees in Georgia and the scheme of George Berkeley, bishop of Cloyne, for founding an American college. He also was often criticized for his liberal views by Gov. Francis Nicholson, who served in New York, Virginia, Maryland, and South Carolina.

35. 4 Jan. 1733, Abstract Letter Book 1/16 – 12018, Society for Promoting Christian Knowledge (SPCK) as quoted in Neale, "Charles Bridges," 27.

36. One of the Georgia trustees, Oglethorpe was a philanthropist and social reformer who worked to help the poor and debtors in prison in England. His settlement of Georgia was a philanthropic effort that was known to many in England. He was also a member of the Association for Founding Clerical Libraries and Supporting Negro Schools, another group established by Thomas Bray. The latter was a subject of much interest to Bridges and also, as will be pointed out, to Commissary James Blair in Virginia.

37. Bridges to Bishop Edmund Gibson, 19 Oct. 1738, Lambeth Palace Library, Fulham Papers, vol. 12, FPII, 1724–1746, 237, as quoted in Hood, *Bridges and Dering,* 7.

38. See Hvidt, *Von Reck's Voyage,* 7–25, for a summation of the planning and implementation of voyages.

39. The son of a Presbyterian clergyman, Blair attended Marischal College in Aberdeen for two years, earned his master's degree at the University of Edinburgh in 1673, and moved to London. In 1685, the bishop of London, Henry Compton, sent him to Virginia, where he served churches in Henrico Parish and Jamestown before going to Bruton Parish in Williamsburg. There he remained. He was named commissary of the bishop of London in 1689. He founded the College of William and Mary and served as its president until his death.

40. Meade, *Old Churches,* 419. There is no mention of Bridges's ordination in British church records; however, those were unusual times for the church as it tried to fund and manage parishes at home as well as those formed or being formed in America. For example, in 1708, when Gideon Johnston arrived in Charleston to assume his duties as commissary at St. Philip's Church, he discovered that the church's parishioners had selected Richard Marsden as a clergyman

without the bishop's approval or knowledge. See page 113 and Klingberg, *Carolina Chronicle,* 19–21.

41. Edward Carpenter, *Protestant Bishop,* 292–293.

42. Corwin, *Ecclesiastical Records,* 55, 329. Existing records that contain the Bridges or Bridge name are conflicting, making it difficult to identify men with those names and their movements. For now at least, an association with the artist is speculative at best. Numerous references to a curate named Bridge in Narragansett in the SPG papers at Lambeth Palace Library list his first name in brackets as "Christopher," but there is no further explanation of how or by whom the first name was established. See SPG XVI, American Colonies, 1702–1710.

43. As quoted in Edward Carpenter, *Protestant Bishop,* 292.

44. Bridges to Bishop Gibson, 20 Oct. 1735, Fulham Palace Papers, as quoted in Hood, *Bridges and Dering,* 7n9.

45. Ibid. It is possible that the word "Character" as Bridges used it in this quotation could refer to a personal reference, that is, to a person who could speak for Bridges's ability. However, in this context, the word refers to his personal traits and behavior.

46. See Meade, *Old Churches,* 419.

47. 26 May 1735, letter used by permission of Sir Arthur Gooch, Suffolk, Eng., accessed on microfilm at the John D. Rockefeller, Jr. Library, CWF, VA.

48. Byrd to Alexander Spotswood, 30 Dec. 1735, in William Byrd II, "Letters of the Byrd Family," 211. Byrd may have been aware of or known the artist's brother John Bridges, the antiquary and topographer who studied law and who was a member of Lincoln Inn and a Fellow of the Royal Society in London. In 1791, some of John Bridges's writings were published posthumously in two volumes, compiled by the Rev. Peter Whalley as *The History and Antiquities of Northamptonshire. Compiled from the Manuscript Collections of the Late Learned Antiquary John Bridges, Esq.*

49. Byrd to Alexander Spotswood, 30 Dec. 1735, in William Byrd II, "Letters of the Byrd Family," 212. Tinling, *Correspondence of Three Byrds,* dates the same letter 22 Dec. 1735 (2:468).

50. *Bridges and Dering,* 9.

51. Parks's *Virginia Gazette* (Williamsburg), Feb. 3–10, 1737 (O.S.), no. 80. Foote notes that the advertisement ran again the following week but "not thereafter" ("Charles Bridges," 12). Hood speculates that the larger box might have been for portrait frames and the longer one for artist canvas and wooden strainers on which to stretch the canvas (*Bridges and Dering,* 10).

52. See Hood, *Bridges and Dering,* 10. See also Neale, "Charles Bridges," 12–14, from which much of this information originally came.

53. As Hood points out throughout his book, Bridges painted only a few portraits for clients living in the Hanover area, but he also continued to have clients in or near Williamsburg.

54. Hood, *Bridges and Dering,* 10. The 1744 date is based on the child, who was born in April 1743 and was about a year old in the portrait.

55. "Charles Bridges," 57–58. George Vertue was the English engraver who became the official engraver to the Society of Antiquaries in 1717. The reference reads: "For Mr. Charles Bridges to Tho Martin at Palgrave in Suffolk near Dis[s] in Norfolk" (as quoted in Thorne, "Trivia"). Thomas Martin, also known as "Honest Tom" Martin of Palgrave, was a well-known antiquarian and lawyer. A fellow of the Society of Antiquaries, he collected coins, pictures, prints, drawings, and many other things, and he probably knew Charles Bridges's brother John.

56. "Mr. Ainsworth," "Dorothea Dandridge," and "Elizabeth Hill Carter." *Bridges and Dering,* 92, fig. 57; 93, fig. 58; 96, fig. 61.

57. The Baker portraits are not signed; one or more can be assigned to Bridges on the basis of the Simon engraving that carries the artist's name.

58. *Bridges and Dering,* 35–37.

59. Unless otherwise noted, information regarding Dering has been synthesized from Hood, *Bridges and Dering;* Weekley, "Further Notes on Dering"; and Pleasants, "William Dering."

60. Dering's whereabouts before Philadelphia are unknown. Given his family ties (see page 408), he may have arrived from England or South Carolina.

61. *American Weekly Mercury* (Philadelphia), July 1, 1736.

62. *Pennsylvania Gazette* (Philadelphia), May 13, 1736.

63. Parks's *Virginia Gazette* (Williamsburg), nos. 69 and 70.

64. *Bridges and Dering,* 99–100. York County records reveal that the suit was brought by William Prentis, Henry Wetherburn, and Dr. George Gilmer of Williamsburg and John Harmer Pits, possibly of Williamsburg, for debts Dering owed them (York County, VA, Records, Wills and Inventories 18, 1732–1740, 549, as found in the MESDA Craftsman Database). Prentis came to Williamsburg in 1715 at the age of fifteen and worked first at a store owned by Dr. Archibald Blair, brother of Commissary James Blair. Through various transactions following the deaths of the Blairs, Prentis became manager and part owner of the store. Henry Wetherburn was a tavern keeper. In 1731, he married Mary Bowcock, widow of the keeper of the Raleigh Tavern in Williamsburg. Wetherburn first operated the Raleigh, and, after it was sold in 1742, he opened a tavern in his own house (built in 1738 or afterwards) across from the Raleigh on Duke of Gloucester Street. Dr. George Gilmer immigrated to Virginia and settled in Williamsburg in 1731. By the mid-1730s, he owned and operated an apothecary shop in town.

65. Robins, *Register of Abingdon Parish,* 55.

66. Hood, *Bridges and Dering,* 100. William Byrd II, *Another Secret Diary,* 144, 166–167, 178. Chairs or chaises were relatively common in Virginia by the mid-eighteenth century. Dering's chair was not described, but it could have been either a two-wheeled or larger four-wheeled vehicle; these often had collapsible hoods. "Mr. Cary" was probably Henry Cary II of Ampthill who, in August 1742, sold two lots in Williamsburg, conveyed by a deed in the General Court, to William Dering. The lots contain what is today the Thomas Everard House on Palace Green.

67. Stephenson, Gibbs, and Townsend, *Brush-Everard House Report,* 23. Numerous Bernard Moores and Augustine Moores lived in Virginia during this period. It is not clear whether the mortgage holder was the son of Augustine Moore of Chelsea.

68. Hood, *Bridges and Dering,* 100.

69. *Bridges and Dering,* 101.

70. For more on the 1744 and 1745 inventories of Dering's property, see McWilliams, *Brush-Everard House Historical Report,* 6–10.

71. York County, VA, Records, Wills and Inventories 19, 1740–1746, page 370, as found in the MESDA Craftsman Database. The use of the address "Gent." probably signified Dering's social status and referred to some degree of elevated rank or personal qualities.

72. Hood, *Bridges and Dering,* 100.

73. York County, VA, Files, CWF Research Department. Dr. de Sequeyra was a Williamsburg doctor who, according to existing records, arrived there in 1745. He later became involved with the mental hospital that was built in Williamsburg in 1771.

74. As found in the MESDA Craftsman Database. The reference appears on page 16.

75. York County, VA, Files, CWF Research Department.

76. *Bridges and Dering,* 103 and 103n71. The John Mercer Ledger, quoted by Hood, is folio 100, Bucks County Historical Society, Doylestown, PA. Hood notes that the only portraits noted for Mercer are two associated with John Hesselius, one of which is known only from a book illustration. Mercer was educated at Trinity College in Dublin and immigrated to Virginia as an adult. He had an impressive library and kept detailed journals, including information on plants and their potential uses.

77. Between 1744, when he first mortgaged the property, and 1749, Dering had reduced his debt of £400 by a modest £115. Stephenson, Gibbs, and Townsend, *Brush-Everard House Report,* 37.

78. "Diary," 136.

79. Public Record Office, Colonial Office, Virginia, Original Correspondence, Secretary of State 1746–1753, C. O. 5/1338 f. 998-100, M-246 as quoted in Stephenson, Gibbs, and Townsend, *Brush-Everard House Report,* 38–39.

80. Charleston County, SC, South Carolina Mortgages, no. V.V., 1750–1753, p. 90, May 6, 1751, as found in MESDA Craftsman Database.

81. These collections became the foundation of the British Museum. Dering could have learned of Sloane through William Byrd II, who certainly was acquainted with the English collector.

82. Bushnell, "Sloane Collection," 672, 673.

83. Robert's brother Edward, 3rd Baronet, married an Elizabeth Cholmely, daughter of Sir William Cholmely, Baronet, and sister of Hugh Cholmely. In England, the name Cholmely or its variants were carried through several later generations of the Surrenden Derings and does not appear to be common elsewhere. Another William Cholmeley (Cholmondeley, Colmondley, Cholmedy) Dering was born in Charleston in 1739.

84. Mary Harvey, the Lady Dering, was Henrietta Dering Johnston's mother-in-law by her first marriage. Lady Dering was also the first English woman composer whose works were published under her own name. Lady Dering's husband was Sir Edward Dering. Henrietta Dering Johnston had at least two daughters by Sir Edward and Lady Dering's son Robert Dering. Robert Dering had inherited one thousand pounds owed to his father's estate by Sir Hugh Cholmely in 1693/94. See the Dering family tree in appendix C.

85. Charleston County, SC, South Carolina Mortgages, no. V.V., 1750–1753, p. 90, May 6, 1751, as found in MESDA Craftsman Database.

86. Salley, *Marriage Notices,* 29, 30.

87. The previously attributed portrait of Maria Byrd Carter (1727–1744) (see 115, fig. 71, in Hood, *Bridges and Dering*) displays considerable skill in rendering fabric; it was done by someone with more training than the hand responsible for the Stith and other paintings. The likeness of William Randolph (1712–1746) of Tuckahoe, also illustrated in Hood (119, fig. 74), relates more closely to the early work of John Hesselius and John Wollaston Jr. Randolph died in 1743 before Wollaston came to Virginia, but the picture, owned by the Virginia Historical Society, is probably a later copy, or the sitter is misidentified. The portraits of Randolph's wife, Maria Judith Page Randolph (1715–1740/43) of Rosewell, and an unidentified woman of the Randolph family (see 120, fig. 75, and 121, fig. 76, in ibid.) do not compare favorably with Dering's work in the drawing of facial features or painting of the fabrics.

88. Middleton, *Jeremiah Theus,* 14–23. Unless otherwise noted, information regarding Theus has been synthesized from this source. Middleton concluded that the family came from Felsberg, Canton Grison (now Canton Graübunden), in Germany and arrived in Charleston in July 1735 on Capt. Hugh Percy's ship that had disembarked from Rotterdam with 250 Switzers aboard. The land grant to Simon Theus, Jeremiah's father, was dated Sept. 17, 1736, more than a year after the arrival of Captain Percy's ship but prior to the arrival of

a second contingent of settlers the week of Sept. 25, 1736. As further proof of the family's arrival with the first Swiss immigrants, Middleton notes the will of Gabriel La Ban of St. John's, Berkeley. Signed on Nov. 6, 1749, this record states that son "Simon" (Simeon Jorg) Theus had served La Ban as a bookkeeper for fourteen years, putting Simeon Jorg's employment date at 1735. However, Simeon Jorg, who sued La Ban's estate for expenses and remaining salary amounting to £1,265, claimed that he had entered into La Ban's service on Mar. 20, 1739, four years later. Simeon may also have been employed later by John Colleton. Colleton was probably the son of John Colleton and the grandson of Sir John Colleton, all of whom were descendants of one of the seventeenth-century investors and proprietors who established the Carolina Colony.

89. Dresser, "Jeremiah Theus."

90. Middleton, *Jeremiah Theus,* 25–26. Christian Theus signed birth certificates created by the Ehre Vater fraktur artist who worked near Columbia, SC, in the late eighteenth century. Kolbe and Holcomb "Fraktur in the 'Dutch Fork' Area," 41.

91. Muhlenberg was influential in the founding of the first Lutheran denomination in America and is often cited as the patriarch of the American Lutheran Church. He was one of the teachers at Halle (Saale) and was well acquainted with the leaders of the Salzburger settlement in Georgia, where he also visited. He immigrated to Philadelphia in 1742 and led the congregation at Augustus Lutheran Church in what is now Trappe, PA, as well as others in Maryland and New York. In 1748, he called the first permanent Lutheran synod. Muhlenberg traveled frequently, as indicated by his connections with the Theus family: in 1742, he stayed at the home of Jeremiah Theus in Charleston on his way to Ebenezer, GA, via Captain McClellan's brigantine *Georgia Packet* from London; on Oct. 20, he returned and stayed again with Theus while awaiting his ship to Philadelphia; and, in 1774, he visited with "an old, upright Reformed preacher Mr. Christian Theus" (Muhlenberg, *Journals,* 578). Muhlenberg's journal indicates that, thirty-two years earlier, he had been entertained by Christian Theus's brother, "the recently deceased painter" (ibid., 592). See Muhlenberg, *Journals,* for the complete account.

92. Simeon Jorg Theus also worked for the government by providing lodging for Native Americans who traveled through the area, presumably on official business. In 1783, one of Jeremiah Theus's daughters, one of the two Marys, married her first cousin James Theus, the son of Simeon Jorg.

93. This conclusion was reached after study of numerous tradesmen's advertisements and addresses existing in Charleston papers and available in the MESDA Craftsman Database.

94. Cathrina and her father, John, were from Germany. Their family name is also variously spelled "Shaumloffel" and "Chaumloffel."

95. Middleton, *Jeremiah Theus,* 40, 42–43, 48–53.

96. See Middleton, *Jeremiah Theus,* 43. Theus's advertisement noted

that the property joined that of Rawlins Lowndes, one of the most well-known political figures in Charleston who, on Mar. 10, 1778, succeeded to the presidency of South Carolina. Theus painted portraits of several members of the Lowndes family, including Rawlins's wife, brother, and sister-in-law.

97. Register 1732–1776, Independent Congregational (Circular) Church, Charleston, SC, 88, South Carolina Historical Society, as found in the MESDA Craftsman Database.

98. George W. Williams, *St. Michael's, Charleston,* 143. See also Riley, "German Romanticism," 67. Riley notes that the pew list is from 1760 and that other Charlestonians on the list include the cabinetmaker Thomas Elfe, Bernard Beekman, Henry Laurens, and Henry Timrod (Heinrich Deimroth). Timrod was a German immigrant who was father of William Henry Timrod, a Charleston bookbinder, and grandfather of poet Henry Timrod, often called "laureate of the Civil War." The immigrant Timrod began as a shoemaker in Charleston and, like other tradesmen, was able to advance to the position of a successful merchant.

99. Middleton also notes that, in the will of George Hunter of Charleston, made in 1745 and proven in 1755, Theus is again listed as a limner though the word is spelled "Lumner." Hunter left Theus several items, including the "Ox Eyed Camera." As quoted in *Jeremiah Theus,* 47. Surveyor general for South Carolina, Hunter was responsible for charting and laying out parts of Charleston as well as the path to Cherokee country through Monck's Corner, where Theus's brother lived and entertained Cherokees who were en route to meet with government officials in Charleston. Hunter also created "The Ichnography of Charles-Town. at High Water" signed "G. H. delin." (fig. 4.3), which was engraved by W. H. Toms in London and published on June 9, 1739, by Toms and Bishop Roberts in Charleston.

100. Daniel Schwenter, a German professor of mathematics and Oriental languages, developed the ox-eye lens, or scioptic ball, in 1685. It consisted of a universal joint allowing an optical instrument mounted on a ball to be swiveled to a point anywhere in a wide arc. The ox-eye lens had many applications as a camera obscura, projecting images from the outside onto walls in darkened rooms to aid in drawing panoramic views.

101. Middleton, *Jeremiah Theus,* 47–48.

102. Evidence of Theus's wealth is also supported by the numerous mortgages he gave to tradesmen in Charleston, including Frederick Strubell, bricklayer; John Vendel Sigerist, blacksmith; and Stephen Townsend, cabinetmaker. Charleston County, SC, South Carolina Mortgages, No. [W. W.], 1753–1756, p. 365, 20 July 1754; No. X. X., 1757–1759, p. 63, 14 Sept. 1756; No. Y. Y., 1759–1761, p. 187, 1 Jan. 1760; all as found in the MESDA Craftsman Database.

103. *South-Carolina Gazette* (Charleston), May 23, 1774. Simeon Theus, executor of Jeremiah's estate, advertised the sale of "ALL the Utensils for the Limner's Business, with a good Assortment of the

best Paints, Canvas, &c." Ibid., July 25, 1774. After the artist's death, Edward Oats (dates unknown) advertised in Charleston that he had "in his Possession a great many PORTRAITS of Men, Women, and Children, purchased by him at the Sale of Mr. THEUS's Estate; whosoever is interested in any of them may have them on very reasonable Terms by applying as above." *South-Carolina and American General Gazette* (Charleston), Sept. 9, 1774. The ad suggests an unusual market for portraits: purchasers were probably persons other than relatives of the sitters.

104. Middleton, *Jeremiah Theus,* xiv–xv. Elias Gottlob Haussmann is best known for his 1746 oil-on-canvas portrait of Johann Sebastian Bach.

105. "Corbett" was Thomas Corbett, Esq., of Charleston, an attorney-at-law who accompanied Manigault to England.

106. "Letters," 31, no. 3: 176, 181, and no. 4: 277–278. The portrait of Peter Manigault (fig. 4.35), painted in 1751, is unlocated. "Keble" was most likely the William Keable (Keeble) of London, who painted portraits of Mrs. Benjamin Smith (fig. 4.36) and Thomas Smith Jr., the former now owned by the Gibbes Museum of Art, Carolina Art Association, and the latter privately owned. For additional information on Keable, see McInnis and Mack, *In Pursuit of Refinement,* 94–95, wherein Ellen G. Miles notes that Keable was in Naples, Italy, by 1761 and that he settled in Bologna in 1765. Several English portraits are either attributed or assigned to him as well as a portrait of Francesco Maria Zanotti (1692–1778), secretary and later president of the Instituto di Scienze. Zanotti's portrait is now owned by the Palazzo Poggi Museum in Bologna, Italy. In 1754, Ramsay painted a portrait of David Deas (1680–1757) of Perth, Scotland. That portrait was also in South Carolina by 1782 when one of the sitter's sons who had immigrated to the colony mentioned it in his will. In 1999, the Deas portrait was reportedly privately owned in the United States, but its current whereabouts is unknown. See Smart, *Allan Ramsay,* 99, 377.

107. See Mack and Savage, "Reflections of Refinement," 26, and Middleton, *Jeremiah Theus,* 146.

108. "Journal," 20, no. 2: 128, 129.

109. 31 July 1772, in Habersham, *Letters,* 19. See also Middleton, *Jeremiah Theus,* 9–10. Middleton includes the following information as to what Theus charged for his paintings: "Thirty pounds . . . in full" for the picture of a Mr. Richard Baker, "one hundred & thirteen Pounds fifteen Shillings being the full value" for three pictures for a "Mr. Richd. Bohn. Baker," and "Three Hundred and twenty Pounds South Carolina Currency" for seven family pictures for Governor Habersham. "Eighteenth Century Receipts," 170–171; and James Habersham to Theus, 31 July 1772, in Habersham, *Letters,* 197. The original Baker receipts are in the Baker Grimke Papers, Receipts, South Carolina Historical Association, 11-535/359, 33–35.

110. 31 July 1772, in Habersham, *Letters,* 197. The portrait of Governor Habersham is owned by the Telfair Academy, Savannah, GA. That of Mary Habersham is illustrated in fig. 4.43. "Mr Clay" was likely Joseph Clay (1741–1804), listed in Middleton's book as from Beverly, Yorkshire, Eng., and the nephew of James Habersham (*Jeremiah Theus,* 124); he went to Georgia with his uncle. The grandchild of Colonel Jones was Sarah, the daughter of Noble Wymberley Jones and the granddaughter of Colonel Noble Jones of Savannah (ibid.). It was Colonel Jones who created the plan of Savannah shown in fig. 3.22.

111. Charleston County, SC, Wills, vol. 6, 1747–1752, sec. l, 452, recorded on 26 Jan. 1750/51, and Wills, etc., vol. 77B, 1748–1751, p. 665, 8 Feb. 1750/51, wherein Theus is listed as "Jerk Theus," all as found in the MESDA Craftsman Database.

112. *South-Carolina Gazette* (Charleston), Feb. 1, 1739.

113. Hunter's *Virginia Gazette* (Williamsburg). Just over a year later, on May 15, 1752, an article in the same paper indicated that *"John Keef,"* a painter who had arrived in Virginia in 1750 and had lived in Williamsburg for several months, was "confined in the Public Goal [Gaol]." He had "offered to dispose of three *Dublin* Bank Notes" to a gentleman in town. Apparently he had "used some unlawful Means to procure these Bills."

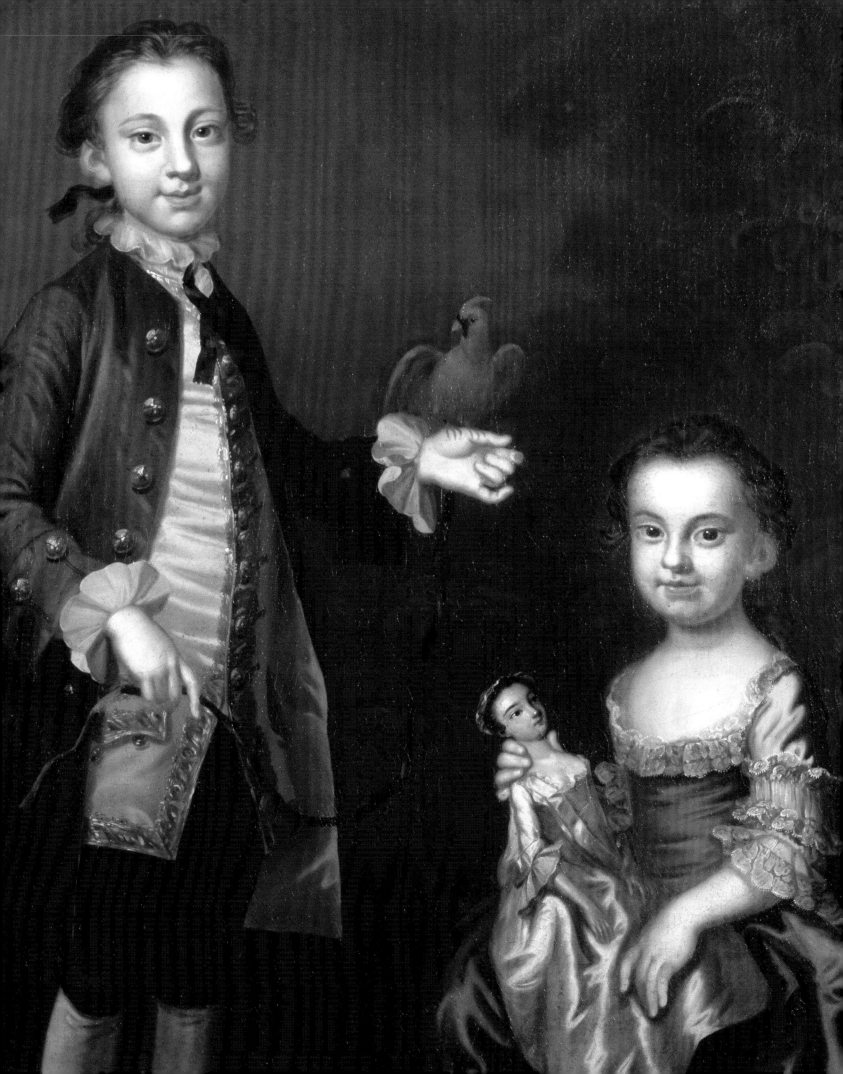

BEHOLD the wond'rous Power of Art!
That mocks devouring Time and Death,
Can Nature's ev'ry Charm impart;
And make the lifeless Canvas breathe.

DR. T. T., 1753[1]

CHAPTER 5

An Increase in Successful Artists

During the 1750s and early 1760s, portraits continued to be essential commodities and possessions of the wealthy southern population that had inherited or acquired social and economic superiority. Increasingly, however, the South's successful tradespeople and merchants were also among those who purchased paintings, perhaps more often than is generally recognized. Most of the pictures bought by both groups were created by artists working in the colonies, though a few well-heeled and well-traveled colonists continued to commission portraits from abroad.

Contrary to what has been claimed in the past, evidence indicates that several of the artists who worked in the South during these years also executed other types of paintings. Landscapes were consistently mentioned in artists' advertisements, the best known of which were for Jeremiah Theus (1716–1774) and Gustavus Hesselius (1682–1755). Both of these men were capable of creating religious and mythological scenes as well, and it is likely that most other painters in the colonies also could provide, or at least attempt, a variety of paintings other than portraits. For example, an artist named Warwell arrived from London and advertised in Charleston in 1766. Although no portraits or other works have been identified as his to date, he offered a full range of services, including the painting of history pieces, altar pieces, landscapes, seascapes, flowers, fruits, heraldry, coaches, window blinds, chimney blinds, and screens. In addition, he did gilding; copied, cleaned, and mended pictures; and painted rooms in oil or watercolor paints with "Deceptive Temples, Triumphal Arches, Obelisks, Statues, &c for Groves or Gardens."[2] Later that year, his advertisements mentioned the more mundane business of whitewashing rooms, perhaps because there were few customers for other sorts of work. Warwell was in South Carolina a very brief time. He died in May, and, on June 2, 1767, his wife published a notice that she and her son, Michael Angelo Warwell, intended to leave.[3] Their names do not appear elsewhere in the colonies before or after that date.[4]

The fact that so few nonportrait paintings by Warwell or others have survived reinforces the notion that portraits continued to be the most valued pictures and

Detail of fig. 5.21

the ones most sought after by clients. Warwell was not an itinerant painter as defined in this study: one who traveled frequently looking for commissions as opposed to one who rarely traveled. Itinerancy—the undertaking of painting trips by artists seeking commissions—was infrequent among painters in the South before the late 1750s. A few southern artists such as Jeremiah Theus made brief visits to areas outside of their hometowns during the 1740s to honor commissions they had probably received either by letter or word of mouth; they would continue to do so in the next decade. As in previous decades, most artists who were in the South took up residence for several years in one place, and, when they moved to work elsewhere, they also moved their residence; otherwise, their names simply disappear from the records, and they, like Warwell's wife and child, probably left the colonies.

In fact, during this period and later, some artists' practice of changing their residence is much more complex and intriguing than has sometimes been observed. The dynasty of Badger family painters—active in Boston, Massachusetts; Charleston, South Carolina; Baltimore, Maryland; and Petersburg, Virginia—demonstrates this point. Attempting to grasp the particulars—the who, where, and when—of the Badger painters and paint shop owners can be bewildering, for genealogical details are extensively available for some and virtually unknown for others. Little survives in the way of artwork for most of the so-called painters in the family, although the existing portraits and other references suggest that several Badgers had the ability to produce pictures of various kinds. What is known about the Badgers is included here in hopes of generating further interest and the discovery of additional works.

Giles Badger, the progenitor of the family in America, journeyed from England to Newbury, Massachusetts, about 1635. His son John Giles Badger was the father of Stephen Badger, a tailor from Charleston, Massachusetts, who fathered several children, including Joseph (1707–1765), the well-known Boston painter; Stephen Jr.;[5] Daniel (1699–1786); and other children who do not figure into this discussion.[6]

In 1731, Joseph Badger, who worked most of his life in Boston and advertised there as a house painter, married Catharine Smith Fletch. Among their children were Joseph Jr. (1731–1800); William; and Benjamin (fig. 5.1). Joseph Jr. and William both moved to Charleston, South Carolina, about 1766, at which time a relative of the family who was already in the city placed a notice of their arrival in local papers.[7] Joseph Jr. took his wife, Rhoda Cox Badger, with him to Charleston, along with three children: James (1757–1817), Joseph III (1761–1803), and Rhoda. A painter and glazier, Joseph Jr. is known to have decorated the local constables' staffs in 1786;[8] provided Charleston cabinetmaker Thomas Elfe with a painted floorcloth for twenty-four pounds in 1766;[9] participated in the town's Federal Procession and Order of March with other painters and glaziers carrying tools decorated with ribbons in May 1788;[10] and helped to settle the estate of John Ruger, another Charleston painter, about the same time.

Joseph Badger III and James Badger, the two sons of Joseph Badger Jr. were both painters as well. James lived in Charleston at various locations and died there in 1817.[11] In addition to painting, he operated an oil and "colour" shop,[12] and he was a member of the Painters, Glaziers and Paper Hangers Company. Like another of his relatives in Charleston, James Badger was a member of the Independent Congregational Church of Charleston, and he taught psalmody and vocal music. His advertisements are especially helpful in learning about the materials available to professional and amateur artists during the period. One listed gold leaf, camel-hair pencils (i.e., brushes), brushes, black lead pencils, and other items. Later he was selling silver leaf, "Finest" coach varnish, boxes of watercolors "No. 6" and "Do." numbers "12," "18," "24," and "with drawers," sets of drawing instruments, ivory pencil sticks, lead pencils, camel-hair pencils, "Fetch" pencils, ebony-handle pallet knives, green-handle pallet knives, and complete sets of drawing crayons.[13] Clearly this James Badger was very familiar with artists' supplies, and he undoubtedly knew how to use them. Two references give information regarding his decorative painting work; of those, one suggests his ability to do

5.1

figural work and, probably, canvas pictures: In 1789, he advertised as a coach and sign painter and indicated that he also lettered coffin plates, and, in 1791, James was employed by the local fire company, furnishing it fire buckets "well made . . . and well painted by Mr. Badger." Unfortunately, these are the only specific references to any of his decorative painting.[14]

Two of the brothers of Joseph Badger Sr. of Boston also had connections with Charleston: Daniel, who moved to Charleston, and Stephen Jr., who had a son named Jonathan who also lived in Charleston. Brother Daniel is first mentioned in Charleston in 1735 as a house and ship painter. He too was a member of the Independent Congregational Church, also known as the Circular Church, where he married Christian Eagle on June 24, 1736; they lived on Tradd Street in the 1740s.[15] The couple had at least three children, one of whom was Daniel (d. 1819), a painter and glazier. He is listed in the Charleston city directory for 1819 at 29 and 30 Archdale Street. Another son, John (d. 1801), probably in Charleston as early as 1794, is listed in the Charleston city directory on Broad

Street before 1797 but disappears from the city afterwards. This is probably the John Badger who moved to Ipswich, Massachusetts, and later to Maryland. After his death in 1801, his orphaned son John (b. 1787) was apprenticed to Hussey and Fisher of Baltimore to learn painting.[16]

The nephew of Joseph Badger Sr., Jonathan Badger (son of Stephen Badger Jr.), moved to Charleston sometime before 1746/47 and built the Jonathan Badger tenements in Charleston. He is listed as a cabinetmaker in 1746. He taught psalmody at the Circular Church and, in 1774, married Mary Baxter in Providence, Rhode Island, where the family moved in 1770. His children included Sarah Badger Noyes (fig. 5.2) and William Badger (b. 1760). Their portraits and a likeness that is probably Sarah's daughter, Sally Noyes, (fig. 5.4) by their uncle Daniel Badger survive.[17]

Another son of Joseph Badger Sr., also named Jonathan (1736–1799), first appears in Charleston records in 1790 when he is listed in the Charleston city directory as a painter living at 49 Meeting Street. In 1792, he advertised at 49 Meeting Street as a house, ship, and sign painter as well as a glazier, gilder, and paper hanger.[18]

FIGURE 5.1. Joseph Badger Sr. or Daniel Badger, *Benjamin Badger* ?, 1763–1769, oil on canvas, 42" x 32½". Courtesy Winterthur Museum.

The portrait, first documented by the historian Lawrence Park, was published in 1918 when it was in a private collection in Massachusetts. Park and later historians have recorded the child as a son of Boston painter Joseph Badger Sr., possibly Benjamin (before 1748–1832). Unfortunately, that identification cannot be confirmed. Although the painting is typical of Joseph's work, it also shows many similarities to that of Daniel Badger, including the wooden stance of the sitter and the inclusion of pets— here, the squirrel.

Joseph Badger Sr. also painted a portrait of another child in his extended family, usually identified as his grandson James Badger (1757–1817), son of Joseph Badger Jr. and Rhoda Cox Badger, who moved to Charleston, South Carolina, around 1765. The Metropolitan Museum of Art, in New York City owns the portrait of James, who lived in Charleston until his death. Dated 1760, that portrait has a history of descent in a Charleston family.

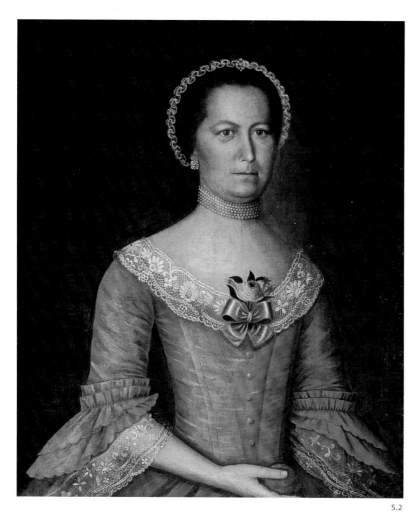

5.2

FIGURE 5.2. Daniel Badger, *Sarah Badger*, probably 1767, oil on canvas, 29½" x 24½". Dallas Museum of Art, the Faith P. and Charles L. Bybee Collection, gift of Faith P. Bybee.

The portrait of Sarah Badger (1747–1788) has been attributed to both John Durand and Joseph Badger, but stylistically it bears a much stronger relationship to the work of Daniel Badger, who also painted a likeness of Sarah's daughter (fig. 5.4), parents, and possibly her brother, William. Sarah was the daughter of Jonathan and Mary Badger of Charleston, South Carolina. In 1766, she married Oliver Noyes of Charleston. After his death around 1768, she moved with her parents to Providence, Rhode Island, where she met and, in 1773, probably married her second husband, the Reverend Joseph Snow Jr. The coloring of Sarah's face, the shape of her lips, and the overall treatment of the dress fabric are consistent with such passages in other portraits attributed to Daniel Badger.

Like other members of the extended Badger family in Charleston, Jonathan was a member of the Independent Congregational Church. On July 16, 1794, probably in anticipation of leaving the colony, he mortgaged considerable household furniture, including a dozen pictures and a painted floorcloth, to Solomon Legare Jr.[19] He was living in Petersburg, Virginia, by April 22, 1799, when he submitted an advertisement that appeared in the local papers saying he had opened a shop in Old Street, next to Captain William Durrel, where he carried on the coach, house, and sign painting business and did paper hanging, glazing, gilding of looking glasses, and repairing of "Decayed Portraits & Landscapes repaired, nearly equal to their first lustre."[20]

Jonathan's motivation for moving to Virginia is unknown, but he was likely joining his nephew Joseph III, who was in Petersburg by 1786 and who died there in 1803. On September 29, 1791, Joseph Badger III advertised in the *Virginia Gazette, and Petersburg Intelligencer* that he had opened a retail color shop and did coach and sign painting "as usual." Presumably he had been in that business since the 1780s. Additional references to a Joseph Badger (possibly Joseph III) in Petersburg, Virginia, include his having an elegant phaeton for sale in 1792; his partnership in coach and sign painting, gilding, paper hanging, and other work with "Shiphard" (probably Shephard since Joseph Badger married Nancy Ann Shepherd in 1786); and his partnership with James Atkins (dates unknown) in 1796–1797 in the shop previously occupied by Devereux J. Manley (dates unknown), deceased.[21]

The portrait of Sarah Badger Noyes by Daniel Badger (fig. 5.2) was copied by an artist named Moore (possibly Abel Moore, 1806–1897) of Troy, New York, in 1847. This picture bears a copy of an old inscription on the verso that reads "Sarah Badger of Charleston S. C. / Age 22."[22] Sarah was the widow of Oliver Noyes when she moved from Charleston to Providence, Rhode Island, with her parents on May 8, 1770.[23] The use of Badger, her maiden name, on the inscription helps verify that her portrait was likely created before her marriage and that its place of execution was Charleston, where she lived before 1770.

The portrait of an unidentified child (fig. 5.3), also with a Charleston history, is the only signed work by Daniel Badger. This painting and a second portrait of a child (fig. 5.4), believed to be Sally Noyes, were recently discovered and researched by Leigh Keno of New York City. Another likeness, dated 1781 and depicting a gentleman identified only as "PF" (fig. 5.5), was likely painted by Badger. When acquired by the Abby Aldrich Rockefeller Folk Art Museum, it was believed to represent Peter Farrington of Boston by an unidentified artist. Its inscription on the back of the original canvas, now obscured by a new lining, is said to read "AE 33y PF / Dec. 12 / 1781." The subject stands before a pipe organ with his hand on the keyboard. He also is holding a music book with the name "S. Brockiner" painted on the right page. Neither the Farrington nor Brockiner name has been found in sources related to eighteenth-century organs or organists, psalmody, music, or musicians in America or England. If the picture is by Daniel Badger, then it was probably painted in Charleston, South Carolina. The artist died there in 1786, five years after the picture was painted, and there is no evidence that he left the town during the Revolutionary War years. The inscribed date is curious. For many months prior to December 12, 1781, Charleston had been occupied by British forces, and it had endured military skirmishes through at least December 7. On December 14, the British forces began their evacuation of Charleston, an event that was much welcomed but that also created considerable turmoil. That was hardly a time to have one's portrait painted. A future investigation of the now-obscured inscription on the back of the picture needs to be made to verify its authenticity and the date and the initials of the sitter.

Additional research is also needed on the Badgers, particularly Jonathan (son of Stephen Badger Jr.), who taught psalmody, and James (son of Joseph Badger Jr.), who taught sacred music and vocal music. There may have been some connection between one or both of these two Badgers and the portrait sitter who posed as an organist.

There are many striking similarities between the paintings of Daniel and Joseph Badger Sr.—and also some differences. Of importance is that both painters created portraits for middle-class clientele. In the case of Joseph Sr., his customers included merchants and tradespeople of varying levels of wealth. From the few pictures known by Daniel, most of which were for family, it seems that his consumer base was much the same. Both artists developed their portraits carefully with even, tight brushwork, although Joseph's likenesses are slightly more painterly, particularly in his development of the landscape elements. As is typical of portraits by painters of this rank and background, the figures are rather stiffly posed, and they sometimes appear to be floating in their settings. Unlike sitters wearing the fancy imagined or print-source inspired dress seen in a large number of southern portraits, Daniel's Charleston sitters wear rather conservative but nicely colored attire that they may have owned. Their skin tones are dark, probably due to the artist's inexperience or his ignorance of the correct way to model and highlight such areas without mudding the paint. As products of someone who was basically trade-trained, Daniel's pictures are admirable efforts to provide conservatively fashionable and likely inexpensive portraits for persons of middling station.

A marked difference between the work of Joseph Sr. and Daniel is Daniel's delicate, wispy treatment of the highlights on fabric folds as opposed to his brother's smoother and bolder approach. However, the strongest distinguishing feature between the work of the two painters lies in the drawing and development of faces. In Daniel's portraits, the eyes are often very dark with stronger highlights; his facial features in general (and the eyes in particular) tend to be closer together; and the area between the upper lip and nose is often more darkly shaded.

It is likely that other members of the Badger family also painted portraits and other types of pictures. The advertisement of Jonathan Badger (active 1790–1799), the one who moved to Petersburg, Virginia, saying that he repaired "Decayed" portraits and landscape paintings, suggests that he had knowledge of easel art and probably could provide such work. In Charleston, the Badgers would have competed with Jeremiah Theus, the resident and well-respected artist who served Charleston clients

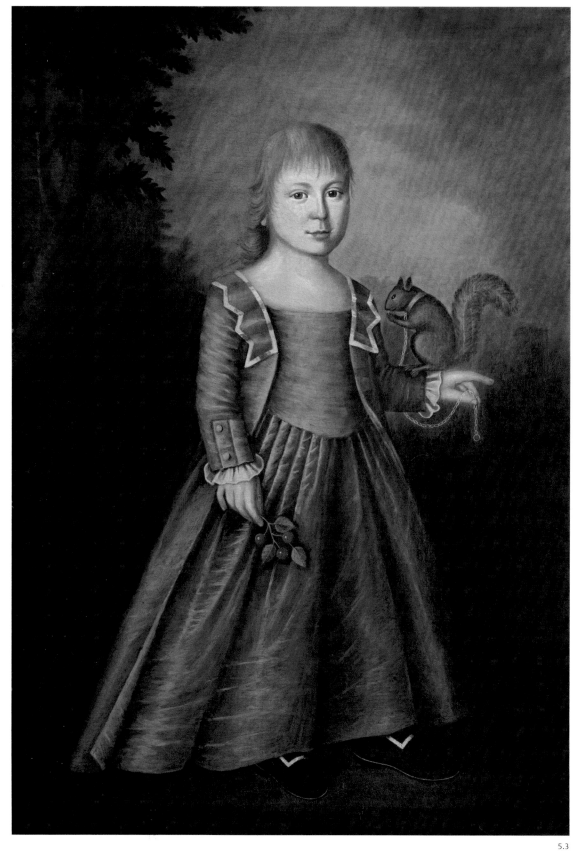

5.3

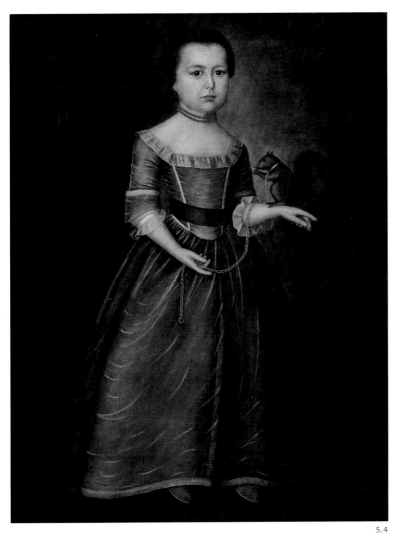

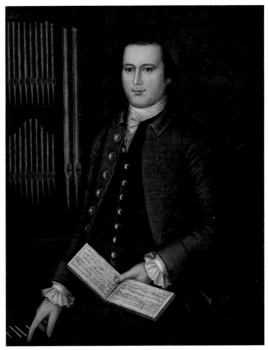

5.4

5.5

FIGURE 5.3. Daniel Badger, *Unidentified Child*, ca. 1765, oil on canvas, 36" x 25¾". Private collection. Image by Lynne McGraw Photography.

Discovered in recent years by Leigh Keno of Leigh Keno American Antiques in New York City, this portrait has become the key to the identification of works attributable to Daniel Badger, the brother of the Boston painter Joseph Badger Sr. A pencil inscription in eighteenth-century script on the verso of the strainer reads, "Painted by Daniel Badger." The identity of the child is unknown, but the picture has a history of coming from Charleston, South Carolina.

FIGURE 5.4. Daniel Badger, probably *Sally Noyes* (previously identified as Sarah Badger), probably 1766–1768, oil on canvas, 39¼" x 30⅜". Private collection. Image by Lynne McGraw Photography.

Along with the portraits of her grandparents Jonathan and Mary Badger and her mother, Sarah Badger Noyes (fig. 5.2), this portrait of Sally Noyes (b. before 1767) shares a common history of descent in a Charleston, South Carolina, family. Sally's father was Oliver Noyes of St. Philips Parish, Charleston, South Carolina. After Noyes's death, Sally and her mother moved to Providence, Rhode Island, with other members of the family. In 1773, Sarah

Badger married Joseph Snow of Providence, Rhode Island. A record left by a Snow descendant describes and correctly identifies this portrait as Sally. That descendant writes: "I recollect I was taught to approach this family [Jonathan Badger's family] with awe and reverence, hence I was impressed ever after that they were a family of high respectability. I remember of calling often at the house of this family . . . to gaze on the portrait of Sally Noyes, with a squirrel drawn to the life on her arm." (See Warren, "Badger Family Portraits," 1045–1046, which includes further discussion of the documentation for this portrait. The Snow descendant reference was in the possession of the portrait's owner in 1980.)

It seems likely from the identification of the child and the known dates of her mother's first marriage that this portrait was painted in Charleston, not in New England, and certainly not by Joseph Badger Sr., although Sally holds a squirrel similar to ones seen in children's portraits by him. However, Sally's squirrel is *identical* to the one seen in figure 5.3, the portrait inscribed "Painted by Daniel Badger." Significant differences between these two Badger painters include the manner in which they painted and highlighted fabrics. On dress skirts, for instance, Daniel used multiple small streaks of light paint for highlights whereas Joseph tended to mix and model his highlights in a more controlled fashion. Daniel's small streaks flow from the upper right of garment skirts to the lower left in this portrait, in the likeness of Sally's mother (fig. 5.2), and in that of the unidentified child (fig. 5.3). Daniel's use of slightly darker tones for skin, eyebrows, and eyes are another distinction between his work and Joseph's. In addition, Joseph tended to use bright light blues for his sky backgrounds, not the darker tones used by Daniel.

FIGURE 5.5. Daniel Badger, *Unidentified Musician*, dated 1781, oil on canvas, 41¼" x 33". Colonial Williamsburg Foundation, Williamsburg, VA. Gift of Abby Aldrich Rockefeller.

until his death in 1774. Competition came also from painters who visited in Charleston for periods of time. For instance, John Wollaston Jr. (ca. 1705–after 1775) and Abraham Delanoy Jr. (1742–1795) were among the trained English painters who went there. Wollaston immediately attracted clients, but to what extent Delanoy did so is unknown, for no southern works by him have been convincingly identified.

John Wollaston Jr. arrived in America in 1749, the same year that his father John Wollaston (Woolaston) Sr. died. The elder Wollaston was a portrait painter in London, and it seems logical that his son first trained with him and perhaps later associated with other artists, namely Joseph van Aken (ca. 1699–1749) and Thomas Hudson (1701–1779). Most of the particulars of both Wollastons' careers have been discussed in several publications or papers in the past but are summarized here and enhanced with new information.[24]

In addition to being a painter, John Wollaston Sr. was a musician in London, where he seems to have been well connected. Horace Walpole wrote that "Woolaston" was "born in London about 1672, was a portrait-painter, and happy in taking likenesses, but I suppose never excellent, as his price was but five guineas for a 3/4 cloth." Walpole went on to say that Wollaston Sr.

> married the daughter of one Green, an attorney, by whom he had several children, of which one son followed his father's profession. In 1704 the father resided in Warwick-lane, and afterwards near Covent-Garden. He died an aged man in the Charter-house.[25] Besides painting, he performed on the violin and flute, and played at the concert held at the house of that extraordinary person, Thomas Britton, the smallcoal-man,[26] whose picture he twice drew, one of which portraits was purchased by sir Hans Sloane, and is now in the British Museum. There is a mezzotinto from it.[27]

Some of this information is sufficiently understated as to be misleading. For instance, the elder Wollaston played *regularly* in Thomas Britton's concerts, not just in a single concert as Walpole implied. One early source states that John Wollaston Jr. also played in these concerts and that his father continued them, holding them at the Wollaston home after Britton's death.[28] These musical events were known to virtually anyone in London who maintained an interest in the arts and music. Contemporaries and commentators of the period write glowingly of Britton's music club performances, noting how extraordinary they were for their time, and concert attendees were described as being "Men of the best Wit, as well as some of the best Quality."[29] Britton (figs. 5.6 and 5.7) practiced the highest branches of music and gathered around him some of the greatest musicians of the age, including George Frideric Handel. One account of Britton's life claims that he

> took a small stable at the south-east corner of Jerusalem Passage [in London]. . . . His coal he kept below, and he lived in a single room above, which was ascended by an external ladder. . . . [He] founded a musical club, which met at his house for nearly forty years [on Thursdays], and at first gave gratuitous concerts, afterwards paid for by an annual subscription of ten shillings.[30]

In addition to the Wollastons, Handel, and Britton, those who routinely played were Philip Hart, a well-known composer and keyboardist; Henry Needler, a celebrated musician and transcriber of the work of Palestrina and others; John Christopher Pepusch, a composer and harpsichordist; John Bannister the Younger, a theater musician, publisher, and member of the royal band performing under Charles II, James II, William and Mary, and Queen Anne; and John Hughes, author and poet.[31] The coal man's concert "club" was one of the most dynamic intellectual and cultural groups of its day. The fact that John Wollaston Sr. was a part of this community of literati is vitally important to an understanding of his son's background, social position, possible contacts in London, and life experience.[32]

Wayne Craven's short but important list of the portraits painted by Wollaston Sr. includes the well-known surviving version of *Thomas Britton* and another of Henry Sherburne (dates unknown), dated 1709–1710.[33] All of the others are known only from engravings after

5.6

Tho: Britton, Small-Coal-Man.

Tho' doom'd to Small Coal, yet, to Arts ally'd,
Rich without Wealth and Famous without Pride:
Musick's Best Patron, Judge of Books and Men,
Belov'd and Honour'd by Apollo's Train;
In Greccae or Rome, sure never did appear
So Bright a Genius, in so dark a Sphere;
More of the Man had artfully been Sav'd,
Had Kneller painted and had Vertue Grav'd.

5.7

FIGURE 5.6. John Wollaston Sr., *Thomas Britton*, dated 1703, oil on canvas, 29¼" x 24½". © National Portrait Gallery, London.

John Wollaston Sr. painted two portraits of Thomas Britton (1644–1714), but only this version survives; it is on display at the Handel House Museum, London. The other, probably similar to the mezzotint published after Britton's death (fig. 5.7), shows considerably more detail of the musician's concert room and the instruments he owned. Some sources say there were as many as twenty-seven instruments in the room, all auctioned after his death.

FIGURE 5.7. Thomas Johnson, engraver, after John Wollaston Sr., *Thos. Britton, Small-Coal-Man*, ca. 1735, ink on paper, 15¾" x 11¼". Gerald Coke Handel Collection, Foundling Museum, London/The Bridgeman Art Library Nationality.

The text of the poem below the portrait, attributed to Matthew Prior, English poet and diplomat, expresses the belated wish that Sir Godfrey Kneller, not John Wollaston Sr., had painted Thomas Britton's portrait and that George Vertue had engraved it:

> Tho' doom'd to Small Coal, yet, to Arts ally'd,
> Rich without Wealth and Famous without Pride:
> Musick's Best Patron, Judge of Books and Men,
> Belov'd and Honour'd by Apollo's Train;
> In Greccae or Rome, sure never did appear
> So Bright a Genius, in so dark a Sphere;
> More of the Man had artfully been Sav'd,
> Had Kneller painted and had Vertue Grav'd.

Edward Ward described Britton's dwelling, saying that the

> Hut wherein he dwells, which has long been honoured with such good Company, looks without Side as if some of his Ancestors had happened to be Executors to old snorling [snarling?] *Diogenes*, and that they had carefully transplanted the *Athenian*-Tub into *Clerkenwell*; for his House is not much higher than a *Canary* Pipe, and the Window of his State-Room, but very little bigger than the Bunghole of a Cask. (*Compleat and Humorous Account*, 302)

John Hughes, one of the musicians who played with Britton's group, wrote the following lines after the small coal man's death:

> Tho' mean thy Rank, yet in thy humble Cell
> Did gentle Peace and Arts unpurchas'd dwell;
> Well pleas'd Apollo thither led his Train,
> And Musick warbled in her sweetest Strain.
> Cyllenius so, as Fables tell, and Jove
> Came willing Guests to poor Philemon's Grove.
> Let useless Pomp behold, and blush to find
> So low a Station, such a liberal Mind.
> (Hawkins, *General History of Music*, 789)

them, making difficult any comparison of the work of father and son. The Britton portrait shows "the small-coal-man" holding a coal bucket and dressed in the blue frock he wore when peddling coal; the picture served as the model for several engravings. A second portrait of Britton by Wollaston Sr., apparently now lost, must have been the one copied by the engraver Thomas Johnson (active ca. 1735) (fig. 5.7). It shows Britton in a similar frock but with one hand on a keyboard, the other holding a cross. A violin and books are in the background. It is revealing that all of the other portraits known from prints by Wollaston Sr. are of clergymen,[34] and one of his son's earliest known pictures is of the evangelical minister George Whitfield (Whitefield) (fig. 5.9). According to one source, the elder Wollaston's house was frequented by religious dissenters.[35]

Born in London about 1705, the younger John Wollaston was probably painting as early as 1725, well before his father's death. Sir Godfrey Kneller's influence on Wollaston's style is seen in his portrait of Sir Theodore Turquet de Mayerne of about 1734 (fig. 5.10) as well as in the surviving likenesses of six other Oxford University physicians and clergy[36] and two recently discovered portraits of Philip Bartholomew (ca. 1672–1749) and his second wife, Mary Thomas Bartholomew (d. 1775).[37] But the style of Wollaston Jr. was in transition, as illustrated by the 1742 view of George Whitfield preaching before a crowd of admirers (fig. 5.9). The Whitfield likeness introduces newer features, including brushwork that is more fluid and sure, and slightly lighter coloration. The figures in the crowd are reminiscent of several seen in portraits by the London painters Arthur Devis (1712–1787) (fig. 5.11), William

5.8

FIGURE 5.8. Detail of map of London, enlarged from John Rocque (ca. 1709–1762), *A New and Accurate Survey of the Cities of London and Westminister, the Borough of Southwark with the Country about It for Nineteen Miles in Length, and Thirteen in Depth,* 1748, ink on paper. Colonial Williamsburg Foundation, Williamsburg, VA.

John Wollaston Jr. probably lived with his father on Warwick Lane, near Covent Garden. Warwick Lane is just northwest of St. Paul's on the map.

Hogarth (1697–1764), Joseph Highmore (1692–1780) (fig. 5.11), and Bartholomew Dandridge (1691–after 1755) (fig. 5.12). The expression, posture, and overall fleshy face, arms, and hand of the woman seated in front were part of Wollaston's transition to a more fashionable style, and they reflect his awareness of the work of Devis and Highmore. In conversation pieces by these painters, the women have fleshy appearances, and they are dressed in pastel colors, as is the Wollaston woman.

The Whitfield commission must have come to Wollaston through some personal contact, perhaps from another university-connected clergyman who moved in the artist's (or his father's) circle of friends. Whitfield was a popular ecclesiastical figure in England and the North American colonies, and his portrait was painted at least three times. An American example is attributed to Joseph Badger Sr. of Boston.[38]

Only a few facts are known about Wollaston's training that might link him to other practitioners of the newer rococo style. Walpole's reference to Wollaston's work in

5.9

5.10

London indicates that the artist was associated with a famous drapery painter. For many years, scholars have conjectured that Joseph van Aken or Peter Toms (1728–1777) may have trained Wollaston to paint the realistic silks and satins that are seen in his best portraits. Van

Aken's business included several unidentified painters, and certainly Wollaston may have been an apprentice or journeyman to van Aken. As discussed in the introduction, drapery painters were considered "mechanics," and shop owners organized their workers to paint specific

FIGURE 5.9. John Wollaston Jr., *George Whitfield Preaching*, ca. 1742, oil on canvas, 32⅝" x 26". © National Portrait Gallery, London.

In his version of George Whitfield (Whitefield) (1714–1770) preaching, intended to function as both a portrait and a history picture, John Wollaston Jr. introduced more fluid brushwork and slightly lighter coloration into his style. The picture is similar, but not identical, to other portraits of Whitfield created about the same time by London artists. In all of the others, Whitfield is shown with his arms extended upwards. Wollaston positioned Whitfield's arms outwards, toward the audience. The distinction probably indicates that Wollaston created the picture from life, or from his own sketches, rather than from other pre-existing sources. Whitfield's strabismus, or crossed eyes, obvious in this likeness, probably resulted from measles contracted in childhood.

Whitfield, an itinerant Anglican minister, became an important figure in British and American religious history. Many credit

him as being the founder of the evangelical movement in both England and America. Early in his career, he was a parish priest in Savannah, Georgia, but he returned to England in 1739. He was back in America in the 1740s as an itinerant, preaching from New York to Charleston. His evangelical messages had a profound impact on American religious mores and attitudes towards worship, familial interactions, and slavery.

FIGURE 5.10. John Wollaston Jr., *Sir Theodore Turquet de Mayerne*, dated 1734, oil on canvas, 25" x 20". Bodleian Libraries, LP 123.

Sir Theodore Turquet de Mayerne (1573–1654/1655) was born in Switzerland. In 1611, after his education and various posts in the French court, he went to England where he served as the first physician of James I. He was elected to the Royal College of Physicians in 1616. He retired in 1625 when Charles I became king.

5.11

5.12

areas such as sky, clothing, lace, and drapery. When Joseph van Aken died in 1749, his brother Alexander (d. 1757) attempted to continue the business but failed.[39]

Wollaston's mature style is especially close to that of Thomas Hudson, Joseph Highmore, and a less well-known English painter, Bartholomew Dandridge, as noted earlier.[40] It is reasonable to suggest that these men

FIGURE 5.11. Arthur Devis or possibly Joseph Highmore, *Seated Lady in Landscape*, 1730–1750, chalk on paper with canvas support, 23½" x 17½". © The Trustees of the British Museum.

FIGURE 5.12. Bartholomew Dandridge, *Uvedale Tomkyns Price (1685–1764) and Members of His Family*, ca. 1728, oil on canvas, 40¼" x 62½". Image © The Metropolitan Museum of Art/Art Resource, NY.

Bartholomew Dandridge, the son of a house painter, studied first with Sir Godfrey Kneller and later at St. Martin's Lane in London. He took over Kneller's studio in 1731 and was one of the first English painters of conversation pieces. He offered all of the traditional sizes of portraits as well, and he developed a French or rococo style that attracted important commissions.

were among a group of London painters—a group that included van Aken and Wollaston—who knew each other and practiced a similar style. Wollaston not only may have worked in van Aken's studio but also may have painted the fabrics in some of Hudson's portraits. Whether Dandridge used a drapery painter is unknown, but both Highmore and Hudson engaged van Aken as their drapery painter. Hudson in particular used poses, costumes, and compositions that Wollaston seems to have freely adopted and imitated. The almond-shaped eyes typically associated with Wollaston's sitters are also seen occasionally in Hudson's work, although in a less pronounced way. Compare, for instance, Wollaston's portrait of Beverley Randolph (fig. 5.14) with Hudson's likeness of the young Virginian David Meade Jr. (fig. 5.15), painted in 1752 when Meade was attending school in England. The similarities in the shapes of the eyes, the poses, the drawing of the hands, the costuming, and the painting of the fabrics are striking.[41] The young man in Hudson's portrait was the son of David Meade (1710–1757?) and Susannah Everard Meade (b. ca. 1714) of Virginia; Wollaston painted the parents' portraits

5.13

FIGURE 5.13. John Wollaston Jr., *Elizabeth Randolph Chiswell*, 1752–1759, oil on canvas, 36″ x 29″. Virginia Historical Society.

Elizabeth Randolph (1715–1776) married Colonel John Chiswell of Williamsburg. She was from the large and wealthy Randolph family of Virginia, for whom John Wollaston Jr. did many portraits. See figures 5.14, 5.20, 5.22, and 5.23.

Elizabeth Chiswell's pose, particularly the position of the hands, is commonly seen in portraits by Thomas Hudson. Wollaston, like Hudson, developed a consistent manner for hand positions, as well as for fabric modeling. Other portraits by Wollaston illustrated in this chapter show these repetitive features that make his work seem formulaic though his clients apparently ignored the repetition in his compositions and his idiosyncrasies.

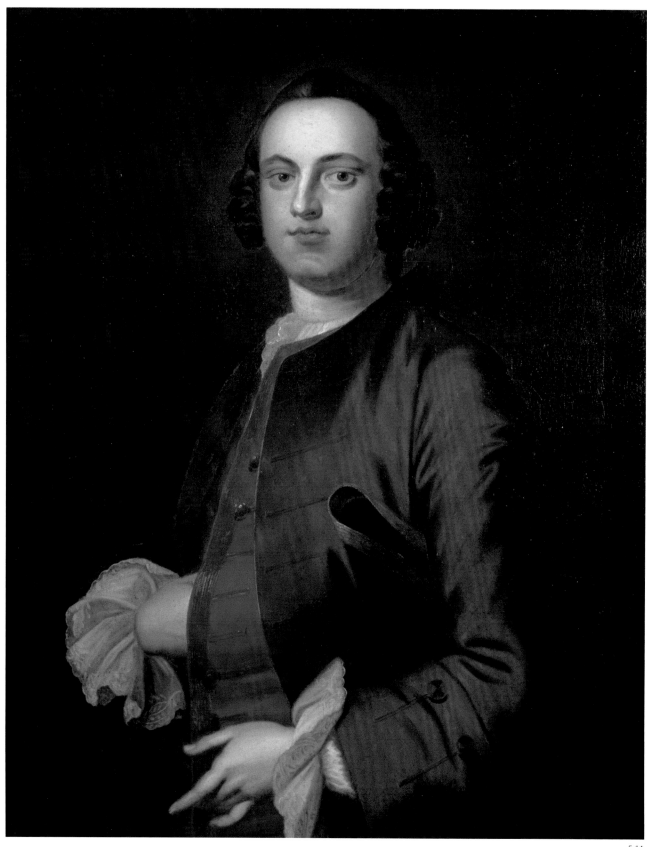

5.14

sometime between 1752 and 1757. It seems more than coincidental that, at roughly the same time, the Meades employed the two artists, Hudson in England and Wollaston in Virginia, whose portrait styles were so similar. Thomas Hudson is also known to have painted a portrait of John Christopher Pepusch (1667–1742) about 1735 and at least three portraits of George Frideric Handel (1685–1759). Both of those men were musicians who played regularly in concert with the Wollastons. Finally, Wollaston, like Thomas Hudson, is known to have painted several naval officers, and many similarities are noted between the two artists in those works.

In the same year that Wollaston left England for America, his two most likely teachers and mentors—his father and van Aken—both died. It seems probable that his move was occasioned by their deaths as well as by the existing competition with other portrait and drapery painters in London. He had sufficient skill and practice to offer his services in the colonies, where no painter of his rank had worked for several years, and he could pursue his trade there as an independent painter, succeeding as a portrait artist and not solely as a drapery specialist.[42]

Wollaston was in New York City by June 23, 1749, at which time he appeared as a witness in a court case.[43] Other documentation regarding his work in New York includes one known painting bearing a paper label for "JOHANNES WOLLASTON LONDONIENSIS PINXIT NOVIEBORACI AD MDCCLI" and several dated examples for 1750, 1751, and 1752.[44] He is also mentioned in the minutes of the Vestry Board of Trinity Church in New York on April 1, 1752, when that group ordered "Mr. Marston, Mr. Duncan, and Mr. Nicholls to treat and agree with Mr. Wollaston to copy the late Revd. Commissary Vesey's picture, a half length, in order to be placed in the Vestry room."[45]

Wollaston painted at least seventy-five portraits in New York, many of which show a close relationship with Hudson's work. The New York pictures are elegant and well finished, among the artist's best American efforts, as illustrated by the portraits of Joseph Reade and his wife (figs. 5.16 and 5.17). The tighter brushwork in these pictures, unlike his later work, is surer than it had been

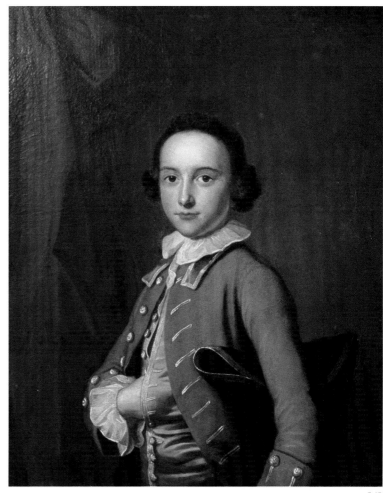

5.15

FIGURE 5.14. John Wollaston Jr., *Beverley Randolph of Turkey Island ?*, 1752–1759, oil on canvas, 36" x 29". Virginia Historical Society.

Either this portrait was painted after the subject's death or copied from a pre-existing portrait by an unidentified artist or the subject is misidentified. Beverley Randolph (1713–1750) was the eldest son of William Randolph II. The pose and composition are typical of John Wollaston Jr.'s waist-length images of men and imitative of English examples.

FIGURE 5.15. Thomas Hudson, *David Meade Jr.*, possibly 1752, oil on canvas, 30" x 25". Colonial Williamsburg Foundation, Williamsburg, VA. Gift of Tyrrell Williams.

Born in Nansemond County, Virginia, David Meade Jr. (1744–1830) was sent to England by his parents for schooling at Harrow, north of London. Thomas Hudson painted this portrait of young David Meade while he was a student in England, about the same time that John Wollaston Jr. painted portraits of the boy's parents in Virginia. It compares favorably with English portraits of other young southern male students but is smaller in size and more conservative in its overall effect. For comparison, see the portrait of Robert Carter (frontispiece).

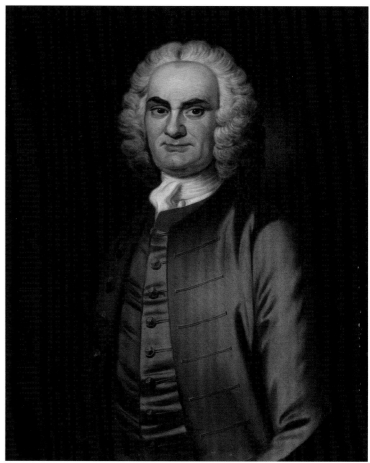

5.16

5.17

FIGURES 5.16 AND 5.17. John Wollaston Jr., *Mrs. Joseph Reade* (Anna?, d. 1778) and *Joseph Reade* (d. 1771), 1749–1752, oil on canvas, 30" x 25". Images © The Metropolitan Museum of Art/Art Resource, NY.

The Reade portraits are typical of John Wollaston Jr.'s exceptionally well-finished but economical waist-length portraits. The fabrics are convincingly rendered with his typical strong highlighting, and the lace on Mrs. Reade's fichu and cap is equally well done. Occasionally Wollaston was able to capture something of the sitter's real appearance and personality; that ability seems evident in these likenesses, making them noteworthy examples of his early work.

in London but still painterly. Wollaston would always be a superb technician, able to paint convincing fabrics for costumes and other accoutrements with ease. He knew how to build these with layers of thin glazes before providing the final highlights with a loaded brush; in fact, some of his highlights approach impasto. Poses, costumes, backgrounds, and most objects seen in Wollaston's likenesses were imagined, remembered, or borrowed from English sources. The Reade pictures reflect styles as interpreted by artists like Hudson; they do not reveal many characteristics of the exuberant rococo manner that Wollaston would practice in the southern colonies.

After several years in New York, Wollaston moved on, making a brief stop in Philadelphia before visiting Annapolis, Maryland, where he completed portraits by March 1753.[46] During that month, a Maryland admirer

identified as "Dr. T. T." was so moved that he wrote and published several complimentary verses in the *Maryland Gazette* (Annapolis) titled "EXTEMPORE: On Seeing Mr. Wollaston's Pictures, in Annapolis":

BEHOLD the wond'rous Power of Art!
That mocks devouring Time and Death,
Can Nature's ev'ry Charm impart;
And make the lifeless Canvas breathe.

The Lilly blended with the Rose,
Blooms gayly on each fertile Cheek;
Their Eyes, the sparkling Gems disclose,
And balmy Lips, too, seem to speak.

Nature and We, must bless the Hand,
That can such heav'nly Charms pourtray,
And save the Beauties of this Land
From envious Obscurity.

Whilst on each perfect Piece we gaze,
In various Wonder we are lost;
And know not justly which to praise,
Or Nature, *or the* Painter, *most.*[47]

Such heady eulogies for painters were uncommon at any time in pre-1790 America, although they were not a unique form of recognition, for European writers occasionally wrote glowingly of important artists and their contributions.[48] Many colonial Americans, or in the very least the gentrified ones, were hungry for such cultural sophistication in the arts, music, and literature. Phrases that claim that the *"Power of Art"* can mock the *"devouring Time and Death"* and save the *"Beauties of this Land / From envious Obscurity"* certainly make a strong case for having portraits. The poem is therefore important for two reasons: first, as an indication of colonial Americans' cultural awareness and desire for portrait paintings and, secondly, as testimony to Wollaston's success as a fashionable painter who, by this time, had introduced the rococo style, with all its attendant charms, to the colonies. Judging from the look of most of

his southern paintings, one might conclude that the pizzazz of Wollaston's portraits was as important to sitters as a faithful or truthful likeness. Over two hundred colonists, approximately two-thirds of whom were southerners, engaged Wollaston during his sojourn.

By the time Wollaston arrived, a few of Maryland's wealthiest families—for example, the Bordleys, Calverts, and Carrolls—were already familiar with London painters and aspects of the latest fashions. Imported furniture, ceramics, fabrics, prints, metalwares, and a broad assortment of other household goods from England were common in the homes of such colonial planters, some of whom were portrayed by London artists when the colonial sitters traveled abroad. During this period, Sir Joshua Reynolds (1723–1792) painted several southerners, including South Carolinian Miles Brewton (1731–1775) in 1756 and, seven years later, Marylander Charles Carroll (1737–1832) of Carrollton. Other members of the extended Carroll family also had sophisticated portraits from abroad.[49] The custom of taking the grand tour of Italy, England, and other areas was not common during this time, though it would be by the 1760s and 1770s when other southern colonists would commission likenesses from painters in both Italy and London.

The logical substitute for a portrait done in England was a portrait painted in the colonies by an English artist.[50] Wollaston qualified as such, and he worked swiftly. Word of his shimmering fabrics had probably already spread to relatives and friends in Maryland and Virginia from his wealthy clients in New York and Philadelphia. The three-quarter-length portraits of Benedict Calvert (fig. 5.18) and Elizabeth Brooke Carroll (fig. 5.19) are among the most elegant of the Maryland pictures, especially in the skillful rendering of fabrics and in the painting of faces. Wollaston also painted a portrait of Mrs. Carroll's husband, Charles Carroll of Annapolis.[51] Several of the wealthy Maryland families were interrelated, and familial relationships also extended through marriage to prominent families in Virginia. Wollaston rarely advertised in the colonies; his reputation and commissions likely resulted from client recommendations passed from family to family and region to region.

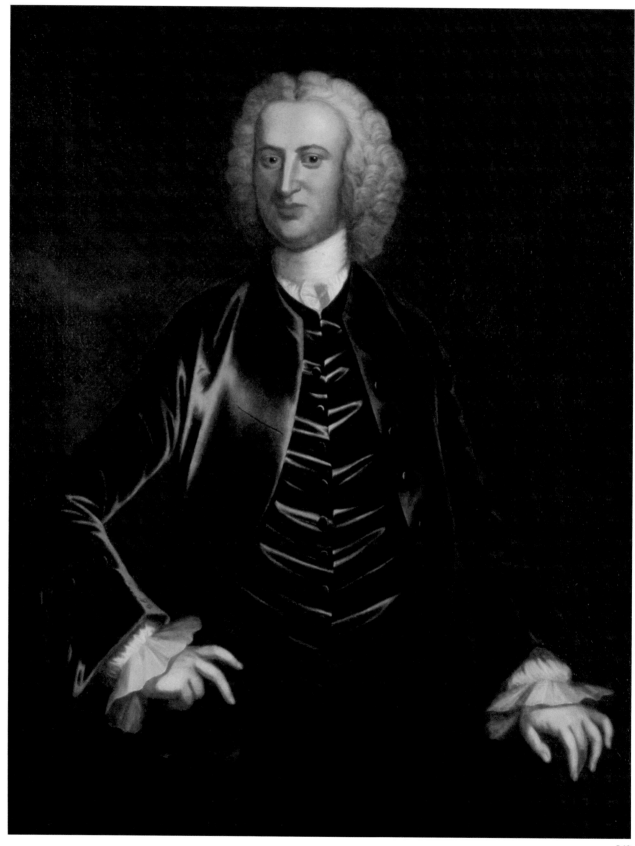

5.18

He was probably back and forth between Maryland and Virginia, working primarily in Virginia from about 1755 to sometime in 1758 or early the next year.

Wollaston worked extensively for the Randolph family in Virginia, painting many of its members in 1755, when he dated a copy portrait of Colonel William Randolph II (fig. 5.20). The Randolph family portraits vary in size, poses, and composition, demonstrating the wide variety of formats the artist offered throughout his career. Like Charles Bridges (1670–1747) and other painters, Wollaston probably owned a collection of portrait prints from which clients could select particular poses and sometimes their dress and background details. He occasionally employed unusual poses, like that for little Elizabeth Randolph who is shown in a horizontal "window" view holding her doll (fig. 5.22). While the same or a similar doll appears in several of Wollaston's other paintings, including the double portrait of Elizabeth Page and her brother Mann Page III (fig. 5.21), the composition is seen only in one other painting, the pendant portrait of Elizabeth Randolph's sister Anne (fig. 5.23).

It was probably during his stay in Virginia that Wollaston executed three portraits for North Carolina residents: Thomas Barker (d. 1789); his second wife, Penelope (1728–1796); and his nephew, all of whom lived in the Cupola House in Edenton, North Carolina. The family had contacts in Virginia and probably traveled

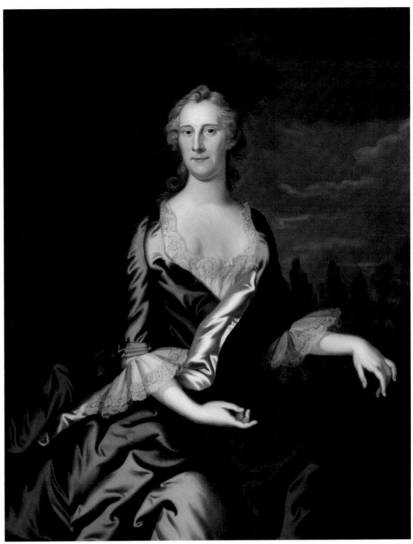

5.19

FIGURE 5.18. John Wollaston Jr., *Benedict Swingate Calvert*, ca. 1754, oil on canvas, 52" x 48". Courtesy of the Maryland Historical Society (Image ID # 1976.2.1.).

Benedict Calvert (b. 1729/1730) was born in England, the fifth son of Charles Calvert, 5th Lord Baltimore. The son immigrated to Maryland in 1742 and lived with Dr. George Steuart, a friend of the Calvert family. Six years later he married his second cousin Elizabeth Calvert, the daughter of Governor Charles and Rebecca Calvert. Benedict Calvert's children included Charles (fig. 5.43), Eleanor (fig. 5.44), Ann, and Elizabeth, all of whom were painted by John Hesselius.

FIGURE 5.19. John Wollaston Jr., *Mrs. Charles Carroll* (Elizabeth Brooke), 1753–1759, oil on canvas, 50" x 40". Detroit Institute of Arts, USA/Founders Society Purchase, Mr. and Mrs. Walter Buhl Ford II Fund/The Bridgeman Art Library Nationality.

The portrait of Elizabeth Brooke Carroll (1709–1761) is an especially good example of John Wollaston Jr.'s three-quarter-length poses that are similar to Hudson's though the position of the arms, as noted earlier, is awkward and wooden in ways typical of Wollaston. The Carroll portraits, like those of the Reades of New York, seem to give more attention to the faces in an attempt to capture their facial features and, in the case of Mrs. Carroll, her graying hair color.

FIGURE 5.20. John Wollaston Jr. after a 1729 original by an unidentified artist, *William Randolph II of Turkey Island*, dated 1755, oil on canvas, 36" x 29". Virginia Historical Society.

With the exception of the eyes, which do not have the characteristic John Wollaston Jr. slant, all features of the likeness are painted in Wollaston's slick, facile, rococo style. The fabrics are strongly highlighted and rich in color, the hands chubby with Wollaston's unnaturally but elegantly posed fingers, and the skin tones well modeled. Since the sitter died in 1742, Wollaston must have based his version on an earlier portrait that no longer survives.

The subject was also known as William Randolph Jr. (1681–1741/42) or Councillor Randolph. The document he holds may allude to his legal profession, although such items appear in eighteenth-century portraits of gentlemen who were not lawyers. The portrait was commissioned by William Randolph III, son of the sitter and the builder of Wilton, the historic house that was moved from Varina, Virginia, to Richmond, Virginia, in the twentieth century.

FIGURE 5.21. John Wollaston Jr., *Mann Page III and Elizabeth Page*, 1754–1756, oil on canvas, 47¹/₁₆" x 38³/₁₆". Virginia Historical Society.

Mann Page III (1749–1803) and Elizabeth Page (b. 1751?, later Mrs. Benjamin Harrison) were the children of Mann Page II and his second wife, Ann Corbin Tayloe Page, of Rosewell plantation in Gloucester County, Virginia. The only three-story mansion house in Virginia at the time, Rosewell was considered second only to the Governor's Palace in Williamsburg in terms of architectural grandeur and style. Elizabeth Page, who holds a doll identical to the one in Elizabeth Randolph's portrait (fig. 5.22), was the second wife of Benjamin Harrison of Brandon. Mann Page III, who has a tethered cardinal perched on his left hand, later practiced law in Virginia and served in the House of Burgesses. He was a delegate to the Continental Congress and a lieutenant colonel in the militia during the Revolutionary War. After the war he married Mary Tayloe (1759–1803), the daughter of John Tayloe II (1721–1779) and Rebecca Plater Tayloe (1731–1787) of Mount Airy in Richmond County, Virginia. Mary Tayloe and Mann Page III were first cousins. The John Tayloes were also painted by John Wollaston Jr. in the late 1750s.

FOLLOWING SPREAD
FIGURE 5.22. John Wollaston Jr., *Elizabeth Randolph*, 1752–1755, oil on canvas, 28½" x 35½". Virginia Historical Society.

The portraits of Elizabeth Randolph (ca. 1742–before 1773, later Mrs. Philip Ludwell Grymes) and her older sister (fig. 5.23) were designed as pendants with similar formats featuring masonry windows. The doll Elizabeth holds is typical of the wooden-headed variety sold in England and

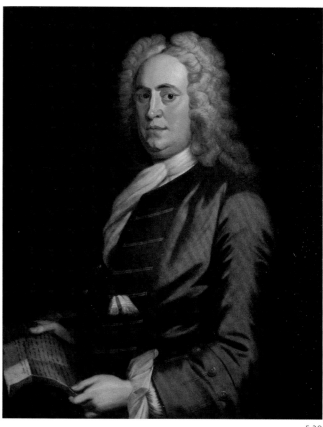

5.20

the colonies during the period. Such toys are rarely shown in American children's portraits by other painters but are included in several of John Wollaston Jr.'s portraits (see fig. 5.21).

Elizabeth was a daughter of William Randolph III, the builder of Wilton House, for whom Wollaston painted many of the family portraits.

FIGURE 5.23. John Wollaston Jr., *Anne Randolph*, 1752–1755, oil on canvas, 28½" x 36". Virginia Historical Society.

Anne Randolph (ca. 1740–1767), the daughter of William Randolph III of Wilton, was named after her mother, Anne Harrison Randolph (ca. 1724–after 1793), whose portrait by John Wollaston Jr. also exists. Anne and her sister Elizabeth (fig. 5.22) were the oldest of the female children. In 1760, the sitter was the first wife of Benjamin Harrison of Brandon in Prince George County, Virginia.

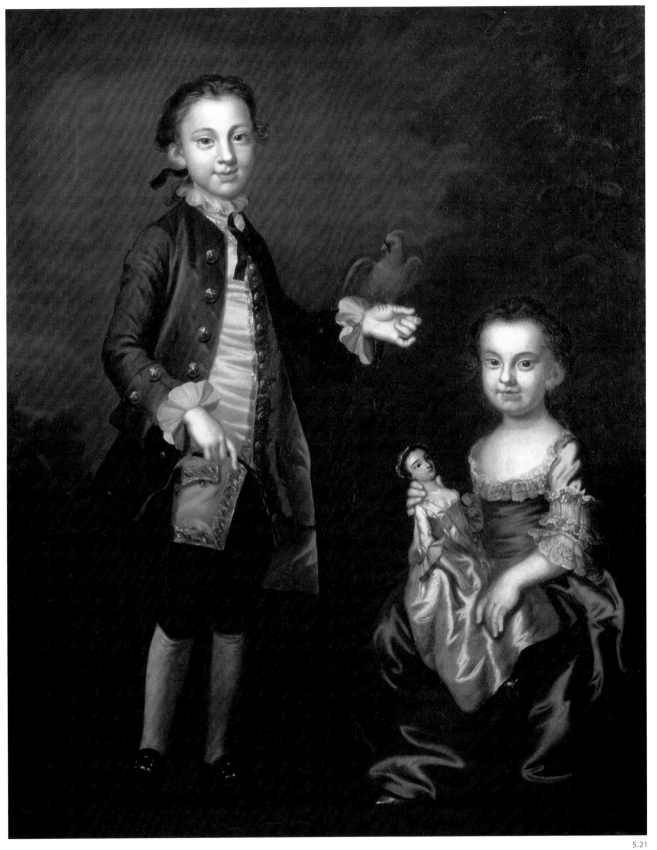

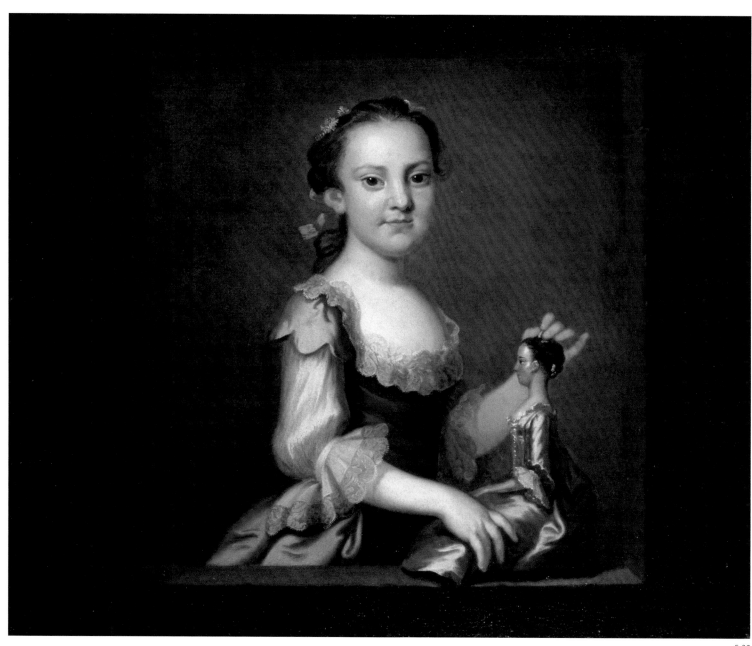

5.22

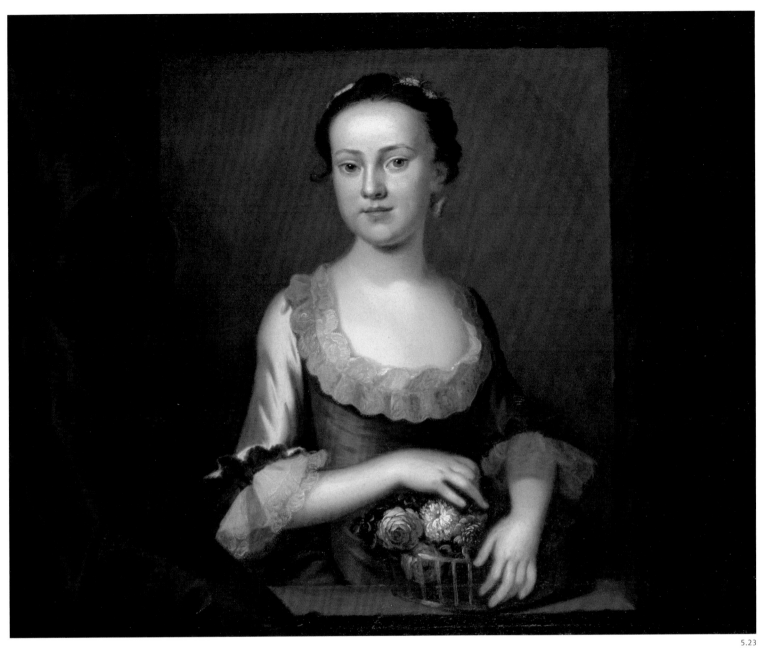

5.23

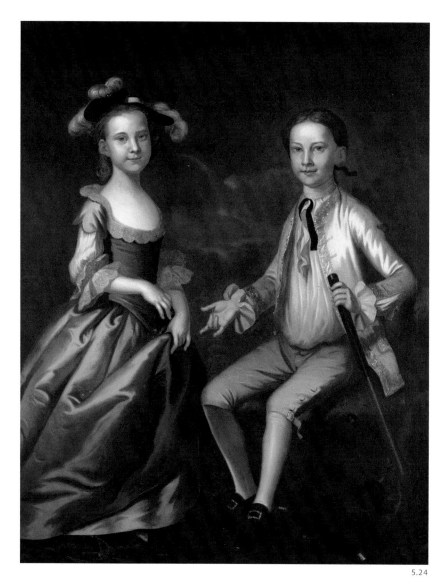

FIGURE 5.24. John Wollaston Jr., *Rebecca Lewis and Warner Lewis II*, 1752–1753, oil on canvas, 47" x 38". Courtesy of Lieutenant Colonel and Mrs. Fielding Lewis Greaves and Nellie Deans Greaves (currently on loan to the Virginia Historical Society).

John Wollaston Jr.'s best Virginia portraits seem to be those for children, as illustrated by this and the three previous examples. Closely related to English compositions, they are elegant in their style and intent, as pictures befitting Virginia's aristocratic planter families. The gun held by Warner II appears in at least one other Virginia portrait by Wollaston, one showing a boy of the Page family.

Warner Lewis II (1747–1791) and his sister Rebecca (b. 1750) were the children of Warner Lewis I (1720–1779) and his wife, Eleanor Bowles Gooch Lewis (dates unknown), of Warner Hall in Gloucester Country, Virginia. The artist also painted the parents and other members of the large Lewis family.

there for their portraits; no other North Carolina works by the artist have been discovered.

Wollaston completed over one hundred portraits in Virginia, the largest number ever painted by a single artist in that colony. Most of these pictures are large, showing the sitters standing or sitting in three-quarter-length poses, as in the double portraits of the Page children, Mann III and Elizabeth, and the Lewis children, Warner II and Rebecca (fig. 5.24). Wollaston worked rapidly, as demonstrated not only by the large number of his surviving portraits but also by the sweeping brushwork evident in so many of them. He usually highlighted a particular fabric fold with one or two strokes and a loaded paintbrush over numerous glaze layers beneath. He worked over only a few passages in these paintings, and he executed shading with an economy of brushwork.

On October 21, 1757, Wollaston received fifty-six pistoles in payment for three portraits completed for the Daniel Parke Custis family in Virginia (fig. 5.25).[52] All three portraits survive and are now in the collections of Washington and Lee University in Lexington, Virginia. No later references to the artist's being in Virginia are known, although he could have returned the next year. He apparently traveled north to Philadelphia, where, in September 1758, the *American Magazine* published yet another poetic tribute to the painter. Written by Francis Hopkinson of Philadelphia and later New Jersey, the poem praised Wollaston's paintings and encouraged the young Benjamin West (1738–1820) to follow the London artist's model. Hopkinson, a poet and musician who became known for his political satires and songs, was also a signer of the Declaration of Independence. He wrote:

Oftimes with wonder and delight I stand;
To view th' amazing conduct of your hand.
At first unlabour'd sketches lightly trace
The glimm'ring outlines of a human face;
Then by degrees the liquid life o'erflows
Each rising feature—the rich canvas glows
With heigthned charms—The forehead rises fair;
And, glossy ringlets twine the nut-brown hair;

The sparkling eyes give meaning to the whole,
And seem to speak the dictates of a soul.
The lucid lips in rosy sweetness drest,
The well-turn'd neck and the luxuriant breast;
The silk that richly flows with graceful air—
All tell the hand of *Wollaston* was there.[53]

"The silk that richly flows with graceful air" could be used today to describe the fabrics seen in many of Wollaston's portraits, especially those of women. Hopkinson may have known Wollaston, but, even if not, he certainly was familiar with the belles lettres of his day. He was young, a recent graduate of the College of Philadelphia (now the University of Pennsylvania), when he wrote the poem. If taken literally, its verses reveal how Wollaston worked—first sketching lightly to trace the "human face" and then gradually bringing up the whole of the picture. These were the approaches of a studio-trained painter of the period. Often, self-taught or minimally trained artists painted discreet parts of the picture individually, without the benefit of gradual development of the whole composition. The academic painter usually gave greatest attention to the face, often completing it before finishing the details of background and clothing. The latter elements were typically part of the preliminary composition but were minimally developed during the process, for they could be finished in the painting room or studio without the sitter's presence. Hopkinson mentions the especially important qualities preferred in a woman's portrait—"sparkling eyes," "lucid lips in rosy sweetness," a "well-turn'd neck," a "luxuriant breast," and "silk that richly flows"—all of which were characteristic of rococo painting.

Wollaston may have been in Philadelphia as late as 1759, after which he disappeared from the American southern colonies until 1765 when he arrived in Charleston, South Carolina.[54] His whereabouts immediately thereafter are uncertain, but he may have returned to England for a part of this time. For many years it was believed that between 1759 and 1765, Wollaston spent a portion of his time in the British East Indies; however, it was the British West Indies at St. Christopher's Island

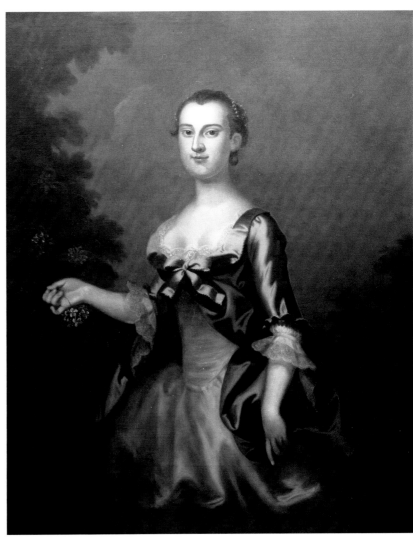

5.25

FIGURE 5.25. John Wollaston Jr., *Mrs. Daniel Parke Custis*, 1756–1757, oil on canvas, 48¹³⁄₁₆" x 39³⁄₁₆". Washington-Custis-Lee Collection, Washington and Lee University, Lexington, VA.

The sitter, Martha Dandridge Custis (1731–1802, later Mrs. George Washington), was the wife of Colonel Daniel Parke Custis, who died in 1757. This and two other portraits were painted before Colonel Custis's death; however, Mrs. Custis transacted the payment for all three, and the artist's receipt for their payment is dated in October 1757. The sitter was the daughter of John Dandridge and Frances Jones Dandridge. She married her second husband, George Washington, in 1759.

(St. Kitts) that he visited.[55] No Caribbean paintings by the artist have been discovered, yet the fine quality of his Charleston portraits supports the idea that there was no interruption in his painting activity between 1758/59 and 1765. It also seems very likely that Wollaston visited more than one of the Leeward Islands and may have spent several years painting in the Caribbean.[56]

After the Islands, Wollaston probably went directly to Charleston, South Carolina, where he was painting by

FIGURE 5.26. John Wollaston Jr., *Mrs. Edward Thomas* (Anne Gibbes), 1767, oil on canvas, 30¹/₁₆" x 25¼". Worcester Art Museum, MA, USA/The Bridgeman Art Library Nationality.

This is the only known American portrait by John Wollaston Jr. that is signed on the front of the canvas. "Wollaston Fecit, 1767" appears at the lower right on the marble slab top, a furniture detail that is seen in several other portraits by the artist. The sitter, Anne Gibbes Thomas (1752–1781) wears a gown that stylistically predates the 1700s. She is shown with her arms crossed as she leans on the table and holds a mask. Both the dress and the mask, common attire for masquerade balls, are associated with the convention of portrait dress, and both are occasionally seen in English eighteenth-century portraits. (See also the frontispiece for Robert Carter's portrait, created in the 1750s in London, showing him in earlier "Vandyke" masquerade ball attire appropriate for men.) The dress worn by Mrs. Thomas is quite similar to one used by Theus, borrowed from a print source and shown in his 1766 portrait of Mrs. Barnard Elliott (fig. 4.38). One wonders if the use of this particular costume was a passing vogue among Charlestonians. In Charleston in the 1750s–1770s, balls and dances were not uncommon; perhaps a masquerade dance, a feature of London balls, was among the offerings on those elegant Charleston evenings. London masquerade balls, known to South Carolinians through newspaper articles and other sources, were commercially organized and attended by persons of all classes, from the poor to the wealthy. Such events reputedly ranged from the merely entertaining to the debauched and immoral. Any hint of their seedier nature was not associated with this charming likeness of a socially prominent Charleston girl, aged fifteen.

Anne Gibbes Thomas was the daughter of William Gibbes and Elisabeth Hasell Gibbes. Gibbes was a merchant and a wealthy planter in Charleston as well as a Mason and a member of St. Michael Parish. Anne's husband, Edward Thomas, owned a large plantation outside of Charleston. He served in the militia and the House of Representatives and held other local offices during his lifetime.

September 27, 1765. On that date, Anne Manigault (Mrs. Gabriel Manigault) recorded in her diary that "Mr. Wolleston [came] to dinner."[57] The Manigault reference is important because the Manigault family, which had extraordinary wealth, was known for its gentility and cultural involvement. As noted in chapter 4, the extended Manigault family was well aware of local and foreign artists. Previously, while in London, Peter Manigault, son of Gabriel and Anne Manigault, had had his portrait painted by Allan Ramsay; Peter's wife had an elaborate companion portrait painted in 1757 by the local Charleston artist Jeremiah Theus.[58]

Some of Wollaston's finest portraits were created in Charleston, including the elegant portraits of Mrs. Edward Thomas and Mrs. John Beale (figs. 5.26 and 5.27).[59] A greater use of elegant front-facing poses and lighter clothing colors is seen in many of Wollaston's Charleston pictures. The faces also seem more realistic and are more softly modeled, lacking the pronounced almond-shaped eyes seen in much of his Virginia and Maryland work. He also gave greater attention to decorative details of the costumes.

The meaning of invented or copied portrait dress in the context of personal and cultural identity during the colonial period has been well researched by other scholars.[60] Although some modern historians have disdained the practice, artists of all ranks in both the colonies and in England used these approaches for many years. Sir Joshua Reynolds wrote about the practice, noting that such borrowed ideas "can hardly be charged with plagiarism; poets practise this kind of borrowing without reserve. But an artist should not be contented with this only"—but should make an effort to improve what he has borrowed and incorporated into his or her own work.[61] Admittedly, the documentary evidence of how portrait dress and accoutrements were selected is slim. The use of print sources has already been mentioned as one possibility, but the choice of colors must have been made by another means. Research on the South indicates that clients took great interest in their portrait dress and poses. Portraits by an artist like Wollaston, who worked in the North, mid-Atlantic, and

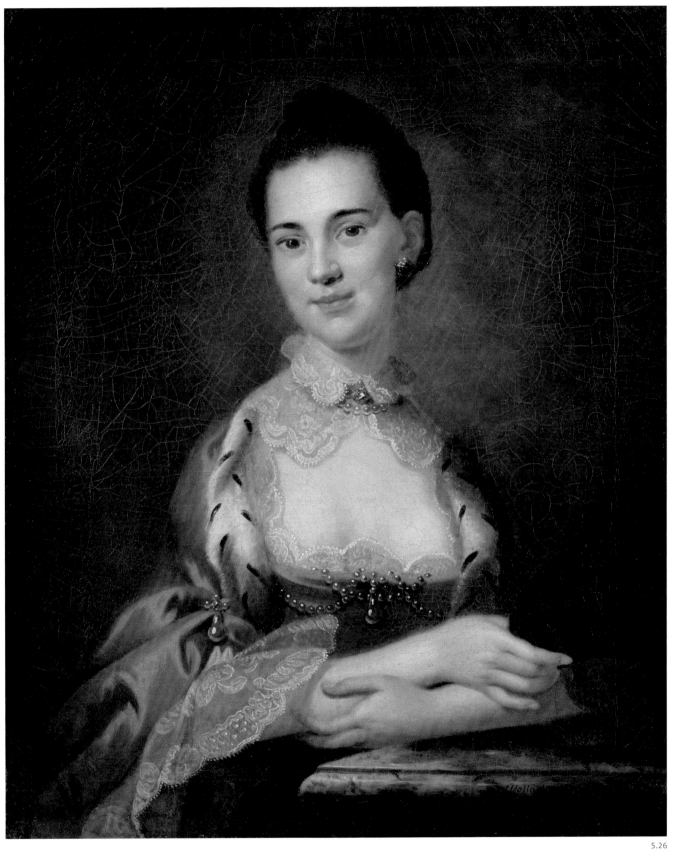

5.26

FIGURE 5.27. John Wollaston Jr., *Mrs. John Beale* (Mary Ross), 1765–1767, oil on canvas, 30" x 20". Courtesy of the Museum of Early Southern Decorative Arts (MESDA) at Old Salem.

Mary Ross (d. 1771) married John Beale (1730–1807), the son of Othniel Beale of Charleston in 1762. The Beale family was well-known in Charleston. Othniel was a successful merchant and builder who also served terms as justice of the peace.

Mrs. Beale's portrait is typical of John Wollaston Jr.'s Charleston work, with the frontal pose and the exquisite fabrics of portrait dress. It also reflects the curvilinear nuances of the rococo style that Wollaston practiced. The sitter's head, like that of Anne Gibbes, is turned slightly to the right towards the light source to give charm. Of interest is the figured material of Mrs. Beale's drape. Figured fabrics are rarely seen in southern portraits, probably for a number of reasons, including the time-consuming task of painting them and the resulting cost of the portrait. There was also the matter of adherence to the English practice that prescribed that dress should not compete with the sitter's face and demeanor.

South during the same approximate period, provide an important set of comparisons for future study. The many differences among his portraits from one region to another must represent more than changes preferred by the artist, and it is likely they were client derived.

In Charleston, Wollaston painted portraits in which he updated his approach and used more current London poses, incorporating dress, jewelry, and other accoutrements that were generally richer and somewhat more ostentatious as compared to his earlier work. He arrived in Charleston in 1765, fourteen years after he first came to America. His stay was brief but probably not because of any competition from Jeremiah Theus, who was still living there. There is no evidence that the two artists met, but each was aware of the other's work. Wollaston dined with the Manigaults, who owned Theus paintings, and he accepted commissions in several other households where paintings by Theus were hanging. There is at least one example of portrait copying by either Wollaston after Theus or of Theus after Wollaston.[62]

Wollaston's last year in Charleston is documented by Eliza Pinckney (1722–1793), who wrote on January 14, 1767, "My DEAR MISS R[avenel],—Tho' Wollaston has summon'd me to-day to put the finishing stroke to my Shadow which streightens [straightens] me for time, I can't help sending a line . . . to acknowledge your kind favour and very handsome present [a pincushion]."[63] During his two years in Charleston, Wollaston had acquired a "very good waiting boy" and a saddle horse, both of which he wanted to dispose of before leaving the colonies on the snow *Portland* for London.[64]

Further documentation that Wollaston settled in Bath comes from the diary of John Baker, a barrister who served as solicitor-general for St. Kitts, Nevis, Montserrat, and Antigua Islands in the 1750s and 1760s. On July 31, 1775, Baker recorded that he "Dined [at Mr. John Smith's with company] Mr. Woollaston, the painter, came up to me before dinner and claimed our acquaintance at Mrs. Cottle's, St. Kitt's, in 1764 or 1765."[65] Baker and his family ranked among the stylish, middle-income residents of Bath and traveled in the well-heeled company of those who were interested in the arts, including

William Hogarth, Thomas Hudson, and Horace Walpole.[66] Unfortunately, no paintings by Wollaston from this period are known.

Wollaston was very likely the first studio-trained painter to have worked extensively in the southern colonies. Robert Feke (1705–1750?) and Charles Bridges both had training and worked there earlier, but their travels were limited and they painted far fewer portraits. Jeremiah Theus was a capable painter who was trained but not exclusively as a portrait artist. Furthermore, he tended to cling to the international baroque style even after its vogue had passed, making a few updated changes in his last pictures. And, as previously noted, Theus traveled for commissions only once, to Georgia; his reputation was confined to Charleston. Wollaston was the one who stood out. Remarking some years later in correspondence with William Dunlap (1766–1839), Robert Sully (1803–1855) characterized Wollaston's American work as "*very good* [his emphasis]" and with a "pretty taste."[67] Coming from Sully, that was high praise.

Wollaston inspired several other painters working in the colonies during the same period. John Hesselius (1728–1778), the son of the Philadelphia artist Gustavus Hesselius, was especially influenced by the English painter—so much and so quickly that one wonders if they met in either Philadelphia or Maryland. Hesselius undoubtedly received his first painting lessons from his father, probably in the early 1740s. When the portrait painter Robert Feke visited Philadelphia in 1749, John Hesselius came under his influence and imitated his style for several years prior to Wollaston's arrival. The especially close stylistic relationship between the younger Hesselius's portraits from 1749/50 to 1756–1757 and those of Feke also suggests that they knew each other. A group of Virginia portraits for the Gordon family by John Hesselius, two of which date to 1750, demonstrate this point (figs. 5.28 and 5.29). All of them have been mistakenly attributed to Feke in the past, and their dates add further credence to the idea of an association between the two painters. In fact, the two artists may have traveled to Virginia together, for three portraits by Feke have been documented to Virginia for the years 1749–

FIGURE 5.28. John Hesselius, *Ann and Sarah Gordon*, 1750, oil on canvas, 50³⁄₁₆" x 40". Virginia Historical Society.

Sisters Ann (1743–1765/1766) and Sarah (1747–1758) Gordon were the daughters of Colonel James Gordon and Millicent Conway Gordon (fig. 5.39) of Gordonsville plantation in Lancaster County, Virginia. Robert Feke's influence on John Hesselius is evident here, particularly in the rigid poses with heads held high and erect but also in the landscape setting and the angularity of the compositional elements. However, the well-developed landscape setting is worthy of an artist who may also have created landscape pictures. Hesselius's portrait of William Byrd III (fig. 5.48) also has a landscape background. That one, which includes a horse, a symbol of the sitter's interests, also supports the notion that Hesselius painted such scenes as decorative pictures.

FIGURE 5.29. John Hesselius, *John Gordon* (1720–1780), dated 1750, oil on canvas, 48³⁄₁₆" x 30³⁄₈". Virginia Historical Society.

1751. These paintings are thought to represent William Nelson (fig. 5.30); his wife, Elizabeth "Betty" Burwell Nelson (fig. 5.31); and Nelson's sister Mary (Mrs. Edmund Berkeley, 1713–after 1772).[68]

The details of Feke's life remain sketchy, but biographical information published on the artist in 1860 and 1907 has been helpful.[69] The first important account of Feke's life was given by William Carey Poland in a paper prepared for the Rhode Island Historical Society.[70] Feke had been of interest to numerous historians before that paper, but Poland was the first scholar to gather and present the information in a well-reasoned and documented manner; he also had the benefit of knowing direct living descendants of the painter, all of whom he interviewed.

According to Poland, Robert Feke descended from a John or Robert Feake who came to America with

Governor John Winthrop in 1630 and settled in Water-town, Massachusetts. John/Robert Feake married Elizabeth Fones Winthrop about 1659. Fones was the widow of Henry Winthrop, who was the son of the governor. After John/Robert Feake's death, disputes over the inheritance of his property forced Mrs. Feake and her children to relocate to Long Island. Her son John Feake, a prominent Quaker, married Elisabeth Prior. They had a son named Robert Feake who married Clemence Ludlam: these two are believed to be the parents of Robert Feke the painter. The 1729 records of the Second Baptist Church in Oyster Bay indicate that Robert Feke, probably the painter, gave two pounds towards rebuild-ing the church. His father was a minister there, ordained by the Rhode Island elders.

Poland mentions the family story that Feke went to sea, was captured, and was imprisoned in Spain, during which time he learned to paint, eventually buying his freedom through the sale of his paintings. No documen-tation has been found to support or refute this story, although it was not unusual for colonial ships to be seized and looted by foreign mariners. Surviving crews were sometimes imprisoned or left to find their way home. In addition to the family story, the marriage record for Feke's daughter, dating 1767, gives Feke's occupation as "mariner," not as a painter or limner.[71]

Feke's earliest portrait may be that of Levinah "Phainy" Cock, painted about 1733, probably in New York.[72] Other early works are described as "a number of family portraits" that were destroyed in Meadowside, the Feke family's Long Island house, when it burned "prior to the Revolution."[73] The artist's aunt Abigail Feake, who married Josiah Coggeshall, lived in Newport, Rhode Island, about this time, which accounts for the artist's travels there from Long Island between 1733 and 1740. He was married in Newport on September 26, 1742, to Eleanor Cozzens at the First Baptist Church.[74] The couple had five children and probably lived in the Newport house owned by Eleanor's father, Leonard Cozzens, who settled in Rhode Island about 1715.

Feke had married and established his residence one year after painting *Isaac Royall Jr. and His Family* in Boston (fig. 5.32). There are no details about when and why Feke visited Boston, but various scholars offer the tempting speculation that he studied with John Smibert (1688–1751), noting that the latter's painting of Dean George Berkeley and entourage in *The Bermuda Group* (fig. 5.33) clearly served as the prototype for Feke's Royall family likeness.[75]

FOLLOWING PAGES

FIGURE 5.30. Robert Feke, *William Nelson*, probably 1749–1751, oil on canvas, 50 11/16" x 40 11/16". Colonial Williamsburg Foundation, Williamsburg, VA. Gift of Mrs. Douglas Crocker.

William Nelson (1711–1772) and his family lived on Main Street in Yorktown, Virginia, directly across from the large brick mansion owned by his father, Thomas "Scotch Tom" Nelson. William's brother Thomas Nelson is often referred to as Secretary Nelson because of his official office in Virginia colonial government. William's son, Thomas Nelson Jr., inherited his grandfather's house, which still stands on Main Street in Yorktown. At the time, Thomas Jr. was the newly elected governor of Virginia and commander in chief of the state militia. He was educated in England where Mason Chamberlin (1727–1787) painted his portrait in 1754 (fig. I.13). All of the Nelsons were adversely affected by the siege of Yorktown in 1781. William's brother Thomas lost his home at the east end of town. It had served as Lord Cornwallis's headquarters. The roof and other sections of Thomas Nelson Jr.'s house were also severely damaged.

FIGURE 5.31. Robert Feke, *Elizabeth Burwell Nelson* (Mrs. William Nelson), probably 1749–1751, oil on canvas, 49 5/8" x 39 5/8". Colonial Williamsburg Foundation, Williamsburg, VA. Gift of Mrs. Douglas Crocker.

Elizabeth Burwell Nelson (ca. 1711–1798) was the daughter of Nathaniel Burwell and Elizabeth Carter Burwell of Fairfield plantation in Gloucester, Virginia. She married William Nelson in 1738. Her portrait and that of her husband (fig. 5.30) show all the characteristics of Robert Feke's style in the manner of painting, composition, and sitters' poses. Extensively overpainted during an earlier restoration, the paintings were recently conserved by Colonial Williamsburg's paintings conservator Shelley Svoboda. In the process, a great percentage of the original paint was found to survive beneath the modern overpainting. The portraits are now fully and sensitively conserved, providing an accurate view of Feke's manner.

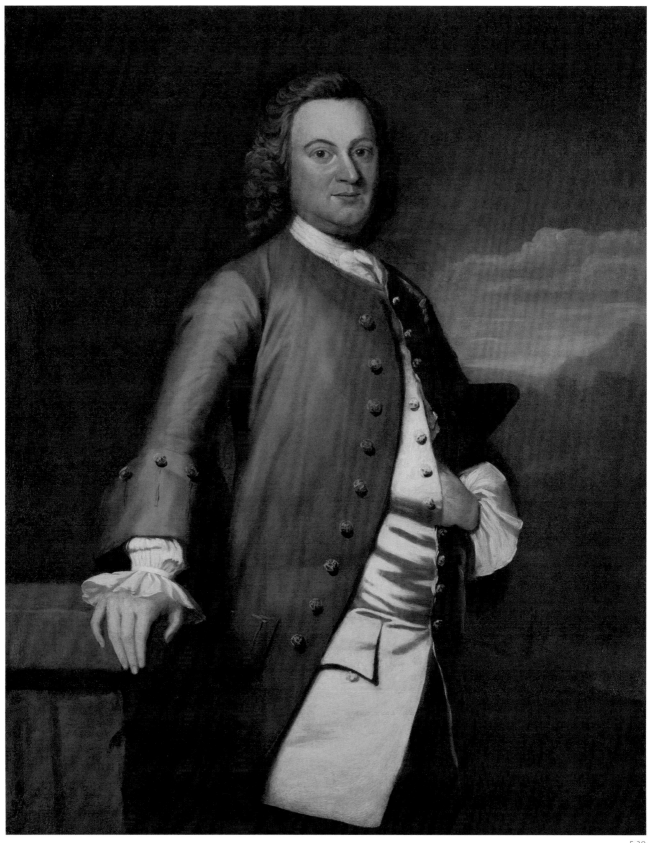

5.30

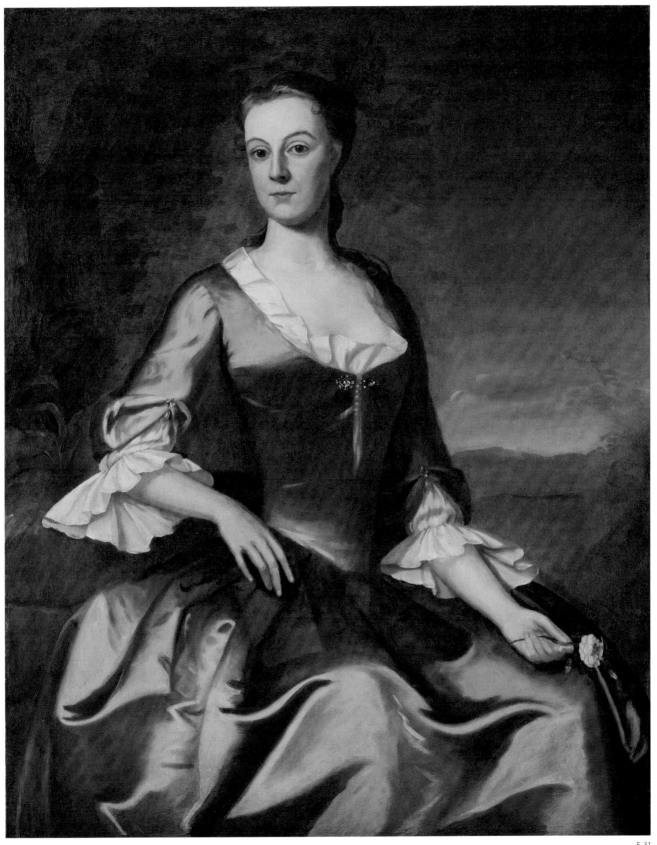

FIGURE 5.32. Robert Feke, *Isaac Royall Jr. and His Family*, 1741, oil on canvas, 54¼" x 77⁷⁄₁₆". Courtesy of Historical and Special Collections, Harvard Law School Library.

The picture shows, from left to right, Penelope Royall (1724–1800), sister of Isaac Royall Jr., who married Henry Vassell; Mary McIntosh Palmer (dates unknown), sister of Mrs. Isaac Royall Jr.; the Royalls' daughter Elizabeth (1747–1775); Mrs. Isaac Royall Jr. (Elizabeth McIntosh Royall, 1722–1770); and Isaac Royall Jr. (1719–1781). Isaac Jr. was the son of the Isaac Royall of Antigua who made his fortune operating a sugar plantation and trading in rum. In 1737, Isaac Sr. took his family to Boston where Isaac Jr. married in 1738 and built the well-known Isaac Royall house, now a museum property. Loyalists, the Royalls fled first to Nova Scotia and then to England during the Revolutionary War. Isaac Royall Jr. never returned to America.

5.32

FIGURE 5.33. John Smibert, *The Bermuda Group* or *Dean George Berkeley and His Family*, 1731, oil on canvas, 69½" x 93". Yale University Art Gallery. Gift of Isaac Lothrop.

John Smibert, who stands at far left, was part of the group accompanying Dean George Berkeley (1685–1753) on his voyage to establish a college in Bermuda where the liberal arts would be taught to the sons of colonists and where training could be provided for Native Americans. Berkeley's proposal was criticized in London. Many authorities, including the Reverend Thomas Bray of the Society for Promoting Christian Knowledge (see pages 175–176), thought the proposal foolhardy; others wanted the college moved to New York. In 1728, its site was changed to Newport, Rhode Island, and the group shown in the picture set sail from London. Smibert had met Berkeley in Florence, Italy, in 1720. In 1726, the two became reacquainted, and Berkeley invited Smibert to serve as an instructor at his new college. (Saunders, *John Smibert*, 27, 58–59.)

In 1728, a John Wainwright commissioned the picture, which shows, from left to right, John Smibert; John James (d. 1741) standing behind Wainwright (dates unknown); Miss Hancock (Handcock, dates unknown), companion to Mrs. Berkeley; Richard Dalton (d. after 1770); Mrs. Berkeley (Anne Forster, dates unknown) and her son Henry (dates unknown); and Dean Berkeley, who proposed the project and obtained a royal charter for the college. The picture was completed in 1731, not in London but in America. Smibert signed and dated the painting 1729, which probably commemorated the group's arrival in Newport rather than the date of the painting's completion. (Saunders, *John Smibert*, 80–81, 170–173.)

5.33

On July 16, 1744, Dr. Alexander Hamilton wrote from Newport that he met with Dr. Moffatt and went to see

> Feake, a painter, the most extraordinary genius ever I knew, for he does pictures tolerably well by the force of genius, having never had any teaching. I saw a large table [tableau?] of the Judgment of Hercules, copied by him from a frontispiece of the Earl of Shaftesbury's, which I thought very well done. This man had exactly the phiz of a painter, having a long pale face, sharp nose, large eyes,—with which he looked upon you steadfastly,—long curled black hair, a delicate white hand, and long fingers.[76]

Other dated portraits that help to define Feke's places of work include *The Reverend John Callender* (1706–1748) and *The Reverend Thomas Hiscox* of Newport (fig. 5.34), signed and dated 1745, and *Anne Shippen Willing* (Mrs. Charles Willing, 1710–1790), *Tench Francis* (1730–1800), *Phineas Bond* (1717–1773), and *Miss Williamina Moore* (dates unknown) of Philadelphia, dated 1746. In 1748, Feke was back in Boston where he painted portraits for Charles Apthorp (1698–1758), paymaster and commissary of the British land and naval forces quartered in Boston, and also for the Bowdoin and Saltonstall families. Scholars believe Feke stayed in Boston for most of 1748 and then returned to Newport. The next year he made his second trip to Philadelphia where he was paid for portraits of the Samuel McCall (1721–1762) family.

As part of his trek south, Feke apparently visited Virginia, where he painted the three Nelson portraits and probably several others before leaving the colonies in 1751 for warmer climes.[77] There is no evidence that the Nelsons ever traveled to Philadelphia during this period. The Nelson portraits compare favorably with the artist's known work from Philadelphia, Newport, and Boston. What other Virginia portraits Feke may have done is highly speculative, but two possibilities show some stylistic relationship to the artist's Boston work. One of these is the three-quarter-length portrait of Landon Carter still owned by the family and displayed at Carter's plantation house, Sabine Hall (fig. 5.35). Landon's rigid pose, his costuming, and the shape and detailing of his head are quite similar to

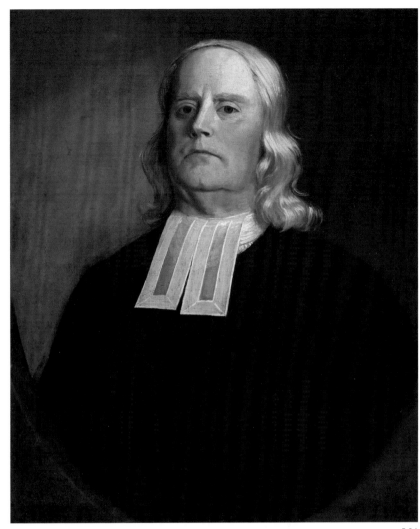

5.34

FIGURE 5.34. Robert Feke, *The Reverend Thomas Hiscox*, dated 1745, oil on canvas, 30″ x 24¹⁵⁄₁₆″. From the collection of the Redwood Library and Athenaeum, Newport, RI.

Feke consistently posed his sitters with erect and slightly up-tilted heads, as seen here. Although he was capable of capturing strong likenesses, like this one of Thomas Hiscox (1683/86–1773), his pictures rarely show the graceful and natural poses associated with his mentor, John Smibert.

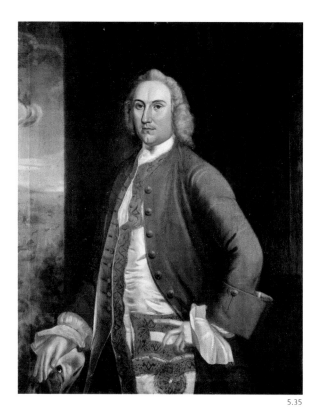

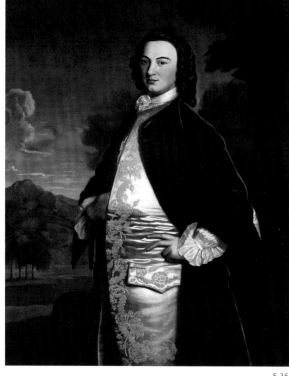

FIGURE 5.35. Possibly Robert Feke or John Hesselius, *Landon Carter*, 1749–1751, oil on canvas, 50" x 40". Private collection. Photograph courtesy of the Colonial Williamsburg Foundation, Williamsburg, VA.

This portrait of Landon Carter (1710–1778) has been attributed to several painters, most recently to John Hesselius. By comparison, Hesselius's known Virginia pictures of this period are flatter, lacking the type of modeling of the face and fabrics observed in Carter's portrait. The sitter's erect posture and pose and his high forehead are like Feke's work and, with the exception of Hesselius, do not relate to pictures by any other artists working in Virginia at the time.

Landon Carter inherited a portion of his father's estate, including lands in Warsaw in Richmond County, Virginia, on which he built the plantation house Sabine Hall. He married three times, first, in 1732, to Elizabeth Wormeley of Rosegill, Middlesex County, Virginia; secondly, in 1742, to Maria Byrd (fig. 5.38) of Westover; and thirdly, in 1746, to Elizabeth Beale (fig. 5.37). At the time of his death, Carter owned some fifty thousand acres of land and at least five hundred slaves.

FIGURE 5.36. Robert Feke, *William Bowdoin* (b. 1713), 1748, oil on canvas, 49³⁄₁₆" x 38³⁄₄". Bowdoin College Museum of Art, Brunswick, ME. Bequest of Mrs. Sarah Bowdoin Dearborn.

those aspects in Feke's portraits of William Bowdoin (fig. 5.36) and William Nelson (fig. 5.30).

Portraits of two of Landon Carter's three wives have traditionally been identified by descendants as representing Elizabeth Wormeley (fig. 5.37), who died in 1740, and Maria Byrd Carter (fig. 5.38), who died in 1744. According to the family, there is no surviving portrait of Landon's third wife, Elizabeth Beale. However, the identities and artists currently associated with the two illustrated paintings may be in question. First, the gown shown in figure 5.37 may be later than 1740, perhaps even later than that seen in the *Maria Byrd Carter*. Figure 5.37 has occasionally been assigned to John Hesselius's early period, when he was influenced by Feke. Her stiff upright pose and some of the folds in her gown are reminiscent of both Feke's style and Hesselius's early style imitating Feke's manner. However, neither a new attribution nor a new identity of sitter can be made on the basis of what is currently known.

The so-called *Maria Byrd Carter* has been attributed to both Charles Bridges and William Dering, neither of

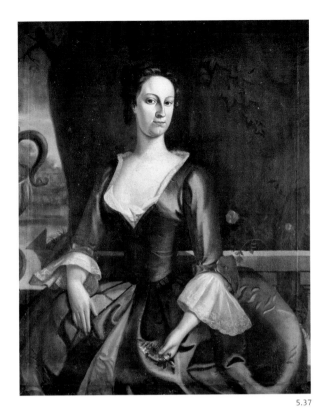

5.37

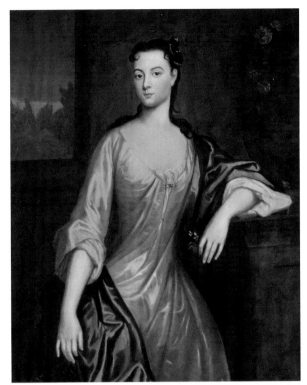

5.38

which seems stylistically correct. The sitter's overall pose is one Feke used repeatedly in women's likenesses, and the shape of the face and eyebrows as well as the position and shape of her proper left arm and hand are identical to those areas in other Feke paintings. It is possible that the *Maria Byrd Carter* is actually a portrait of Landon's third wife, Elizabeth Beale, who would have been alive in 1749 when Feke is thought to have worked in Virginia. If Feke painted Landon Carter, he likely would have created a pendant portrait of his wife. Carter may have learned about Feke through his niece Elizabeth "Betty" Burwell, who married William Nelson (figs. 5.30 and 5.31).

After Feke's departure and before John Wollaston Jr's arrival, John Hesselius provided portraits for several prominent Virginia families. The Landon Carter picture has been attributed to several other painters, most recently to John Hesselius, Feke's follower. However, it does not compare well with early portraits that Hesselius created in Maryland and Virginia. The portrait identified as Millicent Conway Gordon is the earliest known dated work by John Hesselius and one of several portraits he

painted for the Gordon family (fig. 5.39). Millicent continues to be identified as the first wife of Colonel James Gordon of Lancaster County, Virginia. The inscription "J. Hesselius, Pt. 1750" on the front of the canvas appears to be original, but the identity of the

FIGURE 5.37. Artist unidentified, *Mrs. Landon Carter*, traditionally identified as Elizabeth Wormeley, but possibly Elizabeth Beale, 1750–1751, oil on canvas, 50" x 40". Private collection. Photograph courtesy of the Colonial Williamsburg Foundation, Williamsburg, VA.

Elizabeth Beale (b. 1711) was from Richmond County, Virginia, the daughter of Thomas and Elizabeth Tavenner Beale. The portrait has a few characteristics associated with Robert Feke's work; however, these are insufficient to suggest an attribution to the artist.

FIGURE 5.38. Artist unidentified or possibly Robert Feke, *Maria Byrd Carter* (Mrs. Landon Carter)?, before 1744?, oil on canvas, 47" x 38". Private collection.

Maria Byrd Carter (1727–1744), the daughter of William Byrd II (figs. 2.29 and 2.30), grew up at Westover, the family's plantation on the James River.

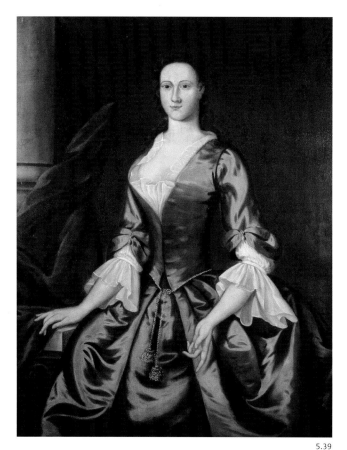

5.39

FIGURE 5.39. John Hesselius, *Millicent Conway Gordon?*, dated 1750, oil on canvas, 50¼" x 39¾". Virginia Historical Society.

Nothing is known about the assigned sitter other than her life dates (1727–1748?) and her marriage to James Gordon (1714–1768), whose portrait by the artist also survives and is owned by the Virginia Historical Society. Either the sitter's death date or identity is incorrect. Regardless, it is a highly important picture because it illustrates Robert Feke's influence so well.

FIGURE 5.40. John Hesselius, *Captain Henry Fitzhugh*, dated 1751, oil on canvas, 29³⁄₁₆" x 24³⁄₁₆". Virginia Historical Society.

Henry Fitzhugh (1687–1758) is said to have been sight impaired at the time this portrait was taken, which might explain his vacant look. Educated in law, the sitter was the second son of William Fitzhugh, who immigrated to Virginia from England sometime in the 1670s. It was that William Fitzhugh who ordered from London a supply of paints for an engraver/painter in his employ (see page 15). That unknown early artist might have created the portrait of William Fitzhugh that was later copied by John Hesselius (fig. 5.41).

sitter is curious, for her death preceded the painting by two years.[78] A portrait of James Gordon (signed and dated 1750); one of his second wife, Mary Harrison (1731–1771), whom he married in 1748, and their son James Gordon Jr. (1750–1793); and a double likeness of their two daughters, Ann Gordon and Sarah Gordon (fig. 5.28), also exist. In addition, Hesselius painted a portrait of John Gordon (fig. 5.29), the brother of James Gordon, about the same time. Other early works by Hesselius that show a strong reliance on Feke's style include several of the 1751 portraits for the Fitzhugh family of Stafford County, Virginia, (figs. 5.40–5.42); portraits of Mr. and Mrs. Gustavus Brown and their two daughters of Charles County, Maryland; and pictures for the Corbin family in Virginia.[79]

Known works by John Hesselius do not appear to predate 1750. Three Philadelphia pictures from the 1740s that were previously attributed to him look more like the work of his father, Gustavus Hesselius. Richard K. Doud's research revealed two early references to the son, one of which concerned his father's purchasing paper for him from Benjamin Franklin's shop in 1739; the second was a letter of July 25, 1750, received by Gustavus from Williamsburg, Virginia, presumably from his son, who was then painting in Virginia.[80]

While John Hesselius's earliest training undoubtedly came from his father, who advertised a wide variety of painting products and services, it is also possible that he learned some techniques from John Winter (active 1740–1771?), a painter from London who worked with Gustavus for an unspecified length of time beginning in 1740.[81] John Hesselius's self-professed occupation as a "limner" implied that he also could provide many painting services.[82] But he more than his father chose to specialize in the more socially prestigious and probably more lucrative career of painting portraits. Other types of paintings, such as landscapes, may have been created by John Hesselius, as revealed by the contents of his household in 1778 and by details in the backgrounds of some of his portraits.

Hesselius's signed and dated portraits for 1751 document another trip to Virginia as well as commissions in

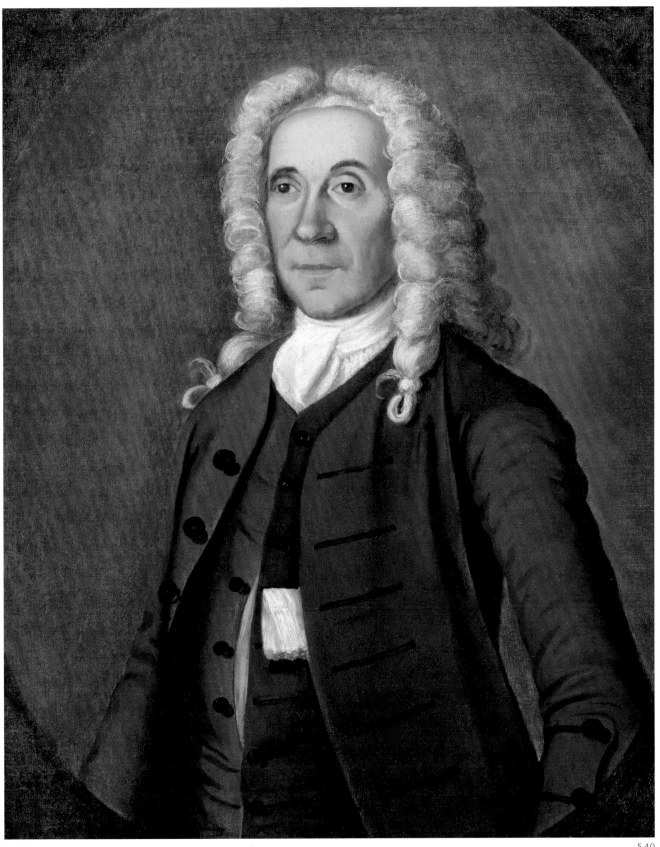

5.40

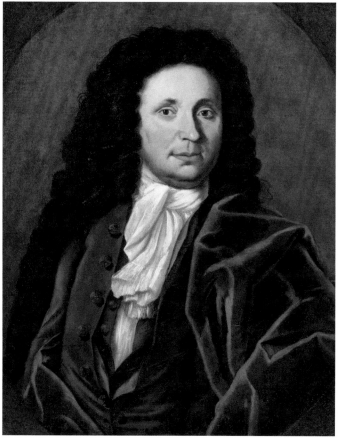

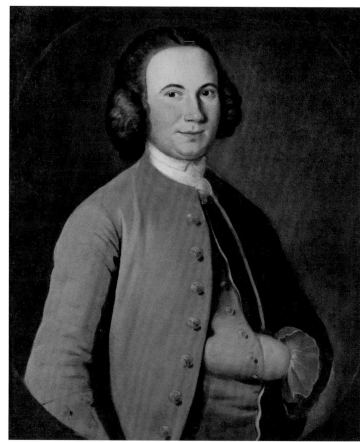

FIGURE 5.41. John Hesselius after an earlier portrait by an unidentified artist, *William Fitzhugh*, dated 1751, oil on canvas, 29⅛″ x 24¼″. Virginia Historical Society.

William Fitzhugh (1651–1701) was a lawyer of middle-class English origin. Through hard work, he was able to amass a comfortable fortune and to accumulate some fifty-five thousand acres of land in Virginia; he owned hundreds of slaves who cultivated and harvested his cash crop, tobacco. Fitzhugh owned 122 pieces of silver, an unusually large amount, and his house was well furnished with other expensive items. His is one of several portraits for the Fitzhugh family commissioned from John Hesselius.

FIGURE 5.42. John Hesselius, *Major Henry Fitzhugh II*, dated 1751, oil on canvas, 30″ x 25″. Virginia Historical Society.

The oldest son of Captain Henry Fitzhugh (fig. 5.40), Henry Fitzhugh II (1723–1783) married Sarah Battaile in 1746. They lived in Bedford, Virginia, where he served as the commander of the local Bedford militia and amassed an impressive collection of family portraits, many of them created by John Hesselius. The portraits of his father and grandfather were among those Fitzhugh commissioned from the artist in 1751.

Maryland and his home town of Philadelphia. Doud noted that the artist continued to live in his parents' Philadelphia house until sometime in the late 1750s, well after their deaths. During that period, John Hesselius was named a godparent of one of his sister's children. When his father, Gustavus, died on May 25, 1755, the artist became executor of his estate. Settling his father's affairs kept Hesselius in Philadelphia longer than he intended. On June 26 of that year, he wrote to Henry Callister in Talbot County, Maryland, that he hoped he would be "moving down to Virginia & as soon as I can dispatch the Business I have in hand there; I intend to Come to Maryland again."[83]

Whether Hesselius went to Virginia in late 1755 or 1756 is unknown, but Doud suggested that he was traveling again to several places by 1757.[84] In Virginia, he may have done additional portraits for the Fitzhughs (figs. 5.40–5.42) and at least one for the Byrd family; in

Delaware, he signed a portrait of Mrs. Jehu Curtis (dates unknown); and, in New Jersey, he signed the portraits of the Reverend Abraham Keteltas (1732–1798) and his wife. He also continued to work in Philadelphia, as documented by tax records and a postscript in Benjamin Franklin's letter of November 22, 1757, to his wife, Deborah Read. Franklin was in London when he wrote,

> I hear there has [been] a miniature painter gone over to Philadelphia, a relative to John Reynolds [likely Joshua Reynolds]. If Sally's picture is not done to your mind by the young man [John Hesselius] and the other gentleman is a good hand and follows the business, suppose you get Sally's done by him and send it to me with *your small picture* that I may get all our little family drawn in one conversation piece.

Franklin identified the portrait as being by John Hesselius when he wrote again in June 1758:

> I fancy I see more likeness in her [Sally's] picture than I did at first and I look at it often with pleasure, or at least it reminds me of her. Yours is at the painters who is to copy it and do me of the same size; but as to family pieces it is said they never look well and are quite out of fashion and I find the limner very unwilling to undertake anything of the kind. However when Franky's comes . . . and that of Sally, by young Hesselius, I shall see what can be done.[85]

Doud believed that the first evidence of Wollaston Jr.'s influence on Hesselius dated to about 1758 when his portraits began to move away from a somewhat flat and linear quality to a more three-dimensional approach that included a better understanding of mass, light and shadow, and overall modeling. It is during this period that Hesselius first used the almond-shaped eyes derived from Wollaston. Hesselius's extraordinary ability to paint fabrics, particularly the dress silks, the thin fichus and lacey cuffs of women's costumes, and the similar passages in men's dress, emerges during this period. He would follow this method until the last years of his life, producing some of Virginia's and Maryland's finest colonial portraits.

John Hesselius's name on the 1756 list of taxable residents of Philadelphia indicates that he was probably still living there and continuing to settle his father's estate. His annual tax rate was £16. These records are also of interest because they list other painters who were residing and working in the city at that time, including several who probably competed with Hesselius for business although not necessarily portraiture. They included James Claypoole Sr. (1721–1784), painter, at £36; Isaac January (dates unknown), painter, at £24; Richard Leacock (dates unknown), painter, at £10; William Leech (dates unknown), painter, at £10; William Williams (1727–1791), painter, at £10; Benjamin Bower (dates unknown), painter, at £12; Martin Fisher (dates unknown), painter, at £14; and John Winter, painter, at £12.[86]

Doud believed Hesselius settled his father's affairs and then moved to Maryland in 1759. Two years later he signed and dated several Maryland portraits, including the four likenesses of the Benedict Calverts' children of Mount Airy in Prince George's County, Maryland (figs. 5.43 and 5.44). Hesselius inscribed the word "Maryland" after his name on all of the 1761 Calvert portraits, probably to emphasize his place of residence.[87] On July 14, 1761, in the vestry minutes of St. Anne's Parish near Annapolis, Hesselius was listed as an unmarried communicant. Three months later, he witnessed the will of Henry Woodward, the deceased husband of Mary Elizabeth Young Woodward, the woman he would later marry.[88] Over the next several years, Hesselius continued to paint in Maryland, where he signed and dated portraits of Mrs. Richard Chew (1720–1791) and her daughter, Elizabeth Chew Smith (fig. 5.45), and another relative known as Samuel Chew (fig. 5.46).[89]

Hesselius may have visited Virginia again about the same time although no dated works by him have been recorded. There are two other references to the artist in Virginia. The earliest appears in the 1762 will of Charles Carter of Cleve, which carries this intriguing passage:

> I do hereby discharge my Son Charles Carter from all Sums of money due from him to me on Acct of the general Sum paid by me for him as well as what I've engaged to pay to

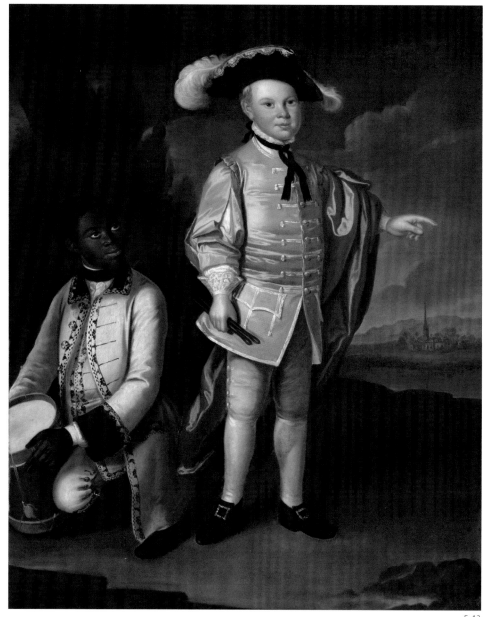

5.43

FIGURE 5.43. John Hesselius, *Charles Calvert*, dated 1761, oil on canvas, 56" x 40". The Baltimore Museum of Art: Gift of Alfred R. and Henry G. Riggs, in Memory of General Lawrason Riggs, BMA 1941.9. Photography by Mitro Hood.

Charles Calvert (1756–1774) was born in Maryland, the son of the wealthy planter Benedict Swingate Calvert, who owned Mount Airy in Prince George's County. Charles was the brother of the Eleanor Calvert shown in figure 5.44. Portraits of their sisters, Ann (b. 1755–d. in childhood at an unknown date) and Elizabeth Calvert (1753–after 1780), a twin to Eleanor and later Mrs. Charles Steuart, and their

mother, all by John Hesselius, also survive. This handsome portrait of Charles Calvert incorporates iconography that defined his social status as the son of a wealthy Maryland family of slaveholders. The slave, carrying the snare drum, sits below and looks up at his young, elegantly dressed master, who holds the drumsticks. The inference of servitude and obedience is clear. Images of slaves are known in only a few surviving southern eighteenth-century paintings (see figs. 2.47, 6.31, 6.32, and 7.62). However, they are not unique to the South but appear in European and Caribbean Island portraiture as well.

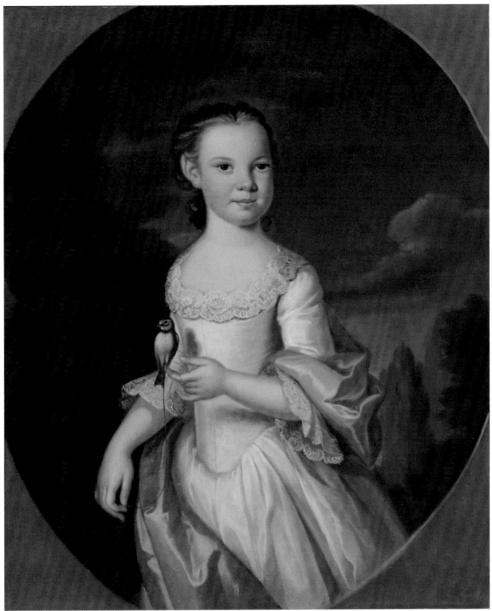

5.44

FIGURE 5.44. John Hesselius, *Eleanor Calvert*, dated 1761, oil on canvas, 30" x 25". The Baltimore Museum of Art: Gift of Alfred R. and Henry G. Riggs, in Memory of General Lawrason Riggs, BMA 1941.4. Photography by Mitro Hood.

In 1774, Eleanor (1753–1811) married her first husband, John Parke Custis of Virginia (fig. 7.33). John Parke Custis had become the stepson of George Washington after the death of his father, Daniel Parke Custis, and the subsequent marriage of his mother, Martha Dandridge Custis (fig. 5.25), to the famous Virginia colonel (figs. 7.28, 7.29, and 7.31).

After John Parke Custis's death, Eleanor married Dr. David Stuart. She spent much of her adult life in Virginia.

Like her brother, Eleanor wears an elegant, showy costume and holds a small bird, elements derived from English portraiture and suitable for likenesses of the South's colonial elite. Although not illustrated here, her sister is shown in a similar dress.

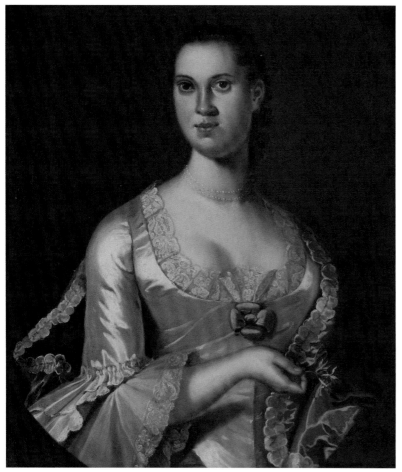

5.45

FIGURE 5.45. John Hesselius, *Elizabeth Chew* (Mrs. ? Smith), probably 1762, oil on canvas, 28⅜" x 25⅛". Brooklyn Museum 39.609 Dick S. Ramsay Fund.

The full name of Elizabeth Chew Smith's (1742/43–1842?) first husband is unknown, but presumably the sitter was either unmarried or about to marry at the time this portrait and others for the family were commissioned. Three of these portraits survive, including those of Elizabeth and her mother, Mrs. Richard Chew, the location of which is unknown, and another relative named Samuel Chew (fig. 5.46). (See Doud, "John Hesselius," 146.)

FIGURE 5.46. John Hesselius, *Samuel Chew*, dated 1762, oil on canvas, 38½" x 30". Courtesy of the Museum of Early Southern Decorative Arts (MESDA) at Old Salem.

This portrait was previously thought to represent Samuel Lloyd Chew, the son of Samuel Chew III and his wife, Sarah Lock Chew, of Anne Arundel County, Maryland. In 2011, the sitter was reidentified by MESDA staff as Samuel Chew who was born in 1737 and died in 1791 and who was also from Maryland. His relationship to other Chews in Maryland, including Sarah Lock Chew, who was also painted by Hesselius in 1762, remains speculative.

William Cuninghame Jnᵒ Neilson & John Hesselius & from all book debts of other demands whatsoever that I have against him to this day witness my hand and Seal_____
This 3ᵈ day of June 1762 Signed Chˢ Carter
Witness Jnᵒ Robinson Walker Taliaferro[90]

Young Charles Carter may have borrowed money from his father to pay John Hesselius for paintings, although no portraits by Hesselius of Charles Carter the son or his family have been recorded. There is a portrait of his father, Charles Carter (1707–1764), by an unidentified painter that might be a copy by Hesselius of an earlier portrait, but its current location is unknown. There is also a portrait of Anne Byrd Carter, Charles Carter of Cleve's second wife, and two of their children (fig. 5.47) that is attributable to John Hesselius. It is unlikely, however, that the son of Charles Carter of Cleve and his first wife would have purchased this picture.

The second Virginia reference to Hesselius appears in a letter John Carlyle (1720–1780) wrote to his brother, George Carlyle (1715–1784), in Scotland on August 1, 1766. John Carlyle exchanged his portrait by John Hesselius for one of his brother, saying of his own portrait that

as to the Likeness I never thought it very like when it was first finished I believe you would have liked it better, but I thought he had flattered me & made him make it Seven years Older at Least, Ever since I had that long illness in 1755 I have never Recoverd what you Remember Of the Spriteliness at the Eyes. You cannot have more pleasure in Yr Picture then I have in mine, & I hope you'l live long & continue to have yr health.[91]

About the time of his 1763 marriage to the widow Mary Woodward, Hesselius purchased a plantation called Belfield (Bellefield, Bellfield) from either Charles Homewood or Homewood's estate.[92] By then, Hesselius was largely responsible for settling Woodward's estate, including the disposal of numerous land parcels, one of which was adjacent to Belfield and was purchased by Governor Horatio Sharpe. The artist's family resided at

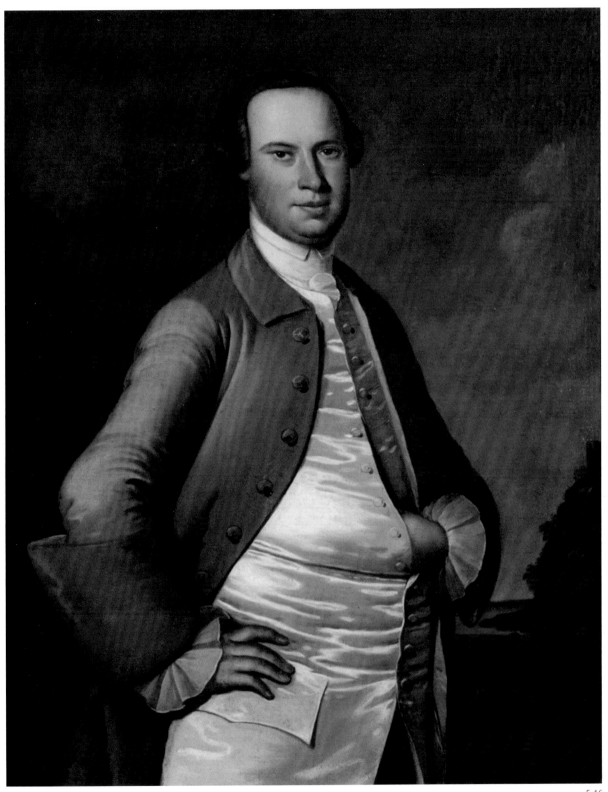

5.46

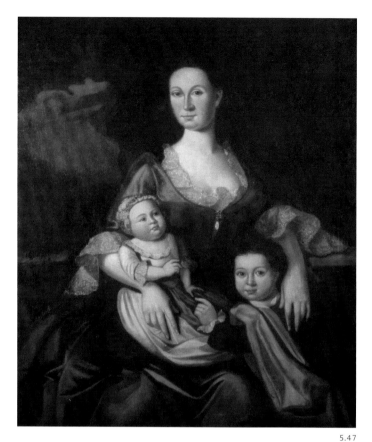

5.47

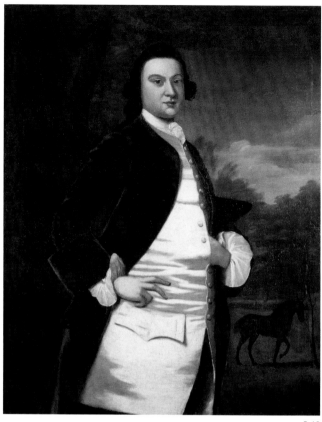

5.48

FIGURE 5.47. John Hesselius, *Mrs. Charles Carter of Cleve and Children*, 1750–1755, oil on canvas, 41⅜" x 35⅜". Courtesy of the Museum of Early Southern Decorative Arts (MESDA) at Old Salem.

Anne Byrd Carter (1725/26–1757), the daughter of William Byrd II of Westover (figs. 2.29 and 2.30), is shown with two of her eight children: A. B. Carter (b. 1743), Maria Byrd Carter (ca. 1745–1804), John Hill Carter (b. 1746–50), Lucy Carter (b. 1748), Landon Carter (1751–1811), Jane Byrd Carter (b. 1752), Sarah Carter (b. 1755), and Coriolianna Carter (b. 1757). Family tradition identifies the youngest child in the portrait as Coriolianna and the older boy as Landon.

FIGURE 5.48. John Hesselius, *William Byrd III*, ca. 1765, oil on canvas, 53" x 43¼". Virginia Historical Society.

Although badly abraded, the painting is important for its subject and for the exterior view. The only portrait like it by Hesselius, it was obviously designed to reflect the sitter's interest in horse breeding and racing. William Byrd III (1728–1777) was heir to the Westover estate, and the painting is probably the one mentioned in his wife's 1813 will (see ch. 2, n29). A gambler, Byrd III lost sizable sums in horse-racing bets, depleting much of the family fortune before he died.

their manor house, Primrose Hill, located about two miles from Annapolis. Twelve children would be raised here—five children by Mary's previous marriage and seven born to her and John Hesselius. Complete inventories for those two properties, taken in July 1778 following the artist's death on April 9 of that year, are revealing.[93] Among a long list of valuable household goods are painting equipment and materials, numerous musical instruments, a few items pertaining to scientific interests,[94] and a large number of paintings. The paintings included two paintings of the holy family, one scripture painting, twelve landscape paintings, "Some Family Pictures," a fruit piece, and over twenty prints (ten flower and two cornucopia). The surviving portraits of the artist's wife and two of their children were likely among these listed items.[95] The presence of landscapes and other types of painted pictures begs the question of who created them. Hesselius and his father, Gustavus, were both capable of such work, as demonstrated by backgrounds in extant portraits as well as Gustavus's *The Last*

Supper (fig. 2.54) and two mythological pictures that survive by him (fig. 2.56). However, no works of this type have been documented to John.

John Hesselius continued to serve as a church warden for St. Ann's Parish in 1763; the following year he was named to the vestry.[96] His travels for commissions can be documented through surviving signed and dated pictures from the mid to late 1760s through the 1770s and include portraits of persons living near him in Anne Arundel County, Charles County, and, by 1777, Baltimore County.[97] During this period he also traveled several times to Virginia to work again for the Fitzhughs in 1767, 1769, and 1773 and for other families, including the Lawsons, whose large portraits are among the most elaborate by the artist (figs. 5.49 and 5.50). In addition, one odd bit of documentation for the artist is found in a period newspaper account describing a black cloud that came from the west and "broke in the neighbourhood of this city [Annapolis], at Mr. Hesselius's, and from thence to London-Town," breaking every pane of window glass on the upper west side of the artist's house.[98]

Doud has convincingly shown that by the mid to late 1760s, Hesselius's work in Maryland began to shift away from the more formulaic approach of the Wollaston-inspired rococo style. While Hesselius was still offering the older-style portraits to some clients, for others he was painting likenesses that were more realistic. The earliest of these probably dates about 1764 when he painted a portrait of Mrs. Richard Galloway Jr. (fig. 5.51). In this sensitive picture, Hesselius shows new concern for individualism and makes an effort to capture the actual features of the sitter. It appears that Hesselius completely abandoned the rococo by the 1770s. His 1771 dated portrait of Ann Fitzhugh Rose is among the most penetrating likenesses by the artist. The style and coloring of her dress are subdued and modest by comparison with similar passages in the artist's earlier and more ambitious portraits. Mrs. Rose, who had been widowed for twenty years, seems quite frail with her thin, though serene face. Her features are realistically drawn and carefully modeled, lacking some of the mannerisms that Hesselius adapted from Wollaston's work and used for many years.

The change to a more classical type of portraiture had been slow for Hesselius, and it was probably prompted by newer approaches brought back to America by younger painters. Chief among them was his former pupil Charles Willson Peale (1741–1827), who left Annapolis in 1765 to study with Benjamin West in London. Peale returned in 1767 to work in Maryland before settling in Philadelphia. Surely the two artists were in contact when Peale returned, and it is likely they continued to be in contact throughout the rest of their lives.

Hesselius had demonstrated his ability to change and update his work throughout his lifetime, and he set an important example and precedent for Peale, who was equally assertive in learning the newest painting techniques and characteristics. The older painter had learned first from his father, then from Robert Feke and John Wollaston Jr., moving from the early and later baroque to

FOLLOWING PAGES

FIGURE 5.49. John Hesselius, *Susannah Rose Lawson* (Mrs. Gavin Lawson), dated 1770, oil on canvas, 49⅝" x 38⅞". Colonial Williamsburg Foundation, Williamsburg, VA.

Like John Wollaston Jr. (and perhaps because of his influence), John Hesselius incorporated a marble slab top table in this picture as well as a side chair that seems to match the armchair in Mr. Lawson's picture (fig. 5.50).

FIGURE 5.50. John Hesselius, *Gavin Lawson*, dated 1770, oil on canvas, 50" x 37⅞". Colonial Williamsburg Foundation, Williamsburg, VA.

Gavin Lawson (1738–1805) and his wife, Susannah Rose Lawson (1749–1825) (fig. 5.49), lived at Hampstead plantation, Stafford County, Virginia, and moved later to Geneva, Seneca County, New York. He was a successful merchant who had married into the prominent Fitzhugh family. No doubt Lawson commissioned these likenesses because of a familiarity with some of the many Fitzhugh portraits John Hesselius created earlier (figs. 5.40–5.42). The Lawson portraits, as later examples of the artist's work, show his fully developed rococo style, and they rank among his most ambitious Virginia pictures. These were highly developed compositions with complex perspective and sophisticated coloring, particularly in the use of warmer hues for shading.

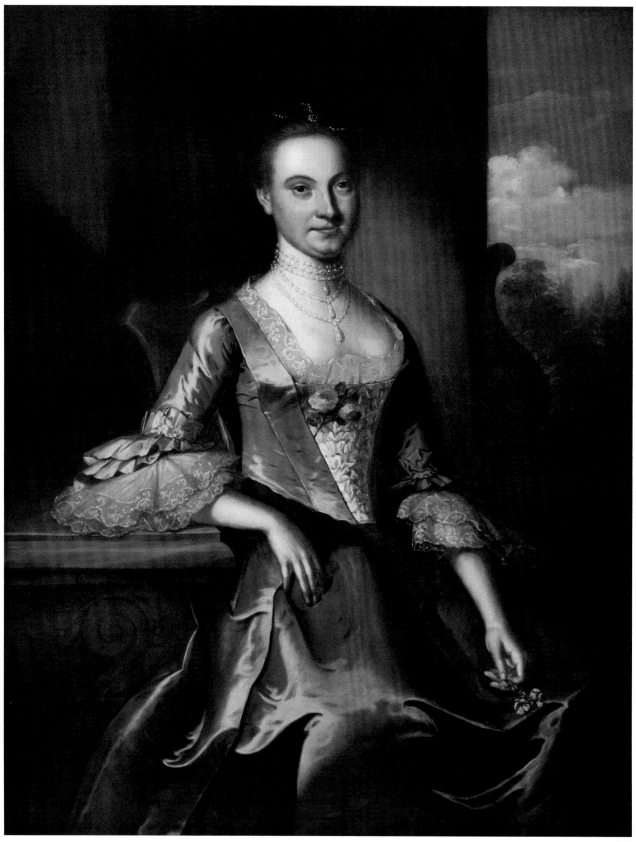

5.49

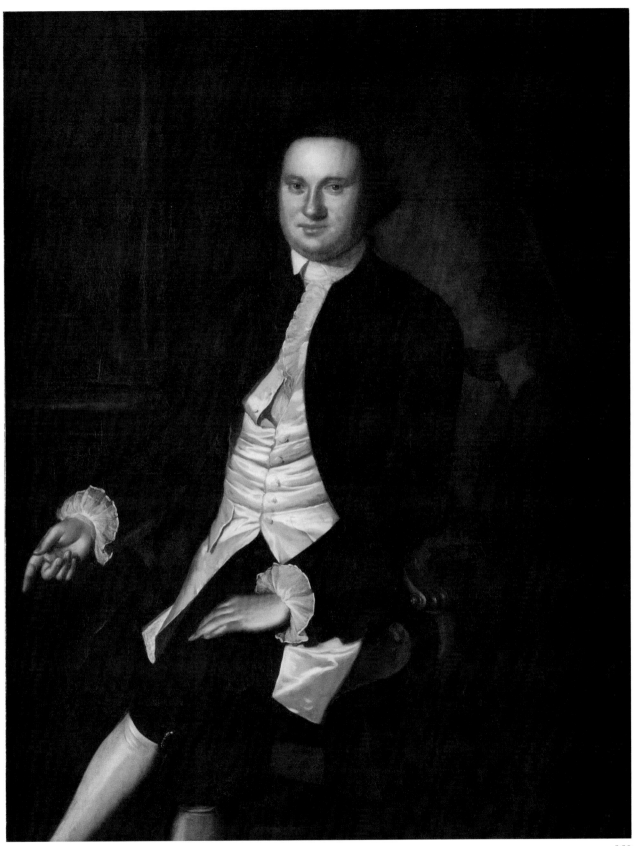

5.50

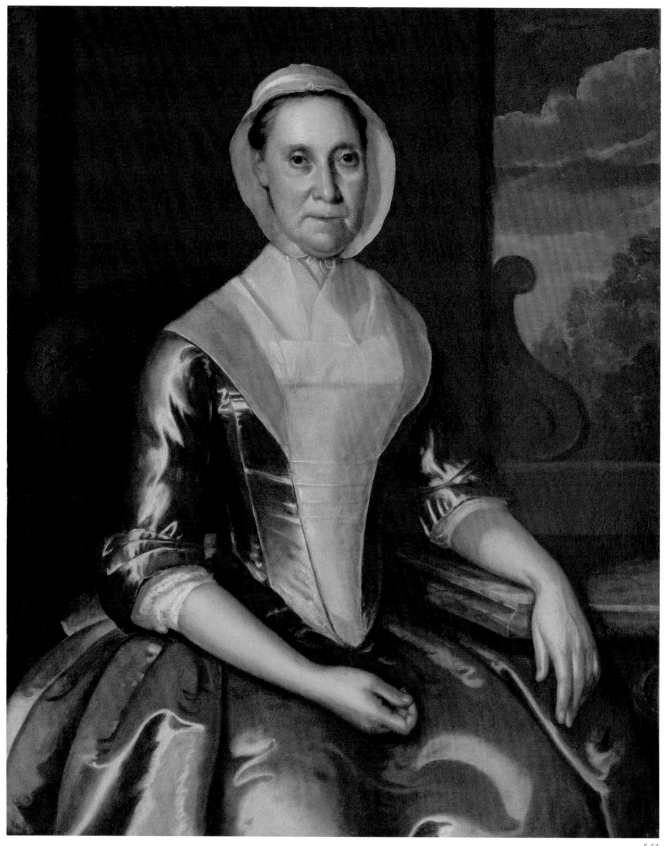

the addition of rococo mannerisms. Looking to Peale for inspiration in the late 1760s was not only sensible but also typical of Hesselius's approach. He was modernizing the look of his portraits in order to be competitive, and he would continue painting for at least another four years.

Hesselius's long and successful career in the middle colonies paralleled that of Jeremiah Theus, the older painter who began painting in Charleston in the 1730s. Each of these painters was able to adjust his style to local tastes over a long period of time by taking watered-down baroque portrait styles and overlaying them with rococo coloration, poses, and other details. These changes are less obvious in Theus's work, but his late portraits, like those of Hesselius, also show an effort at more realistic portrayals. Both Hesselius and Theus were able to accrue an impressive degree of wealth. At the time of his death

5.52

FIGURE 5.51. John Hesselius, *Mrs. Richard Galloway Jr.*, dated 1764, oil on canvas, 36¾" x 30". Image © The Metropolitan Museum of Art/Art Resource, NY.

The sitter's parents were William Richardson and Margaret Smith Richardson. Sophia Richardson Galloway (1696–1781) and her husband were wealthy Quakers who lived in Maryland. Their religious affiliation may be partially responsible for the plainness and subdued coloration of the portrait although it does not explain why Hesselius moved on to a more realistic, penetrating portrait style. The scholar Richard K. Doud believed that Hesselius made a self-conscious attempt to better his work by making it more realistic (see Doud, "John Hesselius," 146–147). While this may account for the skillful rendering of fabrics, it does not fully explain Hesselius's focus on character and the compassionate treatment of this older sitter's face and those of a few others that soon followed.

The 1764 documented date of the Galloway portrait is interesting because it was about this time that Hesselius's pupil Charles Willson Peale heard of John Singleton Copley and visited the Boston painter's studio. One wonders if Hesselius also knew of Copley's work and had seen his lifelike portraits. By 1764, Copley was at the peak of his success in America, and his reputation had spread beyond Boston and New York, his two principal areas of activity. It seems reasonable to consider a Copley influence for this picture, either through Peale or through familiarity with the Boston artist's portraits. The more direct influence of Peale's work after returning from his studies abroad is another factor. In either case, the Galloway portrait is extraordinary.

FIGURE 5.52. John Hesselius, *Ann Fitzhugh Rose* (Mrs. Robert Rose), dated 1771, oil on canvas, 30¼" x 24¾". Colonial Williamsburg Foundation, Williamsburg, VA.

Ann Fitzhugh Rose (1721–1789) was fifty years old when John Hesselius signed and dated her picture. She was the daughter of Captain Henry Fitzhugh (fig. 5.40) and his wife, Susannah Cooke, who lived at Bedford plantation on the Potomac River in Stafford County, Virginia. In 1770, Hesselius had painted likenesses of the sitter's son-in-law and daughter, Gavin and Susannah Rose Lawson (figs. 5.49 and 5.50).

in 1774, Theus's estate was larger than Hesselius's. Four years later in 1778, Hesselius's household inventory was valued at £3,400 11s., exclusive of his large land holdings and bequests of more than £3,600 sterling to his children.[99] Among his property were thirty-one slaves, expensive furniture, and 194 ounces of silver plate.[100] Both artists had specialized in portraiture though they provided other services as well.

Whether their success was atypical of other American painters is unknown, but there is growing evidence that those who established permanent homes and multifaceted businesses in mid-eighteenth-century America faired the best.[101] The sole exception was probably John Wollaston Jr., whose wealth may have come through his daughter or connections made through her husband. Most other artists who worked briefly in the southern colonies tended to move on once ready commissions were exhausted. However, the Badgers in New England and the South; Charles Bridges, who maintained residence in Virginia for nine years; and the Robertses in South Carolina all seem to have made reasonable living wages for their work.

NOTES

1. *Maryland Gazette* (Annapolis), Mar. 15, 1753.

2. Warwell's ad was placed on Jan. 21, 1766, in the *South-Carolina Gazette; and Country Journal* (Charleston). In the Nov. 3, 1766, issue of the *South-Carolina Gazette* (Charleston), Warwell added that he would also whitewash rooms or "passages" and paint "in watercolours, In a new and lively taste."

3. *South-Carolina Gazette; and Country Journal* (Charleston).

4. Warwell should not be confused with James Warrell, an artist who advertised in Alexandria in 1788. See *Columbia Mirror and Alexandria (VA) Gazette*, Aug. 22, 1788, as found in the MESDA Craftsman Database. Other advertisements for James Warrell appear in Virginia papers for the 1800s and can be found in the MESDA Craftsman Database.

5. Little is known about Stephen Badger Jr., the brother of Joseph Badger Sr. of Boston, except that he married a woman named Anne Doubleday. There is no evidence that he ever traveled outside of New England.

6. See the Badger family tree in appendix B for more on births, deaths, and other facts. Information on the first two generations of the Badgers has been gleaned from period church records, newspaper references, and other primary and secondary sources too tedious to list here, as well as from Ancestry.com. Citations and copies of these sources are contained in the CWF Curatorial Research Files.

7. *South-Carolina Gazette* (Charleston), Dec. 1, 1766. Nothing more is known about William Badger or his occupation.

8. *Columbian Herald* (Charleston, SC), Sept. 7, 1786. Badger was paid by the city £39 6s. 4d. for decorating the staffs and numbering "the Houses," presumably the houses in town. Badger lived or worked at two locations listed between 1790 and 1797 in the Charleston city directories: 118 Queen Street and 17 Pinckney Street. On Sept. 27, 1800, at the time of his death, the *City-Gazette and Daily Advertiser* (Charleston, SC) noted that he was a native of Boston.

9. Elfe, "Account Book," 154.

10. *City Gazette, or the Daily Advertiser* (Charleston, SC), May 28, 1788.

11. According to the MESDA Craftsman Database, these locations included the following: in 1795, King Street; from 1797 to 1798, 49 Meeting Street (residence) and 7 Beresford Alley (business). In 1799, he opened a new "Oil and Colour Shop" at 18 Bay Street while continuing to operate a business at Beresford Alley (*City-Gazette and Daily Advertiser* [Charleston, SC], July 17, 1799); in 1804, he moved his business, or part of it, to 74 East Bay Street; and, in 1806–1807, his residence was 39 Trott Street.

12. *City-Gazette and Daily Advertiser* (Charleston, SC), June 8, 1798, and July 17, 1799.

13. Ibid., Oct. 7, 1799. A "fetch" pencil was either a fitch brush made from the hair of a polecat (fitchew) or a small brush made of hog's hair.

14. *City Gazette, or the Daily Advertiser* (Charleston, SC), Oct. 5, 1789, and June 30, 1791, as found in the MESDA Craftsman Database. James's daughter Elizabeth Rhoda Badger (1788–1865), one of at least six children, married the Charleston painter Benjamin Wilkins Ruberry (1783–1806); James was instrumental in settling his son-in-law's estate. Information on James Badger was taken from references in the MESDA Craftsman Database, specifically: *South Carolina Historical and Genealogical Magazine,* vol. 33, nos. 2, 3, and 4, pages 162 and 165, 216, and 310, respectively; *Columbian Herald* (Charleston, SC), Nov. 26, 1793, and Mar. 5, 1794; and *City Gazette and Daily Advertiser* (Charleston, SC), June 2, 1797, Feb. 2 and June 14, 1798, Feb. 11 and Oct. 7, 1799, Mar. 16, 1801 (when he was in partnership with James Harper), Nov. 5, 1805 (noting the marriage of his daughter Rhoda), and Oct. 10, 1806 (at which time he had a school for instruction in vocal music). Other references to James Badger in the MESDA Craftsman Database include *South Carolina State Gazette and Timothy's Daily Advertiser* (Charleston), June 13, 1798; *South-Carolina Gazette* (Charleston), June 13, 1799; and *Charleston (SC) City Gazette and Commercial Advertiser,* Nov. 29, 1813.

15. *South-Carolina Gazette* (Charleston), Dec. 6, 1735; Webber, "Register of the Independent or Congregational Church," 59.

16. Baltimore County, VA, Register of Wills, 1800–1802 (Aug. 7, 1801), 305, records the apprenticeship indenture for John Badger. The first mention of a John Badger in the city directories is for 1794.

17. See Warren, "Badger Family Portraits." Warren believed that the portraits of Jonathan the cabinetmaker, Sarah, Sally as a child, and William were likely created at the same time by Joseph Badger Jr. Warren believed that the portrait of Sarah as a young woman was possibly created by John Durand. These assignments have changed in light of Leigh Keno's discovery of a signed portrait. See comments for fig. 5.3.

18. *City Gazette and Daily Advertiser* (Charleston, SC), Jan. 26, 1792.

19. South Carolina Mortgages, No. 1, H. H. H., 1789–1795, p. 555, as found in the MESDA Craftsman Database.

20. *Virginia Gazette, and Petersburg Intelligencer,* May 7, 1799, as found in the MESDA Craftsman Database. *South-Carolina State Gazette, and Timothy's Daily Advertiser* (Charleston), Aug. 7, 1799, also carried this notice: "Petersburg. *July* 30. Died, a few days ago, in this town, Mr. *Jonathan* Badger, Painter, lately from Charleston." His children were Samuel, James, and Mary Amelia.

21. *Virginia Gazette, and Petersburg Intelligencer,* July 10, 1792, June 10, 1794, and Feb. 9, 1796; Petersburg, VA, Hustings Court Will Book, no. 1, 1784–1805, p. 253, all as found in the MESDA Craftsman Database. Manley is probably the artist who Robert Sully (1803–1855) mentioned to William Dunlap (1766–1839) was one of three early painters remembered in Virginia: Durand, Wollaston Jr., and "Manly" (*History of the Arts,* 1:144).

22. The second part of the inscription gives additional information indicating that the original portrait was painted in 1767, which would make Sarah's birth date 1745. Most genealogical references cite her birth date as 1747.

23. She reportedly married the Reverend Joseph Snow Jr. in Rhode Island at an unknown date, but that marriage cannot be verified from the existing records.

24. The chief sources are Morgan, "Notes on John Wollaston"; Bolton and Binsse, "Wollaston: An Early American Portrait Manufacturer"; Groce, "John Wollaston: Cosmopolitan Painter"; Craven, "Painting in New York City"; and Weekley, "John Wollaston, Portrait Painter."

25. The Charterhouse has a long history dating back to the fourteenth century when it was a Carthusian priory. The facility was rebuilt and renovated, first in 1545, and again in 1611 when the property passed to Thomas Sutton of Snaith, Lincolnshire. Sutton had discovered large deposits of coal on two of his leased properties near Newcastle-on-Tyne from which he made a fortune in his London business. When he died in 1622, he endowed a hospital on the site, calling it the Hospital of King James, as an almshouse for male pensioners such as soldiers

who had borne arms, former servants in the service of monarchs, and those who were gentlemen by descent but without means of support. John Wollaston Sr. fell into the last category, or at least was "father of a gentleman," according to Walpole (*Anecdotes of Painting,* 381). Today it is known as Sutton's Hospital in Charterhouse.

26. Small coal was charcoal, which was used for fuel. Thomas Britton was referred to as the "smallcoal-man" because he was a charcoal merchant, having learned the trade as an apprentice in Clerkenwell, London, where he eventually set up his own shop.

27. Walpole, *Anecdotes of Painting,* 381. *Anecdotes* was based only in part on the notes and other information on artists previously collected by George Vertue, the English antiquarian and engraver (1684–1756). Walpole is known to have collected additional information that appears in his four-volume account.

28. Hawkins, *General History of Music,* 807. Hawkins also includes this note: "Mr. Walpole, in his account of Woolaston the painter, Anecdotes of Painting . . . has taken occasion to mention some particulars of Britton, which he says he received from the son of Mr. Woolaston [John Wollaston Jr.], who, as well as his father, was a member of Britton's musical club" (791). Hawkins goes on to say that the Wollaston house, located in Warwick-court, in Warwick Lane, Newgate-Street, was frequented by religious "Dissenters" (807). The latter comment explains some of the early cleric portraits by John Wollaston Jr.

29. Ward, *Compleat and Humorous Account,* 301.

30. Thornbury, *Old and New London,* 334.

31. Dawes, "Philip Hart," 510.

32. Britton played the viola de gamba but is known to have had a large collection of instruments. Britton, "the commoner," was so celebrated that he was referred to in one of Jonathan Swift's poems and in other poems by John Hughes and Matthew Prior after the musician's death. Swift's 1712 poem "Description of the Morning" describes the sounds and sights of a disorderly London awaking. It includes the line, "The small-coal man was heard with cadence deep," probably an accurate portrayal of Britton's street call, which was described as sonorous and deep (*Poems,* 113). Hughes's verses are quoted in the caption to fig. 5.7.

33. The Sherburne portrait was privately owned in 1975. See Craven, "John Wollaston," 19–20 and 21n5.

34. Clergy portraits known from engravings include William Tong, engraved by John Simon (1675–1751), who also did an engraved version of Britton's portrait; John Nesbitt (active ca. 1714), engraved by George White (dates unknown), ca. 1709; Nathaniel Spinckes (1653–1727), by an unidentified engraver, 1731; and Henry Grove (1684–1738), engraved by George Vertue, 1741.

35. Hawkins, *General History of Music,* 807.

36. All of these sitters were listed in Craven, "John Wollaston," as

"physicians" (22), but two of the sitters, Thomas Willis (d. 1785) and William Harvey (d. 1675), were noted clergymen.

37. The Bartholomew portraits sold at Christie's auction house, London, Sale 8012, Lots 105 and 106. Mrs. Bartholomew's portrait is signed "Wollaston Pt. 1740" at lower left on the front of the canvas. Although the location of the original portrait is unknown, the National Portrait Gallery in London owns a J. Bayly engraving (dates unknown) after it that was published in 1769.

38. The portrait was a gift of Mrs. H. P. (Sarah O.) Oliver to Harvard College in 1852.

39. Peter Toms trained with Thomas Hudson. A drapery specialist, Toms took over much of the work of van Aken after his death. He may have worked for Hudson and Ramsay, and he definitely did drapery work for Sir Joshua Reynolds by about 1755. Early studies of Wollaston associated his training with Toms, but Toms was younger than Wollaston, and his connection with Hudson is unconfirmed.

40. The authoritative work on Hudson is Ellen G. Miles, *Thomas Hudson, 1701–1779: Portrait Painter and Collector: A Bicentenary Exhibition* (1979). Hudson trained under Jonathan Richardson (1667–1745), later marrying Richardson's daughter—against Richardson's wishes. A native of the West Country, Hudson spent much of his time between London and Bath and in adjacent areas. His two most noted pupils were Sir Joshua Reynolds and Joseph Wright (1734–1797). Highmore studied law and worked briefly as a clerk but abandoned those pursuits in favor of painting. Dandridge, the son of a house painter, was a close neighbor and rival of Highmore, according to Vertue, who knew him, and he was working as late as 1753–1754. See C. H. Collins Baker, *"Price Family"*; and Weekley, "John Wollaston," 9–10.

41. See Craven, "John Wollaston," 23, fig. 7, for John Wollaston's signed 1744 portrait of Sir Thomas Hales (ca. 1665–1748) that is similar to Thomas Hudson's circa 1740 portrait of George Graham (1674–1751), instrument and timekeeper maker of London. Hales's portrait is owned by the New-York Historical Society, NY.

42. See Saunders, *John Smibert,* 50–60, for a detailed discussion of Smibert's decision to leave London and accept an offer to teach painting in Dean Berkeley's college in Bermuda, a decision Saunders believes was predicated in part on Smibert's desire to take "refuge from the stifling London art scene" (57–58). While Smibert's background and personality were different from Wollaston's, the two men probably had similar motives for moving. Smibert was not suited for the competitive nature of London's art market; Wollaston was also thoroughly aware of the competition, having witnessed his father's financial difficulties.

43. Groce, "John Wollaston," 147n17.

44. See Morgan, *Early American Painters,* 50, for information on the inscriptions on the backs of the portraits of Judge William Smith (1728–1793) and his son. Both portraits had inscriptions that were copies of earlier ones, presumably by the painter. These were copied when the paintings were restored and received new linings. These read "Johannes Wollaston." See also Craven, "John Wollaston," 26n20, and Bolton and Binsse, "Wollaston," 30–32.

45. As quoted in Morgan, *Early American Painters,* 50.

46. Wollaston was working in Philadelphia before Oct. 20, 1752, when James Hamilton, then lieutenant governor, entered in his cash book "pd. Mr. Woolaston for 2 half length Pictures 36—." James Hamilton Papers, Box 1, #11, Cashbook, 1739–1757, Historical Society of Pennsylvania, Philadelphia, as quoted in Weekley, "John Wollaston," 16.

47. *Maryland Gazette* (Annapolis), Mar. 15, 1753.

48. See Saunders, *John Smibert,* 53. Smibert, who arrived in Boston in 1729, was mentioned in a 1725 poem titled "A Session of Painters Occasioned by the Death of the Late Godfrey Kneller." Charles Willson Peale would later have verses written about one of his pictures, and Henry Benbridge (in Charleston, SC) would also be lauded in this manner.

49. There is a circa 1710 portrait of Henry Carroll (1697–1719) by an unidentified English painter owned by the Maryland Historical Society as well as a privately owned portrait of Mrs. Charles Carroll (Mary Darnall, 1678–1742) by an unidentified, and probably English, artist. The portrait of Charles Carroll ("Charley," later Charles Carroll of Carrollton) was commissioned at the request of his father, Charles Carroll of Annapolis. In a postscript to a letter he wrote to his son on Sept. 2, 1762, he said, "I desire you will get yr Picture drawn by the best hand in London, let it be a three Quarters length, let it be put in a Genteel gilt frame & sent me by the next fleet carefully Cased & packed—." The son responded to his father on Mar. 22, 1763, saying that "I am to set at 1 o'clock being the second time, for my picture. . . . my Portrait without the frame will come to 25 guineas, an extravagant price but you desired it should be done by the best hand: & 25 guineas is a fixed price for a 3/4." Another letter from the son, dated Nov. 12, 1763, indicated that the picture was done by "Reynolds." Hoffman, Mason, and Darcy, *Dear Papa, Dear Charley,* 278, 309, 338. See also Van Devanter, *"Anywhere So Long as There Be Freedom,"* 142–143. The 1763 portrait of "Charley" Carroll by Sir Joshua Reynolds is owned by Yale Center for British Art, Paul Mellon Collection, New Haven, CT.

50. Although the practice was probably rare, it was not unheard of for portraits painted in this country to be shipped abroad for replication by English painters. Charles Carroll of Annapolis wrote to his son saying, "I intend if a peace happens before you leave London to send you wt: family pictures I have wch: are done by shocking hands in order to have the likeness taken by the best hand in London & to have them new dressed" (2 Sept. 1762, in Hoffman, Mason, and Darcy, *Dear Papa, Dear Charley,* 278). While in England in 1757, five years earlier, Benjamin Franklin had his wife, Deborah Read Rogers Franklin (1708–1774), commission John Hesselius to paint portraits of their daughter Sally (Sarah Franklin, 1743–1808) and possibly his son

whom he called "Franky" (probably their son, born in 1732, who died in 1736, in which case the portrait was done posthumously). The two children's portraits, plus one of Deborah, were to be shipped to England for use in preparing a single group portrait or conversation piece. However, Franklin was subsequently told such pictures were out of fashion and the plan was abandoned. See page 259 for full quotation. For information on these and other Franklin portraits, see the query by art historian Charles Henry Hart in "Notes and Queries," 241–242.

51. There are two versions of Charles Carroll's portrait, a three-quarter length that is a pendant to Mrs. Carroll's likeness and a bust-length picture, which descended through the family and is illustrated in Van Devanter, "*Anywhere So Long As There Be Freedom*," 126–127. See 124–125 for a portrait of the sitter as a child, painted by Justus Engelhardt Kuhn in 1712.

52. Virginia Historical Society, Richmond, VA, owns the original receipt: Mss 1 C9698a 187–219, Custis Family Papers, 1683–1858, Sec. 17, Accounts, 1757–1761.

53. *American Magazine*, 608. Hopkinson was born in Philadelphia. Well educated, he worked for Benjamin Chew as a legal assistant. A signer of the Declaration of Independence, he was known for his various songs, political poetry, and pamphlets; he also played the harpsichord and maintained a sizable music library.

54. In 1759, Wollaston's name appeared in the daybook of Samuel P. Moore of Philadelphia for May 19, in reference to frames for paintings by the artist. Whether these were frames for pictures painted that year is unknown; ordinarily, a portrait needed to dry and season for at least six months prior to varnishing, a task sometimes performed by the artist or, in the artist's absence, someone else. The author is grateful to Arthur W. Leibundguth, who, in the 1970s, shared information regarding Wollaston in Philadelphia in 1759. The reference in the text comes from his "Furniture-Making Crafts in Philadelphia," 23–24.

55. See Sartain, *Reminiscences*, 147, regarding a letter to Rembrandt Peale (1778–1860) dated Oct. 28, 1812. Charles Willson Peale wrote, "I must go back to about the year 1755, sometime near that period Wollaston visited Annapolis and painted a number of portraits of the first families in that city. He had some instructions from a noted drapery painter in London, and soon after took his passage to New York, from thence he visited all the principal towns painting, to Charlestown, S. Carolina, and from thence he returned to England. I was in London when he returned from the East Indies very rich. He carried to the East Indies two daughters, one or both of them married and thus acquired great fortunes. They died, and the father, soon after he arrived in London, went to Bath where I believe he died." In this passage, Charles Willson Peale mistakenly refers to Wollaston's going to the East Indies. Wollaston actually traveled to the British West Indies where he met John Baker, who identified Wollaston as a painter. Baker saw the artist again in Bath. See Baker, *Diary*, 324.

56. Information about painters who visited both the southern colonies and the Leeward Islands or Bermuda needs further investigation. Probable examples of known painters are William Dering, John Wollaston Jr., Richard Jennys, and John Stevenson, all of whom worked in Charleston, and Robert Feke, whose southern work seems to be confined to Virginia. Charleston would have been a likely point of departure to and return from the Caribbean as there was a busy trade between that large southern seaport and the West Indies, and numerous residents of South Carolina had investments and relatives there. For instance, Eliza Lucas Pinckney, who sat for Wollaston in 1767, was born in Antigua. Her father owned property there, having served first in the British army and later as lieutenant governor. She was well-known for her cultivation, in South Carolina, of indigo, an island crop to which her father had introduced her.

57. "Journal," 20, no. 3: 209. Wollaston was again dining with Mrs. Manigault on Apr. 7, 1767 (ibid., no. 4: 257).

58. Rutledge, *Artists in Charleston*, 114.

59. There are miniature portraits by an unidentified painter of both Mr. and Mrs. John Beale. These appear to be later copies of Wollaston's larger canvases.

60. For a particularly good discussion, see Lovell, *Art in a Season of Revolution*, 73–93.

61. See Reynolds, *Discourses*, 162–163.

62. Weekley, "John Wollaston," 21.

63. Ravenel, *Eliza Pinckney*, 231. In the seventeenth century and occasionally the eighteenth, the term "shadow" was used rhetorically to denote a portrait image as contrasted to the original, which would be the subject of the portrait.

64. *South-Carolina Gazette* (Charleston), Feb. 2 and 16, 1767.

65. *Diary*, 324. The identity of John Smith is unknown; he may have been member of the House of Commons in 1775. Neither has any information on Mrs. Cottle been located.

66. Ibid., 127. Wollaston's choice of the renowned spa town and resort of Bath for his residence was entirely appropriate. Thomas Hudson had worked there for years, dividing his time between the spa town and London. Thomas Gainsborough (1727–1788) had moved to Bath in 1759 and would remain there until sometime in 1774. During the Georgian era, architects John Wood the Elder (1704–1757) and his son built numerous important buildings, including Queen's Square, the Circus, and the Royal Crescent, which was begun the year Wollaston arrived.

67. Dunlap, *History of the Arts*, 1:144.

68. The Nelson portraits are attributed to Feke on the basis of the will of Elizabeth Burwell Nelson, recorded Feb. 26, 1793, and July 16, 1798, and probated May 17, 1802, and again on Dec. 19, 1803, in York County, VA, Records, Wills and Inventories 23, 1783–1811, 504–505, as

found in the MESDA Craftsmen Database. The pertinent part reads, "I give also to my said son Robert the Small miniature picture of his father now in possession of his sister Judith Nelson [perhaps Judith Page Nelson who married Hugh Nelson] unless his Brother Hugh chooses to give him for it the picture of his father drawn by Feake."

69. In an 1860 issue of *Historical Magazine,* John Gilmary Shea published biographical information about Feke ("Robert Feke"). William Carey Poland's paper "Robert Feke" was first presented in 1904 and subsequently published in 1907. Unless otherwise indicated, all biographical information about Feke comes from the latter source.

70. "Robert Feke: The Early Newport Portrait Painter, and the Beginnings of Colonial Painting."

71. Friends Records, Newport, RI, Friends' Meeting, 15 Oct. 1767, Rhode Island Historical Society, Newport. The marriage record was created after Feke, the painter, died, soon after his departure from the colonies in 1751. The last record of his presence in Newport is Aug. 26 of that year. See Craven, *Colonial American Portraiture,* 294. Craven's analysis includes the theory that Feke died in Barbados in 1752.

72. The portrait, painted on a wood panel, is owned by the Society for the Preservation of Long Island Antiquities, New York.

73. Shea, "Robert Feke," 281. Shea also learned from the descendant Mr. J. D. Feeks that the "only piece of this early New York artist, now preserved in the family, is the portrait of a little girl painted on a panel. It does not bear his name, but has written on the back, apparently an old direction, 'To Robert Feke, at Mr. Judea Hayes, in New York.'" This may be the Phainy Cock portrait. Poland also mentions these details in his history ("Robert Feke," 94).

74. In 1745, Feke painted the portrait of the Reverend John Callender, who performed the marriage.

75. Saunders, *John Smibert,* 113, 118–120. Saunders provides a succinct discussion of the Feke-Smibert relationship, noting that Smibert may have "steered" the Isaac Royall commission Feke's way. Saunders also notes that Feke's style was more up-to-date than Smibert's in terms of palette, pose, and brushwork.

76. Hamilton, *Hamilton's Itinerarium,* 124. Interestingly, Moffatt was the nephew of the artist John Smibert. See Prown, "Review of *Notebook of Smibert,*" 330.

77. Previous scholars have made tentative, unsubstantiated associations between the artist Robert Feke and a Richard Feke whose name appears in Barbados records. On Dec. 10, 1719, St. Philips Parish, Barbados, the will of Roger Webb, Esq., proved on Mar. 23, 1719/20, noted that he had several "Feake" relatives, including his nephews Robert aged 15, Henry, and Frederick Jr.; all were the sons of "Frederick Feake, Gent. Of St. Michaels Town." *English Settlers in Barbados, 1637–1800* [database online]. Provo, UT, USA: Ancestry. com Operations Inc, 2007, 365. http://search.ancestry.co.uk/search /db.aspx?dbid=1123. s.v. "Roger Webb, Esq." There is no indication that these persons were relatives of the artist. While there were many

connections between Barbados and the North American colonies, relationships between other Caribbean islands—such as Jamaica, St. Croix, and Antigua—and the continent were equally significant. Additionally, in 1904, descendants of the artist claimed that he went to Bermuda for reasons of health. Bermudians also had close ties with America, particularly with the South. There are several eighteenth-century portraits surviving for Bermuda. Some of these are attributed to Joseph Blackburn (d. 1778?) who worked in Boston from 1750–1765. However, one of these portraits, of a man of the Tucker family, shares some characteristics with Feke's work. In sum, Feke's where-abouts after 1751 remain uncertain, an island location being conjectural at best.

78. Identification of the sitter as Millicent Gordon (the first Mrs. James Gordon) has a history among descendants. Though Hesselius could have visited Virginia earlier, no information supporting such a trip has been found. It is conceivable that the portrait represents someone else in the family although no candidates have been confirmed, and only one likely possibility can be suggested here: Lucy Churchill (b. 1726) of Surry, VA. If this painting represents Lucy Churchill, it may be a pendant portrait to *John Gordon* (1720–1780) by Hesselius. The brother of James Gordon, John married Lucy in 1745. Curiously, the so-called *Millicent Gordon* is the only one of the family pictures that is dated. The portrait may be a copy of an earlier likeness, for during this period replicated portraits tended to be dated by the copyist. Unfortunately, there is insufficient evidence that the *Millicent Gordon* picture is a copy.

79. The 1751 Fitzhugh portraits by John Hesselius are all inscribed on their backs with the sitters' and artist's names and date, or else they have replicas of original inscriptions on their new linings. These include Henry Fitzhugh, Henry Fitzhugh II, Mrs. Henry Fitzhugh (Sarah Battaile, 1731–after 1783), Colonel William Fitzhugh, Mrs. John Fitzhugh (Alice Thornton, 1729–1790), and John Fitzhugh (1727–1809). Hesselius also painted other portraits for the Fitzhugh family in 1750–1756, 1767, and 1773, including one of Sarah Fitzhugh (1748–1793) dated 1767. A portrait possibly of Mrs. William Fitzhugh (Ann Bolling Randolph, 1747–1805), probably painted in the 1770s, descended in the Lee family and was recorded by MESDA. A portrait of her husband, William Fitzhugh (1741–1809), painted ca. 1770 by Hesselius, also exists, and a portrait of Elizabeth Fitzhugh (1754–1823, later Mrs. Francis Conway) was also painted about this time.

The Brown family portraits include Dr. Gustavus Brown (1689–1762) and his second wife, Margaret Black Brown (1710–after 1751), inscribed on the back of the canvas "Margeret Brown 2d Wife of Dr/ Gustavus Brown AEtatis 41/1751/John Hesselius Pinx." and their daughters, Elizabeth Brown (1723–ca. 1767, later Mrs. Michael Wallace) and Mary Brown (1717–1801, later the wife of the Reverend Matthew Hopkins and then Henry Threlkeld). All of the Brown portraits were likely painted in 1751.

80. "John Hesselius," 130. Previous attributions to John Hesselius of the three portraits in the Historical Society of Pennsylvania collections (Philadelphia), i.e., *Robert Morris Sr.* (ca. 1740) and *Mrs. Thomas*

Fraeme and *Mrs. William Penn* (fig. 2.52), both ca. 1742, are no longer viable. Doud believed that Gustavus Hesselius painted the Penn portrait and probably that of Morris (130n8). Doud's analysis extended beyond that of William Sawitzky who had previously attributed the works to Gustavus (*Catalogue of the Paintings and Miniatures*, 41). A reference in a 1742 letter strongly implies that the Fraeme and Penn portraits were by the same hand and likely by Gustavus, who had painting experience: "They are allowed to be exceeding Good coppys & according to my Judgment they are the best I ever saw of Hesseliu's Painting" (Richard Hockley to Thomas Penn, 18 Sept. 1742, in Hockley, "Selected Letters," 36). They are assigned to Gustavus by Richard Hockley (see page 101) and in fig. 2.52.

81. See, for example, their advertisement in the *Pennsylvania Gazette* (Philadelphia), Sept. 25, 1740. For more on Winter, including an advertisement that a John Winter in Philadelphia had for sale a portrait of Mary, Queen of Scots, see ch. 2 n61.

82. Anne Arundel County, MD, Wills, EV#1, ol. 33, p. 60, proven on May 12 and May 20, 1778, as found in the MESDA Craftsman Database.

83. The Maryland Diocesan MSS, on deposit at the Maryland Historical Society, Baltimore, MD, as quoted in Doud, "John Hesselius," 131. Doud has provided, in chronological order, considerable information on Hesselius's career after 1750. This study supplements that material with additional references.

84. "John Hesselius," 132.

85. Hart, "Notes and Queries," 241. The postscript is actually dated a few days later on Dec. 2, 1757. Franklin's correspondence about the family portraits continues over various dates until Oct. 23, 1788 (242).

86. Roach, "Taxables." Williams and Claypoole are known to have painted portraits; Winter is discussed in ch. 2 on p. 101. The taxable rates as an indication of wealth put Claypoole at the top and Williams among the lowest, an interesting comparison for two painters whose works are well-known.

87. See Doud, "John Hesselius," 132, 144–146. All of the Calvert portraits are owned by the Baltimore Museum of Art, Baltimore, MD.

88. Ibid, 132. Hesselius's worth is cited as more than three hundred pounds. Woodward's will was witnessed on Sept. 18, 1761. Woodward owned various properties in Maryland, including Primrose Hill near Annapolis. A portrait of his wife by Hesselius survives, privately owned, in Annapolis, MD.

89. A second Hesselius portrait of Elizabeth Chew Smith, showing her in three-quarter length, is owned by the Los Angeles County Museum of Art, CA. Her age is the same in this portrait, likely painted in 1762.

90. Carter Family Papers, Special Collections, Swem Library, College of William and Mary, Williamsburg, VA, mss. 39.1 c24, folder 1.

91. John Carlyle to George Carlyle, John Carlyle Papers, Virginia Historical Society.

92. Doud, "John Hesselius," 150. Although Hesselius continued to own this property until his death, he never lived there.

93. See ibid., 151–153, for a transcription of the complete inventory as given by Mary Hesselius on Feb. 10, 1779.

94. John Hesselius's interest in science probably resulted from his father's influence. The Hesselius from Pennsylvania listed in the papers of Carl Linnaeus was undoubtedly Gustavus, who had close connections with persons in his native Sweden. As noted earlier, Gustavus had met with Linnaeus's assistant when he visited Philadelphia. Specifically, Hesselius furnished the European scientist with nature prints (probably of leaves or other plants) sometime in the early 1750s or 1760s, suggesting an interest in botanical collecting and studies. See Clifford and Zigrosser, "World of Flowers," 237.

95. These include *Mrs. John Hesselius* (Mary Young), ca. 1770, privately owned, and *Eleanor Woodward* (1761–1778) and *Gustavus Hesselius Jr.* (1765–1767) *and His Nurse*, both owned by the Baltimore Museum of Art.

96. "Vestry Proceedings, St. Ann's Parish," 38, 40.

97. For various transactions Hesselius had with Nathan Hammond, an Anne Arundel County merchant, see Doud, "John Hesselius," 134–135.

98. *Georgia Gazette* (Savannah), Sept. 27, 1769.

99. It is difficult to compare the estate values precisely since South Carolina's currency was often more inflated than either Virginia's or Maryland's. However, a cursory comparison indicates that Theus's property holdings in the metropolis of Charleston were more valuable than Hesselius's farmland.

100. See Doud, "John Hesselius," 143. The most costly "furniture" item was a chamber organ listed at sixty pounds. This was probably the one owned by the artist's father; according to Doud, it was advertised for sale as a "Genteel Chamber Organ" in the *Maryland Journal and Baltimore Advertiser* on Aug. 18, 1778.

101. See Rutledge, *Artists in Charleston*, 117–118.

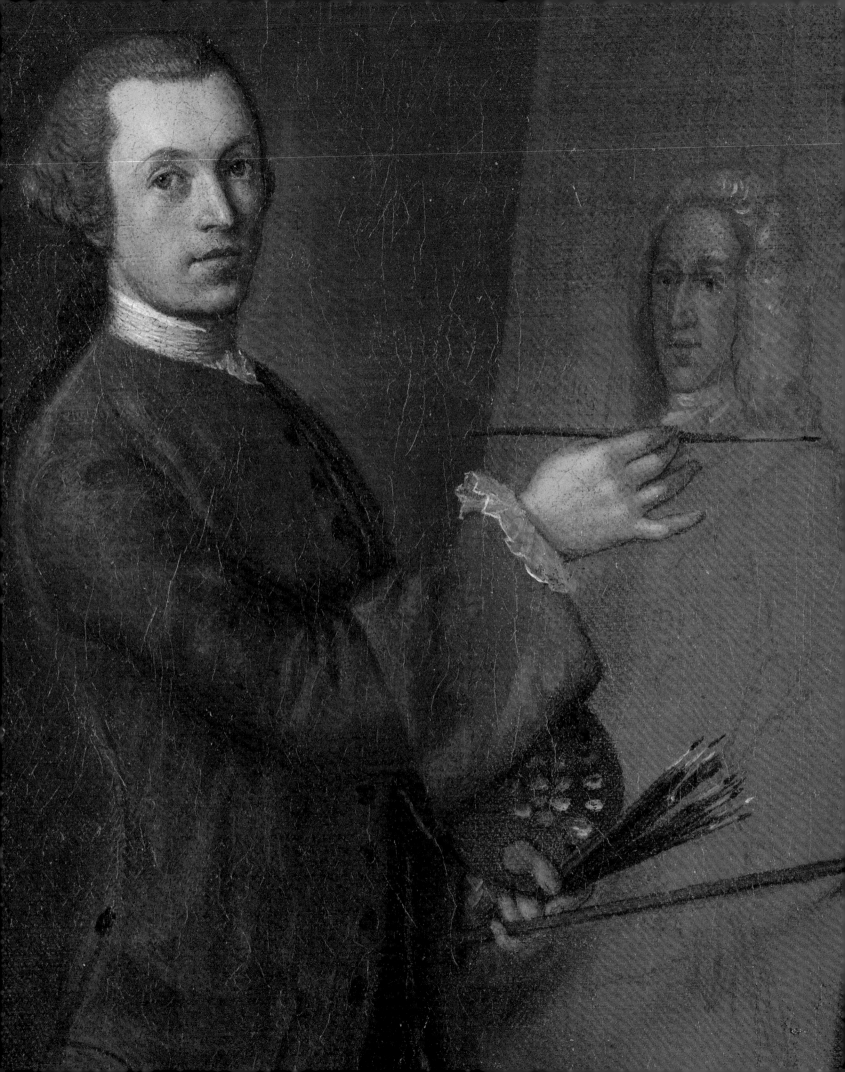

THE Subscriber ... humbly hopes for that Encouragement from the Gentlemen and Ladies of this City and Province, that so elegant and [entertaining an] Art, has always obtain'd from People of the most improved Minds, and best Taste and Judgment, in all polite Nations in every Age.

JOHN DURAND, 1768[1]

CHAPTER 6

Itinerancy Becomes Common

With the exception of Jeremiah Theus in Charleston and John Hesselius in Maryland, most painters who worked in the South beginning in the late 1760s did not have long-term permanent residences there. Travel for commissions became the norm, with artists visiting from the northern colonies or from abroad, as did the Englishman John Wollaston Jr., who returned to South Carolina from the Caribbean Islands in the 1760s.

America's middle class had created a strong commercial base that required frequent intercoastal, Caribbean, and European transport of goods and persons. With such commerce came not only further development of east coast ports, where ships came and went on a regular basis, but also improvements in overland travel. Because painters could depend on established travel routes, their itinerancy naturally increased. Artists often arrived in the South with letters of introduction or preestablished contacts, and they usually took up temporary residence in a prominent town. Some rented a house with enough space to accommodate a painting room. Others rented lodging and painting rooms in a boardinghouse, tavern,

or inn. In any case, the temporary accommodations served as the artists' centers of operation as well as their points of contact and promotion. Artists' advertisements often encouraged prospective clients to view examples of their work by visiting their rooms or their displays in some nearby space. Samples of their work were usually available since artists tended to keep some unclaimed (and often unpaid for) portraits. Portraits and other paintings of various kinds were often among the property advertised in settling the estates of artists such as Jeremiah Theus, and the failure of customers to pay for and retrieve their portraits presented economic problems for several artists, as is often revealed in their ads.[2]

By this time, client convenience was a major consideration. For those who lived in or near the town, sittings could be held in the artists' painting rooms. On the other hand, it was still customary for artists to travel to and stay with clients living in outlying areas while work on portraits was begun. Several artists made this point explicit in their advertisements, and logic suggests that an artist would attempt to organize his out-of-town travels so as to

Detail of fig. 6.16

accommodate more than one client on the same trip. Several sittings were required for a portrait, often several days or weeks apart. Especially revealing of this process is Jeremiah Theus's 1757 commission of three portraits for the Manigaults (figs. 4.34, 4.41, and 4.42).[3] They were begun on two consecutive days in mid-April. About a week later the second sitting occurred, and a third took place another three and a half weeks later in May. Other references also indicate that multiple sittings were required for a portrait. Such references include the letter about Wollaston's portrait of Eliza Pinckney, the notes about John Durand's (1746–after 1782) portraits for the St. George Tucker family, and the papers of Charles Willson Peale.[4] Technical considerations—chiefly the curing times for specific paint layers before others could be applied—dictated the need for sitting intervals. While artists often traveled to remote areas for sittings, portraits begun at those locations were sometimes finished in the artists' painting rooms or studios. Theus, for example, finished portraits he began in Georgia in Charleston and then had them shipped back to Georgia. He used the same process for the Manigault portraits.

Although little else can be documented about the business of commissioning and painting portraits in the South, several scenarios can be suggested. Most artists in the colonies, like their colleagues abroad, established price lists for portraits based on the portrait's size, the number of figures in the portrait, and the complexity of pose and costume. Prices were sometimes advertised, but, because of the variables in choices, it is likely that such lists were merely guides. The final price for a portrait seems to have been negotiated with each customer.[5] The client who paid for the portrait usually made the decisions affecting price, not the painter, although one can imagine an artist making recommendations. Poses, jewelry, clothing, and other items incorporated into portraits were commonly borrowed from portrait prints in the artist's or possibly the client's possession.[6] One revealing example of sitter-owned clothing is described by Peter Manigault's (1731–1773) letter about his dress in his portrait by Allan Ramsay (1713–1784) (see page 199). Print-derived clothing is seen

in southern portraits dating from the earliest years, including those for the Jaquelin-Brodnax families and extending to pictures by such artists as Wollaston, Hesselius, and Theus. However, it is also true that some eighteenth-century southern sitters preferred to use their own clothing. This was particularly true of men, whose portraits tend to display simpler dress.

Most materials needed for oil-on-canvas and water-color paintings were available to artists in the colonies by the mid-eighteenth century. Urban centers such as Charleston, Philadelphia, New York, and Boston all had shops that advertised artist and paint supplies.[7] Often painters owned and operated such establishments, as did the Badger family in Charleston. However, despite the various possibilities, no specific references have been found that indicate where known painters working in the South during the 1750s–1770s obtained their supplies.

Wollaston, Hesselius, and Theus were undoubtedly the most popular of the portrait painters during their time, with the largest number of clients and thus the greatest number of surviving pictures. It should be noted, however, that there were other artists who also supplied southerners with paintings. Of those, some were London based while others traveled or lived in the southern colonies. Most were trade-trained. Information about these painters and their art is often sparse if it exists at all. Nevertheless, such information is important, for it lays the groundwork for future research and discovery.

The painter Robert Orchard (dates unknown), for example, is known only by his name and the inventory of his estate. He lived for an undetermined length of time in York County, Virginia. His estate inventory, completed on February 16, 1756, lists a significant quantity of artists' materials, including paint, painters' grinding stones, brushes, and a small book on painting, the title of which is unfortunately unknown.[8] John Keeff (dates unknown), who moved from London to Virginia and advertised heraldic and landscape painting in 1751, is yet another whose work remains unidentified.[9] Either or both of these men, or others, may have been responsible for the significant number of artist-unidentified portraits that survive for Virginia.

The career of another painter, named Cosmo Medici (de Medici) (b. 1740–50), not to be confused with Cosmo John Alexander[10] (1724–1772) working about the same time, has eluded researchers for decades. Substantially more is now known about him but nothing more about his pictures. The years 1740 and 1750 are both given in North Carolina records for Medici's birth, but no information on any Medici family ancestors in any southern colony has been discovered. It appears that "Cosmo de Medici," as variously spelled in references to the artist, was an assumed name, probably associated with the well-known Cosimo de Giovanni degli Medici (1389–1464), the first of the Italian Renaissance political dynasty, or one of his descendants by that name, most of whom were patrons of the arts.

Various Revolutionary War pension records and a few letters he exchanged with his superior officers provide much of what is known about Medici's adult life. In 1775, he served under a Captain Jones (probably Thomas Jones) as a lieutenant in a light horse company from Franklin County, and he was promoted to the rank of captain sometime before September 8, 1776, at which point he commanded the 3rd Troop of the Independent Company of North Carolina Light Horse. Medici's company participated in the southern campaign in 1776 and 1777 and fought against the British army's first and unsuccessful siege of Sullivan's Island and Charleston. Afterwards, the company was under the command of General Jethro Sumner in Savannah, Georgia, and, on September 11, 1777, Medici and his men were part of the 1st North Carolina Regiment, under the command of Brigadier General Francis Nash, at the Battle of Brandywine in Chester County, west of Philadelphia.[11]

Medici traveled to and from Philadelphia several times. It was probably there that another "Artist-Soldier," Charles Willson Peale (1741–1827), created a miniature portrait of Medici in October 1778.[12] That portrait has not been located, but it must have been similar to Peale's miniature likenesses of other officers. One source states that Medici left the army on January 1, 1779, to be married, and it indicates that the portrait was intended to commemorate that event.[13] However, his marriage

cannot be documented, and it seems that either he did not leave the army or he reenlisted by 1780 when he served as a major of the North Carolina dragoons who fought with Colonel Francis de Malmedy, Marquis de Bretagne, in the second and fateful Charleston campaign.[14] Later references to Medici include listings in 1767 and 1768 *Virginia Gazette*s for letters being held at the Norfolk post office, a listing in the Halifax County tax records in 1783, his household listing in the state census for North Carolina in 1787, and various property transactions occurring as late as January 1787 for Orange County, North Carolina.[15]

Only two portraits by Cosmo Medici are known, both of which were badly damaged and which were later compromised further by an unknown early restorer. The likenesses feature husband and wife Lucy Gray Briggs (fig. 6.1) and Howell Briggs (1709–1775) of Virginia. The portrait of Mrs. Briggs has an inscription on the back of the original canvas that was visible as late as the 1930s. That inscription, subsequently covered by a lining, was copied in modern times onto the strainer of Mrs. Briggs's portrait: "COSMO MEDICI PINXIT AGED 62 1772."[16] Family history indicates that the portrait of Howell Briggs was also dated 1772. Interestingly, a ledger book kept by Gray Briggs, son of Howell Briggs, shows that Gray paid Cosmo Medici for two portraits and miniatures in 1769.[17] Whether there is a relationship between the account payment and the two extant portraits is unknown. Perhaps Medici worked twice for the Briggses, or perhaps the transcribed date is inaccurate. In any case, the reference supports the presence of an artist named Medici working for the Briggs family in Virginia.

Another painter, John Durand, did paint portraits of Gray Briggs and his wife in 1775, as will be discussed shortly. Durand traveled in Virginia, Connecticut, and New York from the mid-1760s through the early 1780s. American art historians, beginning with Frederic Fairchild Sherman in his 1932 *Early American Painting*, have supported the notion that Durand was the son or a close relative of the seventeenth-century French Huguenot Jean or John Durand of Derby in New Haven County, Connecticut. The Derby Durand family was

6.1

large, and several Durands by the name of Jean or John are known there. Other descendants moved to New Jersey. The painter Asher B. Durand (1796–1886) had roots in this branch of the family, but a review of past research and new inquiries reveal no known connection between the Derby or New Jersey families and John Durand the colonial painter.[18] Neither do other early Durand families in the North American colonies or in Canada yield any promising connections with the artist.

FIGURE 6.1. Cosmo Medici, *Mrs. Howell Briggs*, 1772, oil on canvas, 21" x 18". Privately owned. Photograph courtesy of the Colonial Williamsburg Foundation, Williamsburg, VA.

Despite being small and in poor condition, the Briggs portraits are important as the only known examples by Cosmo Medici. In 2009, the companion portraits of Howell and Lucy Gray Briggs (1710/11–after 1772) were examined by Colonial Williamsburg's curatorial and conservation specialists, who tested several small areas to determine the original paint layer. Their findings revealed widespread paint loss and abrasion below a layer of thick overpainting on both pictures that obscures most of the surviving original paint.

It is probable that John Durand, the colonial painter, was the young man of fourteen who apprenticed to Charles Catton (1728–1798) of the Painter-Stainers Company in London, England, on September 3, 1760, and who was released from service at an undetermined date, probably mid-1767. He was most likely the son of Jonas and Elizabeth Durand, who were married in London in 1744. Jonas, a pewterer in St. Martin's Lane who came from a long line of pewterers, is documented as the "King's Pewterer." His grandfather, also named Jonas, was in the same business with an uncle named Nicholas Durand and a great-uncle named James Taudin, whose families came from Bordeaux, France. Thus, the Durands were French Huguenots who immigrated to England, probably in the late seventeenth or early eighteenth century.[19]

Durand's father is not listed by name in the apprenticeship document, an unusual omission but one not without precedent. In England, apprenticeships were a form of contract with legal implications. According to the law, the apprenticeship term, usually seven years, had to be completed before one could practice a trade. Bond payment was often incremental. In London at that time, fourteen year olds were allowed to bind themselves as apprentices, and they sometimes paid for their instruction.[20] The absence of Jonas Durand's name on his son's apprenticeship to Catton may indicate only that John bound himself to Catton and paid his own way. Further, the records do not state the exact length of service. If Jonas Durand did bind and make incremental payments for his son's apprenticeship, he may have been unable to continue such payments in the late 1760s. He experienced financial difficulties, and, by the time of his death in 1775, he was declared bankrupt. His will of that year left money to pay off some of his debts; the rest of his estate, probably personal items, was held in trust for a son "Durand," probably John, who was away in the American colonies.[21]

Charles Catton, Durand's master, was associated with St. Martin's Lane Academy in London and came from the same neighborhood as the Durands. Catton, the son of a schoolmaster, Richard Catton of Norwich, Norfolk,

6.2

6.3

England, was apprenticed to Thomas Maxfield of the Painters' Company on June 5, 1745. The London painter was among the most accomplished heraldic painters of his time, noted for his ability to render naturalistic animals on coats of arms and in scenes (figs. 6.2 and 6.3). He became the coach painter to George III, served as one of the founding members of the Royal Academy in 1768, and was named master of the Painter-Stainers Company in 1783. Catton painted a few portraits but was better known for landscapes, animals, and coach painting.[22] His son and namesake, Charles Catton (1756–1819), also a trained coach painter, became known for scene painting. He immigrated to the United States and settled in New York State in 1804.[23] He was known to Charles Willson Peale who copied at least one of his paintings.

John Durand claimed extraordinary skill in coach and heraldic painting in his *Virginia Gazette* advertisement of June 21, 1770, which noted that he would "also paint, gild, and varnish, wheel carriages; and put coats of arms, or ciphers, upon them, in a neater and most lasting manner than was ever done in this country."[24] This statement alone is a strong indication of his training with a professional, and the phrase "in this country" is one typically used in the advertisements of artists who came from abroad. Furthermore, the flat and linear style Durand used is very characteristic of heraldic, sign, and

FIGURE 6.2. Charles Catton, author and artist, and Francis Chesham (1749–1806), engraver, Hamilton family coat of arms, from *The English Peerage; or, A View of the Ancient and Present State of the English Nobility: To Which Is Subjoined, a Chronological Account of Such Titles as Have Become Extinct, from the Norman Conquest to the Beginning of the Year M,DCC,XC*, vol. 3, published in London, 1790. Courtesy of the Library of Congress.

FIGURE 6.3. Charles Catton, author and artist, and Francis Chesham, engraver, Pomfret family and Waldegrave family coats of arms, from *The English Peerage; or, A View of the Ancient and Present State of the English Nobility: To Which Is Subjoined, a Chronological Account of Such Titles as Have Become Extinct, from the Norman Conquest to the Beginning of the Year M,DCC,XC.*, vol. 3, published in London, 1790. Courtesy of the Library of Congress.

coach painting, and it is especially evident in his first pictures painted in New York (fig. 6.4). Generally, painters who were trained in such trades used a flat, economical approach that relied on line and saturated color for effect. Durand's heavy dark outlining of forms is also very characteristic of sign and coach painting. Although not trained as an easel painter, like others of his rank, he aspired to such work, using the techniques he learned from the trade of heraldic and coach painting. Durand's method evolved and changed as he continued to work in the colonies, but his later portraits still reflect his trade training.

John Durand probably arrived in America in late 1766 or 1767 or after completing all or most of his apprentice-ship. Several New York portraits from those years have been either assigned or documented to him. The most well-known are those for James Beekman's children (figs. 6.5–6.7). Beekman's ledger book for November 12, 1767, states that he paid "monsieur Duran" £19 for six portraits of the children and £1 10s. for altering Mrs. Beekman's picture that had been painted in 1761 by Lawrence Kilburn (1720–ca. 1775).[25] Soon thereafter Beekman hired James Strachan (d. 1768), "Carver and Gilder, from London," and paid him £22 4s., more than the cost of the pictures, to carve and gild frames for the Durand portraits.[26] The Beekman ledger entry is also of interest because it lists the artist as "monsieur" Duran, a French form of address.

Durand quickly discovered that portrait painting alone would not provide an adequate living and he placed the following, his first advertisement, in a New York paper:

FIGURE 6.4. John Durand, *The Rapalje Children*, 1768, oil on canvas, 50¾" x 40". Accession # 1946.201 Collection of the New-York Historical Society.

Standing from left to right are Garret (b. 1757), Joris or George (b. 1759), Anne (b. 1762), and Jacques (b. 1752) Rapalje. They were the children of Garret Rapalje and his wife, Helena de Nyse Rapalje. The father was a wealthy merchant and importer in New York City.

A Drawing-School.
ANY young Gentleman inclined to learn the Principles of Design, so far as to be able to draw any Object and Shade them with Indian Ink or Water-Colours, which is both useful and ornamental, may be taught by JOHN DURAND, at any Time after four in the Afternoon, at his House in Broad-Street, near the City-Hall, for a reasonable Price.[27]

Five months later, he published a more comprehensive and revealing notice in the *New-York Gazette; or, The Weekly Post-Boy* (New York City) in which he was seeking customers for scene or historical paintings. One suspects that Durand's portrait business had greatly decreased by this time and that he was therefore expand-ing his repertoire by introducing historical pictures. Certainly, as a scene and heraldic painter, his teacher would have known and routinely drawn from such pictures. The ad, in full, read as follows:

New York, April 11, 1768.
THE Subscriber having from his Infancy endeavoured to qualify himself in the Art of historical painting, humbly hopes for that Encouragement from the Gentlemen and Ladies of this City and Province, that so elegant and [entertaining an] Art, has always obtain'd from People of the most improved Minds, and best Taste and Judgment, in all polite Nations in every Age. And tho' he is sensible, that to Excel (in this Branch of Painting especially) requires a more ample Fund of universal and accurate Knowledge than he can pretend to, in Geometry, Geography, Perspec-tive, Anatomy, Expression of the Passions, ancient and modern History, &c. &c. Yet he hopes, from the good Nature and Indulgence of the Gentlemen and Ladies who employ him, that his humble Attempts, in which his best Endeavours will not be wanting, will meet with Acceptance, and give Satisfaction; and he proposes to work at as cheap Rates as any Person in America.

To such Gentlemen and Ladies as have thought but little upon this Subject, and might only regard painting as a superfluous Ornament, I would just observe, that History-painting, besides being extremely ornamental, has many important Uses. It presents to our View, some of the most

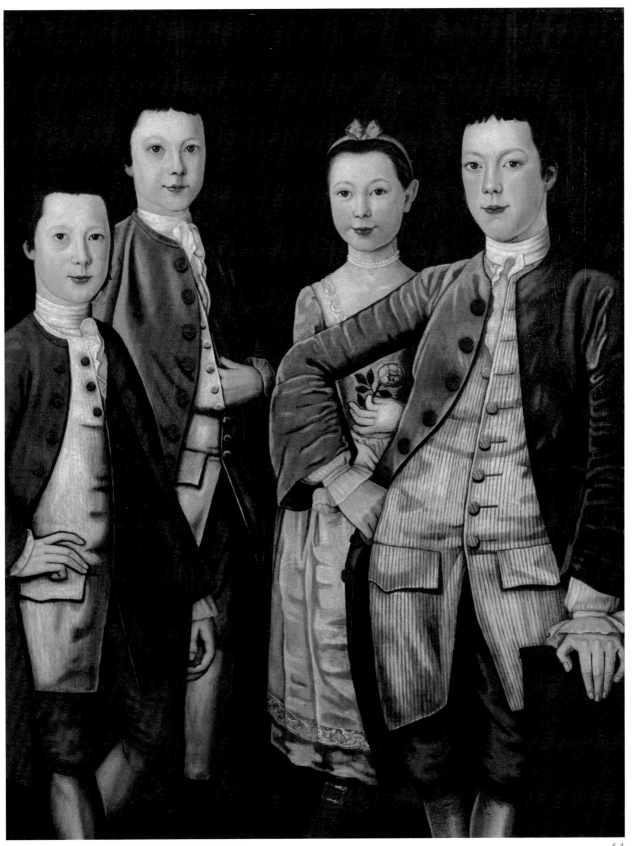

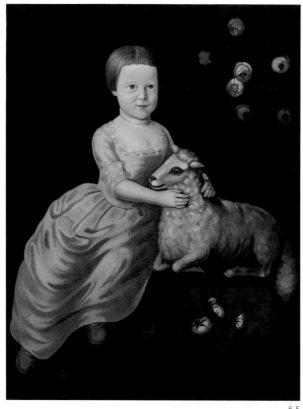

6.5

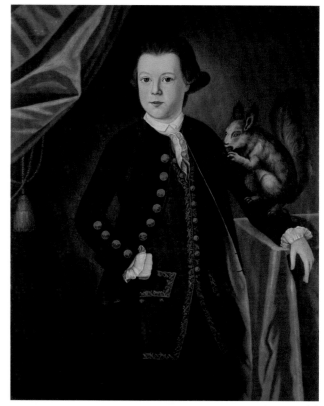

6.6

FIGURES 6.5–6.7. John Durand, *Mary Beekman* (1765–1831), *James Beekman Jr.* (1758–1837), *Catharine Beekman* (1762–1839), 1767, oil on canvas, all 36″ x 28″. Accession # 1962.74, 1962.71, and 1962.73 Collection of the New-York Historical Society.

John Durand's well-known portraits for the James Beekman family, probably the earliest he did in the colonies, are interesting for the number and variety of fashionable props they feature. Although likely borrowed from print sources, other paintings, and the cadre of designs that Durand knew from his heraldic and coach painting training, the props add charm and interest to each child's likeness. In the portraits shown here, the artist has included a lamb, a gray squirrel, and flowers—the squirrel being a bit oversized. In the three portraits not illustrated, Durand included a dog, a sparrow, and a book.

FIGURE 6.8. John Durand, *Sarah Whitehead Hubbard* (1729–1769), 1768, oil on canvas, 33″ x 27⅛″. Philadelphia Museum of Art: The Collection of Edgar William and Bernice Chrysler Garbisch, 1965.

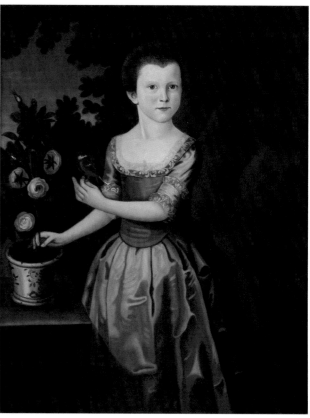

6.7

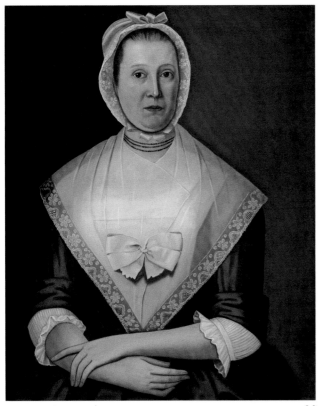

6.8

taste for historical painting. Durand betrays a great deal about his origins and training in this notice, including ideas and attitudes that are strongly linked with teaching concepts associated with St. Martin's Lane Academy. Durand admitted that, to excel in historical painting, he would need more knowledge, although he hoped his attempts would please his customers.

No historical pictures by Durand's hand are known, although one suspects that at least a few were executed as samples for prospective clients to examine. By May 13, less than eight days after his 1768 New York notice, Durand was in Connecticut and had placed this ad:

> JOHN DURAND, Potrait Painter. INTENDS to Stay in this Town part of the warm Season. If any Gentlemen or Ladies, choose to have their Pictures Drawn, they may have them Drawn a good deal cheaper than has yet been seen; by applying to the Subscriber living at Captain Camp's House, where several of his Performances may be seen. And for the more Conveniences of any Gentlemen or Ladies, that would have them Drawn at their Houses, he will wait upon them whenever they please if sent for.
>
> <div align="right">JOHN DURAND.[29]</div>

interesting Scenes recorded in ancient or modern History; gives us more lively and perfect Ideas of the Things represented, than we could receive from an historical account of them; and frequently recals to our Memory, a long Train of Events, with which those Representations were connected. They shew up a proper Expression of the Passions excited by every Event, and have an Effect, the very same in Kind, (but stronger) that a fine historical Description of the same Passage would have upon a judicious Reader. Men who have distinguished themselves for the good of their Country and Mankind, may be set before our Eyes as Examples, and to give us their silent Lessons,—and besides, every judicious Friend and Visitant shares with us in the Advantage and Improvement, and increases its Value to ourselves.

<div align="right">JOHN DURAND,</div>

<div align="right">near the City-Hall, Broad-street.[28]</div>

The embellished language of that 1768 advertisement in New York was meant to convince readers of Durand's knowledge of art and fashion and to foster in them a

Apparently, the painter was moving back and forth from New York to Connecticut and also south to Virginia during this period. Portraits from all three locations can be documented to him, including the 1768 portraits of Mrs. Leverette Hubbard (Sarah Whitehead) (fig. 6.8) and her husband of Hartford, Connecticut; a group portrait for Garret Rapalje (fig. 6.4) of New York, dated 1768; and, that same year, the signed and dated portrait of Elizabeth Boush (later Mrs. Champion Travis) of Norfolk, Virginia (fig. 6.9).[30]

The Boush portrait provides the earliest known date for Durand in Virginia, the only southern colony he seems to have visited. His first *Virginia Gazette* advertisement was placed a year later, on June 7, and again on June 14, 1770. A week later, the ad ran again, with two additions: language advising that he would take only certain forms of payment and notice that he was willing to travel to "the country" if sent for:

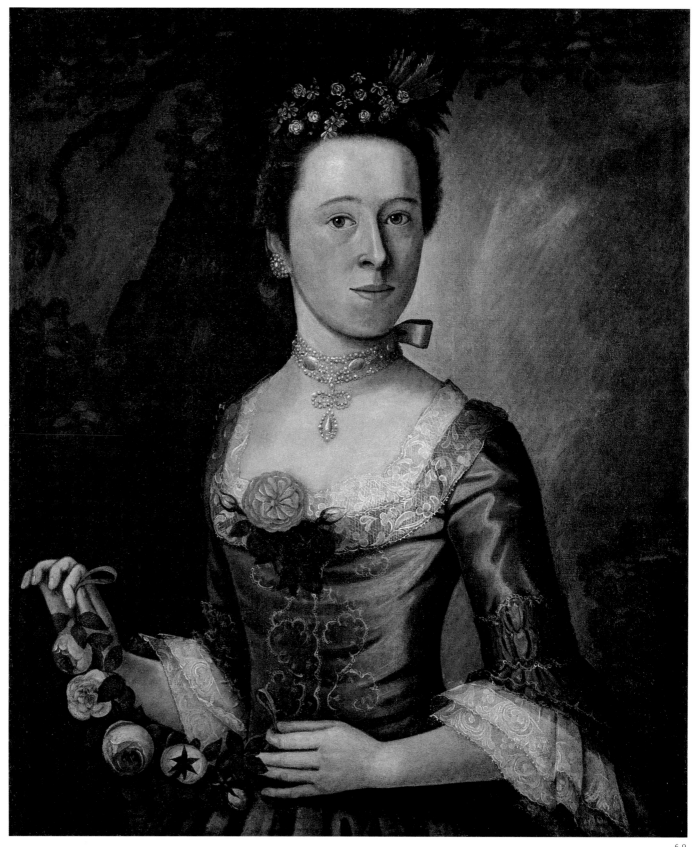

6.9

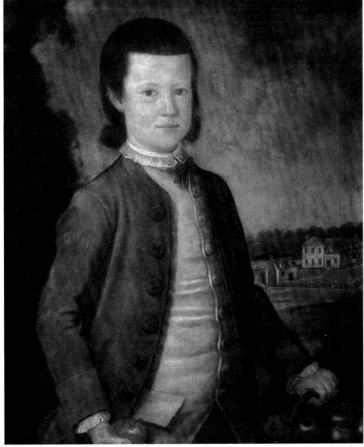

6.10

FIGURE 6.9. John Durand, *Elizabeth Boush*, dated 1769, oil on canvas, 29¾" x 24⁹⁄₁₆". Colonial Williamsburg Foundation, Williamsburg, VA.

The portrait of Elizabeth Boush (b. 1753), later Mrs. Champion Travis, is inscribed and signed by the artist "Elysabeth Boush / AE16 1769 John Durand." The daughter of Samuel Boush of Norfolk, she was related to the Barraud family of Williamsburg and Hampton. Her pose is typical of Durand, as is the profusion of flowers held by the sitter and placed at her breast and in her hair. These probably replicate the fashionable fabric flowers that were imported into the colonies and frequently advertised in newspapers during the mid-eighteenth century. In this case, the sitter may have made her own, for she was a student of Elizabeth Gardner of Norfolk, Virginia, who taught young women how to make artificial flowers. Elizabeth Boush's surviving needlework picture (owned by MESDA, Winston-Salem, North Carolina) carries an embroidered inscription with the date 1767 and notes that it was worked at Mrs. Gardner's. Gardner's advertisement as a needlework teacher appeared in Purdie and Dixon's *Virginia Gazette* (Williamsburg) on March 21, 1766.

Durand also tended to accessorize his female sitters with jewelry, as seen here in the elaborate pearl necklace and earrings. Blue dresses appear often in 1750s–1760s women's portraits in the South, but whether that reflects the fashion of the times or some other influence, such as less expensive or more widely available pigments, is unknown. Nor is it known whether the dresses worn in Durand's likenesses were sitter-owned garments or portrait costumes. In this case, the plainness of dress favors its being the property of the sitter. The portrait poses used by Durand, however, were mostly derived from print sources.

Portrait Painting.

GENTLEMEN and LADIES that are inclined to have their pictures drawn will find the subscriber ready to serve them, upon very moderate terms, either for cash, short credit, or country produce, at their own homes, or where he lives, which is next door to the Hon. the Speaker's. He will likewise wait upon Gentlemen and Ladies in the country, if they send for him.[31]

About the time of these notices, Durand signed and dated several Virginia likenesses, including those of Thomas Newton (1711–1794) and his wife, Amy Hutchinson Newton (1725–after 1770); their son, Thomas Newton Jr. (1742–1807) of Norfolk; and Thomas Atkinson (fig. 6.10) of Dinwiddie County, Virginia. Durand traveled back and forth between Connecticut and Virginia painting portraits during these years. Some of

FIGURE 6.10. John Durand, *Thomas Atkinson*, before 1776, oil on canvas, 28½" x 23¼". Courtesy of the Museum of Early Southern Decorative Arts (MESDA) at Old Salem.

Thomas Atkinson (b. 1766/68) was the son of Roger Atkinson (1725–1784) and his wife, Anne Pleasants Atkinson (ca. 1727–1776), of Dinwiddie, Virginia. The family lived at the house known as Mansfield, shown here in the background to the sitter's proper left. John Durand's portraits of the parents also survive and, like the portrait of their son, have descended in the family. No other surviving southern portraits by Durand contain architectural or house views.

the portraits from this period give the year, month, and day of their execution.

Most itinerant artists spent the warmer season in northern areas and the cold months in the South, but that was not the case with Durand. He was often painting in Virginia in the spring and summer. For example, Durand's 1770 receipt for payment from Thomas Bolling (1735–1804) for "Drawing four Pictures for him Viz: his own Mʳˢ. Bollings, Mʳˢ. Robertsons; & his Daughter Rebecca's " was issued on May 2, 1770. Unfortunately, it does not state the price of the paintings.[32] The 1780 portrait of Lucy Skelton Gilliam (fig. 6.11) is an especially good example of Durand's nature style.

In addition to Marianna Mayo's (1764–1849) signed and dated Virginia portrait for 1779, the signed and dated Mary Orange Rothery likeness (fig. 6.12), and three unlocated portraits of the Bragg family reportedly dated 1782, there are only two other important references to Durand in Virginia. The first is an excerpt from a 1780 letter of Frances Bland Randolph Tucker to her husband, St. George Tucker (fig. 6.13): "Mr. Duran[d] has taken a much better picture of me than I expected, & is now waiting for you[rs], I am very sorry they cou'd not be sent."[33] Secondly, Durand's name appears on a 1782 "List of Tithes & Taxable Property," a personal property tax list for Dinwiddie County, Virginia. Taken on April 10, the list also includes a number of Durand's sitters, including Edward Archer (dates unknown); Roger Atkinson, father of Thomas Atkinson (fig. 6.10); and Gray Briggs (fig. 6.14).[34]

FIGURE 6.11. John Durand, *Lucy Skelton Gilliam* (Mrs. Robert Gilliam), 1780, oil on canvas, 31½" x 25¼". Colonial Williamsburg Foundation, Williamsburg, VA. Partial gift of the estate of Mary Bragg Dodd.

Lucy Skelton (1743–1789), the daughter of James Skelton and Jane Meriwether (Mereweather) Skelton, grew up in Hanover County, Virginia. In 1760, she married Robert Gilliam of Prince George County, Virginia. A planter, Gilliam was of middling wealth, as were many of John Durand's customers.

No later references to the artist are known; he may have left the country or died. The several notices in Connecticut papers pertaining to a John Durand of Derby, who died insolvent sometime between 1782 and 1787, refer not to the artist but rather to a member of the large Derby Durand family mentioned earlier.[35] It is possible that the artist is the John Durand who married Margaret McKinney in New York City in 1767, but this connection cannot be conclusively substantiated.[36] Robert Sully (1803–1855),[37] the academically trained painter who was active in the area of Petersburg, Virginia, corresponded with the early art historian William Dunlap (1766–1839) about Durand and wrote: "The only artists that are remembered by the oldest inhabitants, are DURAND, MANLY, and Woolaston—the first tolerable, the second execrable, and the third *very good*." Of Durand, Sully wrote that he "painted an immense number of portraits in Virginia; his works are hard and dry, but appear to have been strong likenesses, with less vulgarity of style than artists of his *calibre* generally possess."[38] Within the context of the period (i.e., 1834) and the purposes of Dunlap's published history, Sully's assessment seems fair. Durand's handling of costumes, hands, and other accoutrements is usually highly colored, detailed, mechanical, and hard with limited three-dimensional rendering, reminiscent, as noted earlier, of the coach and sign painting techniques he had learned in London.

However, by the mid-1770s in Virginia and Connecticut, Durand was painting with more assurance and skill. His fabrics and other details became more realistic with a greater emphasis on volume, color, and linear perspective, but his most important improvements were in the drawing and painting of hands and faces. Notable changes between the Beekman likenesses and those completed a few years later in Connecticut and Virginia include greater modeling of individual features to achieve depth and volume.

The 1775 portraits of Gray Briggs and his wife Dorothy Pleasants Briggs represent the best of Durand's work and are, as Sully pointed out, strong, convincing likenesses (figs. 6.14 and 6.15). In those pictures, the faces and

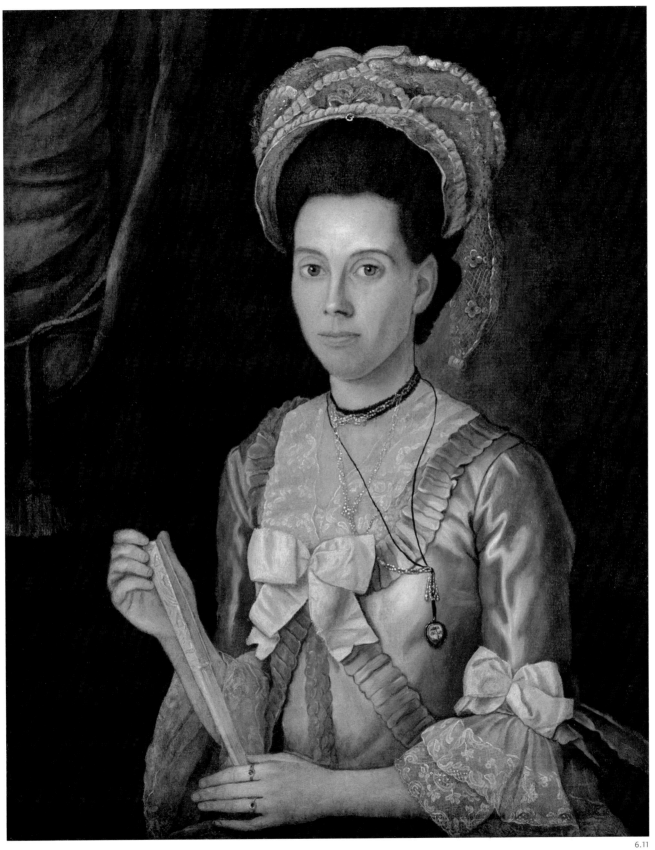

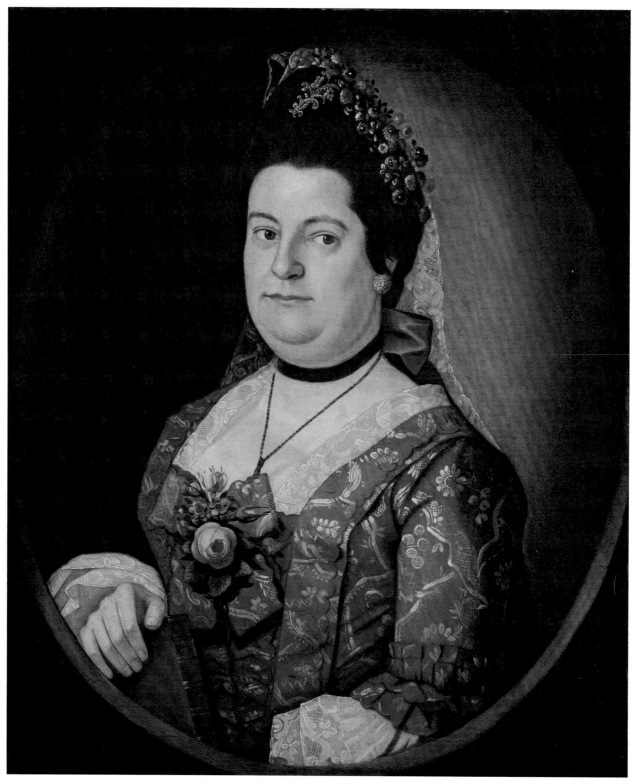

6.12

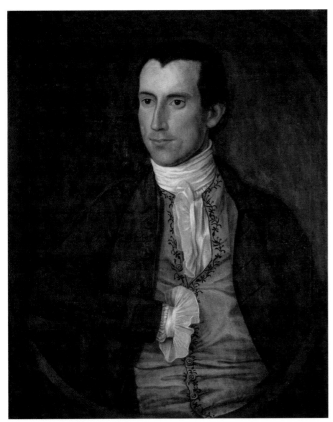

6.13

upper torsos are better modeled with convincing shadows. His color is still fresh, but it does not seem as bright as Durand's first efforts in New York, perhaps due to better modeling as well as experience. Durand was a good draftsman, able to capture the Briggses' faces and to imbue them with earnest and candid expressions.

Durand had little competition during most of the time he worked in Virginia. Other notable artists who were in the area briefly were Cosmo John Alexander,[39] popularly known as the first teacher of the American painter Gilbert Stuart (1755–1828), and Matthew Pratt (1734–1805). Several scholars have researched Cosmo John Alexander , but the most informative discussion is contained in Pamela McLellan Geddy's unpublished 1978 thesis wherein she provides a chronology of the artist's life and travels as well as a checklist of his Virginia paintings.[40]

Cosmo John Alexander (fig. 6.16) was born in Aberdeenshire and lived in Aberdeen, Scotland, until 1746 when he left for England. His first lessons in art undoubtedly came from his father, John Alexander II

(1690?–1760?), a successful engraver and portrait painter who also painted historical scenes. There were other artists in the family as well. Alexander's paternal great-grandfather George Jamesone (1588/89–1644) of Aberdeen became Scotland's first eminent portrait painter. Although the genealogical information on the Jamesone family is confusing and difficult to substantiate, it appears that George and his wife (Isobel or Isabelle Tosche) had two or three daughters that survived to adulthood; one, named Marjorie (Marjory), married a lawyer named John Alexander. Their son John Alexander II (sometimes incorrectly referred to as Cosmo John Alexander I) was an engraver and portrait painter who

FIGURE 6.12. John Durand, *Mary Orange Rothery* (Mrs. Matthew Rothery), oil on canvas, dated 1773, 30″ x 25″. Colonial Williamsburg Foundation, Williamsburg, VA. Conserved through the generosity of the Antique Collectors Guild.

Mary Orange Rothery (b. 1747) was the wife of Matthew Rothery, whom she wed in 1763. John Durand signed and dated this portrait "Marie ['y' added over the 'ie'] Rothery / aged. 26, A.D. 1773 / J. Durand. painted." A note made by Hugh Blair Grigsby in his account book for 1868–1875 stated that he saw this portrait and another of Mary Orange (b. 1719?), the sitter's mother, in the same private collection. Grigsby's account book, titled "Hugh Blair Grigsby / Grigsby's Deaf-man's / Notebook &c. 1868–1875," is owned by the Virginia Historical Society, Richmond, Virginia. The Mary Orange portrait is recorded in this document as "Mary Orange / born A.D. 1719, painted / by John Durand in 1773."

FIGURE 6.13. John Durand, *St. George Tucker*, 1780, oil on canvas, 29¾″ x 24½″. Courtesy of the Bermuda National Trust Collection, Hamilton, Bermuda. Photograph by Ann Spurling of Bermuda.

Born in Bermuda, St. George Tucker (1752–1827) studied law in Virginia. A member of the Virginia military forces during the Revolutionary War, he was present at the siege of Yorktown. Tucker married Frances Bland Randolph in 1778. After the war and until her death, the Tuckers lived in Chesterfield, Virginia. In later life, he served as a professor at the College of William and Mary in Williamsburg, where he lived on Nicholson Street. His famous dissertation on slavery, proposing its gradual abolition in Virginia, was published in 1786.

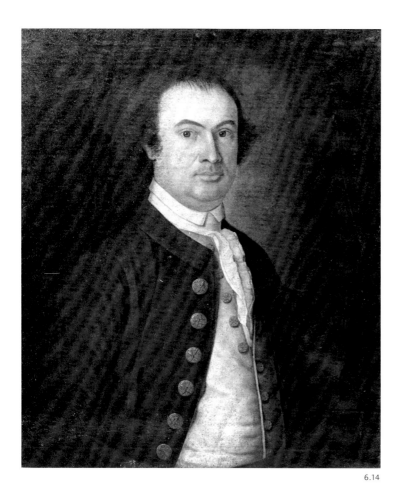

6.14

6.15

FIGURE 6.14. John Durand, *Gray Briggs*, dated 1775, oil on canvas, 29¹⁵⁄₁₆" x 24¹¹⁄₁₆". Courtesy of the Museum of Early Southern Decorative Arts (MESDA) at Old Salem.

The portraits of Gray Briggs (1730–1807) and his wife (fig. 6.15) are among the finest created by John Durand in his late career. A label on the back of the frame has the following inscription, probably an early copy of an original: "GRAY BRIGGS OLD 43 / A 1775 J. DURAND, PINXIT." Briggs was the son of Howell Briggs and Lucy Gray Briggs (fig. 6.1), whose portraits were painted by Cosmo Medici and who lived at their plantation, Wales, in Dinwiddie County, Virginia. A lawyer, Gray Briggs served in the House of Burgesses from 1754 to 1758.

FIGURE 6.15. John Durand, *Mrs. Gray Briggs*, dated 1775, oil on canvas, 29¹⁵⁄₁₆" x 24¹¹⁄₁₆". Private Collection. Photograph courtesy of the Colonial Williamsburg Foundation, Williamsburg, VA.

The sitter, Dorothy Pleasants Briggs (b. 1734/35), was related to the Atkinsons, who also commissioned portraits from John Durand. Dorothy Briggs's portrait is inscribed on its stretcher similarly to her husband's portrait (fig. 6.14): "DOROTHY BRIGGS OLD 39 A 1775 J. DURAND, PINX."

studied in Italy. He was the father of Cosmo John Alexander and Isabella Alexander. The name Cosmo is probably derived from Cosimo de Medici, the reigning duke of Tuscany, to whom John Alexander II had dedicated a series of etchings after Raphael.[41] Isabella married Sir George Chalmers (ca. 1720–1791) of Cults, 4th Baronet,[42] a portrait painter who studied painting with Allan Ramsay.[43]

Both Cosmo John Alexander and his father joined the rebel Jacobite army and were listed as criminals for being associated with the rebellion that ensued. Both would have been arrested had they remained in Scotland. The father disappeared for a year until amnesty was granted; Cosmo went to London and ultimately to Rome where he remained until 1751 and, like his father before him, studied art. He seems to have traveled over the next two to three years to other parts of Italy and France, where he painted portraits. At some point prior to this, he had cultivated a friendship with the noted British architect

6.16

visited New Jersey, where he had been recommended to the governor, William Franklin, the son of Benjamin Franklin, by William Strahan of London.[47] Sometime after June 1769, he went to Newport, Rhode Island, remaining there until 1771 when he was painting in both Philadelphia and Virginia.[48]

There is a tradition that, during the Newport trip, one of Alexander's sitters, Dr. William Hunter (1738–1778), introduced the artist to Gilbert Stuart,[49] although the account of Dr. Benjamin Waterhouse, as recorded by William Dunlap, is slightly different. According to Waterhouse, Alexander

> soon opened a painting room, well provided with cameras and optical glasses for taking prospective views. He soon put upon canvas the Hunters, the Keiths, the Fergusons . . . and this interest led to the recommendation of the youth Gilbert Stuart, to the notice and patronage of Mr. Alexander, who . . . gave him lessons. . . . After spending the summer in Rhode-Island, he went to South Carolina, and thence to Scotland, taking young Stuart with him. Mr. Alexander died not long after his arrival at Edinburgh.

Waterhouse also told Dunlap that Alexander, on arriving in Newport, was "of delicate health," suggesting a lingering illness.[50]

American portraits by Alexander survive for New York City, Rhode Island, Philadelphia, and Virginia, but none are known for South Carolina. In fact, the only reference or document placing the artist in South Carolina is Dunlap's early history. Geddy speculates that perhaps

James Gibbs (b. 1674) who died in 1754, leaving much of his estate to the painter.[44] Cosmo John Alexander moved into Gibbs's London house that year and traveled from there to Scotland and the Netherlands for portrait commissions prior to coming to America in 1765.[45]

Geddy includes a photograph and typescript of an important letter written by the artist in Philadelphia on June 16, 1769, to Peter Remon, a wine merchant in Covent Garden, London. While Alexander detailed his various debts, a likely reason for his going to America, he also sent regards to three family members: "Charles [his brother], as well as Sr. George & My Sister," meaning Sir George Chalmers and his wife, Isabella. The artist also noted that he had arrived and spent some time in New York before going to Philadelphia and that he might "get further northwards to avoid ye heats, which begin now to be excessiver here."[46] During the next three years, Cosmo Alexander traveled back and forth between New York City and Philadelphia. At least once in 1769, he

FIGURE 6.16. Cosmo John Alexander, *Self-Portrait*, probably 1740–1745, oil on canvas, 11¾" x 9½". Private Collection. Photo © Philip Mould Ltd., London/The Bridgeman Art Library Nationality.

This self-portrait is one of several works by the artist owned by the Aberdeen Art Gallery. Cosmo Alexander was a young man at the time of this painting, probably still studying in his native Scotland.

there are extant portraits incorrectly attributed to other eighteenth-century artists for Charleston that might be Alexander's work. She further suggests that Alexander, along with his apprentice Stuart, may have left for Scotland from a Virginia port and, upon arriving in Edinburgh,

> set up a studio in 1771 until Alexander's death on August 25, 1772. Stuart returned to the colonies shortly afterward, refusing information about the trip even to his friend Waterhouse. Something must have gone wrong either in the South or on the trip back to Edinburgh to cause Stuart's silence about the journey.[51]

The earliest of Alexander's Virginia portraits is the handsome likeness of Samuel Griffin (fig. 6.17). When the painting was restored in the nineteenth century, its original inscription was copied on the verso of the lining canvas: "CAlexander/Anno 1770." Another important portrait is signed and dated "Alexr Pinxt, A D 1771" and features Mary Shippen Willing Byrd (Mrs. William Byrd III) and her daughter, Maria Horsmanden Byrd (later Mrs. John Page) (fig. 6.18). The double portrait is known only from a photograph of it at the Frick Art Reference Library (FARL) in New York City and its publication in Anne Hollingsworth Wharton's 1900 *Salons: Colonial and Republican*.[52] It is an ambitious portrait, probably executed in Virginia along with a painting of at least one other member of the Byrd family, Elizabeth Hill Byrd (Mrs. James Parke Farley).[53]

FIGURE 6.17. Cosmo John Alexander, *Samuel Griffin*, dated 1770, oil on canvas, 30" x 25". National Portrait Gallery, Smithsonian Institution; bequest of Alice Dulany Ball.

Samuel Griffin (1750–1810) was born in Richmond County, Virginia, and lived most of his adult life in Williamsburg, Virginia. He was a lawyer and served as a colonel in the Continental army during the Revolutionary War as well as an aide-de-camp to General Charles Lee. Griffin was a member of the Virginia House of Delegates from 1786 to 1788, served as mayor of Williamsburg for several years during the 1780s, and was elected to the first, second, and third Continental Congresses.

The Griffin portrait is perhaps the finest of Alexander's known Virginia works. Also dated 1771 and signed by Alexander is the likeness of Rosanna Hunter Royle Dixon and Mary, her daughter, of Williamsburg, Virginia (fig. 6.19). With the exception of his portrait of Griffin, most of Alexander's European pictures seem better drawn and painted with more convincing modeling. However, there are condition problems with some of his American paintings. Alexander's paint was applied thinly and, as a result, was easily damaged or removed by early restorers, giving the pictures a fuzzy or blurry appearance.

The previously mentioned correspondence with William Franklin states that the artist came to America in debt and resolved to earn enough money to reduce it. Perhaps Alexander's illness, referred to in 1769 by both Franklin and Dunlap, was chronic, adversely affecting his British production and income and accounting for the uneven quality of his American pictures as well as his early death in August 1772.

Thomas Coram (1756/57–1811) is another eighteenth-century southern artist, albeit an obscure one. The Charleston native-born painter Charles Fraser (1782–1860) was among the first to recognize him, and it is Fraser who provided information about Coram to painter-historian William Dunlap. Dunlap wrote that Coram was born in 1756 in Bristol, England; came to America when he was six years old; became interested in and learned engraving; and was a self-taught artist whose work was informed by material from books and by other artists working in Charleston as well as from practice.[54] In his will, Coram himself stated that he had arrived in South Carolina on March 1, 1769, joining his father, John Coram, and an older brother also named John; Coram made no mention of his mother or other siblings. The father and possibly the other son became merchants in Charleston.[55]

Fraser reported to Dunlap that Thomas Coram served as a soldier during the Revolution, although his service cannot be verified from existing military records, and that he studied painting with Henry Benbridge (1743–1812). Fraser characterized Coram's drawings as possessing "neatness and correctness" and said further that

6.17

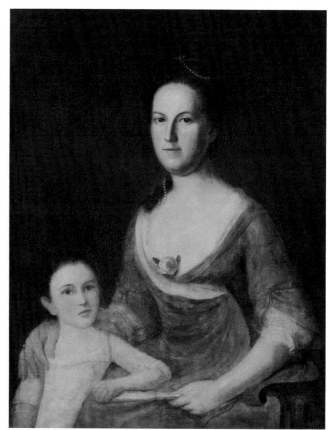

6.18

6.19

FIGURE 6.18. Cosmo John Alexander, *Mary Shippen Willing Byrd* (Mrs. William Byrd III) *and Her Daughter Maria Horsmanden Byrd* (later Mrs. John Page), signed and dated 1771, oil on canvas, probably about 40" x 40". Location unknown, image copied from Wharton, *Salons: Colonial and Republican*, between pages 144 and 145.

Mary Shippen Willing Byrd (1740–1814) was the daughter of Charles and Anne Shippen Willing of Philadelphia. She married William Byrd III (fig. 5.48) in 1761 and moved to Westover in Virginia. After he committed suicide in 1777, leaving her with considerable debts to the estate, she managed both the family properties, preserving the ownership of them for her ten children, the oldest of which was Maria Horsmanden Byrd (1761–1811).

FIGURE 6.19. Cosmo John Alexander, *Mrs. John Dixon* (Rosanna Hunter Royle Dixon) *and Daughter Mary Dixon* (1767–1867?), 1771, oil on canvas, 36" x 28¹⁄₁₆". Valentine Richmond History Center.

Mrs. John Dixon (1739–1790) was the daughter of William Hunter, a merchant in Elizabeth City County, Virginia, and the sister of William Hunter Jr., who was associated with the publishing of the *Virginia Gazette*. She married first Joseph Royle (d. 1766), another Williamsburg printer who succeeded her brother in the publishing business. Her second husband was John Dixon (ca. 1740–1791), also associated with the *Virginia Gazette*. His portrait is signed by Cosmo Alexander and dated 1771. The history of the *Virginia Gazette* and its various publishers/editors is complex beginning with the period of the Revolutionary War when politics influenced the establishment of two papers and later a third, all three of which were associated with one or more of the printers named here as well as others such as Alexander Purdie.

in his oil paintings there was a harmony of colouring and felicity of execution rarely surpassed by those who have had more extensive opportunities of study and observation. His reading embraced almost every subject connected with his favourite art: he delighted in the history of it, and the biography of eminent painters; and of both it was his habit to collect and transcribe such anecdotes and passages as were striking and useful.

Using other information Charles Fraser provided, Dunlap writes that Coram

> presented to the Orphan Asylum [in Charleston] a picture after a design of Mr. [Benjamin] West, from the passage, "Suffer little children," &c. From Mr. Fraser . . . we learn, that Thomas Coram was . . . nearly [i.e., closely] related to the philanthropist of the name, to whose benevolent exertions the Foundling Hospital, in London, is indebted for its existence.[56]

Proving a familial relationship between Thomas Coram of Charleston and Thomas Coram, the philanthropist of London, is problematic, but it deserves further note. The elder Coram, the philanthropist, was born in Lyme Regis, Dorset, England. He came to the American colonies sometime before 1694 and married Eunice Waite of Boston in 1700. From the time of his arrival until 1705, he owned a shipbuilding enterprise in Massachusetts. He then returned to England, eventually moving to London where he became a successful merchant. In 1732, Coram served as one of the trustees for the establishment of the Georgia Colony, and he was also involved in the transportation of the Salzburgers to that region.[57] Coram supported many charitable causes, the most famous of which was the Foundling Hospital built in Lamb's Conduit Fields, Bloomsbury, London, for which he obtained a royal charter from George II. Among its first governors was William Hogarth, who painted a portrait of Coram (fig. 6.20). Hogarth and many other well-known London artists contributed works to the hospital, which soon became one of the first art galleries in London. George Frideric Handel is known

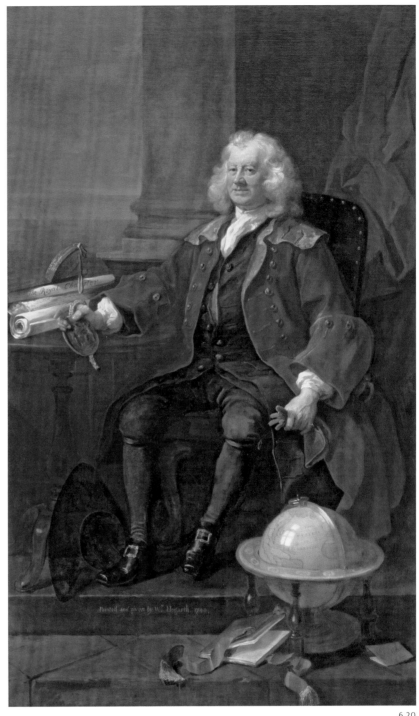

6.20

FIGURE 6.20. William Hogarth, *Thomas Coram* (ca. 1668–1751), 1740, oil on canvas, 93″ x 58¾″. © Coram in the care of the Foundling Museum, London/The Bridgeman Art Library Nationality.

to have written an anthem for the hospital, and he also agreed to a benefit performance of his *Messiah* there.[58]

The London philanthropist named Coram and his wife Eunice had no children. The most recent study of Coram indicates that his brother, William, died as an infant and suggests that there may have been a godson named Thomas Coram who was born either in or before 1727.[59] Nothing more is known about the godson Thomas or his possible relationship with the artist. There were many other Corams in England, but no connection between them and the artist's family has been made. However, an interesting possibility is suggested by the Foundling Hospital records, which show that two and possibly more resident children of undetermined age were baptized with the name Thomas Coram in honor of the institution's founder. One of those children died young while another lived and was apprenticed to a shipbuilder in the spring of 1753. Records for the other Thomas Corams are unknown. In the first years of the Foundling Hospital's operation, many orphaned children were named after other famous hospital benefactors, such as William Hogarth. It has been said that, when some of them grew up, they claimed blood relationship with their famous namesakes.[60] Perhaps Thomas Coram, the Charleston painter, was the son of a foundling, as no information about his father or brother has been located in England.

In addition to his work as a painter, Thomas Coram of Charleston was also an engraver, and, as such, he became responsible for bills of credit in legal tender, lawful money for South Carolina issued on February 8, 1779 (figs. 6.21–6.24). Each denomination had different mottos, figures, and decorative borders of bellflowers and other devices. The reverse sides are especially revealing of Coram's talent, for they illustrate a variety of classical vignettes with mythological subjects: Atlas bearing the weight of an immense boulder; an armorial containing horns, flags, and a lyre; and a similar emblematic device with a shield, liberty cap, horns, arrows, and palm and olive branches. Other vignettes he used on the bills include Hercules wrestling the Nemean lion and a bound Prometheus being attacked by a large bird. "T. Coram Sculp/1772" originally appeared on the

reverse of the bills, engraved below the scenes; however, in most surviving examples, that feature has been cut off.

The fifty-dollar example illustrated here bears the motto *Providentia nostris præaesideat* ("Let foresight guide us") and shows the figure of Providence pointing to a globe. Coram is known to have signed some, if not all, of the fifty-, seventy-, and ninety-dollar bills. Related to his printed money, and also attributed to his hand, is an engraved officer's shoulder belt plate made for the South Carolina Royalists about 1780 (fig. 6.25). It is the only known southern example dating from the Revolutionary War. Coram was working in British-occupied Charleston at the time he made the plate, and he seems to have produced items for both American and British clientele.[61] The engraved banners and lettering on the belt plate are very similar to those on some of the printed bills, although the prominent pine tree on the belt is not seen elsewhere in Coram's work.

In 1809, two years before Coram's death, David Ramsay of Charleston wrote in *The History of South-Carolina* that "Thomas Coram has merit as a self-taught engraver," saying also that Coram,

> by an innate love of the art [of landscape painting] and great industry, has far exceeded what could have been expected from his slender opportunities for improvement. His picture of the presentation of children to the Saviour of the world, which he executed from a design of Benjamin West, and gave to the orphan house, is a work of extraordinary merit. It does great honor to the elegance of his taste, and the liberality of his heart.[62]

Coram's "slender opportunities for improvement" must refer to the lack of engravers in Charleston who could instruct him. If the reference pertains to painting, it is inaccurate since Coram reportedly had some lessons from the academically trained Henry Benbridge who arrived there in 1772 (when Coram was sixteen years old) and continued to work in Charleston through part of the 1790s. Although elderly, Jeremiah Theus continued to paint until his death in 1774. Other "opportunities" in Charleston at the time would have included William and

6.21

6.22

FIGURES 6.21 AND 6.22 (front and reverse). Thomas Coram, artist and engraver, *South Carolina Fifty Dollar Bill*, April 10, 1779, ink on paper, 5" x 3". Colonial Williamsburg Foundation, Williamsburg, VA. Gift of the Lasser Family.

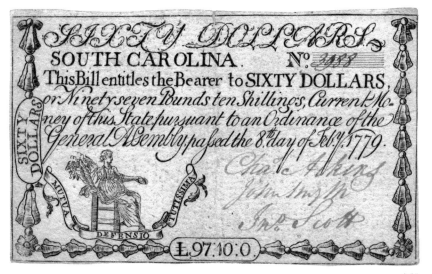

6.23

6.24

Mary Lessley, who taught painting and drawing in the early 1770s; Thomas Leitch (Leech) (active ca. 1755–1775), whose highly finished view of Charleston was in process as early as 1774; and John Grafton (dates unknown), who in 1774 advertised himself as a pupil of Sir Joshua Reynolds (1723–1792).

Coram was twenty-eight or twenty-nine years old in 1784, the year he first advertised his drawing school in Charleston papers.[63] Apparently he had already received some training by that time, and he was probably capable of engraved work. By 1777, he was advertising in local papers that he sold all sorts of goods and services, including engravings for coats of arms, ciphers, ornaments, names, and devices on plates and other objects. His engraved view of the engagement between American and British forces that occurred at Sullivan's Island on June 18, 1778, was apparently finished and offered for sale by September 1778. This same view was still being advertised in 1779. Coram sold the "plain" view of the engagement for twenty shillings; a "coloured," or water-colored, one could be purchased for forty shillings.[64] His offering of colored prints predates the first mention of his watercolor and oil pictures by two years when he gave notice of his move to Queen-Street in Charleston.[65] By 1782, Coram was advertising that he engraved regimental and fancy buttons, items probably similar to the belt plate shown in figure 6.25.

Charleston City directories indicate that Coram continued to live on Queen Street for the remainder of his life. Those listings carry his occupation variously as an "engraver" from 1782 to 1797; beginning in 1802, as a "painter and engraver"; in 1803, as a "limner"; and, in later years, as a "painter and engraver." Interestingly, he is not listed among the five limners or miniaturists in a special artist section of the 1807 directory. His wife, Ann Coram, was listed in later issues as his "widow" living on Queen Street.[66]

In 1784, Coram once again opened a drawing school, one he was still operating in 1786. In 1785, the South Carolina Treasury paid the artist for casting and engraving interest bills for indentures for the state, drawing twelve models for silver and copper coins, and painting

6.25

possession since he delighted in reading about and collecting information on art. Two years later, in August and October, he thanked the public for their support of his first efforts and said he had "a second set of Paintings to be disposed of."[70]

Soon after his death in 1811, an inventory was taken of Coram's house, left to his widow, Ann. She inherited all of his paintings, prints, drawings, and implements for painting, "intended as an auxiliary support to be by her disposed of." These included twenty-three oil paintings worth sixty dollars in one of the primary front rooms on the first floor, seven small pictures and one small mirror in the shed valued at two dollars, and one painting from "Gulliver's travels" at five dollars.[71]

In addition, Coram left his library of books,[72] the principal from his stock, and his women slaves to the commissioners of the orphan house in Charleston. As previously noted, Charleston's Dr. David Ramsay provided an early description of the circa 1805 painting that Coram presented to the orphan house in Charleston (fig. 6.26). This history of the picture is difficult to confirm; another slightly different theory claims it was part of the artist's estate inherited by his wife, who gave it to the orphan house. The institution still owns the picture but placed it on deposit with the Gibbes Museum of Art in Charleston many years ago. *Jesus Said Suffer Little Children* is an impressive picture measuring over seven feet in width. Because of the large size, Coram used the more durable support of wood. It is a copy of Benjamin West's (1738–1820)

Spanish flags.[67] Later that year, on December 14, residents celebrated the anniversary of the evacuation of Charleston by the British troops. Local papers published a long description of the festivities, the parade, and the participating troops and militia, making special note of the "new set of colours" that was raised, "the quarterings of which were new, strikingly emblematical, and did honor to the inventive genius of Mr. Coram."[68]

The earliest documentation of Coram's landscape paintings comes from his 1786 ad that lists for sale "A few Pieces of Landscape Paintings, Some of them copied from capital works, and . . . offered to the public, as the result of his first essays in that art."[69] "Copied from capital works" probably indicates that Coram was copying old masters' or other well-known artists' scenes from print sources. He would have had these in his

FIGURE 6.25. Probably Thomas Coram, *Uniform Belt Plate for South Carolina Royalists*, ca. 1780, engraved silver, 2¼" x 1¾". Colonial Williamsburg Foundation, Williamsburg, VA.

The plate is decorated with a large loblolly pine (*Pinus taeda*), one of the most common plant species in South Carolina. Above the tree is a crown and the letters "G R" (for *Georgius Rex*), and surrounding it are two ribbands with the inscriptions "So. Carolina" and "Royalists." The ribband around the tree trunk is engraved *Sub rege florescit* ("Under the king it flourishes"). The border in the form of a belt with a buckle carries the inscription *Honi soit qui mal y pense* ("Shame to the one who thinks ill of it").

Jesus said suffer little Children to come unto me and forbid them not, for of such is the kingdom of God;
And he took them up in his Arms and put his hands upon them and blessed them.

6.26

FIGURE 6.26. Thomas Coram, *Jesus Said Suffer Little Children*, ca. 1805, oil on wood, probably mahogany, 50¾" x 85". © Image Courtesy Gibbes Museum of Art/Carolina Art Association.

FIGURE 6.27. Thomas Coram, *Mrs. Charles Glover*, dated 1794, oil on paper on wood panel, 9⅞" x 7¾" oval. Courtesy of the Museum of Early Southern Decorative Arts (MESDA) at Old Salem.

The subject, Ann Coachman Glover (1766–1791), was married to Charles Glover, a Charleston merchant and planter. The picture was painted posthumously and has this original inscription on its verso: "To Chas Glover Esq., this humble attempt / to bestowe to his memory / this portrait of his beloved / departed Wife, / is / presented by his friends Tho. Coram / 1794." The likeness is under life-size. The oval format and the inclusion of only the head are features usually associated with miniature painting.

This picture and his small oil of Mulberry plantation (fig. 6.29), along with his skill in providing small, engraved details, indicate that Coram was comfortable working in diminutive formats. Watercolor on ivory miniature portraits by his hand will likely be identified in the future.

FIGURE 6.28. Thomas Coram, *Michael Kalteisen*, ca. 1802, oil on canvas, 36½" x 28½". Courtesy of the German Friendly Society of Charleston, SC.

Michael Kalteisen (1729–1807), born in Machtolsheim in the duchy of Württemberg, Germany, was best known as the founder of the German Friendly Society in Charleston, South Carolina, in 1766. He holds a copy of the society's rules. Although not himself a member, Thomas Coram would have been interested in the society because of its philanthropic activities (see fig. 6.30) (Riley, "Michael Kalteisen," 29).

6.27

6.28

1781 picture, owned by the Royal Academy of Arts in London and titled *Christ Blessing the Little Children.*[73]

Only a few other works by Coram are known, and most of those date from the 1790s to about 1800. They include the dated 1794 portrait of Mrs. Charles Glover (Ann Coachman Glover) of Charleston (fig. 6.27) and the circa 1802 portrait of Michael Kalteisen (fig. 6.28) attributed to Coram. The portraits and the larger religious picture illustrated in figure 6.26 share many of the same stylistic characteristics. All were painted in oils and show strong brushwork made with rather large brushes. The sitters tend to have formulaic features: heavily lidded eyes, rounded faces with full cheeks, and small, cherubic lips. The fabrics were also rendered with bold brushwork, especially in the highlighting. While these pictures are adequate, they lack the clarity and interpretation of sitters' personalities, two features that both sitters and other painters considered important during this period.

Coram seems to have been more comfortable with smaller work, such as engraving and painting cabinet-size landscapes, several of which survive. The most famous of his known examples are several nearly identical views of Mulberry Plantation (fig. 6.29). Dating to about 1790, the one illustrated here is inscribed "Thomas Coram Artist" on the back. Mulberry, built by Thomas Broughton about 1714, still stands near Monck's Corner, South Carolina. The Coram view is among the few rare surviving American pictures showing slave quarters, in this case two rows of buildings that flank the road leading to the main residence. Delicately drawn, the picture has considerable detail. This view and several other small landscapes assigned to Coram show his familiarity with print techniques in the rendering of linear perspective, trees and other foliage, and poses of the diminutive human figures.

Another important work attributed to Coram is the banner painted for the Fellowship Society of Charleston about 1800 (fig. 6.30). The faces of the children and mother are especially close to those seen in Coram's picture of Christ with children. From what is known about his life,

6.29

FIGURE 6.29. Thomas Coram, *Mulberry Plantation*, 1790, oil on paper, 4¹⁄₁₆" x 6¹¹⁄₁₆". © Image Courtesy Gibbes Museum of Art/Carolina Art Association.

Mulberry plantation house and its lands were painted in seven separate views by Thomas Coram, probably for descendants of its builder and owner Thomas Broughton. Indigo and rice were the cash crops grown on the property. The row of small buildings to the left and right of the main house were dwellings for slaves. The picture is delicately painted and skillfully drawn with convincing linear perspective, shading, and coloration.

FIGURE 6.30. Thomas Coram, *Fellowship Society Banner*, ca. 1800, oil on silk now mounted on canvas, 24¾" x 29". Courtesy of the Museum of Early Southern Decorative Arts (MESDA) at Old Salem.

This rare survival bears the Latin motto *Posteri mea dona laudbuni* ("Descendants will praise my gifts"). The Fellowship Society was founded by several Charlestonians, including Michael Kalteisen (fig. 6.28), whom Thomas Coram painted about 1802. There were several philanthropic organizations established in Charleston about this time. This one assisted the indigent poor in Charleston.

Coram seems to have made an adequate living wage in Charleston as a resident artist and engraver for at least twenty or more years. It therefore seems likely that other works by him will be identified, possibly providing additional information on the range and quality of his art. His known portraits tentatively indicate a clientele of mostly middle-income, tradesman, and merchant families.[74]

Probably the most famous late eighteenth-century South Carolina painting that shows an exterior scene with landscape elements is the small watercolor known as *The Old Plantation* (fig. 6.31). Found in Columbia, South Carolina, among descendants of the original owner and acquired in 1935 for Abby Aldrich Rockefeller's folk art collection, the picture also ranks as the earliest view of southern slaves. In 2008, Colonial Williamsburg acquired a second watercolor painting created by the same artist, this one showing a single African-American woman (fig. 6.32).[75] The remnants of its original pen-and-ink-title "Bre" appear below the figure, and her full name, "Miss Breme Jones," is inscribed on the back of the picture. Her name, the few historical facts known about her, and the provenance of *The Old Plantation* led to extensive new research and important discoveries by Susan P. Shames, decorative arts librarian with the Colonial Williamsburg Foundation. Ultimately, Shames was able to identify the artist as John Rose (1752/53–1820), who resided first on his plantation on the Coosaw River near Beaufort and later on property in Dorchester, South Carolina. Through numerous complex genealogical investigations, Shames has concluded that Breme Jones was most likely a slave owned by Rose's first wife, whom he married when in Beaufort. The watercolor of slaves and the plantation, also probably painted in Beaufort about 1790 or earlier, likely shows Rose's dwelling and slave quarters.[76] Both *The Old Plantation* and *Miss Breme Jones* show a delicate yet sure style of watercolor painting that came from practice and, possibly, some training. A third picture, with the inked title "*TRANQUIL=HILL / The Seat of Mrs. Ann Waring, near Dorchester,*" a property near Rose's in Dorchester, may also have been painted by Rose.[77]

Shames's research included the discovery of Rose's undated will. That document refers to several paintings,

6.30

prints, and drawings and artists' paints, and it mentions a "drawing representing Negroes drawing." Some or all of those pictures were likely by his hand. As Shames points out in her book, the phrase "Negroes drawing," as found in the court clerk's copy of Rose's will, could easily represent a miscopying of the phrase "Negroes dancing."[78]

The artist John Mare (1738/39–1804) never advertised or promoted his painting. What we know of his life prior to his arrival in North Carolina comes largely from previously published information.[79] When he was twenty, he married Ann Morris and went to Albany, New York, where his son was christened in 1760. He was painting in New York City by 1769. Several likely sources for his training include the older painter William Williams (1727–1791), who married Mare's sister Mary about 1757; the Duyckinck family of painters; and Lawrence Kilburn (active 1754–1775). Mare certainly knew the work of John Wollaston Jr., for in 1767 he copied the English artist's portrait of Henry Lloyd (dates unknown).[80] That year

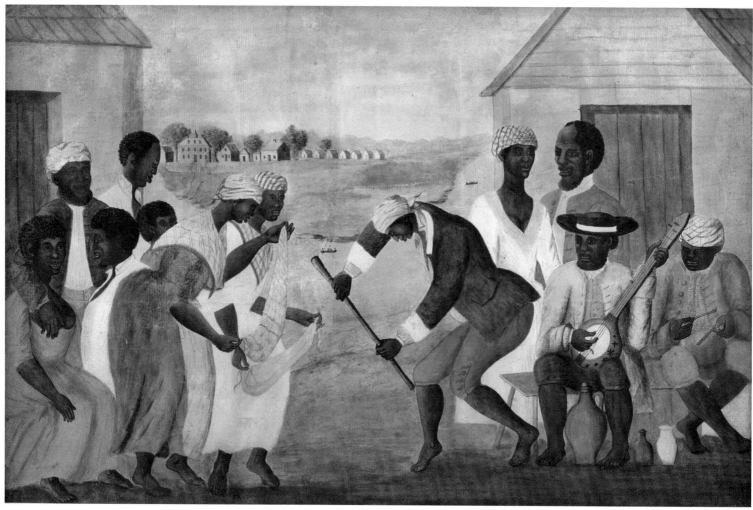

6.31

FIGURE 6.31. John Rose, *The Old Plantation*, probably 1785–1790, watercolor and ink on laid paper, 11⅞" x 17⅞". Colonial Williamsburg Foundation, Williamsburg, VA. Gift of Abby Aldrich Rockefeller.

John Rose arranged his figures in two basic groups, one at right and one at left, with a building behind each. The two women on the left who each shake a *shegureh*, a rattle of African origin, and the man at right with a stick serve to unite the two groups, as does the landscape vista with manor house and slave quarters beyond them. The overall composition is complex not only because the numerous figures are all differently posed but also because it tends to form a large X. One leg of the X runs from the roofline at left through the stick at center while the other runs from the roofline at upper right through the foremost dancing woman's arm. Whether the X arrangement was intentional is unknown. Rose's painting is highly detailed in the rendering of objects and even more particularly in the execution of faces, which are individualized and which undoubtedly represent persons he knew. The picture has been widely published by many scholars, and the dance or ceremony, the

instruments, the clothing, and other details interpreted in various ways. The best summary of these is contained in *The Old Plantation* by Susan Shames.

FIGURE 6.32. John Rose, *Miss Breme Jones*, probably 1785–1787, watercolor and ink on paper, 7½" x 6⅛". Colonial Williamsburg Foundation, Williamsburg, VA. Acquisition funded by the Friends of Colonial Williamsburg Collections.

Breme Jones (dates unknown) is shown in profile standing on a brick walkway. Like the persons shown in *The Old Plantation* (fig. 6.31), Jones's face is both detailed and sensitively painted. On the upper left of the page, across from her face and bust, is an inscription comprising lines paraphrased from John Milton's *Paradise Lost* as published by James Harris in his 1772 book on art, music, painting, poetry, and happiness. The inscription reads, "Grave in her steps / Heaven in her eye's / And all her movement / Dignity and Love." Both Milton and, later, Harris give the first word as "Grace" rather than "Grave." The passage describes Eve in book 8 of Milton's poem. (See Shames, *Old Plantation*, 26, 72n50.)

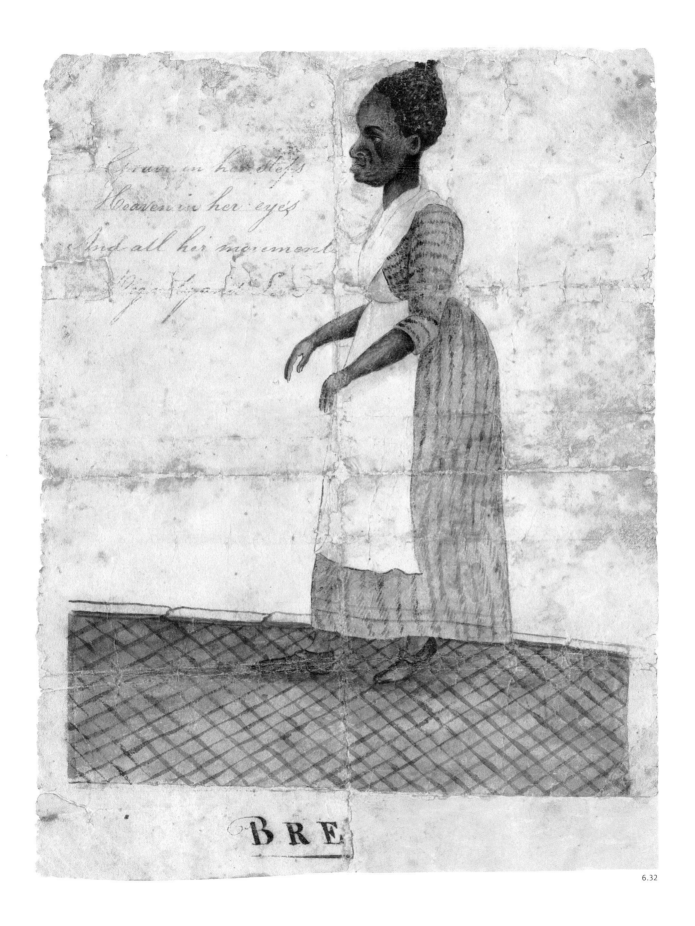

Grace in her steps
Heaven in her eyes
And all her movements

BRE

6.32

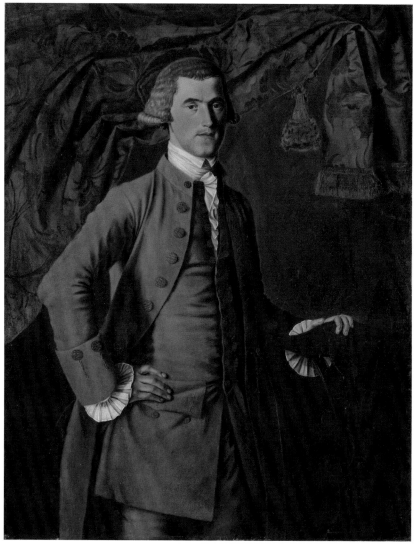

6.33

Mare also signed and dated his well-known portrait of Jeremiah Platt (fig. 6.33), which illustrates his love of detail as well as the precise, linear quality of his work. Mare seems to have moved back and forth between Albany and New York City. In 1772, Mare was in Boston and then Albany. In 1774, he was again in New York City. His 1774 portrait of Dr. Benjamin Young Prime (1733–1791), now at the New-York Historical Society, is still considered his last known work for New York.

Mare was a member of St. John's Masonic Lodge in New York City, probably until 1777 when he switched his membership to the lodge in Edenton, North Carolina.[81] Why the artist moved to North Carolina is unknown, but he quickly became a leader in Masonic local and state affairs. In 1786, he is listed in the North Carolina census for Edenton in Chowan County, North Carolina. Living in his household were two free white males of sixteen years or older, three free white females, one other free person, and twenty-two slaves. His ownership of that many slaves, as opposed to the average one to three in most other 1786 Edenton households, suggests considerable wealth.

No North Carolina portraits or references to Mare's painting have been located, but it is difficult to believe that someone with his talent would completely abandon such work. Research by Helen Burr Smith and Elizabeth V. Moore indicates that Mare was a successful merchant in North Carolina and that he was continually involved with Freemasonry.[82] In December 1787, Mare attended the Masons' Tarboro Convention,[83] where he was appointed as the presiding officer who would oversee proceedings and deliver the charge to the elected grand master and his deputy. For several years Mare served as master of the Edenton Lodge, stepping down at the end of 1782.[84] He continued to live in Edenton until his death in 1804. The absence of any North Carolina or southern pictures by Mare makes him marginally important to this discussion, but examples may be identified in the future. A possible relationship to the southern artist William Joseph Williams (1759–1823), whose career falls into the last decade of this study, is another reason to include Mare. Both created pastel portraits, and the work of Williams does bear a stylistic relationship to that of Mare.

FIGURE 6.33. John Mare, *Jeremiah Platt* (1744–1811), dated 1767, oil on canvas, 48⁷/₁₆″ x 38⁷/₁₆″. Image © The Metropolitan Museum of Art/Art Resource, NY.

The painting is signed on the front of the chair's crest rail, to the left and below the sitter's shirt cuff. John Mare was among the first American painters to experiment with *trompe l'oeil* or highly detailed and realistic representations meant to "fool the eye."

Family tradition indicates that Williams was John Mare's nephew and the son of the painter William Williams of England, New York, and Philadelphia, although sources offer conflicting information on this point.[85] The younger Williams launched his career in New York City, Mare's hometown and residence for many years. The earliest known work by Williams is a portrait of Sarah F. Warner, signed and dated "Wm Williams Pinxit Nov. 30th 1781" (fig. 6.34). The first indication of his being in North Carolina is a signed and dated 1786 pastel portrait of a member of the Little family, probably executed in Hertford County.[86] A small number of other southern pastels by the artist date to the 1780s. They include the 1785 likenesses of the Reverend Charles Pettigrew and his first wife, Mary Blount Pettigrew (figs. 6.35 and 6.36).

William Dunlap's version of Williams's life is especially informative. The two met when Dunlap was first learning to paint.[87] Williams was born in New York City and died in New Bern, North Carolina. Dunlap relates that he lived with his widowed mother "east of the Collect,"[88] in the suburbs of New York City, and "painted portraits in crayon or pastil." Williams "was at this time an officer in the militia, as enrolled by the British," probably as a lieutenant in the army that occupied New York City. After the war, he moved to Halifax, Nova Scotia, along with hundreds of other Loyalists. On his first encounter with Williams, Dunlap observed that the artist "attempted nothing below the head and shoulders," by which Dunlap meant he did only bust-length portraits. Williams and Dunlap met again in 1814 when the latter was employed by the government in the paymaster's department. The aging Williams "presented himself for settlement of his accounts, as a quarter-master of sea-fencibles in the U. S. service" during the War of 1812.[89]

Throughout the 1780s and for much of his later life, Williams traveled for commissions to several places in the South. The known areas include Alexandria, Virginia, in 1793 and 1799; Fredericksburg, Virginia, in 1792 and 1793; Georgetown, then Maryland, in 1797 and 1799; Baltimore, Maryland, in 1793 and 1794; Charleston, South Carolina, from 1801 through 1806; New Bern,

North Carolina, in 1817, 1819, and 1820; Norfolk, Virginia, in 1787; and Richmond, Virginia, in 1792.[90] Williams established residences in only three of these areas: Charleston, from 1801–1806; New York City, from 1809 to sometime in 1816, and New Bern, North Carolina, where he probably moved permanently in 1816. His wife, described as Catherine Williams, "daughter of James Simpson, esq. of Georgetown, in Maryland," was with him in Charleston, where she died in 1803 of "a consumptive complaint."[91] The next year, the artist was in custody of the sheriff of Charleston District, "at the suit of the President, Directors and Company of the Bank of the United States," as an insolvent debtor.[92] Williams married again in Charleston to "Ann," by whom he had a daughter who was baptized at the Independent Congregational Church in 1806. He lived at various times in Charleston and also on Sullivan's Island during his stay in South Carolina.[93] There is also a tradition that Williams was a member of an Episcopal Church in Georgetown, South Carolina, but that he converted to Catholicism after moving to New Bern and added "Joseph" to his name at that time.[94]

No works by Williams's hand can be documented after about 1810–1815, a fact that might substantiate Dunlap's 1814 observation that Williams "was old and almost blind." But the aging painter also boasted to the historian "that he could paint better than any man in America."[95] He was certainly painting in 1817–1819 when he placed two advertisements in New Bern papers. The 1817 notice reads:

NEWBERN ACADEMY
OF
PAINTING.
MR. WILLIAMS
PORTRAIT PAINTER.

RESPECTFULLY informs the Citizens of Newbern, and its vicinity, that he intends (with sufficient encouragement) to open an Academy of Drawing and Painting, for the instruction of young Ladies and Gentlemen, in the elegant and useful art of Painting—elegant, because it is an art which embraces all the objects of nature for its subject—expands and enlarges the mind, by filling it with ideas of whatever is great and beautiful—

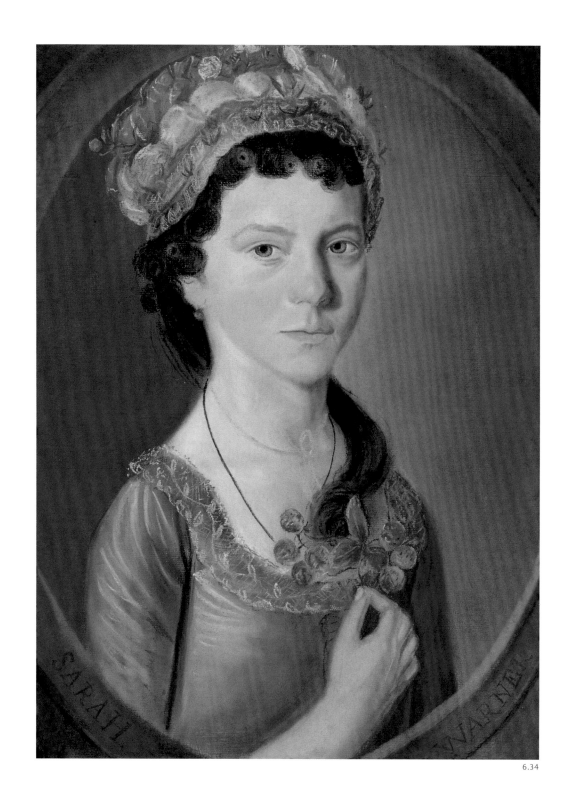

6.34

FIGURE 6.34. William Joseph Williams, *Sarah F. Warner*
(1771–1848), dated 1781, pastel on paper, 20¹⁄₁₆" x 14¹⁄₂".
Courtesy Winterthur Museum.

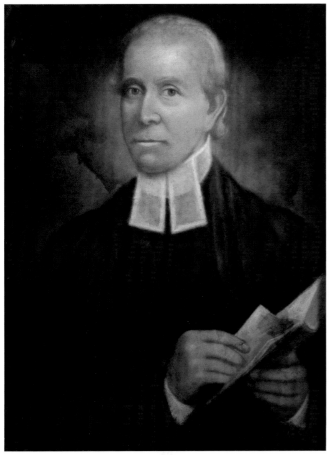

6.35

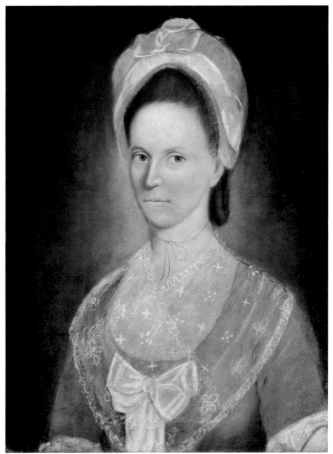

6.36

FIGURE 6.35. William Joseph Williams, *The Reverend Charles Pettigrew*, dated 1785, pastel on paper, 24½" x 18⅛". Courtesy of the Museum of Early Southern Decorative Arts (MESDA) at Old Salem.

The parents of Charles Pettigrew (1744–1807) emigrated from Ireland to Pennsylvania where the subject was born. The family later moved to Lunenburg County, Virginia; then to Granville County, North Carolina; and finally to South Carolina. Charles, however, remained in North Carolina where he taught school in Edenton and joined the church. In the mid-1770s, he was in England where he was ordained a deacon and priest. After his return to North Carolina, he assisted at St. Paul's in Edenton, eventually becoming rector there. He amassed considerable land in North Carolina where he grew cash crops and married twice (see fig. 6.36).

Williams signed and dated the Pettigrew portraits and several others, making it possible to trace his travels in several regions of the South.

FIGURE 6.36. William Joseph Williams, *Mrs. Charles Pettigrew*, 1785, pastel on paper, 24½" x 18¼". Courtesy of the Museum of Early Southern Decorative Arts (MESDA) at Old Salem.

Mary Blount Pettigrew (1734–1786), Charles Pettigrew's first wife, died in childbirth. She was the daughter of Colonel John Blount and Elizabeth Vail Blount, who lived on their plantation, Mulberry Hill, near Edenton.

corrects the imagination, and cultivates a just and refined taste, for whatever is grand and sublime in nature or art—useful, because it enables the Husbandman, the Mechanic, the Gentleman the Architect, to make out their designs with correctness and intelligence; and gives a peculiar facility to the eye in discovering the minute inaccuracies in any performances of design and invention. To the fair sex it is highly ornamental and useful; and to them, its utility needs no comment. In fine, it is an art, honored, cultivated and encouraged by all enlightened Nations, both Ancient and Modern.

Those Gentlemen and Ladies, who may be desirous of taking advantage of this opportunity, to establish this institution, will please call at S. Hall's Bookstore, where Subscriptions will be received until the first of April, and the terms made known.

March 8, 1817.[96]

The advertisement is noteworthy for its language in support of art and painting, especially its references to the "great and beautiful" and the "sublime." In fact, Williams may have borrowed some of the wording from theoretical works of men such as Edmund Burke and others whose philosophical language was often paraphrased by artists and other cultural commentators—and not always with complete understanding. Williams apparently used such language to promote art education, yet his message leans heavily on the importance of art's "usefulness" as opposed to its inspiring qualities associated with the imagination and the sublime. That emphasis makes infinite sense given his New Bern clientele—merchants, trades persons, and "the fair sex," who were mostly concerned with ornamenting personal and household items. Art education had steadily grown, first in the colonies and then in the new nation. Williams's late career typifies the renewed interest in art's utility and its importance to the decorative household arts. It also evidences Williams's need for income during a time when there was a shortage of portrait commissions.

A year and a half later, his 1819 advertisement drops the philosophical rhetoric and promotes portraiture equally with decorative painting or utilitarian work:

Mr. Williams,
PORTRAIT PAINTER,
HAS removed to the House next to Mrs. Oliver's, on Middle street.—Portraits taken as usual, in oil and crayons—Signs, Cornices, &c. painted in the best and most elegant manner—Gilding and Ornamental Painting, in all their varieties—Drawing, of every kind.

He will also take Pupils in Drawing and Painting.
Newbern, Oct. 16, 1819.[97]

The New Bern ads Williams placed are well beyond the scope of this study, but they are quoted here to indicate how one aging painter, whose career began in the 1770s, struggled to make a living in the early nineteenth century when competition was far greater. His last newspaper notice published in 1820 does not specifically mention his painting at all. It indicates only that his watch had been stolen.[98] The absence of any mention of his artwork in other advertisements from 1820 or later, coupled with Dunlap's 1814 reference to his blindness, suggests that Williams had given up his artwork.

Among the other lesser artists that are identified as being in the South during the 1760s and later are Joseph Fournier (dates unknown), Boyle Aldworth (active 1758–?), husband and wife William J. and Mary Lessley (active 1770–1775), Samuel Folwell (1765–1813), James Warwell (d. 1767), Benjamin Blyth (1746–1786), Frederick Kemmelmeyer (active 1783–probably 1821), John Grafton (active 1774–1775), John Allwood (active 1773), Thomas Laidler (active 1768), Lewis Turtaz (active 1767), "Miss Read's niece" (active 1772),[99] David Oliphant (active 1784), and Richard Jennys Jr. (1734–probably 1809). In some cases, no attributable works are known for these painters, and information about their lives is modest.

The advertisement of Joseph Fournier in Charleston in 1770 offered miniature portraits, plans of architecture, and classes in drawing. Fournier apparently remained in Charleston through 1771 and visited Georgia in 1772.[100] With the exception of one profile portrait attributed to Fournier—a miniature portrait of a much later date—nothing more is known about this artist.[101]

Boyle Aldworth (active 1758–?), who called himself a *"Limbner,"* was the only painter to advertise in North Carolina papers between 1758 and 1778. His services included miniature portraits for rings at $130 and for bracelets at $100 and portraits in sizes one to two feet for $75. His advertisement appeared several times in October 1758.[102] By December 31, 1778, he was in Charleston, South Carolina, where he offered miniature likenesses and teaching. No examples by his hand for the South have been identified.[103]

Also in Charleston about the same time was the married couple William J. and Mary Lessley. They were in town before February 20, 1770, when notices appeared in the *South-Carolina Gazette; and Country Journal* (Charleston) indicating that Nicholas Langford, bookseller, was auctioning a lot of pictures consigned by William. On May 15 of that year, and in the same paper, Langford advertised a similar auction that included fifty drawings of flowers, fruit, birds, beasts, "Landskips . . . exquisitely coloured after Life, and executed by Mr. LESLEY." In October 1770, William Lessley published a far more revealing advertisement informing the public that

> The Death of *Mr. Jackson,* obliges him to give up all Thoughts of a CHINA MANUFACTURY, which they intended to establish in Charles-Town. Therefore he repeats this former Advertisement, of TEACHING Ladies and Gentlemen DRAWING and PAINTING, in as genteel a Taste as any Artist in England, or elsewhere; He also paints, and teaches on Silks, &c. and takes Birds, Flowers, and Plants from Nature, for any Gentleman curious therein; also paints on China and the Cream coloured Ware Gentlemen's Coat of Arms, or any Patterns they choose, equal to any Paintings in Europe.
>
> He takes MINIATURES.[104]

The first mention of Mary Lessley's artistic work appeared in the same paper for November 19, 1771. In this notice, she offered to teach drawing to ladies, while her husband taught drawing and painting to ladies and gentlemen. In addition, William was once again selling a parcel of paintings. By October 1774, and continuing through February of the next year, the couple placed notices in two Charleston papers stating their intention to leave in the spring and to sell "a Set of twelve Birds of this Country taken from the Life, several Sets of Pencils and different Paints [oil and watercolor] . . . between twenty and thirty Sets of Jars and Beakers painted beautifully in Birds, Flowers and Fruit" as well as a "handsome" guitar and a spinet by Baker Harris. Their ads, which mention teaching drawing and painting, continued to appear in Charleston papers through 1775.[105]

Numerous American paintings from New England are associated with the artist Richard Jennys Jr., who was born in Boston, Massachusetts, the son of Richard Jennys, a notary public who frequently advertised his services in Boston papers.[106] In October 1767, just before his father's death, Jennys Jr. advertised a "Large and general Assortment of Goods" at his store on King Street, Boston. He would continue to place such ads until June 1778 although he must have begun painting, or was learning to paint, sometime between these two dates.[107] Later that month, he advertised his intent to leave Boston and offered for sale at his house on Wings Lane mahogany chairs, tables, a desk, a bureau, looking glasses, carpets, beds, an organ, and other items.[108] According to scholar Richard Miller, Jennys was educated at the Boston Latin School. He married Sarah Ireland in 1770, and the couple had five children, including William Jennys (1774–1859), who followed his father's profession as a painter. Miller also notes that the couple divorced about 1787.[109]

In 1764, the Boston silversmith Paul Revere made and sold to Jennys a gold frame with glass, likely a small frame designed for a miniature portrait painting. Whether Jennys was painting miniatures or had simply acquired one from another artist that needed a frame is unknown, but at least two scholars have suggested that this reference may be the first to his painting portraits.[110] The earliest work associated with Richard Jennys Jr. is usually cited as a portrait, now lost, on which he based a mezzotint print of the Reverend Jonathan Mayhew (fig. 6.37). The print has the inscription, "Rich. Jennys Junr. pinxt. [meaning painted] & Fecit [meaning etched the engraving] / The

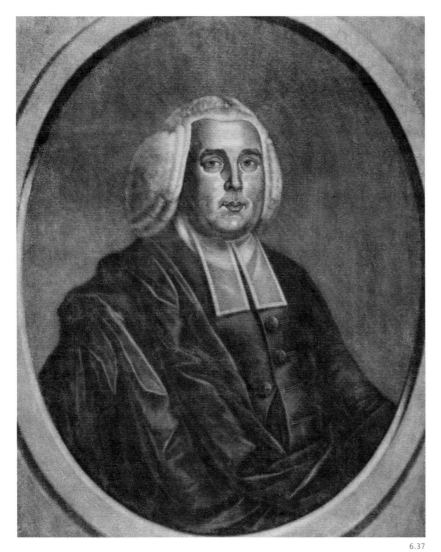

FIGURE 6.37. Richard Jennys Jr., engraver? and painter?, probably copied after John Greenwood, painter, *Jonathan Mayhew*, ca. 1766, ink on paper, published in Boston after 1745, 11¹⁵/₁₆″ x 9⅝″ oval. National Portrait Gallery, Smithsonian Institution.

This mezzotint of the Reverend Jonathan Mayhew (1726–1766) was likely engraved by Richard Jennys Jr. after a circa 1745 oil-on-canvas portrait by John Greenwood, owned by the Congregational Library, Boston, Massachusetts. Striking similarities between this mezzotint and Greenwood's painting include the shape, folds, and highlighting on Mayhew's proper right sleeve, his pose within a feigned oval, the shape of his head, and his facial expression.

Revd. Jonathan Mayhew D. D. / Pastor of the West Church in Boston. / Printed & Sold by Nat. Hurd Engrar. on ye Exchange." The engraving is usually dated 1765 or 1766, the latter being the year of Mayhew's death and the year in which an advertisement for the print appeared in the *Boston (MA) News-Letter* on July 17.[111] The engraved portrait is quite similar to the circa 1745 portrait of Mayhew by John Greenwood (1727–1792) that depicts the minister at about the same age. Jennys probably copied the Greenwood portrait in oils and then engraved it for Hurd.

From Boston, Jennys probably made his first trip to the "West-Indies," although it is not known which island or islands he visited. He arrived in Charleston in 1783, at which time he placed this advertisement:

> Richard Jennys,
> *Just arrived from the* NORTHWARD,
> BEGS Leave to inform the Gentlemen and Ladies of this City and State, that he purposes following the Business of
> PORTRAIT PAINTING
> in its various Branches; and, as he has followed that Business, at the Northward, and in the West-Indies, with considerable Success, he flatters himself to be able to give Satisfaction to all those who may think proper to make Trial of his Abilities. He may be heard of, and his Terms known, by applying to Mess. *Cudworth, Waller,* & *Co.* at their Auction-Room, Broad-street, No. 92.[112]

In 1785, he advertised "Portrait Painting in Miniature" in Savannah, Georgia; in 1786 and again in 1790, he was working in Savannah, where he advertised both life-size and miniature portrait painting. The 1786 ad also indicated that he was resuming his work "having just returned from the West Indies."[113] His whereabouts between 1790 and 1797 are partially unknown. William Bright Jones, the current Jennys scholar, indicates that Jennys defaulted on his taxes in Savannah in 1788–1791, which may or may not mean he was living in the city at that time. Jones has suggested that Richard Jennys may have begun working with his son the painter William Jennys as early as the 1780s when the father is documented as being in the South. His father's work with him

may have been part of William's training, for he did not advertise on his own until 1793 when he was in Norwich, Connecticut. Both father and son would occasionally work together in New England until as late as 1807.[114]

No southern, or by extension Caribbean, portraits have been definitively assigned to Richard Jennys Jr. The problem of identification is compounded by the large number of paintings alternately attributed to both him and his son William. It is unlikely that Richard's southern pictures can be identified without locating documented or signed portraits by him or by the successful separation of his and his son's earliest portraits.

Two other painters who deserve mention here are Benjamin Blyth and Frederick Kemmelmeyer. Blyth (1746–1789) was born in Salem, Massachusetts, but nothing is known about his training or early life as a painter except that he began doing portraits about 1764/65.[115] He was the son of Samuel and Abigail Blyth. His earliest portraits (all pastels) date between 1764 and 1766. Older brother Samuel (1744–1795) painted heraldic devices and did other decorative work. In 1771, Benjamin Blyth advertised in Boston that he did "Limning," and numerous pastel portraits from that area are documented or attributed to him. In 1785, he, or someone with the same name, was married in Norfolk, Virginia. In 1786, he placed a notice in papers in Richmond, Virginia, that he did "Limning in Oil, Crayons, and Miniature." He also did gilding and ornamental painting, and he wanted to engage an apprentice to his business.[116] His southern pictures, however, remain unknown.

Frederick Kemmelmeyer, born sometime prior to 1755,[117] was in Baltimore as early as 1788 when he opened a drawing school and painted portraits in miniature and other sizes in both oil and watercolor. He was probably the Frederick Kemmelmeyer who was married on February 28, 1783, in St. John's Evangelical Lutheran Church in Charleston, South Carolina. Less than five months later, on July 21, he prepared an advertisement that appeared later that week in a local paper announcing that "they have this day by mutual consent agreed to be for ever separate as MAN and WIFE; and for the purpose . . . entered into articles of separation."[118] If this is

the artist, then his full name as given in church records was John Frederick Christian Kemmelmeyer, and he was born in the duchy of Württemberg. His wife was the widow of Christian Gruber of Charleston.[119] A child born on October 2, 1782, and named Anna Rosina Maria Kemmelmeyer, whose father was named "Christian Kemmelmeyer," may have been conceived out of wedlock or was perhaps fathered by Gruber.[120] Information gathered by the National Gallery of Art, Smithsonian Institution, suggests that the artist may be the Frederick Kimmel*meiger* whose naturalization papers were issued in Maryland in 1788.[121] His training is also unknown, but his pictures suggest trade training, probably as a sign, coach, or ornamental painter in his native Germany.

In 1788, 1790, and 1792, Kemmelmeyer advertised similar work as well as sign painting in Baltimore; in 1793, he was teaching at "Mr. Black's Academy."[122] Advertisements or references to him in Baltimore also exist for other dates in 1793 and 1796–1803. He later visited areas that included Georgetown, D. C. (1803); Alexandria, Virginia (1803); Frederick and Hagerstown, Maryland (1805–1806); and possibly Charles Town and Shepherdstown, West Virginia (1813).[123]

Kemmelmeyer's extant work includes a number of history pictures, particularly those associated with the Revolutionary War and General Washington. Although scholars currently believe these were created before the 1790s, the chronological dating of Kemmelmeyer's work is tentative and not well researched. His view of Washington reviewing the troops near Fort Cumberland, Maryland, painted about 1795, or possibly earlier, ranks among the most elaborate of his known paintings (fig. 6.38). An entirely different composition by Kemmelmeyer showing Washington seems to date a few years later (fig. 6.39).

Kemmelmeyer was a capable "mechanic" painter— and one of the few artists in the South who offered history paintings that survive. His Washington pictures, including several others not illustrated here, are better known than his portraits. A particularly fine example of the latter is *Martin Luther* (fig. 6.40).

Contrary to what might be expected, several artists were working in the South just prior to, during, and

FIGURE 6.38. Frederick Kemmelmeyer, *Washington Reviewing the Western Army at Fort Cumberland, Maryland*, ca. 1795, oil on canvas, 22¾" x 37¼". Image © The Metropolitan Museum of Art/ Art Resource, NY.

The view shows the American army before its 1794 march into Pennsylvania to suppress the Whiskey Rebellion, or Whiskey Insurrection, as it was popularly called. During President George Washington's administration, the federal government determined to tax whiskey makers, as opposed to whiskey consumers, in order to pay off national debt. Citizens, particularly farmers living in western areas, were angered by the decision and believed the new laws discriminated against those who converted their extra grain crops into distilled spirits. These settlers lived in remote areas without access to good roads or markets. More easily transportable than grain, whiskey was an important trading commodity for many of them. Tensions increased to the point of rebellion and armed conflict. President Washington had a militia force of nearly 13,000 men under his command. Assisted by Alexander Hamilton and General Henry "Lighthorse Harry" Lee, he led the army to confront the rebels. By the time they arrived in western Pennsylvania, the civil protestors had disbanded. There were a few arrests, but nothing more.

FIGURE 6.39. Frederick Kemmelmeyer, *The American Star* (George Washington), ca. 1803, oil and gold leaf on paper, 22" x 17¾". Image © The Metropolitan Museum of Art/Art Resource, NY.

This remarkable little picture is but one of many memorials created to celebrate the nation's hero George Washington although few were so fancy as to include gold leaf. Kemmelmeyer's trade training, as a sign or ornamental painter, is readily apparent in this picture and in figure 6.38. Both are flat, linear, and highly colored, characterized by strong outlining of forms and minimal modeling. The lettered message on the front of the plinth reads, "First in War. / First in Peace. / First in defence / of / our Country." Below that is a parchment titled "Independence / of / AMERICA." Above Washington's likeness and lettered within the ribbon is "THE AMERICAN STAR"; the ribbon below him is lettered with the general's name. Emblems of the nation and its war for independence are contained in the armorials on either side of the plinth and in the American eagle and shield at the center top.

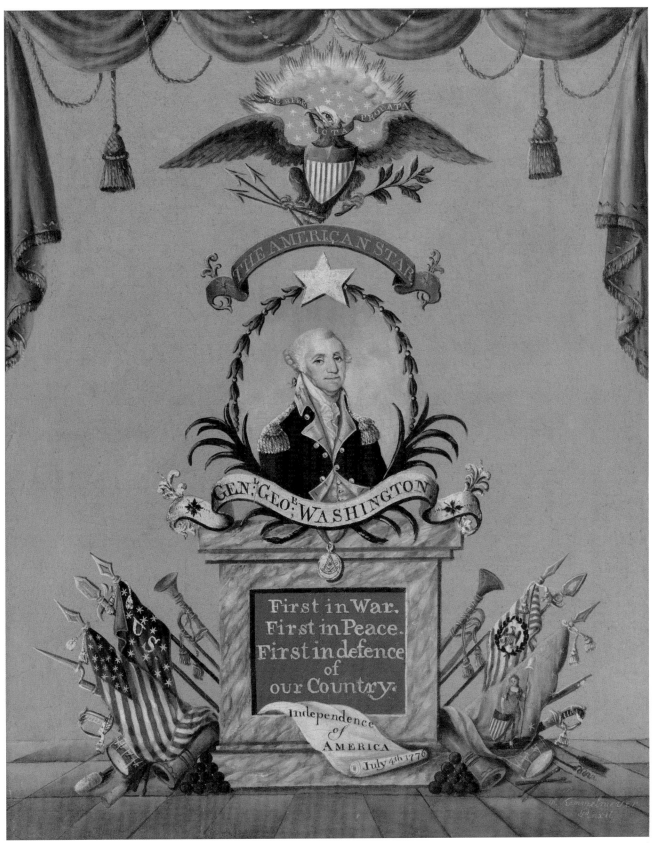

6.40

immediately following the Revolutionary War. Some may have been discouraged by the upheavals of the war, and a few left. Others, however, remained and continued to paint. Some, like Charles Willson Peale (whose career is discussed in the next chapter), Cosmo Medici, and possibly Thomas Coram, served with the American forces, while several were forced into exile because of their loyalty to Great Britain. In addition to the painters discussed here and in the next chapter, the names of other artists, mostly itinerants, are known either through brief advertisements or from earlier checklists, such as Anna Wells Rutledge's for Charleston. Their life dates are, at this time, not known. They include Austin Florimont, who painted miniatures, crayon portraits, and possibly full-scale portraiture in Baltimore; John Fleming, a painter who worked in Williamsburg, Virginia; Thomas Campbell, who did sign and heraldic painting in Virginia; and Ernest Gerard, a miniature painter in Charleston, South Carolina. They also include partners and brothers Hamilton and John Stevenson in Charleston, who produced naturalist pictures, miniatures, land- and seascapes, portraits, and historical paintings from 1773–1774. Hamilton Stevenson worked alone through 1782 as an architect and painter.[124]

Undoubtedly the names of other painters from this period will become known as research continues. For now, it seems clear that, in addition to resident artists like Jeremiah Theus and John Hesselius, a steady and growing influx of painters came to the South during the last half of the 1760s through the 1770s. This pattern would continue in the years after the Revolutionary War. Many of the artists and painters had careers that extended well beyond this period, a period which also saw a significant increase in the purchase of paintings, especially portraits, by working-class Americans. Of the artists who were attracted to the southern colonies, some were trained at home while some were trained abroad, and their skill levels varied. These factors contributed to an inevitable disparate quality of art acquired by southerners.

Perhaps the most important lesson learned from the careers of the painters in this chapter—and the South's

upper and middle classes that supported them—is that aesthetic discernment in the third quarter of the eighteenth century was formed less by firsthand knowledge of European styles and more by what was available and acceptable. Paintings had become fairly plentiful in the southern colonies, and the reputations of artists were still conveyed by word of mouth, from one sitter or family to the next, as evidenced by how sitters or families of sitters and their associates in a given geographical area tended to employ the same artists at about the same time. In addition, a few artists advertised their work, usually those who stopped in a significant town or city and who wanted to make the period of their stay known. Among the elite, some continued to seek paintings abroad, but the greater number of surviving southern pictures suggests middling satisfaction with locally available artists, whether visiting or resident.

FIGURE 6.40. Frederick Kemmelmeyer, *Martin Luther*, ca. 1800, oil on canvas, 58½" x 48". Corcoran Gallery of Art, Washington, DC.

Kemmelmeyer probably based his full-length portrait of Martin Luther (1483–1546) on a version of a popular print of nearly identical composition. That print is seen in various late nineteenth-century publications, but a version that dates to or before Kemmelmeyer's painting is yet to be found. The artist faithfully copied Luther's image, the swan, and some of the interior details. However, Kemmelmeyer "re-created" the loaded bookcases and upholstered and carved armchairs, table, and other details to suit his own taste. Luther is flanked by the Holy Bible on the floor at his proper left and a large white swan at his right. The sitter referred to himself as the swan whose coming John Huss (1370–1415) prophesied. The hourglass on the table beside Luther is a reminder of human mortality.

John Huss was an early religious dissenter who was excommunicated from the Roman Catholic Church and burned at the stake in 1415. His name "Huss" means "goose" in Bohemian, and "Luther" means "swan." Before his death in the flames, Huss was said to have had a vision that prompted him to exclaim, "You this day burn a goose, but a hundred years hence a swan will arise, whom you will not be able to burn" (Strobel, *Salzburgers and Their Descendants*, 150n).

1. From Durand's advertisement in the *New-York Gazette; or, The Weekly Post-Boy* (New York), Apr. 11, 1768.

2. William Joseph Williams, for example, gave such notice in the Charleston, SC, *City-Gazette and Daily Advertiser,* on Apr. 1, 1803: "Having suffered considerable inconvenience in consequence of several ladies and gentlemen, whose portraits he has in hands, and neglecting to attend to have them finished, many of whom are in this predicament for near two years; he therefore requests that those persons who know their portraits to be in this situation, will be good enough either to call and have them finished, or pay for them. William Williams." The next year Williams, in debt, was declared insolvent in a lawsuit by the Bank of the United States.

3. See chapter 4, pages 199–203.

4. For the portrait of Pinckney, see Ravenel, *Eliza Pinkney,* 231. The Tucker reference comes from the Bolling Papers, Flowers Collection, Duke University Library, Durham, NC. The Charles Willson Peale Family Papers are part of the holdings of the National Portrait Gallery, Smithsonian Institution, Washington, DC. The ongoing editing of these papers by Lillian B. Miller et al. has resulted in several volumes of *The Selected Papers of Charles Willson Peale and His Family* published by Yale University Press for the National Portrait Gallery: vol. 1, *Charles Willson Peale: Artist in Revolutionary America, 1735–1791,* 1983; vol. 2, *Charles Willson Peale: The Artist as Museum Keeper, 1791–1810,* 1988; vol. 3, *The Belfield Farm Years, 1810–1820,* 1991; vol. 4, *Charles Willson Peale: His Last Years, 1821–1827,* 1996; and vol. 5, *The Autobiography of Charles Willson Peale,* 2000.

5. The discrepancies in prices charged for portraits of similar sizes by artists like Theus, John Durand, and others support this notion, as does the varying degree of detail seen in portraits of similar sizes by a given artist.

6. Clients as well as artists often had sizable print collections, as documented by references in the Byrd, Manigault, and Drayton family records mentioned elsewhere in this study. Many of these pictures featured landscape and genre views as well as maps, botanicals, and natural history subjects. Colonists also advertised and purchased portraits of royalty and other notable persons and political prints.

7. Specialists in paint mixing were evident in London by the mid-1720s, but whether or not merchants who advertised as "colourmen" in the colonies were adept at mixing artists' paints to sell in pigs' bladders or glass syringes is unknown. The aluminum tube variety of oils was not introduced until 1841, although "cakes" for watercolor paints were available for many years before that date. Sets of watercolors with cakes were advertised in late eighteenth-century southern newspapers.

8. York County, VA, Records, Wills and Inventories 20, 1745–1759, 391, as found in the MESDA Craftsmen Database. Other seventeenth-century Virginia records reference a man by the name of Robert Orchard, but there is no evidence that he was related to Robert Orchard the painter. This information is courtesy of Sally Gant, MESDA Craftsman Database.

9. Hunter's *Virginia Gazette* (Williamsburg), Apr. 18, 1751.

10. For more on Cosmo John Alexander, see pages 291–294.

11. There are a variety of other spellings of the name in period documents, including Medecia, Meddsy, Medice, and Medicy. For his birth date, see Heitman, *Historical Register of Officers,* 387. Information on Cosmo Medici's army career is gleaned from numerous documents, including the following: "Pension Application of David Arnot (Arnold or Arnott) S41417," "Pension Application of Moses Upchurch S7776," and "Pension Application of Charles Upchurch S16562," transcribed by Will Graves, and "Pension Application of Joel Riggan (Riggins) W4322" and "Pension Application of Peter Callaway W10564," transcribed and annotated by C. Leon Harris, in Southern Campaign Revolutionary War Pension Statements & Rosters, accessed Oct. 10, 2011, http://southerncampaign.org/pen/. These applications are statements from men who served with Medici for all or part of their military terms.

12. According to Peale biographer Horace W. Sellers, George Washington Parke Custis was at Arlington House in August 1857 when he wrote Rembrandt Peale (1778–1860) a "tribute" to Peale's father, Charles Willson Peale, saying, "Honor to the memory of the Soldier Artist, who hung up his palette in the Spring, girded on his sword and fought a campaign in the War of Independence—then resumed his palette and painted the portraits of the general officers." As quoted in Horace W. Sellers, "Charles Willson Peale, Artist-Soldier," 257. Horace W. Sellers also noted that Peale, though still in military service, continued to keep his painting rooms for business in Philadelphia during the late 1770s.

13. Charles C. Sellers, *Portraits and Miniatures,* 141.

14. O'Kelley, *"Nothing but Blood and Slaughter,"* 39.

15. Purdie and Dixon's *Virginia Gazette* (Williamsburg), May 28, 1767, and Feb. 18, 1768; Joseph Jones Papers, 1681–1895, LCXVII, No. 3403, Duke University Library, Durham, NC; Ratcliff, *North Carolina Taxpayers,* 130; and Register, *State Census of North Carolina,* 73.

16. Curator's worksheet prepared by intern Molly Prince, CWF, ca. 1976, includes this information and other details on the portrait of Mrs. Howell Briggs (Lucy Gray Briggs).

17. Portraits of Gray Briggs and his wife Dorothy Pleasants Briggs are discussed on pages 288, 291. These pictures are strong attributions to John Durand and seem to have no stylistic relationship to the work of Medici. If the latter also created portraits of Gray and Dorothy Briggs, they are unknown today. MESDA files contain 1994 correspondence from a descendant, Marino de Medici, indicating the whereabouts of the two miniatures, but they were not at that location in 2012 and remain missing.

18. The recent and standard genealogical reference on the Derby family is *Dr. John Durand of Derby, Connecticut,* compiled by Alvy Ray Smith and published in 2003 as an imprint of the New England Historic Genealogical Society. Smith knows of no genealogical references to the artist John Durand (e-mail to author, Jan. 2008).

19. Records of the Painter-Stainers Company, Guildhall Library, Aldermanbury, London, UK, show that John Durand came from the parish of St. Martin in the Fields, Middlesex, and was fourteen years old when he commenced his apprenticeship. Parish records of St. Anne and St. Agnes, Aldergate, in the City of London, record the marriage of Jonas Durand and Elizabeth Holland (spinster) on Sept. 19, 1744. Information on Jonas as a pewterer from Records of the Pewterers Guild for 1685 in the collection of the Guildhall Library, Aldermanbury, London, UK. Information courtesy of Peter Ross, Guildhall Library, Aldermanbury, London, UK. See also Cooper, *Lists of Foreign Protestants,* 37, for Jonas Durand's, the artist's grandfather's, arrival in England in 1682/83.

20. See Giovanopoulos, "Legal Status of Children," 50.

21. 3 Aug. 1775, Will Registers, Records of the Prerogative Court of Canterbury, National Archives, Richmond, Surry, Eng., PROB 11/1010. In 1777, the son, John Durand, was still absent from London and debts to the estate matters were still open. John Durand is referred to in this document as a painter. London Metropolitan Archives, ACC/0265, 27 Jan. 1777.

22. Information courtesy of the Norfolk Museums and Archaeology Service, UK. Records of the Painter-Stainers Company, Guildhall Library, Aldermanbury, London, UK, suggest that Charles Catton ran a large shop with many apprentices. Between 1760 and 1785, apprenticeship bonds were issued for ten young men, two of whom were siblings, sons, or other relatives with the last name of Catton.

23. Kirker, "The New Theater," 37.

24. Purdie and Dixon's *Virginia Gazette* (Williamsburg).

25. The New-York Historical Society owns the ledger book. The Museum of the City of New York owns Durand's portraits of Richard Bancker (1728–1775) and Sarah Duyckinck Bancker (1731–1785) that are dated 1766 on their versos but are not signed by the artist.

26. See Beckerdite, "Immigrant Carvers," 247–248.

27. *New-York Journal; or, The General Advertiser* (New York City), Nov. 26, 1767.

28. Apr. 11, 18, 21, and 25 and May 2 and 5, 1768.

29. *Connecticut Journal, and New-Haven Post-Boy,* May 13, 20, and 27, 1768.

30. The Boush picture was probably executed in Norfolk, VA. Elizabeth Travis was related to the Barraud family, other members of which were also painted by Durand, including the 1770 dated likeness of Catherine Curle Barraud (Mrs. Daniel Barraud) (1730–after 1770)

and the 1774 or later portrait of her husband (dates unknown). Interestingly, the Barrauds were French Huguenots who immigrated to Norfolk via England. Their son, Philip Barraud, who moved to Williamsburg, VA, in 1782, was a close friend of St. George Tucker (1752–1827), another Durand subject. See Powers, *Barraud House Report,* 6–9.

31. Purdie and Dixon's *Virginia Gazette* (Williamsburg). Virginia's Speaker of the House of Burgesses in 1770 was Peyton Randolph, who lived on Nicholson Street. The still-standing Grissell-Hay House next door was then a "gentell" lodging house; presumably Durand was renting a house, or rooms, in the vicinity.

32. The receipt is in the Bolling Papers, Flowers Collection, Duke University Library, Durham, NC.

33. February [no day] 1780, Tucker-Coleman Papers, Special Collections, Earl Gregg Swem Library, College of William and Mary, Williamsburg, VA.

34. "Personal Property List Dinwiddie County, 1782," 250–251.

35. *Connecticut Journal* (New Haven), Apr. 13, 1785; *New-Haven Gazette and the Connecticut Magazine,* June 28, 1787.

36. "Records of Trinity Church Parish," 273.

37. This Robert Sully was the nephew of the better-known painter Thomas Sully (1783–1872) and his older brother, Lawrence Sully (1769–1804).

38. Dunlap, *History of the Arts,* 1:144. Dunlap and his correspondents rarely chronicled artists of Durand's rank, making the mention in Dunlap's history all the more revealing of what must have been a large number of pictures. That Sully recalled [Devereux?] Manley is curious, however, as no works by him have been identified, and Sully's reference implies that he was well-known.

39. When Alexander was eighteen years old, he copied one of his great-grandfather's portraits and signed it, giving his age and thus establishing his birth date. The inscription read: "A Prototypᵉ Georg Jameson, Depict. Cosmus Ioan. Alexʳ Pinxit. A.D. 1742 Aetatis suae 18." See Caw, *Scottish Painting,* 28.

40. Geddy based much of her genealogical information on Goodfellow's 1961 thesis, "Cosmo Alexander: The Art, Life, and Times of Cosmo Alexander." Unless otherwise noted, biographical information for Alexander is taken from Geddy and Goodfellow.

41. During his studies in Italy in 1712, John Alexander II went to Florence where he prepared the etchings. He and the artist Allan Ramsay both signed the indenture of the Edinburgh School of St. Luke in Scotland. The indenture, intended to create an early society to encourage the fine arts in Scotland, was short-lived. Ramsay was only sixteen at the time and one of only eighteen artists and eleven honorary members who signed. See Caw, *Scottish Painting,* 23, 28.

42. Chalmers, the son of Roderick Chalmers (active 1720s–1740s), a

heraldic painter, studied in Italy, where he met Cosmo John Alexander. Chalmers likely met his future wife through Cosmo. See Chalmers, "Sir George Chalmers," par. 3.

43. Caw, *Scottish Painting,* 48. The life dates for several of the Alexander and Chalmers family members may be inaccurate, and some are unknown. However, the preponderance of evidence indicates the lineage cited here.

44. Goodfellow, "Cosmo Alexander," 14–15 and 42, and Geddy, "Cosmo Alexander," 3. The Gibbs will gives "to Mr. Cosmo Alexander, painter, my house I live in, with all it's furniture as it stands with pictures, bustoes, etc." (as quoted in Goodfellow, "Cosmo Alexander," 42).

45. Goodfellow, "Cosmo Alexander," 42 and 63.

46. Geddy, "Cosmo Alexander," 74–78. Unfortunately, the photographed letter is difficult to read. Information about the owner and location of the original letter is not given, and thus the actual letter could not be consulted.

47. Strahan was a Scottish member of Parliament and a printer who became a well-known publisher. His clients included British intellectuals like Samuel Johnson and David Hume. In a January 1769 reply to Strahan, Governor Franklin mentioned that Alexander had "been for several weeks together at my house, and I employed him in doing as much painting as came to ninety Guineas, besides getting him business in that way from several of my friends." The governor went on to say that Alexander "was last year deprived of the use of his limbs by a fit of sickness but is since recovered & got to work again." Hart, "Letters from Franklin to Strahan," 445.

48. The chronology of Alexander's travels established by Geddy is based on the few known documented references and on portraits signed and dated by the artist. See appendix 1 in Geddy, "Cosmo Alexander," 72–73, and her "Catalogue Raisonné," 19–67, which lists twenty-one paintings.

49. Geddy, "Cosmo Alexander," 12.

50. Dunlap, *History of the Arts,* 1:165–166. Dunlap's reference to illness in addition to the one in the William Franklin letter of 1769 (see n47) suggests that Alexander's departure was influenced as much by his declining health as by the growing conflict between Britain and her colonies.

51. Geddy, "Cosmo Alexander," 14–16. "His friend Waterhouse" was Dr. Benjamin Waterhouse, who was eighteen years old when Cosmo Alexander arrived in Newport, Rhode Island. He began studying medicine in Newport and then went abroad to further his studies in London, Edinburgh, and Leyden. Waterhouse returned to America in 1782 when he joined the teaching faculty at the new Harvard Medical College in Boston. He was the first to test the smallpox vaccine in the United States.

52. According to Lawrence Park, in correspondence with the Frick

Art Reference Library, the picture was at Westover, home of the Byrds, and then was taken to Brandon, home of the Harrisons, when the daughter/granddaughter of the two sitters married Benjamin Harrison. Park indicated that it was sold, but when and to whom remains unknown. See Geddy, "Cosmo Alexander," 48–50.

53. See Geddy, "Cosmo Alexander," 51.

54. Dunlap, *History of the Arts,* 1:242.

55. South Carolina Wills, vol. 31, 1807–1818, for Mar. 20, 1811, as found in the MESDA Craftsman Database. Coram indicated in that document that he was thirteen years old when he arrived in Charleston. If he was fifty-four at the time of his death in 1811, he would have been born in 1756 or 1757, depending on his birth month. Whaley Batson's research presented in "Thomas Coram: Charleston Artist," the most recent study on Coram, includes much of the genealogical information from the MESDA Craftsman Database that is also cited here. Other important articles on Coram include Middleton, "Thomas Coram, Engraver and Painter," and Pringle, "Thomas Coram's Bible." Batson's research reveals that John Coram, the father, was a merchant in Charleston. He had two sons, John II and Thomas, the artist. John Coram II turned his store over to Thomas Coram in 1778 because he was leaving the colony. Batson notes that John the father was deceased by that time. "Thomas Coram," 35, 46nn4–5.

56. Dunlap, *History of the Arts,* 1:242. See also Batson, "Thomas Coram," 38–39. Batson summarizes the information from Fraser and notes that he may have written an editorial on Coram that appeared on May 3, 1811, in the *Charleston (SC) Times.*

57. The Reverend Thomas Bray, founder of the Society for Promoting Christian Knowledge (SPCK) and a colleague of the artist Charles Bridges, was also a close friend of Thomas Coram, the philanthropist. Bray was deeply interested in establishing a colony for the poor in the part of South Carolina that became Georgia. Coram probably became involved in this venture because of Bray.

58. Wagner, *Thomas Coram,* 182. Biographical information on Coram is summarized from this volume.

59. Ibid., 61, 149.

60. Ibid., 148. The practice was eventually stopped in favor of naming foundlings after historical figures and other notables.

61. Information courtesy of Erik J. Goldstein, curator of mechanical arts and numismatics, CWF.

62. *History of South-Carolina,* 269–270.

63. *Columbian Herald* (Charleston, SC), Nov. 26, 1784.

64. *South Carolina and American General Gazette* (Charleston), Sept. 10, 1778; Jan. 28, 1779; July 30, 1779, as found in the MESDA Craftsman Database.

65. *Royal Gazette* (Charleston, SC), Oct. 24, 1781, as found in the

MESDA Craftsman Database. The notice states, "Coats of Arms, etc., painted in a masterly manner either in oil or water colours."

66. Anne Coram is listed in the Charleston directories as late as 1816, as a widow living on Queen Street; her death is recorded as Oct. 5, 1825, in the *City Gazette* (Charleston, SC), Oct. 6, 1825, as found in the MESDA Craftsman Database.

67. South Carolina Treasury Records, 1783–1791, Journal, January 1783–May 1790, July 21, 1784, 40, as found in the MESDA Craftsman Database. Coram was also paid for engraving the seal for the Secretary's Office in 1792. See South Carolina Treasury Ledgers and Journals, Charleston, 1791–1865, Journal A, Apr. 10, 1792, 72, as found in the MESDA Craftsman Database. Coram was still doing this sort of work as late as 1804 when he was paid for an engraved silver seal for the Independent Congregational Church in Charleston.

68. *Charleston (SC) Evening Gazette,* Dec. 14, 1785.

69. *Columbian (SC) Herald, or The Independent Courier of North-America,* Nov. 23, 1786.

70. *City Gazette, or the Daily Advertiser* (Charleston, SC), Aug. 4, 1788. On Oct. 10, he "has several Valuable Paintings On hand, which will be disposed of in small lots."

71. Charleston Inventories, vol. E, 1810–1818, undated, 47, as found in the MESDA Craftsman Database. Batson indicates that Coram received "a full service" at St. Philip's Church on May 3, 1811, and that the church register states that he was 54 and died in an "apopoplectick Fit." "Thomas Coram," 39.

72. See page 297. Charles Fraser described this library as being highly specialized and as containing books pertaining to art and artists, including anecdotes written by Coram.

73. Coram probably knew this picture from a print source. When in Rome, West had made a copy of the same subject from a version painted by Raphael Mengs (1728–1779).

74. In addition to the portraits already mentioned, there may be a likeness of Jacob Sass (1750–1836), the Charleston cabinetmaker, who immigrated to the colonies in 1773. Its current location is unknown, but it was reportedly displayed or owned in the early twentieth century by the German Friendly Society in Charleston, SC.

75. Shames, *Old Plantation,* 19. The author notes that Connecticut antiques dealer Gary Stass was the first to recognize a stylistic relationship between the *Miss Breme Jones* and *The Old Plantation* pictures.

76. Ibid., 20–46.

77. Ibid., 47–49. The view of Tranquil Hill is owned by the Gibbes Museum of Art/Carolina Art Association, Charleston, SC.

78. John Rose, Will, undated, Probate Court, Charleston County, Will Book F, pp. 189-193, South Carolina Department of Archives and History, ser. L10125. See Shames, *Old Plantation,* 45–46.

79. See Gardner, "Portrait by John Mare," 61–62, and Craven, "Painting in New York City," 277–281.

80. Gardner, "Portrait by John Mare," 61–62. Gardner notes that the last reference to Mare in New York appears in a land conveyance record of 1795, although the record does not mention his whereabouts.

81. Parramore, *Launching the Craft,* 74 and 191n75. According to the minutes of Unanimity Lodge in Edenton, John Mare established his membership there on Jan. 27, 1777.

82. "John Mare: A Composite Portrait."

83. The convention was called to reestablish the Grand Lodge of North Carolina and elect its officers. This followed the years of disruption caused by the Revolutionary War.

84. Parramore, *Launching the Craft,* 88.

85. An unpublished article by Jerome Williams, "Williams Family of Craven County, NC," promotes this relationship and explores related details. The author, a descendent of the artist, has done extensive research on the family.

86. The picture, owned by the Mordecai House in Raleigh, is signed and dated on the back; the inscription includes "Maney's Neck," a town in Hertford County.

87. Dunlap, *History of the Arts,* 1:227. The author writes, "My father made an arrangement with Williams to teach me, but after two or three visits the teacher was not to be found, or if found, was unfit for service either from ebriety or its effects."

88. "The Collect" was a pond, also known as the Fresh Water Pond, located at the southern end of Manhattan Island. A favorite picnicking area in the eighteenth century, it originally covered about forty-eight acres. In the early nineteenth century, it was filled in.

89. Dunlap, *History of the Arts,* 1:227–228. Williams also worked in oil paints, but nothing is known of these pictures. The waist-length portrait of George Washington standing in Masonic regalia is the only known larger format by Williams. In addition to portraiture, Williams advertised teaching drawing in Fredericksburg in 1792, painting in Charleston in 1803, drawing and painting at his Newbern Academy in 1817, and painting signs and cornices in New Bern in 1819.

90. These various references to the travels and residences of Williams come from the MESDA Craftsman Database as extracted from *Colonial Mirror and Alexandria (VA) Gazette,* May 15, June 8, and Aug. 17, 1793; *Baltimore (MD) Daily Intelligencer,* Nov. 14, 1793, and Feb. 17, 1794; *City Gazette & Daily Advertiser* (Charleston, SC), Dec. 19, 1801, Nov. 8, 1802, Apr. 1, 1803, and Oct. 12, 1803; *Times* (Charleston, SC), June 3 and Nov. 8, 1802, Jan. 5, 1803, May 17, 1803, Oct. 18, 1803, and Jan. 18, 1804; *Virginia Herald, and Fredericksburg Advertiser,* Nov. 8, 1792, Jan. 3, 1793, Mar. 14 and Mar. 21, 1793, and July 3, 1794; *Centinel of Liberty & Georgetown (DC) Advertiser,* Oct. 13, 1797;

Carolina Federal Republican (New Bern, NC), Mar. 8, 1817; *Carolina Centinel* (New Bern, NC), Oct. 16, 1819, and May 27, 1820; *Norfolk and Portsmouth (VA) Journal,* Nov. 21, 1787; *Virginia Gazette, and Weekly Advertiser* (Richmond), Feb. 24, 1792. See also Charleston, SC, city directory for 1802, 1803, and 1806; and New York city directory for 1809, 1810, 1811, 1811a, 1812, 1812a, 1813, 1814, 1814a, and 1815.

91. *Times* (Charleston, SC), May 17, 1803, as found in the MESDA Craftsman Database.

92. Ibid., Jan. 18, 1804, as found in the MESDA Craftsman Database.

93. "Register of the Independent Congregational (Circular) Church of Charleston," 50.

94. For example, see Richardson, "William Williams," 23.

95. Dunlap, *History of the Arts,* 1:228.

96. *Carolina Federal Republican* (New Bern, NC), Mar. 8, 1817.

97. *Carolina Centinel* (New Bern, NC), Oct. 16, 1819.

98. Ibid., May 27, 1820.

99. *South-Carolina Gazette* (Charleston), Dec. 31, 1772.

100. Rutledge, *Artists in Charleston,* 120.

101. An illustration of that profile miniature can be seen at www .askart.com, accessed Oct. 30, 2011.

102. See Wallace, "Cultural and Social Advertising," under "Religious and Professional Advertising." Wallace places Aldworth's date of arrival in North Carolina as "toward the end of September, 1778," noting his advertisements in the *North Carolina Gazette* (New Bern) in October of that year.

103. *South Carolina and American General Gazette* (Charleston). The Boyle Aldworth name is not common in either America or England, but it is common to a family in Newmarket, County Cork, Ireland, in the eighteenth century. Unfortunately, no formal connection has been made with the artist.

104. *South-Carolina Gazette; and Country Journal* (Charleston), Oct. 23, 1770. The "Mr. Jackson" mentioned in this advertisement is unknown.

105. *South-Carolina and American General Gazette* (Charleston), Oct. 28, 1774. See also *South Carolina Gazette, and Country Journal* (Charleston), Dec. 5, 1769; Feb. 20, May 15, Oct. 23, and Dec. 4, 1770; Nov. 19, 1771; and Feb. 21, 1775; *South-Carolina and American General Gazette* (Charleston), Nov. 18, 1771, and Oct. 28, 1774; *South-Carolina Gazette* (Charleston), Feb. 13, 1775; all as found in the MESDA Craftsman Database. Baker Harris was a well-known organ, spinet, and harpsichord maker in London from about 1740 to 1780. He exported instruments to many places outside of England.

106. An early advertisement for the father indicates that he was from

London, where he was sworn in as a notary and tabellion public in 1736. *Boston (MA) Weekly News-Letter,* Oct. 1, 1747.

107. These ads appeared in various issues of Boston papers beginning on Oct. 1, 1767, in the *Massachusetts Gazette and Boston News-Letter,* for example, and continuing through June 29, 1778.

108. *Independent Ledger, and the American Advertiser* (Boston, MA), Sept. 18, 1780.

109. Wertkin, *Encyclopedia of American Folk Art,* 254.

110. William B. Jones, "Portraits of Richard and William Jennys," 67.

111. Saunders and Miles, *American Colonial Painters,* 275. See also Paine, *Early American Engravings,* 9.

112. *South-Carolina Weekly Gazette* (Charleston), Oct. 31, 1783. Rutledge, *Artists in Charleston,* 204, also cites Charleston advertisements for Nov. 1–4, 1783, and July 15, 1784.

113. *Gazette of the State of Georgia* (Savannah), Jan. 13, 1785, and Feb. 2, 1786; *Georgia Gazette* (Savannah), Feb. 11 and 25, 1790, as found in the MESDA Craftsman Database. Jennys seems to have made at least two trips to the West Indies, one before 1783 and one just prior to his 1786 advertisement in Savannah. More thorough research of his family background needs to be conducted, but it is worth noting that Jennys may have had family connections in the Leeward Islands through persons who may have been relatives. One reference is mentioned in Dexter, *Biographical Sketches,* who records that the daughter of a Richard Jennys of "Nassau, New Providence, Bahama Islands" married Algernon S. Jones in Hartford in 1812 (137). Another genealogical note on the Jennys family appears in Waters, *Genealogical Gleanings,* 1094, and cites the will of a Nicholas Coxe, proved on Nov. 16, 1765. Coxe mentions a niece, Elizabeth Jennys, who lived in England; a nephew, Richard Jennys (Elizabeth's brother), who lived in Boston (and who had a son also named Richard Jennys); and another niece, Rebecca Armstrong (Mrs. Martin Armstrong, sister of Elizabeth and the elder Richard Jennys), who lived in Jamaica, a West Indian island with regular shipping in and out of both Savannah and Charleston.

114. William B. Jones, "Portraits of Richard and William Jennys," 74–75, 89. Jones gives particular attention to the many different areas that both painters visited in the northern United States, sometimes together and often separately, until Richard's death in 1809. Jones documented that they were in the same cities and likely working as a team: in 1796, in Milford and Stratford, CT; in 1799, in Becket, MA; in 1801, in Rutland, VT; in 1803 and 1807, in Newburyport, MA. Jones points out that both painters also worked in New York State, New Hampshire, and Maine, either together or separately.

115. All information about Blyth is from Foote, "Benjamin Blyth, of Salem."

116. *Boston (MA) Evening-Post,* Dec. 9, 1771; Bentley, *Virginia Marriage Records,* 349; *Virginia Gazette, or the American Advertiser*

(Richmond), July 19, 1786, as found in the MESDA Craftsman Database.

117. "Frederick Kemmelmeyer," National Gallery of Art, Smithsonian Institution, http://www.nga.gov/cgi-bin/tbio?tperson=1433&type=a (accessed Oct. 30, 2011), based on the 1800 federal census that lists the artist as forty-five years or older.

118. *South-Carolina Gazette; and General Advertiser* (Charleston), July 26, 1783.

119. German St. John's Evangelical Lutheran Congregation of Charleston, South Carolina, Records, 1763–1787, translation, 99, as found in the MESDA Craftsman Database.

120. As noted in the Mormon *Family Search International Index,* vol. 5, and derived from the records of St. John Lutheran Church, Charleston, SC, located through the Family Search Page at http://www.familysearch.org/eng/search/frameset_search.asp?PAGE=/eng/search/ancestorsearchresults.asp, s.v. "Anna Kemmelmeyer."

121. The record was issued on Oct. 8 in Annapolis, MD, as noted in "Frederick Kemmelmeyer," National Gallery of Art, Smithsonian Institution, http://www.nga.gov/cgi-bin/tbio?tperson=1433&type=a (accessed Oct. 30, 2011).

122. *Maryland Gazette; or, the Baltimore Advertiser,* June 3, 1788; *Maryland Journal and Baltimore Advertiser,* Dec. 3, 1790, and Jan. 3, 1792; and *Baltimore (MD) Daily Repository,* Feb. 6, 1793; all as found in the MESDA Craftsman Database.

123. These references are mostly advertisements in local papers. There is little change in the artist's offerings; consult the MESDA Craftsman Database for details. Kemmelmeyer also worked in Chambersburg, PA, where he advertised in the *Franklin Repository* on Nov. 25, 1806. Information courtesy of Linda Crocker Simons, former curator, Corcoran Gallery of Art, Washington, DC.

124. *South Carolina Gazette* (Charleston), Dec. 12, 1774; *South Carolina and American General Gazette* (Charleston), Nov. 25 and Dec. 23, 1774; *Royal Gazette* (Charleston, SC), June 5, 1782; all as found in the MESDA Craftsman Database; Rutledge, *Artists in Charleston,* 121.

The Arts have always travelled westward, and there is no doubt of their flourishing hereafter on our side [of] the Atlantic, as the Number of wealthy Inhabitants shall increase, who may be able and willing suitably to reward them, since from several Instances it appears that our People are not deficient in Genius.

BENJAMIN FRANKLIN, JULY 4, 1771[1]

CHAPTER 7
Trained Painters for Discerning Consumers

The Revolutionary War for independence from Great Britain ended with the signing of a peace treaty and the formation of a democracy of independent states—the United States of America. Although historians have scrutinized the complex causes and results of the war in numerous ways, no single social, political, or philosophical theory has emerged from these studies to explain fully the war's impact on the lives of Americans in general or southerners in particular. Yet most scholars observe that the intellectual ideas leading to the American Revolution, as well as to the French, questioned rank and aristocratic birth as ideals out of which governance should be established and to which society should be subject. French philosophers exercised impressive leadership in examining such traditional ideals and in identifying others, ones that included individualism and civil rights such as are reflected in the protests of a captive ancient warrior: *"Civis romanus num"* ("I am a Roman citizen"). That phrase and others like it became popular during the period of the American and French revolutions and implied that certain rights should

accompany citizenship, irrespective of a citizen's birth, be it aristocratic or humble. The concepts of civil rights and human rights, as well as the notion of the common good, grew out of the same thinking and resulted in significant changes of all sorts, not just in America but also in England, France, and other European countries. However, neither all colonists nor all their European contemporaries welcomed the new thinking, much less the kinds of transformation it inspired. Many families with wealth and social status continued to adhere to old habits of material consumption and the desire for social prominence that had little to do with the common good.

The art world also experienced transformation, one that embraced classical models derived from many of the same ideas and that followed a similar cultural process. In painting, change was gradual at first, and it was particularly subtle among second- and third-rank painters. In America, the cultural milieu in which most artists worked remained dependent on European styles for inspiration. The classical or neoclassical style, as it came to be called, often included symbolic material and inference to a

greater degree than those styles that had preceded it, requiring more than technical painting knowledge. In addition to the inclusion of objects, settings, and sometimes clothing derived from antique sources, paintings were also greatly influenced by the work of old masters, many of whom were Renaissance painters.

The demise and disappearance of gentrified portraiture was also gradual, and, among studio-trained painters, any adoption of the new style was supported by the artists' considerable knowledge of painting methods. In such portraits, one observes a discernable shift from likenesses of "self-deception" (with sitters in elaborate "borrowed" attire and artificial poses mimicking European portraits of royalty and aristocrats) to likenesses that were often more pragmatic and conservative in taste, though still elegant and sophisticated in style. As the work of academic painters, especially those trained in London, became more common in America, minimally trained and trade-trained painters began to imitate what they observed in the work of their studio-trained counterparts, often with little understanding of studio techniques. This practice had always been the case in the colonies, but, during the late eighteenth century, the number of trained painters working in America increased dramatically, making their work more accessible to local artists.

As leading Americans and some Europeans embraced a more expansive and democratic approach to government associated with the republics of Greek and Roman antiquity, so art theorists also found inspiration in the material world of antiquity—its ruins, sculpture, and other art forms. The "antique world" (eclectically defined, as just noted, to include Renaissance works of old masters) was lauded for providing a correct and accurate vision of universal, ideal beauty. Painters effected that beauty, found in the world of the mind, through a greater concentration on form and drawing and with a different approach to color. The earlier baroque and rococo painting styles were replaced by neoclassical work that was more linear and more concerned with localized color, as opposed to the previously admired masses of shaded, radiant color and tonal

values. For American painters, London remained the center of painting style, and many of the artists who studied there would travel to the South, where coastal towns remained the artistic centers.

Many of the South's towns and cities had suffered from the Revolutionary War. As they quietly recovered through the resumption of full trade with Europe, they provided channels, just as they had before the war, through which the new country transacted its commerce. In the young Union, Virginia's towns of Norfolk, Richmond, and Fredericksburg were important cultural and commercial centers.[2] Baltimore, Maryland, emerged during the 1780s and 1790s as a major urban and mercantile center, becoming one of the largest cities in America by 1810; ultimately, a number of artists would look for work there. Before 1790, only a few artists seem to have lived in or visited Georgia and its growing metropolis of Savannah or the Annapolis area of Maryland. Smaller settlements and rural homesteads dotted the interior South, but most of these were not large centers with any real social, economic, or political prowess.

Little is known about painters who may have visited Florida, the sparse settlements in the South's western regions, or Louisiana's ports along the Gulf Coast during those years. In fact, the only painter whose work survives for that region is José Francisco Xavier de Salazar y Mendoza (ca. 1750–1802). About 1782, Salazar arrived in New Orleans and began to paint portraits for wealthy residents and local officials, including the likenesses of Bishop Luis Ignacio Maria de Peñalver y Cárdenas (1742–1810) (fig. I.1) and Officer Michel Dragon (1739–1821) (fig. I.2). Francisca de Salazar y Magana (1780–after 1802), Salazar's daughter, also became an artist and is said to have assisted in her father's studio. One signed work by her is known to survive. Salazar himself was still working in Louisiana as late as 1802; his work seems competent, judging by the two dozen pictures now associated with him.[3]

Above all, it was Charleston, South Carolina, that dominated the South's artistic activities both immediately before and after the war. For many years, Charleston had been one of the few major port cities in America

that had attracted the scrutiny of Europeans. Although at least one British officer described, probably honestly, the unsavory aspects of urban life in Charleston, most comments were flattering. For example, in 1742, Eliza Lucas Pinckney wrote to her brother that

> Charles Town, the Metropolis, is a neat pretty place. The inhabitants [are] polite and live in a very gentile manner; the streets and houses regularly built; the ladies and gentlemen gay in their dress. Upon the whole you will find as many agreeable people of both sexes for the size of the places as almost any where.

Eight years later, the Reverend John Martin Bolzius opined that the "splendor, lust, and opulence [in Charleston] has grown almost to the limit." In 1765, Pelatiah Webster made the following notes in his journal: "May 27. Spent in viewing the town. It contains about 1000 houses, with inhabitants, 5000 whites and 20,000 blacks." On June 18, having left Charleston, he commented that the town was "an agreeable & polite place in which I was used [treated] very genteely & contracted much acquaintaince for the time I stayed here. The heats are much too severe, the water bad, the soil sandy, the timber too much evergreen; but with all these disadvantages, 'tis a flourishing place, capable of vast improvement." In 1769, a "Capt. Martin, captain of a Man of War," delivered his assessment of Charleston in verse:

> Black and white all mix'd together,
> Inconstant, strange, unhealthful weather
> ..
> Musquitos on the skin make blotches
> Centipedes and large cock-roaches
> ..
> Men and women without thinking
> Every thing at a high price
> But rum, hominy and rice
> Many a widow not unwilling
> Many a beau not worth a shilling
> Many a bargain, if you strike it,
> This is Charles-town, how do you like it.[4]

7.1

In addition to written comments from travelers, Bishop Roberts's (d. 1739) subscription view (figs. 4.9 and 4.10) were probably the earliest effort to show Charleston's impressive 1737 waterfront. Thomas Mellish (active 1761–1778), a London marine painter who never actually went to Charleston, created another view that was engraved by "C. Canot" (Pierre Charles Canot, ca. 1710–1777) in 1762 (fig. 7.1).[5] In addition, Thomas Leitch (Leech) (active ca. 1755–1775), who worked in the colonies in the 1770s, painted a detailed prospect of Charleston, providing an accurate view of the busy seaport with its impressive skyline (fig. 7.2). The Leitch view, along with Samuel Smith's (b. ca. 1745) engraving after it, was yet another attempt to illustrate what that important seaport looked like just before the Revolutionary War.[6] The British attack on Fort Moultrie in 1776 inspired another round of views by both British and South Carolina witnesses, but those in no way illustrated

FIGURE 7.1. Pierre Charles Canot, engraver, after Thomas Mellish, artist, *A View of Charles Town the Capital of South Carolina in North America*, 1768, ink on paper, 13″ x 20½″. Yale Center for British Art, Paul Mellon Collection, USA/The Bridgeman Art Library Nationality.

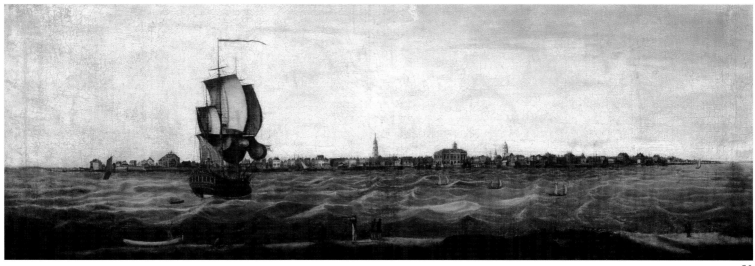

the commercially advanced city of Charleston and, by extension, its sophisticated wealthy class.[7]

The effects of the war, including British occupation, and the presence of European-trained artists in Charleston after the war did not diminish the desire for portraits and other pictures created in studios of well-known painters then practicing the neoclassical style abroad. South Carolina's wealthiest citizens continued to acquire portraits and, increasingly, other types of paintings from artists working in London, France, Italy, and elsewhere, artists such as Thomas Gainsborough (1727–1788), John

FIGURE 7.2. Thomas Leitch (Leech), *A View of Charles-Town*, 1773–1774, oil on canvas, 20″ x 66″. Courtesy of the Museum of Early Southern Decorative Arts (MESDA) at Old Salem.

FIGURE 7.3. John Francis Rigaud, *John Moultrie III and Family*, ca. 1782, oil on canvas, 77½″ x 60⅜″. © Image Courtesy Gibbes Museum of Art/Carolina Art Association.

The portrait includes John Moultrie III (1764–1823) and his wife, Catherine Gaillard Ball Moultrie (1766–1828), the daughter of Elias Ball of Wambaw plantation near Charleston. The Moultries were married in England in 1786 and continued to live there because of their Loyalist beliefs. The couple's son, George Austin Moultrie (1787–1866), is shown at his mother's side.

Francis Rigaud (1742–1810), Philip Reinagle (ca. 1749–1833), George Romney (1734–1802), and the London-based American painters Benjamin West (1738–1820) and John Singleton Copley (1738–1815).[8]

One of the most extraordinary portraits of Americans painted in England during this period is the *John Moultrie III and Family* by John Francis Rigaud (fig. 7.3). Born in Turin, Rigaud came from a family of Protestant merchants who, after the revocation of the Edict of Nantes, moved to Geneva. He studied in Florence, Bologna, Rome, and other areas of Italy on two occasions, and also in Paris for a short time, before going to London in 1771; he died in Warwickshire, England, in 1810.

During the lifetime of John Moultrie III, the painting hung in his estate in England. It did not go to Charleston until after his death, but it nevertheless illustrates how quickly the accrual of colonial wealth led to acquired gentility and material tastes. The subject was the son of Dr. John Moultrie Jr. and the grandson of Dr. John Moultrie, who went to South Carolina from Scotland before 1729. Dr. Moultrie was well educated. However, he and his family were neither gentry nor members of the aristocracy; rather they were middle-class people of property whose gentility and fondness for material quality matched their growing pocketbooks. The Moultrie family accrued its wealth through work, social connections, and, ultimately, marriages and political

appointments. Thus, by the early 1780s, John Moultrie III was able to commission a grand style portrait with all the trappings of high society. The concept of grand portraiture or elegant portraiture may seem, on first consideration, in conflict with the ideas of neoclassicism, but that was not necessarily the case. Wealthy sitters continued to

FIGURE 7.4. François-Xavier Fabre, *[Joseph] Allen Smith, Seated above the Arno, Contemplating Florence*, 1797, oil on canvas, 27¼" x 35⅛". Fitzwilliam Museum, University of Cambridge, UK/The Bridgeman Art Library Nationality.

Born in Montpellier, France, François-Xavier Fabre was one of the most talented students of French artist Jacques-Louis David (1748–1825). In 1787, he won the coveted Prix de Rome that allowed him to study in Italy for several years. He became a well-known neoclassical portrait and history painter and a member of and teacher at the Florentine Academy. Fabre's refined and subtle coloring and his deft handling of details, hallmarks of his work, are evident in this picture of Joseph Allen Smith (1769–1828). His flowing fabrics often have a velvety quality. Previous art historians have noted that the white robe draped around the sitter's body and over one shoulder may have been a type of cloak worn in the 1780s and 1790s by Italians and that Smith himself may have chosen the elegant composition (Jane Munro in McInnis and Mack, *In Pursuit of Refinement*, 134–135, and Aileen Ribeiro, *Art of Dress*, 222). The setting, which includes the remnants of an elaborate Corinthian cap from a column at lower right, and Smith's attire, which is reminiscent of the dress of ancient Rome, combine to make this a powerful neoclassical portrait.

FIGURE 7.5. François-Xavier Fabre, *[Joseph] Allen Smith Overlooking the Roman Campagna*, ca. 1797, oil on canvas (sketch), 7" x 8½". © Musée Fabre de Montpellier Agglomération. Photograph by Frederic Jaulmes.

François-Xavier Fabre's correspondence about Joseph Allen Smith's picture purchases mentions two portraits. This sketch may be a preliminary to the second portrait Smith had apparently commissioned from the painter. Figure 7.4 shows the other. A similar Corinthian column cap and an elaborate classical plinth are seen at right and left. Art historian Maurie D. McInnis has observed that the composition for this picture and likely that for figure 7.4 were derived from Wilhelm Tischbein's (1751–1829) portrait of *Goethe in the Roman Campagna*, painted between 1786 and 1788. She notes that the composition of the Fabre painting is nearly identical to the Tischbein, though the cloak in the Tischbein painting is white. (McInnis and Mack, *In Pursuit of Refinement*, 137.)

purchase expensive and stylish material goods, including clothing, paintings, and furnishings. What is new, that is, neoclassical, in this painting is the more relaxed nature of the sitters; the clear, precise delineation of all aspects of the picture; the realistic (though still somewhat idealized) portrayals of the sitters; and the prominent classical architectural features behind the subjects. The dress is elegant but not extraordinarily fancy. The picture, grand in scale, is also elegant, both in its conception and in its depiction of the sitters.

The occasion for European portraits had changed little from earlier years, and the Revolution itself provided an opportunity for some of the wealthiest southerners to acquire them. Those consumers left the colonies, moving to England or elsewhere, because they did not embrace the American cause. Some remained abroad, but others returned to America after the war when transatlantic transportation and commercial trade had safely resumed. In either case, many took advantage of the self-imposed interlude to acquire material finery, including portraits and other paintings, and to take a "grand tour,"[9] a phenomenon that had been in vogue for several decades. The tour afforded additional opportunity for exposure to neoclassical taste and for the acquisition of paintings—particularly in Florence and Rome, where a number of artists catered to both European and American travelers—as well as books and other items.

Political and social relationships forged during the war years and afterwards between America and its ally France led to a natural taste for French fashion in clothing, furniture, ceramics, and other items. Painters who lived in France or had French connections were among the first to develop a neoclassical painting style. They were also among the small cadre of artists engaged to do portraits for southerners, including Rigaud's group likeness of the Moultrie family and François-Xavier Fabre's (1766–1837) two likenesses of Joseph Allen Smith of Charleston, created in the late 1790s when the sitter was first traveling in Italy (figs. 7.4 and 7.5).[10] Smith, who returned to America in 1807, was the son of Benjamin and Mary Wragg Smith of Charleston. Jeremiah Theus (1716–1774) had painted his father's portrait, and, beginning in 1755, the

7.4

7.5

elder Smith served several terms as Speaker of the Commons House of Assembly. By the mid-eighteenth century, the Smith family ranked among the socially prominent in Charleston, but they had neither the wealth nor the influence of other large landholders, such as the Izards or Manigaults.

The two portraits of Joseph Allen Smith are exquisite, rich in classical detail and nuance. The larger one shows a seated Smith overlooking Florence across the river Arno. In the smaller painting, Smith is also seated, but he looks out over the Roman Campagna. In both pictures, he is alone as he ponders the fascinating world of ancient Rome. The poses may seem contrived and overly dramatized to modern viewers, but they accurately reflect the neoclassical genre that was part of the larger climate of philosophical and social change. The sitter also commissioned later works from Fabre, and he collected a variety of pictures including landscapes and mythological views on his several tours of Europe. Ultimately, his collection was given to the Pennsylvania Academy of the Fine Arts in Philadelphia, an institution that grew out of Charles Willson's Peale's (1741–1827) efforts.

As evidenced by Smith's portraits, leading artists of this period and a few from earlier periods in both France and England looked to the achievements of ancient art in Rome, Pompeii, and Herculaneum for inspiration—and, ultimately, for the fashioning of new theory.[11] The artists Raphael Mengs (1728–1779) and Pompeo Batoni (1708–1787), both of whom had their studios in Rome, were the consummate practitioners of the neoclassical style. In addition to painting portraits and mythological and religious pictures, they met with or taught many fledgling painters who traveled there, ultimately encouraging them to pursue the new theory of ideal beauty, which emphasized that beauty was not found in the world of nature but in the mind. True beauty was therefore universal and could be attained through thought and reason. The German art critic and archaeologist Johann Joachim Wincklemann taught that drawing and form were the principle elements of art and that color was subordinate because it tended to evoke the emotions. Classical sculpture (believed at that time to have been natural,

unpainted stone) quickly arose as the model for ideal beauty. Artists visiting Rome and other sites were encouraged to study antique sculpture as inspiration for their work, including history painting and other painting formats. The assertion in neoclassical painting that the clear and precise delineation of form took precedent over color and the richness of tone was a radical change from the theories of Sir Joshua Reynolds (1723–1792), president of the Royal Academy before Benjamin West. Reynolds had emphasized conception as being more important than either the delineation of form or the exact copying of details, and he had taught that the distinct colors of blue, red, and yellow (not those comprised by further mixing of shades) aroused the emotions or passions.

Interestingly, the American-born West was among the first to break some of Reynolds's painterly rules. Significantly, however, West and other painters adopted certain neoclassical ideas and techniques even while they retained others associated with Reynolds and with earlier eighteenth-century painting. For instance, West and several of his American students continued to use glazes and rich color techniques and atmospheric tones. Furthermore, West was as interested in modern history as he was in ancient, an interest reflected in many of his pictures. Later in his career, West also became interested in romanticism, and he was influential in the emergence of the romantic style in British painting.

The painters who studied abroad—either with West in London or with other teachers in Italy—before returning to America came to dominate the art market. However, they were not the first to offer more realistic, perceptive likenesses of the type often and perhaps erroneously associated with the neoclassical style. As early as the late 1760s, artists like John Durand (1746–after 1782) and John Hesselius (1728–1778), both of whom had painted for many years in a provincial rococo manner, were creating portraits in ways that captured their sitters' "true" likenesses. Whether Hesselius's and Durand's earnest approaches resulted from actual contact with European-trained painters or simply from seeing those painters' works in America is speculative. The latter may have been the case with Hesselius, Charles Willson

Peale's first teacher, who could have seen the pictures his former pupil created immediately after Peale's return to America in 1769, or, as discussed earlier, he may have been aware of John Singleton Copley's Boston or New York portraits. But, regardless of how older, resident painters came to know and offer more realistic likenesses, change was necessary if their businesses were to remain strong. In the South, painters of this rank served the expanding middle and lower middle classes while commissions from the upper middle class and wealthiest consumers went to academic, usually London-trained painters who understood neoclassicism. This general pattern continued into the early nineteenth century.

Benjamin West probably exerted more influence on painting in America than anyone living before or immediately after him, not only through commissions from wealthy Americans who wanted portraits by him but also through his teaching of eager young American painters. Most of the London-trained artists who worked in the South studied with Benjamin West. West was born in Springfield, Pennsylvania, the son of John West, an innkeeper, and Sarah Person West, his wife. The family later moved to nearby Newtown Square.[12] According to William Dunlap, West painted a number of portraits in Pennsylvania from 1746 to 1759. His work came to the attention of Dr. William Smith, provost of the College of Philadelphia, who provided for his education and introduced him to various well-connected families.[13] In 1763, after three years of studying the old masters in Italy, West went to London, where he soon drew the attention of King George III and received commissions to paint portraits of the royal family. In 1768, West cofounded the Royal Academy of Arts with Sir Joshua Reynolds, its first president. West himself served in that position from 1792 to 1805; he was reelected in 1806. He was well-known for his innovative neoclassical history pictures, including the modern historical view of *The Death of General Wolfe* (fig. 7.6), completed in 1771 and exhibited at London's Royal Academy that same year. The next year the king appointed West as his historical painter.

While West's style may have seemed too eclectic and even pedestrian for prospective clients such as Joseph Allen Smith, the transplanted American artist continued to fulfill important portrait commissions and to create history paintings in London until his death. His grand family portrait of Arthur Middleton and his wife, Mary Izard Middleton, with their son Henry Middleton of South Carolina is one of the finest surviving portraits for its era and place (fig. 7.7). The execution of the fabrics and other materials is precise and admirable, though the faces, while nicely done, are somewhat somber and wooden, a characteristic common to West's portraits. Arthur Middleton had studied first at St. John's College, Cambridge, and then at Inner Temple, London, where he studied law. He was undoubtedly familiar with West, for the artist had painted his brother Thomas Middleton (fig. 7.8) in 1770. Moreover, in 1763, Middleton's school friend Ralph Izard had commissioned *The Cricketers* (fig. 7.9).[14] A third portrait by West, showing a young man of about the same age in a similar pose, is thought to represent Thomas Middleton (ca. 1750–1779) of Crowfield, a first cousin. Finally, there is a portrait, presumably signed by West, which is thought to represent Henry Middleton (1717–1784), the father of Thomas and Arthur.[15] It is further known that George Izard, son of Ralph Izard, also commissioned a portrait of his father based on his image in *The Cricketers*. That picture, now privately owned, shows Ralph and the little dog standing in front of a classical wall carving.[16] With the two exceptions of West's 1767–1769 portrait of his student Charles Willson Peale (fig. 7.23) and his earlier likeness of Severn Eyre (fig. I.3), no other portraits by West for southern clients are known though they likely exist.

West's American students who returned and worked in the South during the last quarter of the eighteenth century figure prominently in the story of painting in the South. They include Henry Benbridge (1743–1812), Abraham Delanoy Jr. (1742–1795), Ralph Earl (1751–1801), Charles Willson Peale, Matthew Pratt (1734–1805), and Joseph Wright (1756–1793). Though not one of West's students, John Singleton Copley also figured prominently. Copley, as well as other eighteenth-century painters, painted well into the nineteenth century.[17]

Portrait painting in America was transformed by such artists and their clients, who in the last quarter of the

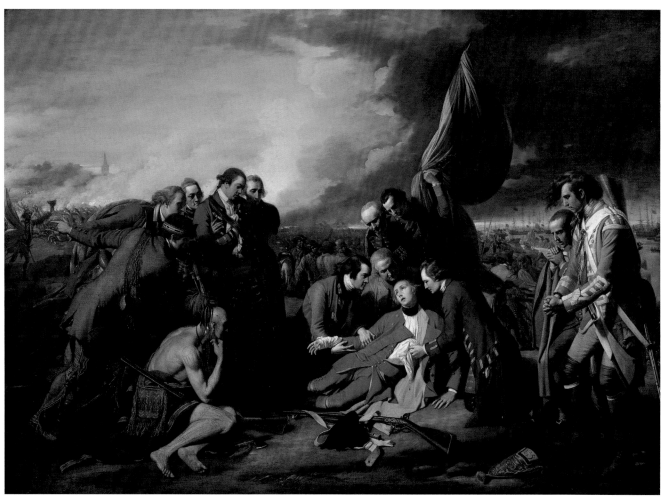

FIGURE 7.6. Benjamin West, *The Death of General Wolfe*, 1771, oil on canvas, 60" x 84½". Courtesy, photo © National Gallery of Canada. Transfer from the Canadian War Memorials, 1921 (Gift of the 2nd Duke of Westminster, England, 1918), National Gallery of Canada, Ottawa.

The painting is a contrived view of an event that occurred during the 1759 Battle of Quebec, an engagement of the Seven Years' War in which British General James Wolfe died. The composition has been analyzed by many historians and art historians who have pointed out the similarity between the death vignette at center and paintings of the Pietá, in which Christ is held by the Virgin Mary. They have also noted the kneeling Native American

at lower left, whose pensive pose is often associated with the concept of "noble savage." West made a copy of this picture for King George III in 1771.

FIGURE 7.7. Benjamin West, *Arthur Middleton, His Wife Mary Izard, and Their Son Henry Middleton*, 1772, oil on canvas, 60" x 71½". The Middleton Place Foundation, Charleston, SC.

The portrait was painted in London, where Arthur (1742–1787) and Mary (1747–1814) Middleton lived between 1768 and 1771. Their son Henry was born in 1770.

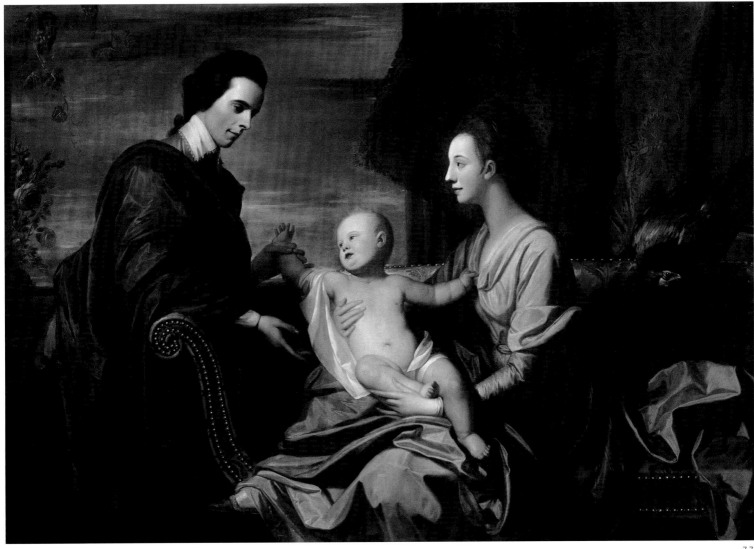

eighteenth century represented a broader range of the population, including a large number of wealthy middling merchants, planters, and trades persons. Most Americans of this class came to view themselves as being successful and respectable, more pragmatic and less socially stratified than the English gentry. Many of America's leading patriots, including its wealthy literati and cognoscenti, were interested in democratic rationalism—with its recognition of the individual and its rewarding of the individual's efforts—that grew out of European thinking and writings. Those

philosophers initially included Sir Isaac Newton, John Locke, and David Hume. Later in America, Benjamin Franklin, Thomas Jefferson, and others joined their ranks. Expatriates like John Moultrie III would not have been especially comfortable in America's wealthy middling social environment although others of his station were. In any case, the neoclassical style that developed in the hands of West's American students seemed especially well suited, for it recognized and sensitively interpreted the individual and his or her personality.[18]

FIGURE 7.8. Benjamin West, *Thomas Middleton of the Oaks*, 1770, oil on canvas, 51¾" x 39½". © Image Courtesy Gibbes Museum of Art/Carolina Art Association.

Thomas Middleton (1753–1797) was the younger brother of Arthur Middleton, shown in the family group portrait in figure 7.7. Like his brother, Thomas was educated in England where West painted his portrait in 1770. About the same time, West also painted a similar portrait of the brothers' cousin Thomas Middleton of Crowfield (ca. 1750–1779), now owned by the Middleton Place Foundation in Charleston. Both portraits show the young men in Vandyke-style dress, attire seen in earlier eighteenth-century pictures such as the portrait of Robert Carter by Thomas Hudson (frontispiece).

FIGURE 7.9. Benjamin West, *The Cricketers*, 1764, oil on canvas, 40" x 50". Private collection.

Recent research on this picture indicates that the sitters include, from left to right, James Allen (1742–1778) of Pennsylvania; Ralph Wormeley V (1745–1806) of Virginia (see also fig. 7.58); Andrew Allen (1740–1825), brother of James, also from Pennsylvania; Ralph Izard (1741/42–1804) of Charleston; and either Arthur Middleton (1742–1787) or, possibly, Peter Beckford (1739?–1811) of Dorset, England, and Jamaica. The picture's name is derived from the cricket bat held by Izard, who was noted as an avid sportsman. It is also referred to as *Ralph Izard and His Friends*, a more accurate title. (McInnis and Mack, *In Pursuit of Refinement*, 100–102.)

The facial expressions in this picture seem more animated than those in most other portraits by West, probably because the sitters were youthful and the setting informal. The picture also seems carefully designed, with special prominence given to the commissioner, Ralph Izard, who wears the brightest clothing and stands with his hat rakishly pushed back on his head.

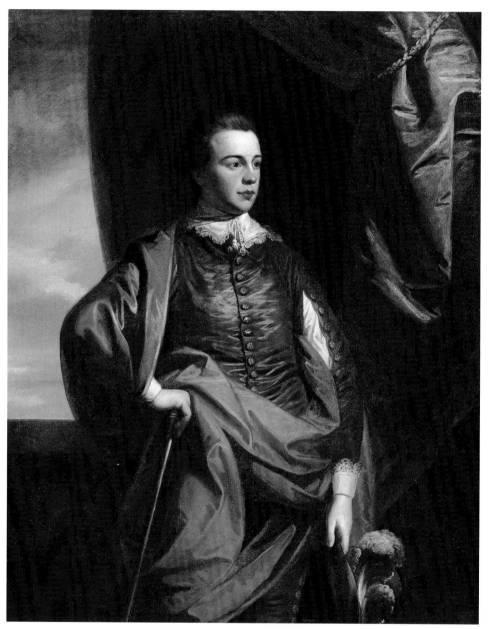

7.8

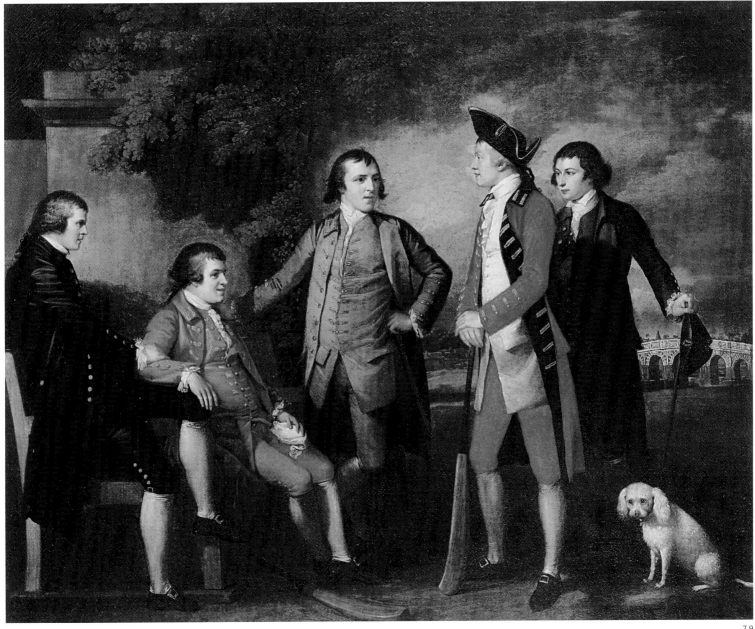

7.9

Though never a student in West's studio, the American-born painter John Singleton Copley received considerable advice and instruction via correspondence with West before meeting him in person in London. Copley would eventually complete portrait commissions for several South Carolinians, including the American statesman Henry Laurens (fig. 7.10), Mr. and Mrs. Ralph Izard (fig. 7.11), and possibly Peter Egerton Leigh (1711–1759). The details of Copley's life and career,

also widely known and published, need only summary here.[19] He was born in Boston, Massachusetts, the son of Richard Copley and Mary Singleton Copley, both of whom had emigrated from County Limerick, Ireland, two years before. After Richard died, Mary married Peter Pelham (1696–1751) in 1748. Pelham, who could draw and engrave, probably provided some early lessons and encouragement to his stepson although the older artist would never possess more than modest skills

7.10

7.11

John Singleton Copley painted this portrait following Henry Laurens's (1724–1792) release from the Tower of London in exchange for England's General Lord Cornwallis, who had been held by the Americans after he surrendered at Yorktown, Virginia. Laurens had been imprisoned since the fall of 1780 when he was captured by the British navy on his return voyage from Holland. At the time of the portrait, Laurens was not in good health, having suffered both emotionally and physically from imprisonment. His depiction celebrates an earlier time when he served as president of the Continental Congress. The documents on the table pertain to the ratification of the Congress's 1778 alliance with France that was formed under his presidency.

Laurens had been painted in bust length the year before by Lemuel Frances Abbott (ca. 1760–1802), an English artist. That painting is in the collection of the U. S. Senate, Washington, D.C.

Mrs. Ralph Izard was Alice Delancey (1745–1832), the daughter of Peter Delancey and Elizabeth Colden Delancey of New York. She met Ralph Izard through his friend and her cousin, Captain James Delancey.

The Izards' double likeness, like the two portraits of Joseph Allan Smith (figs. 7.4 and 7.5), contains a number of neoclassical decorative devices, including the carved and gilded details of the table, the black and red krater vase near the column above Ralph, the sculpture, and the view of the ruins of Rome's Coliseum in the background. Ralph holds a drawing of the statue, which he apparently discusses with his wife, who leans forward and lightly touches the edge of the drawing. If it were not for the light skin tones of the figures, her fichu, and the pale light grey of his suit, the Izards would not be the focal points of this otherwise elegant, aristocratic portrait but would instead be consumed in the mélange of furnishings and the exuberant damask drapery at upper right.

and lived only three years after marrying Mary Single-ton Copley.

Copley presumably learned about painting the way most American-born artists did: from seeing existing paintings and from observing resident or visiting portrait-ists, many of whom had similar backgrounds or training as trades painters. In Copley's case, some likely early teachers include Robert Feke (1705–1750?), who worked in Boston during the late 1740s to 1750 (see pages 247–255); John Smibert (1688–1751), who resided in Boston and died there in 1751; and Joseph Badger Sr. (1707–1765), who advertised as a house painter but who also did portraits in Boston (see pages 220–221). John Greenwood (1727–1792), who was painting in the Boston area during the late 1740s until he left in 1751 and likely knew Copley, is another possibility. However, Copley never acknowledged know-ing the work of those painters, and his son, the first Lord Lyndhurst, John Singleton Copley, later exaggerated the point when he wrote that his father was "entirely self-taught, and never saw a decent picture, with the exception of his own, until he was nearly thirty years of age."[20]

In 1766, Copley wrote to Benjamin West that "In this Country as You rightly observe there is no examples of Art, except what is to [be] met with in a few prints indiferently exicuted, from which it is not possable to learn much."[21] These were harsh and demeaning words, given all the painters who had worked in America before Copley, especially artists with some training, such as Smibert in his own hometown, John Wollaston Jr. (ca. 1705–after 1775), and several other skilled artists who were painting portraits elsewhere in the colonies. But Copley never tolerated what he considered mediocrity, even in his own work. An exceptional painter who learned quickly, he was highly motivated to perfect his painting to English studio standards. Family members remembered him as having great powers of concentration, and his contemporaries noted further that his success was achieved through long, intense hours in perfecting his work. He was, as his son wrote later to the American painter Samuel F. B. Morse (1791–1872), "entirely devoted to his art,"[22] and Copley's granddaughter commented that the artist often tried the patience of his sitters with long

sessions of posing, adding that "no persuasions, no complaints of fatigue, nor want of time, could induce him to hurry or neglect the most unimportant detail."[23]

To many clients in America, Copley's portraits far surpassed those of other known painters. One admirer wrote that no painter in America and probably in Europe exceeded him.[24] Copley's clear colors, his smooth, exact-ing brushwork, and his facility with glazes and small details are as amazing to viewers today as they were to his contemporaries. His ability to transform the three-dimensional world of sitters and their surroundings into radiant, realistic pictorial illusion still surprises his viewer. Such qualities fueled Copley's popularity in America, but, by English academic standards, his portraits were some-what unrefined. West, Sir Joshua Reynolds, and others in London who corresponded with the Boston painter between 1765 and 1773, criticized his version of painting "from nature" and his faithfulness to capturing real-world textures. In fact, it was often Copley's attention to very realistic detail and his brilliant coloring that West and others found troubling. West, commenting on *Boy with Squirrel,* Copley's portrait of his younger half-brother, Henry Pelham (1748/49–1806) (fig. 7.12), found the painting less than agreeable because, he said, of the effect

which arrises from Each Part of the Picture being Equell in Strenght of Coulering and finishing, Each Making to much a Picture of its silf, without that Due Subordanation to the Principle Parts, viz the head and hands. . . . Your Picture is in Possession of Drawing to a Correctness that is very Surpriseing, and of Coulering very Briliant, tho this Brilantcy is Somewhat missapplyed.[25]

What West meant was that the picture was too minutely detailed, the contrast of light and dark colors was too strong in terms of the new neoclassical style, and the colors were too bold for the sitter's flesh and its shadows.

Copley was receptive to such comments, but he found it difficult to achieve the qualities West recommended without firsthand training. He therefore set out in 1773 for Italy to examine the works of great painters; by the next year, he resided in England, where he had access to

West, Reynolds, and others for advice and criticism as he painted portraits. Within several years, Copley evolved a more painterly style, one usually lacking the slavish detailing and vibrant coloring of his American portraits. He also cultivated clients in order to earn a living so that his family could join him in England. Copley never returned to America, and, though he was successful in London, he never attained the same high rank there as Reynolds, West, and Allan Ramsay (1713–1784).

Like West's large portrait of the Middleton family (fig. 7.7), Copley's handsome 1775 portrait of Mr. and Mrs. Ralph Izard (fig. 7.11) is indicative of the sophisticated tastes of Charleston's elite. It was painted when both the sitters and Copley were in Rome. Various pieces of correspondence between Copley and Henry Pelham in the colonies in 1775 indicate that the artist was proud of this picture, which had drawn positive comments from another painter, Gavin Hamilton (1723–1798).[26] By comparison to the Middleton portrait, the Izard painting is more opulent and reflective of extraordinary wealth; it shimmers with various textures of rich fabric and gilded furniture, and it is replete with an elegant landscape view and mythological figures.[27] The faces, Mrs. Izard's in particular, are superior to the likenesses seen in West's painting. As noted earlier, while a student at Cambridge, Ralph Izard had commissioned *The Cricketers* from Benjamin West. By 1775, his wife, Alice Delancey Izard, was equally familiar with London art. Thomas Gainsborough had painted her portrait in 1772, the year after her marriage, and, two years later, Henry Spicer (1743–1804), enamel painter to the Prince of Wales, painted a miniature portrait of her.[28] Ralph Izard's sister and brother-in-law, Lady William Campbell (Sarah Izard, d. 1784) and Lord William Campbell (before 1736–1778), were painted by the Irish artist Nathaniel Hone (1718–1784), who was then working in London. In 1774 and 1783, the Ralph Izards commissioned miniature portraits of two of their daughters by the London artist Jeremiah Meyer (1735–1789), a German emigrant who was the miniature portrait painter to the queen and painter in enamels to the king. Finally, in 1785, Ralph Izard commissioned a portrait of himself from Johann Zoffany (1733–1810).[29]

7.12

FIGURE 7.12. John Singleton Copley, *Boy with Squirrel* or *Henry Pelham*, 1765, oil on canvas, 30¼" x 25". Photograph © Museum of Fine Arts, Boston. Gift of the artist's great-granddaughter, 1978.297.

Over a period of about nine years before 1775, John Singleton Copley sent examples of his work to London for comment and critique by Benjamin West and others. This was one of the pictures that West and Sir Joshua Reynolds commented on in 1766. Copley's realism, that is, his ability to create illusion and lifelike portraits, was the basis for his American popularity and the admiration of artists such as Matthew Pratt and Gilbert Stuart. *Boy with Squirrel* continues to be one of the most popular of Copley's portraits. It was undoubtedly a planned work, one that incorporated a variety of materials and textures that challenge artists even today—metals, glass, water, several different fabrics, wood, human flesh and hair, and fur. Copley illuminated these items in brilliant light that falls off into deep shadows, reminiscent of the work of several old masters. The graceful pose of Henry Pelham's (1748/49–1806) hand, cuffed in white and holding the delicate metal chain attached to the squirrel, and the reflection of light on the water and the glass and from those items to the table's surface are important, highly deceptive passages in this remarkable painting.

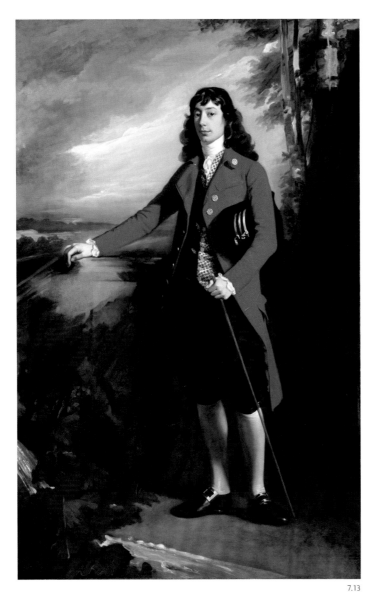

FIGURE 7.13. John Singleton Copley, *George Roupell*, 1779–1780, oil on canvas, 84" x 54". Detroit Institute of Arts, USA/ Founders Society Purchase, R. H. Tannahill Foundation Fund/ The Bridgeman Art Library Nationality.

In 1773, John Singleton Copley began his journey abroad to study art, traveling first to Italy. The next year he was in England, where he encountered a number of artists and found an environment where he could seriously pursue his art among masters. There he earned a living by painting a few history pictures but mostly portraits. He never returned to America, dying in England in 1815. The portrait style he developed in England is adequately represented in George Roupell's (1762–1838) likeness. Painterly in approach and lovely in its coloration, the Roupell portrait nevertheless lacks the intensity and crispness of Copley's American manner in the treatment of details and the sympathetic interpretation of character that is seen in his American portraits.

Ralph Izard's correspondence with various persons from 1774 to 1804 also demonstrates his knowledge of art and makes note of several of his paintings and his concern for their care. For example, having leased his London house during the period of his travels, he revealed his concern for his own pictures to George Dempster on August 8, 1774: "You mention nothing about my two pictures. The conversation piece, over the chimney, in the parlor, and Mrs. Izard's portrait, in the middle drawing-room. Will you be so good as to have them sent to Mr. West's, in Newman-street, and beg the favor of him to take care of them for me."[30]

The Ralph Izards were among a number of Charlestonians who took the grand tour. They arrived in England in 1771, traveling first to Italy and then, in 1777, to France. Copley became acquainted with them in Italy and accompanied them on trips to see ancient temples and other sites, including Naples and the antiquities of Rome. Their portrait reflects their interests and travels in many of its details: the classical figures representing Orestes and Electra, the Roman coliseum in the background, a classical vase at upper left, and details of the furniture.[31] Fortunately for those of us who admire Copley's American style, the Izard portrait was completed soon after the artist arrived in England and before he incorporated the softer colors and painterly techniques—advocated by London's academicians—that gradually replaced the freshness and brilliance seen in his colonial pictures.

Copley's other Southern portraits include the likeness of George Boone Roupell (fig. 7.13), completed in 1780, and the impressive 1782 painting of Henry Laurens (fig. 7.10). Roupell was the son of George Roupell (1726–1794) (see pages 154–156), the amateur artist and botanical illustrator in Charleston. Young George traveled to London with his father during the Revolutionary War years. He never returned to America and never claimed the portrait.[32] Henry Laurens was the son of a Huguenot immigrant who went to Charleston as a saddler and enlarged his income through other interests. Though the Laurens family had been in South Carolina for less than a century, its hard work had paid off in social and political status as well as in wealth. Henry

Laurens traveled to England to learn about commerce, returning to South Carolina in 1747 to become a wealthy merchant and rice planter. A political leader during the Revolutionary War, he served first as a delegate to and later as president of the Continental Congress. In 1779, the Congress named him minister to Holland to negotiate support for the war. He and the papers revealing his mission were captured en route by the British navy; he was arrested and imprisoned. Copley's portrait of Laurens was created shortly after the American statesman had been released.

The portrait of Henry Laurens is one of the artist's most powerful English paintings, and it reflects sensibilities that were true to Laurens. The fine furniture, fabrics, and architectural details assure us of the sitter's wealth and sophistication, yet they are far more subdued and conservative than those included in the Izard portrait. The late George C. Rogers Jr. best described Laurens and this likeness when he wrote that the "attitude of Henry Laurens was American, not European; it was republican, not aristocratic. Land and objects were to be acquired for use rather than ornament." Rogers went on to say that "Laurens did . . . have his share of vanity. . . . [and] wanted to be remembered by posterity."[33] This portrait, with Laurens elevated above the viewer on his conservatively ornate neoclassical chair and footstool, reflects what Rogers said.

The first of America's young painters to study with Benjamin West was Matthew Pratt, the son of a Philadelphia goldsmith. In 1749, he was apprenticed to his uncle James Claypoole Sr. (1721–1784), a glazier and local painter of portraits, signs, and houses who probably also ornamented other objects as a result of trade training.[34] Pratt was painting portraits for a living in Philadelphia by the late 1750s although the only identified early examples date to 1760–1763.[35] In 1764, Pratt escorted his cousin Elizabeth Shewell to London, where he remained to study or work for Benjamin West for two years before returning to America. Shewell was betrothed to West, and Pratt "had the pleasure of officiating, as father in the marriage ceremony." He also traveled with the Wests and lived in their house in Castle Street, Leicester Fields.

Pratt later wrote that West treated him "as if I was his Father, friend and brother."[36]

In 1765, just one year after his arrival in London, Pratt showed his now famous view of West's studio, *The American School* (fig. 7.14), at the Society of Artists.[37] Although there are awkward passages in the picture, particularly in some of the anatomical drawing, it nonetheless qualifies as an impressive conversation piece by an American-born painter with less than two years of formal instruction. West is thought to be the gentleman standing at left. The other students may be Abraham Delanoy Jr., Henry Benbridge (although some scholars believe he did not study directly with West), and, possibly, James Smith (ca. 1749–ca. 1794). Pratt is probably the artist seated at right with a palette, brush, and mall stick.[38] Scholars have analyzed the picture many times as to its iconography, purposes, and meanings.[39] Thomas Sully (1783–1872) wrote that the "picture . . . was so well executed that I had always thought it was a copy from West."[40]

Pratt studied with West for about two years and then went to Bristol, England, to paint portraits before returning to Philadelphia in 1768. He then painted in Philadelphia, New York, Virginia, and elsewhere although he failed to establish a strong clientele for his portraits, which are often modest in quality. Charles Willson Peale and other returning painters posed significant competition for Pratt beginning in the late 1760s. Unable to make a living by painting canvases, Pratt reverted to painting signs, a trade he undoubtedly knew well from his apprenticeship with James Claypoole Sr.

Pratt's presence in Virginia is documented through his known works and through this advertisement that he placed in a Williamsburg newspaper on March 4, 1773:

MR. PRATT,
PORTRAIT PAINTER,
Lately from ENGLAND and IRELAND,[41]
But last from NEW YORK,
HAS brought with him to *Williamsburg* a small but very neat Collection of PAINTINGS, which are now exhibiting at MRS. VOBE's, near the Capitol; among which are, first, a very

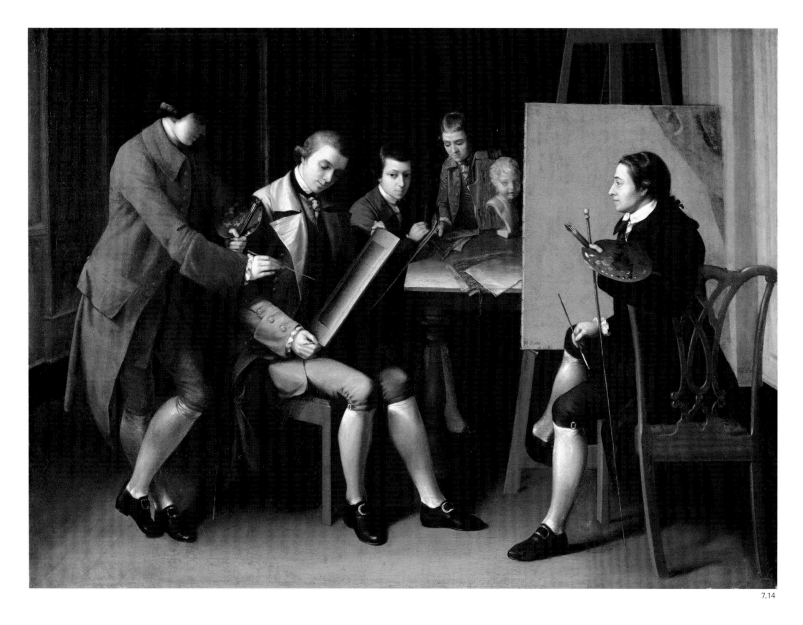

7.14

FIGURE 7.14. Matthew Pratt, *The American School*, 1765, oil on canvas, 30" x 50¼". Image © The Metropolitan Museum of Art/Art Resource, NY.

FIGURE 7.15. Antonio de Pellegrino Allegri (Corregio), *The Holy Family with St. Jerome*, ca. 1519, oil on panel, 27¹/₁₆" x 22¼". The Royal Collection © 2010 Her Majesty Queen Elizabeth II.

Corregio (1489–1534) created several paintings of this subject, one of which is thought to be the prototype for Matthew Pratt's lost version. This example was acquired by Charles I, dispersed from the Royal Collection during the reign of Oliver Cromwell, and reacquired by Charles II. Whether Pratt actually saw the picture in England is unknown; there were probably copies of it in other London studios.

good Copy of *Corregio*'s ST. JEROME [fig. 7.15] . . . ranks next to RAPHAEL'S TRANSFIGURATION. Secondly, VENUS and CUPID, the only Copy from an original Picture by Mr. *West,* whose rising Reputation has already done great Honour to *America*. Thirdly, a HOLY FAMILY. Fourthly, a Copy of *Guido*'s JUPITER and EUROPA [figs. 7.16 and 7.17], from the Original in the Collection of a Gentleman who travelled through *Italy* with Lord *Northampton*. Fifthly, FLORA, a Companion to the above. Sixthly, a very fine FRUIT PIECE. The above Pictures are to be disposed of at the Prices to be fixed on each Picture, on *Saturday* the 13th Instant, with a Number of choice PRINTS.

7.15

Mr. Pratt has a few Copies of some of Mr. *West*'s best Portraits, to be seen with the above every Day from ten o'Clock till five.[42]

Several days later, on March 18, Pratt placed a similar ad in the same paper and noted that prices could be obtained from John Lockley, who was a barkeeper, painter, plaisterer, and ordinary keeper in Williamsburg from 1773 to 1782.[43] He asked that anyone wanting to employ him should leave a note at the Williamsburg Post Office. Although he placed the ads in a Williamsburg paper, Pratt was actually in Richmond. He stated that he planned to spend the summer months in Hampton, Virginia. The importance of Pratt's ads goes beyond their documentation of his presence in Virginia, for they detail several types of art—old master copies, works by imminent contemporary artists, and pictures featuring neoclassical subject matter—once again proving that paintings other than portraits were available to southerners. That Pratt

does not offer explanation of these items suggests he assumed readers were knowledgeable about such art—an assumption that may have been a misjudgment on his part. The paintings may not have sold, for they were still there after Pratt's departure. The Jupiter and Europa picture is a rare survival of its kind in America (fig. 7.17).[44]

Only a few Virginia portraits by Pratt survive. Among them is a double portrait thought to represent Martha Parke Custis and her brother, John Parke Custis (fig. 7.18). Additional Pratt portraits in Virginia include Sarah Waters Meade (b. ca. 1750);[45] Thomas Bolling (fig. 7.19); and Elizabeth Gay Bolling (fig. 7.20) with the Bollings' twin daughters. Thomas Bolling's likeness is ambitious, a complex composition with the sitter in a standing position before a cloth-covered table; he leans forward on one of his books with shelves of other books in the background to the right. Both his likeness and that of his wife are ably painted and probably rank among Pratt's best Virginia works. Pratt's other surviving and important pendant portraits for Virginia include the likenesses of James Balfour with his son, George Balfour, (fig. 7.22) and Mary Jemima Balfour (fig. 7.21), James's wife (and George's mother). Like the Bollings, these are handsome paintings that demonstrate Pratt's neoclassical style in America.

Pratt had been in New York just before he came to Virginia;[46] his travels elsewhere are not well documented. During 1785, 1791, and 1793, he was listed as a limner or as a portrait and sign painter living on Pine Street in Philadelphia.[47] He died there in 1805.

The second American painter to study with West was probably Abraham Delanoy Jr. His life history has yet to be fully researched, but what is known is summarized here. There were at least two (and perhaps three) Abraham Delanoys in New York City during the 1760s, although only one advertises as "Jr." The painter was probably the Abraham Delanoy born in New York in 1742 who married Rachel Martling and who died in the mid-1790s.[48] The Abraham Delanoy who may have been the painter's father advertised his business of pickling oysters and lobsters from June 22, 1774, to May 4, 1775, in various New York papers.[49] The first advertisements posted by Abraham Delanoy Jr. appeared on January 25

7.16

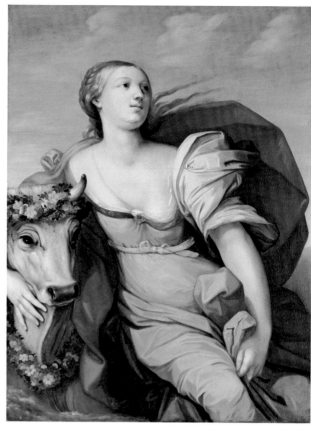

7.17

FIGURE 7.16. Guido Reni (1575–1642), *Jupiter and Europa*, 1636, oil on canvas, 58¼" x 40¹⁵⁄₁₆". Musée des Beaux-Arts, Tours, France/The Bridgeman Art Library Nationality.

The ancient myth of Jupiter and Europa's stormy love affair was a popular subject among Italian painters. Jupiter, who fell in love with Europa, deceived and abducted her by assuming the appearance of a tame bull. As she approached and petted the animal, he charged into the sea with her on his back, ultimately taking her to the island of Crete.

This is one of several nearly identical versions of the subject by Guido Reni. The Reni version that Pratt copied is thought to be the one owned by the Hermitage Museum in Russia. (Letter of Sept. 1, 1998, from Miles Chappell, Department of Art and Art History, College of William and Mary, Williamsburg, VA, to Barbara Luck, Curatorial Department, Colonial Williamsburg Foundation.)

FIGURE 7.17. Matthew Pratt after Guido Reni, *Jupiter and Europa*, probably 1770–1771, oil on canvas, 52¼" x 39¼". Colonial Williamsburg Foundation, Williamsburg, VA. Partial gift of William H. Cameron.

Matthew Pratt exhibited this picture in Williamsburg at Mrs. Vobe's Tavern (now the King's Arms) although he likely created it when he was in England. The picture did not sell in Williamsburg and remained in Pratt's estate until his death.

FIGURE 7.18. Matthew Pratt, *The Custis Children*?, 1770–1773, oil on canvas, 30" x 29½". Virginia Historical Society.

The sitters have been said to be Martha Parke Custis (1756/57–1773) and her brother, John Parke Custis (1754/55–1781), referred to in family papers as "Patsy" and "Jacky." However, if what is known of Matthew Pratt's career is accurate, their identity is probably incorrect. The younger of the children, the little girl, appears to be no older than seven or eight years, making the latest possible painting date 1765. Pratt left for England in 1764 and did not return until 1768. His work in Virginia is generally thought to date from about 1770. Perhaps these were children of the Bolling or Lee families through which the picture descended.

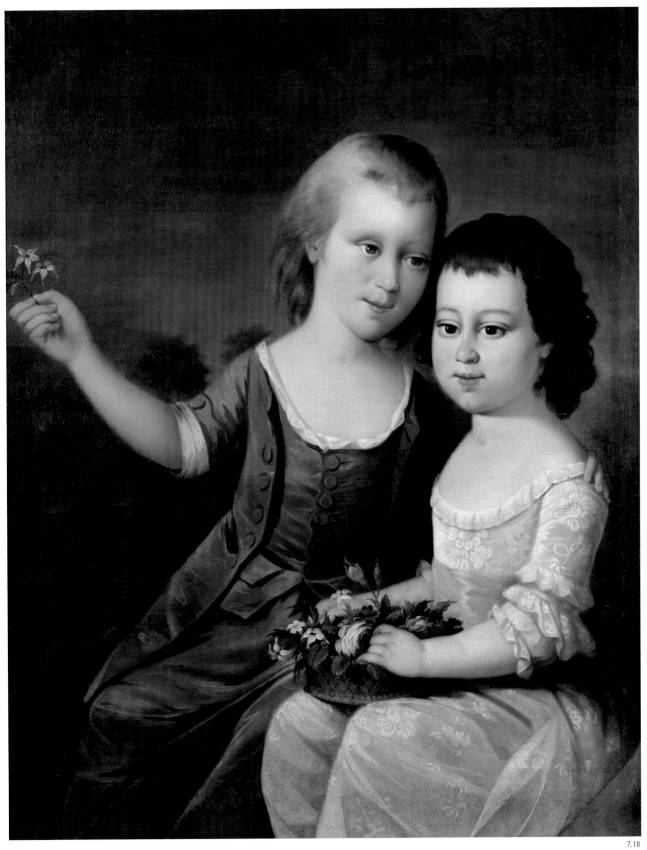

7.18

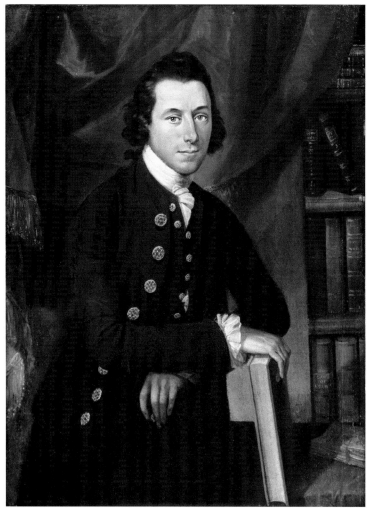

7.19

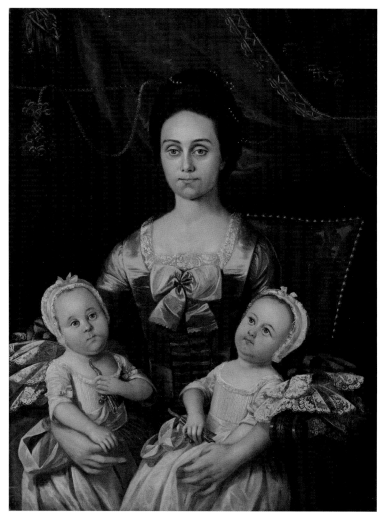

7.20

FIGURE 7.19. Matthew Pratt, *Thomas Bolling*, 1773, oil on canvas, 40¼" x 30⅛". Colonial Williamsburg Foundation, Williamsburg, VA. Gift of Mrs. Sarah G. Henry Willis in memory of Roberta Bolling Henry.

The portraits of Thomas Bolling (1735–1804) and his wife, Elizabeth Gay Bolling (1738–1813), with two of their children (fig. 7.20) are among the best Virginia portraits by Matthew Pratt. Thomas was the son of John Bolling Jr. and Elizabeth Blair Bolling. In addition to the twins, the subjects had several other children, three of whom, born with speech and hearing impediments, were educated with a specialist at Braidwood Academy in Edinburgh, Scotland. Early twentieth-century sources state that another child, William, assisted by John Braidwood of Scotland, the son of the Bollings' Edinburgh doctor, established a small school for the deaf in Virginia. It was the first American school of its type.

There are inconsistencies in the published genealogies regarding the identities of the children. Transcriptions from a family Bible on file at the Volta Bureau for the Deaf, Washington, D.C, identify the twins as Sarah and Ann (1772–1773) and the other children as Elizabeth (1758–1830); John (1761–1783, born deaf); Rebecca (1763–1826); Mary (1765–1826, born deaf); Thomas (1766–1836, born deaf); William Gay (1769–1771); Susanna (1771–1773); Archibald Blair (1779–1781); and William (1777–1845).

FIGURE 7.20. Matthew Pratt, *Elizabeth Gay Bolling* (Mrs. Thomas Bolling) *and Twin Daughters Sarah and Ann*, 1773, oil on canvas, 40⅜" x 30⅜". Colonial Williamsburg Foundation, Williamsburg, VA. Gift of Mrs. Sarah G. Henry Willis in memory of Roberta Bolling Henry.

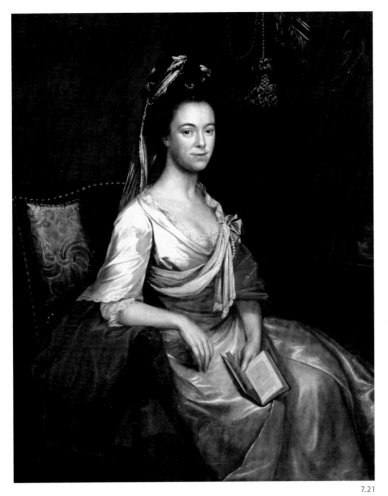

7.21

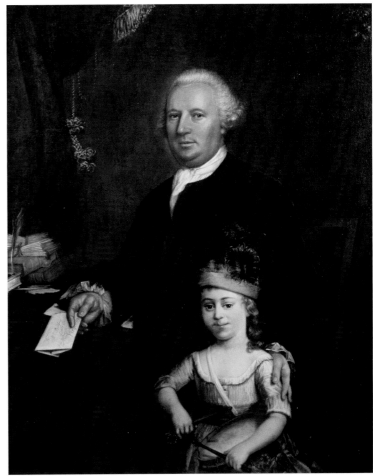

7.22

FIGURE 7.21. Matthew Pratt, *Mary Jemima Balfour*, ca. 1770, oil on canvas, 49″ x 39½″. Virginia Historical Society.

This elegant portrait of Mrs. James Balfour (d. 1785) ranks among the best of Matthew Pratt's known Virginia paintings. She wears portrait or studio costume, clothing especially contrived to give grace and a sense of richness and fashion to what might otherwise be ordinary trappings. Here, the effect is similar to that created by some of the clothing seen in Henry Benbridge's work in Philadelphia and Charleston. It is noteworthy that both painters had studied in Rome where such elegant attire was routinely incorporated into women's portraits.

FIGURE 7. 22. Matthew Pratt, *James Balfour and George Balfour*, oil on canvas, 49″ x 40″, ca. 1770. Virginia Historical Society.

Little is known regarding the origins of the Balfours although the name is common in both Scotland and Ireland. The father, James Balfour (d. 1775), came to Virginia about 1741 as an agent for the British mercantile house of Hanbury and Company, and he later formed a business partnership with Daniel Barraud that operated under the name of Balfour and Barraud. Balfour owned property at various times in Brunswick County and Elizabeth City County (now part of Hampton, Virginia), where he and his family resided. He served in various county positions. Son George (1771–1830), a surgeon who lived in Norfolk, first served with the U. S. Army and later became senior surgeon of the U. S. Navy.

and on February 1, 1768, and indicate that he had been painting in the city for an undetermined length of time:

ABRAHAM DELANOY, Junior, TAKES this Opportunity to inform those Ladies and Gentlemen that have proposed to favour him with their Commands, that he intends for the West-Indies in the Spring; it is therefore necessary that they apply speedily: He expresses his Acknowledgement to those that have employed him hitherto. He continues to paint Portraits at his Room in New Dutch-Church-street, near Col. Robinson's. His Name [is] over the Door.[50]

After this notice appeared, Delanoy probably went to South Carolina before leaving for the Islands if, in fact, he ever did go to the Caribbean. On November 14, 1768, he announced his arrival in Charleston to carry out the portrait painting business. His length of stay there is unknown, and no portraits by him have been identified. The Abraham Delanoy Jr. who advertised as a wholesale and retail merchant in New York City in 1771 and 1776 may have been the artist. Portraits attributed to him have been found for New Haven, Connecticut, where letters for him were being held in January and October 1786. He was back in New York City in 1789, at which time he advertised glazing and coach, sign, house, and ship painting on Maiden Lane.[51] He made no mention of portraiture in the last advertisement; perhaps he had given up that line of work. William Dunlap wrote about meeting Delanoy at that address: "[Delanoy] certainly had no inconsiderable knowledge of colours and the mechanical part of the art. . . . Mr. Delanoy's occupation, at this time, was sign-painting, and his poverty did not tempt to become a painter." Dunlap also wrote that Delanoy

had undertaken to paint a head of Sir Samuel Hood . . . and found himself puzzled to make a likeness that the sailors would acknowledge. In this dilemma the artist came to me. I took his palette, and with a bold brush dashed in the red face and hair, long nose, and little grey eyes of the naval hero. The sign swung amidst the acclamations of the Jack tars.

Dunlap makes no reference to Delanoy's later whereabouts or death.[52]

Charles Willson Peale (fig. 7.23), a native of Maryland, was probably the next American artist to study with West. His fame as a painter and as an American patriot was widely known during his lifetime and afterwards. Typical of the veneration in which he was held is George Washington Parke Custis's tribute to the artist, written in 1857:

Honor to the memory of the Soldier Artist, who hung up his palette in Spring, girded on his sword and fought a campaign in the War of Independence—then resumed his palette and painted the portraits of the general officers.[53]

The story of Peale's life is long and impressive, as is the body of artwork that survives by his hand. Numerous books and articles have been written about him, the family dynasty of painters he established in America, his interest in science and natural history as well as inventions, his work as an engraver, his establishment of two museums, and his many paintings.[54] Peale was a remarkable man of many talents and great intellectual curiosity. He was the son of Charles Peale, a schoolteacher, and Margaret Triggs Peale, who lived in the small town of Chester in Queen Anne's County, Maryland.[55] Around 1742, the father had lived in Annapolis, where he taught in the "Publick School" and married.[56] He died when Charles Willson was nine years old; Mrs. Peale supported herself and her five children by doing needlework in Annapolis. In 1753, Charles Willson was apprenticed to a wood carver and saddlemaker in the same town, and about ten years later he established his own saddle shop in Church Street, Annapolis. Peale also repaired watches and clocks and attempted silversmithing and casting brass. Tradition indicates that he exchanged a saddle for painting lessons from John Hesselius, who was also living in the Annapolis area. Sometime afterward, Peale also traveled to Boston to meet with and study the works of John Singleton Copley.

Once Peale returned to Maryland, it was not long before his portrait work drew the attention of some notable residents—the eleven gentlemen who subscribed seventy-four guineas and eight pounds to pay for Peale's studies under Benjamin West in London. The young artist left for England in 1767, spent two years working in

West's studio, and returned to America in 1769. While in London, he received his first southern commission. Edmund Jenings of Virginia charged Peale with painting the portrait of William Pitt, Earl of Chatham (fig. 7.24), as a presentation piece to several gentlemen from Westmoreland County. In 1766, Pitt had held the office of Lord Privy Seal and was a member of the House of Lords. The next year Charles Townsend, whom Pitt had appointed to the Exchequer, revealed his plan for imposing duties on tea, lead, glass, paper, and other commodities imported into the colonies. Townsend's plan was put into place without Pitt's approval and probably against his wishes. The resulting acts created a furor among the American colonists, adding considerable fuel to the growing dissention between Great Britain and her American colonies. Pitt was perceived as sympathetic to American interests and to the colonists' pleas to maintain fundamental liberties. Created in this context, the Peale portrait depicted an important British official who seemed to understand and support colonial concerns.

Jenings, who knew Peale, considered the commission a means of bringing attention to the young artist's work. Its arrival, along with a description of it, was published in Alexander Purdie's *Virginia Gazette,* Williamsburg, on April 20 and 21, 1769. The portrait was not taken from life but from a bust created by the sculptor Joseph Wilton (1722–1803), a founding member of the Royal Academy.[57] Pitt is shown as a statesman, classically attired in a red Roman toga over a light-colored tunic. Another classical motif used symbolically in the painting is the scroll he holds, inscribed at top "Magna Charta" (short for Magna Charta Libertatum, or the Great Charter of Freedoms), referring to the legal charter issued in England in 1215. Other classically influenced details include the female statue at upper left, representing Liberty as she holds a liberty cap on a pole, and the two heads (one reads "Sydney," the other "Hampden") on the stone altar holding the flame in front of Pitt.[58] The picture hung in the home of Richard Henry Lee and was still in the Lee family in 1825. It was moved to the Capitol building in Richmond before being returned to Westmoreland County where it was hung in the courthouse.[59]

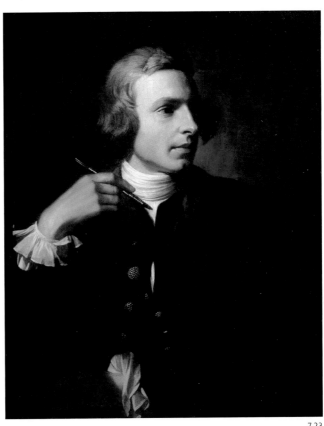

7.23

Despite the importance of the Pitt commission and its association with the American cause, it was criticized by Richard Henry Lee, in whose house, Chantilly, the picture hung for many years. Lee found Peale's paints unstable and prone to fading. Landon Carter had asked Lee to deliver a letter to Charles Willson Peale, and Lee responded to Carter on October 9, 1772:

FIGURE 7.23. Benjamin West, *Charles Willson Peale,* 1767–1769, oil on canvas, 28¼" x 23". Accession # 1867.293 Collection of the New-York Historical Society.

There are several self-portraits of Charles Willson Peale, but none are as sensitively painted as this likeness completed by Benjamin West when young Charles was a student in London. Peale's hand holding his paintbrush and the proper left side of his face are strongly lit, making them the two most important aspects of the picture. His face is striking, handsome with its perfectly sculpted and toned features, and his hand is relaxed and gracefully posed.

I am just now favored with yours covering a letter for M[r]. Peele. For the following reason I have returned the letter to you. So far as I am able to judge, I think M[r]. Peele has much merit in his profession, but in the article of mixing colors for duration, he would seem to be deficient, by the picture he has drawn of Lord Chatham now at Chantilly. The colors of that piece have greatly faded in the short time since it was drawn. I observe in your letter to M[r]. Peele that this is one of your capital objections to the copies that have been already taken of your mothers picture. This Gentleman may possibly have by experience improved in this material branch of his art, but this circumstance I am not acquainted with, and therefore concluded it the better way to submit the matter to your own determination. If in this respect he would answer, I think he would in every other, and perhaps there is much propriety in encouraging American Artists in America. I would beg leave to refer you to my brother Frank on his

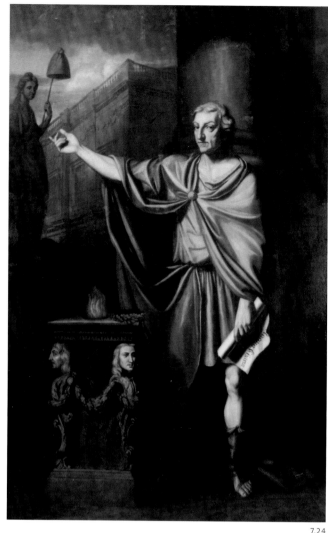

7.24

FIGURE 7.24. Charles Willson Peale, *William Pitt, Lord Chatham*, 1768, oil on canvas, 95¼" x 61¼". Property of the Westmoreland County Museum, Westmoreland, VA. Photography image by Opendoor Communications. Used with permission. All rights reserved.

Edmund Jenings, who issued this commission to Charles Willson Peale, knew that other images of William Pitt (1708–1778) had been and were still being imported into America. Both Peale and Jenings hoped that a mezzotint after the commissioned portrait might become popular. Indeed, some copies were sold, especially in America, though not in great numbers. Previous scholars have suggested two reasons for this lack of interest: first, a decline in Pitt's popularity as his leadership in England unfolded, and second, the public's preference for a different print that showed Pitt in regular dress and a wig. In 1774, Peale gave one other painted version of his Pitt likeness to its current owner, the state of Maryland. That version, according to Charles Coleman Sellers, Peale's biographer, was the first of the two to be painted. (Charles C. Sellers, *Portraits and Miniatures*, 172–173.) It probably served as the prototype for the signed and dated Westmoreland County one. The latter, shown here, is historically important, for it exemplifies the American recognition of Peale's artistry and demonstrates his familiarity with classical devices. However, it is relatively mediocre as a "portrait," limited in aesthetic appeal and lacking the colorful liveliness of his best portraits.

return from Annapolis, where he will have many opportunities of see M[r]. Peels performances, and knowing the opinion entertained of them there by the best Judges.[60]

In Maryland between 1770 and 1773, Peale began his large group portrait of his family, including his siblings, wife, and children (fig. 7.25). The artist's biographer claims that it was intended as an exhibition piece to be hung in the painting room or studio. It undoubtedly was in his studio, but Peale did not finish it until 1808. Five years later it was in the catalog for Peale's museum in Philadelphia, and the artist included that information in his signed inscription on the picture at right center. As the largest and most complex picture by the artist, it has

FIGURE 7.25. Charles Willson Peale, *The Peale Family*, begun between 1770 and 1773 and completed in 1808 or 1809, oil on canvas, 56½" x 89½". Accession # 1867.298 Collection of the New-York Historical Society.

Although the artist began this portrait in 1770, it sat unfinished in his studio until 1808. Writing to his son Rembrandt on September 11, 1808, Charles Willson Peale said, "I have the family picture on the easel and I have made some progress towards finishing it.... It is my ... hope of making it deserving a place in the Museum, which will prevent any disputes which might arise about the future destiny of it with my children." Clockwise from upper left, Charles Willson leans over the group and holds a palette in his hand; James Peale (1749–1831) sits in front of his brother Charles Willson; Margaret Jane Peale (1743–1788) stands beside her brother; Rachel Brewer Peale (1744–1790), the artist's wife, sits holding their daughter Eleanor, who died in infancy; Peggy Durgan (dates unknown), the family nurse, stands behind the next group; Elizabeth Digby Peale Polk (Mrs. Robert Polk, 1746/47–1773/77), another of Charles Willson's sisters, sits next to Margaret Triggs Peale (1709–1791), the artist's mother,

who holds in her lap Margaret, the artist's daughter who also died in infancy. Seated at the opposite end of the table at left is St. George Peale (1745–1788), another brother of the artist. Argus sits in front of the table. Argus died sometime on or before October 4, 1803, at which time someone in the family wrote an elegy in his memory:

> Full seventeen revolving years.
> Since first began his watchful cares,
> Their wonted course have run.
> We found him in a soldier's arms,
> Who weak and feeble asked alms,
> And gave him in return.

(The excerpt from Peale's letter, identification of the sitters, and the lines about Argus are all from Charles C. Sellers, *Portraits and Miniatures*, 157.)

The background shows part of Charles Willson's studio, located at his Philadelphia residence. Three plaster busts, along with part of a fourth, line a shelf at upper right. A partially completed and unidentified painting on the easel shows three female figures.

ten portraits as well as a likeness of Argus, the family dog, which was added sometime before October 4, 1803.[61] Writing about the picture that year, Peale said he had "very much improved several parts of it, having painted and improved the effect of the background, painted my head so that some likeness may be seen, which I was enable to do by coloring my plaster bust."[62] Although the many members of the family are crowded together in the composition, the painting is still seen as one of Peale's finest conversation pieces and one that provides a rare glimpse of the artistic interests of this family of painters.

Peale and his growing family lived in Annapolis before moving to Philadelphia in 1776. There he established a painting room in his home on Arch Street where he received sitters and finished the portraits that he had commenced while traveling. He continued to work in Maryland, and he also had clientele in New York, Virginia, and Washington City (now the District of Columbia), although the vast majority of his pictures were painted in the Baltimore and Philadelphia areas. He was successful, and, after Copley's departure, he soon became the chief portrait painter in the colonies.

In America, Peale's painting skills were admired by many, as were his gregarious, affectionate personality and his loyalty to American interests. He shared with middle-class Americans a desire for achievement and financial success, and he was devoted to advancing the arts in America. In his now famous and often-quoted 1771 letter to Benjamin Franklin, Peale wrote: "The people here have a growing taste for the arts, and are becoming more and more fond, of encouraging their progress amongst them." Franklin, in his equally well-known reply, concurred: "The Arts have always travelled westward, and there is no doubt of their flourishing hereafter on our side [of]the Atlantic."[63]

Much of Peale's energy and enthusiasm for his native country and its citizens is reflected in his portraits and other pictures. His likenesses of Mr. and Mrs. Robert Gilmor of Baltimore (figs. 7.26 and 7.27), painted in 1788, are superior examples that portray the intelligence and strength of two Baltimoreans who were interested in the

arts. One of their sons, Robert Gilmor Jr., formed an impressive art collection that is well-known among scholars.[64] Peale used soft coloring and provided crisp, firm modeling in these likenesses; in both their simplicity and their pragmatism, they epitomize the artist's fully developed brand of the neoclassical style. Peale's American style was substantially different from the neoclassical one he found in proffered theories and saw realized in West's studio. Writing in November 1772 to John Beale Bordley, one of the gentlemen who helped to finance his studies abroad, Peale confessed his shortcomings, saying,

My reputation is greatly increased by a Number of New Yorkers haveing been here, who have given me the character of being the best painter of America—that I paint more certain and handsomer Likenesses than Copley—what more could I wish—I am glad I can please . . . But Sir how far short of that excellence of some painters, infinately below that perfection, (*which I have some Idea*) that even portrait Painting I have seen may be carried to in a Vandyke My enthusiastic mind forms some idea of it but I have not the Execution, have not the ability, or am I a Master of Drawing—what little I do is by mear immatation of what is before me, perhaps I have a good Eye, that is all, and not half the application that I now think is necessary—

Peale continued his letter by noting that he was not well acquainted, as some artists were, with classical models (see page 21).[65]

In 1775, as war approached, Peale again wrote to Edmund Jenings[66] in London about his business, this time expressing concern about his career in words that also indicated the true patriot he was: "I rejoice that the times have allowed me to do so much but alas, I fear I shall have no more to paint, and I well remember your once telling me that when my brush should fail, that I must take the musket and I believe you foresaw all that has since happened." In the same letter, he described General George Washington as "uncommonly modest, very industrious and prudent."[67] Beginning in 1772, Peale painted Washington's portrait approximately forty-five times. These were oils on canvas or panels of varying sizes

(fig. 7.28). Some of the portraits were commemorative in nature—and thus monumental in size—such as the famous picture of the general that hung for more than one hundred years at Shirley plantation (fig. 7.29).[68] Other versions include miniature and cabinet-size portraits (fig. 7.31).[69] Both Charles Willson and his brother James created small views such as the one of Washington and the generals standing on the shores of Yorktown, Virginia, after the American victory there (fig. 7.32).

Although the story of Charles Willson Peale's seven sittings from life with Washington from 1772 to 1795 is not particularly well-known from American art history surveys, it constitutes an important chapter in southern painting.[70] What is known about the earliest of these sittings comes from an unlocated manuscript written by Peale in his later years that was probably edited and reduced in detail by Rembrandt Peale (1778–1860), who issued a shorter summary in his circa 1858 pamphlet titled *Portrait of Washington*. Additional information comes from George Washington Parke Custis's *Recollections and Private Memoirs of Washington* and an unpublished lecture by Rembrandt Peale titled "Washington and His Portraits."[71]

The 1772 three-quarter-length portrait by Charles Willson shows Washington as a young colonel serving in the Alexandria militia (fig. 7.28). Various anecdotes have been put forth by members of the Peale family about the artist's visit to paint the likeness although none can be verified by Peale's writings. We do know that two years later, Peale had formed a clear impression of Washington when he wrote:

> I am well acquainted with General Washington, who is a man of very few words but when he speaks it is to the purpose. What I have often admired in him is he always avoided saying anything of the actions in which he was engaged in [the] last war. He is uncommonly modest, very industrious and prudent.[72]

In May and June 1776, Peale met with Washington again, this time in Philadelphia, to paint portraits of both the general and his wife. The general and the artist met at Washington's headquarters, then located at Pennypacker's Mill in present-day Montgomery County, Pennsylvania. The 1777 sitting for a miniature portrait for Martha Washington was completed on September 28, the day after the British, led by Lord Cornwallis, had taken Philadelphia. These paintings were commissioned by John Hancock, then president of the Congress, and were taken to Boston. The Brooklyn Museum in Brooklyn, New York, eventually purchased Washington's likeness.

The remaining four sittings for portraits were, like the 1776 one, held in Philadelphia. From the originals

FOLLOWING PAGES

FIGURE 7.26. Charles Willson Peale, *Louisa Airey Gilmor* (Mrs. Robert Gilmor) *and Her Daughters Jane and Elizabeth*, dated 1788, oil on canvas, 36″ x 29″. Colonial Williamsburg Foundation, Williamsburg, VA. Bequest of Mary Mercer Carter Stewart Vivian.

Louisa Airey Gilmor (1745–1827) is shown with her two daughters, Jane (1780–1804) and Elizabeth (1779–after 1848). According to Charles C. Sellers, Robert Gilmor bequeathed these portraits (i.e., figs. 7.26 and 7.27) to one of his daughters as "the Portraits of her Mother and myself Painted by Peale in 1786" (as quoted in *Portraits and Miniatures*, 87). The date cited in Sellers is incorrect, and the children are not mentioned as being in the portraits, probably an oversight, for no other likenesses of the parents are known.

FIGURE 7.27. Charles Willson Peale, *Robert Gilmor*, dated 1788, oil on canvas, 36⅛″ x 29⅛″. Colonial Williamsburg Foundation, Williamsburg. VA. Bequest of Mary Mercer Carter Stewart Vivian.

Robert Gilmor (1748–1822), a merchant and the son of a prosperous merchant, was born in Paisley, Scotland. He came to America in 1767, living first in St. Mary's County but moving to Baltimore in 1778. After forming a successful merchant partnership with two gentlemen in Philadelphia, Gilmor worked abroad for the firm and became a specialist in foreign commerce. His business grew through contacts he made there, and eventually he joined in partnership with his son Robert Jr., who became famous as an art collector and connoisseur in Baltimore. (Clayton C. Hall, *Baltimore*, 624–625.)

Gilmor paid the artist thirty guineas for two portraits (i.e., figs. 7.26 and 7.27) in 1788, the year the artist signed and dated them.

7.26

FIGURE 7.28. Charles Willson Peale, *George Washington*, dated 1772, oil on canvas, 50⅜″ x 41″. Washington-Custis-Lee Collection, Washington and Lee University, Lexington, VA.

This portrait, signed by the artist in 1772, was commissioned by the sitter, George Washington (1732–1799); Charles Willson Peale traveled to Mount Vernon, Washington's Virginia home, for the sittings. Washington wrote about those in his diary: "[May] 20. . . . I sat to have my Picture drawn"; "[May] 21. . . . I set again to take the Drapery"; "[May] 22. Set for Mr. Peale to finish my face" (as quoted in Charles C. Sellers, *Portraits and Miniatures*, 218). Washington paid £18 4s. to Peale, who left Mount Vernon in late May or early June; he also painted portraits of Mrs. Washington and her two children at the time.

FIGURE 7.29. Charles Willson Peale, *George Washington*, 1780, oil on linen ticking, 96¼″ x 61¾″. Colonial Williamsburg Foundation, Williamsburg, VA. Gift of John D. Rockefeller Jr.

In 1779, the Supreme Executive Council of Pennsylvania commissioned a portrait of George Washington to honor him and the various American victories he had won during the Revolutionary War. The result was the grand original painting now hanging in the Pennsylvania Academy of Fine Arts in Philadelphia. The painting, America's first "state portrait," was an immediate success, and it quickly came to serve as the basis for numerous replicas that were shipped to foreign dignitaries and private owners in this country. Charles Willson Peale's ideas for the portrait were undoubtedly drawn from many sources, including his personal experience with, and the known histories of, the battles of Trenton and Princeton. The composition was carefully designed to contain many symbolic elements relating to the war and to Washington's victorious leadership. The general stands in a dignified, relaxed, and quietly confident pose, with his hand resting on a canon, a powerful instrument of war. The British ensign flag lies fallen to one side on the ground, as do several others captured by American forces. A soldier holds the general's horse just behind him, and as far as the eye can see on the left is the Princeton battlefield, some of the college buildings, the debris of war, and the marching of captured British soldiers. American victory is impressively celebrated here, but the picture is not pretentious. It captures much of Washington's character as a gentleman, and it shows him resolute, having led and won battles but remaining vigilant. Though this portrait is signed and dated by the artist, many others are not; they are usually assigned dates according to changes made to the uniform details, the backgrounds, and the flags. For example, this version shows stars with ribbons on the epaulettes instead of rosettes, a change ordered by the general on June 17, 1780. The ribbons were eliminated sometime before August, 1780, making it possible to confirm the portrait's date between then and June 17, 1780. (Charles C. Sellers, *Portraits and Miniatures*, 225–230.)

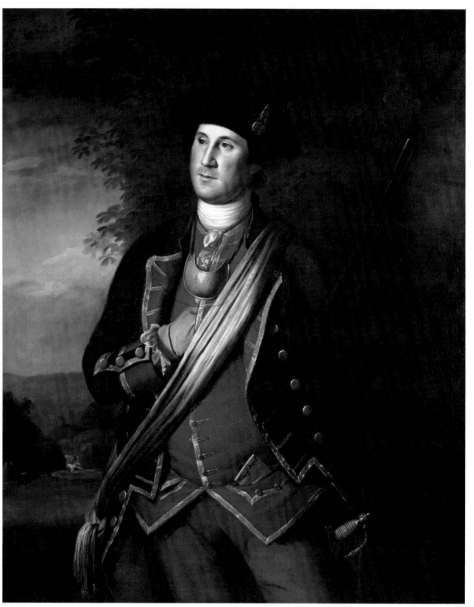

7.28

completed during the seven sittings, Charles Willson Peale painted many replicas. So too did others in the family, namely James Peale (1749–1831) (who also painted Washington twice from life), Rembrandt Peale, and Charles Peale Polk (1767–1822). Charles Willson, who had great admiration and respect for Washington, wrote in his diary that he visited Mount Vernon in 1804: "To me it was a mixture of pain to reflect that in this room I

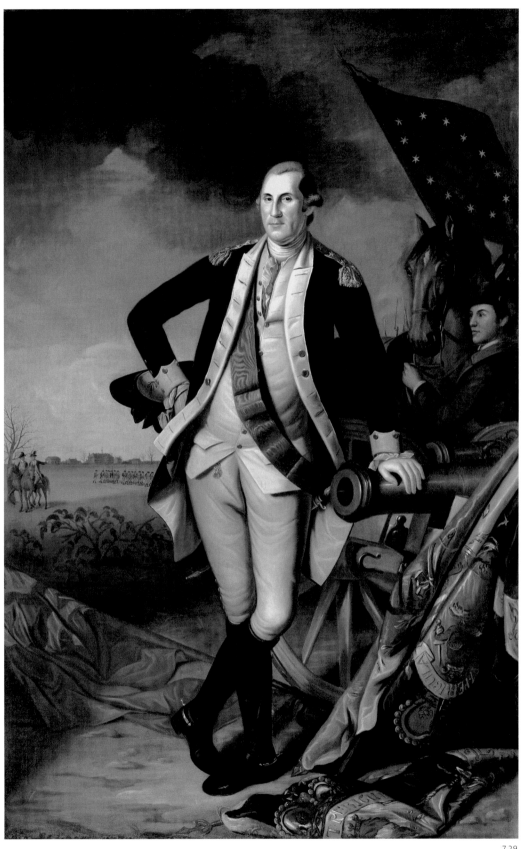

7.29

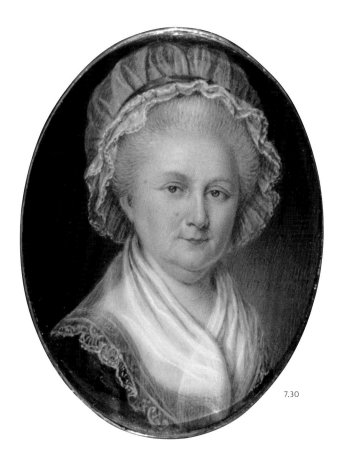

7.30

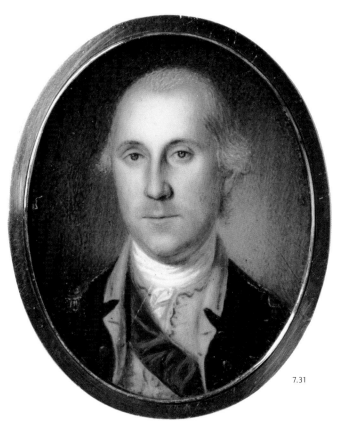

7.31

FIGURES 7.30 AND 7.31. Charles Willson Peale, *Martha Dandridge Custis Washington* and *General George Washington*, 1776, watercolor on ivory, each 1¹¹⁄₁₆" x 1³⁄₈" oval. Courtesy of Mount Vernon Ladies' Association.

These two miniature portraits were created in 1776, probably at the request of Mrs. Washington (Martha Dandridge Custis Washington, 1731–1802). She was the daughter of John Dandridge and Frances Jones Dandridge. Her first husband, Daniel Parke Custis, died in 1757. They had several children, including Daniel Parke Custis Jr., Frances Parke Custis, John "Jacky" Parke Custis, and Martha "Patsy" Parke Custis. For an earlier portrait of Martha from her previous marriage, see John Wollaston Jr.'s likeness in fig. 5.25. The receipt for these miniatures is in the collections of the Virginia Historical Society, Richmond, Virginia.

FIGURE 7.32. James Peale, *Washington and His Generals at Yorktown*, 1781–1790, oil on canvas, 20³⁄₈" x 29⁵⁄₈". Colonial Williamsburg Foundation, Williamsburg, VA.

In July 1781, General Charles Lord Cornwallis was ordered to establish a coastal base in Virginia as an embarkation point for British troops. After reviewing several possibilities, Cornwallis selected Yorktown to the south and Gloucester Point on the north side of the York River's narrowest point. Both areas were fortified by the British. General George Washington's forces converged on the southern Yorktown side in September 1781 to begin the siege on British forces that resulted in Cornwallis's October surrender. The several versions of this little painting show Washington and five men, his generals, standing at right and northwest of the village of Yorktown; a few intact ships and other sunken ones in the middle ground; other battle debris on the beach; and Gloucester Point at left middle ground. The dead horses on the beach were not an artistic contrivance but a depiction of actual casualties and property of the British army. Cornwallis had ordered the horses killed once it became apparent that he and his forces were defeated. From left to right, the officers in the front row are Major General Marie Joseph Paul Yves Roch Gilbert du Ma[o]tier, marquis de Lafayette (1757–1834); General George Washington; General Jean-Baptiste Donatien de Vimeur, comte de Rochambeau (1725–1807); and Lieutenant Colonel Tench Tilghman (1744–1786). The two officers in the second row are believed to be, left to right, Brigadier General Benjamin Lincoln (1733–1810) and, in the red uniform, Major General François-Jean de Beauvoir, chevalier de Chastellux (1734–1788).

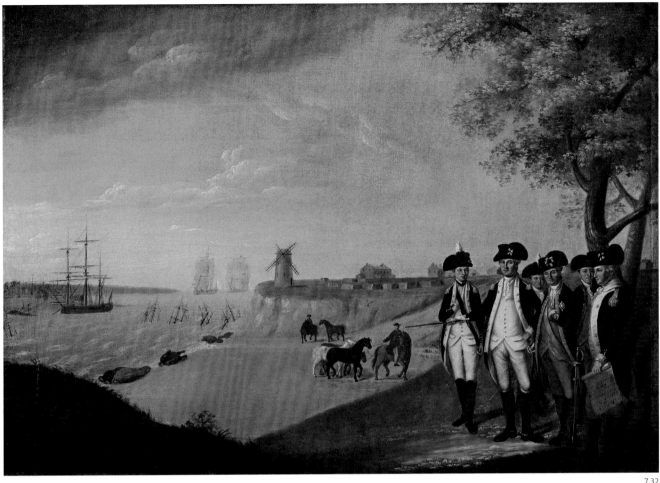

sat and drank with Col. Washington, his lady, son- and daughter-in-law. I remember many conversations . . . when we walked together to enjoy the evening breezes."[73]

Peale served as an officer in the American forces in 1776 and 1777. He marched to the battle of Trenton at the age of thirty-six, witnessing various skirmishes in the area and becoming fully engaged in fighting at the battle at Princeton. His journal for 1776 details the equipment he carried with him on these marches, including a paint box and his miniature "apparatis" that he packed in a chest.[74] Peale completed a number of miniature portraits during this period. In the winter of 1777, he spent much of his time at Valley Forge painting miniature portraits of American army officers. His experiences during these years set the stage for his later collection of American officers who served with distinction during the Revolution. The preparation of these bust-length portraits

consumed much of Peale's time after the war, but he continued his painting trips and completed a large number of portraits, including miniatures, throughout the mid-Atlantic region. His likenesses of John Parke Custis (fig. 7.33), the stepson of George Washington, and James Madison (fig. 7.34) are two exceptional examples.

One of Peale's most sensitive southern portraits is that of William Buckland (1734–1774) (fig. 7.35), the English-born architect engaged by Thomson Mason to go to Virginia and build a home for his brother, George Mason. The Mason house, Gunston Hall, was finished in the late 1750s. Buckland continued to work in Virginia until 1771 when he settled in Annapolis. Peale began the portrait in 1774 while Buckland was working on a design for the Hammond-Harwood house. Appropriately, Buckland is pictured with his drawing instruments and a sheet of paper showing the first floor of the house. The

7.33

7.34

FIGURE 7.33. Charles Willson Peale, *John Parke Custis*, 1776, watercolor on ivory, 2½″ x 2″ oval. Courtesy of Mount Vernon Ladies' Association.

John Parke Custis (1754/55–1781) was the son of Martha Dandridge Custis (figs. 5.25 and 7.30) and her first husband, Daniel Parke Custis. She married secondly George Washington (figs. 7.28, 7.29, 7.31, 7.32, and 7.62), after which John Parke and his siblings moved to Mount Vernon. In 1774, he married Eleanor Calvert (fig. 5.44), descendant of the Lords Calvert of Baltimore. From 1778 to 1781, he served in the Virginia House of Delegates. It was also in 1781 that Custis joined Washington at Yorktown as a civilian aide-de-camp and contracted "camp fever," probably dysentery. Though he lived to see the surrender, he died soon thereafter.

FIGURE 7.34. Charles Willson Peale, *James Madison*, 1783, watercolor on ivory, 1¹¹⁄₁₆″ x 1¼″. Courtesy of the Library of Congress.

James Madison (1751–1836) was born and raised on his family's plantation in Orange County, Virginia. As the oldest son, he inherited that property, and his acquisition of additional acreage made him one of the largest landowners in Orange County. Madison became a leading politician during the early years of American independence, including service as the principal author of the Constitution. He also served as a member of the newly formed House of Representatives; as the secretary of state in the administration of U. S. President Thomas Jefferson; and, from 1809 to 1817, as the country's fourth president. With Jefferson, Madison helped form the Republican Party (later known as the Democratic-Republican Party) in opposition to the Federalists.

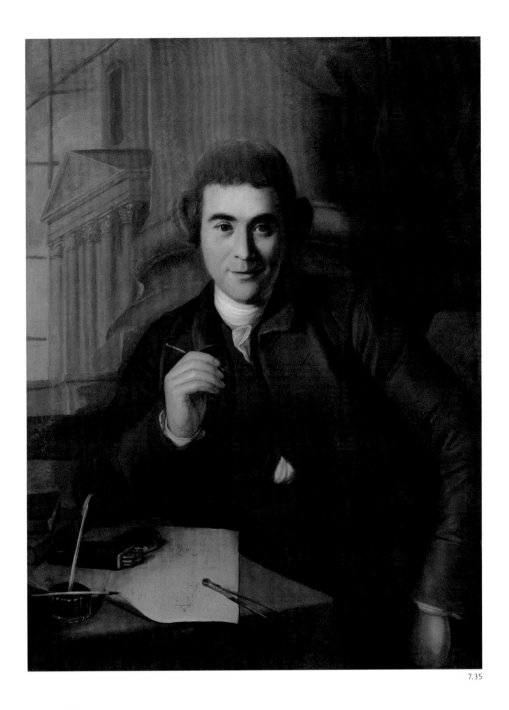

7.35

FIGURE 7.35. Charles Willson Peale, *William Buckland*, begun in 1774 and completed in 1787, oil on canvas, 36⅝" x 27½". Yale University Art Gallery, Mabel Brady Garvan Collection.

William Buckland (1734–1774) was born in Oxford, England, where he served an apprenticeship with his uncle, a master builder. Buckland is shown here seated before an elaborate classical building amid his drawing instruments and an architectural plan. Thomson Mason apparently met Buckland in England and engaged him to come to Virginia. Buckland moved to Annapolis in 1771.

Charles Willson Peale was in his early thirties in 1774 and Buckland was only seven years his senior, still quite young when he died. Both men had achieved some success at this point in their careers, and the architect's death was deeply felt by his friend Peale. This may be why the expression on Buckland's face is both captivating and haunting.

sitter died in November of that year. Peale grieved the loss of his friend for many months and did not finish the picture until April 1787. Presumably, Peale gave the painting to Buckland's daughter Sarah about that time.[75]

In addition to portraits for private citizens and commemorative portraits of Washington and other American officers of the Revolutionary War, Peale also created transparencies and pictures associated with noteworthy people or events and significant banners or flags.[76] One example of the former is the likeness of Nancy Hallam in her role as Imogene in William Shakespeare's play *Cymbeline* (fig. 7.36). Performed by the American Company in Annapolis in the fall of 1770, the show played next in Williamsburg and returned to Annapolis for the 1771 fall season when Peale apparently created the picture. Subsequently, the "Poets Corner" in the November 7, 1771, *Maryland Gazette* (Annapolis) published verses that read in part:

> To Mr. PEALE, *on his painting Miss* HALLAM *in the Character of* Fedele *in* Cymbeline.
> THE grand Design in *Grecian* Schools was taught,
> *Venitian* Colours gave the Pictures Thought:
> In thee, O PEALE, both Excellences join,
> *Venetian* Colours, and the *Greeks* Design.

FIGURE 7.36. Charles Willson Peale, *Nancy Hallam as Imogen*, 1771, oil on canvas, 50" x 40¼". Colonial Williamsburg Foundation, Williamsburg, VA.

Charles Willson Peale's picture of Nancy Hallam (d. after 1775) is rare because of its subject matter and its association with the early American theater. She is shown here as Imogen disguised as a young boy, Fidele, after being falsely accused of adultery. Emerging from a cave, she meets her two brothers and their kidnapper, Bellarius.

Hallam was probably the niece of Lewis Hallam Sr., manager of the American Company of Comedians. Joining the company in 1765, she became a leading actress. She continued to perform until 1774 when she left for Kingston, Jamaica, where she married. Her identity has often been confused with Sarah Hallam, which is the name of both her mother and her sister-in-law, the wife of Lewis Hallam Jr. (Charles C. Sellers, *Portraits and Miniatures*, 95–96.)

> Thy Stile has match'd what ev'n the Antients knew,
> Grand the Design, and as the Colouring true. . . .
> Thy Pencil has so well the Scene convey'd,
> Thought seems but an unnecessary Aid;
> How pleas'd we view the visionary Scene,
> The friendly Cave, the Rock and Mountain green:
> Nature and Art are here at once combin'd,
> And all *Elysium* to one View confin'd.[77]

In addition to praising Peale, the writer conveyed the public's sentiment regarding a short but impressive series of performances in Annapolis. Painted for his personal collection, the picture of Hallam was first on exhibit in Peale's studio before being eventually moved to his museum in Philadelphia.[78]

Peale is known to have had students, two of whom are associated with Virginia. In 1775, William Pierce Jr. (dates unknown) advertised in a Williamsburg paper that he "is just returned to this city from Annapolis in Maryland, where he has studied PAINTING under the celebrated MR. PEELE, and we hear intends residing here for some time."[79] No paintings by Pierce have been identified. William Mercer (ca. 1773–1839), the son of General Hugh Mercer of Fredericksburg, Virginia, was also one of Peale's apprentices; he advertised portrait and miniature painting several times in Virginia. Sometime after General Mercer's death at the battle of Princeton, his friend and fellow officer General George Weedon became involved in the care of Mercer's family and served as young Mercer's godfather. In November 1783 and again in November 1786, Weedon paid Charles Willson Peale £214 16s. for apprentice fees and board for William Mercer.[80] Writing from Fredericksburg, Weedon noted in a letter of September 20, 1786, that he was sending "Billy" back for a few months to continue his studies. At that time, Mercer had produced six pictures of family members.[81] He advertised portrait and miniature painting in Fredericksburg and Richmond in 1788 and painted a miniature portrait of Edmund Pendleton of Virginia (fig. 7.37) that was later copied by Thomas Sully.[82] Mercer's obituary was published in at least two Virginia papers and in both, as well as in the artist's

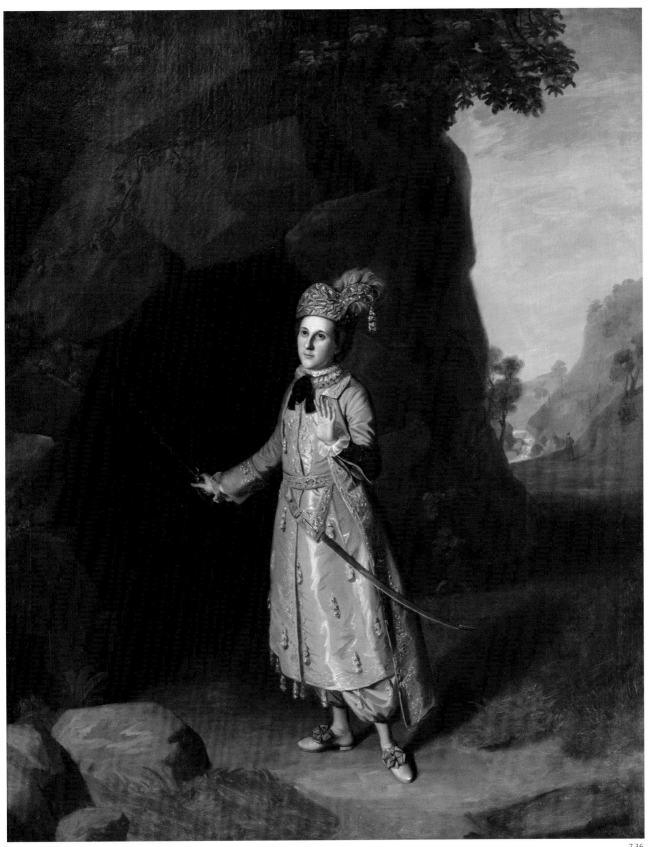

7.36

7.37

7.38

advertisements, he is described as the son of the late General Hugh Mercer.[83]

Charles Willson Peale inspired—and taught painting and drawing to—nearly all the members of his large immediate family, many of whom became professional painters and naturalists who also drew and painted specimens.[84] They included his younger brother James Peale (fig. 7.38); his sons Raphaelle Peale (1774–1825), Rembrandt Peale (1778–1860), Rubens Peale (1784–1865), and Titian Peale (1799–1885); and one of his two daughters, Angelica Kauffmann Peale (1775–1853). There were also at least three nieces who painted: Sarah Miriam Peale (1800–1885), Anna Claypoole Peale (1791–1878), and Margaretta Angelica Peale (1795–1882), daughters of James; and two granddaughters, Rosalba Carriera Peale (1799–1874), daughter of Rembrandt, and Mary Jane Peale (1827–1902), daughter of Rubens. Charles Willson also taught his nephew and namesake Charles Peale Polk (1767–1822), who was orphaned at the age of ten.[85]

James Peale was the fifth child of Charles and Margaret Triggs Peale. He worked as a carpenter and cabinetmaker on Maryland's Eastern Shore for several years prior to his

brother's return from England in 1769. James worked first as Charles Willson's Maryland studio assistant and framer. A 1771 family letter stated that James "copies well and has painted a little from the life," probably a reference to one or more family pictures he had completed (fig. 7.39).[86] During the war, James Peale was commissioned an ensign in William Smallwood's regiment in the Continental army; he fought in New York and at the battles of Trenton, Brandywine, Germantown, and Princeton. He was promoted to first lieutenant, and he resigned his commission on June 1, 1779, although he probably served as a volunteer with Washington's army during 1781. It was several years later that James collaborated with Charles Willson on his views of the generals at Yorktown (fig. 7.32)—or painted his own versions—and also created his portraits of Washington.[87] In 1782, he married Mary Claypoole, the sister of the Philadelphia painter James Claypoole Jr. (ca. 1743–1822). He was probably painting and repairing miniature portraits about that time, as indicated by Charles Willson's comments on June 14, 1783, to John Beale Bordley about James's good work. On October 19, 1786, the brothers announced that Charles Willson would have James take over the miniature painting business. The elder brother did occasionally offer miniatures after that, but his eyesight was not as good as it had been for close work.[88]

As James's art evolved, it became clear that his oeuvre would be broader than that of his more famous brother, featuring a greater number of landscapes and still-life pictures. In fact, his conversation pieces, still-life paintings, and miniature paintings are equally numerous and equally well-known. Even a cursory study of James's mature painting style suggests that, as an artist, he was as skilled as—if not more skilled than—Charles Willson. The miniature portrait of John Greer Jr. (fig. 7.40), dated 1794, is typical of James Peale's delicate and realistic portrayals, with fine skin tones and modeling. His still-life pictures are his most important artistic contributions. Unlike miniature portraits, still-life paintings were much more complex in the rendering of forms, spatial relationships, and color. Each individual fruit seen in *Apples, Grapes and Pears* (fig. 7.41) required

nearly equal attention given to its drawing, modeling, and coloring. Moreover, each fruit required its own successful placement into the composition in order to yield a pleasing unified whole. The artist also used two light sources, not only in *Apples, Grapes and Pears* but also in similar pictures, most often with the strongest light illuminating the front of the arrangement and the lesser light defining the back. Peale's fruits are luscious and enticing but not perfect, for a number of imperfections can be detected, particularly among the larger pieces. Variations of this arrangement and the neoclassical bowl are seen in several of the artist's other still-life pictures. James visited Charleston, South Carolina, in 1800, and he may have traveled to other areas of the South about that time. About 1810, his failing eyesight forced him to turn over his miniature work to his daughter Anna Claypoole and later Sarah Miriam. He spent the last years of his life painting larger portraits and still lifes. He died in Philadelphia on May 24, 1831.

Charles Peale Polk was the son of Elizabeth Digby Peale Polk, the sister of Charles Willson Peale, and Robert Polk of Accomack County on the Eastern Shore of Virginia. The family moved to Annapolis at an undetermined date before the artist was born in 1767. After their mother's death,[89] the children went to live with the Charles Willson Peale family in Maryland and later Philadelphia. Robert Polk, the father, died at sea in a skirmish with British forces in 1777.

It was in Peale's household that Polk learned to paint portraits. He launched his career in Baltimore where, beginning in 1785, he placed numerous newspaper advertisements indicating that he painted oil portraits and shrewdly noting that he had just finished his studies under the "celebrated Mr. PEALE" of Philadelphia.[90] A similar advertisement appearing in the *Virginia Journal and Alexandria Advertiser* on June 30, 1785, noted that he was also painting portraits for clientele in that area. It is thought that Polk married Rachel Ellison of New Jersey about then.[91] Polk's first attempts in painting in Maryland and Virginia were apparently unsuccessful. He returned to Philadelphia in 1787 and advertised as a ship, house, and sign painter.[92] By 1791, he advertised in Baltimore

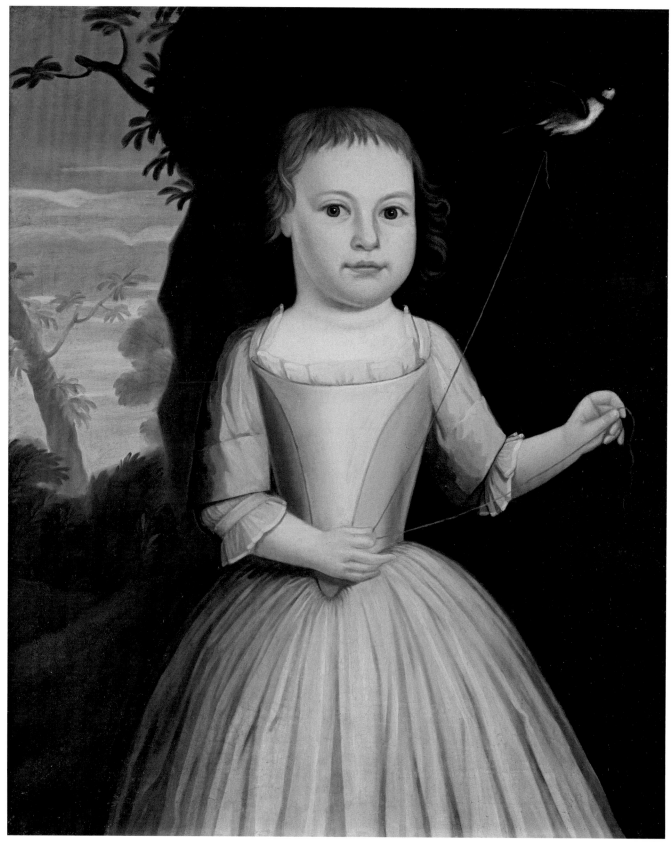

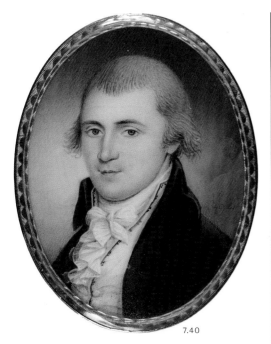

7.40

7.41

newspapers that he was setting up an exhibition room and was displaying and selling portraits of President Washington.[93] About this time, he opened a drawing school as well as a general dry goods store, but, by 1795, he was selling his property with the intention of leaving the city.[94] Polk was in Frederick, Maryland, by 1798 when he advertised as a portrait painter; advertisements followed in Elizabethtown, Maryland, and Richmond, Virginia.[95] He is also known to have painted portraits in the Shenandoah Valley area of Virginia and West Virginia.

According to Polk's biographer, Linda Crocker Simmons, his portrait work for the Hite and Madison families in northern and central Virginia led to his meeting James Madison and subsequently to his employment as secretary of the Republican Citizens of Frederick County, a post he assumed in June 1800. Following the election of President Thomas Jefferson in 1801, Polk created a large transparent celebratory painting that was displayed at his house in Frederick. Around the same time, his work with the Republicans was completed, and he wrote both James Madison and Thomas Jefferson of his financial problems, problems that only grew worse as the months progressed. About 1802, he was given the

FIGURE 7.39. Probably James Peale, *Unidentified Child*, 1770–1775, oil on canvas, 30″ x 25″. Colonial Williamsburg Foundation, Williamsburg, VA. Gift of the John D. Rockefeller, 3rd, Fund, Inc., through the generosity and interest of Mrs. John D. Rockefeller 3rd and members of the family.

In 1935, Abby Aldrich Rockefeller purchased this portrait from Edith Gregor Halpert, a dealer in New York City, for use at Bassett Hall, the Rockefellers' Williamsburg, Virginia, home. It is attributed to James Peale on the basis of an unidentified child's portrait created in Chestertown, Maryland, signed by James Peale and dated 1771. When the portrait shown here was acquired, the sitter was called Anna Peale. No child by that name is known in Charles Willson Peale's household although a son, James Willson, was born in 1767. James Peale, the brother of Charles Willson, to whom this portrait is attributed, did not marry until 1782, but he did have a daughter named Anna Claypoole Peale. It is likely that the sitter in this portrait was a Peale family child painted by James, but the subject's exact identity has been lost.

FIGURE 7.40. James Peale, *John Greer Jr.* (dates unknown), dated 1794, watercolor on ivory, 2⅛″ x 1⅝″ oval. Courtesy of the Maryland Historical Society (Image ID # 1953.66.1).

FIGURE 7.41. James Peale, *Apples, Grapes and Pears*, 1822–1825, oil on wood, 18³⁄₁₆″ x 26⅜″. Munson-Williams-Proctor Arts Institute/Art Resource, NY.

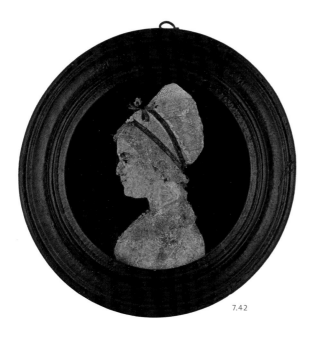

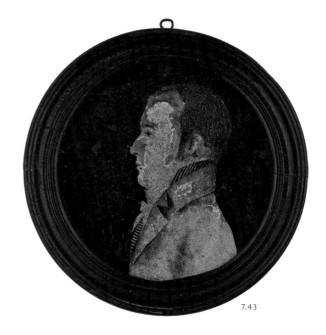

7.42

7.43

position of clerk in the office of the first auditor in the Department of the Treasury, where he continued to work, probably in the same position, until 1815. Although he received a salary, he continued to have debts. He declared bankruptcy in 1804 and again in 1812.[96]

In 1806, Polk advertised in Richmond, Virginia, papers that he did profile portraits engraved in gold. Several of these simple, unprepossessing works survive (figs. 7.42 and 7.43).[97] He moved to Richmond County, Virginia, in 1820 and lived on land his third wife inherited from her father called Mount Pleasant. Two years later, on May 6, 1822, he died.[98]

FIGURES 7.42 AND 7.43. Charles Peale Polk, *Burr Powell* and *Mrs. Burr Powell*, ca. 1805, verre églomise (black paint on glass with gold leaf), sight 3⅜" x 3¼" diameter and sight 3⅛" x 3⅛" diameter. Colonial Williamsburg Foundation, Williamsburg, VA. Gift of Eric D. and Hollace S. W. Swanson.

The portrait of Burr Powell (1768–1838) has an inscription by the artist created by scratching through the gilding of his coat at lower left: "CP Polk Fecit." The subject was a school commissioner and sheriff in Loudon County, Virginia. In 1804, he was elected to the state's General Assembly. Mrs. Burr Powell (Katherine Brooke Powell, 1770–1851) was probably from Fauquier County, Virginia.

The earliest of Polk's known portraits probably date to 1783 and include *Jean Baptiste Donatien de Vimeur, Comte de Rochambeau* and *George Washington,* both copies by Polk after his uncle's versions. One of his portraits of the marquis de Lafayette (fig. 7.44) was probably given by the subject to Henry Lee III, "Light-horse Harry," of Virginia.[99] Polk's version was based on Peale's likeness begun in 1778 and completed in 1780–1781.[100] Most of Polk's portraits between 1785 and 1800 were for clients in Pennsylvania, Virginia, and Maryland, clients who represented well-to-do members of the merchant, farmer, and tradesmen classes. His likeness created about 1800 for Adam Stephen Dandridge Sr. typifies many of the characteristics associated with his style (fig. 7.45). Charles Willson Peale's influence is readily evident in the shape of the head, in the strong lighting on the face, and in the modeling of some of the sitter's features. The large, swagged curtain in the background, the somewhat stiff pose, and the awkward handling of arms and fabrics are characteristic of a number of Polk paintings. Polk was also fond of detail, meticulously rendering hair, lace, embroidery, and other aspects. His often bright coloring was judged by some to be too garish.

The many paintings by Peale family members featuring officers and events of the Revolutionary War represent an important change in American painting. As so many artists and, occasionally, consumers had lamented prior to 1775, history painting had no audience in the colonies. John Singleton Copley had been among those who had aspired to history painting, but he had received little encouragement in the colonies. For that and for the related needs of academic training and firsthand access to old master works, Copley had moved to London. Even the Londoner John Durand, who had advocated the merits of possessing history paintings in one of his early New York advertisements, was aware that history painting was not a popular format in the colonies and that its benefits to society needed explanation and justification. Whether he received many commissions as a result of his public appeal is not known. From Maryland at roughly the same time, Charles Carroll[101] wrote to Charles Willson Peale, who was then studying with West in England, saying,

> I observe your Inclination Leads you much to Painting in miniature I would have you Consider whether that may be so advantageous to you here or whether it may suit so much the Taste of the People with us as Larger Portrait Painting which I think would be a Branch of the Profession that would Turn out to Greater Profit here you Likewise mention the Copying of good Painting by which I suppose you mean the Study of History Painting This I Look upon as the most Difficult Part of the Profession and Requires the utmost Genius in the artist few arrive at a High Point of Perfection in it And indeed in this Part of the world few have a Taste for it.[102]

However, a taste for history painting in America did emerge, and it did so as a direct result of the successful war for independence from Great Britain, a war through which Americans created history on their own soil. Accounts of heroic events and patriotism abounded to inspire artistic expression and imagery, and Charles Willson Peale and members of his immediate family were among the first artists to create pictures so inspired.

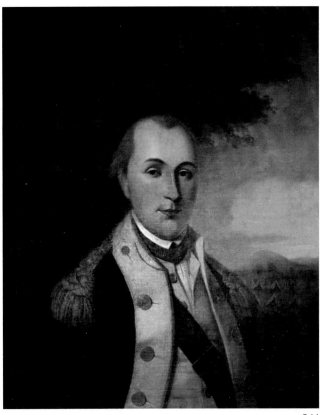

7.44

Though the earliest American efforts at history painting were never as sophisticated or refined as British examples, the new country's citizens eagerly bought both paintings and prints of heroes and events. Imagery associated with the war and its heroes was hugely popular well into the nineteenth century; elaborate large canvases were commissioned for public spaces, and prints after them were widely distributed and sold.

FIGURE 7.44. Charles Peale Polk, *Marie Joseph Paul Yves Roch Gilbert du Ma[o]tier, Marquis de Lafayette*, ca. 1790, oil on canvas, 30″ x 24⅞″. Stratford Hall Plantation, Stratford, VA. Gift of Thomas Clagett Berry in memory of Tiernan Brien Berry. Photography by Terry Cosgrove.

This portrait of Lafayette, a copy of Charles Willson Peale's 1778–1781 versions, is neither signed nor dated by Polk but is attributed to him by Linda Crocker Simmons on the basis of stylistic distinctions. Simmons has dated the picture early in Polk's career and notes that he may have had some assistance from his uncle Charles Willson Peale. (*Charles Peale Polk*, 38.)

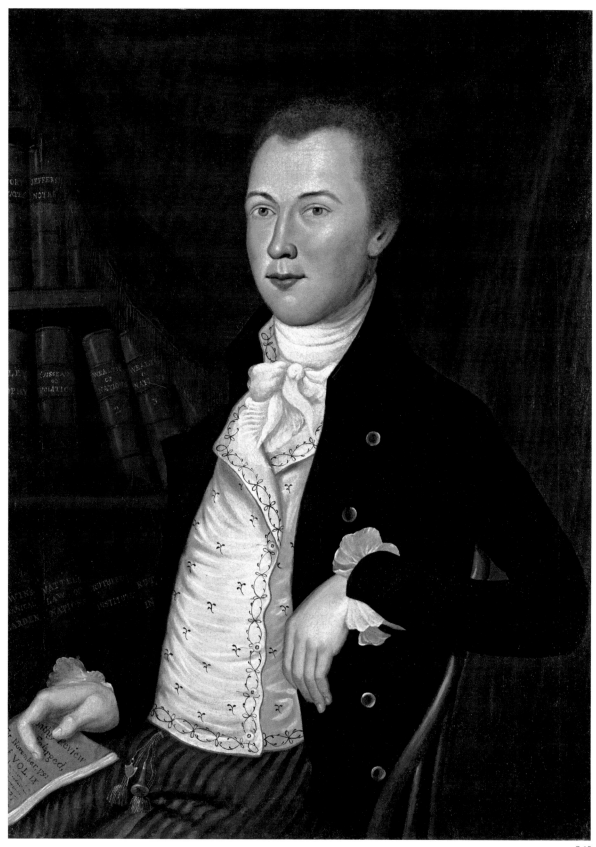

7.45

Some of the earliest of these pictures for the South represent battles and naval engagements. One example is the Peale image of the generals at Yorktown (fig. 7.32). Others include scenes documenting the attack on Fort Moultrie at Sullivan's Island, South Carolina, in June 1776. Among those are three small gouache drawings titled separately to reflect the sequence of events—*Attack, Engagement,* and *Retreat* (figs. 7.46–7.48). Created in 1776, they are attributed to Walter Miles, an Englishman who was on a merchant vessel in the Charleston Harbor when the battle took place between British warships and the fort. Other views of the event, including two watercolor versions, one showing the attack and the other illustrating the morning after the attack, were painted by Lieutenant Henry Gray (dates unknown). A third version of the same battle was witnessed and later painted by Lieutenant William Elliott (d. 1792) of the Royal Navy about 1784 (fig. 7.49). Elliott advanced to captain just before his death. Most of his surviving pictures feature naval actions and views of ports such as Canton in China, Port Royal in Jamaica, and Calcutta in Bengal. He also sketched aquatints. Elliott is believed to have exhibited his work at the Royal Academy from 1784–1792.[103] Henry Benbridge was painting in Charleston at the time of the attack, but there is no evidence that he recorded the event, perhaps because his wife died that June.

Henry Benbridge (fig. 7.50), two years younger than Charles Willson Peale, is the next known important American-born artist to study abroad. The details of his life and work have been the subject of two published studies and several articles.[104] He was born in Philadelphia, the second son of James Benbridge and Mary Clark Benbridge. The artist's father died when he was eight years old, and his mother married secondly to Thomas Gordon (d. 1772), a wealthy Philadelphia merchant. Although Benbridge sometimes referred to Benjamin West as his cousin, their relationship, which came through the sister of his maternal grandfather, was distant.[105] Charles Willson Peale noted that, as a youth, Benbridge had painted murals on all the walls, ceilings, and hallways of a family's house in Lodge Alley, Philadelphia, before the structure was pulled down. Peale added

that the subjects were taken from prints, some of which were Raphael's cartoons, and that some of Benbridge's images were painted life-size.[106]

Henry Benbridge was enrolled at the Academy of Philadelphia in 1751 and continued there through part of July 1758. According to family tradition, he quit school to pursue painting, receiving his first lessons from John Wollaston Jr. who was visiting Philadelphia for several months. The story goes that Benbridge observed Wollaston as he painted the waist-length portrait (now privately owned) of Thomas Gordon, Benbridge's stepfather. The account might seem fictitious were it not for Gordon's 1770 letter to Benbridge advising him regarding clientele. Gordon suggested that, "if you should have a Patient, as Woolaston used to call the Ladies whose pictures he drew, worth ten or twenty thousand pounds," be sure to court and marry her.[107] Several early Benbridge portraits of members of the Gordon family survive in private collections. They vary in both quality and style, reflecting Benbridge's early attempts to emulate the work of Wollaston, West, and probably Gustavus Hesselius (1682–1755).

In 1760, Benbridge left Philadelphia to pursue studies in Europe, traveling first to Italy, where he was enrolled in Pompeo Batoni's academy. Batoni's portraits were popular with both British and American travelers on the grand tour, who often commissioned portraits from him.[108] Some scholars have also proposed that Benbridge was influenced by the work of Thomas Patch (1725–1782),

FIGURE 7.45. Charles Peale Polk, *Adam Stephen Dandridge Sr.*, 1799–1800, oil on canvas, 35" x 26". Colonial Williamsburg Foundation, Williamsburg, VA. Gift of Edmund P. Dandridge Jr. and Mrs. Elizabeth Dandridge McDonald.

This portrait of Adam Stephen Dandridge Sr. (1782–1821) was painted along with three other likenesses of his young half brothers and a sister. Polk's fondness for detail and strong coloring, often seen in his portraits, is evident here. Dandridge was the son of Alexander Spotswood Dandridge of Berkeley County, Virginia (now West Virginia), and lived most of his adult life in Jefferson County, Virginia (also now West Virginia).

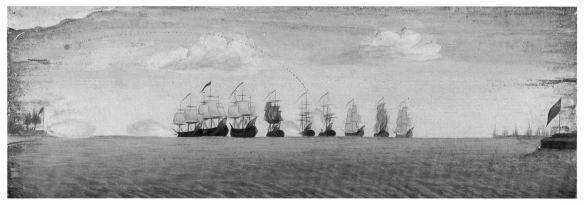

7.46

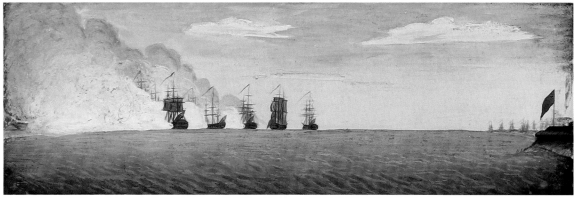

7.47

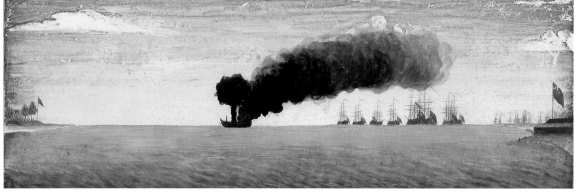

7.48

FIGURES 7.46–7.48. Walter Miles, *Attack*, *Engagement*, and *Retreat*, probably 1776, gouache on paper, all 3″ x 9″. Courtesy of South Caroliniana Library, University of South Carolina, Columbia.

Walter Miles (dates unknown), an Englishman on a merchant vessel in Charleston Harbor, claimed to be an eyewitness to the attack by the British fleet on Fort Sullivan's Island, situated about five miles from the town of Charleston, South Carolina. The engagement occurred on June 28, 1776. The

HMS *Actaeon*, which went aground during the battle, was set on fire by her crew, as seen in *Retreat*, and ultimately destroyed. She was a new twenty-eight-gun, sixth-rate frigate launched in England the previous year. The paintings descended in Miles's family before they were purchased for the South Caroliniana Library.

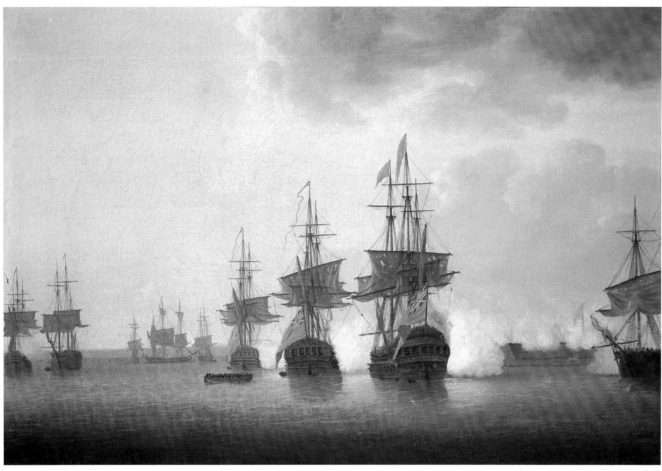

7.49

an English painter in Italy known for his small conversation pieces and cartoons,[109] although that suggestion has not been verified. Certainly the two men knew of each other, for Patch published a caricature image of Benbridge in 1770 (fig. 7.50). However, as the current Benbridge scholar Maurie D. McInnis has argued, it is more likely that Benbridge advanced his technical knowledge in studies with Batoni, particularly the gradual building of thin layers and modeling of translucent colors and the inclusion of romanticized landscapes and classical architectural elements (fig. 7.51).[110] It would be inaccurate to say that Benbridge's layers of paint were always thin

FIGURE 7.49. "Lt. Elliott" (probably William Elliott) as excerpted from what is probably a modern label on the frame, *Charlestown South Carolina: The Abortive Attack on Fort Moultrie 26th June, 1776*, ca. 1784, oil on canvas, 26¼" x 38½". Historic Charleston Foundation.

William Elliott was a landscape engraver living on Romilly Street in London during the 1760s; he later joined the Royal Navy. He is known to have exhibited at the Royal Academy in London between 1784 and 1792 (as found in the MESDA Object Database, S-8180). Elliott, like Walter Miles (figs. 7.46–7.48), is thought to have been an eyewitness to the attack on Fort Moultrie although each cites a different date for the engagement. In addition to the *Actaeon*, the painting label also names other British ships involved in the incident, including the HMS *Bristol*, *Sphinx*, *Siren*, *Soleby*, and *Thunder*.

7.50

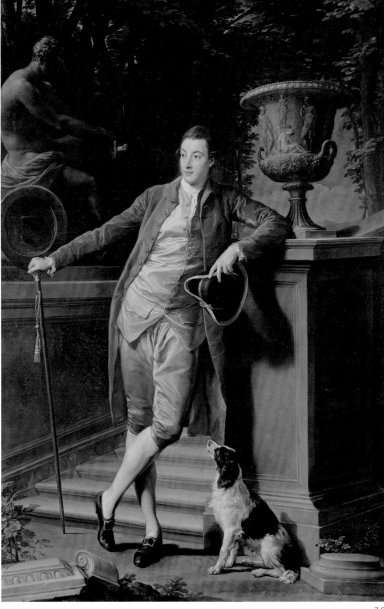

7.51

FIGURE 7.50. Thomas Patch, artist and engraver, *Henry Benbridge*, dated 1769, ink on paper, 13″ x 6½″. © V&A Images/Victoria and Albert Museum, London.

In 1747, Thomas Patch went to Rome, where he knew Sir Joshua Reynolds and other artists. About 1755, Patch moved to Florence, where he studied the works of grand masters, painted portraits for travelers on their grand tours, and worked as an art dealer. This etching is signed with the cipher "TP" and the date "1769," the year that Henry Benbridge left Italy for England. Although a caricature, one from a set of twenty-five published by Patch in Florence, it is also the earliest known picture of Benbridge. (Stewart, *Henry Benbridge*, 26–27.)

FIGURE 7.51. Pompeo Batoni, *John Chetwynd Talbot, 1st Earl Talbot*, dated 1773, oil on canvas, 108″ x 71¾″. J. Paul Getty Museum, Los Angeles.

John Chetwynd Talbot (1749–1793) commissioned the portrait while on his grand tour in Italy. Among the important classical elements shown in the picture are the Ludovisi Mars statue and architectural fragment at left and the Medici Vase atop the architectural plinth at right, important and iconic Roman antiquities.

and in the form of glazes. In fact, his paint is often applied with a filled brush, and his highlights are quickly worked. This is especially true of his fabrics. Benbridge's details are finely crafted with minimal brushwork, and his settings evoke the ancient, classical world. These elements are especially noticeable in the large portrait of the Hartley family of Charleston (fig. 7.52).[111]

Benbridge left Italy for London in 1769, probably to continue refining his painting methods and style and to set up a portrait studio.[112] As McInnis indicates, there is no specific documentation of his studying with Benjamin West, but they certainly met and knew each other, as revealed in several passages of letters between the artist and his family members in Philadelphia. The first of these is a letter written to his stepfather, Thomas Gordon, describing the artist's preparations for an exhibition that included a portrait of a Mr. Coombs, a portrait of a Mr. Franklin (probably Benjamin), and a self-portrait. Benbridge wrote that West approved of both his self-portrait and the likeness of Coombs, saying that "Mr. West intends to decline Portrait Painting and to follow that of History, which will enable him to re[com]mend me much stronger."[113] West had also held letters for Benbridge, who dined with the Wests soon after his arrival in London. Additionally, West would have accommodated Benbridge had there been room in his house; instead, Benbridge rented lodgings nearby on Panton Square. It seems likely that communication between the two artists was frequent and that Benbridge received and appreciated criticism from West, regardless of what their formal relationship may have been.[114]

In 1770, Benbridge returned to his hometown of Philadelphia armed with a letter of recommendation from West to Francis Hopkinson and another from Benjamin Franklin to his wife. While there, Benbridge painted only a few pictures. Sometime in 1771 or early 1772, he married Letitia (Hetty) Sage (d. 1776) of Philadelphia, a competent miniature painter who had studied with Charles Willson Peale.[115] Benbridge made two trips to Charleston in the spring of 1772. On March 26, local papers noted that the "ingenious Limner" returned to Philadelphia "Friday last";[116] a similar notice appeared in papers on May 14, indicating his second trip to Charleston.[117] Henry Jr., referred to as "Harry," was born on December 12 or 13, 1772, and was baptized at Christ Church, Philadelphia, the following February.[118] On April 1, 1773, Hetty, her mother, and the son arrived in Charleston on the brigantine *Charles Town Packet,* along with the botanist William Bartram (1739–1823), who wrote later about the gale force winds and delays they had encountered en route.[119] The Charleston newspaper notice that includes this information also described Hetty as "a very ingenious Miniature Paintress." She lived just over three years in Charleston, dying in June 1776, possibly from complications associated with pregnancy. The artist never remarried; he continued to work in Charleston before and after the Revolutionary War.[120]

Benbridge quickly achieved success. He had little competition, for no other painters in Charleston had his connections, training, and skill. Jeremiah Theus died the year after Benbridge arrived; Thomas Coram (1756/57–1811) was reportedly his student; and James Earl (1761–1796), who did not arrive until 1794, died soon thereafter. Charles Willson Peale never visited Charleston, but he would have known about Benbridge's work through his sister and through correspondence with Dr. Ramsay.[121] Richard Jennys Jr. (1734–probably 1809) of Boston was in Charleston only in 1783, coming from the West Indies, and no Charleston paintings by him have been identified. The first visits of James, Rembrandt, and Raphaelle Peale occurred between 1795 and 1800. Edward Savage (1761–1817), who also studied with West, was a capable painter but no match for Benbridge. John Trumbull (1756–1843) visited only in 1791, and, although Joseph Wright, also a West student, published a notice with Samuel Brooks (dates unknown) in the *Boston (MA) Independent Chronicle* in 1790 saying that the two of them intended to go to South Carolina the next month, no evidence of their presence there together has been found.[122] However, works by Wright have been discovered and are being researched by MESDA. The vast majority of other trained painters visiting or living in Charleston during these years were miniaturists or else they worked in other branches. Examples by many of

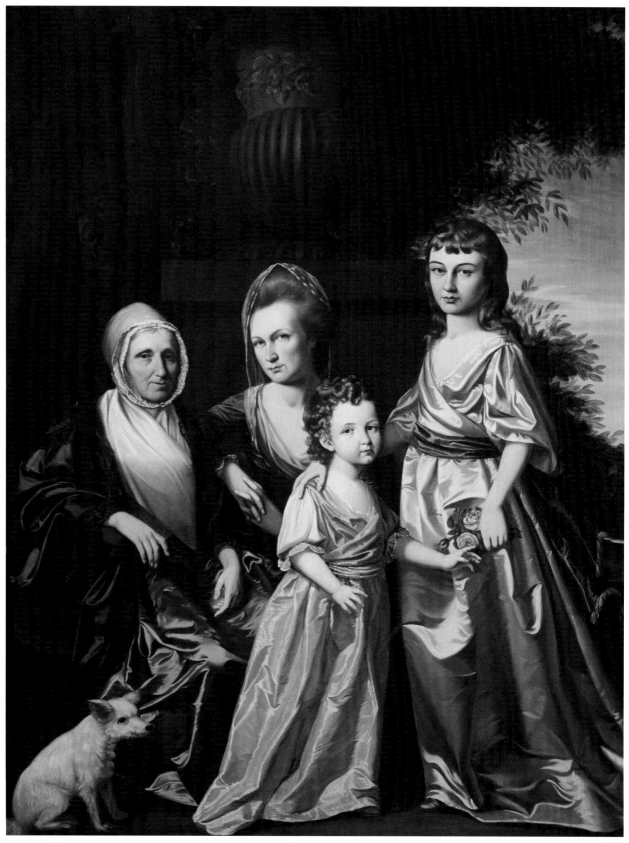

them, such as Joshua Canterson, or Canter, (active ca. 1788–1822) who advertised as a portrait and landscape painter in the *Columbian Herald* (Charleston) on April 21, 1788, and who was still in Charleston in 1822, have not been identified. This writer knows of no works by his hand. The short stays of most artists like Canterson suggest that they had difficulty in attracting many clients, and there is no doubt that Benbridge's presence and popularity would have been daunting and discouraging to most of them.[123]

In 1778, two years after his wife's death, Benbridge's mother died in Philadelphia, leaving an estate that contained twenty-three paintings, including the family portraits Benbridge had completed after his return from London.[124] The period of 1772–1780 was especially difficult for the painter. In addition to losing his wife and his mother, he witnessed Charleston's defeat by the British in 1780, and he was among a number of civilians first incarcerated in British prison ships and then transported to St. Augustine, where they were imprisoned. Two years later, on December 14, the American patriots were released, and Benbridge went to Philadelphia before returning to Charleston. During that stay in Philadelphia, Benbridge painted the portrait of Bushrod Washington (fig. 7.53), the nephew of George Washington.[125] Young Bushrod Washington was then reading law in Philadelphia, and from there he wrote several letters to his mother, Hannah Bushrod Washington, in Virginia about his choice of Benbridge. These letters are exceptionally revealing about the importance of portraiture and the care clients exercised in choosing an artist. The letters were written just before Washington's twenty-first birthday, the occasion which, according to Stephen E. Patrick who researched and published the letters, probably prompted Washington's desire for a portrait. The following excerpts from Washington to his mother in Virginia are given in chronological sequence:

April 12, 1783:
I have at length determined to have my picture taken, even before I am able to pay for it— . . . It had been for some time a subject of much doubt with m[e] who I should employ—

There were two Painters, whose talents were great, though in some Respects different—I discovered in Peale's paintings the most striking likenesses—In Bembridge's the most elegant and superior Drapery—Whether I should prefer the first of these qualities or the last in a picture, I was not long in determining, since the principal End, is to give an absent friend, or posterity, an idea of a face whi[ch] they had never seen, or If the likeness then is a Bad one, the most perfect drapery will not stamp its value . . . —But the Question which perpl[exed m]e was, whether, it would not be better to run the risque of Bemb[ridge taking] my likeness.

Washington went on to say that he had the advice of "M[r]. Powell" (his friend, Samuel Powel of Philadelphia) who believed that Benbridge was superior and "besides he has paints brought with him from Italy, which Peale cannot procure—."[126] Bushrod concluded:

I then determined at all events to fix my choice on him [Benbridge], and I am happy to assure you that the best performance has fully justified the measure— . . . I think I can see [the resemblance] myself and that is not very

FIGURE 7.52. Henry Benbridge, *The Hartley Family*, probably 1787, oil on canvas, 76⅜" x 59⁷⁄₁₆". Princeton University Art Museum. Gift of Maitland A. Edey, Class of 1932 (y1986-84). Photo by Bruce M. White.

The well-known *Hartley Family* ranks among Henry Benbridge's finest Charleston pictures in terms of composition and the painting of various textures. The somewhat insipid demeanor of the subjects is a characteristic occasionally seen in other works by the artist. Although not signed by Benbridge, the picture shares many of the features documented to his hand, including the positioning of the figures and their tilted heads, the brilliance of the fabrics, and the classical landscape setting. The picture represents four generations of the family. Margaret Miles Hartley (1722–1771), the older woman at left, married James Hartley and secondly Robert Williams. Sarah (1745–1783?), the daughter of Margaret and James Hartley, is seated in the center. She also married twice; at the time of the portrait, she was Mrs. William Somersall. Mary Somersall (1775–1813), her daughter, is standing at right with her right arm extended around a young girl, Margaret Philip Campbell (dates unknown), the great-granddaughter of Margaret Miles Hartley Williams. (Stewart, *Henry Benbridge*, 31 and 40.)

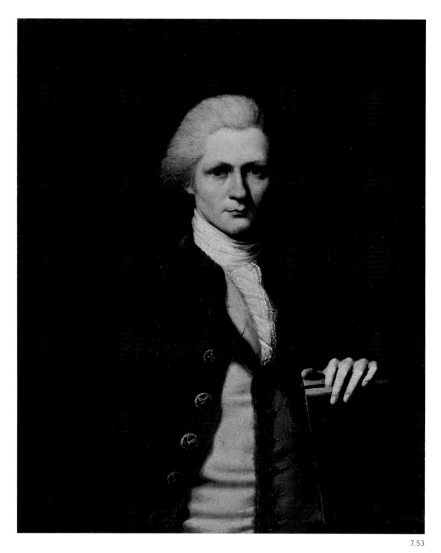

7.53

easy—I am sure at least that Peale could not have taken a stronger—And I can venture to affirm that in every other respect he [Peale] is not equal to it— . . . If I Remember well you desired it to be drawn to the knees—But I have ventured to oppose this. . . . I acted from the advice of my friends, as well as my own opinio[n that a] Gentleman . . . if you stop at the kn[ees] with the disagreeable idea, of his . . . standing on his stumps— . . . Besides the price would have been much greater.

FIGURE 7.53. Henry Benbridge, *Bushrod Washington* (1762–1829), 1783, oil on canvas, 36″ x 31½″. Courtesy of Mount Vernon Ladies' Association.

Later in the letter, Washington made it clear that the real purpose of the portrait was a good likeness, but, if that were not achieved, Benbridge's "superior talents in drapery would make his, (not nature's work) elegant." The portrait was completed by April 22, 1783, and Washington wrote in June that he was still waiting to send it to his mother. By July 1, 1783, his mother had received the portrait and Washington awaited her comments. On that date, he wrote her again, referring to the likeness and Benbridge:

> I think he has cautiously avoided flattering me . . . —He has thrown me into a thoughtful posture which in my opinion rather borders on austerity than intense meditation — . . . Some say, that having a Book in my hand which I appear to have been Just reading, that the Countenance is very properly expressed—Some Join with me in thinking that their is a degree of ill Nature in it—But . . . Mʳ. & Mʳˢ Powel. . . . say, that the Countenance is not an ill natured one, nor entirely thoughtful, but rather a mixture of thought with Pensiveness, and that they have sometimes seen me in that situation.[127]

Benbridge's return to Charleston in 1784 was celebrated in the *South Carolina Gazette, and General Advertiser* (Charleston) from January 3–6 and again from February 5–7 and in the *South-Carolina Weekly Gazette* (Charleston) on January 9. The first articles said he had arrived in town aboard the sloop *Phoenix,* not from Philadelphia but from Virginia, where he may have painted portraits before returning to Charleston. His arrival in South Carolina was mentioned again in the *South-Carolina Weekly Gazette,* on January 9, stating that he was a "Historical and Portrait Painter; a gentleman of the greatest abilities in his profession" and that he was at the home of Mrs. Elizabeth Ratcliffe, widow of Thomas, at 4 George Street.

The February notices, well-known today through other publications, found his work especially praiseworthy, and they also mentioned Benbridge in relationship to both Charles Willson Peale and Joseph Wright, a lesser-known itinerant painter in the South who had studied with West and painted in various American

cities.[128] Signed anonymously as "ANOTHER PATRIOT," the importance of these notices (quoted here in part) lies in their promotion of the arts in general along with their promotion of Benbridge:

It is amazing what progress the Pencil made at Philadelphia, in the most distressing periods of the war, in the hand of a Peele. The season of peace, so favorable to Science, is now our own;—let, therefore, a generous emulation arise, and what our sister of Philadelphia has made a Peele, let Charleston make a Wright and a Banbridge.[129]

Benbridge probably continued to work in Charleston during some portion of the 1790s, although whether he was resident there during the entire decade is unknown. The last reference in South Carolina appears in the Charleston directory for 1790 when he was located at 30 Broad Street; his name does not appear in the 1794 directory.[130] Benbridge was in Norfolk, Virginia, by 1801. His son, Harry, had moved to Norfolk between 1796 and 1800;[131] presumably the artist joined his son there. Other references contained in Norfolk records and newspapers and in William Dunlap's *History of the Rise and Progress of the Arts of Design in the United States* and his diary indicate that Benbridge probably met Lawrence (1769–1804) and Thomas Sully in Norfolk. Dunlap said that the praise Sully received on his first paintings encouraged him "to try portraits from life, of a small size, in imitation of Mr. Bembridge."[132] The group portrait of William Boswell Lamb, Margaret Stuart Lamb, and daughter Martha Anne (fig. 7.54) and another group portrait for the Taylor family of Norfolk are both of a small size and typical of Benbridge's late work. They compare favorably in style and technique with the artist's earlier pictures although the change in dress fashions that occurred in the late eighteenth century and the artist's age account for some differences in the detailing and in the muted coloration. The picture also reflects the more conservative style of portraiture that emerged during the late eighteenth and early nineteenth century in the South. Benbridge continued to reside in Norfolk, either with or near his son, until at least 1810 and possibly until his death in 1812.[133]

Both Letitia and Henry Benbridge painted miniatures although no examples by her hand for Charleston or Philadelphia have been documented.[134] Examples assigned to Henry include the penetrating portrait of Richard Moncrieff (fig. 7.55), a Charleston carpenter by trade. The likeness, typical of Benbridge's style in this medium, is a very good one, showing a robust man of not-so-pleasant demeanor dressed like the tradesman he was. Benbridge's miniatures are sensitive and often softly colored; their quality is on par with, and often exceeds, similar work by lesser-known painters visiting Charleston during that period.

However, it is Benbridge's full-scale and smaller, conversation-size paintings that are so appealing and that show his talent to best advantage. One of the most remarkable large-scale portraits created by Benbridge is the previously mentioned *Hartley Family* (fig. 7.52), probably painted in 1787 and showing four generations of South Carolina women—and their dog. Although a little contrived and rigid because of Benbridge's inexperience in handling such complex compositions, the picture has exquisite detail and coloration. The women, elegantly but simply dressed in richly saturated, shimmering fabrics, are posed against a landscape background with a classical urn resting on a plinth. As other scholars have noted, the costumes are fictional, in the style of portrait dress acceptable for neoclassical portraiture. Benbridge's years of study in Italy and his personally evolved neoclassical style are also clearly evident in this painting.

The artist was equally successful in his smaller, half-length pictures, two superb examples being the companion portraits of James Gignilliat and his wife Charlotte Pepper Gignilliat, painted about 1775 (figs. 7.56 and 7.57). The Gignilliat portraits are somewhat conservative, lacking the elaborate landscape backgrounds or swagged curtains seen in many of the artist's other likenesses. James is shown in his own softly colored clothes against a palely lit, dark background. Charlotte's background is similar, but she wears a "portrait dress." Similar dresses are seen in other Benbridge portraits. Whether such clothing existed in the painting rooms of

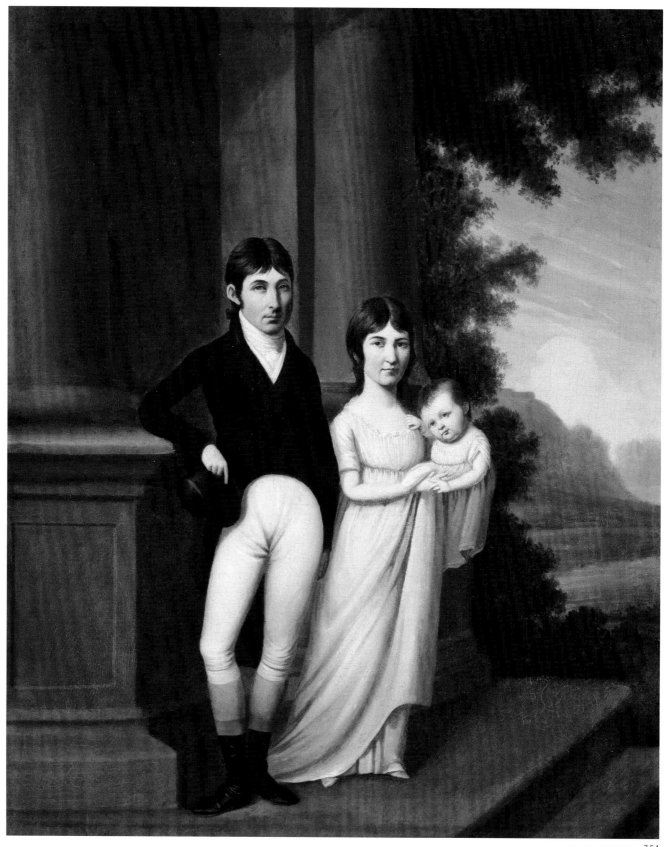

7.54

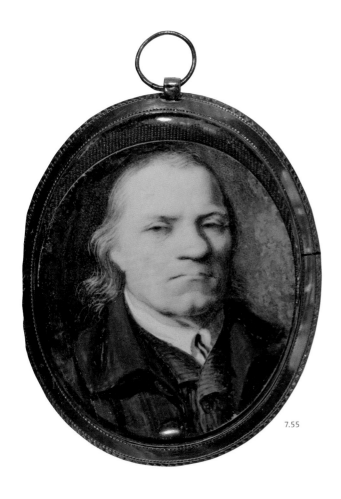

7.55

the artists is unknown,[135] but the coloring was entirely of Benbridge's choosing. Benbridge was aware of Charlestonians' predilection for fashionable dress, and he wrote to his sister from Charleston on February 21, 1773, that "every kind of news here is very dull, the only thing attended to is dress & dissipation, & if I come in for share of their superfluous Cash, I have no right to find fault with them, as it turns out to my advantage."[136] This observation is pertinent, indicating that at least some Charlestonians may have owned the elegant costumes shown in some of Benbridge's portraits.

Prints may have been another tool used by Benbridge, for the borrowing of costume styles and other details from English engravings and mezzotints continued to be a common practice among painters during this period. Charles Willson Peale, for instance, had a large collection,

FIGURE 7.54. Henry Benbridge, *Mr. and Mrs. William Boswell Lamb and Their Daughter, Martha Anne*, ca. 1803, oil on canvas, 29¾" x 24¾". Courtesy of the Museum of Early Southern Decorative Arts (MESDA) at Old Salem.

William Lamb (d. 1852) was active in Norfolk politics, became a bank president, and served as mayor of Norfolk in 1810, 1812, 1814, part of 1816, and 1823. He married Margaret Stuart (dates unknown) in 1801, and Martha Anne, their daughter, was born in 1802. For more on Lamb, see Weekley, "Henry Benbridge," 64n14.

FIGURE 7.55. Henry Benbridge, *Richard Moncrieff*, before 1790, watercolor on ivory, 1⅜" x 1³⁄₁₆" oval. © Image Courtesy Gibbes Museum of Art/Carolina Art Association.

Richard Moncrieff (d. 1789) was a highly skilled carpenter, joiner, and cabinetmaker in Charleston, South Carolina, from about 1749, when he advertised his work in local papers, to the time of his death. He was also elected a constable in Charleston in 1741. His name is associated with the repair of various buildings in Charleston, including St. Michael's Church.

FOLLOWING PAGES
FIGURE 7.56. Henry Benbridge, *James Gignilliat*, ca. 1775, oil on canvas, 29¾" x 24¾". Colonial Williamsburg Foundation, Williamsburg, VA. Partial gift of Thomas McCutchen Gignilliat.

The handsome portraits of James (1746–1794) and Charlotte Pepper Gignilliat (1748–1803) (fig. 7.57) of Charleston, South Carolina, and later Darien, Georgia, descended in the family until they were acquired by Colonial Williamsburg. The couple married in 1766; the portraits were painted about ten years later when he was thirty or younger and she was in her twenties. In the seventeenth century, the Gignilliat family had moved from Switzerland to Charleston, where they became large landowners. James and Charlotte had residences in Charleston and at Tickton Hall, their plantation on the Broad River. After the Revolutionary War, they moved to Georgia, where he operated a rice plantation named Contentment.

FIGURE 7.57. Henry Benbridge, *Charlotte Pepper Gignilliat* (Mrs. James Gignilliat), ca. 1775, oil on canvas, 29¾" x 24¾". Colonial Williamsburg Foundation, Williamsburg, VA. Partial gift of Thomas McCutchen Gignilliat.

Henry Benbridge's use of color is balanced and lovely, featuring a satin, peach-colored dress with scalloped sleeves, a deep rose drape from the sitter's right shoulder to below her waist, and a multicolored dress sash.

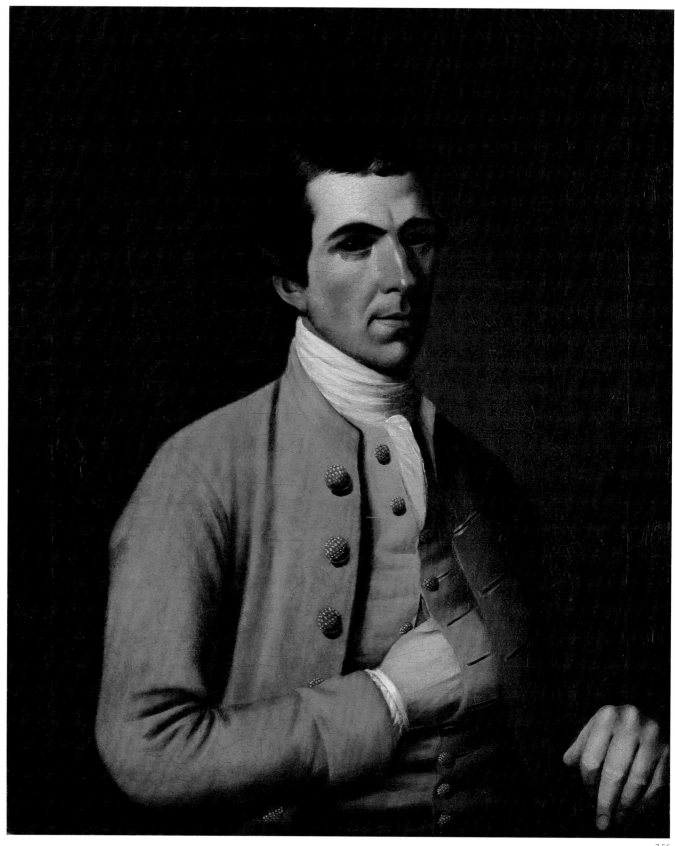

7.56

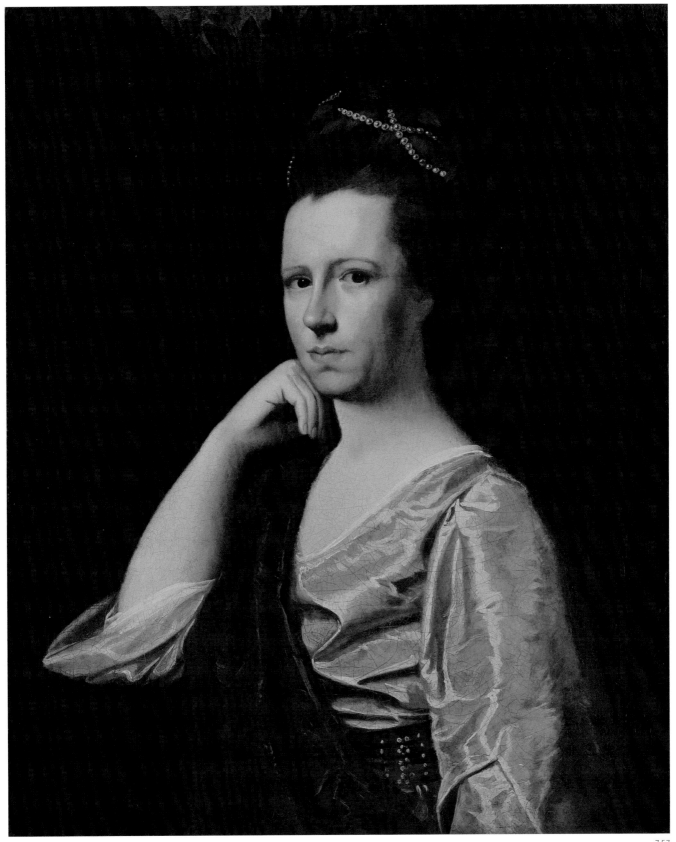

generously increased in 1784 when he and James Peale inherited all of the prints and drawings from the deceased Edmund Price of Primrose Hill in Maryland.[137] An interesting inference supporting the widespread use of the "portrait dress" appears in Peter Manigault's previously mentioned April 15, 1751, letter to his mother in Charleston which describes his portrait by London painter Allan Ramsay and makes it clear that he is *not* shown in "borrowed" clothes:

> The Drapery is all taken from my own Clothes, & the very Flowers in the lace, upon the Hat, are taken from a Hat of my own. . . . the Ruffles are done charmingly, and exactly like the Ruffles I had on when I was drawn, you see my Taste in Dress by the Picture, for every thing there, is what I have had the Pleasure of wearing often.[138]

Leslie Reinhardt provides a particularly insightful summary of the history of the phenomenon of portrait dress and a detailed discussion of its appearance in Benbridge's work.[139]

Robert Edge Pine (1730–1788) was the last significant painter of his generation to paint portraits for southerners.[140] He was born in London, the son of John Pine (1691–1756), an engraver who probably gave him some early drawing lessons. Pine came to America in 1783 and, according to William Dunlap, planned to "paint portraits of the heroes and patriots of the American Revolution, and combine them in historical pictures of the great events which had made the United States an independent nation." Pine had met with some success in painting portraits and historical pictures in England. He had established himself in St. Martin's Lane in London in

1761–1762, and he was there in 1763 when he signed and dated the portrait of Ralph Wormeley V of Virginia (fig. 7.58). Dunlap went on to describe Pine as chiefly a portrait painter who was noted for his coloring and composition. On the death of his brother Simon (d. 1772), Pine went to Bath, England.[141]

Pine continued to paint in Bath until 1779 or later, but he was back in London by 1782 when he held a large exhibition of his pictures featuring scenes from Shakespeare. According to Dunlap, the end of the Revolutionary War and the resulting peace settlement "opened a new field for Pine" and "he quitted England and went to America."[142] Pine worked in both Maryland and Virginia, moving to Philadelphia sometime in either 1785 or 1786. He died in Philadelphia in 1788.[143]

The portraits of Frances (Fanny) Bassett (fig. 7.59) and Elizabeth Parke Custis (1776–1831), both owned by the Mount Vernon Ladies' Association, Virginia, were created at the same time and are fine examples of Pine's American work.[144] The group portrait of Alexander Contee Hanson and family (fig. 7.60), another excellent example, is one of two known conversation pieces by the artist, and it provides a particularly comprehensive study of his neoclassical style. Pine's forms tend to be softly modeled and more painterly than those seen in both Peale's and Benbridge's work, and he was also adept in handling large compositions with several figures, a result of his experience in historical painting.

Like a number of other painters who were trained abroad during and after the War for Independence, Pine was, as Dunlap noted, especially interested in capturing images of military heroes and events leading to the separation of England's colonies and the formation of the new United States of America. He began the large historical picture *Congress Voting the Declaration of Independence* (fig. 7.61), owned by the Historical Society of Pennsylvania, but was unable to finish it before his death. Edward Savage (1761–1817), the American-born painter who went abroad to study with West in 1791, finished the large composition in 1801. Engravings were made after both this picture and Savage's well-known group portrait of Washington and his family (fig. 7.62). These were

FIGURE 7.58. Robert Edge Pine, *Ralph Wormeley V*, 1763, oil on canvas, 49½" x 39½". Virginia Historical Society.

Robert Edge Pine's portrait of Ralph Wormeley V shows the sitter as a young man of eighteen at the time of his graduation from Trinity Hall in Cambridge. A view of Cambridge is seen behind the sitter, who wears his college gown and holds his mortarboard in his left hand. The coloring is handsome but subdued, as befitting an academician and intellectual.

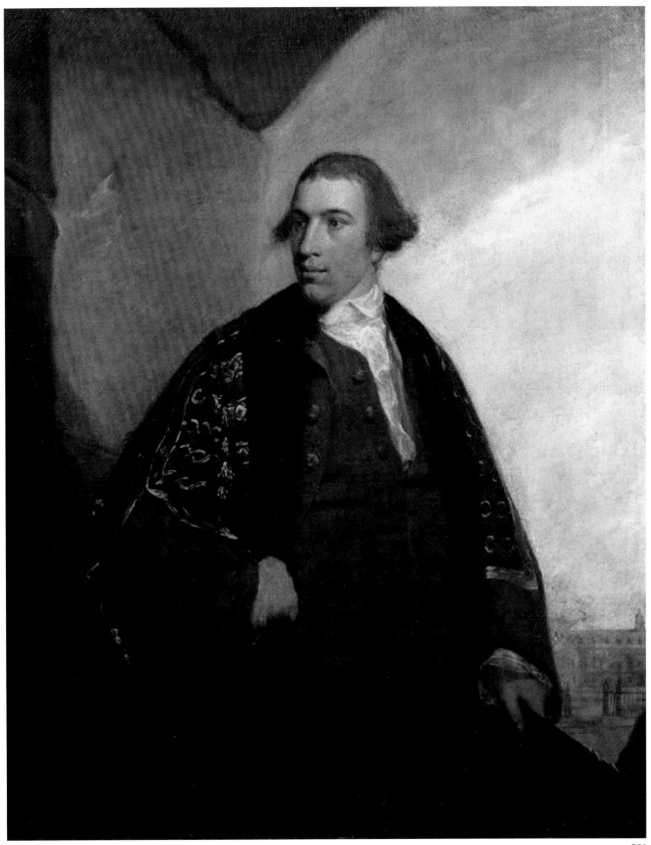

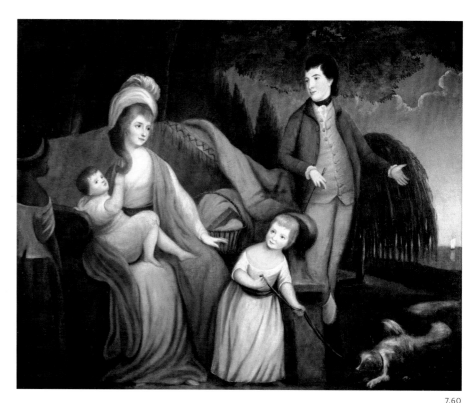

7.59

7.60

FIGURE 7.59. Robert Edge Pine, *Fanny Bassett*, 1785, oil on canvas, 25" x 20⅛". Courtesy of Mount Vernon Ladies' Association.

Fanny Bassett (1767–1796) was the daughter of Burwell Bassett and Anna Maria Dandridge Bassett of Williamsburg, Virginia. She is said to have been the favorite niece of Martha Washington. At the time her portrait was painted in 1785, she was living at Mount Vernon. In October 1785, probably after the portrait was painted, she married George Augustine Washington, George Washington's nephew, who had helped manage the general's lands and estate since the 1750s.

FIGURE 7.60. Robert Edge Pine, *Alexander Contee Hanson Sr., and His Family*, after 1786, oil on canvas, 47¾" x 63⅝". Courtesy of the Maryland Historical Society (Image ID # 1985.62).

Featured from left to right in the portrait are an unidentified servant; Mrs. Hanson (Rebecca Howard Hanson, 1759–1806) holding her son Alexander Contee Hanson Jr. (1786–1819); an older son, George (dates unknown); and Alexander Contee Hanson Sr. (1749–1806). Hanson Sr. was a member of the Annapolis Convention's first session in 1774 and served as clerk of the Maryland Senate from 1777–1778. He resigned to become judge of General Court from 1778–1789. He was also a delegate to the Constitution Ratification Convention held in Annapolis in 1788. His youngest son, Alexander Contee Hanson Jr., became a lawyer, statesman, and publisher of the *Federalist Papers* in Baltimore and later Georgetown in Washington, D.C. He represented Maryland in the U. S. Senate from 1816 until his death.

patriotic images meant to instill in its American viewers a sense of pride and loyalty and to reinforce the expectations for personal and national success.

America's first chapter in historical painting owed its origins to the Revolution and found no shortage of subject matter or heroes, and images that Pine and others first created soon proliferated in engravings and copies by artists of every rank. The South had produced much of the political and military leadership that not only led to independence but also framed the documents of the new country. Moreover, southerners had been among the first to experience the results of the war, including the disruption of various older social patterns and traditions, especially the dominance by wealthy Americans of social, cultural, and political matters. The middling sort in the South, which had been on the rise for decades, would come to dominate commerce and consumerism, continuing to seek out the material comforts and symbols of a good life—including paintings.

Edgar P. Richardson once wrote: "Artists in colonial America were lonely figures. In the neoclassic period

7.61

they became numerous enough to create an artistic life."[145] Richardson went on to identify Philadelphia as the place where this transformation occurred. Joseph Downs, another scholar, announced in 1949 that little of artistic merit was produced south of Baltimore. However, while Philadelphia was certainly a city of large population and sophistication during the late eighteenth century, Charleston in South Carolina, Norfolk in Virginia, and Baltimore in Maryland were equally impressive with their significant cultural offerings, intellectual interests, and artistic achievements.

In fact, a transformation of the sort described by Richardson had no particular center in America. The transformation in American painting after the Revolutionary War arose from the country's rapidly growing middle class that wanted more pictures of varying quality and type. Artists continued to travel throughout the country. Academies were formed and reformed in many places over many years, and clientele for paintings could be found in most populated areas.

While the South was still largely agrarian in its geographical nature and economic base, it played a

FIGURE 7.61. Begun by Robert Edge Pine and completed by Edward Savage, *Congress Voting the Declaration of Independence*, 1784–1801, oil on canvas, 19¾" x 26½". Courtesy of the Philadelphia History Museum at the Atwater Kent, the Historical Society of Pennsylvania Collection.

significant role in the transformation whereby colonial America's cultural milieu grew from having a lonely few painters to being an environment rich with artistic activity. In 1790, Baltimore was rapidly becoming one of the largest commercial port cities in the country, with

FIGURE 7.62. Edward Savage, *The Washington Family*, begun in 1789 and completed in 1796, oil on canvas, 84½" x 111⅞". Image courtesy National Gallery of Art, Washington, Andrew W. Mellon Collection.

After Edward Savage exhibited this portrait in 1796, public demand for images of it increased, resulting in the artist's stippled engravings after it, published in 1798 in Philadelphia.

Shown in the portrait are President and Mrs. Washington to the left and right with two of her grandchildren, George Washington Parke Custis (1781–1857) and Eleanor Parke Custis (1779–1852), and a family slave sometimes identified as William Lee (ca. 1750–1828) but more likely Lee's nephew Christopher Sheels. Sheels was born about 1774 and was owned by the estate of Daniel Parke Custis, Martha's first husband.

hundreds of skilled artisans who knew and produced furnishings and architecture in the very latest urban fashions. Its sophisticated citizens had many close business and family connections with persons in Philadelphia and Virginia. Much like Philadelphia and Charleston, Baltimore was comprised of wealthy merchants, tradespeople, entrepreneurs, and landowners who had the means and desire to purchase paintings and other quality goods. In addition, Virginia, with its towns of Norfolk, Fredericksburg, Alexandria, and the new state capital of Richmond, was no less sophisticated; nor was Georgia, where consumers in its oldest town of Savannah had been attracting an increasing number of artists since the 1780s.

By the end of the eighteenth century, large-scale likenesses were still being created, but smaller, less expensive likenesses were increasingly popular. Miniatures and under life-size likenesses in pastels and watercolors, often

with the sitter posed in profile, were numerous from about 1790 onwards. In addition to being more affordable, such likenesses reflected trends in France and England. Miniature portraits often held special sentimental and romantic values for loved ones, and they were portable. Cut profiles or silhouettes were sometimes collected in a manner similar to modern-day photographs. The survival of several Quaker family albums filled with profiles of relatives and friends attests to this tradition.[146] While small, inexpensive images filled the portrait needs of many consumers, middle-class and wealthy Americans often purchased them in addition to large-scale portraiture. Portraiture continued to be the favored format until its virtual demise in the nineteenth century due to the introduction of photography, a cheap and quick alternative for obtaining likenesses of friends and loved ones.

Still-life paintings and, to a lesser degree, genre, townscape, and landscape pictures were also readily available to most consumers, sometimes created by professionals like various members of the Peale family and sometimes by schoolchildren and other amateurs for educational purposes or for pleasure. Wealthy Americans who traveled abroad continued to engage artists there, and the practice of collecting, particularly the practice of collecting copies of old masters, escalated as wealthy Americans continued to tour abroad, acquiring both portrait and nonportrait art for themselves and friends and family at home. At the same time, however, American artists who trained abroad became more numerous, offering their services throughout America. In addition, the purchase of copy paintings by America's leading painters such as Charles Willson Peale increased dramatically—especially copy paintings that featured war and political leaders and were replicas of important works commissioned by local, state, and the U. S. governments. Art education was also on the rise in schools and among women.

By the turn of the century, the available art varied in quality dependent, of course, on the skill and training of artists. Increasingly, self-taught or minimally trained artists were offering portraiture and related pictures, and their presence swelled the ranks of painters in many areas of the country. Artists with little training, unable to compete for work in large urban centers, often worked close to home or in nearby towns and continued the tradition of performing trades work such as sign painting. These painters, often called folk artists, had a significant impact on arts awareness, and they contributed greatly to the popularity of paintings in small towns and rural communities.

During the period from 1790–1810, the artist population in the South more than doubled—and in some places tripled.[147] Over 150 artists ranging from amateurs to trained professionals worked in Virginia, and almost an equal number painted in the Baltimore area of Maryland from 1790 to 1810. Although South Carolina ranked third with about 95 artists, a large percentage of them were highly skilled or trained in easel and miniature painting. Approximately 50 artists worked in North Carolina and Georgia during these years while the back parts of the South—Tennessee and Kentucky—were visited by 10 to 15 painters, several of whom established residence there. Similar statistics apply to the lower South, including Mississippi and Louisiana. Thus, the story of painters and paintings in the early South presented in this volume foreshadows a much larger artist population and introduces a larger story that continues well into the nineteenth century.

NOTES

1. Franklin to Charles Willson Peale, in Miller, *Selected Papers,* 100. Franklin was likely responding to Peale's letter of Apr. 21, 1771, in which Peale wrote: "Since my (*arrival in*) return to America the encouragement and patronage I have met with exceed my most sanguine expectation" (98).

2. Williamsburg's commercial and political importance declined after 1780 when the capital was moved to Richmond (founded 1737). Fredericksburg had been established in 1728, and, as settlement expanded, its location on the Rappahannock River made it an important port for the immediate area and points west. Norfolk was Virginia's largest urban center during this and later periods. Established in 1680, it experienced significant population growth from about 1770 to 1820. Situated adjacent to Hampton Roads and the Chesapeake Bay, Norfolk had a deepwater harbor to accommodate North Atlantic shipping. By 1765, it had over four hundred houses; by 1775, it was Virginia's most important urban center. Several major

fires in the late eighteenth and early nineteenth centuries destroyed much of the city's material culture; undoubtedly paintings were among those items. Although a few paintings from early Norfolk are shown in this volume, there is a dearth of surviving pictures that can be associated with the town before ca. 1820.

3. All information on the Salazars is courtesy of Cybele Gontar, whose recent research appears in her forthcoming article "Salazar y Mendoza's *The Family of Dr. Joseph Montégut* (c. 1797–1800)," *The Magazine Antiques.*

4. As quoted in "Charles Town: Descriptions," 3, 4, 6, 7.

5. From 1761–1778, Mellish exhibited marine pictures regularly at the Society of Artists in London. Little else is known about his life or career.

6. The only information known about Leitch—that he came from London—appeared in the Charleston paper wherein he advertised the view by subscription, noting that the finished painting, on which he was working at the time, would be sent "Home" to London to be engraved by "Messrs. WOOLLETT and SMITH." Leitch's advertisement appeared in the *South-Carolina Gazette* (Charleston) on Oct. 17, 1774, and again in the paper's supplement for Oct. 31, 1774. "Woollett" was William Woollett (1735–1785), a draftsman and line engraver from Maidstone, England, who went to London to study and work. "Smith" was Samuel Smith who worked in London and was noted for his landscape views. One earlier work by Leitch, a signed oil-on-canvas painting dated 1750, features ships moored in the New York harbor. That picture is owned by the Winterthur Museum, DE; whether it was created in England or the colonies is not known.

7. Raymond D. White's article "Marine Art in the South" provides a good summary of this subject. It includes a discussion of the early overmantel painting titled *The Shipyard on Grady's Inn Creek,* oil on pine panel, ca. 1720, Kent County, MD, owned by the Maryland Historical Society.

8. See McInnis and Mack, *In Pursuit of Refinement,* which provides in-depth information on paintings, the practice of traveling abroad, and the tastes and fashions popular in Charleston. It discusses and illustrates not only the Charleston portraits mentioned here but other important examples as well.

9. The custom of the grand tour began among Europeans in the 1660s and was first pursued by upper-class and upper middle-class young men as part of their education, to give them cultural awareness of and exposure to fashionable society. By the eighteenth century, Americans were among those who traveled to parts of Europe, including France, and then journeyed south to the Mediterranean countries, returning through Europe to, perhaps, Holland before crossing the channel to England.

10. For more information on Smith, see McNeal, "Joseph Allen Smith."

11. Archaeological excavations in these areas began during the second quarter of the eighteenth century. From about 1750 to 1755, James

Stuart and Nicholas Revett, two Englishmen, were the first to survey the ruins and ancient monuments, including sculpture, of Greece and Rome. Their findings were widely published and circulated in England and Italy. While their work was of immediate interest to—and had an immediate influence on—architects working in Europe, it also contributed to the more pervasive interest in ancient art and culture. At the same time, many other references, pamphlets, and articles praised the superiority of ancient painting, architecture, and various objects and generated interest in seeing and studying these works firsthand.

12. The artist's life and meteoric rise to fame have been extensively documented in American painting literature since John Galt's 1816 biography, *The Life and Studies of Benjamin West.* For the purposes of this study, only key events and dates are mentioned. For more information, see von Erffa and Staley, *Paintings of Benjamin West;* Abrams, *Valiant Hero;* Flexner, "Benjamin West's American Neo-Classicism"; Evans, *Benjamin West and His American Students;* Sawitzky, "American Work of Benjamin West"; and Dunlap, *History of the Arts,* 1:33–97.

13. Dunlap, *History of the Arts,* 1:45. West probably painted the portrait of Severn Eyre (fig. I.3) that hangs at Eyre Hall in Northampton County on the Eastern Shore of Virginia. It is not known whether West traveled there or painted it in Pennsylvania.

14. See McInnis and Mack, *In Pursuit of Refinement,* 100–101. McInnis and Mack identify the young men in the portrait from left to right as James Allen; Ralph Wormeley; Andrew Allen, brother of James; Ralph Izard; and possibly Arthur Middleton or Peter Beckford. The identification of Middleton is problematic because he returned to Charleston the year the painting was completed and may not have been available to sit for it. Wormeley and Izard had attended English schools since they were twelve. At the time of the painting, both were studying at Cambridge. Wormeley is also shown in another portrait in fig. 7.58.

15. Fant, Hollis, and Meynard, *South Carolina Portraits,* 268. The portrait is owned by Middle Place Foundation, Charleston, SC.

16. McInnis and Mack, *In Pursuit of Refinement,* 102. Thomas Sully (1783–1872) painted the copy portrait in 1818.

17. American painters of the next generation who studied with Benjamin West also had southern clientele. These painters included Washington Allston (1779–1843), William Dunlap (1766–1839), Charles Bird King (1785–1862), Edward Greene Malbone (1777–1807), Samuel F. B. Morse (1791–1872), Rembrandt Peale (1778–1860), Henry Sargent (1770–1845), Gilbert Stuart (1755–1828), John Trumbull (1756–1843), Samuel Lovett Waldo (1783–1861), John Blake White (1781–1859), and Thomas Sully. James Earl (1761–1796), who worked in Charleston, SC, in the 1790s, may also have been a student of West.

18. A particular artistic discernment among many southerners favored a conservative aesthetic, one that avoided lavish, ostentatious furnishings in favor of things that were more "neat and plain."

However, prior to the 1760s, southern portraits did not always evidence such restraint, possibly due to the options painters presented clients for the selection of poses and costumes.

19. The authoritative study on the artist is Jules David Prown, *John Singleton Copley: In America 1738–1774.*

20. Letter dated 1827 as quoted in Amory, *Life of John Singleton Copley,* 9.

21. 12 Nov. 1766, in Copley and Pelham, *Letters and Papers,* 51.

22. 27 Dec. 1827 as quoted in Dunlap, *History of the Arts,* 1:104.

23. Amory, *Life of John Singleton Copley,* 16.

24. In a letter to Copley dated Aug. 16, 1772, William Carson called Copley "a man of some Genius" and went on to say, "I doubt much if there is your superiour in Europe." Copley and Pelham, *Letters and Papers,* 187–188.

25. West to Copley, 20 June 1767, in ibid., 57.

26. Saunders and Miles, *American Colonial Portraits,* 245.

27. Ironically, Ralph Izard was never able to pay for the portrait due to financial losses associated with the Revolutionary War. The painting did not arrive in Charleston until 1831. See Mack and Savage, "Reflections of Refinement," 32.

28. See McInnis and Mack, *In Pursuit of Refinement,* 108–115, for more detail on the Gainsborough, Spicer, and Hone paintings. McInnis and Mack include a number of other paintings of South Carolinians that were commissioned abroad from other artists that are not discussed here; for this period, they include Dr. John Moultrie Jr. (1729–1798), painted by Philip Reinagle between 1784 and 1798, and the 1785 likeness of Joseph Manigault (1763–1843) by Gilbert Stuart. See also Fant, Hollis, and Meynard, *South Carolina Portraits,* 359, for a portrait of Mrs. Roger Smith (1747–1837) assigned to the London painter George Romney from 1786. Several other possible British portraits illustrated and cataloged in that volume need further research to verify provenance and identity of the sitters.

29. Mack and Savage, "Reflections of Refinement," 27 and 37n17.

30. In *Correspondence of Ralph Izard,* 10. Benjamin West lived at No. 14 Newman Street.

31. Craven, *Colonial American Portraiture,* 350.

32. McInnis and Mack, *In Pursuit of Refinement,* 120–121.

33. "Changes in Taste," 3, 9.

34. See Richardson, "James Claypoole, Junior," for information on James Claypoole Sr.'s son the artist James Claypoole Jr. (ca. 1743–1822) See Miller, *Selected Papers,* 513n104, for more on Claypoole Sr.'s daughter Mary, who married James Peale, the younger brother of Charles Willson Peale, on Nov. 14, 1782.

35. John Neagle of Philadelphia wrote the following to William Dunlap about Pratt's signs: "I have seen the works of Pratt—portraits and other subjects. I remember many signs for public houses (now all gone) painted by his hand, and I assure you they were by far the best signs I ever saw. They were of a higher character than signs generally, well coloured, and well composed. They were like the works of an artist descended from a much higher department." Dunlap, *History of the Arts,* 1:102–103.

36. Sawitzky, *Matthew Pratt,* 19. Susan Rather quotes Shewell as saying that her cousin's art was "merely mechanical," and she further cites Shewell's even more critical assessment of her cousin's personality: that he seemed to have "a great share of vanity & always overrated his Ability" ("Painter's Progress," 170–171).

37. Pratt is one of only a few early American painters whose palette of paints has been studied. His 1765 palette was arranged from left at the thumb hole to the right: flake white, vermillion, crimson lake mixed with white, burnt sienna, yellow ochre (?), brown ochre (?), light red, ivory black, ivory black. In the center of the palette were yellow ochre, spot of vermilion, greenish tint, bluish tint (the last two mixed with white), black. This data was taken from a study of the palette that Pratt is shown holding in *The American School.* See Schmid, "Some Observations on Artists' Palettes," 336.

38. Saunders and Miles, *American Colonial Portraits,* 265–267.

39. The most revealing of these interpretations is credited to Rather, "Painter's Progress," 171–182. Her discussion also compares the Pratt work to similar studio views by John Hamilton Mortimer (1740–1779) and George Romney.

40. Dunlap, *History of the Arts,* 1:101.

41. Pratt is known to have visited Ireland in 1770.

42. Purdie and Dixon's *Virginia Gazette* (Williamsburg), Mar. 4, 1773.

43. Stephenson, *Lots 41 and 42,* 1–2.

44. As previously discussed, two mythological pictures by the earlier Philadelphia artist Gustavus Hesselius (1682–1755) survive (see fig. 2.56 for one of them). In the 1780s or later, a member of the Middleton family of South Carolina acquired the painting of Cymon and Iphigenia by Angelica Kauffman (1741–1807). See McInnis and Mack, *In Pursuit of Refinement,* 156.

45. The Meade portrait is owned by the Virginia Historical Society, Richmond, VA.

46. One unidentified visitor to Pratt's New York City "exhibition-room" wrote that he "observed the portrait of the beautiful Miss Achmuty, under which were written some verses by her impassioned admirer Major Montcrief. The portrait was rather indifferently executed, and the poetry scarcely rose to mediocrity; upon which he [Pratt] took out his pencil, and wrote the following lines at the foot of the canvass—— 'To *paint* or *praise* thy charms how vain the hope, / *Pratt* is no *Titian,* nor *Montcrief* a *Pope.*'" *Daily Advertiser* (New York, NY), Apr. 22, 1788. The location of Miss Achmuty's portrait is unknown.

47. Philadelphia City Directories as found in the MESDA Craftsman Database.

48. The Delanoy family was of Dutch origin; several branches were in New York beginning in the seventeenth century. Abraham Delanoy Jr., the artist, was distantly related to the Duyckinck family that included several painters. In *American Colonial Portraits,* Saunders and Miles name Delanoy as the stepfather of New York painter Evert Duyckinck III (1677–1727) (273). Delanoy was also related through marriage to the Beekman family. Portraits by Delanoy were commissioned by James Beekman soon after the artist returned from London.

49. See *Rivington's New-York Gazetteer* (New York City), June 22, July 21, and Oct. 6, 1774, and Apr. 6 and 20, 1775.

50. *New-York Mercury* (New York City).

51. *Daily Advertiser* (New York City, NY), June 30, 1789.

52. Dunlap, *History of the Arts,* 1:250, 254. The only other references to Abraham Delanoy, probably the artist, consist of correspondence with William Beekman in 1783. Delanoy had painted portraits for Beekman and other members of the prominent New York family about 1767. The correspondence, located in the Beekman papers at the New-York Historical Society, is described in Van Buskirk, *Generous Enemies,* 183, 230, and 232.

53. Horace W. Sellers, "Charles Willson Peale, Artist-Soldier," 257. The tribute was sent by Custis to Rembrandt Peale, the son of Charles Willson Peale and also a painter.

54. Charles Coleman Sellers's various writings about the artist are the most authoritative. They include *The Artist of the Revolution: The Early Life of Charles Willson Peale;* its companion volume, *Charles Willson Peale. Vol. 2, Later Life (1790–1827);* and *Portraits and Miniatures by Charles Willson Peale.* Lillian Miller served as the editor of the Peale family papers, published in five volumes as *The Selected Papers of Charles Willson Peale and His Family* (see n4 in ch. 6).

55. Unless otherwise noted, the biographical information on Charles Willson Peale is taken from the companion volumes of Charles C. Sellers, *Artist of the Revolution: The Early Life of Charles Willson Peale* and *Charles Willson Peale. Vol. 2, Later Life (1790–1827).* Peale's father was apparently banished from England on account of a misdemeanor.

56. Barnes, "Charles Peale," 2.

57. See Miller, *Selected Papers,* 16n4, 77n1. Some of the communication about the portrait commission may have been passed through Edmund Jenings Jr., the son, who was acquainted with Peale in London between 1767 and 1769.

58. The heads represent two early British proponents of religious and civil liberties, John Hampden, who was killed during the English Civil War, and Algernon Sydney, who was beheaded by Charles II. In 1775, Hampden-Sydney College in Virginia, the oldest private charter college in the South, was named after these men. The college was advertised as the Academy of Prince Edward until its name was chosen by its founder, Samuel Stanhope Smith.

59. Charles C. Sellers, *Portraits and Miniatures,* 172–173. Sellers notes that the painting was transferred to the Capitol building in Richmond, presumably by a descendant of Richard Henry Lee. In 1901–1902, it was transferred to Westmoreland County by an act of the Virginia General Assembly.

60. In Lee, *Letters,* 76–77.

61. Charles C. Sellers, *Portraits and Miniatures,* 157. Given to the family by one of the homeless war veterans who roamed the streets of Philadelphia, Argus lived for seventeen years.

62. Peale to Rembrandt Peale, 11 Sept. 1808, as quoted in ibid., 157. Peale created two plaster busts in his lifetime; one was a self-portrait and the other was of George Washington in 1778. See ibid, 224.

63. 21 Apr. 1771 and 4 July 1771 in Miller, *Selected Papers,* 98–100.

64. One of the earliest, if not the earliest, important collections of southern paintings belonged to William Byrd II (discussed on pages 24, 84–96). A number of paintings from that collection are now owned by the Colonial Williamsburg Foundation and by the Virginia Historical Society in Richmond. In addition, Thomas Jefferson was especially interested in European art and was among the first to collect items for his home in Virginia. Robert Gilmor Jr. in Maryland and Joseph Allen Smith, previously discussed, were two others. W. G. Constable provides an important outline on this subject in his *Art Collecting in the United States of America.*

65. Miller, *Selected Papers,* 127. Bordley was an amateur artist who sought Peale's advice. The frequent correspondence between them nearly always addressed matters of art.

66. Jenings was born in Virginia but spent most of his life in England. His sympathies with the colonies were well-known. Peale indicated that he wanted to paint his portrait either in miniature or life-size as noted in his papers and correspondence of 1766–1767. Whether he ever did is speculative. A likeness of Jenings at the Virginia Historical Society previously attributed to Peale is now thought to be by an unidentified artist.

67. Horace W. Sellers, "Charles Willson Peale, Artist-Soldier," 265.

68. Charles C. Sellers, *Portraits and Miniatures,* 230.

69. According to George Escol Sellers, a descendant of the artist, Charles Willson Peale wrote a full and detailed account of his portraits of Washington; its location remains unknown (Sellers to Coleman Sellers, 4 Aug. 1898, in ibid., 216). See ibid., 216–241, for a detailed discussion of Peale's likenesses of Washington.

70. Peale was one of several artists involved in the creation of some two dozen portraits of George and Martha Washington between 1789 and 1797. An important discussion of those portraits is found in

George and Martha Washington: Portraits from the Presidential Years by Ellen G. Miles.

71. Charles C. Sellers, *Portraits and Miniatures,* 216–217. The lecture manuscript is in the Roberts Collection at Haverford College, PA.

72. Peale to Edmund Jenings, 29 Aug. 1775, as quoted in ibid., 218.

73. Ibid., 219.

74. Miller, *Selected Papers,* 208, 210.

75. In 1782, Sarah married John Callahan (ca. 1754–1803), who trained under St. George Peale as a clerk in the Annapolis Land Office. St. George Peale, who died in 1788, was the brother of the artist Charles Willson Peale. See ibid., 43.

76. From Philadelphia in September or October 1774, Peale wrote to John Dixon in Williamsburg that he had sent by boat to Norfolk a painting that Dixon had requested. The item in question was a flag for the Independent Company of Williamsburg at the cost of twelve guineas. Peale said it was done in oil paints on two pieces of fabric so that the colors would not bleed through. Ibid., 136–137. Transparencies were usually paintings on translucent material such as linen. They were illuminated from behind by lamps of various sorts. Peale's most famous transparent scenes were associated with celebrations marking the arrival of George Washington in Philadelphia in 1781 and those commemorating the peace treaty with Great Britain. The latter were prepared for display on a large, elaborate triumphal arch, erected in 1784 and destroyed by fire shortly after it was built. See ibid., 396–401. Also in Miller, see Peale's letter to George Weedon dated Feb. 10, 1784 (405–406).

77. The entire poem also appears in Miller, *Selected Papers,* 107–108. See also Miller 108n1 regarding the Reverend Jonathan Boucher as the possible author of the verses.

78. See also Charles C. Sellers, *Portraits and Miniatures,* 96. Sellers mistakenly identified the woman as "Sarah" Hallam, who did, as he wrote, teach drawing in Williamsburg, VA, in 1775. However, she was not the actress in the play.

79. Purdie's *Virginia Gazette* Postscript (Williamsburg), Aug. 11, 1775. A Colonel William Pierce Jr. served with the American forces in the years following 1775. He may have been the same person since no other references to a painter by that name have been found.

80. George Weedon Account Book (1777–1793), Special Collections, University of Virginia Library, 15.

81. A. K. Ford Manuscript Collection, Minnesota Historical Society, St. Paul, MN, reel no. 5, item no. 1507, as found in the MESDA Craftsman Database.

82. Both portraits are owned by the Virginia Historical Society.

83. For his advertisements, see *Virginia Herald* (Fredericksburg), June 5, 1788, and *Virginia Independent Chronicle* (Richmond), Nov. 5, 1788, as found in the MESDA Craftsman Database. Mercer's obituary was published in the *Political Arena* (Fredericksburg, VA), Aug. 27, 1839, and the *Richmond (VA) Compiler,* Sept. 2, 1839, as found in the MESDA Craftsman Database. In addition to Mercer, Pierce, and members of his own family, Charles Willson Peale's students in Maryland included Edmund Brice (1751–1784), John Beale Bordley (1764–1815), Matthias Bordley (1757–1818), Elizabeth Bordley Gibson (1777–1863), and others. Brice was the husband of John Hesselius's stepdaughter Harriet Woodward. They were married in 1783.

84. Peale married three times: in 1762, to Rachel Brewer; in 1791, to Elizabeth de Peyster; and, in 1805, to Hannah Moore.

85. Polk's mother, Elizabeth, who died about 1773 when Polk was six, was Charles Willson Peale's youngest sister. Her husband, the master of a privateering vessel, was killed in 1777 during an encounter with a British naval ship. See Simmons, *Charles Peale Polk,* 2.

86. As quoted in Charles C. Sellers, "James Peale," 29. Unless otherwise noted, all biographical information regarding James Peale is from this source.

87. Sellers writes, "It is probable that he [James] followed the army to Yorktown as a volunteer, bringing back studies of the scene which appear in some of the Peale *Washingtons*" (ibid., 29). James's sketches probably served both himself and Charles Willson in preparing the various views of the generals at Yorktown and in painting the larger portraits of Washington.

88. Charles C. Sellers, *Portraits and Miniatures,* 8, 15.

89. Conflicting dates for Elizabeth's death are cited by Simmons, *Charles Peale Polk,* 2, who gives the date as "around 1773," and Charles C. Sellers, *Artist of the Revolution,* 6, 91, 178, and 179, which says she died in 1776. Other genealogical sources give 1775 and 1777.

90. *Maryland Journal and Baltimore Advertiser,* Mar. 25, 1785.

91. Charles C. Sellers, *Charles Willson Peale: Later Life,* 422. According to Simmons, *Charles Peale Polk,* 15–16, Rachel died in 1810, and Polk married soon after to a Mrs. Brockenborough from Fredericksburg; her dates are not known, but apparently she was either dead or divorced by Dec. 25, 1816, when Polk married Ellen Ball Downman of Richmond County, VA.

92. Charles C. Sellers, *Artist of the Revolution,* 264.

93. *Maryland Gazette; or, the Baltimore Advertiser,* May 24, 1791, and *Maryland Journal and Baltimore Advertiser,* July 22, 1791, as found in the MESDA Craftsman Database.

94. *Baltimore (MD) Daily Repository,* May 30, 1793; *Baltimore (MD) Daily Intelligencer,* Apr. 24, 1794; *Federal Intelligencer, and Baltimore (MD) Daily Gazette,* Apr. 27, Sept. 21, and Oct. 5, 1795; all as found in the MESDA Craftsman Database.

95. *Bartgis's Federal Gazette, or the Frederick-Town (MD) and County Weekly Advertiser,* Jan. 3, 1798; *Maryland Herald & Elizabeth-Town Advertiser,* Aug. 23, 1798; and *Virginia Gazette and General Advertiser*

(Richmond), Nov. 22, 1799; all as found in the MESDA Craftsman Database.

96. Simmons, *Charles Peale Polk,* 12–14.

97. Batson, "Charles Peale Polk," 52.

98. Simmons, *Charles Peale Polk,* 17.

99. Lee was the father of the Confederate General Robert Edward Lee.

100. Simmons, *Charles Peale Polk,* 38.

101. This Charles Carroll (1723–1782) was a distant cousin of Charles Carroll of Carrollton.

102. 29 Oct. 1767, in Miller, *Selected Papers,* 70–71.

103. The MESDA Object Database provides information on the original label on the painting that reads "Charleston South Carolina The Abortive Attack on Fort Moultrie 26th June 1776, by a British Naval Force under Commodore Sir Peter Parker. consisting of the MS's Bristol, Active, Experiment, Solebay, Actaeon, Syren, Sphinx, and Bomb Vessel Thunder. Lieut. William Elliott, RN, Fl 1784–1792. Hon. Exhibitor at the Royal Academy." Miles, Gray, and Elliot may have studied at Woolrich's Royal Military Academy.

104. Unless otherwise noted, biographical information on Benbridge is derived from Stewart, *Henry Benbridge,* 13–23, or Weekley, "Early Years," 33–34. The most recent published material on Benbridge, Maurie McInnis's "'Our Ingenious Countryman Mr. Benbridge,'" includes many of Stewart's findings along with important additional information about the artist's studies abroad.

105. Stewart writes, "The sister of Henry [Benbridge]'s maternal grandfather was married to Abraham Bickley Jr. (1709–1743), and their son Abraham Bickley III married Mary Shewell. Mary's sister Elizabeth Shewell became Mrs. Benjamin West." *Henry Benbridge,* 13. This is the same Elizabeth Shewell who was a cousin of Matthew Pratt and who was accompanied by him to London in 1764. See page 345.

106. Ibid., 15. According to Stewart, Peale also wrote that Benbridge "was sent to Italy for improvement," that the two of them met in Philadelphia, and that Benbridge married a Miss Sage "who had acquired some knowledge of miniature painting from her friend Peale."

107. Mar. 2, 1770, the Henry Benbridge Papers, MSS, Gordon Saltar Collection, Henry Francis du Pont Winterthur Museum, Winterthur, DE, as quoted in Stewart, *Henry Benbridge,* 14.

108. McInnis, "'Our Ingenious Countryman,'" 8. McInnis also discusses Benbridge's likely knowledge of paintings by Raphael Mengs. Benbridge's surviving sketchbook is illustrated in McInnis's study and contains mostly details of sculptural forms, antique vessels, and other ancient Roman or Greek pieces.

109. Stewart, *Henry Benbridge,* 18. See also Stewart, "Portraits of Henry Benbridge," 67.

110. "'Our Ingenious Countryman,'" 7–8.

111. See Stewart, *Henry Benbridge,* 40. This is probably the picture mentioned in Benbridge's Apr. 28, 1787, letter to his stepsister Elizabeth Saltar, who lived in Pennsylvania: "I have begun a large picture of four whole lengths the size of life." Henry Benbridge Papers, MSS, Gordon Saltar Collection, Henry Francis du Pont Winterthur Museum, Winterthur, DE, as quoted in Stewart, *Henry Benbridge,* 18.

112. McInnis, "'Our Ingenious Countryman,'" 10 and 11; Stewart, *Henry Benbridge,* 18 and 19.

113. 23 Jan. 1770, in Mack, *Henry Benbridge,* 125.

114. Benbridge also carried endorsements of his portrait work from West and Franklin to persons in America when he left England in 1770. See Stewart, *Henry Benbridge,* 19.

115. Saunders and Miles, *American Colonial Portraits,* 319.

116. *South-Carolina Gazette* (Charleston), Mar. 26, 1772.

117. Ibid., May 14, 1772.

118. Stewart, *Henry Benbridge,* 19, 22n1, 23n40.

119. *South-Carolina Gazette* (Charleston), Apr. 5, 1773. Bartram, *Travels through North & South Carolina,* 2.

120. See also Brunhouse, "David Ramsay." Dr. David Ramsay of Charleston, in his letter to Benjamin Rush in Philadelphia, Apr. 8, 1777, wrote: "Mrs Sage lives next door to me with her son in law Mr Bambrage. Poor man, his wife and mine were both buried in one day [in 1776]. This climate is very fatal to women, their sex & inaction, & et all cooperate with the climate to relax them. Query. Should not ladies in warm countries delay marriage till the age of twenty. There are strong reasons both for and against this. . . . Our women here upon an average do not live above 33. Many die in the first or second pregnancy" (55). Ramsay mentioned Mrs. Sage, the mother of Hetty, several times in his letters to Rush. Apparently Hetty's mother continued to live in Charleston and occasionally visited Philadelphia. She was there as late as 1779 (63, 65). During these same years, Ramsay carried on an active correspondence with Charles Willson Peale. See also Simmons, *Charles Peale Polk,* 2. Ramsay's brother Nathaniel had married first to Margaret Peale, Charles Willson Peale's sister. Charles Willson Peale, his wife, and probably other members of his family lived with the Ramsays in their Charles Town, Maryland, house during the fall and winter of 1775.

121. See previous note.

122. Rutledge, *Artists in Charleston,* 124.

123. For the names and a brief discussion of other lesser-known artists in South Carolina and other areas of the South, see appendix A.

124. Stewart, *Henry Benbridge,* 19–20. Benbridge's stepfather had died on June 2, 1772.

125. Information on the Bushrod Washington portrait is from critically important research conducted and published by Stephen E. Patrick, "'I Have at Length Determined to Have My Picture Taken.'"

126. These would have been ground pigments, not premixed, liquefied "paints."

127. As quoted in Patrick, "'I Have at Length Determined,'" 79–80.

128. See appendix A for additional information on Wright.

129. *South-Carolina Gazette, and General Advertiser* (Charleston), Feb. 5–7, 1784.

130. Weekley, "Henry Benbridge," 53.

131. Stewart, *Henry Benbridge,* 21. Harry is believed to have lived in Philadelphia until his move to Norfolk. He may have lived in Perth Amboy for an unknown length of time. His wife, Sarah Truxton Benbridge, was from Perth Amboy, Middlesex, NJ. They married there on Aug. 7, 1796. Of their eight children, the two oldest and the youngest were born in Norfolk, four of the remaining five were born in Philadelphia, and the fifth in Perth Amboy. Birth and christening records from Christ Church, Philadelphia; St. Peter's Church, Philadelphia; and the Church of Jesus Christ of the Latter Day Saints, Ancestral Files (AFN:108F-FXN, F2N, 84T, 23L, DHS, 868, 88N, 89V, 852, 833, 829, 8DH, and 87G).

132. Dunlap, *History of the Arts,* 2:104–107.

133. Stewart, *Henry Benbridge,* 21. Philadelphia records for the Board of Health and Christ Church refer to his burial on Jan. 25, 1812. Stewart also notes that Harry and his family moved to Cincinnati, OH, in 1815.

134. See Aiken, "Observations," 46–47, for an excellent reevaluation of miniatures associated with both of the Benbridges. Aiken asserts that Letitia (Hetty) may not have painted in Charleston, or, if she did, examples by her have yet to be documented or identified.

135. Curiously, these and other "props" commonly associated with colonial portraits are not listed in the artists' inventories that are currently known. This seems odd, for other small items, often irrelevant to painting, are listed. It may be that such costumes had been memorized or were made up by painters such as Benbridge, who would have been very familiar with them from his experience abroad and subsequent practice.

136. Benbridge to Betsy Gordon in Mack, *Henry Benbridge,* 130.

137. Maryland Register of Wills (Inventories) 1784–1792, TG #1, vol. 34, 220, entry for Jan. 25, 1784. The copy of the will in the register shows the testator as Edmund "Price," but, considering that John Hesselius owned Primrose Hill and Hesselius's stepdaughter Harriet Woodward married an Edmund Brice who died in 1784, it is likely that the name in the record is misspelled, in which case the collection belonged to Edmund Price, John Hesselius's stepson-in-law and Charles Willson Peale's former pupil (see note 83).

138. "Letters," 31, no. 4: 277–278.

139. See Reinhardt's essay, "'Dress and Dissipation': Costume in Henry Benbridge's Charleston Paintings." Reinhardt writes that Benbridge's attire for women was "part of a widespread phenomenon in Anglo-American portraiture of creating dress that explicitly avoided fashion. This imaginary dress . . . is marked by its departure from fashion" (21). Benbridge frequently used such fictional dress in female portraits, but he very likely copied or provided dress in current fashion for some portraits, namely those of Mrs. Archibald Bulloch (dates unknown), Mrs. George Flagg (dates unknown), possibly Mrs. Peter Horry (1742–1815), Mrs. Benjamin Simons (1710–1776), and Mrs. John Morel (Mary Bryan, 1744–1822), all of whom are wearing gowns that existed abroad and in America during their lifetimes.

140. The primary modern study of Pine is Robert G. Stewart, *Robert Edge Pine: A British Portrait Painter in America, 1784–1788.* Much of what is known about Pine comes from William Dunlap and correspondence of the period.

141. Dunlap, *History of the Arts,* 1:316–317.

142. Ibid., 317.

143. Pine wrote to George Washington on Dec. 16, 1785, that he had sent him the Bassett and Custis pictures, saying also that "I have been some time at Annapolis, painting the Portraits of Patriots, Legislators, Heroes, and Beauties, in order to adorn my large Pictures and expect to pass a few Weeks at Baltimore" and noting that he planned to go to Philadelphia afterwards. Abbot, *Papers of Washington,* 460.

144. Burwell Bassett's son—and Fanny's brother—Burwell Bassett Jr. owned Bassett Hall, the restored home now owned by Colonial Williamsburg that served as the Williamsburg residence of Mr. and Mrs. John D. Rockefeller Jr. in the 1930s–1940s.

145. *Painting in America,* 127.

146. The Abby Aldrich Rockefeller Folk Art Museum, CWF, owns two such albums that descended in the Rumford-Canby-Morris families of Delaware and Philadelphia. For more information on this tradition among the Quakers, see Verplanck, "Silhouette and Quaker Identity."

147. Such statistics are hard to render accurately and well may be on the low side, for they are based primarily on advertisements and information gathered from other written records. Many artists never signed their works, advertised, or left other evidence of their activities.

Other Known Painters
Associated with the South between 1760 and 1791

Note: Life dates are unknown for many of the artists listed here, and few or no works survive for most of them. Joseph Wright and Robert Fulton are two notable exceptions since both created numerous portraits in the mid-Atlantic and elsewhere.

ALLWOOD, JOHN

Allwood was probably trained as a house and ornamental painter who eventually tried his hand at easel painting. On leaving South Carolina in 1773, he noted in an advertisement that he was disposing of "His NEGRO FELLOWS, *Painters*," most likely house painters. Allwood also noted that he had "a few well-painted Pictures to dispose of," although there is no indication of what they represented. (*South Carolina Gazette* [Charleston], Mar. 8, 1773.)

ANSON, WILLIAM

Anson advertised in the *Augusta (GA) Chronicle and Gazette of the State* on March 10, 1792, that his services included portraits, miniatures, and sign and house painting. He could be engaged by applying to Noah Kelsey on Greene Street. This is probably the same man who advertised in the *Virginia Centinel; or, the Winchester Mercury,* April 2, 1788, that he was a "painter and upholsterer." At that time his services included painting shew-boards and "walls of rooms in water colours," paper hanging, house painting, and putting on "gold or silver bordering, &c." (All sources as found in the MESDA Craftsman Database.)

BOOTH, BARTHOLOMEW

Booth's association with the painting trades is established through information from his Washington County, Maryland, estate inventory, registered on November 3, 1785 (Register of Wills [Inventories], 1784–1792, A #2, 33–40, as found in the MESDA Craftsman Database). The inventory includes a variety of navigational aids, mathematical tools, and related equipment as well as painting utensils, miniature pictures, pencils, inks, a drawing board, various drawings and papers for drawing, two groups of picture frames, old glass, ten oil paintings, six drawings in chalk, and seven prints in frames. His total estate was valued at £2,285 16s. 2d.

BOURGOIN, FRANCIS JOSEPH

This artist worked in Charleston, South Carolina, as early as 1789 when he advertised that he had arrived from New York and that he painted miniatures and taught drawing (*City Gazette, or the Daily Advertiser* [Charleston, SC], Jan. 22, 1789, as found in the MESDA Craftsman Database). He was listed in the Charleston city directory in 1790 at the address where Henry Benbridge, the painter, also lived. His name also appears in the New York City directories as early as 1806 and 1807. (As found in the MESDA Craftsman Database.)

CAMPBELL, JAMES

References to James Campbell in Maryland date as early as April 8, 1785, when he published his intent to settle in Baltimore where he would carry on the coach, sign, house, landscape, and ornamental painting business (*Maryland Journal and Baltimore Advertiser*). He was a "Painter" at Perry Hall, presumably working in some capacity for Harry Dorsey Gough, who had purchased the property and built his estate beginning in the mid-1770s. Although there does not seem to be any relationship between Campbell and the slightly later painter Francis Guy, it is worth noting that a surviving view of Perry Hall has traditionally been assigned to Guy as having been executed in 1805.

Campbell was settled in Baltimore near Andrew Stigar's tavern by November 1785, and his advertisement there listed the same services, with the addition of teaching drawing, sketching, and architecture in his evening school near Charles Street and St. Paul's Lane (*Maryland Journal and Baltimore Advertiser,* Nov. 8, 1785). Two newspaper notices followed in 1787, with information challenging the legal ownership of a slave named Charles—one claimant being the artist and the other being Mrs. Frances Mudie (*Maryland Gazette; or, the Baltimore Advertiser,* Aug. 17 and Sept. 4, 1787, as found in the

MESDA Craftsman Database). In 1790, Campbell cautioned creditors against transacting any charges on his accounts placed by his wife, Frances (*Maryland Gazette; or, the Baltimore Advertiser,* Nov. 30, 1790, as found in the MESDA Craftsman Database). By 1793, Campbell was concentrating his career on teaching architecture, plain and perspective, in a room near the Baltimore courthouse (*Baltimore [MD] Daily Intelligencer,* Nov. 1, 1793; *Baltimore [MD] Daily Repository,* Oct. 17, 1793, as found in the MESDA Craftsman Database). The last reference to Campbell appears in the *Federal Gazette & Baltimore (MD) Daily Advertiser,* July 5, 1797, and concerns a letter waiting at the post office. See also *History of the Arts* (vol. 1, 224), in which Dunlap refers to a letter in which General Washington thanked "Col. Jos. Reed" for a picture he sent to Mrs. Washington. This picture presumably was a portrait of the general in uniform painted by a "Mr. Campbell."

CHEFDEBIEN, LOUIS MARIE PAUL

Chefdebien was a miniature painter who was active from about 1779 to 1805 or possibly a year or two later. He was in Maryland intermittently during those years; in Williamsburg, Virginia, in 1779; and in Richmond, Virginia, in the 1780s through 1792. An 1804 notice in Charleston, South Carolina, newspapers indicates that his family was attempting to make contact with him. (See Colwill, "Chronicle of Artists," 71–72.)

CHRISTOPHE, L. (LEWIS) M.

This artist was an itinerant whose name first appears in newspapers in 1790 in Winchester, Virginia, where he was living on Cameron Street, near the Market House, and advertising likenesses in miniatures (*Virginia Gazette, or the Winchester Advertiser,* Sept. 15, 1790, as found in the MESDA Craftsman Database). By 1791, he was also advertising oil portraits on canvas to life-size, half-length, and half as well as smaller sizes. He visited Richmond in 1791 and possibly 1792, and he traveled to the Norfolk-Portsmouth area in late 1791. He also worked in Baltimore, Alexandria, and Fredericksburg, presumably in these same years. His advertisements note that he was a student of the Royal Academy of Painting in Paris. (*Virginia Gazette, and Weekly Advertiser* [Richmond], Sept. 30, 1791; *Norfolk and Portsmouth [VA] Chronicle,* Dec. 10, 1791, as found in the MESDA Craftsman Database.) The *Virginia Gazette, and General Advertiser* (Richmond) included "Lewis Christopher, Limbner" for letters remaining in the post office on January 4, 1792 (as found in the MESDA Craftsman Database).

CLARKE, WILLIAM

Clarke worked as a miniature and portrait painter and probably moved to the Baltimore area about 1788, after working in the vicinity of Lancaster, Pennsylvania, in 1785. He may also have had a school in Baltimore in the 1790s. Evidence that he worked on the Eastern Shore of Maryland is supported by a signed overmantel in a private collection and his 1793 portrait of Mrs. William Polk (Anne Purnell, b. 1760), also in a private collection. (See Colwill, "Chronicle of Artists," 72, and Weekley and Colwill, *Joshua Johnson,* 166.)

CLEPHAN, LEWIS

The Museum of Early Southern Decorative Arts (MESDA) field research program documented three portraits by the painter, all under life-size. Two of the portraits show waist-length seated men from Maryland; the third shows a New York merchant in similar pose. One of the Maryland pictures is signed and dated 1788. Clephan advertised in the *Independent Journal: or, The General Advertiser* (New York, NY), on May 16, 1787, as a "Portrait Painter," who had moved his business from Chapel Street to 28 Crown Street, where he painted whole-, half-, and quarter-length-size portraits. He also noted that he did miniatures and "Hair Work." (See Kelby, *Notes on American Artists,* 31.) A signed 1788 example of Clephan's work, a portrait of John Remsen (dates unknown), was created in New York and is owned by the Museum of the City of New York. Other examples have been attributed to his hand, including a privately owned example and MESDA's portrait, circa 1805, of Leonard Harbaugh (1749–1822) of Maryland.

FLAGG, JOSIAH

Flagg published one brief advertisement in Baltimore in 1784, noting that he offered miniature painting and worked with "HAIR DEVICES, for Lockets," "Brasslets" (bracelets), and rings. He could be contacted at Mrs. Sanderson's on Market Street, opposite South Street. (*Maryland Journal and Baltimore Advertiser*, Aug. 31, 1784.)

FULTON, ROBERT

Robert Fulton (1765–1815), a painter, was also the inventor associated with the development of steam-propelled boats. He worked as a miniature painter from the age of seventeen until he went abroad in 1787 with a letter of recommendation to Benjamin West for further study. Fulton's earliest American work is usually associated with Pennsylvania, but at least one

small portrait by his hand survives of a southerner, a likeness of the artist William Prentis Jr. (active 1770s–1790s), signed and dated 1786, owned by the Virginia Historical Society, Richmond. Prentis was the publisher of the *Virginia Gazette, and Petersburg Intelligencer* and a surveyor. Fulton was in Europe until 1806. In 1806, he was in New York, where presumably he continued to live until his death at age fifty.

GIBSON, ROBERT

Gibson was located in Charleston, South Carolina, from 1783 to 1792 as a teacher, briefly in partnership with W. Falconer, in an academy located at 11 Tradd Street, where he taught mathematics, English grammar, geometry, navigation, architecture, drawing, and painting in watercolors (*Chronicle of Liberty, or the Republican Intelligencer* [Charleston, SC], Mar. 25, 1783; *South-Carolina Gazette, and the Public Advertiser* [Charleston], Sept. 24, 1785). Little is known about either of these men. Falconer claimed to have been educated at a celebrated university in Europe (*South-Carolina Gazette, and the Public Advertiser* [Charleston], Nov. 8, 1785); his partnership with Gibson was dissolved in 1786 (*Charleston [SC] Morning Post, and Daily Advertiser,* Sept. 18, 1786; see also Jan. 12, 1787). Gibson continued to teach in Charleston until he was named superintendent of a seminary known as Beresford's Bounty in Cainhoy, northeast of Charleston (*Charleston [SC] Morning Post and Daily Advertiser,* Feb. 10, 1787). He returned to Charleston in 1791 and taught there until his death in January 1792. His wife, Anna M. Gibson, was the administrator of his estate. (*State Gazette of South-Carolina* [Charleston], Jan. 31, 1791, July 7, 1791, and Jan. 5 and June 11, 1792; *City Gazette & Daily Advertiser* [Charleston, SC], Sept. 10, 1792.)

HAMILTON, ALEXANDER

A native of Edinburgh, Hamilton earned his medical degree from the University of Edinburgh in 1737, the year he moved to Annapolis, Maryland. He traveled throughout the northeast, visiting the studios of Robert Feke in Newport, Rhode Island, and John Smibert in Boston, Massachusetts. An amateur artist, he included his only known work, an ink-on-paper self-portrait, in the minutes of the Tuesday Club of Annapolis. Hamilton was a cofounder of that club. (See Saunders and Miles, *American Colonial Portraits,* 187, which also includes an illustration of the portrait, owned by the Maryland Historical Society Library, Baltimore.)

HAWES, ANN AND ADINO (ADONIAH)

Ann Hawes's first advertisement, which appeared in the October 11, 1770, edition of the *South-Carolina Gazette* (Charleston), indicates that she had been in Charleston for some time and had moved her residence to a house in Market Square at the sign of Bacchus. At the time, she was running an ordinary, a fish market, or both. Her work as a painter and glazier was not announced until 1781, although that notice stated that she "continues" this work (*Royal Gazette* [Charleston, SC], Sept. 1, 1781). By 1783, she had expanded into hanging paper; she also sold prepared oils and colors at 2 Church Street (*South Carolina Gazette, and General Advertiser* [Charleston], supplement, Oct. 21, 1783). Three years later she turned that business over to her son, Adino Hawes, and moved to 10 Amen Street, where she took on boarders and cared for children (*Charleston [SC] Evening Gazette,* Aug. 30, 1786). By 1789, she was back in the painting, glazing, and paper-hanging business, living at 254 King Street (*City Gazette, or the Daily Advertiser* [Charleston, SC], Apr. 21, 1789, as found in the MESDA Craftsman Database). Whether she or her son ever did pictorial work is unknown, but such a possibility cannot be ruled out.

Adino Hawes's marriage to Mary Libby was announced in the *Charleston (SC) Morning Post, and Daily Advertiser*, on July 3, 1786. Hawes trained with his mother, took over the business in 1786, and continued to work in Charleston as late as 1816. He and his wife, Mary, were involved in various family estate settlements during the early nineteenth century. (Charleston County, SC, Chancery Court Bills of Complaint, Pt. 29, Nos. 1–58, 1816, No. 47, Oct. 1, 1816, and Pt. 22, Nos. 1–49, 1812, No. 38, Mar. 9, 1816, as found in the MESDA Craftsman Database; *City Gazette & Daily Advertiser* [Charleston, SC], Aug. 17, 1792. See also Charleston County, SC, Wills, No. 28, 1800–1807, Bk. D, Apr. 1, 1800, 272; Charleston County, SC, Land Records, Misc., Pt. 106, Books P8-R8, 1816–1817, Mar. 4, 1817, 322–324, as found in the MESDA Craftsman Database.)

HICKEY, MR.

A crayon portraitist by this name advertised in the Maryland papers in May 1788 that he would be in Baltimore briefly at "Mr. CLARK's in Market-Street," where "Specimens of his Performance may be seen" (*Maryland Journal, and Baltimore Advertiser*, May 9 and 13, 1788).

HODGSON, WILLIAM

Three references to this artist from London are found in advertisements in Virginia papers, the first of which was published in Richmond on June 11, 1788. In this and his December 1788 ad, Hodgson gave a long list of prices for his artwork, beginning with full-length oil portraits at £7; a small version of full-length for £3 10s.; and three-quarter-length oil, large at £4 10s. and small versions at £2. Miniature portraits were £1 10s. Both notices also mention "Hairwork in various devices" and that he was working on the cross street opposite to Mr. Trower's tavern in Richmond. (*Virginia Independent Chronicle* [Richmond], June 11, Dec. 3, 1788, as found in the MESDA Craftsman Database.) Ten years later, in Norfolk papers, Hodgson called himself a limner and advertised that he continued to make likenesses in oil. Portraits by him of local persons could be seen in a room at Lindsay's Hotel. (*Norfolk [VA] Herald*, Apr. 10, 1798, as found in the MESDA Craftsman Database.)

LUNDBERRY, PETER

According to his advertisement in the *Royal South-Carolina Gazette* (Charleston), Lundberry opened a shop in Charleston at 46 Queen Street and carried out "his Business in LIMNING; likewise COACH, SIGN, and HOUSE PAINTING, PAPER HANGING, &c." (June 6, 1782).

MEWSE, THOMAS

Mewse is known from his Maryland newspaper advertisements and notices about his death and estate sale and settlement in Talbot County, Maryland. A 1784 ad indicated that he was a miniature painter, that he was from England, and that he could be spoken with "at Captain HARRISON's near the Post-Office" (*Maryland Journal and Baltimore Advertiser,* Sept. 24, 1784). The sale of his property after his death included such items as Masonic aprons, floorcloths, fancy pieces on satin, miniatures, ivory blanks, gold leaf, lockets, rings, books on heraldry, set of types, and "Plotting Instruments." (*Maryland Herald, and Eastern Shore Intelligencer* [Easton], Dec. 6, 1796.)

MOLL, BERNHARD ALBRECHT

Born at St. Alban's in Wallerstein, Germany, in 1743, Moll died in Charleston, South Carolina, in 1788. He studied at the Academy of Fine Arts in Vienna, Austria, and the Friedrich Schiller University in Jena, Germany. In 1780, Austrian Emperor Joseph II appointed him "Imperial-Royal Cabinet Painter." In 1782 he resigned that post and joined the emperor's ill-fated expedition to America (and other countries) to record the flora and fauna of those regions. The group left Austria in 1783, arriving in Philadelphia later that year. There Moll spent much of his time cutting profiles. Having become disenchanted with his travel companions, Moll left that assignment in 1784, the year he first advertised in Charleston, South Carolina. He continued to live in Charleston until his death. An album of his profiles and individual examples survive. However, nothing is known of his painted works that are referenced in his death notice and in correspondence by and about him. (See Riley, "Charleston's Drawing Master.")

QUESNAY, ALEXANDER-MARIE

Quesnay advertised his Richmond Academy (Virginia) from 1785 to 1793. In 1785, he was located "opposite the Bridge" and next door to Captain Mitchell's, where he taught dancing, drawing, French, and music (*Virginia Gazette, or the American Advertiser* [Richmond], Oct. 1, 1785). By 1786, Quesnay had developed an elaborate plan for the school on three acres along Main Street on Shockoe Hill. The property, held in deed of trusteeship for the subscribers of the academy by John Harvie, included a garden leading down to Shockoe Creek. At the time, Quesnay claimed that he had 10,001 subscriptions. The school opened the next winter, but until that time he continued to teach at the house of Mr. Vandewell in Richmond. (Ibid., May 17, 1786; *Virginia Gazette, and Petersburg Intelligencer,* Sept. 14, 1786; Hustings Deeds, No. 1, 1782–1792, May 26, 1786, 119–120, as found in the MESDA Craftsman Database.) Nothing more is heard about the school endeavor until June 1793 when the subscribers were called to a meeting at "Mr. Moss' TAVERN" in Richmond (*Virginia Gazette and Richmond and Manchester Advertiser,* June 27, 1793). Quesnay also taught in Petersburg in 1786.

STEVENSON, JOHN AND HAMILTON

These two painters advertised in Charleston via notices in the *South-Carolina Gazette; and Country Journal,* September 21, 1773, and the *South-Carolina and American General Gazette,* November 18–25, 1774. "J. Stevenson" called himself a "limner" and painted history, portrait, landscape, and miniature pictures for bracelets, rings, and the like. He also claimed to do conversation pieces, "either the Size of Nature or small Whole Lengths, in the Stile of *Zoffani*; Perspective Views from Nature, of Towns, Streets, Villas or Plantations, &c. &c." He maintained

painting rooms in Charleston, where he made examples of his work available for inspection. He also moved his brother Hamilton to Charleston (presumably from England) to assist him. Hamilton Stevenson was a painting and drawing teacher back "at Home," and, once he arrived in South Carolina, the two brothers established a drawing school. The length of their stay is unknown, but by 1780 they were advertising in Jamaica as limners and coach painters who did portraits, family pictures, and miniatures (*Royal Gazette* [Kingston, Jamaica], Apr. 8, 1780, as found in Richardson, "James Claypoole, Junior," 165–166; see also Wright, *Revels in Jamaica,* 140). No works by them have been identified.

STRATON, OSBORNE

Straton had established his "British Academy" on the green at the west end of Broad Street, Charleston, South Carolina, by 1767 (*South-Carolina Gazette; and Country Journal* [Charleston], June 9, 1767). In a 1768 newspaper ad, he described teaching mathematics, grammar and languages, navigational techniques, accounting, writing and drawing "prettily," platting, and creating designs for architecture (*South-Carolina Gazette; and Country Journal* [Charleston], Oct. 4, 1768).

TURTAZ, LEWIS

Turtaz's advertisement as a "limner," which appeared in the *South Carolina Gazette* (Charleston) on March 23–30, 1767, indicated that he was from Lausanne, Switzerland, and that he intended to open, in Charleston that same April, a school for "DRAWING in all its branches, and also in MINIATURE." He was willing to wait on ladies at their houses, and he also drew miniature portraits at the rate of "*Twenty Pounds* for a head and bust."

WRIGHT, JOSEPH

Wright was born in 1756 in Bordentown, New Jersey, the son of Patience Lovell Wright and her husband, Joseph Wright, a cooper. He became a well-known portrait painter in America after his studies with Benjamin West in London. Wright was especially well-known for his portraits of George Washington. Additionally, he was the diesinker for the U. S. Mint in Philadelphia. Several early nineteenth-century portraits attributed to or signed by Wright are currently associated with the western parts of Virginia, but information on the artist's visit there has not been found. In 1790 Wright indicated in a newspaper advertisement that he planned to travel to Carolina, presumably South Carolina (*Independent Chronicle: and the Universal Advertiser* [Boston, Mass.], Sept. 30, 1790).

Wright's mother was probably more famous than he. She was the American-born sculptor who, after her husband's death, moved to England and became the highly skilled and famous sculptor of portraits in tinted wax. In England, she opened a profitable museum of waxworks, visited by many dignitaries, including Benjamin Franklin and the king and queen of England.

ZIEGUESAR, WILLIAM

Zieguesar is documented as a painter and teacher in Baltimore in 1786, located at G. P. Van Horne's house on Market Street. His services included *"Painting, Drawing* and *Designing,"* and he taught music and dancing. (*Maryland Journal and Baltimore Advertiser,* Feb. 14, 1786.)

Badger Family Tree

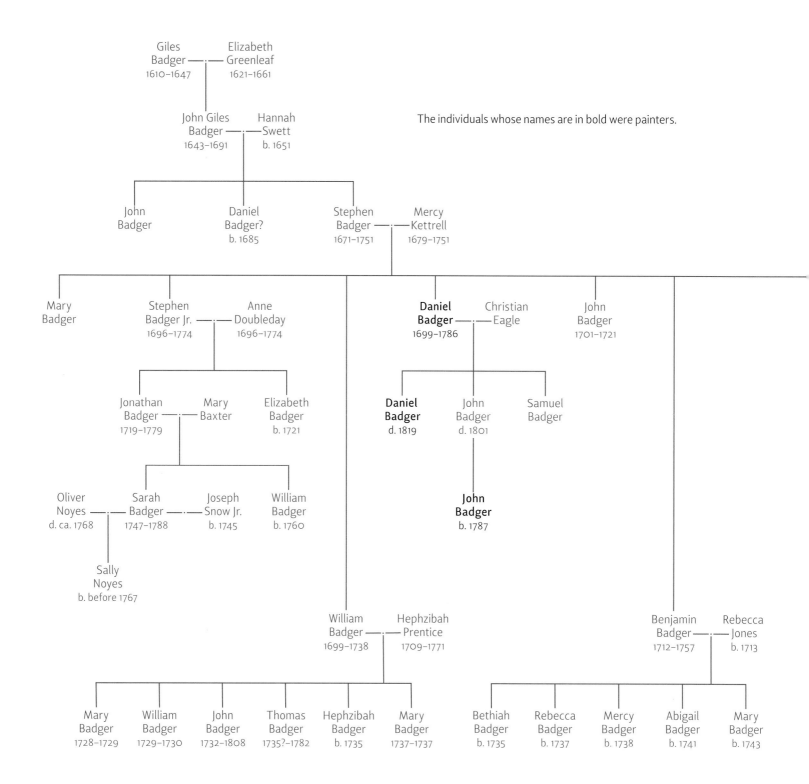

The individuals whose names are in bold were painters.

Giles Badger 1610–1647 — Elizabeth Greenleaf 1621–1661

John Giles Badger 1643–1691 — Hannah Swett b. 1651

John Badger

Daniel Badger? b. 1685

Stephen Badger 1671–1751 — Mercy Kettrell 1679–1751

Mary Badger

Stephen Badger Jr. 1696–1774 — Anne Doubleday 1696–1774

Daniel Badger 1699–1786 — Christian Eagle

John Badger 1701–1721

Jonathan Badger 1719–1779 — Mary Baxter

Elizabeth Badger b. 1721

Daniel Badger d. 1819

John Badger d. 1801

Samuel Badger

Oliver Noyes d. ca. 1768 — Sarah Badger 1747–1788 — Joseph Snow Jr. b. 1745

William Badger b. 1760

John Badger b. 1787

Sally Noyes b. before 1767

William Badger 1699–1738 — Hephzibah Prentice 1709–1771

Benjamin Badger 1712–1757 — Rebecca Jones b. 1713

Mary Badger 1728–1729

William Badger 1729–1730

John Badger 1732–1808

Thomas Badger 1735?–1782

Hephzibah Badger b. 1735

Mary Badger 1737–1737

Bethiah Badger b. 1735

Rebecca Badger b. 1737

Mercy Badger b. 1738

Abigail Badger b. 1741

Mary Badger b. 1743

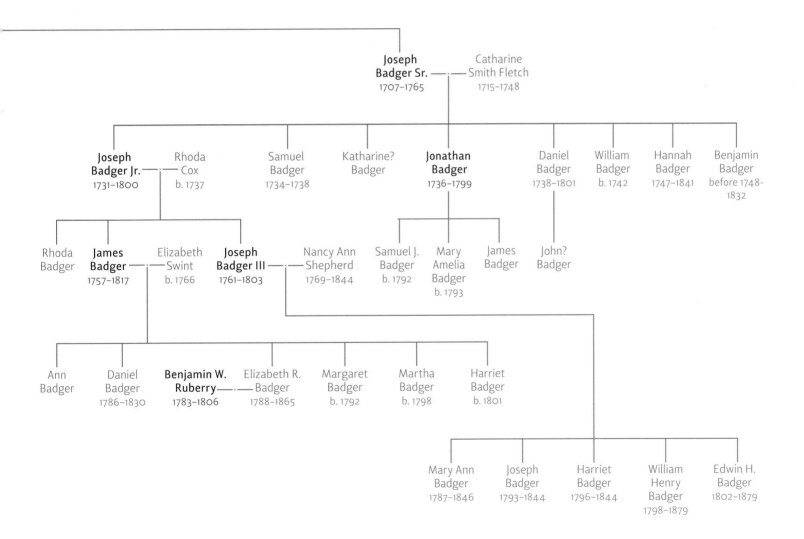

Dering Family Tree

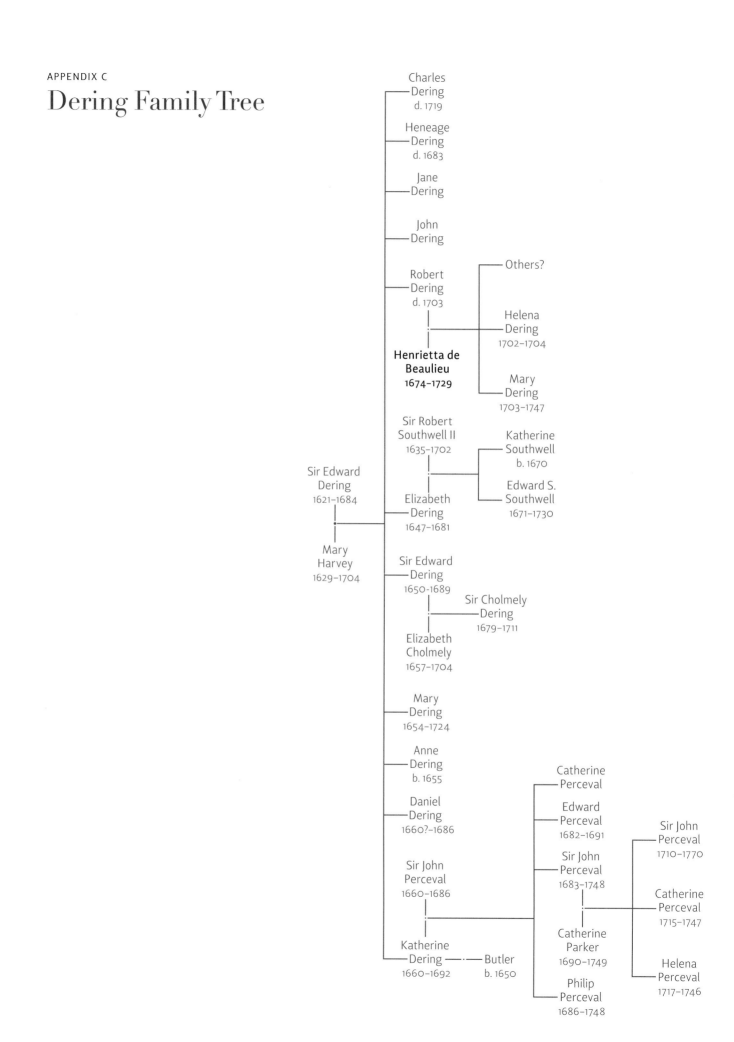

Charles
Dering
d. 1719

Heneage
Dering
d. 1683

Jane
Dering

John
Dering

Robert
Dering
d. 1703

Others?

Helena
Dering
1702–1704

**Henrietta de
Beaulieu
1674–1729**

Mary
Dering
1703–1747

Sir Robert
Southwell II
1635–1702

Katherine
Southwell
b. 1670

Edward S.
Southwell
1671–1730

Sir Edward
Dering
1621–1684

Elizabeth
Dering
1647–1681

Mary
Harvey
1629–1704

Sir Edward
Dering
1650-1689

Sir Cholmely
Dering
1679–1711

Elizabeth
Cholmely
1657–1704

Mary
Dering
1654–1724

Anne
Dering
b. 1655

Catherine
Perceval

Edward
Perceval
1682–1691

Daniel
Dering
1660?–1686

Sir John
Perceval
1683–1748

Sir John
Perceval
1710–1770

Sir John
Perceval
1660–1686

Catherine
Perceval
1715–1747

Catherine
Parker
1690–1749

Katherine
Dering — Butler
1660–1692 b. 1650

Philip
Perceval
1686–1748

Helena
Perceval
1717–1746

Acknowledgments

I am deeply grateful to Juli and David Grainger and the Grainger Foundation for their generous support of this publication and the exhibition by the same title. The Graingers' interest in American art and their friendship with Colonial Williamsburg have a long history, one that continues to be distinguished by their interest in critical research, important publications, and significant educational offerings. My dedication of *Painters and Paintings in the Early American South* to Juli and David reflects my gratitude for their support of my own research and writing for many years. It has been an honor to carry Juli's name as part of my title since 1989, when the Grainger Foundation endowed my position, knowing that it signified both for Juli and for me a lifetime of interest in and love for early American painting.

This book represents a forty-year dream, one spanning the whole of my professional career. My curiosity about early southern paintings began when I was a graduate student in the Winterthur Program for Early American History and Culture at the University of Delaware working under Dr. Wayne Craven on my thesis on John Wollaston's painting career in Virginia. Having grown up in Virginia, that topic seemed a comfortable—and perhaps even easy—choice. However, like this project, as the work evolved, I found there was considerably more material than I had imagined, including the inevitable and often confusing genealogical work and sitters' biographies—and always the hunt for long-lost but previously published or recorded paintings. As a student, I often withered at what lay ahead, but research and probing are incurable obsessions for every curator-to-be, and so I continued. I was incredibly fortunate to have Dr. Craven, a gifted professor of American painting, as my advisor. I was equally fortunate in securing in 1971—with the late Frank L. Horton, founder of the Museum of Early Southern Decorative Arts (MESDA)—the only curatorial job that emphasized research of the South's early material culture. As scholars, both of those men influenced my research, and, through their own fine publications, they have contributed to the information in this book. Working with Frank, I was one of a small team of people who established MESDA's field and

manuscript research program devoted to the early arts of the South, now in its fourth decade of continual development. The resultant archives on southern artists and craftspersons to about 1821 are without precedent. They have served many other scholars—and this particular project—well. I owe special appreciation to MESDA's Sally Gant, director of education and special programs, who helped me verify source citations and locate images; Robert Leath, chief curator and vice president for collections and research, who served as a reader for the manuscript and provided information on several paintings and artists; and Martha Rowe, retired research center associate manager, and Kim May, research center manager, for their assistance. My thanks go also to Whaley Batson, now retired from the MESDA staff, for sharing her research notes on Henrietta Johnston. Her published work on Johnston and others is also cited in the book.

My research for and writing of the book received the complete support of colleagues in the Colonial Williamsburg Foundation's Curatorial Department. Over several years they have given generously of their time and knowledge, most especially Barbara R. Luck, curator of paintings, drawings, and sculpture, and Margaret Beck Pritchard, curator of prints, maps, and wallpapers. Both of them are respected authors and scholars who know many parts of this subject better than I, and each read the manuscript, supplying copious notes—and corrections. Laura Pass Barry, associate curator of prints, maps, and paintings, also helped track down elusive information on often obscure printers, engravers, and prints. Shelley Svoboda, conservator of paintings and a learned historian of American eighteenth-century painting, put enormous amounts of time into examining paintings and giving counsel as to their condition and the best treatment procedures. Her major conservation work on the Foundation's two important eighteenth-century portraits, by Robert Feke, of the Nelsons of Yorktown, Virginia, uncovered much of the original surviving paint and returned them to being the handsome paintings they were meant to be. Colonial Williamsburg historian Linda Rowe helped with early research materials as I reviewed references in the York County project files. I also wish to thank Linda

Baumgarten, curator of textiles and costumes, whose sage advice on costumes has always benefited those of us who work closely with early portraiture. Erik Goldstein, curator of mechanical arts and numismatics, generously furnished me with detailed information on Thomas Coram's engraved currency and related data that made the story of that artist's life all the more meaningful. Collections photographer Craig McDougal and retired senior photographer Hans Lorenz deserve special praise for their accurate color photography for many of the illustrations in the book. Eunice Glosson, former registrar; Virginia Foster, registrar; and Kaitlyn Gardy, assistant registrar, served as able managers of loans for the exhibition, and associate registrar Angelika Kuettner scheduled new photography and helped to correct existing photography.

I gladly recognize the DeWitt Wallace Decorative Arts Museum's Patricia A. Waters, administrative specialist for the Colonial Williamsburg Art Museums, and Richard Hadley, director of museum design and operations, for their willing and enthusiastic support over a nearly three-year period during which they assumed essential administrative duties while I was on sabbatical to research and prepare the book. Rick also led the exhibit design and production team. Gloria McFadden, exhibitions assistant, had the arduous task of locating, sorting, and ordering photographs and other scholarly materials for the book. To her and to Jan Gilliam, manager of exhibition planning and associate curator of toys, who coordinated many of the details of the exhibit production and assisted in the review of photography for the book, I offer my gratitude. I also want to acknowledge the fine contributions of the exhibitions staff—James Armbruster, James Mullins, David Mellors, Wayne Carter, and Carla Watkins. Mary Cottrill, manager of the Hennage Auditorium, and Patricia Balderson, manager of museum education, along with assistant manager Christina Westenberger, worked their usual magic in putting together a series of public programs that contributed greatly to the museum visitors' understanding of the subject.

I am equally grateful for advice and guidance to sources provided by the Foundation's staff at the John D. Rockefeller, Jr. Library, particularly Susan Shames, decorative arts librarian and an exceptional researcher; Juleigh Clark, public services librarian; and Del Moore, reference librarian. Others at Colonial Williamsburg who have been involved in this project include Albert O. Louer, director of principal gifts; Brenda A. Howard, executive secretary, museums administration; and Patricia R. G. Collupy, secretary, Department of Collections.

Many institutions and their staffs provided essential information for both the book and the exhibition. An important thank you is due to Peter Ross of the Guildhall Library, Aldermanbury, London, U.K., for furnishing all of the London research on the artist John Durand. My appreciation goes also to staff at the Ashmolean Museum, University of Oxford, U.K.; the Trustees of the British Museum, London, U.K.; the New York Public Library, N.Y.; the Library of Congress, Washington, D.C.; Hardwick Hall/the Devonshire Collection, the National Trust, U.K.; William Rasmussen, the Virginia Historical Society, Richmond, Va.; the Muscarelle Museum of Art and Louise Kale, the College of William and Mary in Virginia, Williamsburg; Angela Mack, the Gibbes Museum of Art, Carolina Art Association, Charleston, S.C.; Victoria and Albert Museum, London, U.K.; Peter Grover and Patricia Hobbs, the Washington-Custis-Lee Collection, Washington and Lee University, Lexington, Va.; Martha MacLeod, the Dallas Museum of Art, Tex.; Jean Noonan, the Chrysler Museum of Art, Norfolk, Va.; Grahame Long, the Charleston Museum, S.C.; Sylvia Yount and Mitchell Merlin, the Virginia Museum of Fine Arts, Richmond; National Portrait Gallery, London, U.K.; Philip Mould Ltd., London, U.K./The Bridgeman Art Library Nationality; Maryland Historical Society, Baltimore, Md.; Philadelphia History Museum at the Atwater Kent, the Historical Society of Pennsylvania Collection; American Philosophical Society, Philadelphia, Pa.; Burgerbibliothek Bern, Switz.; the Royal Collection, Her Majesty Queen Elizabeth II, U.K.; Fitzwilliam Museum, University of Cambridge, U.K.; Hargrett Rare Book and Manuscript Library, University of Georgia, Athens; the Royal Library, Manuscripts and Rare Books Department, Copenhagen, Den.; Independence National Historical Park, Philadelphia, Pa.; the National History Museum, London, U.K.; Thomas Savage and Linda Eaton, the Henry Francis du Pont Winterthur Museum, Del.; Archives nationales d'outre-mer, Aix-en-Provence, Fr.; Peabody Museum of Archaeology and Ethnology, Harvard University, Cambridge, Mass.; Peale Museum, Baltimore, Md.; the Metropolitan Museum of Art/Art Resource, New York, N.Y.; Bodleian Libraries, Oxford, U.K.; Special Collections, John D. Rockefeller, Jr. Library, the Colonial Williamsburg Foundation, Williamsburg, Va.; National Maritime Museum, Greenwich, London, U.K.; Foundling Museum, London, U.K.; Detroit Institute of Arts, Mich.; Worcester Art Museum, Mass.; Historical and Special Collections, Harvard Law School Library, Cambridge, Mass.; Bowdoin College Museum of Art, Brunswick, Maine; the Baltimore Museum of Art, Md.; Brooklyn

Museum, New York, N.Y.; Collection of the New-York Historical Society, New York; Valentine Richmond History Center, Va.; Brandon Fortune, the National Portrait Gallery, Smithsonian Institution, Washington, D.C.; Corcoran Gallery of Art, Washington, D.C.; Yale Center for British Art, New Haven, Conn.; National Gallery of Canada, Ottawa; the Middleton Place Foundation, Charleston, S.C.; Museum of Fine Arts, Boston, Mass.; Musée des Beaux-Arts, Tours, Fr.; Mount Vernon Ladies Association, Va.; Munson-Williams-Proctor Arts Institute, Albany, N.Y.; South Caroliniana Library, University of South Carolina, Columbia; J. Paul Getty Museum, Los Angeles, Calif.; and National Gallery of Art, Washington, D.C. Some of these same institutions were lenders to the exhibition. They are listed separately on page 412.

I also wish to thank Leigh Keno of Keno Auctions, New York, N.Y., for sharing all of his research on Daniel Badger, the heretofore unknown Charleston artist related to Boston painter Joseph Badger Sr. The extensive research of several other scholars whose published works greatly informed the material published in this volume include Graham Hood and his work on Charles Bridges; Robert G. Stewart, Maurie D. McInnis, Leslie Reinhardt, and Angela D. Mack and their work on Henry Benbridge; Henrietta McBurney and Amy R. W. Meyers on Mark Catesby; Wayne Craven on John Wollaston and colonial American portraiture; Maurie D. McInnis and Angela D. Mack with J. Thomas Savage, Robert A. Leath, and Susan Ricci Stebbins in their publication titled *In Pursuit of Refinement: Charlestonians Abroad, 1740–1860;* Whaley Batson and Martha Severens work on Henrietta Johnston; Margaret Simons Middleton's book on Jeremiah Theus and the revised edition with a supplement by Dorothy Middleton Anderson and Margaret Middleton Rivers; Kim Sloane's recent published catalog on the drawings of John White; Richard K. Doud, who provided much of the information we now know on the painter John Hesselius; Anna Wells Rutledge, whose *Artists in the Life of Charleston,* first published in 1949, remains one of the most valuable sources for those researching South Carolina artists; and Charles Coleman Sellers, whose many publications on his ancestor Charles Willson Peale are also important sources for today's scholars with interests in the Peale family of painters. Other scholars whose previous publications and research were of significant importance in researching data for this book included that of Richard H. Saunders of Middlebury College, Vt., and Ellen Miles formerly of the National Portrait Gallery, Smithsonian Institution, Washington, D.C.

This book represents the efforts of many people over several years of research and writing. Angier Brock, its principal editor, worked closely with me from the onset of writing to strengthen the prose within chapters and to sort out the tedious technical details of notes, the accuracy of sources, and the building of a comprehensive bibliography. I am indebted to her for the readability of this book, particularly her attention to the smallest details of word choice and the sequencing of sentences. Amy Watson, book editor for the Colonial Williamsburg Foundation, reviewed and provided the many final editorial adjustments to the manuscript and had the arduous tasks of styling the notes and bibliography and tracking down the primary sources associated with quotations and the notes. Paul Aron, director and managing editor of Colonial Williamsburg's Publications Department, coordinated many details of production and kept us on schedule. Jo Ellen Ackerman, the book's designer, provided the book's appealing design and layout. Her ability to juggle and attractively arrange the hundreds of illustrations and captions needed for this book still boggles this writer's mind. Thanks too to Elizabeth Eaton for preparing the family trees in the appendixes and to Shanin Glenn for overseeing the color corrections and shepherding the book on press.

In closing, I must make special mention of Beatrix T. Rumford and Graham S. Hood, both retired Colonial Williamsburg vice presidents with whom I worked for many years and who were responsible for the institution's museums and collections during their tenures. I am indebted to Trix, a reader of the manuscript, for her insights regarding clarity and her critical notes on content—and, moreover, for her belief that the book should be done. To Graham, I owe appreciation for reading the manuscript and providing comprehensive suggestions on matters of artists' styles and the artistic quality of their work. Not only has Graham done research on and published writings about several of the painters included in this book, but he also has an extraordinary understanding of the aesthetics associated with eighteenth-century painting. Finally, I am indebted to Ronald L. Hurst, my colleague and the Foundation's Carlisle H. Humelsine Chief Curator and vice president of collections, conservation, and museums, for his continued encouragement, his critical review of the text, his patience, and, as always, his affable leadership that made this book and the exhibit possible.

Carolyn J. Weekley
Juli Grainger Curator, The Colonial Williamsburg Foundation

Lenders to the
Painters and Paintings in the Early American South Exhibition
The Colonial Williamsburg Foundation
Williamsburg, Virginia

Carnegie Museum of Art
4400 Forbes Avenue
Pittsburgh, PA 15213

Charleston Museum
360 Meeting Street
Charleston, SC 29403

Corcoran Gallery of Art
500 Seventeenth Street NW
Washington, DC 20006

Dallas Museum of Art
1717 N. Harwood Street
Dallas, TX 75201

Gibbes Museum of Art
135 Meeting Street
Charleston, SC 29401

Francis Whitney Rile Hansen
Washington, DC

Gustave Pitot and
Louisiana State Museum
1000 Chartres Street
New Orleans, LA 70116

Metropolitan Museum of Art
1000 Fifth Avenue
New York, NY 10028

Muscarelle Museum of Art
Lamberson Hall
College of William and Mary
PO Box 8795
Williamsburg, VA 23187

Museum of Early Southern Decorative Arts
924 S. Main Street
Winston-Salem, NC 27101

National Portrait Gallery
Smithsonian Institution
PO Box 37012
Victor Building
Suite 410, MRC 973
Washington, DC 20013

New-York Historical Society
170 Central Park West
New York, NY 10024

Virginia Historical Society
PO Box 7311
Richmond, VA 23221

Virginia Museum of Fine Arts
200 N. Boulevard
Richmond, VA 23220

Washington and Lee University
The Reeves Center
204 W. Washington Street
Lexington, VA 24450

Washington County Museum of Fine Arts
PO Box 423
401 Museum Drive
Hagerstown, MD 21741

Winterthur Museum
5105 Kennett Pike
Winterthur, DE 19735

Anonymous (2)

Bibliography

Abbot, W. W., ed. *The Papers of George Washington.* Confederation Series, vol. 3, May 1785–March 1786. Charlottesville and London: University Press of Virginia, 1994.

Abrams, Ann Uhry. *The Valiant Hero: Benjamin West and Grand-Style History Painting.* Washington, DC: Smithsonian Institution Press, 1985.

An Account of the Society for Promoting Christian Knowledge. London, 1797.

Aiken, Carol. "Observations on the Attribution of Portrait Miniatures to Henry Benbridge and His Wife, Esther Sage." In Mack, *Henry Benbridge,* 39–50.

Alexander, Forsyth, ed. *Henrietta Johnston: "Who Greatly Helped . . . by Drawing Pictures."* Winston-Salem, NC: Museum of Early Southern Decorative Arts; Charleston, SC: Gibbes Museum of Art, 1991.

Allen, W. O. B., and Edmund McClure. *Two Hundred Years: The History of the Society for Promoting Christian Knowledge, 1698–1898.* New York: Burt Franklin, 1970. Reprint of original 1898 edition.

Ambler, John Jaquelin. Excerpt from the narrative of John Jaquelin Ambler in "Smiths of Virginia." *William and Mary Quarterly* 5, no. 1 (July 1896): 50–53.

American Magazine and Monthly Chronicle for the British Colonies 1 (October 1757–October 1758). Philadelphia: William Bradford, 1757–1758.

Amory, Martha Babcock. *The Domestic and Artistic Life of John Singleton Copley.* New York: Kennedy Galleries and Da Capo Press, 1969. Republication of the first edition published in Boston 1882.

Arnborg, Carin K., trans., and Roland E. Fleischer. "'With God's Blessings on Both Land and Sea': Gustavus Hesselius Describes the New World to the Old in a Letter from Philadelphia in 1714." *American Art Journal* 21, no. 3 (1989): 5–17.

Arnold, Janet, ed. *Queen Elizabeth's Wardrobe Unlock'd: The Inventories of the Wardrobe of Robes Prepared in July 1600 Edited from Stowe MS 557 in the British Library, MS LR 2/121 in the Public Record Office, London, and MS V.b.72 in the Folger Shakespeare Library, Washington, DC.* Leeds, GB: W. S. Maney & Son, 1988.

Ayres, James. *English Naive Painting, 1750–1900.* London: Thames and Hudson, 1980.

———. "The Vernacular Art of the Artisan in England." *The Magazine Antiques* 151, no. 2 (February 1997): 312–321.

Bacon, Francis. *Francis Bacon: A Selection of His Works.* Edited by Sidney Warhaft. New York: Odyssey Press, 1965.

Baine, Rodney M., and Louis De Vorsey Jr. "The Provenance and Historical Accuracy of 'A View of Savannah as It Stood the 29th of March, 1734.'" *Georgia Historical Quarterly* 73, no. 4 (Winter 1989): 784–813.

Baker, C. H. Collins. "*The Price Family* by Bartholomew Dandridge." *Burlington Magazine for Connoisseurs* 72, no. 420 (March 1938): 132–139.

Baker, John. *The Diary of John Baker: Barrister of the Middle Temple, Solicitor-General of the Leeward Islands.* Edited and transcribed by Philip C. Yorke. London: Hutchinson, 1931.

Baldwin, Agnes Leland. *First Settlers of South Carolina, 1670–1700.* Easeley, SC: Southern Historical Press, 1985.

Barker, Virgil. *American Painting: History and Interpretation.* New York: Bonanza Books, 1950.

Barnes, Robert. "Charles Peale: A Marriage and a Birth Proved by Depositions." *Archivists' Bulldog* (Newsletter of the Maryland State Archives) 18, no. 7 (July 15, 2004): 1–2.

Bartram, William. "Travels in Georgia and Florida, 1773–74: A Report to Dr. John Fothergill." Annotated by Francis Harper. *Transactions of the America Philosophical Society,* n.s., 33, no. 2 (November 1943): 123–232.

———. *Travels through North & South Carolina, Georgia, East & West Florida, the Cherokee Country, the Extensive Territories of the Muscogulges. . . .* Philadelphia, 1791.

Batson, Whaley. "Charles Peale Polk: Gold Profiles on Glass." *Journal of Early Southern Decorative Arts* 3, no. 2 (November 1977): 51–57.

———. "Henrietta Johnston (c. 1674–1729)." In Alexander, *Henrietta Johnston,* 1–16.

———. "Thomas Coram: Charleston Artist." *Journal of Early Southern Decorative Arts* 1, no. 2 (November 1975): 35–47.

Beckerdite, Luke. "Immigrant Carvers and the Development of the Rococo Style in New York, 1750–1770." In *American Furniture 1996,* edited by Luke Beckerdite, 233–265. Milwaukee, WI: Chipstone Foundation, 1996.

Bentley, Elizabeth Petty. *Virginia Marriage Records: From "The Virginia Magazine of History and Biography," "The William and Mary College Quarterly," and "Tyler's Quarterly."* Baltimore, MD: Genealogical Publishing, 1982.

Berkeley, Edmund, and Dorothy Smith Berkeley. *John Clayton: Pioneer of American Botany.* Chapel Hill: University of North Carolina Press, 1963.

Beverley, Robert. *The History and Present State of Virginia.* Edited by Louis B. Wright. Chapel Hill: University of North Carolina Press, 1947. Reprinted from original 1705 London edition.

Biggar, H. P., ed. "Jean Ribaut's Discoverye of Terra Florida." *English Historical Review* 32, no. 126 (April 1917): 253–270.

Black, Mary. "The Case of the Red and Green Birds." *Arts in Virginia* 3, no. 2 (Winter 1963): 3–9.

———. "The Case Reviewed." *Arts in Virginia* 10, no. 1 (Fall 1969): 12–21.

Blair, John. "Diary of John Blair: Copied from an Almanac for 1751, Preserved in Virginia Historical Society." Verified by Lyon G. Tyler. *William and Mary Quarterly* 7, no. 3 (January 1899): 134–153.

Bolton, Charles Knowles. *The Founders: Portraits of Persons Born Abroad Who Came to the Colonies in North America Before the Year 1701*. 3 vols. Boston: Boston Athenaeum, 1919–1926.

Bolton, Theodore, and Harry L. Binsse. "Wollaston: An Early American Portrait Manufacturer." *Antiquarian* 16 (June 1931): 30–33, 50, 52.

Boswell, James. *The Life of Samuel Johnson, LL.D. Including a Journal of a Tour to the Hebrides*. A New Edition with Numerous Additions and Notes by John Wilson Croker. 2 vols. Boston: Carter, Hendee, 1832. Originally published in London 1791.

Bransford, Margaret. "A Hurricane That Made History." *French Review* 23, no. 3 (January 1950): 223–226.

Bridenbaugh, Carl. *Cities in Revolt: Urban Life in America, 1743–1776.* New York: Knopf, 1955.

Bridges, John. *The History and Antiquities of Northamptonshire. Compiled from the Manuscript Collections of the Late Learned Antiquary John Bridges, Esq.* Compiled by Peter Whalley. 2 vols. Oxford, 1791.

Britton, Allen P., and Irving Lowens. "Unlocated Titles in Early Sacred American Music." *Notes,* 2nd ser., 11, no. 1 (December 1953): 33–48.

Broadwater, Jeff. *George Mason: Forgotten Founder.* Chapel Hill: University of North Carolina Press, 2006.

"Brodnax Family." *William and Mary Quarterly* 14, no. 1 (July 1905): 52–58.

Brunhouse, Robert L., ed. "David Ramsay, 1749–1815: Selections from His Writings." *Transactions of the American Philosophical Society,* n.s., 55, no. 4 (August 1965): 1–250.

Brydon, G. McLaren, ed. "The Virginia Clergy." *Virginia Magazine of History and Biography* 33, no. 1 (January 1925): 51–64.

Bushnell, David I., Jr. "The Sloane Collection in the British Museum." *American Anthropologist,* n.s., 8, no. 4 (October–December 1906): 671–685.

Byrd, Mary Willing. "Letters of the Byrd Family." *Virginia Magazine of History and Biography* 38, no. 2 (April 1930): 145–156.

Byrd, William, II. *Another Secret Diary of William Byrd of Westover, 1739–1741, with Letters and Literary Exercises, 1696–1726.* Edited by Maude H. Woodfin. Translated and collated by Marion Tinling. Richmond, VA: Dietz, 1942.

———. "Letters of the Byrd Family." *Virginia Magazine of History and Biography* 36, no. 3 (July 1928): 209–222.

———. "Letters of William Byrd, 2d, of Westover, VA." *Virginia Magazine of History and Biography* 9, no. 3 (January 1902): 225–251.

———. *The Secret Diary of William Byrd of Westover, 1709–1712.* Edited by Louis B. Wright and Marion Tinling. Richmond, VA: Dietz, 1941.

Byrd, William, II, and Hans Sloane. "Letters of William Byrd II, and Sir Hans Sloane Relative to Plants and Minerals of Virginia." *William and Mary Quarterly,* 2nd ser., 1, no. 3 (July 1921): 186–200.

Carpenter, Edward. *The Protestant Bishop, Being the Life of Henry Compton, 1632–1713, Bishop of London.* London: Longmans, Green, 1956.

Carpenter, Nathanael. *Geography Delineated Forth in Two Bookes. Containing the Sphaericall and Topicall Parts Thereof.* Book 2, *Geography: The Second Booke. Containing the Generall Topicall Part Thereof.* Oxford, 1625.

Carter, Robert. *The Diary, Correspondence, and Papers of Robert "King" Carter of Virginia, 1701–1732.* Transcribed and edited by Edmund Berkeley Jr. University of Virginia Library, Charlottesville. http://etext.virginia.edu/users/berkeley.

Catesby, Mark. *The Natural History of Carolina, Florida and the Bahama Islands: Containing the Figures of Birds, Beasts, Fishes, Serpents, Insects, and Plants: Particularly, the Forest-Trees, Shrubs, and Other Plants, not Hitherto Described, or Very Incorrectly Figured by Authors. Together with Their Descriptions in English and French. To Which, Are Added Observations on the Air, Soil, and Waters: with Remarks upon Agriculture, Grain, Pulse, Roots, &c. To the Whole, Is Perfixed a New and Correct Map of the Countries Treated of.* 2 vols. London: 1731–1743.

Catton, Charles. *The English Peerage; or, A View of the Ancient and Present State of the English Nobility: To Which Is Subjoined, a Chronological Account of Such Titles as Have Become Extinct, from the Norman Conquest to the Beginning of the Year M,DCC,XC.* Vol. 3. London, 1790.

Caw, James L. *Scottish Painting, Past and Present, 1620–1908.* Edinburgh, SCOT: T. C. and E. C. Jack, 1908.

Chalmers, J. "Sir George Chalmers, (c 1720–1791), Portraitist of James Lind." *JLL Bulletin.* The James Lind Library. www.jameslind library.org/contents.

Chaplin, Joyce E. "Mark Catesby: A Skeptical Newtonian in America." In Meyers and Pritchard, *Empire's Nature,* 34–90.

———. *Subject Matter: Technology, the Body, and Science on the Anglo-American Frontier, 1500–1676.* Cambridge, MA: Harvard University Press, 2001.

"Charles Town: Descriptions of Eighteenth-Century Charles Town before the Revolution. . . ." Becoming American: The British Atlantic Colonies, 1690–1763. National Humanities Center Resource Toolbox, 2009. http://nationalhumanitiescenter.org /pds/becomingamer/growth/text2/charlestowndescriptions.pdf.

Chippendale, Thomas. *The Gentleman and Cabinet-Maker's Director.* New York: Dover, 1966. Facsimile reprint of third edition published in London 1762.

Clifford, Henry, and Carl Zigrosser. "A World of Flowers: Paintings and Prints." *Philadelphia Museum of Art Bulletin* 58, no. 277 (Spring 1963): 93, 97–243.

Collections of the New-York Historical Society for the Year 1885. Publication Fund Series. New York: New-York Historical Society, 1886.

Colwill, Stiles Tuttle. "A Chronicle of Artists in Joshua Johnson's Baltimore." In Weekley and Colwill, *Joshua Johnson,* 69–94.

Conlin, Jonathan. "'At the Expense of the Public': The Sign Painters' Exhibition of 1762 and the Public Sphere." *Eighteenth-Century Studies* 36, no. 1 (Fall 2002): 1–21.

Constable, W. G. *Art Collecting in the United States of America: An Outline of a History.* London: Thomas Nelson and Sons, 1964.

Cooper, Wm. Durrant, ed. *Lists of Foreign Protestants, and Aliens, Resident in England, 1618–1688.* Westminster, ENG: Camden Society, 1862.

Copley, John Singleton, and Henry Pelham. *Letters and Papers of John Singleton Copley and Henry Pelham, 1739–1776.* Massachusetts Historical Society, Collections, 71. Boston: Massachusetts Historical Society, 1914.

Corwin, E. T., under the auspices of the state historian, James A. Holden. *Ecclesiastical Records, State of New York.* Vol. 7, Index. Albany, New York: University of the State of New York, 1916.

Craven, Wayne. *Colonial American Portraiture: The Economic, Religious, Social, Cultural, Philosophical, Scientific, and Aesthetic Foundations.* Cambridge: Cambridge University Press, 1986.

———. "John Wollaston: His Career in England and New York City." *American Art Journal* 7, no. 2 (November 1975): 19–31.

———. "Painting in New York City, 1750–1775." In Quimby, *American Painting to 1776,* 251–297.

Cumming, W. P., R. A. Shelton, and D. B. Quinn. *The Discovery of North America.* New York: American Heritage Press, 1972.

Custis, John. *The Letterbook of John Custis IV of Williamsburg, 1717–1742.* Edited by Josephine Little Zuppan. Lanham, MD: Rowman & Littlefield, 2005.

Darlington, William. *Memorials of John Bartram and Humphry Marshall with Notices of Their Botanical Contemporaries.* Philadelphia: Lindsay and Blakiston, 1849.

Davis, Richard Beale. *Intellectual Life in the Colonial South, 1585–1763.* 3 vols. Knoxville: University of Tennessee Press, 1978.

Dawes, Frank. "Philip Hart." *Musical Times* 106, no. 1469 (July 1965): 510–515.

Dexter, Franklin Bowditch. *Biographical Sketches of the Graduates of Yale College with Annals of the College History.* Vol. 6, *September, 1805–September, 1815.* New Haven, CT: Yale University Press, 1912.

[Diderot, Denis, and Jean le Rond d'Alembert, eds]. *Recueil de Planches, sur les Sciences, les Arts Libéraux, et les Arts Méchaniques, avec leur Explication* [Collection of Plates on the Sciences, Liberal and Mechanic Arts with Their Explanation]. Vol. 2, part 2 [Vol. 20 of *Encyclopédie*]. Paris, 1763.

Doud, Richard K. "John Hesselius, Maryland Limner." *Winterthur Portfolio* 5 (1969): 129–153.

Dresser, Louisa. "Jeremiah Theus: Notes on the Date and Place of His Birth and Two Problem Portraits Signed by Him." *Worcester Art Museum Annual* 6 (1958): 43–44.

Dunlap, William. *A History of the Rise and Progress of the Arts of Design in the United States.* Edited by Rita Weiss. 2 vols. bound as 3. New York: Dover, 1969. Reprint of original 1834 edition.

Earle, Alice Morse. *Two Centuries of Costume in America, 1620–1820.* Vol. 2. New York: Macmillan, 1903.

Easterby, J. H., ed. *The Journal of the Commons House of Assembly, November 10, 1736–June 7, 1739.* The Colonial Records of South Carolina. Columbia: Historical Commission of South Carolina, 1951.

Edwards, George. *A Natural History of Uncommon Birds, and of Some Other Rare and Undescribed Animals, Quadrupedes, Reptiles, Fishes, Insects, etc. . . .* 4 vols. London, 1743–1751.

"Eighteenth Century Receipts: From the Papers of Mrs John Drayton Grimké." *South Carolina Historical and Genealogical Magazine* 34, no. 3 (July 1933): 170–172.

Elfe, Thomas. "The Thomas Elfe Account Book, 1768–1775." Contributed by Mabel L. Webber. *South Carolina Historical and Genealogical Magazine* 35, no. 4 (October 1934): 153–165.

The English Baronetage: Containing a Genealogical and Historical Account of All the English Baronets, Now Existing: Their Descents, Marriages, and Issues; Memorable Actions. . . . Illustrated with Their Coats of Arms . . . with an Explanatory Index. . . . Vol. 4. London, 1741.

Evans, Dorinda. *Benjamin West and His American Students.* Washington, DC: Smithsonian Institution Press, 1980.

"Families of Lower Norfolk and Princess Anne Counties." *Virginia Magazine of History and Biography* 5, no. 3 (January 1898): 327–334.

Fant, Christie Zimmerman, Margaret Belser Hollis, and Virginia Gurley Meynard. *South Carolina Portraits: A Collection of Portraits of South Carolinians and Portraits in South Carolina.* Clemson, SC: National Society of the Colonial Dames of America in the State of South Carolina, 1996.

Fitzhugh, William. "Letters of William Fitzhugh." *Virginia Magazine of History and Biography* 6, no. 1 (July 1898): 60–72; and no. 2 (October 1898): 158–162.

———. *William Fitzhugh and His Chesapeake World, 1676–1701: The Fitzhugh Letters and Other Documents.* Edited by Richard Beale Davis. Chapel Hill: University of North Carolina Press, 1963.

Fleischer, Roland E. "Emblems and Colonial American Painting." *American Art Journal* 20, no. 3 (1988): 2–35.

———. "Gustavus Hesselius and Penn Family Portraits: A Conflict between Visual and Documentary Evidence." *American Art Journal* 19, no. 3 (1987): 5–18.

———. "Gustavus Hesselius: A Study of His Style." In Quimby, *American Painting to 1776,* 127–158.

Flexner, James Thomas. "Benjamin West's American Neo-Classicism: With Documents on West and William Williams." *New-York Historical Society Quarterly* 36, no. 1 (January 1952): 5–41.

Foote, Henry Wilder. "Benjamin Blyth, of Salem: Eighteenth-Century Artist." *Proceedings of the Massachusetts Historical Society,* 3rd ser., 71 (October 1953–May 1957): 64–107.

———. "Charles Bridges: 'Sergeant-Painter of Virginia,' 1735–1740." *Virginia Magazine of History and Biography* 60, no. 1 (January 1952): 3–55.

Frick, George Frederick, and Raymond Phineas Stearns. *Mark Catesby: The Colonial Audubon.* Urbana: University of Illinois Press, 1961.

Galt, John. *The Life and Studies of Benjamin West, Esq., President of the Royal Academy of London, Prior to His Arrival in England.* Philadelphia: Moses Thomas, 1816.

Gardner, Elizabeth E. "A Portrait by John Mare." *Metropolitan Museum of Art Bulletin,* n.s., 14, no. 3 (November 1955): 61–63.

Gaudio, Michael. "Surface and Depth: The Art of Early American Natural History." In Prince, *Stuffing Birds, Pressing Plants, Shaping Knowledge,* 55–73.

Geddy, Pamela McLellan. "Cosmo Alexander: His Travels and Patronage in America." Master's thesis, Virginia Commonwealth University, 1978.

Gee, Wilson. "South Carolina Botanists: Biography and Bibliography." *Bulletin of the University of South Carolina* 72 (September 1918).

Gibson-Wood, Carol. "Picture Consumption in London at the End of the Seventeenth Century." *Art Bulletin* 84, no. 3 (September 2002): 491–500.

Gill, Harold B., Jr. "Dr. de Sequeyra's 'Diseases of Virginia.'" *Virginia Magazine of History and Biography* 86, no. 3 (July 1978): 295–298.

Giovanopoulos, Anna-Christina. "The Legal Status of Children in Eighteenth-Century England." In *Fashioning Childhood in the Eighteenth Century: Age and Identity,* edited by Anja Müller, 43–52. Aldershot, ENG; Burlington, VT: Ashgate, 2006.

Goodfellow, Gavin Maitland. "Cosmo Alexander: The Art, Life, and Times of Cosmo Alexander (1724–1772), Portrait Painter in Scotland and America." Master's thesis, Oberlin College, 1961.

Goodwin, W. A. R. *Historical Sketch of Bruton Church, Williamsburg, Virginia.* Petersburg, VA: Franklin Press, 1903.

Grenville, Richard. "The Voiage Made by Sir Richard Greenvile [Grenville], for Sir Walter Ralegh [Raleigh], to Virginia, in the Yeere 1585." In vol. 8 of *The Principal Navigations Voyages Traffiques and Discoveries of the English Nation Made by Sea or Over-land to the Remote and Farthest Distant Quarters of the Earth at Any Time within the Compasse of These 1600 Yeeres,* edited by Richard Hakluyt, 310–318. Glasgow, SCOT: James MacLehose and Sons, 1904.

Groce, George C. "John Wollaston (Fl. 1736–1767): A Cosmopolitan Painter in the British Colonies." *Art Quarterly* 15, no. 2 (Summer 1952): 133–149.

Habersham, James. *The Letters of Hon. James Habersham, 1756–1775.* Vol. 6 of *Collections of the Georgia Historical Society.* Savannah: Georgia Historical Society, 1904.

Hakluyt, Richard. *A Particuler Discourse Concerning the Greate Necessitie and Manifolde Commodyties That Are Like to Growe to This Realme of Englande by the Westerne Discoveries Lately Attempted, Written in the Yere 1584.* Edited by David B. Quinn and Alison M. Quinn. London: Hakluyt Society, 1993.

Hall, Clayton Colman, ed. *Baltimore: Its History and Its People.* Vol. 3, *Biography.* New York: Lewis Historical Publishing, 1912.

Hall, Virginius Cornick, Jr., comp. *Portraits in the Collection of the Virginia Historical Society: A Catalogue.* Charlottesville: University of Virginia Press, 1981.

Hamilton, Alexander. *Hamilton's Itinerarium: Being a Narrative of a Journey from Annapolis, Maryland, through Delaware, Pennsylvania, New York, New Jersey, Connecticut, Rhode Island, Massachusetts and New Hampshire from May to September, 1744.* Edited by Albert Bushnell Hart. St. Louis, MO, 1907.

Hariot, Thomas. *A Briefe and True Report of the New Found Land of Virginia.* Frankfurt, 1590. Facsimile edition by Readex Microprint, 1966.

Harrison, Charles, Paul Wood, and Jason Gaiger, eds. *Art in Theory, 1648–1815: An Anthology of Changing Ideas.* Malden, MA: Blackwell, 2000.

Hart, Charles Henry. "Gustavus Hesselius: The Earliest Painter and Organ-Builder in America." *Pennsylvania Magazine of History and Biography* 29, no. 2 (1905): 129–133.

———, ed. "Letters from William Franklin to William Strahan." *Pennsylvania Magazine of History and Biography* 35, no. 4 (1911): 415–462.

———. "Notes and Queries." *Pennsylvania Magazine of History and Biography* 30, no. 2 (1906): 241–251.

Hawkins, John. *A General History of the Science and Practice of Music.* A New Edition, with the Author's Posthumous Notes. Vol. 2. London: J. Alfred Novello, 1853.

Hazard, Ebenezer. "The Journal of Ebenezer Hazard in Virginia, 1777." Edited by Fred Shelley. *Virginia Magazine of History and Biography* 62, no. 4 (October 1954): 400–423.

Heitman, Francis B. *Historical Register of Officers of the Continental Army during the War of the Revolution, April, 1775 to December, 1783.* Baltimore, MD: Genealogical Publishing, 1982. Reprint of original 1914 edition.

Heitzler, Michael J. *Goose Creek: A Definitive History.* Vol. 1, *Planters, Politicians and Patriots.* Charleston, SC: The History Press, 2005.

Hemphill, C. Dallett. "Middle Class Rising in Revolutionary America: The Evidence from Manners." *Journal of Social History* 30, no. 2 (Winter 1996): 317–344.

Henshaw, J. P. K. *Memoir of the Life of the Rt. Rev. Richard Canning Moore, D.D., Bishop of the Protestant Episcopal Church in the Diocese of Virginia.* Philadelphia: William Stavely, 1842.

Herdeg, John A. "Re-Introducing Helena." *Antiques & Fine Art Magazine.* www.antiquesandfineart.com/articles/article.cfm?request=572.

Higgins, W. Robert. "Charles Town Merchants and Factors Dealing in the External Negro Trade, 1735–1775." *South Carolina Historical Magazine* 65, no. 4 (October 1964): 205–217.

"Historical Notes." *South Carolina Historical and Genealogical Magazine* 10, no. 1 (January 1909): 69–70.

Hockley, Richard. "Selected Letters from the Letter-Book of Richard Hockley, of Philadelphia, 1739–1742." *Pennsylvania Magazine of History and Biography* 28, no. 1 (1904): 26–44.

Hoffman, Ronald, Sally D. Mason, and Eleanor S. Darcy, eds. *Dear Papa, Dear Charley: The Peregrinations of a Revolutionary Aristocrat, as Told by Charles Carroll of Carrollton and His Father, Charles Carroll of Annapolis, with Sundry Observations on Bastardy, Child-Rearing, Romance, Matrimony, Commerce, Tobacco, Slavery, and the Politics of Revolutionary America.* Vol. 1. Chapel Hill and London: University of North Carolina Press, 2001.

Holland, Eugenia Calvert, Romaine Stec Somerville, Stiles Tuttle Colwill, and K. Beverley Whiting Young. *Four Generations of Commissions: The Peale Collection of the Maryland Historical Society.* Baltimore: Maryland Historical Society, 1975.

Hood, Graham. *Charles Bridges and William Dering: Two Virginia Painters, 1735–1750.* Williamsburg, VA: Colonial Williamsburg Foundation, 1978.

———. "'Easy, Erect and Noble.'" *Colonial Williamsburg: The Journal of the Colonial Williamsburg Foundation* 24, no. 2 (Summer 2002): 52–57.

Horn, James. *A Land as God Made It: Jamestown and the Birth of America.* New York: Basic Books, 2005.

Hulton, Paul. "Jacques Le Moyne de Morgues: A Biographical Sketch." In Hulton, *Work of Jacques Le Moyne de Morgues*, 1:3–12.

———. "Jacques Le Moyne de Morgues, *Peintre.*" In Hulton, *Work of Jacques Le Moyne de Morgues*, 1:75–83.

———. *The Work of Jacques Le Moyne de Morgues: A Huguenot Artist in France, Florida and England.* With contributions by D. B. Quinn, R. A. Skelton, William C. Sturtevant, and William T. Stearn. 2 vols. London: British Museum Publications, 1977.

Hvidt, Kristian, ed. *Von Reck's Voyage: Drawings and Journal of Philip Georg Friedrich von Reck.* With the assistance of Joseph Ewan, George F. Jones, and William C. Sturtevant. Savannah, GA: Beehive Press, 1990. Originally published 1980.

Izard, Ralph. *Correspondence of Mr. Ralph Izard, of South Carolina, from the Year 1774 to 1804; with a Short Memoir.* Edited by Anne Izard Deas. Vol. 1. New York: Charles S. Francis, 1844.

Jefferson, Thomas. *The Writings of Thomas Jefferson.* Edited by Andrew A. Lipscomb and Albert Ellery Berg. Vol. 14. Washington, DC: Thomas Jefferson Memorial Association, 1903.

Jervey, Elizabeth Heyward, trans. "Marriage and Death Notices from the *City Gazette* and *Daily Advertiser.*" *South Carolina Historical and Genealogical Magazine* 33, no. 1 (January 1932): 63–77; and 33, no. 2 (April 1932): 140–147.

Jones, George Fenwick. *The Georgia Dutch: From the Rhine and Danube to the Savannah, 1733–1783.* Athens: University of Georgia Press, 1992.

Jones, William Bright. "The Portraits of Richard and William Jennys and the Story of Their Wayfaring Lives." In *Painting and Portrait Making in the American Northeast*, the Dublin Seminar for New England Folklife Annual Proceedings 1994, edited by Peter Benes, 64–97. Boston: Boston University Press, 1995.

Jourdan, Elise Greenup. *Abstracts of the Land Records of Prince George's County, Maryland, 1726–1733, Taken from Microfilm of Prince George's County Court (Land Records): 1726–1730 M,i. CR 49,518; 1730–1733 Q,i. CR 49,519.* Westminster, MD: Willow Bend Books, 2005.

Kalman, Andras. *English Naive Paintings: From the Collection of Mr. and Mrs. Andras Kalman, London.* London: Crane Kalman Gallery, 197-.

Katheder, Thomas. *The Baylors of Newmarket: The Decline and Fall of a Virginia Planter Family.* Bloomington, IN: iUniverse, 2009.

Kerr, Jessica M. "Mary Harvey: The Lady Dering." *Music and Letters* 25, no. 1 (January 1944): 23–33.

Kelby, William, comp. *Notes on American Artists, 1754–1820: Copied from Advertisements Appearing in the Newspapers of the Day.* John Divine Jones Fund Series of Histories and Memoirs 5. Bew York: New-York Historical Society, 1922.

Kimber, E., and R. Johnson. *The Baronetage of England: Containing a Genealogical and Historical Account of All the English Baronets Now Existing . . . Illustrated with Their Coats of Arms . . . To Which Is Added, an Account of Such Nova-Scotia Baronets as Are of English Families; and a Dictionary of Heraldry. . . .* Vol. 3. London, 1771.

Kirker, Harold. "The New Theater, Philadelphia, 1791–1792." *Journal of the Society of Architectural Historians* 22, no. 1 (March 1963): 36–37.

Klingberg, Frank J. *Carolina Chronicle: The Papers of Commissary Gideon Johnston, 1707–1716.* University of California Publications in History, vol. 35. Berkeley: University of California Press, 1946.

Kolbe, Christian, and Brent Holcomb. "Fraktur in the 'Dutch Fork' Area of South Carolina." *Journal of Early Southern Decorative Arts* 5, no. 2 (November 1979): 36–51.

Lawson, John. *The History of Carolina; Containing the Exact Description and Natural History of That Country: Together with the Present State Thereof. And a Journal of a Thousand Miles, Travel'd thro' Several Nations of Indians. Giving a Particular Account of Their Customs, Manners, &c.* London, 1714.

Lee, Richard Henry. *The Letters of Richard Henry Lee.* Vol. 1, *1762–1778.* Edited by James Curtis Ballagh. New York: MacMillan, 1911.

Leibundguth, Arthur W. "The Furniture-Making Crafts in Philadelphia, c. 1730–c. 1760." Master's thesis, University of Delaware, 1964.

Lennam, T. N. S. "Sir Edward Dering's Collection of Playbooks, 1619–1624." *Shakespeare Quarterly* 16, no. 2 (Spring 1965): 145–153.

Lewis, Jan. *The Pursuit of Happiness: Family and Values in Jefferson's Virginia.* Cambridge: Cambridge University Press, 1983.

Lockridge, Kenneth A. *The Diary, and Life, of William Byrd II of Virginia, 1674–1744.* Chapel Hill: University of North Carolina Press, 1987.

———. "Overcoming Nausea: The Brothers Hesselius and the American Mystery." *Common-Place: The Interactive Journal of Early American Life* 4, no. 2 (January 2004). www.common-place.org/vol-04/no-02/lockridge.

Lovell, Margaretta M. *Art in a Season of Revolution: Painters, Artisans, and Patrons in Early America.* Philadelphia, PA: University of Pennsylvania Press, 2005.

Mack, Angela D. *Henry Benbridge: Charleston Portrait Painter (1743–1812).* Charleston, SC: Gibbes Museum of Art, 2000.

Mack, Angela D., and J. Thomas Savage. "Reflections of Refinement: Portraits of Charlestonians at Home and Abroad." In McInnis and Mack, *In Pursuit of Refinement,* 23–38.

Manigault, Ann. "Extracts from the Journal of Mrs. Ann Manigault, 1754–1781." Edited by Mabel L. Webber. *South Carolina Historical and Genealogical Magazine* 20, no. 2 (April 1919): 128–141; no. 3 (July 1919): 204–212; and no. 4 (October, 1919): 256–259.

Manigault, Peter. "Peter Manigault's Letters." Edited by Mabel L. Webber. *South Carolina Historical and Genealogical Magazine* 31, no. 3 (July 1930): 171–183; and no. 4 (October 1930): 269–282.

McBurney, Henrietta. *Mark Catesby's "Natural History" of America: The Watercolors from the Royal Library, Windsor Castle.* London: Merrell Holberton, 1997.

McCully, Bruce T. "Governor Francis Nicholson, Patron *Par Excellence* of Religion and Learning in Colonial America." *William and Mary Quarterly,* 3rd ser., 39, no. 2 (April 1982): 310–333.

McDaniel, George W., and Carter C. Hudgins. "Mystery at Drayton Hall." *The Magazine Antiques* 177, no. 4 (Summer 2010): 148–151.

McInnis, Maurie D. "'Our Ingenious Countryman Mr. Benbridge.'" In Mack, *Henry Benbridge,* 5–19.

McInnis, Maurie D., in collaboration with Angela D. Mack. *In Pursuit of Refinement: Charlestonians Abroad, 1740–1860.* Columbia: University of South Carolina Press, 1999.

McNeal, R. A. "Joseph Allen Smith, American Grand Tourist." *International Journal of the Classical Tradition* 4, no. 1 (Summer 1997): 64–91.

McWilliams, Mary E. *Brush-Everard House Historical Report, Block 29 Building 10 Lot 165 and 166.* Colonial Williamsburg Foundation Library Research Report Series 1575. Williamsburg, VA: Colonial Williamsburg Foundation, 1943, 1990.

Meade, Bishop [William]. *Old Churches, Ministers and Families of Virginia.* Vol. 1. Philadelphia: J. B. Lippincott, 1857.

Meschutt, David. "William Byrd and His Portrait Collection." *Journal of Early Southern Decorative Arts* 14, no. 1 (May 1988): 19–46.

Meyers, Amy R. W. "'The Perfecting of Natural History': Mark Catesby's Drawings of American Flora and Fauna in the Royal Library, Windsor Castle." In McBurney, *Mark Catesby's "Natural History" of America,* 11–27.

———. "Picturing a World in Flux: Mark Catesby's Response to Environmental Interchange and Colonial Expansion." In Meyers and Pritchard, *Empire's Nature,* 228–261.

———. "Sketches from the Wilderness: Changing Conceptions of Nature in American Natural History Illustrations: 1680–1880." PhD diss., Yale University, 1985.

Meyers, Amy R. W., and Margaret Beck Pritchard, eds. *Empire's Nature: Mark Catesby's New World Vision.* Chapel Hill: University of North Carolina Press, 1998.

Middleton, Margaret Simons. *Jeremiah Theus: Colonial Artist of Charles Town.* rev. ed. With supplement by Dorothy Middleton Anderson and Margaret Middleton Rivers. Columbia: University of South Carolina Press, 1991. Originally published 1953.

———. "Thomas Coram, Engraver and Painter." *The Magazine Antiques* 29, no. 6 (June 1936): 242–244.

Miles, Ellen G. *George and Martha Washington: Portraits from the Presidential Years.* Charlottesville: National Gallery, Smithsonian Institution, in association with University Press of Virginia, 1999.

———. "Justus Engelhardt Kuhn (Died 1717)." In Saunders and Miles, *American Colonial Portraits,* 88–89.

———. "The Portrait in America, 1750–1776." In Saunders and Miles, *American Colonial Portraits,* 28–76.

———. *Thomas Hudson, 1701–1779: Portrait Painter and Collector: A Bicentenary Exhibition.* London: Greater London Council, 1979.

Miller, Lillian, et al., eds. *The Selected Papers of Charles Willson Peale and His Family.* Vol. 1, *Charles Willson Peale: Artist in Revolutionary America, 1735–1791.* New Haven, CT: Yale University Press, 1983.

Mooz, R. Peter. "Robert Feke: The Philadelphia Story." In Quimby, *American Painting to 1776,* 181–216.

Morgan, John Hill. *Early American Painters.* New York: New-York Historical Society, 1921.

———. "Notes on John Wollaston and His Portrait of Sir Charles Handy." *Brooklyn Museum Quarterly* 10, no. 1 (January 1923): 1–9.

Muhlenberg, Henry Melchior. *The Journals of Henry Melchior Muhlenberg.* Translated by Theodore G. Tappert and John W. Doberstein. Vol. 2. Philadelphia, PA: Muhlenberg Press, 1945.

Murphy, Arthur. *The Works of Samuel Johnson, LL.D., with an Essay on His Life and Genius.* Vol. 1. New York: George Dearborn, 1837.

Neale, Suzanne. "Charles Bridges: Painter and Humanitarian." Master's thesis, College of William and Mary, 1969.

O'Kelley, Patrick. *"Nothing but Blood and Slaughter": The Revolutionary War in the Carolinas.* Vol. 2, *1780.* Lillington, NC: Blue House Tavern Press, 2004.

Page, Richard Channing Moore. *Genealogy of the Page Family in Virginia: Also a Condensed Account of the Nelson, Walker, Pendleton and Randolph Families, with References to the Byrd, Carter, Cary, Duke, Gilmer, Harrison, Rives, Thornton, Wellford, Washington, and Other Distinguished Families in Virginia.* New York: Jenkins & Thomas, 1883.

Paine, Nathaniel. *Early American Engravings and the Cambridge Press Imprints, 1640–1692.* Worcester, MA: American Antiquarian Society, 1906.

Palmer, Wm. P., ed. *Calendar of Virginia State Papers and Other Manuscripts, 1652–1781, Preserved in the Capitol at Richmond.* Vol. 1. New York: Kraus Reprint, 1968. Reprint of original 1875 edition.

Parramore, Thomas C. *Launching the Craft: The First Half-Century of Freemasonry in North Carolina.* Raleigh, NC: Litho Industries, 1975.

Patrick, Stephen E. "'I Have at Length Determined to Have My Picture Taken': An Eighteenth-Century Young Man's Thoughts about His Portrait by Henry Benbridge." *American Art Journal* 22, no. 4 (1990): 68–81.

"Paul Sandby and His Times." *Arnold's Magazine of the Fine Arts, and Journal of Literature and Science* 2, no. 11 (December 1831): 338–345.

Perry, William Stevens. *The History of the American Episcopal Church,*

1587–1883. Vol. 1, *The Planting and Growth of the American Colonial Church, 1587–1783*. Boston: James R. Osgood, 1885.

"Personal Property List Dinwiddie County, 1782." *William and Mary Quarterly* 26, no. 4 (April 1918): 250–258.

Pilkington, Matthew. *The Gentleman's and Connoisseur's Dictionary of Painters. Containing a Complete Collection, and Account, of the Most Distinguished Artists. . . .* London, 1770. Editions after 1824 titled *A General Dictionary of Painters,* commonly known as "Pilkington's Dictionary."

Pitcher, Edward W. "A Busk—An Indian Council: A Use Not Cited in *OED*." *ANQ: A Quarterly Journal of Short Articles, Notes and Reviews* 4, no. 2 (April 1991): 87.

Pleasants, J. Hall. *Justus Engelhardt Kühn: An Early Eighteenth Century Maryland Portrait Painter.* Worcester, MA: American Antiquarian Society, 1937.

———. "William Dering: A Mid-Eighteenth Century Williamsburg Portrait Painter." *Virginia Magazine of History and Biography* 60, no. 1 (January 1952): 56–63.

Poland, William Carey. "Robert Feke: The Early Newport Portrait Painter, and the Beginnings of Colonial Painting." In *Proceedings of the Rhode Island Historical Society, 1904–1905,* 73–96. Providence: Rhode Island Historical Society, 1907.

Powers, Lou. *Barraud (Dr.) House Historical Report, Block 10 Building 1 Lot 19.* Colonial Williamsburg Foundation Library Research Report Series 1193. Williamsburg, VA: Colonial Williamsburg Foundation, 1988, 1990.

Pratt, Matthew. "Autobiographical Notes of Matthew Pratt, Painter." Contributed by Charles Henry Hart. *Pennsylvania Magazine of History and Biography* 19, no. 4 (1895): 460–467.

Prince, Sue Ann, ed. *Stuffing Birds, Pressing Plants, Shaping Knowledge: Natural History in North America, 1730–1860.* Philadelphia: American Philosophical Society, 2003.

Pringle, Ashmead F., Jr. "Thomas Coram's Bible." *The Magazine Antiques* 30, no. 5 (November 1936): 226–227.

Pritchard, Margaret B. "John Drayton's Watercolors." *The Magazine Antiques* 163, no. 1 (January 2003): 166–173.

———. "A Protracted View: The Relationship between Mapmakers and Naturalists in Recording the Land." In *Knowing Nature: Art and Science in Philadelphia, 1740–1840,* edited by Amy R. W. Meyers. New Haven, CT: Yale University Press, forthcoming.

Pritchard, Margaret Beck, and Virginia Lascara Sites. *William Byrd II and His Lost History: Engravings of the Americas.* Williamsburg, VA: Colonial Williamsburg Foundation, 1993.

Pritchard, Margaret Beck, and Henry G. Taliaferro. *Degrees of Latitude: Mapping Colonial America.* Williamsburg, VA: Colonial Williamsburg Foundation in association with Harry N. Abrams, 2002.

Prown, Jules David. *John Singleton Copley: In America 1738–1774.* 2 vols. Cambridge, MA: Harvard University Press for the National Gallery of Art, 1966.

———. "Review of *The Notebook of John Smibert*." *Art Bulletin* 52, no. 3 (September 1970): 330–331.

Quimby, Ian M. G., ed. *American Painting to 1776: A Reappraisal.* Winterthur Conference Report 1971. Charlottesville: University Press of Virginia, 1971.

Quinn, David B. "The Attempted Colonization of Florida by the French, 1562–1565." In Hulton, *Work of Jacques Le Moyne de Morgues,* 1:17–44.

———, ed. *English Plans for North America. The Roanoke Voyages. New England Ventures.* Vol. 3 of *New American World: A Documentary History of North America to 1612.* New York: Arno and Hector Bye, 1979.

Ramsay, David. *The History of South-Carolina, from Its First Settlement in 1670, to the Year 1808.* Vol. 2. Charleston, SC: David Longworth for the author, 1809.

Ratcliff, Clarence E. *North Carolina Taxpayers, 1679–1790.* Vol. 2. Baltimore, MD: Genealogical Publishing, 1987.

Rather, Susan. "Carpenter, Tailor, Shoemaker, Artist: Copley and Portrait Painting around 1770." *Art Bulletin* 79, no. 2 (June 1997): 269–290.

———. "A Painter's Progress: Matthew Pratt and *The American School*." *Metropolitan Museum Journal* 28 (1993): 169–183.

Ravenel, Mrs. St. Julien [Harriott Horry]. *Charleston: The Place and the People.* New York: Macmillan, 1906.

———. *Eliza Pinckney.* Women of Colonial and Revolutionary Times. New York: Charles Scribner's Sons, 1896.

"Records of Trinity Church Parish, New York City." *New York Genealogical and Biographical Record* 70, no. 3 (July 1939): 271–276.

Register, Alvaretta Kenan. *State Census of North Carolina, 1784–1787.* Baltimore, MD: Genealogical Publishing, 1974. Reprint of 1971 second edition, revised.

"Register of the Independent Congregational (Circular) Church of Charleston, South Carolina, 1784–1815." *South Carolina Historical and Genealogical Magazine* 34, no. 1 (January 1933): 47–54.

Reinhardt, Leslie. "'Dress and Dissipation': Costume in Henry Benbridge's Charleston Paintings." In Mack, *Henry Benbridge,* 21–29.

Reynolds, Joshua. *Sir Joshua Reynolds's Discourses.* Edited by Edward Gilpin Johnson. Chicago: A. C. McClurg, 1891.

Ribeiro, Aileen. *The Art of Dress: Fashion in England and France, 1750 to 1820.* New Haven, CT: Yale University Press, 1995.

Richardson, E. P. "James Claypoole, Junior, Re-discovered." *Art Quarterly* 33, no. 2 (Summer 1970): 159–175.

———. *Painting in America from 1502 to the Present.* New York: Thomas Y. Crowell, 1965.

———. "William Williams—A Dissenting Opinion." *American Art Journal* 4, no. 1 (Spring 1972): 5–23.

Riley, Helene M. Kastinger. "Charleston's Drawing Master: Bernhard Albrecht Moll and the South Carolina Expedition of Emperor Joseph II of Austria." *Journal of Early Southern Decorative Arts* 21, no. 1 (Summer 1995): 5–88.

———. "German Romanticism in Old Charles Towne? Rediscovering William Henry Timrod (1792–1838), Bookbinder-Poet." *South Atlantic Review* 59, no. 1 (January 1994): 65–85.

———. "Michael Kalteisen and the Founding of the German Friendly Society in Charleston." *South Carolina Historical Magazine* 100, no. 1 (January 1999): 29–48.

Roach, Hannah Benner. "Taxables in the City of Philadelphia, 1756." *Pennsylvania Genealogical Magazine* 22, no. 1 (1961): 3–41.

Roark, Elisabeth L. *Artists of Colonial America.* Westport, CT: Greenwood, 2003.

Robins, Robert W., comp. *The Register of Abingdon Parish, Gloucester County, Virginia, 1677–1780.* Arlington, VA: Honford House, 1981.

Rogers, George C., Jr. "Changes in Taste in the Eighteenth Century: A Shift from the Useful to the Ornamental." *Journal of Early Southern Decorative Arts* 8, no. 1 (May 1982): 1–23.

Rouse, Parke, Jr. *James Blair of Virginia.* Chapel Hill: University of North Carolina Press, 1971.

Rutledge, Anna Wells. "After the Cloth Was Removed." *Winterthur Portfolio* 4 (1968): 47–62.

———. *Artists in the Life of Charleston: Through Colony and State from Restoration to Reconstruction.* Columbia: University of South Carolina Press, 1980. Reprint of original 1949 edition by American Philosophical Society, Philadelphia, PA.

Salley, A. S., Jr., ed. *Marriage Notices in the South-Carolina Gazette and Its Successors (1732–1801).* Albany, NY: John Munsell's Sons, 1902.

Salmon, William. *Polygraphice; or, The Art of Drawing, Engraving, Etching, Limning, Painting, Washing, Varnishing, Colouring and Dying.* London, 1672.

Salt, S. P. "The Origins of Sir Edward Dering's Attack on the Ecclesiastical Hierarchy, c. 1625–1640." *Historical Journal* 30, no. 1 (March 1987): 21–52.

Sanders, Albert E., and William D. Anderson Jr. *Natural History Investigations in South Carolina: From Colonial Times to the Present.* Columbia: University of South Carolina Press, 1999.

Sartain, John. *The Reminiscences of a Very Old Man, 1808–1897.* New York: D. Appleton, 1899.

Saunders, Richard H. *John Smibert: Colonial America's First Portrait Painter.* New Haven, CT: Yale University Press, 1995.

Saunders, Richard H., and Ellen G. Miles. *American Colonial Portraits, 1700–1776.* Washington, DC: Smithsonian Institution Press, 1987.

Sawitzky, William. "The American Work of Benjamin West." *Pennsylvania Magazine of History and Biography* 62, no. 4 (October 1938): 433–462.

———. *Catalogue, Descriptive and Critical, of the Paintings and Miniatures in the Historical Society of Pennsylvania.* Philadelphia: Historical Society of Pennsylvania, 1942.

———. *Matthew Pratt, 1734–1805.* New York: New-York Historical Society with Carnegie Corporation of New York, 1942.

Schimmelman, Janice G. "Books on Drawing and Painting Techniques Available in Eighteenth-Century American Libraries and Bookstores." *Winterthur Portfolio* 19, nos. 2–3 (Summer–Autumn 1984): 193–205.

———. "A Checklist of European Treatises on Art and Essays on Aesthetics Available in America through 1815." In *Proceedings of the American Antiquarian Society, April 27, 1983, and October 19, 1983,* 95–195. Vol. 93. Worcester, MA: American Antiquarian Society, 1983.

Schmid, F. "Some Observations on Artists' Palettes." *Art Bulletin* 40, no. 4 (December 1958): 334–336.

Sellers, Charles Coleman. *The Artist of the Revolution: The Early Life of Charles Willson Peale.* Hebron, CT: Feather and Good, 1939. This book was republished by the American Philosophical Society in 1947 as *Charles Willson Peale.* Vol. 1, *Early Life (1741–1790),* the companion volume to *Charles Willson Peale.* Vol. 2, *Later Life (1790–1827).* Together the two volumes form volume 23 of the Memoirs of the American Philosophical Society series.

———. *Charles Willson Peale.* Vol. 2, *Later Life (1790–1827).* Philadelphia, PA: American Philosophical Society, 1947.

———. "James Peale: A Light in Shadow, 1749–1831." In Holland et al., *Four Generations of Commissions,* 29–33.

———. *Portraits and Miniatures by Charles Willson Peale.* Philadelphia, PA: American Philosophical Society, 1952.

Sellers, Horace Wells. "Charles Willson Peale, Artist-Soldier." *Pennsylvania Magazine of History and Biography* 38, no. 3 (1914): 257–286.

Severens, Martha R. "Jeremiah Theus of Charleston: Plagiarist or Pundit?" *Southern Quarterly* 24, nos. 1–2 (Fall–Winter 1985): 56–70.

———. "Who Was Henrietta Johnston?" *The Magazine Antiques* 148, no. 5 (November 1995): 704–709.

Shames, Susan P. *The Old Plantation: The Artist Revealed.* Williamsburg, VA: Colonial Williamsburg Foundation, 2010.

Shaw, William A. *Letters of Denization and Acts of Naturalization for Aliens in England and Ireland, 1603–1700.* Publications of the Huguenot Society of London, vol. 18. Lyminton, ENG, 1911.

Shea, John Gilmary. "Robert Feke." *Historical Magazine, and Notes and Queries Concerning the Antiquities, History, and Biography of America* 4, no. 9 (September 1860): 280–281.

Sherman, Frederic Fairchild. *Early American Painting.* New York: Century, 1932.

Simmons, Linda Crocker. *Charles Peale Polk, 1776–1822: A Limner and His Likenesses.* Washington, DC: Corcoran Gallery of Art, 1981.

Sloan, Kim. *A New World: England's First View of America.* Chapel Hill: University of North Carolina Press, 2007.

Smart, Alastair. *Allan Ramsay: A Complete Catalogue of His Paintings.* New Haven, CT: Yale University Press, 1999.

Smith, Adam. *An Inquiry into the Nature and Causes of the Wealth of Nations.* Edited by Edwin Cannan, with a new preface by George J. Stigler. Chicago: University of Chicago Press, 1976. Cannan's edition originally published 1904.

Smith, Alvy Ray, comp. *Dr. John Durand (1664–1727) of Derby, Connecticut: His Family through Four Generations, Featuring the Branch of His Youngest Son, Ebenezer Durant, through Ten Generations to 2003.* Boston: Newbury Street Press, 2003.

Smith, Daniel Blake. *Inside the Great House: Planter Family Life in*

Eighteenth-Century Chesapeake Society. New York: Cornell University Press, 1980.

Smith, Helen Burr, and Elizabeth V. Moore. "John Mare: A Composite Portrait." *North Carolina Historical Review* 44, no. 1 (January 1967): 18–52.

Smith, James Edward, ed. *A Selection of the Correspondence of Linnaeus, and Other Naturalists, from the Original Manuscripts.* Vol. 1. London, 1821.

Smith, John. *The Generall Historie of Virginia, New-England, and the Summer Isles with the Names of the Adventurers, Planters, and Governours from Their First Beginning Ano: 1584. to This Present 1624.* London, 1624. Facsimile edition by Nova Anglia Press, Hinesville, GA.

Solomon, Benvenuta. "Pope as a Painter." *Temple Bar: A London Magazine for Town and Country Readers* 121 (September–December 1900): 268–276.

Stallybrass, Peter. "*Admiranda narratio:* A European Best Seller." In Hariot, *Briefe and True Report of the New Found Land of Virginia,* 9–30.

Stanard, Mary Newton. *Colonial Virginia: Its People and Customs.* Philadelphia: J. B. Lippincott, 1917.

Stearn, William T. "The Plant Portraitist and the Herbalist." In Hulton, *Work of Jacques Le Moyne de Morgues,* 1:55–68.

Stearns, Raymond Phineas. *Science in the British Colonies of America.* Urbana: University of Illinois Press, 1970.

Stephenson, Mary A. *Lots 41 and 42 Historical Report, Block 14 Lot 41–42.* Colonial Williamsburg Foundation Library Research Report Series 1306. Williamsburg, VA: Colonial Williamsburg Foundation, 1959, rev. 1990.

Stephenson, Mary A., Patricia Gibbs, and Raymond Townsend. *Brush-Everard House Historical Report, Block 29 Building 10 Lot 165, 166 and 172.* Colonial Williamsburg Foundation Library Research Report Series 1572. Williamsburg, VA: Colonial Williamsburg Foundation, 1956, rev. 1970, 1990.

Stewart, Robert G. *Henry Benbridge (1743–1812): American Portrait Painter.* Washington, DC: Smithsonian Institution Press, 1971.

———. "The Portraits of Henry Benbridge." *American Art Journal* 2, no. 2 (Fall 1970): 58–71.

———. *Robert Edge Pine: A British Portrait Painter in America, 1784–1788.* Washington, DC: Smithsonian Institution Press, 1979.

Strobel, P. A. *The Salzburgers and Their Desdendants: Being the History of a Colony of German (Lutheran) Protestants, Who Emigrated to Georgia in 1734, and Settled at Ebenezer, Twenty-five Miles above the City of Savannah.* Baltimore, MD, 1855.

Strong, Roy. *Gloriana: The Portraits of Queen Elizabeth I.* London: Pimlico, 2003.

Sturtevant, William C. "The Ethnological Evaluation of the Le Moyne-De Bry Illustrations." In Hulton, *Work of Jacques Le Moyne de Morgues,* 1:69–74.

Swem, E. G., ed. *Brothers of the Spade: Correspondence of Peter Collinson of London, and of John Custis, of Williamsburg, Virginia, 1734–1746.* Barre, MA: Barre Gazette, 1957.

Swift, Jonathan. *The Poems of Jonathan Swift,* vol. 1. Vol. 37 of *The British Poets, Including Translations.* Chiswick, ENG, 1822.

Taylor, Brandon. *Art for the Nation: Exhibitions and the London Public, 1747–2001.* Manchester, UK: Manchester University Press, 1999.

Thornbury, Walter. *Old and New London: A Narrative of Its History, Its People, and Its Places.* Vol. 2. London: Cassell, Petter, & Galpin, [1881].

Thorne, Thomas. "Trivia: Note on Charles Bridges, the Painter." *William and Mary Quarterly,* 3rd ser., 8, no. 2 (April 1951): 248.

Tinling, Marion, ed. *The Correspondence of the Three William Byrds of Westover, Virginia, 1684–1776.* 2 vols. Charlottesville: University Press of Virginia, 1977.

Tyler, Lyon G. "Grammar and Mattey Practice and Model School." *William and Mary Quarterly* 4, no. 1 (July 1895): 3–14.

Urlsperger, Samuel, ed. *Detailed Reports on the Salzburger Emigrants Who Settled in America.* Vol. 3, *1736,* translated and edited by George Fenwick Jones and Marie Hahn. Athens: University of Georgia Press, 1972.

Van Buskirk, Judith L. *Generous Enemies: Patriots and Loyalists in Revolutionary New York.* Philadelphia: University of Pennsylvania Press, 2002.

Van Devanter, Ann C. *"Anywhere So Long as There Be Freedom": Charles Carroll of Carrollton, His Family and His Maryland.* Baltimore, MD: Baltimore Museum of Art, 1975.

Verplanck, Anne. "The Silhouette and Quaker Identity in Early National Philadelphia." *Winterthur Portfolio* 43, no. 1 (Spring 2009): 41–78.

"Vestry Proceedings, St. Ann's Parish, Annapolis, MD." *Maryland Historical Magazine* 10, no. 1 (March 1915): 37–41.

Von Erffa, Helmut, and Allen Staley. *The Paintings of Benjamin West.* New Haven, CT: Yale University Press, 1986.

Wagner, Gillian. *Thomas Coram, Gent., 1668–1751.* Woodbridge, UK: Boydell Press, 2004.

Wallace, Wesley H. "Cultural and Social Advertising in Early North Carolina Newspapers." Colonial Records Project, Historical Publications section, North Carolina Office of Archives and History. Accessed Oct., 10, 2011. www.ncpublications.com /colonial/Nchr/Subjects/wallace.htm.

Walpole, Horace. *Anecdotes of Painting.* Vol. 3 of *The Works of Horatio Walpole, Earl of Orford.* London, 1798.

Ward, Edward. *A Compleat and Humorous Account of All the Remarkable Clubs and Societies in the Cities of London and Westminster. . . .* London, 1745.

Warren, Phelps. "Badger Family Portraits." *The Magazine Antiques* 118, no. 5 (November 1980): 1043–1047.

Waselkov, Gregory A., and Kathryn E. Holland Braund, eds. *William Bartram on the Southeastern Indians.* Lincoln: University of Nebraska Press, 1995.

Waterhouse, Ellis. *The Dictionary of British 18th Century Painters in Oils and Crayons.* Woodbridge, GB: Antique Collectors' Club, 1981.

———. *Painting in Britain: 1530 to 1790.* Harmondsworth, Middlesex, ENG: Penguin Books, 1969.

Waters, Henry F. *Genealogical Gleanings in England.* Vol. 2. Boston: New-England Historic Genealogical Society, 1901.

Webber, Mabel L. "Register of the Independent or Congregational (Circular) Church, 1732–1738." *South Carolina Historical and Genealogical Magazine* 12, no. 2 (April 1911): 53–59.

Weekley, Carolyn J. "The Early Years: 1564 to 1790." In *Painting in the South: 1564–1980,* 1–41. Richmond, VA: Virginia Museum of Fine Arts, 1983.

———. "Further Notes on William Dering, Colonial Virginia Portrait Painter." *Journal of Early Southern Decorative Arts* 1, no. 1 (May 1975): 21–28.

———. "Henry Benbridge: Portraits in Small from Norfolk." *Journal of Early Southern Decorative Arts* 4, no. 2 (November 1978): 51–64.

———. *John Singleton Copley: An American Painter Entirely Devoted to His Art.* Williamsburg, VA: Colonial Williamsburg Foundation, 1994.

———. "John Wollaston, Portrait Painter: His Career in Virginia, 1754–1758." Master's thesis, Winterthur Program in Early American Culture, University of Delaware, 1976.

Weekley, Carolyn J., and Stiles Tuttle Colwill with Leroy Graham and Mary Ellen Hayward. *Joshua Johnson: Freeman and Early American Portrait Painter.* Williamsburg, VA, and Baltimore, MD: Abby Aldrich Rockefeller Folk Art Center and Maryland Historical Society, 1987.

Wertkin, Gerard C., ed. *Encyclopedia of American Folk Art.* New York: Routledge, 2004.

Wharton, Anne Hollingsworth. *Salons: Colonial and Republican.* Philadelphia and London: J. B. Lippincott, 1900.

White, Raymond D. "Marine Art in the South: A Brief Overview." *Journal of Early Southern Decorative Arts* 6, no. 2 (November 1980): 49–65.

Williams, George W. "Charleston Church Music, 1562–1833." *Journal of the American Musicological Society* 7, no. 1 (Spring 1954): 35–40.

———. *St. Michael's, Charleston, 1751–1951: With Supplements, 1951–2001.* Charleston, SC: College of Charleston Library, 1951, 2001. Republication of the original 1951 edition with supplements.

Williams, Jerome. "Williams Family of Craven County, NC." Unpublished. Curatorial Files. Abby Aldrich Rockefeller Folk Art Museum, Williamsburg, VA.

Williams, William. *An Essay on the Mechanic of Oil Colours, Considered under These Heads, Oils, Varnishes, and Pigments, with Respect to Their Durability, Transparency, and Force. . . .* Bath, England, 1787.

Wilson, Samuel, Jr. "Louisiana Drawings by Alexandre De Batz." *Journal of the Society of Architectural Historians* 22, no. 2 (May 1963): 75–89.

Winsor, Justin, ed. *The Memorial History of Boston, Including Suffolk County, Massachusetts, 1630–1880.* Vol. 2, *The Provincial Period.* Boston: Ticknor, 1886.

Wright, Richardson. *Revels in Jamaica, 1682–1838.* New York: Benjamin Blom, 1969. Reissue of original 1937 edition.

Wyand, Jeffrey A., and Florence L. Wyand. *Colonial Maryland Naturalizations.* Baltimore, MD: Clearfield, 1975.

Young, William, Jr. *Botanica neglecta.* Edited by Samuel N. Rhoads. Philadelphia: privately printed, 1916. Facsimile edition of *Catalogue d'arbres arbustes et plantes herbacees d'Amerique* published in Paris 1783.

Index

Peale, Rosabella Carriera, 368

Peale, Rubens, 368

Peale, Sarah Miriam, 368, 369

Peale, St. George, 31n17, *355*, **355**

Peale, Titian, 368

Peale family, 3, 354–356, *355*, **355**, 368, 373, 393

Pelham, Henry, 342, *343*, **343**

Peñalver y Cardenas, Luis Ignatius, *2*, **2**, 328

Pendleton, Edmund, 366, *368*, **368**

Penn, Hannah Callowhill, *100*, **100**, 275n80

Pennsylvania, map of, *164*, **164–165**

Pepusch, John Christopher, 226, 233

Perceval, Philip, **110**, *111*

Perceval, Third Baronet, Sir John Perceval, 107, *111*, 408

Perceval, Sir John. *See* Egmont, First Earl of

Peter Manigault (Allan Ramsay), 199, *201*, **201**

Peter Manigault and His Friends (George Roupell), 155, **156**, *157*

Petiver, James, 126–127

pets in portraits, 98; deer, 98, **98**; dogs, **4**, **97**, **192**; parrots, 9; squirrels, **221**, **225**, **284**, **343**

Pettigrew, Mary Blount, 309, *311*, **311**

Pettigrew, Rev. Charles, 309, *311*, **311**

Philadelphia, 25, 30, 186, 391–392; artists in, 3, 8, 100, 101, 148, 170, *171*, 186, 208, 243, 247, 256, 258–259, 293, 369; Benjamin West in, 5, 345, 347; camera obscura in, *197*; naturalists in, 148, 150–151, 158n6, 160n39, 275n94; Peales in, 212n8, 265, 320n12, 354, 366

Philip II, King (Spain), 38

Philip Perceval (Henrietta Johnston), **110**, *111*

Pictish Woman, A (John White), *58*, **58**

Pierce, William, Jr., 20, 32n33, 366

Pilkington, Matthew, 19, 163

Pinckney, Charles, 174

Pinckney, Charles Cotesworth, 107

Pinckney, Eliza Lucas, 247, 273n56, 278, 329

Pine, Robert Edge, 388, *388*, **389–391**, *390*, **390**, *391*, 399n143

Pine and Pinecone (Jacques Le Moyne de Morgues), *47*, 48

Pitt, William. *See* Chatham, Earl of

plantation, plantations, 63–64, 117n3, 262–264; in Caribbean, *252*; definition of, 3; increase of, 163; in South Carolina, 7, 121n66; in Virginia, *248*, *249*, *255*, *265*, *269*; of wealthy families in Charleston, 7, 135

Platt, Jeremiah, 308, *308*, **308**

Podophyllum peltatum (Mayapple) (William Bartram), *154*, **154**

Poland, William Carey, 248–249, 274n69, 274n73

Polk, Charles Peale, 3, 360, 368–372, *372*, *373*, **372–374**, *375*

Polk, Elizabeth Digby Peale, *355*, **355**, 369

Polk, Robert, 369

Pomfret family coat of arms (Charles Catton and Francis Chesham), *281*, **281**

portrait dress, 244–247, *244*, 388; Benbridge and, 383–384, 399n139; Durand and, *287*; neoclassical, 332, 353, 383; price based on, 278; prints as sources for, 199, 278, 385; studio costume as, *351*; Vandyke costume, **ii**, *iv*

Portrait of a Child (Jeremiah Theus), 208, *209*, **209**

Portrait of Washington (Rembrandt Peale), 357

portraits, portraiture, 10, 24–26, 125, 148, 242, 244, 265, 327–328; of clergy, 271n34; collections of, 84; English influence on, 3, 181, 208, *261*; European, 116, 119n29; gentrified, 193, 328; idealization in, 13; importance of, in South, 125, 170, 235, 244–246, 381; popularity of, 1, 6, 24–26, 125, 235; prices for, 8–9, 29–30, 278; process of painting, 277–278; of royalty, 13, 168, 170, 320n6, 335; sittings for, 9; slaves in, *260*; southern preferences in, 3; style in, 10–14; three-quarter-length,

15; in wills, 168. *See also* miniature portraits; poses; royal portraits; *and names of sitters and portrait artists*

poses, 5, 10, 223, 237, 244, *244*; changes in, 328, 269; by Feke, *248*, 253–255, *253*, *254*; formulaic European, 101; by Hudson, 230; by Joseph Badger Sr., *221*, 223; Kneller and, *86*, *92*; neoclassical, 334; by Peale, *360*, 372; price based on, 278; prints as sources for, 199, 278; by Wollaston, *229*, *230*, *231*, *233*, *234*, 237, *237*, 244, *244*, 247

Powell, Burr, and wife, *372*, **372**

Pratt, Matthew, 3, 12, 395n35, 395n37; *The American School*, 345, **346**, 395n37; C. Alexander and, 291; Copley and, 13, *343*; *The Custis Children?*, 347, *348*, **349**; *Elizabeth Gay Bolling and Twin Daughters . . .*, 347, *350*, **350**; *James Balfour and George Balfour*, 347, *351*, **351**; *Jupiter and Europa*, 346–347, *348*, **348**; *Mary Jemima Balfour*, 347, *351*, **351**; *Thomas Bolling*, 347, *350*, **350**; West and, 335, 345

Precour, Peter, 16

Prentis, William, Jr., 403

Price, Uvedale Tomkyns, **230**

Price, William, *172*

prices, 8, 136–137; bartering and, 9; for portraits, 29, 73, 226, 272n49, 278, 320n5, 404

Prime, Dr. Benjamin Young, 308

Pritchard, Margaret Beck, 1, *75*, *139*, 140, 150, 159n27, 161n76

Prospect of Charles Town (Bishop Roberts), *iv*, **vi–vii**, *172*, **173**, 174

provincial style, 10, 25, 33n48, 73, 107, 199, 334

Purdie, Alexander, *287*, *296*, 353

Purry, Jean Pierre, 147, 161n58

Queen Elizabeth I (unidentified artist), *36*, **37**, 51, **52**

Quesnay, Alexander-Marie, 404

Quincy, Josiah, 13

Rachel Moore (Henry Benbridge), 5, **5**

Raleigh, Sir Walter, 38, *38*, **39**, 46, 48, 50, 60nn33–34

Ralph Wormeley V (Robert Edge Pine), 388, *388*, **389**

Ramsay, Allan, 13, 168, 292, *343*; *Anne Bayne Ramsay*, 14, **14**; *Peter Manigault*, 199, *201*, **201**, 244, 278, 388; portrait of Queen Charlotte by, *201*

Ramsay, Anne Bayne, *14*, **14**

Ramsay, Dr. David, 298, 301, 379, 398n120

Randolph, Anne, 237, *238*, **241**

Randolph, Anne Harrison, *238*

Randolph, Beverley, 230, *233*, **233**

Randolph, Elizabeth, 237, *238*, **240**

Randolph, Elizabeth Beverley, *69*, *81*

Randolph, Isham, **80**, 118n25

Randolph, Mary Isham, 65, **69**, *80*

Randolph, William, 65, **69**, *80*, 118n25, 215n87

Randolph, William, II, 80, **81**, *233*, 237, *238*, **238**

Randolph, William, III, *238*

Rapalje, Garret, children of, *282*, **283**, 285

Rapalje Children, The (John Durand), *282*, **283**, 285

Ratcliffe, Elizabeth, 382

Rather, Susan, 12, 14, 31n15, 33n48, 395n39

Rawlinson, Richard, *142*

Ray, John, 130, 131

Reade, Joseph, 233–234, *234*, **234**, *237*

Rebecca Bonum Eskridge (unidentified artist), **82**

Rebecca Lewis and Warner Lewis II (John Wollaston Jr.), 242, *242*, **242**

Rebeckah Champion (possibly Robert Dowsing), *92*, **92**

Red-Winged Blackbird (George Edwards), *139*, **139**

Reinagle, Philip, 330